THE HISTORY OF PAINTING IN EAST ASIA
Essays on Scholarly Method

Papers Presented for an International Conference
at National Taiwan University
October 4–7, 2002

Editors

Naomi Noble Richard

Donald E. Brix

Rock Publishing International
Taipei

The essays in this book were presented at the *Taiwan 2002 Conference on the History of Painting in East Asia* (October 4–7, 2002) held at National Taiwan University, Taipei. The following institutions were primary supporters of the conference:

 Metropolitan Center for Far Eastern Art Studies, Kyoto

 National Taiwan University, Graduate Institute of Art History

 National Palace Museum, Taipei

 Academia Sinica, Taipei

The following institutions also supported the conference:

 Shitennoji International Buddhist University, Osaka

 Hosomi Bijutsukan, Kyoto

 Korea Foundation, Seoul

 National Science Council, Taipei

 Council for Cultural Affairs, Taipei

 Chiang Ching-kuo Foundation for International Scholarly Exchange, Taipei

 Asian Cultural Council, New York

 Mary Livingston Griggs and Mary Griggs Burke Foundation, St. Paul, Minnesota

 Ruth and Sherman Lee Institute for Japanese Art at the Clark Center, Hanford, California

The following organizations also provided support for this publication:

 Metropolitan Center for Far Eastern Art Studies, Kyoto

 Rock Publishing International, Taipei

 Chien Huei Cultural and Educational Foundation, Taipei

 National Taiwan University, Graduate Institute of Art History

Chief editors: John Rosenfield, Shih Shou-chien, Takeda Tsuneo

Editors: Naomi Noble Richard, Donald E. Brix

Copy editors: Hongkyung Anna Suh, Judith Whitbeck, Donald E. Brix

Book design and typesetting: Degar Design, Donald E. Brix

Printed and bound by Choice Lithograph

Published and distributed by Rock Publishing International, Taipei

ISBN 978-986-6660-03-0

Illustration facing title page and section headings: Adapted from the Chinese character for "painting" (*hua* 畫) calligraphed by Chang Kuang-pin 張光賓.

Illustrations facing individual papers: Details from figures in this book, as indicated by italics in the respective captions.

Contents

List of Contributors

(In alphabetical order)

Helmut Brinker *Zürich University*

James Cahill *University of California*

Chen Pao-chen *National Taiwan University*

Chen Wei-chao *National Taiwan University*

Craig Clunas *University of Oxford*

Donohashi Akio *Kobe University*

Ebine Toshio *Tokyo National University of Fine Arts and Music*

Wen C. Fong *Princeton University*

Fu Shen *National Taiwan University*

Robert E. Harrist, Jr. *Columbia University*

Jonathan Hay *New York University*

Itakura Masaaki *University of Tokyo*

Lee Yu-min *National Palace Museum, Taipei*

Lothar Ledderose *Heidelberg University*

David R. Packard *Metropolitan Center for Far Eastern Art Studies, Kyoto*

Youngsook Pak *School of Oriental and African Studies, University of London*

John Rosenfield *Harvard University*

Sano Midori *Gakushuin University*

Satō Dōshin *Tokyo National University of Fine Arts and Music*

Satō Yasuhiro *University of Tokyo*

Timon Screech *School of Oriental and African Studies, University of London*

Shih Shou-chien *Academia Sinica, Taipei*

Shimao Arata *Tama Arts University*

Yoshiaki Shimizu *Princeton University*

Jerome Silbergeld *Princeton University*

Takeda Tsuneo *Osaka University*

Tsuji Nobuo *University of Tokyo*

Richard Vinograd *Stanford University*

Wan Qingli *University of Hong Kong*

Marsha Weidner *University of Kansas*

Wu Hung *University of Chicago*

Yen Chüan-ying *Academia Sinica, Taipei*

Yi Sŏng-mi *Academy of Korean Studies*

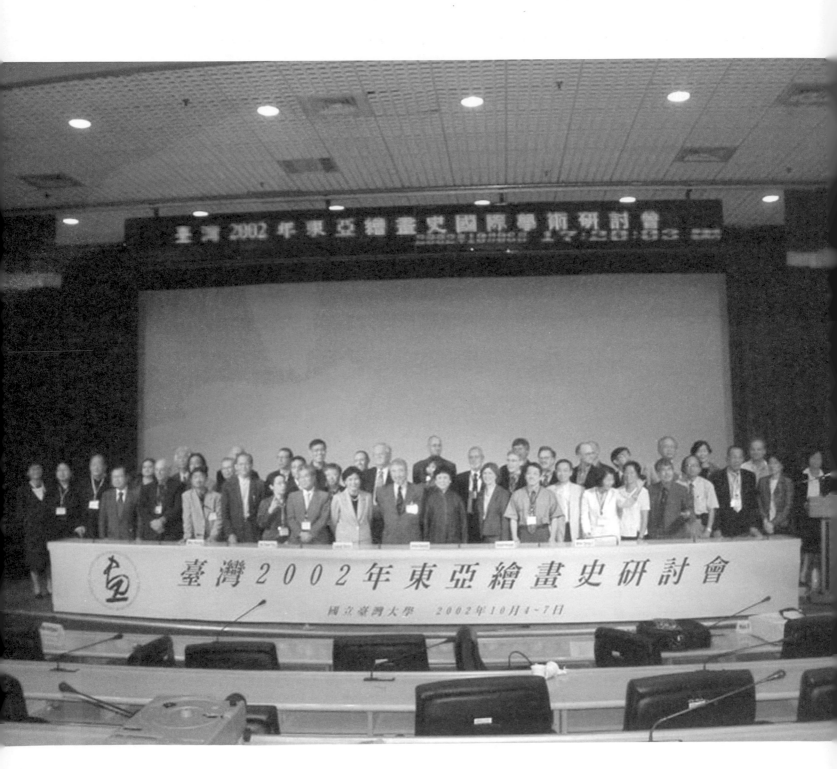

臺灣2002年東亞繪畫史研討會

國立臺灣大學　2002年10月4~7日

Foreword

Chen Pao-chen

Graduate Institute of Art History, National Taiwan University

This volume of essays was generated by the *Taiwan 2002 Conference on the History of Painting in East Asia* convened October 4–7, 2002, at National Taiwan University, Taipei, which was attended by more than 350 people. The objectives of this conference were threefold. The first was to honor the scholarship of the pioneering generation of scholars who led the development of the field after World War II. Although most of them are now (or soon to be) retired, they continue to make important contributions to the field. The second was to confirm the current state of scholarly development. Finally, the third was to explore new directions for future research and publish new research perspectives and methodologies.

This conference volume encompasses the history of painting in China, Taiwan, Korea and Japan. The five topical categories include "Studies of Canonical Paintings," "Buddhist Painting," "Literati Painting," "Art Historical Methodology," and "Recent and Contemporary Painting." The conference keynote address delivered by Professor Emeritus Tsuji Nobuo 辻惟雄 of the University of Tokyo explored the aesthetic concept of the "masterpiece" in traditional East Asian painting and how many modern art critics have made efforts to try and replace it. Authors of the following essays are, for the most part, scholars from major universities from around the world. In addition to introductions, critiques by scholars of the elder generation follow each group of essays.

At the conference, so that every participant fully understood the contents of each presentation, the conference organizers had prepared printed transcripts of the presentations in the three languages of Chinese, English, and Japanese. Each presentation was delivered in one language and simultaneously translated into the other two languages. Unfortunately, because so many persons attended the conference, it was not possible to allow for open discussion. However, there were numerous opportunities for discussion among the participants themselves.

Those jointly responsible for the publication of this volume are Professor Shih Shou-chien 石守謙, research fellow at Academia Sinica and former director of the National Palace Museum in Taipei; Professor Emeritus Takeda Tsuneo 武田恒夫 of Osaka University; and Professor Emeritus John Rosenfield of Harvard University. Because the conference presenters came from eight different countries and their presentations were written in three languages, the editing of the transcripts was extremely complicated. Primary responsibility for translating from Chinese into English was assumed by Jeffrey Moser (presentations by Chen Wei-chao, Chen Pao-chen, Fu Shen), Peggy Wang (Shih Shou-chien), Albert Wu (Lee Yu-min [revised by Jeffrey Moser]), and Thomas E. Smith (Yen Chüan-ying).

Martha J. McClintock was responsible for translation from Japanese to English (Ebine Toshio). In addition to presenting a paper, Professor Itakura Masaaki 板倉聖哲 also kindly translated transcripts from Chinese into Japanese, while Hild Mami and Takeda Masafumi 武田雅史 translated from English to Japanese. The content editor of the papers was Naomi Noble Richard with significant contributions later from Judith Whitbeck and Donald E. Brix. We are especially grateful to Mr. Brix for solving many of the technical issues that arose in the final stages of production, and for arranging a major portion of the overall layout and individual parts of the book. Our heartfelt appreciation also goes to Chen Chi-te 陳啓德, President of Rock Publishing International, Taipei. At the Graduate Institute of Art History of National Taiwan University, the administrative assistant, Liao Tso-hui 廖佐惠, and Professor Hsieh Ming-liang 謝明良, have strived to make possible the publication of this volume.

As the person in charge of organizing the conference, I would like to take this opportunity to offer my sincerest gratitude to the staff at the National Palace Museum, Academia Sinica, the Tjing Ling 慶齡 Industrial Research Institute and the Graduate Institute of Art History of National Taiwan University who helped with the conference preparation, and to express my deepest gratitude for those who assisted with the publication of this volume. Special thanks goes to Cheng Yuk-wah 鄭玉華 and Yang Chan-hui 楊展慧; their tireless effort is particularly noteworthy.

前言

陳葆眞

國立臺灣大學藝術史研究所

本論文集源起於「臺灣 2002 年東亞繪畫史國際學術研討會」（臺北：國立臺灣大學，2002.10.4–7），與會者超過 350 人。該會的宗旨有三：首先是對二次大戰之後，領導本領域發展的前輩學者致敬，他們雖已（或即將）退休，但仍持續對本領域產生貢獻；其次是確定目前學術發展的現況；再次是探索未來的研究方向，發表新的研究觀點和方向。

　　本次研討會的內容涵蓋了中國、臺灣、韓國和日本等整個東亞地區的繪畫史。主題包括：經典名畫、佛教繪畫、文人畫、藝術史研究方法、和近現代繪畫等五個議題。辻惟雄教授在他的專題演講中闡述了傳統東亞繪畫上「名品」的美學概念，以及現代藝評者如何嘗試用其他觀點來取代的努力。其他的論文發表者多爲來自世界各地主要大學或博物館中已經接棒的中生代學者。前輩學者則應邀在每一主題段落之後擔任評論者。每一篇論文都以一種語言宣讀，同時提供其他兩種語言的同步翻譯。爲了使每位與會人士都能充分了解演講內容，大會籌備處並已在會前印製好中、英、日三種文字的演講稿。由於與會者人數太多，因此會中無法開放給聽眾公開討論，但仍有許多機會讓參與者彼此之間私下討論。會後，經由修訂，研討會中所發表的論文和評論於今彙編成爲這本論文集。

　　本書之出版主要由臺北國立故宮博物院前院長石守謙、大阪大學榮譽教授武田恆夫和哈佛大學榮譽教授羅森福（John Rosenfield）等三位教授共同負責。由於所有論文的作者來自八個國家，分別以三種文字寫成，因此文稿的編輯極爲複雜。中文的英譯工作主要是由 Jeffrey Moser 先生、Peggy Wang 女士和 Thomas E. Smith 先生等人擔任。日文譯成英文則由 Martha McClintock 女士擔任。而將中文譯成日文者爲板倉聖哲教授。將英文譯成日文者爲 Hild Mami 和武田雅史先生。本書的主編爲 Naomi Noble Richard 女士，而 Judith Whitbeck 女士和 Donald E. Brix 先生也在這方面貢獻良多。特別是 Brix 先生更在書中三種文字名詞呈現的格式上作了許多技術上的統一，以及在全書整體的編排上和校讀上費心處理。我們十分感謝他們的努力與成效。在此我們也衷心感謝臺北石頭出版社的社長陳啓德先生、和臺灣大學藝術史研究所的行政助理廖佐惠小姐、以及謝明良教授的協助，終於使本書得以順利出版。

　　作爲本次研討會籌備總部的負責人，個人趁此機會在這裡向國立故宮博物院、中央研究院、慶齡工業研究所、及臺灣大學藝術史研究所中所有協助本會之舉行，以及本書之出版的工作人員，表示深深的感謝。尤其是鄭玉華小姐和楊展慧小姐，她們兩位的辛勞值得特別肯定。

序文

陳葆真

国立台湾大学芸術史研究所

本書は、2002年10月4日より7日まで台北、国立台湾大学にて開催された台湾2002年東洋絵画史学会に基づくものである。世界各地より350名以上が参加した同学会には、3つの目的があった。1つは、第二次世界大戦以降、当分野の発展を導いた先達の学者の名誉を讃えること。次に、近年における研究の発展を論じること。そして、未来の研究方向を探求し、新しい視座と方法論を提示することであった。

同学会は中国本土、台湾、韓国、日本からの題目を網羅し、作品研究、仏教絵画、文人画、美術史学方法論、近代・現代絵画の5つのセクションで発表が行われた。辻惟雄氏による基調講演は、伝統的な東洋美学における「傑作」の概念を、現代の批評理論家がそれを他のどのような概念に置き換えてきたかに目を向けながら考察したものであった。主たる発表は、主要大学、美術館において先達の学者の研究成果を継承発展させる研究者によって行なわれた。各セクションの最後には、先達の学者が一つ一つの発表に対し詳細な論評を加えた。各発表は、同時通訳にて他の2カ国語でもなされた。大会開催に先立って、大会本部はすべての発表の3カ国語の原稿を準備し、聴衆の方々に発表内容を十分に理解していただけるようにした。大勢の聴衆のため質疑応答が不可能であったが、個人同士の議論の機会は数多くあった。学会終了後、発表者は聴衆の反応を考慮に入れながら原稿を改める機会を得た。

本書の出版にあたっては、中央研究院歴史語言研究所研究員及び台北国立故宮博物院元館長・石守謙、大阪大学名誉教授・武田恒夫、ハーバード大学名誉教授・John Rosenfield が監修を務めた。8カ国の著者が3カ国語にて執筆したため原稿準備は複雑をきわめた。中国語の英訳は主に Jeffrey Moser 氏、Peggy Wang 氏、Thomas E. Smith 氏が、日本語の英訳は Martha McClintock 氏が、中国語の和訳は板倉聖哲准教授が、英語の和訳はヒルド麻美と武田雅史が行なった。Naomi Noble Richard 氏が編集主幹を務めた、また Judith Whitbeck 氏と Donald E. Brix 氏も本書の編集・校訂作業に多大な貢献をされました。特に Brix 氏は本書に掲載される三種類の言語表現による名詞の書式を技術的に統一してくださり、本書の編成や校正作業に尽力してくださりました。私たちは上記の先生方の努力と、それがもたらした成果に深甚なる謝意を表したいと思います。とり

わけ台北の Rock Publishing International の Chen Chi-te 陳啓徳氏と、国立台湾大学芸術史研究所事務助手 Liao Tso-hui 廖佐惠さんには感謝の意を捧げる。

　私は大会本部の統括者として、大会ならびに本書の準備に尽力して下さった国立故宮博物院、中央研究院、厳慶齢工業研究センター、国立台湾大学芸術史研究所の職員の皆様に感謝したい。そして Cheng Yuk Wah 鄭玉華さん、Yang Chan-hui 楊展慧さんの多大な貢献に特に謝意を表したい。

Chen Pao-chen

Opening Remarks

Opening Remarks

David R. Packard

Metropolitan Center for Far Eastern Art Studies, Kyoto

The Metropolitan Center for Far Eastern Art Studies is pleased to be a sponsor of the *Taiwan 2002 Conference on the History of Painting in East Asia* and of its subsequent publication. The conference grew from a challenge by Dr. Takeda Tsuneo 武田恒夫, the Metropolitan Center's adviser for grants in Japan, to imagine an event to celebrate the twenty-fifth anniversary of the Center's research grant program. Dr. John Rosenfield, the Center's adviser for non-Japanese grants, accepted Dr. Takeda's challenge, and they and Dr. Shih Shou-chien 石守謙 arranged for scholars from around the world to join in a conference on the history of painting in East Asia. The generous collaboration of the National Taiwan University, Academia Sinica, and the National Palace Museum was instrumental in its success.

The Metropolitan Center's first scholarly adviser, Shimada Shūjirō 島田修二郎 (1907–1994), believed strongly in this type of collaboration. Still a powerful guide to the Center's activities, his broad international point of view was the inspiration for this conference and publication, so let me briefly sketch his career. Graduating from Kyoto University in 1931 with a major in Chinese and Japanese art, he undertook graduate training while serving as a research scholar at prominent institutions such as the Tokyo National Institute for Cultural Properties and the Kyoto National Museum. In 1958-59, the Ford Foundation invited him to the United States, and Harvard University appointed him visiting scholar. In 1962, he joined the faculty of the Department of Art History and Archaeology at Princeton University, where he served until his retirement as professor emeritus of Far Eastern art, having taught graduate students who have since become outstanding authorities throughout the world.

Returning to Japan in 1977, Dr. Shimada served, *inter alia*, on the National Commission for the Protection of Cultural Properties, as president for the Society for International Exchange of Art Historical Studies, and, until his death in 1994, as adviser to the Metropolitan Center in Kyoto. I will never forget his presence at the annual meetings of the Center—his dark, thick eyebrows angled upward as he considered his opinion of the applications. My father, Harry Packard, a student of Dr. Shimada and founder of the Center, had eyebrows equally thick and uncontrolled; his were blond, though. The interaction of this extraordinary duo was never dull.

In 1993, to commemorate Dr. Shimada's contributions and to encourage scholarship at the highest level, the Metropolitan Center and the Freer Gallery of Art and Arthur M. Sackler Gallery of the Smithsonian Institution in Washington, D.C., established a biennial award for outstanding publications. The Shimada Prize is administered by

the Freer-Sackler Galleries but selected by an autonomous committee of scholars, some of whom are prominently represented in this publication.

Dr. Takeda succeeded Dr. Shimada as artistic advisor for the Center's grant program in Japan. The non-Japanese grants, selected by a committee of advisers in the United States, are awarded in four categories: doctoral studies, advanced scholarly research, library acquisition, and institutional support. While its resources are not vast and its grants are often for seed money or discrete purposes, the Center in its first twenty-five years has awarded over five hundred grants totalling five million US dollars. The Center plans to continue its programs indefinitely.

The Metropolitan Center is proud of its collaboration with National Taiwan University, Academia Sinica, and the National Palace Museum in Taiwan as primary sponsors of this conference. Many other institutions, listed in the following remarks by Chen Wei-chao 陳維昭, also gave additional support. I hope that this publication will be an enduring contribution to the history of East Asian painting.

開幕詞

David R. Packard

京都大都會東洋美術研究中心

The Metropolitan Center for Far Eastern Art Studies 非常榮幸主辦此次臺灣二〇〇二東亞繪畫史國際研討會。此次會議，係出自本中心日本獎項顧問武田恆夫博士為慶祝本中心研究獎助成立二十五週年所提出的構想。Rosenfield 博士樂於接受挑戰，於是欣然接受武田博士此項提議。

且不論此會議的原動力，若無周延的策劃及各方支持，我們今天是不可能在此聚會的。本會協辦單位名單詳見大會編印的出版品。對所有協辦單位我等深表謝忱，尤其是國立臺灣大學的教職員們竭盡心力為我們安排會議室，住房，更遑論美味的飲食。

本會的籌備委員包括 Rosenfield 博士，武田恆夫博士，石守謙博士，以及—為某種原因—還有我本人。諸位委員們投入許多時間精力奠定本會規模。我則肩負本會最為艱巨的任務—那就是節制 Rosenfield 博士。如您在議程表中所見，我顯然是有虧職守了。

今天我希望在此強調讓世界各國學者齊聚一堂的重要性。在座各位有許多是故舊好友，也有許多是初次會面。我們希望借此機會促成珍貴的學術意見交流與合作。本中心首位藝術方面的顧問，島田修二郎博士（1907–1994），對此類合作極為重視。島田博士自一九七七年本中心研究獎項成立以來，即負責該獎項的執行運作，直至一九九四年去世為止。島田博士是一位偉大的導師，世界各地許多的學者都因他而產生對東亞藝術的熱愛。

島田教授在京都大學開始學習日本和中國藝術史，並於一九三一年取得學士學位。在研究生學習階段，他還在包括東京國立文化財研究所和京都國立博物館的幾個主要研究單位從事研究。一九五八至一九五九年間，他應福特基金會之邀，以訪問學者身份在哈佛大學講學。一九六二年應聘至普林斯頓大學藝術史與考古學系任教，自此他在該校繼續從事研究並指導研究生，直至一九七五年以終生榮譽教授退休。一九七七年島田教授返回日本後，仍身兼數項要職，包括擔任日本政府文化財保護特派團成員，以及藝術史學國際交流協會主席。島田博士宏觀的國際視野，正是我等在此聚會的緣由。本中心早期的獎助審查會，令人回味再三。島田博士又濃又黑而且上揚的眉毛，與家父 Harry Packard—亦即本中心創辦人—失控的濃眉儘管顏色不同，卻有異曲同工之妙。他們實在是令人難忘的絕配。

有鑒於島田博士在學術上的貢獻，Metropolitan Center 與華盛頓特區的弗利爾-賽克勒藝術館於一九九三年成立了島田大賞。該獎項每兩年頒發給傑出的東亞藝術史學術著作。

在座部份與會學者也曾是島田賞評審委員。

　　本中心繼任島田博士的諸位藝術顧問們均遵行島田博士的行事準則。他們全都是優秀的學者與教授。本中心的非日本研究獎項以及日本研究獎項，分別設有不同的顧問。武田博士是日本獎項藝術類的顧問。武田博士的夫人，武田まさこ女士是本中心的行政助理。非日本研究獎項由 John Rosenfield 博士主持，並由理奇蒙大學 Stephen Addiss 教授和 Richard Mellott 先生襄助，以及 Laura Allen 女士擔任行政助理。在座諸位大都知道本中心獎助美國的基礎研究和博士階段研究，並贊助學術出版和展覽。二十五年來，已經提供逾五百個研究獎項，總值達五百萬美元。今後還將持續不斷。

　　我在此對促成本會順利開展的大會籌備委員，各協辦單位，以及主辦單位－國立臺灣大學致上謝意。謝謝各位。

歓迎挨拶

David R. Packard
京都メトロポリタン東洋美術研究センター

メトロポリタン東洋美術研究センターは、台湾 2002 年東洋絵画史学会の主催者であることを喜びとする。当学会は、メトロポリタン・センターの研究助成金プログラム二十五周年を記念するため、何らかのイベントを開催しようというセンターの日本側助成金顧問、武田恒夫教授の構想から生まれた。日本以外の助成金顧問、ローゼンフィールド博士がその要請に応じ、石守謙博士と共に、東洋絵画史学会に参加する研究者を世界中から選んだ。この学会の成功にとって忘れてはならないのは、国立台湾大学、中央研究院、国立故宮博物院の寛大なる協力であった。

メトロポリタンセンター初代学術顧問、島田修二郎教授 (1907-1994) はこうした形の共同研究を強く望んでいた。今なお当センターの活動の力強い指針となっている島田教授の広範な国際的視野は、本学会ならびに本書刊行の原動力となっており、ここに教授の経歴を簡単に紹介しておきたい。中国と日本の美術を専攻して、1931 年に京都大学を卒業した後、東京国立文化財研究所、京都国立博物館といった第一級の研究所で研究員として勤務するかたわら、大学院での研究を続ける。1958 年から 1959 年にフォード財団の招きにより渡米し、ハーバード大学にて客員研究員に任じられた。1962 年、プリンストン大学美術史考古学科の教授に就任し、1975 年に退官、極東美術の名誉教授となった。その間、教授が教えた大学院生から、傑出した権威が世界中に輩出されている。

1977 年に帰朝した後、島田教授は日本政府文化財保護委員会の専門委員、国際交流美術史研究会の会長といった重職に就かれた。1994 年に亡くなるまで、京都のメトロポリタン・センターの顧問を勤められた。センターの年次会合に出席されていた先生のお姿を私は忘れることはない。先生が奨学金申請書について考えを巡らされる時、その黒く濃い眉毛が上を向いていた。私の父ハリー・パッカードは、島田教授の弟子であり、メトロポリタン・センターの創設者であるが、同様に濃いゲジゲジ眉をしていた。もっとも私の父のは金髪だったが。二人は忘れ難きパートナーであった。

1993 年、島田教授の学術的貢献を記念し、高い水準の研究を奨励する目的で、メトロポリタン・センターと、ワシントン D.C. にあるスミソニアン研究所のフリーアーサッ

クラー美術館は島田賞を設けた。この賞は東洋美術史の卓越した学術的出版物に対して二年に一度授けられる。島田賞はフリーアーサックラー美術館が運営しているが、学者による独立した委員会が選考を行なっている。この学会参加者の幾人かも島田賞選考委員である。

　武田教授は、センターの日本における助成金プログラムの学術顧問の地位を島田教授から引き継いだ。アメリカの顧問委員会によって選考される日本以外の助成金には、博士論文研究・先進的学術研究・図書購入・施設支援の四種がある。その財源は決して巨額ではいが、過去二十五年の間に五百件以上の申請に対して総額五百万ドルに及ぶ助成金を授与してきた。センターはこの助成金プログラムを今後も継続してゆく計画である。

　メトロポリタン・センターは国立台湾大学、中央研究院、国立故宮博物院との共同により、本学会ならびに本書刊行を後援できたことを誇りに思う。陳維昭総長が紹介された他の多くの機関も追加的支援をして下さった。私は、本書の出版が東洋絵画史研究に永続的に貢献することを願ってやまない。

Opening Remarks

Chen Wei-chao

National Taiwan University

Confucius said, "When friends come from distant places, how can I not be happy?" Indeed, as President of National Taiwan University, I am very happy to welcome so many honored guests, who have made journeys from around the world to attend the *Taiwan 2002 Conference on the History of Painting in East Asia*. With over three hundred and fifty attendees, I believe the scale of this conference to be unprecedented in this field. I also honestly consider this to rank close to the top of the list for conferences in the field of humanities and art research. Not only are the participants many, the issues are complex, as one can see from the conference goals, which include honoring scholars who have led the development of Asian art history studies since World War II, confirming recent scholarly developments, and exploring new perspectives and methodologies. Put more simply, this conference aims to honor our teachers, transmit knowledge, and exchange academic ideas.

We all know that to honor one's teachers is a core value in many traditional Asian cultures. This spirit reminds us of the origins of our body of knowledge and lays upon us the great responsibility of humbly transmitting that knowledge to the next generation. With regard to the transmission of knowledge, I might point out that many of the presenters here are in the prime of their careers, the respondents are all respected elders in the field, and the audience is mostly made up of younger scholars and students. This coming together of three generations for the purpose of academic discussion and debate is a fine example of this ideal of transmitting knowledge. After all, the goal of academic research is the search for truth. Recognition and the pursuit of truth help us avoid confusion—for knowledge is power and the transmission and accumulation of knowledge and experience is one of the driving forces behind the advancement of human civilization. I turn lastly here to the goal of academic exchange. Because the art history of each East Asian country was built upon its own distinctive cultural traditions, the scholars of each culture naturally observe art in different ways, adopt varying methodologies, and utilize individual interpretative paradigms. In addition to researching the formal representation, symbolic significance, and cultural meanings of works themselves, the field of art history has many other perspectives and topics waiting to be explored. This is where the interests of every scholar is focused. The academics presenting papers here hail from around the world, including such places as Taiwan, Hong Kong, Korea, Japan, America, England, Germany, and Switzerland. The topics of their essays range across hundreds of years of painting history in Taiwan, mainland China, Korea, and Japan. Such a meeting of the minds certainly produces new insights and cannot help but achieve the purpose of academic exchange. It is my

sincere hope that it will lead to new topics and methods, expand the scope of research, and thereby help the field develop into something even greater than that found today. That, I believe, is also our common hope.

This conference is sponsored by the Metropolitan Center for Far Eastern Art Studies in Kyoto and the National Palace Museum, Academia Sinica, and this university's own Graduate Institute of Art History here in Taiwan. We especially appreciate the local and overseas organizations who have provided their support, including, in Japan, the Shitennoji 四天王寺 International Buddhist University in Osaka and the Hosomi 細見 Museum in Tokyo; in Korea, The Korea Foundation in Seoul; in America, the Asian Cultural Council in New York, the Mary Livingston Griggs and Mary Griggs Burke Foundation in St. Paul, Minnesota, and the Ruth and Sherman Lee Institute for Japanese Art at the Clark Center in Hanford, California; and here in Taiwan, the National Science Council and Council for Cultural Affairs of the Executive Yuan of the Republic of China government, as well as the Chiang Ching-kuo 蔣經國 Foundation for International Scholarly Exchange. We want to especially thank each of the presenters, respondents, and other honorable guests for finding time in their busy schedules to be with us here. In addition, we also thank Professors John Rosenfield and Takeda Tsuneo 武田恒夫, and their respective teams, as well as the students and staff of the National Palace Museum, Academia Sinica, Graduate Institute of Art History, and Tjing Ling 慶齡 Industrial Research Institute. These individuals not only took responsibility for a multitude of administrative tasks, but also helped translate the presentations, design the conference poster, and set up the venue. It is only because of their hard work that the conference is able to be presented. Finally, I would like to thank all for coming and wish everyone good health and a successful conference.

開幕辭

陳維昭

國立臺灣大學

孔子說：「有朋自遠方來，不亦樂乎？！」今天早上，個人以十分喜悅的心情，在此歡迎各位佳賓不辭辛勞地從世界各地，來到這裡，參加「臺灣二〇〇二年東亞繪畫史研討會」。這次研討會，可謂盛況空前，共有三百多人參加。個人認爲這樣的盛會在人文藝術研究領域中，可謂前所未有：不但參與人數衆多，而且意義非凡，特別是本次會議的宗旨。本次會議的宗旨在於對二次大戰之後的第一代退休學者致敬；確定目前學術發展的現況；以及探索未來的研究方向，發表嶄新的研究觀點與方法。簡言之，便是尊師重道，知識傳承，和學術交流等三個目的。

我們都知道，向前輩學者致敬便是尊師重道。這種精神是傳統東方文化的核心價值。由於這種精神使得我們在知識的領域中飲水思源，知所感恩，並且更加謙虛地去承擔學術命脈中承先啓後的重大責任。其次，在知識的傳承方面，我們將可以發現在本次研討會中，論文發表者都是中年學者，評論者則大都是他們的師長前輩，而聽衆大多數爲年青學子。這種集三代學者於一堂以論辯學問的方式，正爲知識傳承提供了良好的示範模式。學術研究的目的在於追求眞理。認知與追求眞象正可助使我們免於困惑；因爲知識便是力量。而知識與經驗的傳承與累積更是驅使人類文明向前邁進的主要動力。再次是學術交流。由於東亞各國的藝術史研究都建立在各自的文化傳統上，因此各文化中的學者對藝術品的觀察角度、研究方法、和詮譯方式，自然也就各具特色。美術史除了研究美術品本身的圖像表現、象徵意義，和文化意涵之外，還有許多角度和議題等待開發。這是各位學者的興趣所在。在這次研討會中要發表論文的學者分別來自世界各地，包括臺灣、香港、韓國、日本、美國、英國、德國、和瑞士等等地區。他們的論文題目涵蓋了臺灣、中國大陸、韓國、和日本等地千餘年來的繪畫史議題。大家齊聚一堂，各發己見，彼此切磋，必能激發出許多新的靈感，而達到學術交流的目的，更進而開發新的議題，尋思新的研究方法，拓展更大的研究空間，使這門學問更加蓬勃發展。這是我們大家所共同期待的。

這次研討會是由京都的大都會東洋美術研究中心（Metropolitan Center for Far Eastern Art Studies in Kyoto）、國立故宮博物院、中央研究院，以及本校的藝術史研究所共同主辦。我們要特別感謝國內、外許多機構熱心的贊助，包括日本：大阪的四天王寺國際佛教大學（Shitennoji International Buddhist University）和京都的細見美術館（Hosomi

Bijutsukan）；韓國：漢城的韓國國際交流財團（The Korea Foundation）；美國：Asian Cultural Council, New York；Mary Livingston Griggs and Mary Griggs Burke Foundation in St. Paul, Minnesota；Ruth and Sherman Lee Institute for Japanese Art at the Clark Center in Hanford, California；以及國內：行政院國家科學委員會；行政院文化建設委員會；和財團法人蔣經國國際學術交流基金會等。我們也要特別感謝各位學者在百忙之中，撰寫論文和評論，以及各位貴賓的蒞臨。此外，我們更要感謝 Professor John Rosenfield 和 Professor Takeda Tsuneo 和他們的工作團隊，以及國立故宮博物院、中央研究院、本校藝術史研究所、和慶齡工業研究中心所有參與這次研討會工作的師生和同仁。他們不但承擔各種繁瑣的聯絡和服務工作，並且幫忙翻譯文稿和同步口譯，以及設計海報和佈置會場等事項。由於他們辛勞的服務，才讓我們得以齊聚一堂。最後，再一次謝謝各位貴賓的蒞臨，並祝各位身心康泰，大會圓滿成功。

歓迎挨拶

陳維昭

国立台湾大学

孔子曰く：『朋有り遠方より来たる、亦楽しからずや？！』今日は、この「台湾2002 年東洋絵画史学会」に参加するため、世界各地からはるばるお越し頂いた皆様を歓迎致します。今回のシンポジユウムは、空前の盛況と言ってもよいでしょう。参加者は全部で 350 人余りもおります。私は、このような盛大なシンポジユウムは人文芸術研究の領域に於いては、実に未曾有の事だと思っております。単に参加者の人数が多いだけではなく、その主旨にもまた非凡な意義が備わっております。この大会の主旨は、退官された戦後初代目の碩学の方々を称え、学術発展の現状を明確にし、また未来の研究方針を模索しつつ、斬新な研究観点や方法を論証することです。略して言えば、師を尊び道を重んじ、知識を継承し、また学術交流を図るなど三つの目的です。

周知の通り、先学に敬意を表すとは師を尊び道を重んじると言う事で、この精神は伝統的な東洋文化の核心的な価値観であります。この精神のお蔭で、我々は知識の領域において先学に恩を感じる事を知り、またより謙虚な態度をもって学術の文脈のなかで先学の業績を受け継ぎ、後輩を啓発する重大な責任を担う事ができるのです。その外、知識の継承と言う方面についてですが、この大会でひときわ目立っておりますのは、発表者が皆中年学者であるのに対し、コメンテーターは殆ど彼等の先生や先輩に当たり、また聴講者の大部分は青年学生だと言う事です。

このように、三代の研究者を一堂に集めて学問を論じると言うやり方は、まさに知識の継承を実行する絶好の模範と言っていいでしょう。学術研究の目的は真理の追究にあり、認知することや真相を追い求める事は困惑をなくします。なぜなら、知識とは力だからです。更に、知識と経験の継承と蓄積は、人類文明を推進させる主な原動力であり、その次が学術交流であります。東アジア各国の芸術史研究は皆、それぞれの国の伝統文化の上に築かれてきましたので、異なる文化に属する学者は、芸術品を観察する視角、研究方法、及び解釈の仕方などにおいて、言うまでもなくおのおのの特色を備えております。美術史は、美術品自体の図像表現、象徴的な意義、及び文化的な意味などを研究する他、まだまだ沢山の捉え方や課題が残っております。そこに学者の方々は関心を寄せました。この大会で論文を発表してくださる学者たちは世界各地からいらしてお

ります、日本、韓国、香港、台湾、アメリカ、イギリス、ドイツ、及びスイスなどから
です。従って彼等のテーマも台湾、中国大陸、韓国、及び日本などにおける、千年余り
にも渡る絵画史の問題であります。ここにおいて、沢山の学者が一堂に集まり、己の意
見を発表し、お互いに磨き合うと言う事は、必ず数多くの新しいインスピレーションを
産み出し、学術交流の目的を果し、更に新しい課題を開発し、新しい研究方法を考え出
し、より雄大な研究領域を開拓し、この学問を更に発展させることにつながるでしょう。
これこそ我々一同、共に願うことだと思います。

　この学会は京都メトロポリタン東洋美術研究センター、国立故宮博物院、中央研究
院、及び本校の芸術史研究所による共同主催であります。また、海外、及び国内にお
ける沢山の機構がこの大会に寄せてくださりました熱心な援助に深く感謝の意を表し
ます。これらの機構とは、日本の大阪四天王寺国際仏教大学、及び京都細見美術館、
韓国のソウルの韓国国際交流財団、アメリカの Asian Cultural Council, New York; Mary
Livingston Griggs and Mary Griggs Burke Foundation in St. Paul, Minnesota; Ruth and Sherman
Lee Institute for Japanese Art at the Clark Center in Hanford, California、及び国内の行政院国
家科学委員会、行政院文化建設委員会、及び財団法人蒋経国国際学術交流基金会などで
す。また、ご多忙中にも拘わらず、論文を執筆してくださり、コメントを引き受けてく
ださりました学者の方々、及び参加者一同に厚くお礼申し上げます。更に、プロフェッ
サー・ジョン・ローゼンフィールド、武田恒夫教授、及び彼等の率いるスタッフ一同、
また国立故宮博物院、中央研究院、本校芸術史研究所、及び厳慶齢工業研究センターな
どで、この大会に協力を寄せてくださりましたあらゆる方々に深く感謝致します。彼等
は様々な煩わしい連絡や事務作業を引き受けてくださっただけではなく、原稿を翻訳
し、同時通訳を担当して下さり、更にポスターデザインや会場を整える仕事までも負担
してくれました。彼等の苦労があってこそ、この集まりがあったのです。最後に、もう
一度皆様のご出席に深く感謝致します。では、皆様のご健康とご健勝をお祈りしつつ、
大会の成功をお祈り申し上げます。

Selected Chronology of East Asian History

(periods and dates may differ from other conventions based on varying criteria)

China

Shang Dynasty 商朝 ca. 1600–ca. 1046 BCE

Zhou Dynasty 周朝 ca. 1045–256 BCE

Qin Dynasty 秦朝 221–206 BCE

Han Dynasty 漢朝 206 BCE–220 CE
 Western Han 西漢 206 BCE-9 CE
 Wang Mang 王莽 (Xin 新) Interregnum 9-23
 Eastern Han 東漢 25-220

Three Kingdoms Period 三國時代 220–280
 Wei 魏 220–265
 Shu 蜀 221–263
 Wu 吳 222–280

Six Dynasties Period 六朝時代 222–589

Jin Dynasty 晉朝 265–420

Northern Dynasties Period 北朝時代 386–581
 Northern Wei 北魏 386–534
 Eastern Wei 東魏 534–550
 Western Wei 西魏 535–556
 Northern Qi 北齊 550–577
 Northern Zhou 北周 557–581

Southern Dynasties Period 南朝時代 420–589
 Liu Song 劉宋 420–479
 Southern Qi 南齊 479–502
 Liang 梁 502–557
 Chen 陳 557–589

Sui Dynasty 隨朝 581–618

Tang Dynasty 唐朝 618–907

Five Dynasties Period 五朝時代 907–960

Song Dynasty 宋朝 960–1279
 Northern Song 北宋 960–1126
 Southern Song 南宋 1127–1279

Western Xia Dynasty 西夏 1032–1227

Jin Dynasty 金朝 1115–1234

Yuan Dynasty 元朝 1260–1368

Ming Dynasty 明朝 1368–1644

Qing Dynasty 清朝 1644–1911

Republic of China 中華民國 1912–

People's Republic of China 中華人民共和國 1949–

Japan

Kofun Period 古墳時代 ca. 3rd c.–538

Asuka Period 飛鳥時代 538–710

Nara Period 奈良時代 710–794

Heian Period 平安時代 794–1185

Kamakura Period 鎌倉時代 1185–1333

Nambokuchō Period 南北朝時代 1336–1392

Muromachi Period 室町時代 1392–1573

Momoyama Period 桃山時代 1573–1615

Edo Period 江戶時代 1615–1868

Meiji Period 明治時代 1868–1912

Taisho Period 大正時代 1912–1926

Showa Period 昭和時代 1926–1989

Heisei Period 平成時代 1989–

Korea

Three Kingdoms Period 三國時代 57 BCE–668 CE

Unified Silla Period 統一新羅時代 668–935

Koryŏ Dynasty 高麗朝 918–1392

Chosŏn Dynasty 朝鮮國 1392–1910

Japanese Imperial Period 日帝時代 1910–1945

Republic of Korea (South) 大韓民國 1948–

Democratic People's Republic of Korea (North)
 朝鮮民主主義人民共和國 1948–

Keynote Address

Keynote Address
On the Characteristics of "Masterpiece" in East Asian Painting: From a Japanese Viewpoint

Tsuji Nobuo

University of Tokyo, Emeritus

The organizers of this conference asked me to consider "the phenomenon of excellence" in East Asian painting and to explore the ways by which paintings have been evaluated and appreciated in China, Korea, and Japan. Unfortunately, this is somewhat beyond my purview. A specialist in the history of Japanese painting, I do not have the broad vision or insight of the late Shimada Shūjirō 島田修二郎, whose mastery of those fields inspired the conference from which this volume springs. I must therefore confine myself to a Japanese viewpoint.

The term "masterpiece" in the West has been the subject of several recent symposia in Europe and America. The interest has been aroused by the belief that the Western notion of "masterpiece" is linked to the Renaissance concept of "Fine Arts," which affects museum exhibitions and art collecting as well as arbitrarily forces canonical values and authority on the viewer. That traditional concept has provoked opposition and criticism from the "New Art History" (J: *shinpa bijutsushi* 新派美術史) and "New Critical Theory" (J: *hyōka shinron* 評価新論), which question the absolute value of canons of masterpieces.

I must profess, however, that I have less interest in this issue. Instead, I shall explore how the "phenomenon of excellence," or "masterpiece," in Western art criticism may be compared with similar ideas in East Asia. I shall emphasize that the notion can be traced to an early date in China and that, from time to time, it has been subject to change.

Mingpin and *Minghua* in China

Which Chinese terms best correspond to "masterpiece"? I shall first consider *mingpin* 名品 ("excellent class," "excellent thing"). In China, the term *mingpin* appears in the Northern Song painting treatise *Chunquan's Compilation on Landscape* (*Shanshui chunquanji* 山水純全集) of the early twelfth century. In the chapter entitled "On Observing and Discriminating Among Paintings" (*Lun guanhua shibie* 論觀畫識別), the text states that *mingpin* belong "to the ranks of the inspired (*shen* 神) and excellent (*miao* 妙). Each is imbued with principle (*li* 理)." This wording derived from the term *meipin* as used by Xie He 謝赫 (act. ca. 500–535) of the Southern Qi, in whose famous *Classification of Old Painters* (*Guhua pinlu* 古畫品録) the term *huapin* 畫品 ("classification of painting") was used for the first time. It was later applied, however, to more than just painters and painting. For example, in a verse entitled "Peonies" (*Mudan shi* 牡丹詩), the Northern Song poet Mei Yaochen 梅堯臣 (1002–1060) wrote, "There are many *mingpin* peonies in Luoyang (*Luoyang mudan mingpin duo* 洛陽牡丹名品多)," which indicates that the term could be applied to "splendid objects" of diverse sorts. In this sense, it seems to match the extended meanings of "masterpiece" in the West.

Since this volume is limited to the subject of painting, a more appropriate term here would be *minghua* 名畫, which means, specifically, "excellent painting." Probably the earliest examples of the use of *minghua* are found in the late Tang period *Record of Famous Paintings of the Tang Dynasty* (*Tangchao minghua lu* 唐朝名畫録) by Zhu Jingxuan 朱景玄 (act. 806–820) and in the celebrated *Record of Famous Paintings of All Dynasties* (*Lidai minghua ji* 歷代名畫記) written by Zhang Yanyuan 張彦遠 in 847. *Record of Famous Paintings of All Dynasties* mentions many famous paintings extant at the time, and in the chapter entitled "Notes on Wall Paintings in Buddhist and Daoist Temples of the Two Capitals and the Provinces" (*Ji liangjing waizhou siguan huabi* 記兩京外州寺觀畫壁), Zhang discusses wall paintings in sanctuaries in Chang'an 長安 and Luoyang 洛陽, many of which were lost in the persecution of Buddhism in 845 under Emperor Wuzong 武宗. Zhang's intention in this record, apparently based on notes made when observing paintings prior to that date, was to convey to later generations his memory of magnificent *minghua* that he had seen in temples.

Zhang's *Record of Famous Paintings of All Dynasties* gives the names of painters for a majority of the wall paintings, but also cites those by unknown artists found in such important temples as Xingransi 興然寺, Ciensi 慈恩寺, Dingguangsi 定光寺, Haijuesi 海覺寺, and Dayunsi 大雲寺. Commenting on them, Zhang would write, "Excellent" (*zhi miao* 至妙), "Artist's name lost," or "Most excellent (*shen miao* 甚妙), artist's name lost." In other words, he considered a picture to be superb, though its painter was unknown. Unaccountably, he rarely applied such commendations to wall paintings for which the artists were known. Indeed, on the painting of a phoenix by Lang Yu 郎餘 in the Imperial Secretariat (Bishusheng 祕書省), Zhang wrote, "It is not a painting; I cannot bear to look at it (*bu chenghua, bu kanguan* 不成畫，不堪觀)."

By contrast, as I shall discuss below, most Chinese treatises on painting strongly emphasized the biographies and styles of well-known painters, but provided just brief notations about the individual works of art, and only rarely commended as *minghua* a painting for which the artist was unknown. Zhang's emphasis on his firsthand observations and his apportioning of praise therefore stand out among Chinese traditional painting treatises.

In addition, Zhang's chapter on paintings in the two capitals does not deal with wall paintings alone, but it also mentions a few Buddhist statues and ritual implements. In the Jing'aisi 敬愛寺, for example, there is note of a group of dry-clay statues in the Buddha hall, including one of the Maitreya bodhisattva. It mentions a large shrine box and an incense burner in the lecture hall, noting the names of the craftsmen who made them, the workshop head, and those who provided the designs (or the models). This mingling of paintings, sculpture, and applied arts is also not to be seen in later painting treatises.

Digressing slightly, I should like to assess here the meaning of the Japanese term *bijutsu* 美術. It is essential that we remember that *bijutsu* translates the term "art," which was imported from the West in the late nineteenth century. In the volume *Springtime Studio Discourse on Painting* (*Chunjuezhai lunhua* 春覺齋論畫) by the Chinese critic Lin Shu 抒紓, who died in 1925, the article entitled "Discourse on Art" (*Meishu lun* 美術論) shows the difficulties a

tradition-minded scholar encountered when applying Western concepts. Lin begins by saying that "Westerners discuss 'artists' (*meishuzhe* 美術者) as including builders, painters, sculptors, and writers. How astonishing would it be to find such famous authors and calligraphers as Han Tuizhi 韓退之 [Yu 愈], Liu Zongyuan 柳宗元, Ouyang Xun 歐陽詢, and Wang Xizhi 王羲之 classed with masons (*nishuijiang* 泥水匠)." Lin concludes, however, by saying he fully agrees with Western views: "A stonemason's work is far and away more difficult than that of a writer or calligrapher, and I praise the work of sculptors." Lin, in fact, confused his main point by using old-fashioned words. He writes "carpenter" (*mujiang* 木匠) where he intends "builder" (*jianzhujia* 建築家), "artisan painter" (*huagong* 畫工) instead of "creative painter" (*huajia* 畫家), "stone mason" (*keshi* 刻石) for "sculptor" (*tiaokejia* 彫刻家), and "student of ancient texts" (*guwenjia* 古文家) for "poet" (*shiwenjia* 詩文家). In pre-modern China, a *huagong*, because he did coloring, was classed as an artisan. The Chinese cultural tradition, which esteems highly such literati art forms as poetry, calligraphy, and ink painting, clearly differentiates them from the work of artisans (*zhiren* 職人). This deprecatory literati distinction between high arts and artisanry was not so firm in the Tang period, but from Song onward it became increasingly so.

Returning to my main theme, other kinds of references to famous paintings occur in *Record of Famous Paintings of All Dynasties*. For example, near the end of the chapter "Notes on Wall Paintings in Buddhist and Daoist Temples of the Two Capitals and the Provinces" with its discussion of the destruction of Buddhist temples in the persecution of 845 is an account of a painting of Vimalakīrti by Gu Kaizhi 顧愷之 (ca. 344–ca. 406) being carried by a high official to safety in the Ganlusi 甘露寺 and later being taken by Emperor Xuanzong 宣宗, who kept it in his palace and showed it to his ministers. Nearly one hundred notable "secret paintings" (*mihua* 秘畫) and "rare pictures" (*zhenhua* 珍畫) were also listed, but they are now lost, and we have only the written record of their existence. But from the time of *Record of Famous Paintings of All Dynasties*, such books were created in an atmosphere of increasing regard for collecting and preserving famous paintings, activities in which the throne took the lead.

Classification of Old Painters by Xie He refers to an old three-rank "hierarchy of merit," sorting people in general into three classes (*san pin* 三品): upper, middle, and lower. Soon writers, calligraphers, and painters were specified, and *Classification of Old Painters* itself divides painters into six classes. Zhu Jingxuan's *Record of Famous Painters of the Tang Dynasty* establishes four classes, labelled "inspired" (*shen*), "excellent" (*miao*), "capable" (*neng* 能), and "untrammeled" (*yi* 逸). *Record of Famous Paintings of All Dynasties* established five classes, each of which is further subdivided into three grades: high, middle, and low. The five classes are: (1) "naturally spontaneous" (*ziran* 自然*; "highest in the top grade" [*shangpin shang* 上品上]), (2) "inspired" (*shen*; "middle in the top grade" [*shangpin zhong* 上品中]), (3) "excellent" (*miao*; "lowest in the top grade" [*shangpin xia* 上品下]), (4) "refined" (*jing* 精; "highest in the middle grade" [*zhongpin shang* 中品上]), and (5) "careful and delicate" (*shenxi* 愼細; "middle in the middle grade" [*zhongping zhong* 中品中]). In the Five Dynasties period, Jing Hao 荊浩 (act. late 9th–early 10th c.) set up four classes: inspired (神), excellent (妙), extraordinary (*qi* 奇), and skillful (*qiao* 巧).

Tsuji Nobuo

This type of painting treatise classifies the artists rather than their individual paintings. Works by top-ranked painters are judged solely according to the artist's rank; and in the case of older paintings, the Chinese reverence for the past accords merit solely on the basis of age. This way of evaluating painters has not varied greatly over time, but the treatises themselves subtly reflect attitudes of the times in which they were written. For example, according to Nakamura Shigeo 中村茂夫, the high praise in *Record of Famous Paintings of All Dynasties* for the dynamic mode of painting by Wu Daozi 吳道子 (act. ca. 710–760) demonstrates Zhang Yanyuan's personal admiration for that artist, whose innovative "spirit movement" (*qiyun* 氣韻) surpassed the meticulous, objective realism current at the time. Zhu Jingxuan added the untrammeled class in his *Record of Famous Paintings of the Tang Dynasty*, because he so admired the innovative "art of ink" (*mo yishu* 墨藝術) developed by Wang Mo 王墨 (ca. 740–ca. 804) and Zhang Zhihe 張志和 (ca. 730–810), among others, with its freedom from the restrictions of traditional methods.

In the Northern Song period, "untrammeled" was ranked above "inspired," "excellent," and "capable" by Huang Xiufu 黃休復 in his *Record of Famous Painters of Yizhou* (*Yizhou minghua lu* 益州名畫錄). Deng Chun 鄧椿, author of *Painting, Continued* (*Hua ji* 畫繼), agreed but noted that Emperor Huizong 徽宗 (r. 1100–1126) placed "untrammeled" below "inspired" and above "excellent" and "capable." The "untrammeled" (*yi*) or "extraordinary" (*qi*) class, although an unorthodox addition to the time-honored, orthodox "three-class" merit-based hierarchy mentioned by Xie He, became an important criterion for establishing *minghua*. "Untrammeled," which differs from the Western concept of "masterpiece," is an integral part of the Chinese or East Asian "phenomenon of excellence."

Record of Famous Painters of Yizhou places the late Tang artist Sun Wei 孫位 (fl. 9th c.) alone in the untrammeled class, noting that his painting style surpassed that of Wu Daozi in dynamism. That text has also left us careful impressions of paintings of the day, beginning with those of Sun Wei, for today no works by either him or Wu Daozi survive. According to the detailed documentary study of Song texts made by Ogawa Hiromitsu 小川裕充 (for the 1981 Suzuki Kei 鈴木敬 *festschrift*), the Jade Hall (Yutang 玉堂) at the Institute of Academicians (Xueshiyuan 學士院) within the palace of the Northern Song capital of Kaifeng 開封 contained wall paintings by Dong Yu 董羽 (act. 960–970) and Juran 巨然 (act. 960–980), folding screen paintings by Yan Su 燕肅 (961–1040), and a large number of wall and screen paintings by Guo Xi 郭熙 (ca. 1001–1090). However, at the time of writing, these had already been scattered and lost. Han Zhuo 韓拙 (act. ca. 1095–ca. 1125), the author of *Chunquan's Compilation on Landscape*, noted that Wang Shen 王詵 (ca. 1046–after 1100), the noted scholar-artist and imperial son-in-law, hung a painting by Li Cheng 李成 (ca. 919–ca. 967) on the east wall of a room in the imperial palace and one by Fan Kuan 范寬 (act. ca. 990–1030) on the west wall. Han Zhuo recorded with great precision his impressions of the distinctive qualities of the two artists. The finest works of the great masters of that period were praised in closely similar terms, but their paintings exist only in our imaginations. In fact, countless *minghua* have been lost in the destruction and pillaging accompanying dynastic change.

The Place of Copying and Copies in the Concept of *Minghua*

In Chinese painting from early times, "transmission by copying" (*chuanyi moxie* 傳移模寫) was a means of studying the brushwork of old masters and an important part of pictorial training (tracing was known as *taxie* 搨寫). As early as Gu Kaizhi's treatise *Essays on Painting* (*Lun hua* 論畫), a detailed explanation of gaining the spirit (of an old master) through tracing may be found, and *Record of Famous Paintings of All Dynasties* tells of the continual practice of copying in four departments of the Tang imperial court. In *Painting, Continued* by Deng Chun are also two interesting accounts of copying. In the first, when Emperor Huizong painted a round fan (*tuanshan* 團扇), his courtiers would compete in copying it, and sometimes several hundred versions would result. In the other, a certain wily high-ranking collector, coming upon a *minghua*, would filch the original and replace it with a copy without the owner being aware.

The tradition of copying and the high degree of skill brought to it often confuse the connoisseurship of *minghua* and shed doubt on the authenticity of famous works. In Japan, for example, a famous example is a round fan painting of a dove on a branch of flowering peach (*Fig. 1*) that is attributed to Huizong, but an American scholar has doubted its authenticity and some Japanese scholars confidentially have agreed. Also in a private Japanese collection is a truly splendid level-distance landscape (*pingyuan shanshui* 平遠山水) attributed to Li Cheng (*Fig. 2*), which Suzuki Kei called a Ming period copy. Copies and forgeries are not unknown in the West, but nowhere are they mistaken for originals to the same extent as in China.

Mingpin in Japan

Shifting the discussion to Japan, let us consider the use there of the term *mingpin* (J: *meihin*), which in Chinese art criticism was an expression of praise slightly different and more inclusive than *minghua*.

Beautifully ornamented paper distinguishes *The Anthology of Thirty-six Poets* (*Sanjūroku'nin kashū* 三十六人歌集), an album of Japanese poems by the Thirty-six "Poet-Immortals," registered today as a National Treasure (J: *kokuhō* 国宝) in Japan (*Fig. 3*). The album is said to have been produced about 1112, on the occasion of a banquet celebrating the sixtieth birthday of the Cloistered Emperor Shirakawa 白河, at which the guests competed in bringing splendid albums; it could well have been awarded first place. Works of this kind became influential models for seventeenth-century artists like Hon'ami Kōetsu 本阿弥光悦 (1558–1637) and Tawaraya Sōtatsu 俵屋宗達 (d. ca. 1640), who ardently sought to revive the arts of the imperial court. No document or appraisal of this work survives from its own time, and it seems to have gone unnoticed in a temple storehouse until it was discovered in the twentieth century. The illustrations, by the criteria of Western art, serve not as painting but as ornamentation (*sōshoku* 装飾).

The twelfth-century *Personal Record of Pilgrimage to the Seven Great Temples* (*Shichidaiji junrei kōki* 七大寺巡礼私記) by the Kyoto aristocrat Ōe Chikamichi 大江親通 (d. 1151), written on the occasion of his visit to famous Nara temples, contains the terms of praise "superb, marvelous" (*yūmyō* 尤妙) and "exceedingly superb" (*jinmyō* 甚

妙). Ōe Chikamichi was familiar with imported Chinese books, and he may well have been prompted to compare his *Personal Record of Pilgrimage* with Zhang Yanyuan's *Record of Famous Paintings of All Dynasties* and its chapter on wall paintings in the two Tang capitals. Ōe prefaced his work by stating that he was moved to compose it by the desolation of Nara temples. Mainly he documents here Buddhist statues, ceremonial halls, objects ornamenting the interiors, and temple records. He mentions few wall paintings and pictorial scrolls, either because not many existed, or because he did not consider them important.

These examples suggest that the Japanese did not wholly accept aesthetic attitudes established by Song Chinese court officials and literati (as explained above), who celebrated painting and ignored sculptures and craft objects as "artisanry," and hence beneath critical judgement.

From the twelfth to the sixteenth century, splendid paintings and fine craft goods were newly imported from Song, Yuan, and Ming China. They were called *karamono* 唐物 ("Chinese objects"), and the Ashikaga shoguns collected them avidly. When they invited members of their circle—personal retainers, Zen monks, wealthy merchants, and court aristocrats—to tea ceremonies or linked verse (*renga* 連歌) gatherings, they proudly displayed *karamono* as "reception room adornments" (*zashiki kazari* 座敷錺). One guest extolled such a display, remarking, "It was as though we were looking at the solemn splendor of paradise."

In 1436, the emperor honored the shōgun 将軍 Ashikaga Yoshinori 足利義教 with a formal visit to the shōgun's villa. Each room of the reception hall was embellished with splendid Chinese objects, and their appearance was officially recorded in great detail by the artist Nōami 能阿弥 (1399–1471), who was in charge of the display of *karamono*. According to him, in the *tokonoma* 床の間 (decorative alcove) and on the walls hung paintings by such Song and Yuan artists as Muqi 牧谿 (act. until 1279), Li Di 李迪 (1163–1225), Liang Kai 梁楷 (act. early 13th c.), Xia Gui 夏珪 (act. ca. 1190–ca. 1230), Huizong, and Yujian 玉澗 (act. mid-13th c.). Fortunately, almost all of these works have been preserved to the present day.

Nōami served as a sort of curator for the shogun's art collection. He and his grandson Sōami 相阿弥 (d. 1525) wrote a guide to the vast shogunal holdings of Chinese paintings, and in it they included a list entitled "Painters: upper, middle, and lower (rank)." Using methods of critical evaluation in Chinese painting treatises as a model, they ranked Chinese painters from the Tang onward, especially artists whose works were in the shogunal collection. Although most of these were regarded as first-rate in China, some serve to exemplify subtle differences between Japanese and Chinese critical evaluation. Chinese critics, for example, have condemned Muqi's paintings of the "untrammeled" class. Xia Wenyan 夏文彦 of the Yuan period, for example, in his 1365 collection of biographies entitled *Precious Mirror of Painting* (*Tuhui baojian* 圖繪寶鑑), judged him as "coarse, lacking old methods (*cu'e, wu gufa* 粗惡，無古法)." In Japan, however, Muqi was highly favored and the painter most represented in the Ashikaga collection. Some of his works are universally recognized as of the very finest, such as the triptych of Guanyin 觀音 (J: Kannon), crane (*Fig. 4A*), and gibbons (*Fig. 4B*), once in the shogunal collection and now the property of Daitokuji 大德寺 in Kyoto.

Zen Buddhist monks who went to study in China brought Chinese paintings back home in substantial numbers. Many trained at Liutongsi 六通寺 near West Lake at Hangzhou, where Muqi lived as a monk. The Japanese monks called him *oshō* 和尚 ("revered teacher of doctrine"), and out of veneration they returned home with many of his works. Preserved in Japan, these exerted great influence on painters of the Momoyama period. Hasegawa Tōhaku 長谷川等伯 (1539–1610), for example, judged them "as free as the movement of a piece on a *go* board (碁盤に玉を転がすように自由だ)" and yearned to paint in a like manner. A masterpiece among masterpieces of Japanese painting is Tōhaku's *Pine Grove Screen* (*Shōrin byōbu* 松林屛風; *Fig. 5*), in which he utilized the ink-painting techniques of Muqi and Yujian to render Japanese sensibility.

The masterworks of Chinese painting selected by Sōami were combined with various fine craft wares—tea caddies, tea bowls, teacups, flower vases, *go* boards, lacquer trays, incense boxes, inkstones, and wind bells—which were intended to serve as functional and ornamental components of the tea room. All were considered "ornaments" (*kazari* 飾), and all might be ranked as *meihin* or *meibutsu* 名物 ("famous objects"), a parity between craft wares and paintings which clearly reveals characteristics of Japanese taste. This unified vision originated in the Japanese tea ceremony as it developed in the sixteenth century and became increasingly formalized over time. Paintings considered *meibutsu* were hung in the tearoom *tokonoma* with much attention given to the painter's name and the subject matter. Like tea bowls and tea caddies, paintings were carefully chosen by the host of a tea ceremony for their subtle consonance with the rest of the ensemble. As aesthetic eminence shifted from imported Chinese objects (*karamono*) to those made in Japan (*wamono* 和物), in which works by Japanese ink painters such as Mokuan Reien 黙庵靈淵 (act. 1323–1345), Kaō Sōnen 可翁宗然 (d. 1345), and Sesshū Tōyō 雪舟等楊 (1420–1506), as well as local pottery wares such as Iga 伊賀 and Bizen 備前, might be judged *meibutsu*.

Chinese *minghua* preserved in Japan are generally smaller than average Chinese paintings, solely because they were selected to fit the diminutive space of the Japanese tea house. *Views of Mt. Lu* (*Lushan tu* 廬山圖) by Yujian, for example, was purposely separated and mounted as two hanging scrolls. Similarly, a pair of paintings of plum blossoms and birds attributed to Ma Lin 馬麟 (ca. 1180–after 1256) were originally larger but are thought to have been trimmed. Undoubtedly *mingpin* suffered when they were cut down in order to serve in the Japanese tea ceremony.

Diaries of tea gatherings in the sixteenth and seventeenth centuries record how *meihin* served to ornament the *tokonoma* of tea houses, but "excellent paintings" (*minghua*) have survived that were not connected to the tea ceremony. We know they were highly esteemed because early copies and adaptations are extant. For example, the so-called *Long Scroll* (*Chōkan* 長巻) by Sesshū, an undoubted masterpiece, was copied by Unkoku Tōgan 雲谷等顔 in 1593, more than one century after the original was painted. Tōgan modelled much of his work after Sesshū and called himself his "descendant" (*matsuei* 末裔). Similarly, there is an excellent genre screen of the first half of the seventeenth century, known as the *Hikone Folding Screen* (*Hikone byōbu* 彦根屛風), of which a number of versions are known. Finally, a contemporary copy of the aforementioned *Pine Grove Screen* by Hasegawa Tōhaku has recently come to light. Inter-

Tsuji Nobuo

estingly, the artist interpreted the morning mist scene as a night view and added the moon, making it an adaptation rather than a copy. This type of adaptation clearly demonstrates contemporary critical evaluation.

How did guests express their admiration for *meihin* when displayed in a tea room? Documents concerning this interesting question are extremely scarce, but we do have the following record. At a tea gathering in Hasegawa Tōhaku's time, a tea master said concerning a Chinese painting, "Ah, a tranquil picture!" a comment which Tōhaku admired. The Japanese did not often intellectualize about paintings but were content with receiving their immediate sensory impact. Indeed, one may generalize that the Chinese responded to paintings more rationally than did the Japanese—but not as much as Westerners.

Restricted Access to Celebrated Objects and Paintings

By comparison with the West, access to celebrated paintings in East Asia has been much restricted. The circumscribed environment in which the "celebrated paintings" (*minghua*) of China, Korea, and Japan were enjoyed and preserved was related to the long prevalence of feudalism, to the delayed growth of the urban classes in East Asian society, and to the elite status of the persons who usually owned and enjoyed paintings.

In Japan, those who enjoyed or authenticated paintings included many devotees of the tea ceremony, the so-called "tea adepts" (*chajin* 茶人). They were generally reluctant to show "ordinary" people their treasured paintings, saying that such viewing left behind "optical grime" (*meaka* 目垢). Though this custom survives to the present day and obstructs scholarly research, it is gradually weakening as time passes and the arts spread more widely in society.

During the seventeenth century, an appreciation of the nation's artistic heritage as such began to take root. In the second half of the century, several collections of biographies of Japanese artists were composed, their formats modelled on imported Ming and Qing Chinese painting treatises. *History of the Nation's Painters* (*Honchō gashi* 本朝画史) by Kanō Einō 狩野永納 (1631–1697) contains biographies of more than four hundred Japanese artists. Research and documentation of artworks were conducted as well. By the eighteenth century, picture albums with woodblock illustrations of selected famous paintings were published as introductory instruction for beginning artists. In the nineteenth century, members of the Kanō school compiled *Remarks on Old Paintings* (*Koga bikō* 古画備考), giving birth to a dictionary of four thousand artists' names. This compilation also contains a chapter on *Yamato-e* 倭絵, in which many examples of Japanese-style narrative scroll paintings are cited. The data, however, came mostly from documentary sources and the names of the finest works of the twelfth century known today, such as the *Legends of the Shigisan Temple* (*Shigisan engi* 信貴山縁起) or *Bandainagon Scroll* (*Bandainagon emaki* 伴大納言絵巻), were not listed.

Fuller understanding of native Japanese pictorial tradition coincided with the rise in the nineteenth century of the Yamato-e Revival School (*Fukkō Yamatoe ha* 復古倭絵派), which aimed at rejuvenating earlier native Japanese narrative painting techniques. Its members, however, supported the political opposition to the Tokugawa *bakufu* 徳川幕府 military government, resisting pressure from Europe and America to open Japan's ports to trade. A central figure

in the school, Reizei Tamechika 冷泉爲恭 (1825–1864), hoped to copy the *Bandainagon Scroll* in the collection of the Sakai family 酒井家, domain rulers (*daimyō* 大名) who were closely associated with the military government. Because of this, Tamechika was judged a traitor by the anti-*bakufu* camp and murdered. Obstacles of many kinds prevented the viewing of famous paintings, but they have been gradually disappearing.

Starting in the Meiji period in the late nineteenth and early twentieth century, it became possible to compile the first objective histories of Japanese art and to study European art history as well. Observing the concepts by which outstanding works of Western art were designated "masterpieces," pioneer Japanese art historians advocated the selection of Japanese "masterpieces" as essential to the formation of the history of the nation's art. At the direction of Japan's Ministry of Education (Monbushō 文部省), Ernest Fenollosa (1853–1908), Okakura Tenshin 岡倉天心 (1863–1913), and their associates, beginning in Nara and Kyoto, visited temples, shrines, and private collections throughout the country, seeking to discover *meihin*. National museums were founded, and works of art began to be accessible to the general public.

In 1923, the Sakai *daimyō* family sold the *Kibi Scroll* (*Kibi nittō emaki* 吉備入唐絵巻), which was acquired by the Museum of Fine Arts, Boston, a decade later. Dismayed by the removal of a famous work abroad, thoughtful people appealed to the government to prevent the export of cultural properties. In 1929, the Cultural Properties Protection Law (*Bunkazai hogohō* 文化財保護法) was enacted, and in 1933 laws concerning the protection of Important Art Objects (*Jūyō bijutsuhin* 重要美術品) were completed. The present system of regulating National Treasures and Important Cultural Properties (*Jūyō bunkazai* 重要文化財) is the result of revisions made after World War II. By the year 1997, 1,045 objects were designated as National Treasures, of which 154 were paintings. The paintings, however, are not all Japanese and also include Chinese works imported before the Meiji period and revered as *meihin*, including the aforementioned *Guanyin, Gibbons, and Crane* by Muqi.

Paintings designated as National Treasures may be regarded as a new type of *meiga* 名画 in Japan, selected by the government on the advice of scholars and protected by the authority of the regime. Critics of the concept of "masterpiece" do not oppose this Japanese "hierarchy of merit" as vehemently as in the West, because it is closely linked with policies of preservation as well as with preventing the export of cultural resources.

The concept of *minghua* or *meiga* has engendered an enduring belief in canons of excellence, but the criteria of the canon itself have varied over time. For example, in 1967 James Cahill organized an exhibition called *Fantastics and Eccentrics in Chinese Painting*; this, with other of his exhibitions and essays, fundamentally challenged the prevailing critical disparagement of the unorthodox, expressive paintings of the Yuan and later periods—works by Wang Meng 王蒙 (1309–1385), Dong Qichang 董其昌 (1555–1636), Wu Bin 吳彬 (act. 1573–1625), Chen Hongshou 陳洪綬 (1598–1652), and Gong Xian 龔賢 (1618–1689) (*Fig. 6*). Thus, a twentieth-century aesthetic consciousness created a new canon of *minghua*.

Tsuji Nobuo

About the same time and in the same way, it became known that in Japan during the Edo period there existed a lineage of innovative, individualist painters the likes of Itō Jakuchū 伊藤若冲 (1716–1800) and Soga Shōhaku 曽我蕭白 (1730–1780), who also appealed to present-day artistic taste. They were discussed in 1970 in a book entitled *Lineage of Eccentrics* (*Kisō no keifu* 奇想の系譜), written by the present author, whose views are also perhaps occasionally unconventional and expressionist. From a more orthodox point of view, Money Hickman, a specialist on Shōhaku, and Joe Price, a collector of Jakuchū paintings, have evaluated those artists as traditional great masters. From our differing viewpoints, we cast bright light upon Shōhaku and Jakuchū, who hitherto had been largely ignored as eccentric and minor artists.

The reputations of the six painters whom I introduced in *Kisō no keifu* have gradually grown, and they are now seen as representative artists of the Edo period. In particular, an exhibition in 1999 of Jakuchū at the Kyoto National Museum created great excitement; more than one hundred thousand visitors crowded to see it. His masterworks, such as those in the *Colorful Realm of Living Beings* (*Dōshoku sai-e* 動植綵絵) series (*Fig. 7*) or *Roosters and Cactus* (*Ondori saboten* 雄鶏仙人掌), have now been firmly judged to be *meiga*.

I am convinced that if Shōhaku were given the same scale of exhibition in Kyoto or Tokyo, he would be judged in no way inferior to Jakuchū. His masterworks, such as *The Four Sages of Mt. Shang* (*Shōzan shikō* 商山四皓; *Fig. 8*) and *Hanshan and Shide* (*Kanzan Jittoku* 寒山拾得), are without question *meiga* of the Edo period. Of considerable interest is the similarity between the strange, grotesque compositions of Shōhaku and those of Chen Hongshou, which in all probability Shōhaku never saw. Why they seem to share the same spirit is an intriguing question.

Conclusion and a Word About Korean *Myŏnghwa*

In China, the concept of *minghua* was established early and derived from the aesthetic awareness of literati who were government officials or independent scholars and artists. Their critical evaluations took the form of ranking ancient and modern painters, and the appellation *minghua* was limited mostly to works of high-ranking artists. The judgement of art works was therefore closely linked to the judgement of the painters themselves. However, because of the tradition of "transmission by copying," it is difficult to authenticate the painter of a given *minghua*. Exceedingly rare are works the quality and authenticity of which are unquestioned—such as *Early Spring* (*Zaochun tu* 早春圖) by Guo Xi, *Spring Festival on the River* (*Qingming shanghe tu* 清明上河圖) by Zhang Zeduan 張擇端 (act. early 12th c.), or *Dwelling in the Fuchun Mountains* (*Fuchunshan ju tu* 富春山居圖) by Huang Gongwang 黄公望 (1269–1354).

From early times, a special characteristic of the "phenomenon of excellence" in Chinese painting has been the recognition that works which deviate from orthodox techniques may qualify as "extraordinary" (*qi*) and "untrammeled" (*yi*). Within these rubrics, the adaptations of earlier classic works by painters of the Yuan, Ming, and Qing periods might also be deemed *minghua*. Literati critics, who embraced such "expressionist" works, dismissed professional artisan painters as "bricklayers" or "mud workers" and judged their products as inferior. In the twelfth-century *Chun-*

quan's Compilation on Landscape, mentioned above, is the following anecdote. A man of Wuchang 武昌 practiced the "broken ink" (*pomo* 潑墨) technique. Asked for a picture, he took off his loincloth, applied black ink heavily to his buttocks, and sat down on a piece of white silk. Then, with his brush, he added leaves and branches to the imprinted shapes and produced a large painting of a peach tree. The aforementioned tradition-minded twentieth-century critic Lin Shu condemned this, saying, "This is truly a bad practice. A reputable person wants to laugh. Painting is refined. How is this necessary? And how did things come to this? (是眞惡道。令人欲笑。畫雅事也。何必是。亦何至是)." He might well have regarded the paintings of Soga Shōhaku in the same way. For my part, I hope that young scholars question this dismissive elite literati opinion and evaluate on their own merits the bold, openhearted expressions that originate in the life of common people.

Although the practice of keeping paintings shut away from public view is common to collectors around the world, it is especially strong in East Asia. Treating *minghua/meiga* as sacred or magical treasures may, perhaps, protect them from the dangers of warfare and plunder, but it has also delayed their discovery and prevented critical judgement and authentication. Portraits of lay persons, for example, were long taboo because, it is said, that the sitters feared they might become the objects of a curse—this according to studies by the Kyoto scholar Akamatsu Toshihide 赤松俊秀. In the twelfth century, the prohibition was finally overcome, but even after that public display of portraits of laymen was resisted. The twelfth-century portraits preserved at Jingoji 神護寺—said to include those of Minamoto no Yoritomo 源頼朝像 (*Fig. 9*) and Taira no Shigemori 平重盛像—are works of unimpeachable quality, but these, like many other National Treasures, did not surface until the Meiji period and scholars are still debating their dates. Enthusiasts of the tea ceremony, *sukisha* 数寄者 ("men of refinement"), collected curious objects for use as tea implements, and likewise kept their treasures from public view. As with *meiga*, this custom of close-keeping had both positive and negative effects.

Because I lack specialized knowledge, I can only touch upon Korean painting. Buddhist paintings, such as the exquisite *Water-moon Kwanŭm* (*Suwŏl Kwanŭm* 白衣觀音; *Fig. 10*) have been widely esteemed, and the study of secular painting is making rapid progress. The Japanese edition of *History of Korean Painting* (*Kankoku kaigashi* 韓国絵画史) by Ahn Hwi-joon 安輝濬 is a splendid survey, filled with ideas about the characteristics of Korean *myŏnghwa* (J: *meiga*). For example, the 1445 *Record of Paintings* (*Hwagi* 畫記) is the catalogue of the collection of the powerful Prince Anp'yŏng 安平大君 and comparable to the Japanese *Catalogue of the Shogunal Collection* (*Gyōmotsu on'e mokuroku* 御物御絵目録) of the Ashikaga family painting collection. The latter contains mostly Song and Yuan works; the former, by contrast, emphasizes the Yuan-period Li-Guo school (based on the styles of Li Cheng and Guo Xi). Korea, next door to China, was apparently more strongly influenced by the ideals and critical values of the Chinese literati. *Record of Paintings* records thirty works by An Kyŏn 安堅 (act. ca. 1440–1470), the leading Korean artist of the Li-Guo school. Unfortunately, all but one of the paintings are lost, the sole survivor being the famous *Dream*

Tsuji Nobuo

Journey to the Peach Blossom Land (*Mongyu dowon do* 夢遊桃源圖) in Japan (*Fig. 11*). It is regrettable that this work, recognized as a supreme masterpiece of Korean painting, is not in Korea.

We admire the highly refined aesthetic vision of Buddhist paintings of the Koryŏ period, and the splendid landscapes in the style of Ma Yuan 馬遠 by Yi In-mun 李寅文 (1745–1821) and Yi Sang-ja 李上佐 (act. late 15th to mid-16th c.). The names of those who created Korean *myŏnghwa* are legion—Yi Am 李巖 (b. 1499), Su Mun 秀文 (mid-15th c.), Kim Hong-do 金弘道 (1745–1806), Hong Se-swop 洪世燮 (b. 1832), and many others. Additionally, I hope that Korean folk painting, which is already well received internationally, will be judged apart from the long-established art criticism category of fine arts masterpiece, or *meiga*. With its spontaneous and unadorned strength, it deserves a special category of its own.

To conclude, long ago a group of graduate students from Tokyo University led by Suzuki Kei visited the National Palace Museum in Taipei and were offered a special viewing of *mingpin*. When Guo Xi's famous *Early Spring* was about to be displayed, Mr. "S," an assistant, suddenly fished something out of his pocket and, holding it up, cried out, "Friends, this is a tranquilizer. Whenever I see this painting by Guo Xi, I get over-excited, and to avoid that, I take this!"

A genuine masterpiece will strike the heart of a person who, even unprepared, suddenly encounters it. I have little knowledge of Western art, but I reacted like Mr. "S" upon seeing *The Return of the Prodigal Son* by Rembrandt in the Hermitage Museum and the *Burial of Count Orgaz* by El Greco in Toledo. And I find it difficult to express how I felt, over twenty years ago, upon encountering the handscroll *Fishing Boats in Autumn* (*Qiujiang yuting* 秋江漁艇) by Xu Daoning 許道寧 (970–1052) (*Fig. 12*) in the Nelson-Atkins Museum of Art in Kansas City. A great panorama stretched before my eyes, a space deep and wide beyond all imagination and also resonant with life—perhaps with the very truth of creation.

Whatever may be the criticisms of the masterpiece, it simply transcends them. Without the exhilaration and joy that I feel before a masterpiece, my studies in art history would not exist.

主題演講
論東亞繪畫中「Masterpiece（名品）」的性質—
從日本繪畫的觀點談起

辻惟雄

東京大學名譽教授

若將西洋美術中的 phenomenon of experience，亦即 masterpiece 的概念（concept）或意象（image）轉移到東亞美術上，會是什麼樣的情況呢？我想以繪畫爲主題加以思考。

（1）與 masterpiece（以下簡稱 MP）對應的中文用語是名品（mingpin），若限定指稱畫作，那就是名畫（minghua）。這些用語的概念不見得與 MP 嚴密對應，但有許多重疊之處。

所謂「名品」是北宋《山水純全集》的「論觀畫識別」一章中的用語：「達之名品，參乎神妙，各適於理者。」這是中國繪畫批評自古以來的傳統：「畫品」，也就是「品評畫家」之詞。《唐朝名畫》、《歷代名畫記》可能是最早使用「名畫」一詞的例子，但即使是這些書中也有「畫品」一項，《唐朝名畫錄》分作神、妙、能、逸四品；《歷代名畫記》則分別列出自然、神、妙、精、慎細等五品。這種畫人品第是評價畫家之意，並不適於評價無名畫家的「名品」。利用幾個品地區分評價的方法，是否比 MP 精密，當中不無疑問。但這些品第裡引人注目的是有「逸」、「奇」等和西洋 MP 不同，基於東洋獨特標準的評價。

環繞中國名畫的話題中也觸及模寫。名畫的模寫，也就是「傳移模寫」，是習畫的重要課目。高度的模寫技術因此發達，成了鑑識名畫時的干擾。傳徽宗筆《桃鳩圖》、傳李成《平遠山水圖》（皆爲日本私人收藏）等即爲其例。

（2）將焦點轉到日本，可發現與中國「名畫」評價、觀賞略有不同的方式。日本並沒有像中國對繪畫與書法採取特別待遇，將雕刻與工藝品置於評價之外的強烈文人價值觀傳統。名畫的用語不常被使用，反而偏好名品之詞。究其原因，是由於在中國，除了繪畫之外，名品也用來形容像「牡丹」的花，具有十分寬廣的意義。

十二至十六世紀，宋、元、明三朝優異的繪畫與工藝品流傳至日本，被當作「唐物」，廣受歡迎。歷代足利將軍在自家宅邸召開連歌會或茶會時，驕傲地在會場陳列唐物名品，觀者不禁感嘆「彷彿見到極樂莊嚴之像」。這是繪畫、工藝合而爲一的 display（展示），主角是牧谿、李迪、梁楷、夏珪、徽宗、玉澗等宋元巨匠。上述畫家中，牧谿在當時的中國很難想像會有什麼好評價；然而他是許多日本禪僧前往留學的六通寺中

的僧侶，因此可與之親善，使如《觀音猿鶴圖三幅對》（大德寺藏）等可稱爲世界名畫的大作傳至日本。

茶湯在十六世紀後半至十七世紀前半，發展出稱爲「侘び茶（wabicha）」的洗鍊形式。作爲「名物」的中國繪畫和書法，懸掛於茶會席的凹壁牆面上，和茶會主人選的名物茶碗、裝茶具等產生微妙的對應。默庵、雪舟等日本水墨畫家的作品，伊賀、信樂等地方燒製的陶器也被當作「名物」擺置在會場。中國繪畫與書法被切裁懸掛於窄小至極的茶室凹壁上。

（3）這種以茶湯爲媒介鑑賞名畫的風習，經過近世、近代，確實培養出對古畫的眼力，但反之其封閉的態度亦妨礙名畫對一般人公開。茶人認爲開放自己的收藏給外人看，會使作品沾上眼垢般，感到十分嫌惡。不欲使人觀看名畫的風氣，是東亞世界的共通點。

到了明治時期，日本人學習西洋的美術史學與MP的概念。費諾羅沙和岡倉天心受政府委託，探訪全國寺社與個人收藏家，努力發掘MP。博物館被設置，打開美術品對一般大眾公開的道路。與此同時，爲防止名畫流出海外，1929年設立「國寶保存法」制度。換言之，這可說是政府的名畫選拔制度。

（4）名畫爲後代提供經典（canon），但決定經典的基準隨因時代而異。第二次世界大戰後，James Cahill教授闡揚王蒙、董其昌、吳彬、陳洪綬、龔賢等畫家奇幻（fantastic）而特異（eccentric）的圖像表現系譜的價值。我也與之呼應，介紹十八世紀京都的伊藤若冲、曾我蕭白等日本特異表現畫家的系譜。

如前所述，中國從正統中分離出來的「奇」、「逸」等價值，自古以來即被肯定，卻與尊重文人和士大夫的畫作、稱民間藝匠爲「泥水工」，輕視其工作的態度相左。清末的《春覺齋論畫》中，武昌有一名男子在赤裸的臀部沾滿墨後，坐到畫絹上，在印出的圖案旁畫上枝葉，成爲一張桃子畫的故事。作者強烈指責此「是眞惡道，令人欲笑，畫雅事也。」或許像曾我蕭白等畫風奇異的畫家，也會被此書作者指責爲「下流」吧。然而，這種文人畫至上的價值觀，是否能得到現今年輕世代的認同，實有疑問。

沒有提及韓國繪畫的MP，是因爲我所知甚少，深感可惜。韓國美術的MP與其說是在宮廷美術領域，不如說是在民眾創造的工藝與民間繪畫中。最後我要提出的是，眞正的名作是不帶有先入爲主的偏見和投射，超越作品的時代與場所、創作者的階級與性別，打動觀者的作品。

基調講演
東アジア絵画におけるMasterpieceの性質について—
日本絵画の視点から

辻惟雄

東京大学名誉教授

　西洋美術におけるphenomenon of excellenceすなわちmasterpieceのconceptやimageは、場所を東アジアに移せばどのようになるのか？これを絵画に話題を限って考えてみたい。

　（1）Masterpiece（以下MPと略称）に対応する中国の用語は名品（mingpin）であり、絵画だけに話題を限れば名画（minghua）という言葉がある。これらの言葉の概念は、MPと必ずしも厳密に対応するものではないが、重なる点も多い。

　「名品」とは北宋の『山水純全集』のなかの一章「論観画識別」で使われている用語であり、「名品は神品・妙品と並ぶ、理にかなった作品が示している趣きである」と書かれている。そしてこれは、中国の絵画批評に古くから伝統としてある「画品」、すなわち「画家の品評」の用語であった。『唐朝名画録』、『歴代名画記』は、おそらく「名画」という言葉を用いたもっとも早い例に属するが、これらにも「画品」の項があり、『唐朝名画録』は神、妙、能、逸の四品等を、『歴代名画記』は、自然、神、妙、精、慎細の五品等をそれぞれ立てている。このような画人の品等分けは、画家の評価を意味するものであり、無名画家による「名品」の評価には適さない。いくつもの品等に分ける評価の仕方がMPよりも精密かどうか、疑問がなくはない。ただしこの品等分けに関して注目されるのは、「逸」、「奇」といった、西洋のMPとは別の、東洋独特の価値基準による評価が含まれているということである。

　中国の名画にまつわる話題として模写にもふれておく。名画の模写すなわち「伝移模写」は、絵画習練のための重要な課目であった。高度な模写の技術がこれによって発達し、名画の鑑識上のさまたげとなっている。徽宗筆と伝えられる「桃鳩図」や、李成筆と伝えられる「平遠山水図」（ともに日本の個人蔵）など、そのよい例である。

　（2）日本に眼を移すと、ここには中国の「名画」の評価・観賞とはやや違った方式が認められる。中国では絵画を書と同様に特別扱いして、彫刻や工芸品を評価の外に置くという文人の価値観が強い伝統としてあるが日本にはそれがない。名画という用語はあまり用いられず、それに対し名品という用語が好んで用いられる。なぜなら

ば、名品とは、中国でも絵画以外に「牡丹」のような花に対しても用いられる言葉であり、巾の広い意味を含んでいるからである。

　12世紀から16世紀にかけ、宋、元、明からすぐれた絵画や工芸品が日本にもたらされ、「唐物」としてもてはやされた。足利将軍たちは、自己の邸宅で連歌や茶の湯の会を開くとき、会場に唐物の名品を自慢げに陳列し、見る人は「まるで極楽の荘厳のさまを見るようだ」と感歎した。それは絵画と工芸とが一体となったdisplayだが、なかで中心の役割は、牧谿、李迪、梁楷、夏珪、徽宗、玉澗ら宋・元の名匠の作品であった。これらのうち牧谿は、当時中国でさほど高い評価を得ていたとは思えない。だが日本の禅僧が多く留学した六通寺の僧であったことから親しまれ、「観音猿鶴図三幅対」（大徳寺）のような、世界の名画と呼ぶにふさわしい作品が日本に伝えられている。

　茶の湯は、16世紀後半から17世紀前半にかけ、「侘び茶」と呼ばれる洗練された形式をつくりだす。「名物」としての中国の絵画や書は、茶会の席の床の間に掛けられ、それは茶会のホストが選んだ名物の茶碗や茶入れなどと微妙に対応する。黙庵、雪舟ら日本の水墨画家の作品や、伊賀、信楽ら国産の焼物も、「名物」としてそこに加わる。極限にまで狭められた茶室の床の間には、中国の絵や書が、切り縮められて掛けられる。

　（3）こうした、茶の湯を媒体とする名画鑑賞の風習が、近世、近代を通じて、古き名画に対する眼を養ってきたことは事実だが、反面その閉ざされた態度が、名画を一般に公開することを妨げてきた。茶人は自己のコレクションを人に見せることを、眼垢がつく、といって嫌がった。名画を人に見せたがらない風習は、東アジアに共通するものである。

　明治時代になると、日本人は西洋の美術史学とMPの概念を学ぶ。フェノロサや岡倉天心は、政府に依頼され、全国の寺社や個人の蒐集家を訪れてMPの発掘に努めた。博物館が設置され、美術品の一般公開への道が開かれた。と同時に、名画の国外流出を防ぐため1929年「国宝保存法」の制度が設けられた。政府が名画を選ぶ制度とこれを言い換えることもできる。

　（4）名画とは、後の世代に対しcanonを提供するものである。しかしcanonを決める基準は時代により異なる。第二次大戦後、James Cahill教授が、王蒙、董其昌、呉彬、陳洪綬、龔賢らによるfantasticでeccentricなimage表現の系譜の価値付けを訴えた。私もそれに呼応して、18世紀の京都における伊藤若冲や曾我蕭白ら、日本におけるeccentricな表現者の系譜を紹介した。

　先述のように、中国では、正統から離れた「奇」や「逸」の価値が、古くから認め

られてきた。しかしそれは、文人・士大夫の画を尊重し、民間の職人を「泥水匠」と呼んでその仕事を軽蔑する態度と裏腹であった。清末の『春覚斎論画』には、武昌のある男が、裸の尻にたっぷりと墨をつけ、絹地の上に坐り、プリントされたかたちに枝葉を加えて、桃の絵ににしたという話が載せられている。著者はこのことを、「是真悪道、令人欲笑、岨雅事也」と強く非難している。曾我蕭白のような奇抜な画家も、多分この著者によって同様に「下品」と非難されるだろう。だが、こうした文人画至上の価値観が、今日の若い世代の共感を得るかは疑問である。

　韓国絵画のMPについてふれなかったのは、私の知識の足りなさゆえであり残念だが、韓国美術のMPは宮廷美術よりむしろ民衆の手による工芸や民画のなかにあるのではないか。真の名作とは、先入観や思い入れなしに、つくられた時代や場所、つくった人の階級や性別をこえて、見る人の心を打つものだと、最後に申し上げたい。

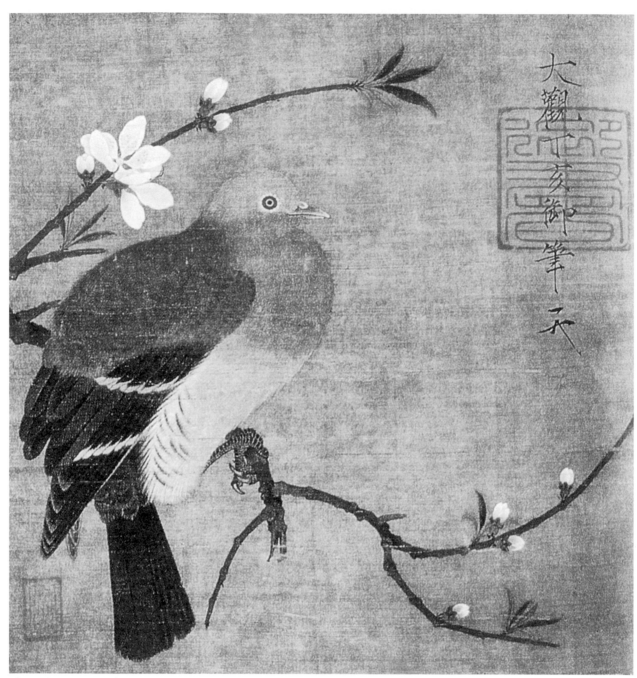

Fig. 1. Attributed to Emperor Song Huizong (r. 1101–1126). *Dove on a Flowering Peach Branch*. Album leaf mounted as hanging scroll, ink and color on silk, 29 × 26 cm. Private collection, Japan.

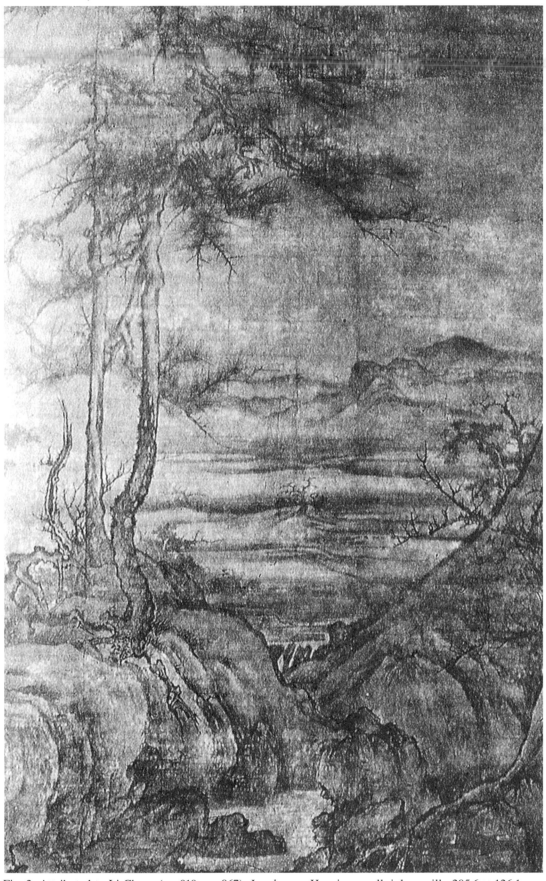

Fig. 2. Attributed to Li Cheng (ca. 919–ca. 967). *Landscape*. Hanging scroll, ink on silk, 205.6 × 126.1 cm. Chōkaidō Bunko, Mie.

Tsuji Nobuo

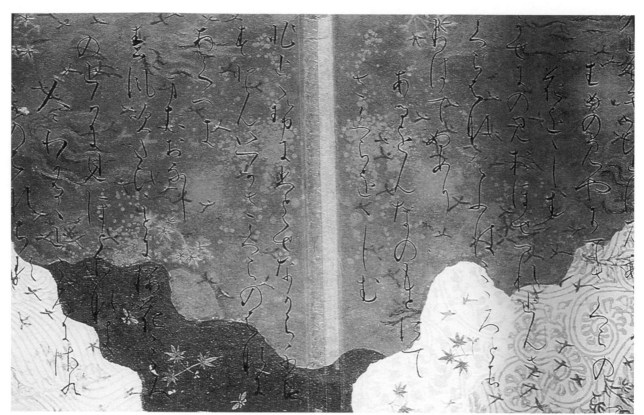

Fig. 3. *The Anthology of Thirty-six Poets*, the Motozane version. Nishi Honganji, Kyoto.

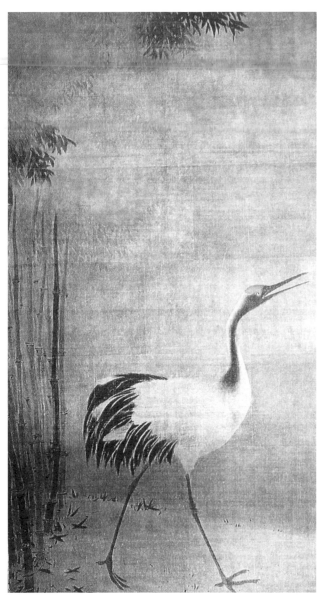

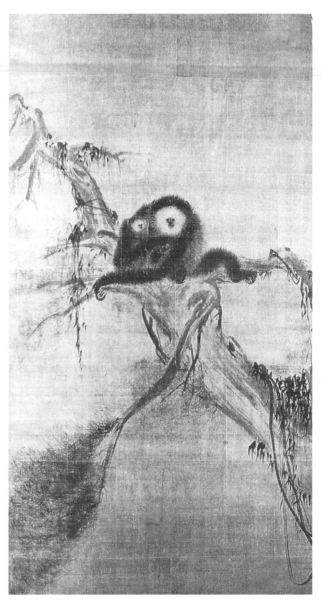

Fig. 4A. Muqi (early 13th c.–ca. 1279). *Crane*. From a triptych of hanging scrolls: *Guanyin, Gibbons, and Crane*. Hanging scroll, ink and light color on silk, 173.9 × 98.8 cm. Daitokuji, Kyoto.

Fig. 4B. Muqi. *Gibbons*. Hanging scroll from the triptych *Guanyin, Gibbons, and Crane*.

Tsuji Nobuo

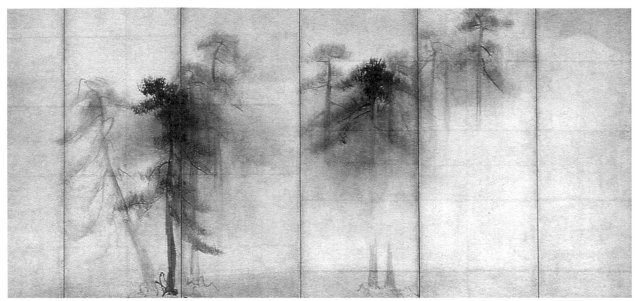

Fig. 5. Hasegawa Tōhaku (1539–1610). *Pine Grove Screen*. One of a pair of six-fold screens, ink on paper, h. 155.7 cm. Tokyo National Museum.

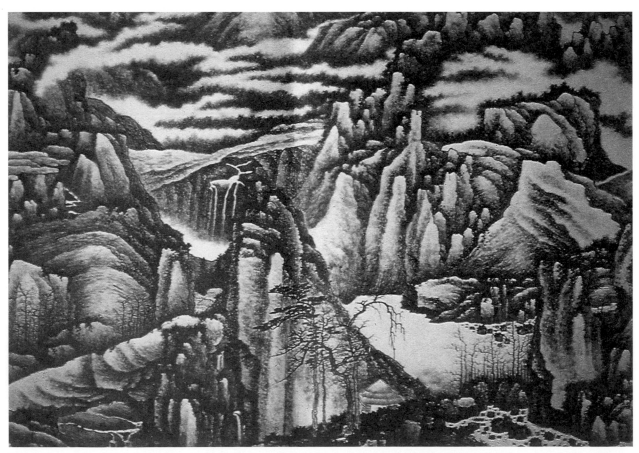

Fig. 6. Gong Xian (1618–1689). *Thousand Peaks and Myriad Ravines*. Section of a hanging scroll, ink on paper, 62 × 102 cm. Museum Rietberg, Zürich.

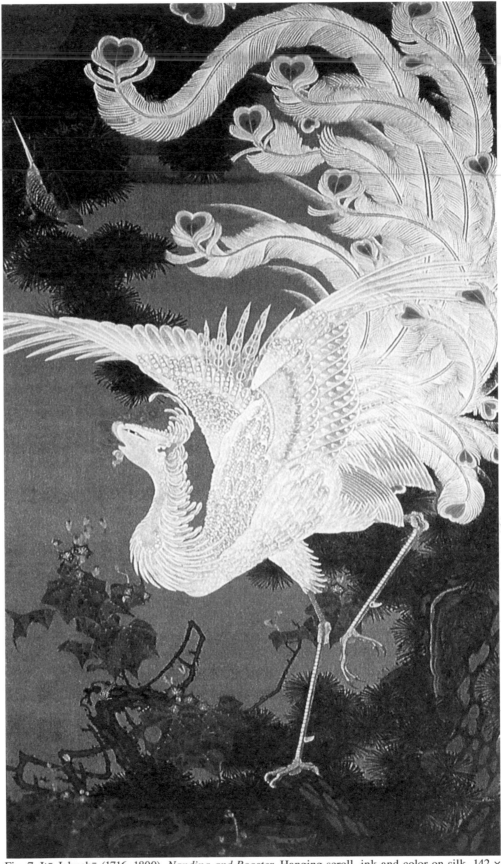

Fig. 7. Itō Jakuchū (1716–1800). *Nandina and Rooster*. Hanging scroll, ink and color on silk, 142 × 72.9 cm. From *The Color Realm of Living Beings* series. Sannomaru Shōzōkan Museum, Imperial Household Agency, Japan.

Tsuji Nobuo

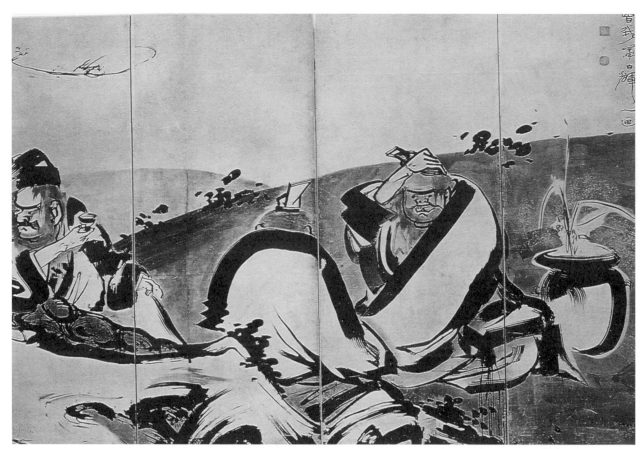

Fig. 8. Soga Shōhaku (1730–1780). *The Four Sages of Mt. Shang*. Detail from a pair of six-fold screens, ink and gold dust on paper, 156.2 × 60.6 cm (each panel). Museum of Fine Arts, Boston.

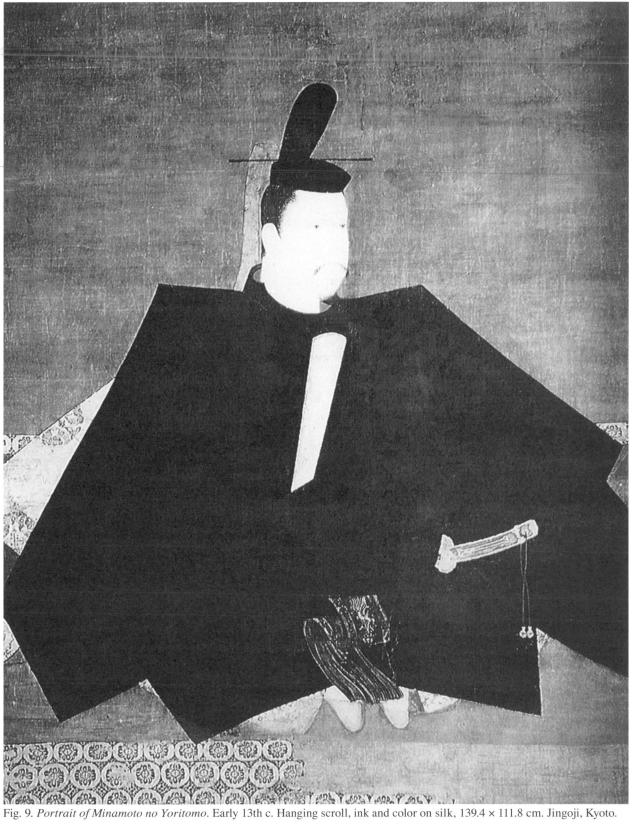

Fig. 9. *Portrait of Minamoto no Yoritomo*. Early 13th c. Hanging scroll, ink and color on silk, 139.4 × 111.8 cm. Jingoji, Kyoto.

Tsuji Nobuo

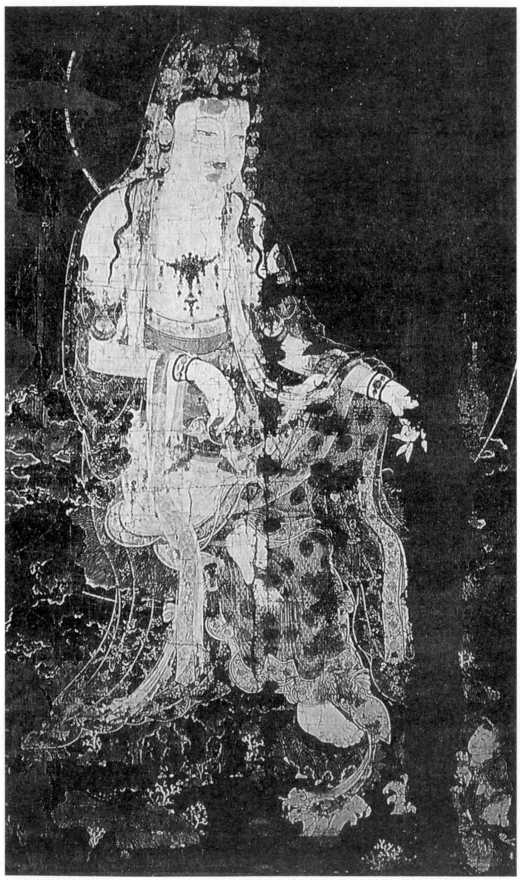

Fig. 10. *Water-moon Kwanŭm*. Dated to 1310. Hanging scroll, ink and color on silk, 419.5 × 254.2 cm. Kagami Shrine, Saga Prefecture.

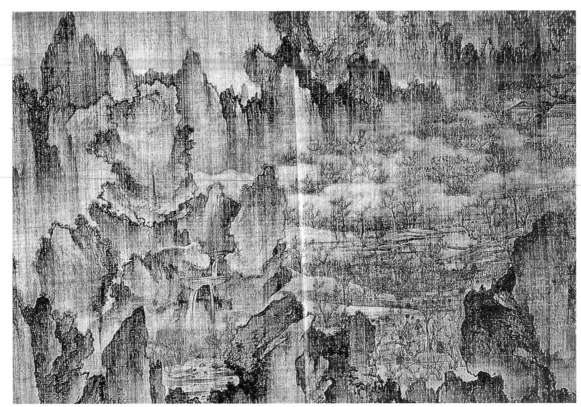

Fig. 11. An Kyŏn (act. ca. 1440–1470). *Dream Journey to the Peach Blossom Land*, dated to 1447. Section of a handscroll, ink and light color on silk, 38.6 × 106.2 cm. Tenri Central Library, Tenri University, Nara.

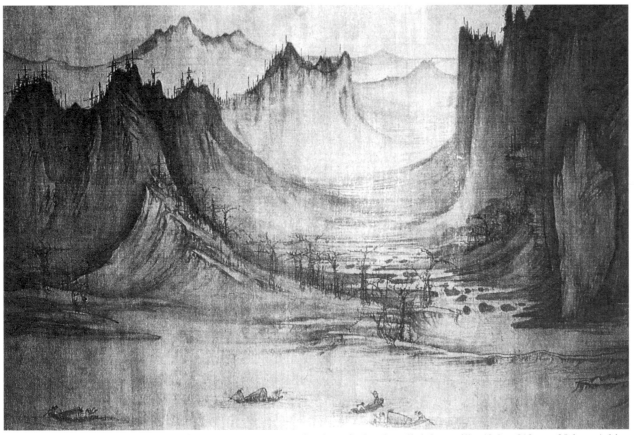

Fig. 12. Xu Daoning (970–1052). *Fishing Boats in Autumn*. Section of a handscroll, ink on silk, 48.9 × 210 cm. Nelson-Atkins Museum of Art, Kansas City. *(detail on page 19)*

Tsuji Nobuo

Section I
Studies of Canonical Paintings

Section I: Studies of Canonical Paintings
Introduction

Takeda Tsuneo

Osaka University, Emeritus

In his opening essay, Tsuji Nobuo 辻惟雄 traces the characteristics of so-called "masterpieces" in the history of Chinese art while also touching on the subject in Japan and Korea. I note with interest his comment that no matter how sublime a work might have been, those by unknown painters were rarely accorded the status of "masterpiece." Such thoughts suggest that we cannot ignore the identity of the artist in a consideration of works that comprise the various canons of "masterpieces."

A new wave of art historical methodology has begun in the West in reaction to the focus on recognized masters and their works, which it deems to be restrictive. The new methodology has been widely adopted by East Asian scholars, and it views art history in much broader terms (discussed elsewhere in this volume). Nevertheless, as seen in the essays of this section, there are scholars in both East and West who also seek to return to the "roots" of art history and to continue research on well-recognized works. As archaeology owes its advances to the excavation and interpretation of new finds, so art history increases knowledge and understanding through fundamental research on individual works. The discovery, analysis, and publication of new works of art stimulate the scholarly community and help it to move forward. Any work of art or art historical method is legitimately the object of a diverse array of questions and is therefore the subject of many different kinds of study. I must point out that the questions being asked will determine the research methods to be employed.

The essay of Shimao Arata 島尾新, for example, does not focus on a specific work. Instead, it explores how celebrated compositions by Sesshū Tōyō 雪舟等揚 (1420–1506), the *Long Landscape Scroll* (*Sansui chōkan* 山水長卷) and *Autumn and Winter Landscapes* (*Shūtō sansuizu* 秋冬山水図), exemplify the manner by which Japanese artists received Chinese landscape paintings and then rearranged elements from them for their own purposes. During the Muromachi period, some Japanese would associate particular brush styles (*hitsuyō* 筆様) with certain Chinese paintings and thence with specific artists' names. Within this "named brush system," Sesshū is said to have derived his painting style from the works of the Song dynasty artist Xia Gui 夏珪 (ca. 1190–1225). Dai Jin 戴進 (1388–1462), the Ming dynasty painter of the Zhe 浙 school, also made his own arrangements of the Xia Gui style, and he and Sesshū may therefore be thought to have shared this common source of imagery. In fact, however, Sesshū's depiction of snow in his *Winter Landscape* can be also traced back to a style identified with the Northern Song painter Fan Kuan 范寛 (act. ca. 980–1030), whereas the massive cliff face in *Winter Landscape* appears to be Sesshū's unique

invention. Though Sesshū was inspired by Chinese painting, his *Winter Landscape* was uniquely his own creation. Shimao's essay is a broad-view study that recognizes the uniqueness of the work of art and the impact of the artist on the work.

The other three essays in this section approach different aspects of canonical works. Chen Pao-chen 陳葆眞 re-examines the dating, attribution, and iconography of a widely celebrated work. Robert Harrist engages the question of authorship of a newly discovered painting. Satō Yasuhiro 佐藤康宏 considers deep levels of meaning to be found in another acclaimed composition.

The well-known *Thirteen Emperors* (*Shisan diwang* 十三帝王) scroll in the Museum of Fine Arts, Boston, presents the conservative painting style associated with the early Tang dynasty and has long been attributed to the hand of Yan Liben 閻立本 (ca. 600–673). With its extensive and circuitous provenance, viewers through the centuries have added many colophons to this scroll. Since entering its present Boston home, opinions have differed about the attribution, dating, and iconography of the painting. In her essay, Chen Pao-chen carefully reconsiders the iconography of the latter half of the scroll as well as the lineages of calligraphic style found in the inscriptions. The latter half is largely divided between emperors from the Chen 陳 and Liang 梁 houses of the Southern Dynasties and emperors from the Later Zhou 周 and Sui 隋 houses of the Northern Dynasties—a selection which Chen takes to symbolize the political philosophy of the Tang emperor Taizong 太宗 (599–649). In essence, Chen's paper encourages a complete reexamination of both the attribution of the *Thirteen Emperors* and the identity of its portraits.

Robert Harrist, who has long studied the enigma of Li Gonglin 李公麟 (1049–1106), investigates the attribution to Li of a painting discovered in 1997 and assigned the title *Danxia Calling on Layman Pang* (*Danxia fang Pang jushi* 丹霞訪龐居士). He suggests that the painting illustrates two episodes described in *Recorded Sayings of Layman Pang* (*Pang jushi yulu* 龐居士語錄), but neither of these scenes actually deals with the visit indicated in the title. Instead, Harrist suggests that one part of the painting shows the Monk Danxia meeting Pang's daughter, while another part presents the only known depiction of the episode in which Pang discusses "birthlessness" (*wusheng* 無生). Historically, Layman Pang was a recluse like the Indian sage Vimalakīrti—with a wife, son, and daughter. So also was Li Gonglin, who reportedly sought to fashion himself as a latter-day version of Vimalakīrti. Harrist thus suggests that this painting may show the painter in the guise of Layman Pang. Whether or not this is actually so, Harrist's carefully constructed essay greatly enhances our understanding of Li Gonglin himself.

Finally, Satō Yasuhiro presents a new and detailed iconological interpretation of *Houses on a Snowy Night* (*Yashoku rōdaizu* 夜色楼台図), a much-acclaimed late work by Yosa Buson 与謝蕪村 (1716–1784). Satō explicates the title assigned by Buson to the picture and considers the composition as part of a lineage of urban scenes that appear to be "true-view," or topographic, depictions. He further shows how the painting conflated traditional night and snow scenes into an instance of pure lyricism. Satō also observes that two different modes of expression coexisted in Edo period arts and letters: the classical (*ga* 雅) and the colloquial (*zoku* 俗), a pairing that can also be translated

as the elegant and mundane, traditional and innovative, refined and coarse. At times, these two tendencies mingled or even merged, sometimes in unequal mixture, but their dynamic interaction generated new forms of art and, specifically, new kinds of painting. Satō says that *Houses on a Snowy Night* "seems to exist within a form of quotation marks." It voices both the antique past of Buson's artistic predecessors and the present of Buson's experience. Its value, like that of all canonical works, lies within the work itself.

Takeda Tsuneo

第一節　經典畫作研究
引言

武田恒夫

大阪大學榮譽教授

　　作品研究雖然是美術史的基礎領域，然而了解作品卻有許多不同的方法。從作品本身的新發現開始，到價值判斷、對題意的解釋，並涉及作者與贊助層面的關係，進而直接連繫到時代的定位。

　　Harrist 教授以 1997 年初次公開的李公麟筆「丹霞訪龐居士圖」為新資料，加以詳盡的考證，他從題意的檢討到畫題的變更，進而談到畫家個人獨創的意圖。

　　與此相對，陳教授對已有定評的波士頓美術館「帝王圖卷」改採圖像學與文化脈絡的角度，進而斟酌題贊考慮書法等，進行整體性的再檢討，可說是以作品的再發現來提出問題。

　　作品的真正價值不僅只限於一件作品，而在於將繪畫史的廣泛意義深層化。與謝蕪村晚年的「夜色樓台圖」將景觀虛構化，寄情於優美的詩意，佐藤康宏教授解讀出隱藏於畫面中二重構造之多樣變化，同時也指出古畫與同時代作品之間的共鳴。

　　日本的中世紀漢畫壇的基調是模倣中國宋元名畫以作為筆樣方式。島尾敷教授從從廣泛樣式史的觀點，探討雪舟水墨山水圖中的雪景表現。並牽涉到作品以及時代背景的問題，可以看作是廣義的作品研究。

第一部 經典画作研究
序言

武田恒夫
大阪大学名誉教授

　作品研究は、美術史にとって基礎的な領域であるけれども、作品へのアプローチは様々なかたちをたどることになる。作品自体の新発見にはじまり、その価値判断や題意の解釈、作者や支持層とのかかわり、ひいては時代への位置づけにも直結する。

　1997年に初公開された李公麟筆「丹霞訪龐居士図」を新資料として詳細な考証を行ったHarrist教授は、題意の検討から画題の変更、さらには筆者の独創的な意図にも言及する。

　これに対し、陳教授は既に定評のあるボストン美術館「帝王図巻」について、改めて図像学や文化コンテクスト、さらには着賛にみる書法の吟味などから総括的な再検討を行い、作品の再発見ともいうべき問題提起をはかる。

　作品の真価は、一個の作品にとどまらず、絵画史的な意義への広がりを宿している。景観の虚構化に見事な詩情を託した与謝蕪村晩年の「夜色楼台図」について、佐藤康宏教授は画面にひそめられた二重構造の多様な変化を読みとり、古画や同時代画との響き合いを指摘する。

　日本の中世漢画壇では中国宋元名画の倣古による筆様方式が基調となっている。島尾教授は、雪舟の水墨山水図をめぐり、その雪景表現を大きな様式史の見地から論じている。作品と時代背景とのかかわりも、広義の作品研究とみなされる。

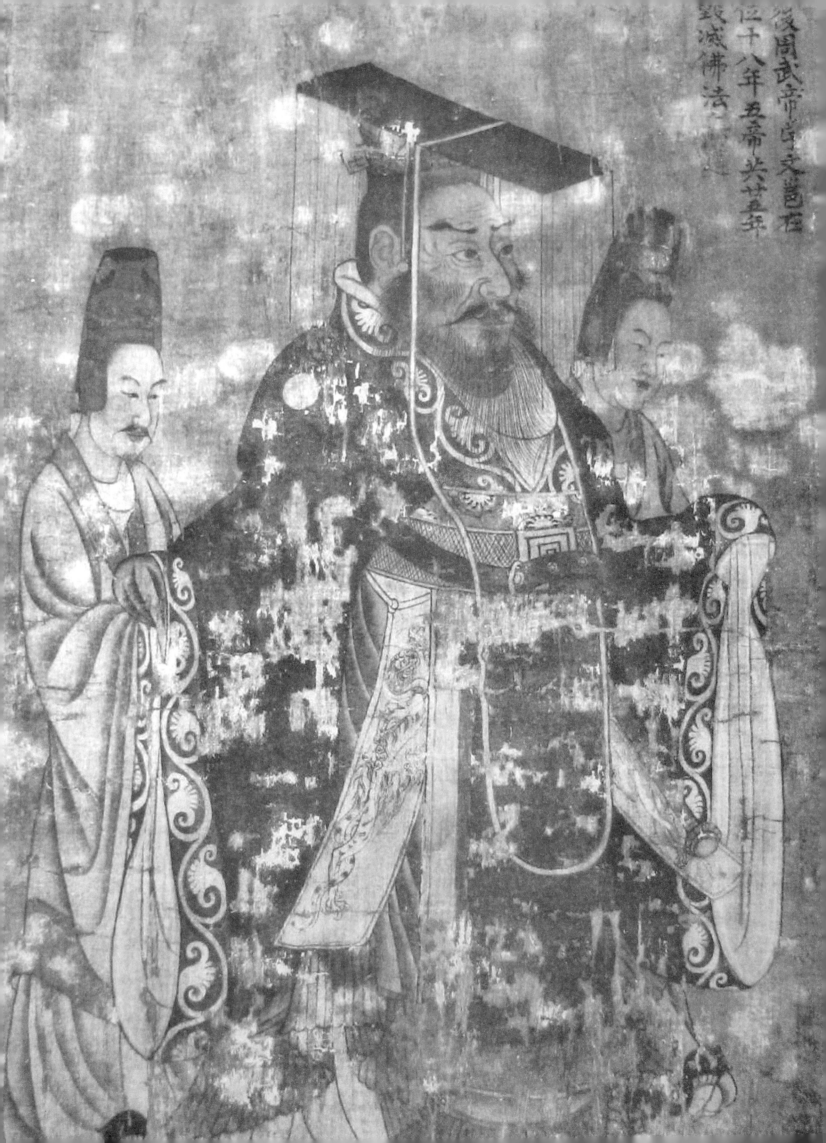

後周武帝宇文邕在
位十八年五帝共廿五年
致滅佛法

Painting as History:
A Study of the Thirteen Emperors Attributed to Yan Liben

Chen Pao-chen

Graduate Institute of Art History, National Taiwan University

Ever since its entry into the collection of the Boston Museum of Fine Arts in 1931, the *Thirteen Emperors* (*Shisan diwang tu* 十三帝王圖; *Fig. 1*), attributed to Yan Liben 閻立本 (ca. 600–673), has been the subject of much debate.[1] In 1932, Tomita Kōjirō 富田幸次郎 published an important article on the work, demonstrating through a close examination of the condition of the scroll silk and painting style that it is actually composed of two separate sections. He concluded that the first section, which features (from right to left) the portraits of the six emperors and rulers Han Zhaodi 漢昭帝 (94–74 BCE), Han Guangwudi 漢光武帝 (6 BCE–CE 57), Sun Quan 孫權 of Wu 吳 (182–252), Liu Bei 劉備 of Shu 蜀 (161–223), Wei Wendi 魏文帝 (187–226), and Jin Wudi 晉武帝 (236–290), is an eleventh-century copy of the damaged original section (*Fig. 2*), while the second section, which contains the portraits of Chen Xuandi 陳宣帝 (530–582), Chen Wendi 陳文帝 (522–566), Chen Feidi 陳廢帝 (554–570), Chen Houzhu 陳後主 (553–604), Wudi 武帝 of the Later Zhou 周 (543–578), Sui Wendi 隋文帝 (541–604), and Sui Yangdi 隋煬帝 (564–617), was completed in the seventh century (*Fig. 3*). He also believed that the pigments and inscriptions of the entire scroll had been retouched at a later date.[2] Tomita's opinions laid the foundation for later studies of the work. Subsequent research has pursued three general lines of inquiry. The first is that of the stylistic analysis of the portraits. This approach can be seen in the studies of Wu Tung 吳同, who, in papers published in 1973 and 1996, pursued comparison with figure paintings in Dunhuang 敦煌 Cave 220 dating to the year 642, whereby he concluded that the seven emperors in the latter section of the scroll were actually painted in the seventh century.[3] The second approach, seen in the 1979 paper

1. Before arriving in Boston, the scroll is purported to have been in Fujian, first in the collection of Lin Shoutu 林壽圖, then passing into the hands of Liang Hongzhi 梁鴻志. Published reproductions of the painting surfaced in 1917 and 1926, generating substantial collector interest. In 1929 the work was exhibited in Tokyo and published as the first plate in *Tang Song Yuan Ming minghua daguan* (*Great Exhibition of Famous Paintings of the Tang, Song, Yuan, and Ming Periods*). In 1931 it was purchased by an American collector, Denman Waldo Ross, who donated it to the Museum of Fine Arts, Boston. For details, see Tomito Kōjirō, "Portraits of the Emperors—A Chinese Scroll Painting Attributed to Yen Li-pen (died A.D. 673)," *Bulletin of the Museum of Fine Arts, Boston*, vol. 30 (1932), pp. 2–8; Tomito Kōjirō, ed., *Portfolio of Chinese Paintings in the Boston Museum of Fine Arts* (Boston: Boston Museum of Fine Arts, 1933, 1938, 1961), vol. 1, pp. 3–5, pls. 10–24; Suzuki Kei, *Zhongguo huihuashi* (*History of Chinese Painting*), trans. Wei Meiyue (Taipei: Gugong bowuyuan, 1987), vol. 1, pp. 56–60, pls. 50–53; Jin Weinuo *et al.*, eds., *Zhongguo meishu quanji* (*Complete Collection of Chinese Art*) (Beijing: Renmin meishu chubanshe, 1988), *Painting*, vol. 2, p. 5, pl. 4; and Wu Tung, *Boshidun bowuguan cang Zhongguo guhua jingpin tulu* (*Catalogue of Selected Ancient Chinese Paintings in the Collection of the Boston Museum of Fine Arts*), trans. Jin Ying (Tokyo: Ōtsuka kōgeisha, 1999), vol. 2, pl. 1, pp. 11–14.

2. See Tomita Kōjirō, "Portraits of the Emperors," pp. 5–6.

3. Jan Fontein and Tung Wu, *Unearthing China's Past* (Boston: Boston Museum of Fine Arts, 1973), pp. 215–18; and Wu Tung, *Boshidun bowuguan cang zhongguo guhua jingpin tulu*, vol. 2, pp. 11–14.

of Jin Weinuo 金維諾, primarily addressed the dating of the work and its creator. Jin concluded that the original artist was not Yan Liben, but rather the early Tang painter Lang Yuling 郎餘令 (act. early 7th c.), and that the present scroll, in its entirety, was not Lang's original work, but rather a Song dynasty copy.[4] The third approach, that seen in the 1987 paper on the painting by Shih Shou-chien 石守謙, discussed the admonitory function of the portraits.[5]

These scholars have all done valuable research on this scroll, but important questions concerning this work still remain. In the present study, I shall first discuss the authenticity and textual sources of the portraits and of the inscriptions found on the latter half of the scroll. Second, I will seek to explain the connotations and cultural context of the portraits. Finally, I shall briefly address the iconographical problems of the portraits in the first section of the scroll.[6]

Authenticity and Textual Sources of the Portraits and Inscriptions on the Second Half of the Scroll

The seven emperors on the latter half of the scroll, together with their attendants, form seven distinct groups (*Figs. 4-10*),[7] each preceded by an inscription. These inscriptions are, in order:

[1] Emperor Chen Xuandi, taboo name Xu, enthroned fourteen years, was a devoted Buddhist and formerly summoned his ministers to discuss the sūtras (陳宣帝諱頊，在位十四年，深崇佛法，曾召群臣講經) [*Fig. 4A*].

[2] Emperor Chen Wendi, Qian, was enthroned eight years and a devoted Daoist (陳文帝蒨，在位八年，深崇道教) [*Fig. 5A*].[8]

[3] Emperor Chen Feidi, Bozong, was enthroned two years (陳廢帝伯宗，在位二年) [*Fig. 6A*].

[4] The Last Ruler of Chen, Shubao, was enthroned seven years (陳後主叔寶，在位七年) [*Fig. 7A*].

[5] Emperor Wudi of Later Zhou, Yuwen Yong, was enthroned eighteen years. The Later Zhou had five emperors, ruling in total for twenty-five years. Emperor Wudi destroyed Buddhism and was unprincipled (後周武帝宇文邕，在位十八年，五帝共廿五年；毀滅佛法，無道) [*Fig. 8A*].[9]

4. Jin Weinuo, "*Gu diwang tu* de shidai yu zuozhe (On the Dating and Authorship of the *Ancient Emperors*)," in Jin Weinuo, *Zhongguo meishu lunji* (*Collected Papers on Chinese Painting*) (Taipei: Mingwen shuju, 1984), pp. 149–56.

5. Shih Shou-chien, "Nan Song de liang zhong guijian hua (Two Types of Southern Song Admonitory Paintings)," in *Fengge yu shibian* (*Style and Cultural Change*) (Taipei: Yunchen chubanshe, 1996), pp. 87–129.

6. For a more detailed discussion than is possible in this brief essay, please see the Chinese version (Chen Pao-chen, Tuhua ru lishi: Chuan Yan Liben 'Shisan diwang tu' yanjiu," *Guoli Taiwan daxue meishushi yanjiu jikan* (*Taida Journal of Art History*), no. 16 (2004), pp. 1–48.

7. In the opinion of Wu Tung, the portrait of Chen Xuandi was originally third in the series (after Chen Feidi), but it was mistakenly placed at the beginning of this section when the scroll was remounted. See Wu Tung, *Boshidun bowuguan cang Zhongguo guhua jingpin tulu*, vol. 2, p. 13.

8. The character Wen 文 was modified, and the character Qian 蒨 added at a later date.

9. The characters *wu dao* 無道 ("unprincipled"), indistinctly written in pale ink, appear to be later additions to the inscription. The Tang referred to the Zhou dynasty founded by Yuwen Yong as the "Later Zhou" (556–581), to distinguish it from the Zhou dynasty of antiquity. In the Song it was referred to as the "Northern Zhou," in contrast to the "Later Zhou" (951–960) of the Five Dynasties period. The present essay follows the phrasing of the scroll, referring, in the manner of Tang commentators, to the dynasty of Yuwen Yong as the Later Zhou.

[6] Emperor Sui Wendi, Yang Jian, was enthroned twenty-three years. The Sui dynasty had three emperors, ruling in total for thirty-six years (隋文帝楊堅，在位廿三年，三帝共三十六年) [*Fig. 9A*].

[7] Emperor Sui Yangdi, Guang, was enthroned thirteen years (隋煬帝廣，在位十三年) [*Fig. 10A*].

It is clear that these seven inscriptions are not all authentic. Stylistically, they fall into three groups by three different calligraphers. Those in the first group are original, the ones in the second are later substitutions, and those in the third show later interpolations. In the following, I shall discuss the calligraphic style of these inscriptions, the textual evidence for their content, and the relationship between each inscription and its portrait.

Group One Portraits and Inscriptions (Originals)

Calligraphic Analysis

Of the seven inscriptions mentioned above, five can be considered original: those accompanying the portraits of Chen Xuandi, Chen Houzhu, Wudi of the Later Zhou (original except for the last two characters, which are a later addition), Sui Wendi, and Sui Yangdi (*Figs. 4A, 7A–10A*). The characters are squarely composed and evenly spaced, and the brushwork is firm and restrained, the horizontal strokes being even and the verticals upright. The hooks and dots show rapid execution, and the flaring diagonal strokes rise and fall in a balanced fashion. Tight vertical spacing of the characters and wide separation between columns give the lines of the composition a balanced and fluid quality, displaying the forthright, regulated beauty of Tang standard script and revealing the stylistic influence of Yu Shinan 虞世南 (558–638) and Ouyang Xun 歐陽詢 (557–641). The following tables transcribe the comparison of characters in Figures 11 and 12 from the five inscriptions with matching characters from works by Yu and Ouyang, thereby demonstrating these stylistic affinities. These works for comparison include Yu Shinan's *Confucius Temple Stele* (*Kongzi miaotang bei* 孔子廟堂碑) and Ouyang Xun's *Huangpu Dan Stele* (*Huangpu Dan bei* 皇甫誕碑), *Huadu Temple Stele* (*Huadusi bei* 化度寺碑), and *Sweet Water at the Palace of Nine Achievements Inscription* (*Jiuchenggong liquan ming* 九成宮醴泉銘).[10]

No.	Example	Location and Character in Scroll	Yu Shinan, *Confucius Temple Stele* (*Shodō zenshū* 書道全集, v. 7)
1	臣	Chen Xuandi: 臣	臣 (p. 69)
2	シ	Chen Xuandi: 深	法、洛 (p. 71); 海、洙、泗 (p. 72)
3	月	Chen Xuandi: 朝	月 (p. 72)
4	後	Chen Houzhu/Hou Zhou Wudi: 後	後 (p. 73)
5	文	Hou Zhou Wudi: 文	文 (p. 71)
6	八	Hou Zhou Wudi: 八	八 (p. 75)
7	周	Hou Zhou Wudi: 周	周 (p. 75)

Table 1. Chart of the characters in Figure 11 compared with those from Yu Shinan's *Confucius Temple Stele*.

10. See Ishida Mikinosuke *et al.*, eds., *Shodō zenshū* (*Complete Collection of Calligraphic Models*) (Tokyo: Heibonsha, 1955), vol. 7, pp. 40–75.

Chen Pao-chen

No.	Example	Location and Character in Scroll	Ouyang Xun's Calligraphy (*Shodō zenshū*, v. 7)
1	七	Chen Houzhu: 七	七 (*Huangpu dan bei*, p. 40)
2	邑	Hou Zhou Wudi: 邑	邑 (*Huadusi bei*, p. 44)
3	周	Hou Zhou Wudi: 周	周 (*Huadusi bei*, p. 51); (*Jiucheng gong*, p. 56)
4	文	Sui Wendi: 文	文 (*Huadusi bei*, p. 52)
5	帝	Hou Zhou Wudi: 帝	帝 (*Jiucheng gong*, p. 55)
6	宇	Hou Zhou Wudi: 宇	宇 (*Jiucheng gong*, p. 56)

Table 2. Chart of the characters in Figure 12 compared with those in Ouyang Xun's calligraphy.

These similarities demonstrate that the calligrapher responsible for this set of inscriptions was active approximately during the same period as Yu and Ouyang and was clearly influenced by the two masters, while at the same time maintaining his own unique approach.

How the Inscriptions Relate to the Official Histories

The reign years of both the dynasties and the emperors recorded in the five inscriptions match those recorded in the official histories, *The Book of Chen* (*Chenshu* 陳書), *The Book of Zhou* (*Zhoushu* 周書), *The Book of Sui* (*Suishu* 隋書), *History of the Southern Dynasties* (*Nanshi* 南史), and *History of the Northern Dynasties* (*Beishi* 北史), which were all completed between the years 638 and 659.[11] Yet despite this correspondence, the inscriptions appear to be deliberately selective synopses of these emperors' accomplishments. In the case of Wudi of the Later Zhou, for example, his eradication of the Northern Qi 齊 and unification of northern China go unmentioned; only his persecution of Buddhism is noted. The inscription for Sui Wendi records neither his conquest of Chen and unification of the south nor his ardent faith in Buddhism. Chen Xuandi's inscription, calling him ". . . a devoted Buddhist, [who] formerly summoned his ministers to discuss the sūtras," is historically inaccurate. According to *The Book of Chen*, Xuandi took no particular actions to promote Buddhism and never summoned his ministers to discuss the sūtras.[12] The discrepancies between the inscriptions and the historical records seem also apparent between the portraits and the historical records.

The Relationship Between the Portraits and the Official Histories

The portrayals of the five emperors display distinctive personalities. Whereas Wudi of the Later Zhou (*Fig. 8*) and Sui Wendi (*Fig. 9*) are both wearing official imperial garb, with expansive robes, elaborate headgear and shoes,

11. For details on the completion dates of the preceding three texts, see Yao Silian (557–637), *Chenshu* (completed 634; repr. 1063), *Siku quanshu* (*Complete Books of the Four Libraries*) edition (hereafter SKQS), vol. 260, p. 511; Liu Zhiji (661–721), *Shitong* (*Penetrating Histories*; ed. 710), chap. 12, pp. 19–20 (SKQS, vol. 685, p. 96); and Ji Yun (1724–1805) *et al.*, *Suishu tiyao* (*Summary of the Book of Sui*), SKQS, vol. 264, p. 14. For information on the *Nanshi* and *Beishi*, see Wang Shumin, *Shibu yaoji jieti* (*Annotations to Important Historical Books*) (Beijing: Zhonghua shuju, 1981), pp. 82–88. I would like to thank Professor Li Donghua 李東華 for providing these references.

12. See *Chenshu*, chap. 5, pp. 1–30 (SKQS, vol. 260, pp. 561–76).

swords, and other imperial accoutrements,[13] the remaining three emperors, Chen Xuandi, Chen Houzhu, and Sui Yangdi (*Figs. 4, 7, 10*), wear various but ordinary-looking robes and headgear. It appears that the painter based his depictions partly on historical records but mostly on other sources, including imperial portraits extant at the time and his own conjecture, overlaid with personal interpretations. The pictorial results at times diverge quite dramatically from the textual record, as demonstrated by a closer examination of the portraits of Chen Xuandi, Sui Wendi, and Wudi of the Later Zhou.

Chen Xuandi, shown in plump middle age, is seated in a sedan chair, holding a *ruyi* 如意 scepter (*Fig. 4*). The depiction matches quite closely the physical description of Xuandi in *The Book of Chen* and *History of the Southern Dynasties*, which record the following two accounts:

> (Xuandi) . . . upon attaining maturity, was of lovely appearance. Standing eight (Chinese) feet and three inches in height, his arms hung past his knees. He possessed great courage and was a skilled rider. . . .[14]
> （宣帝）…及長，美容儀，身長八尺三寸，手垂過膝。有勇力，善騎馬…

> In the spring of the fourteenth year of the Taijian reign (582) . . . , the emperor died in the Palace of Propagating Fortune. He was 53 years of age. . . .[15]
> 太建十四年春…帝崩於宣福殿，時年五十三…

In the portrait, the emperor's head is rather large, with a square face and big ears, and his body is broad and heavyset—creating a rather uncouth appearance. However, his expression suggests intelligence, a sense of some secret unrevealed (*Fig. 4B*). Only in *History of the Southern Dynasties* is there a precedent for this depiction:

> The emperor's expression seems dull. Zhang Zixu, retainer to the Wei General Yang Zhong, saw it and remarked on its uniqueness, saying, "This man has a tiger's head and will undoubtedly attain great position."[16]
> 帝貌若不慧，魏將楊忠門客張子煦見而奇之，曰：「此人虎頭，當大貴也」。

The portrayal of Xuandi in the painting seems to bear out his description in *History of the Southern Dynasties*, which should be regarded as the textual source for this portrait.

Sui Wendi's physical appearance, by contrast, is not clearly described in the historical record. The portrait of Wendi shows a man of average height with a mild expression and a wrinkled, old face (*Fig. 9B*). *The Book of Sui* records that:

> (Wendi) was a man with a "dragon" chin, "five-pillar" mark on his forehead, and a scintillating gaze. He had a pattern on his hand in the shape of the character *wang* 王 ("king"). He was long of torso and

13. See Shen Congwen, *Zhongguo gudai fushi yanjiu (A Study of Ancient Chinese Clothing)* (Taipei: Longtian chubanshe, 1981), vol. 1, p. 167. Shen Congwen believes that this style of imperial costume was first developed in the Sui dynasty. Therefore, these representations may have originated with Yan Pi 閻毗 (act. early 7th c.) and then copied by his son, Yan Liben, in the early Tang.

14. *Chenshu*, chap. 5, p. 1 (SKQS, vol. 260, p. 561); and *Nanshi* (completed 659), chap. 10, p. 1 (SKQS, vol. 265, p. 176).

15. *Chenshu*, chap. 5, p. 29 (SKQS, vol. 260, p. 575); *Nanshi*, chap. 10, p. 9 (SKQS, vol. 265, p. 180); and Li Yanshou, *Beishi*, chap. 11, p. 15 (SKQS, vol. 266, p. 234).

16. *Nanshi*, chap. 10, p. 1 (SKQS, vol. 265, p. 176). This comment is not recorded in *Chenshu*.

short-legged, deep and severe. . . .[17]

(文帝)爲人龍頷，額上有玉(五)柱入頂，目光外射。有文在手，曰「王」。長上短下，深沈嚴重…

Wendi died in 604 at the age of sixty-four.[18] The portrait seen here portrays only advanced age, with no indication of Wendi's unique features, such as the "dragon" chin and "five-pillar" mark recorded in *The Book of Sui*. Here the painter's image is likely based not on the above texts but on another model, such as other portraits of Wendi then extant. We know that at least two different portraits of Wendi existed during the early Tang period—Yuan Yan's 袁彥 portrait of 583 and Zheng Fashi's 鄭法士 done in the Sui period (581–618).[19] Quite possibly many other versions were also circulating at the time. If the present work was not modeled on transmitted portraits, then this representation of Wendi must be regarded as the artist's personal creation.

Sometimes the artist also disregards or misinterprets the known facts about the portrait's subject. In the present scroll, the clearest example of such is the portrait of Wudi of the Later Zhou (Hou Zhou Wudi, *Fig. 8*), pictured with an expansive frame regally garbed, capped, and shod, his arms majestically resting in the hands of his flanking attendants. Indeed, his whole bearing is monumental. His face is square, with a broad forehead and ample chin, deep-set eyes, and large nose. His eyes are intense and his mouth open, revealing his teeth. Wrinkles span his forehead and radiate from the corners of his eyes, and facial hair covers his jaw (*Fig. 8B*). In sum, he has the look of an old and courageous general, impressive and intimidating.

According to *The Book of Zhou* and *History of the Northern Dynasties*, Wudi (543–578) ascended the throne in 560 at the Chinese age of eighteen, and died eighteen years later at the age of thirty-six.[20] It is impossible that he ever looked as old as seen in this portrait. His official biographies do not describe his face, emphasizing only his personal character: "[The emperor] as a youth was filial and respectful, bright and magnanimous."[21] The texts also state that, "Of grave expression, he was resourceful."[22] Wudi's greatest accomplishments were martial in nature. In 577, he destroyed the Northern Qi and unified northern China. He also persecuted Buddhism.[23] The portrait does indeed confer upon the emperor a martial air. However, this representation of the emperor and his subordinates may depart from the

17. *Suishu*, chap. 1, pp. 1–2 (SKQS, vol. 264, p. 16); and *Beishi*, chap. 11, p. 6 (SKQS, vol. 266, p. 229).

18. *Suishu*, chap. 2, p. 26 (SKQS, vol. 264, pp. 4–6); and *Beishi*, chap. 11, p. 38 (SKQS, vol. 266, p. 245).

19. For Yuan Yan's portrait of Wendi, see *Suishu*, chap. 1, pp. 25–26 (SKQS, vol. 264, p. 28); and *Beishi*, chap. 11, p. 19 (SKQS, vol. 266, p. 236). This is not recorded in *Chenshu*. It is mentioned in *Nanshi* and dated to 584. See *Nanshi*, chap. 10, p. 15 (SKQS, chap. 265, p. 183). For Zheng Fashi's portrait, see Zhang Yanyuan, *Lidai minghua ji* (*Record of Famous Painters of All Dynasties*; ed. 847), *Huashi congshu* (*Collection of Books on Painting History*) (Taipei: Wenshizhe chubanshe, 1974), vol. 1, chap. 8, p. 98.

20. *Zhoushu*, chap. 6, p. 20 (SKQS, vol. 263, p. 454); and *Beishi*, chap. 10, p. 29 (SKQS, vol. 266, p. 216).

21. Linghu Defen, *Zhoushu* (completed 644), chap. 5, p. 1 (SKQS, vol. 263, p. 430); and *Beishi*, chap. 10, p. 1 (SKQS, vol. 266, p. 202).

22. *Zhoushu*, chap. 6, p. 21 (SKQS, vol. 263, p. 454); and *Beishi*, chap. 10, p. 30 (SKQS, vol. 266, p. 217).

23. For references to Wudi's accomplishments and attacks on Buddhism, see *Zhoushu*, chap. 5, pp. 21–22; chap. 6, p. 21 (SKQS, vol. 263, pp. 440, 441, 454), and *Beishi*, chap. 10, pp. 13, 14, 16 (SKQS, vol. 266, pp. 208, 209, 210).

living model, since it matches quite closely an imperial portrait, dating to 642, found in Dunhuang Cave 220 (*Fig. 13*). The painters of both portraits seem to have adopted the same early Tang model. The use of this model continued well into the High Tang (ca. 713–ca. 765), as we can see from other portraits in Dunhuang—that of Cave 335, dated to 686, and in Cave 103, datable to the eighth century (*Figs. 14, 15*).

Similarly, the portraits of Chen Houzhu and Sui Yangdi do not entirely coincide with their representation in the historical record. The portrait of Chen Houzhu is that of a man past middle age, with a heavy-set frame wrapped in a large, broad-sleeved robe (*Fig. 7*). With his right arm raised as if to protect his chest, he faces the martial Wudi with an apprehensive expression. The only point of association between this representation and that of the historical record comes from a line that reads, "[The emperor] was heavy and lived for fifty-two years." Other aspects of his character recorded in the histories, such as his enjoyment of poetry, wine, and sensual pleasures,[24] are not in any way conveyed by the portrait. Moreover, to show him confronted by Wudi is inconsistent with the historical record, for the Chen dynasty was swept away by the Sui in 589, eight years after the termination of the Later Zhou. This portrait, in fact, seems almost completely imaginary.

The portrait of Sui Yangdi shows a slightly plump man of average height garbed in a hat and black robe. His arms hang at his sides, and his expression is one of detached indifference (*Fig. 10*). Although a plausible representation of a man at or near age fifty-four (the date of Yangdi's death as recorded in *The Book of Sui* and *History of the Northern Dynasties*), it fails to express other aspects of his physical appearance and personality as they are recorded in the histories. These include ". . . the twin bones of Yangdi's brow bulge, a sign of supreme nobility,"[25] as well as a false and affected manner of speaking and a taste for music and women.[26]

Group Two Portraits and Inscriptions (Copies and Additions)

The portraits of Chen Wendi and Chen Feidi (*Figs. 5, 6*) are treated separately in the present study, because it is felt that this section of the scroll is a later copy.

24. See "Houzhu benji," in *Chenshu*, chap. 6, p. 16 (SKQS, vol. 260, p. 584); and *Nanshi*, chap. 10, pp. 10–22 (SKQS, vol. 265, p. 180–86).

25. *Suishu*, chap. 3, p. 1 (SKQS, vol. 264, p. 49); and *Beishi*, chap. 12, p. 1 (SKQS, vol. 266, p. 250).

26. "When Gaozu 高祖 visited [Yangdi's] residence, he saw that the musical instruments had many broken strings and were covered in dust, as if not in use. Thus, he believed that [Yangdi] did not revel in women and song. . . ." (see Note 25 above). This was all pretense, however, as Yangdi's visits to the cities of the south were occasions for sensual debauchery. See *Suishu*, chap. 3, pp. 8, 20; chap. 4, p. 15 (SKQS, vol. 264, pp. 53, 59, 67); and *Beishi*, chap. 12, pp. 8, 19, 35 (SKQS, vol. 266, pp. 254, 259, 267). It is further recorded that, in the first month of 610 "great wrestling performances were held on the street before Duan 端 Gate. Those with peculiar skills and exotic abilities gathered from all over the land. The festivities lasted for a full month, during which time the emperor repeatedly donned commoner's clothes and snuck out for a look." In the second month of the same year the emperor summoned musicians from Wei, Qi, Zhou, and Chen to the Court of Imperial Sacrifices (Taichang 太常). In the eleventh month of 612, Yangdi ". . . secretly ordered the officials of the southern prefectures to search out refined and lovely young girls from among the populace, and they were annually presented to the court." See *Beishi*, chap. 12, pp. 19, 26 (SKQS, vol. 266, pp. 259, 263); and *Suishu*, chap. 3, p. 19; chap. 4, p. 6 (SKQS, vol. 264, pp. 58, 68).

Chen Pao-chen

Calligraphic Analysis

In calligraphic style, the inscriptions accompanying this pair of portraits differ substantially from the previous five inscriptions. The brushwork is angular, the characters themselves are more elongated (*Fig. 16*), and the flaring, triangular *na* 捺 stroke is more modulated (*Fig. 17*). The two characters *shen chong* 深崇, found in both the Chen Wendi and Chen Xuandi inscriptions, concretely exemplify the differences, in structure and brush technique, between the two styles (*Fig. 18*). Overall, the characters in the Wendi and Feidi inscriptions show tighter internal structure and looser spacing. These features clearly reveal the influence of Ouyang Xun and not that of Yu Shinan, in contrast to the inscriptions of the first group, which show the influence of both calligraphers. Clearly two different hands wrote these two sections.

Identification of the Portraits

Returning to the portraits themselves, the viewer is confronted with a pair of middle-aged men, wearing white hats and loose, casual robes, seated on daises and leaning on three-legged tables. Young servant girls flank the pair. The man on the right, with a handsome visage and full, attractive beard, sits erect, his hands holding a *ruyi* scepter (*Fig. 5*). The ruler on the left has a slighter build and close-trimmed beard. He sprawls lazily on his dais, his *ruyi* scepter held by one of the girls (*Fig. 6*). Such a composition is a far cry from the previous five portraits, where the rulers (except for Xuandi) stand, flanked by male servants. The inscriptions suggest that these are depictions of Chen Wendi and Chen Feidi, but the attributions seem highly problematic.

Chen Wendi's biographies in *The Book of Chen* and *History of the Southern Dynasties* record that he was "sharp-witted, intelligent, and handsome, and he cared for the Classics and Histories. His behavior was proper and elegant, and even when hurried, he always respected the rules of ritual."[27] Wendi died at about age forty. Up to this point, the record and the portrait match quite closely. Yet the histories also record that, as a youth, the future Wendi accompanied the ruler Chen Wudi 陳武帝 (503–559) on various military campaigns, and as a result was "filled with both civil merit and martial virtue."[28] Such a description would lead one to expect a figure of imposing military bearing, not the placid, seated posture of the figure shown in the portrait here. Moreover, the inscription indicates that Wendi was a "devoted Daoist," whereas the histories state that the emperor was a fervent Buddhist follower without mentioning any Daoist beliefs.[29]

27. Chen Wendi's biography records only that he died in 566, providing neither his year of birth nor his age at death. We can safely assume, however, that he was born prior to his younger brother, Emperor Xuandi (b. 528). See *Chenshu*, chap. 3, pp. 1, 19; chap. 5, p. 1 (SKQS, vol. 260, pp. 546, 555, 561); and *Nanshi*, chap. 9, p. 24, 31; chap. 10, p. 1 (SKQS, vol. 265, pp. 169, 172, 176).

28. This comment was made by Yao Cha 姚察 (533–606), father of Yao Silian, who once served as the official historian of the Chen dynasty. He began compilation of *Chenshu*, which was subsequently completed by his son. For his commentary on Chen Wudi, see *Chenshu*, chap. 3, pp. 20–21 (SKQS, vol. 260, pp. 555–56).

29. See *Chenshu*, chap. 3, p. 15 (SKQS, vol. 260, p. 553); and *Nanshi*, chap. 9, p. 29 (SKQS, vol. 265, p. 171).

This portrait actually more closely fits the historical descriptions of Jianwendi 簡文帝 (503–551), second ruler of the Liang 梁 dynasty (502–557). A learned man, he assumed the throne in 549, but died two years later in the Hou Jing 侯景 Disturbance. *History of the Southern Dynasties* records Jianwendi's physical and personal characteristics as follows:

> As a youth, he was quick and intelligent, and at the age of six (already) was able to compose texts. . . . Upon attaining maturity, he had an expansive visage . . . with square cheeks, full jowls, and a beautiful beard. His brows were dark. He often held a *ruyi* scepter in his hand, . . . his words were beautifully expressed, his vocabulary effusive, and he excelled at discussing Daoist matters; . . . he loved composing poetry. Yet the emperor's writing was flawed by its frivolous and sensual nature, and it was known at that time as the "Palace Style."[30]
> 帝幼而聰睿，六歲便能屬文⋯及長，器宇寬弘，⋯方頤豐下，須鬢如畫。雙眉翠色。手執如意，⋯詞藻豔發，博綜群言，善談玄理⋯雅好賦詩⋯然帝文傷於輕靡，時號「宮體」。

Certainly the facial features and *ruyi* scepter in the portrait (*Fig. 5B*) accord with the literary record, and the intelligent expression seems to bear out the attribution of broad learning and literary skill. The description of Jianwendi, found only in *History of the Southern Dynasties* and not in *The Book of Liang* (*Liangshu* 梁書),[31] appears to have served the artist as the basis for the present portrait. It is also interesting to note that the clothing, pose, and *ruyi* are similar to a rendition by Sun Wei 孫位 (ca. 9th c.) in *The Seven Worthies* (*Qi xian tu* 七賢圖; *Fig. 5C*).

The portrait labeled as Chen Feidi (554–570) corresponds not at all to the historical record of that emperor. According to Feidi's biography, he assumed the throne as a child and died at the age of seventeen. The portrait shows a thickly bearded man in the prime of life (*Fig. 6B*), which I believe to be a representation of Liang Yuandi 梁元帝 (508–554). Yuandi, younger brother of Jianwendi, attained the throne at the age of forty-five *sui* 歲 (in 552) and was killed two years later when the Western Wei 魏 invaded.[32] Liang Yuandi's biography in *History of the Southern Dynasties* records the following:

> The emperor was intelligent and handsome, his natural talents clear to all. . . . As an adult, he loved learning, and mastered many books; . . . the emperor was skilled at calligraphy and good at painting. He [once] painted a portrait of Confucius, composed a eulogy [to the master], and inscribed it on the painting with his own calligraphy. People at the time said that he attained the "Three Perfections." [The emperor] often said, "I conceal myself in letters and am a shameful military man."[33]
> 帝聰悟俊朗，天才英發，⋯及長，好學，博極群書⋯帝工書、善畫。自圖宣尼像，為之贊而書之，時人謂之「三絕」。⋯常曰：「我韜於文士，愧於武夫」。

The portrait shows a man in his middle years, dressed as a literatus, in a manner fully consistent with the textual description of Yuandi.

I believe that these two portraits and their accompanying inscriptions are later substitutions, copied from the original portraits and inscriptions, which had become damaged beyond recognition. Probably the substitution oc-

30. *Nanshi*, chap. 8, pp. 4–5 (SKQS, vol. 265, p. 142–43).

31. See Yao Silian, *Liangshu*, chap. 4, p. 8 (SKQS, vol. 260, p. 72).

32. *Liangshu*, chap. 5, pp. 1, 29 (SKQS, vol. 260, pp. 37, 87); and *Nanshi*, chap. 8, pp. 16, 20 (SKQS, vol. 265, pp. 148, 150).

33. *Nanshi*, chap. 8, pp. 16–17 (SKQS, vol. 265, pp. 148–49); see also *Liangshu*, chap. 5, pp. 29, 30 (SKQS, vol. 260, pp. 87–88).

curred during a remounting of the scroll, most likely later during the Five Dynasties period. The painters of the copies faithfully preserved the iconographical details of the originals, but the calligrapher, unclear about the identity of the figures, mislabelled the copies as "Chen Wendi" and "Chen Feidi." The content and calligraphic style of these two inscriptions partly mimic those of Chen Xuandi and Chen Houzhu, respectively. It appears that the calligrapher, lacking the requisite skill, succeeded in capturing only the characteristics of Ouyang Xun's style and not the stylistic traces of Yu Shinan found in the other inscriptions.

As Wu Tung has noted in his study, originally these two portraits may have preceded that of Chen Xuandi, but were misplaced during the remounting (*Fig. 19*).[34] Precisely when this mistake would have occurred is impossible to determine.

Group Three Inscriptions (Later Interpolations)

The third group comprises two inscriptions in which I detect retouched and interpolated characters: that for Chen Wendi (*Fig. 5A*) with the retouched character for Wen 文 and the interpolated character for Qian 蒨, denoting the emperor's name; and that for Wudi of the Later Zhou (*Fig. 8A*) with the appended characters *wu dao* 無道 ("unprincipled"). These latter two characters are rather blurred and difficult to distinguish, which some scholars attribute to an attempt at erasure.[35] Although their blurriness makes a stylistic comparison with the other characters difficult, I believe that these two characters were a much later addition to the text. I base this conclusion on the intensely pejorative quality of the phrase "*wu dao*," a quality entirely lacking in the other inscriptions, which merely record and do not assess their subjects.

The interpolated characters are clearly paler than the remainder of the inscriptions, and also paler than the inscriptions in the other two groups, making them easy to differentiate. It is more difficult, however, to determine when they were added to the work. The mistaken assumption that these four characters were original to the work has led to three incorrect conclusions: (1) that the characters *wen* and *qian* identify the adjacent portrait as Chen Wendi (whose posthumous name was Wen and personal name Qian); (2) that Yan Liben was not the author of the work, as filial piety would have prevented him from applying to Wudi, who was his maternal grandfather, the censure "unprincipled";[36] and (3) that "unprincipled" referred to Wudi's persecution of Buddhism, and therefore that the painter was a devotee of Buddhism.

34. See Wu Tung, *Boshidun bowuguan cang Zhongguo guhua jingpin tulu*, vol. 2, p. 13.

35. Wu Tung also believes that someone attempted to erase the two characters *wu dao,* but, in contrast to the present author, thinks that they were part of the original inscription. See Wu Tung, *Boshidun bowuguan cang Zhongguo guhua jingpin tulu*, vol. 2, p. 12.

36. Jin Weinuo, "'Gu tiwang tu' de shidai yu zuozhe," pp. 150–51.

Connotations and Cultural Contexts of the Seven Portraits

Assuming that my assessments of authenticity and identifications are correct, the seven emperors represented on the second section of the scroll are Jianwendi and Yuandi of the Liang, Xuandi and Houzhu of the Chen, Wudi of the Later Zhou, and Wendi and Yangdi of the Sui. In the pre-Tang period, the first four ruled in southern China, the last three in the north. The contrast between southern and northern rulers is immediately obvious (*Figs. 20, 21*), as seen in the following table:

Features	Liang and Chen	Later Zhou and Sui
Clothing	—casual	—formal, imperial (except Yangdi)
Posture	—seated on dais (Liang emperors) —seated on sedan chair (Chen Xuandi) —standing and surrendering (Chen Houzhu)	—all standing
Face	—elegant (Liang Jianwendi) —indolent (Liang Yuandi) —impassive (Chen Xuandi) —timid (Chen Houzhu)	—fierce, intimidating (Wudi of the Later Zhou) —harmonious (Sui Wendi) —ordinary, dull (Sui Yangdi)
Accoutrements	—*ruyi* scepter (Liang emperors) —short sword (Chen Xuandi)	—long sword in scabbard (Wudi of the Later Zhou and Sui Wendi)
Servants	—two girls (Liang emperors) —eight sedan bearers, two male servants (Chen Xuandi) —one male servant (Chen Houzhu)	—two male servants
Direction	—except Liang Yuandi, all face left	—all face right
Religious affiliation	—ardent believer in Buddhism (Chen Xuandi)	—persecuted Buddhism (Wudi of the Later Zhou)

Table 3. Comparison of features in the portraits of northern and southern rulers in the *Thirteen Emperors* scroll.

These details are rife with connotation. The two Liang emperors, with their white hats, loose robes, elegant expressions, *ruyi* scepters, and relaxed postures, seem to express the ideal image of a lofty scholar, and thereby reflect the elegant style and fashion of the Southern Dynasties. By portraying their attendants as young girls, the artist conveys a sense of feminine softness and an absence of masculine strength. In emphasizing their literati qualities, he also seems to be drawing a connection between their prevailingly "civil" qualities and the political disorders that brought about their deaths (Jianwendi in the Hou Jing Disturbance and Yuandi at the hands of the Wei army). The artist seems to be implying that literary skill and scholarship (*wen* 文) alone, in the absence of martial strength (*wu* 武), cannot bring order to the state.

Chen Xuandi's black robe, *ruyi* scepter, short sword, and impassive expression suggest strength and authority, but these qualities are undercut by the emperor's seated pose. Born in an unstable era, Xuandi was a schemer who for a time succeeded in maintaining peace with the Northern Qi and Later Zhou. Yet after the fall of Northern Qi, war erupted between the Later Zhou and Chen. Within two years of defeat at Lüliang 呂梁 (578), the Chen had lost

Chen Pao-chen

the entire Huainan 淮南 region. Xuandi was forced into a defensive and ultimately unrecoverable position.[37] In the portrait, the signifiers of martial power are constricted by the seated posture. One senses that the artist is trying to communicate both the great ability of the emperor and the historical forces that hemmed him in. The weak state that Xuandi bequeathed to his successor is personified by the overwhelmingly weak and passive imagery in the portrait of Houzhu. The timid expression, defensive posture, empty hands, and reduced retinue (one servant) of Houzhu seem to act as metaphors for the decline of the Chen dynasty.

The four emperors of the Liang and Chen all wear casual robes and, together with their servants, face left (only Liang Yuandi faces right). The Later Zhou and Sui emperors all face to the right, as if confronting the emperors of the south. Wudi of the Later Zhou and Sui Wendi, both in imperial robes, stand with arms extended and resting on their subordinates—figures of power and majesty. Sui Yangdi stands with his arms hanging at his sides, his hands withdrawn into the sleeves of his black robe in a weak and powerless posture. Nevertheless, Yangdi wears the same black robes and faces in the same direction as the mightier Wudi and Wendi, symbolizing that, albeit feeble, he is nonetheless the orthodox inheritor of a unified empire.

I believe that the artist, by means of these iconographic contrasts, was subtly commenting on the political, cultural, and religious policies of both the northern and southern rulers. The imperial garb of the northern emperors symbolizes the political power and legitimacy of the Later Zhou and Sui dynasties, while the more casual garb of the southern emperors signifies mere regional political authority. Contrasting the cultured *wen* of the Liang emperors with the martial *wu* of Wudi of the Later Zhou demonstrates that successful rule must balance both *wen* and *wu*. The insufficiently martial Liang met defeat; Wudi of the Later Zhou, though personally successful, failed to produce a strong successor worthy of a portrait (Wudi is the only emperor of the Later Zhou represented in the scroll). Contrasting Chen Xuandi's commitment to Buddhism with Wudi's persecution of Buddhism makes the point that religious policy has no bearing on the fate of a dynasty. Both the Chen and Later Zhou ended in catastrophe. In other words, support or persecution of Buddhism was neither the savior nor destroyer of a state.

These three observations are reflected quite clearly in the political theory of Emperor Taizong 唐太宗 (599–649) of the Tang dynasty, as it is expressed in regard to the rise and fall of the Northern and Southern Dynasties. These theories can be found in *Political Principles of the Zhenguan Reign* (*Zhenguan zhengyao* 貞觀政要; ca. 720) and *Principles of Rulership* (*Di fan* 帝範; 648).[38] Many scholars have noted the connection between the present scrolls and

37. *Chenshu*, chap. 5, pp. 20–28 (SKQS, vol. 260, pp. 571–75); *Nanshi*, chap. 10, pp. 6–8 (SKQS, vol. 265, pp. 178–79); *Zhoushu*, chap. 7, p. 9 (SKQS, vol. 263, p. 460); and *Beishi*, chap. 10, pp. 39–40 (SKQS, vol. 266, pp. 219–20).

38. *Zhenguan zhengyao*, completed around 720 by Wu Jing 吳競 (670–749), records discussions on political policy and religious topics between Taizong and his officials Wei Zheng 魏徵 (580–643), Fang Xuanling 房玄齡 (578–648), and Du Ruhui 杜如晦 (585–630). See Wu Jing, *Zhenguan zhengyao* (Shanghai: Guji chubanshe, 1973). In the text, one frequently encounters Taizong using the past as a mirror for the present, pondering the successes and failures of former dynasties in an effort to determine the proper means of order in the state. According to my calculations, the text contains 237 entries. Over ten of these reflect on the policy successes and failures of former emperors (see pp. 14, 15, 16, 77, 81, 82, 98–102, 114–15, 117, 118, 120, 125–27, 302).

these two political texts, but none has pursued the issue in depth. In fact, *Political Principles of the Zhenguan Reign* provides several clear examples of an extremely close connection between Taizong's theories on rulership and symbolism in the *Thirteen Emperors* scroll. One such instance is his statement that the ruler should cultivate morality and less emphasize literary studies, for skill with the brush was not enough for order in the state:

> Taizong once said, "In managing affairs, if you do not learn from historical precedent, you may create disorder in policy and harm things. Although you may write in ornate language, in the end you will only be a joke for later generations. There is no need for such. It is just like with Liang Wudi and sons, Chen Houzhu, and Sui Yangdi—all have great volumes of collected writings, yet the many things they did were incorrect, and their states collapsed in a short time. All rulers need only focus on cultivating virtue, for what need is there for writing literature?"[39]
> 太宗謂曰：「…若事不師古，亂政害物，雖有詞藻，終貽後代笑，非所須也。只如梁武帝父子、及陳後主、隋煬帝，亦大有文集，而所爲多不法，宗社皆須臾傾覆。凡人主惟在德行，何必要事文章耶？」

It is noteworthy that Liang Wudi's two sons, Chen Houzhu, and Sui Yangdi all appear in the *Thirteen Emperors* scroll.

A second example is Taizong's belief in the necessity of correct balance between *wen* and *wu* if the ruler is to successfully adapt to changing circumstance. In *Principles of Rulership*, a discussion of the principles of rulership that Taizong wrote for his descendants, he states:

> When great *qi* extends over the earth, victory or defeat is determined by the tips of blades. When vast waves fill the heavens, their rise or fall is decided by the ranks of armies. At these times, greatly value shields and spears while giving no thought to schools. When the sea and mountains are at rest, and the waves and dust have subsided, hold back the remaining might of the seven virtues and spread broadly the works of the nine labors. At these times, disregard helmets and armor and emphasize poetry and writing. Thus, understand that of the two paths of *wen* and *wu*, neither can be abandoned. In good times, one is suitable, in bad times the other. Neither martial warriors nor men of learning can be discarded.[40]
> 至若長氣互地，成敗定乎鋒端，巨浪滔天，興亡決乎一陣。當此之際則貴干戈，而賤庠序。及乎海嶽既晏，波塵已清，偃七德之餘威，敷九功之大化。當此之際，則輕甲胄而重詩書。是知文武二途捨一不可，與時優劣，各有其宜。武士儒人焉可廢也。

This principle of balance is communicated by negative example in the contrasting portraits of the martial Wudi and the civil Chen and Liang emperors.

Taizong believed that the foundation of proper government was based on education. He was a strong proponent of Confucian learning and elevated training in the Confucian classics to a level unprecedented in Chinese history. He had little interest, however, in notions of immortality, *yin-yang* cosmology, or Buddhism. He regarded Buddhism and Daoism as "exotic teachings" (*yifang zhi jiao* 異方之教), in which one should not believe too strongly. Taizong, addressing his assistant, specifically mentioned the Liang emperors as a caveat against an excessive devotion to Buddhism:

The five dynasties of Liang, Chen, Qi, Zhou, and Sui are mentioned in at least eleven places (see pp. 23, 152, 154, 156, 158, 159, 222, 233, 258, 294). Criticisms of the Sui dynasty, in particular the debauchery and slanderous speech of Yangdi and his officials, as well as the failings of Yangdi's reign in domestic policy, diplomacy, military matters, and personnel recruitment occur in more than thirty-seven separate entries, which represent over one-sixth of the total text (see pp. 5, 15, 17, 22, 23, 46, 55–57, 77, 86, 87, 150, 153, 154, 159, 165, 186, 193, 196, 198, 200, 202, 210, 222, 237, 247, 251, 261, 263, 274, 275, 281, 282, 283, 287, 288, 289, 290).

39. *Ibid.*, p. 222.

40. Tang Taizong, *Di fan*, chap. 4, pp. 9–11 (SKQS, vol. 696, pp. 616–17).

Chen Pao-chen

. . . Liang Wudi and his sons aspired to venerate shallow beauty and loved only the teachings of the Buddhists and Daoists. In his later years, Wudi frequently visited the Tongtai Temple and personally lectured on the Buddhist scriptures. . . . All day he spoke of bitter emptiness and never thought of standards for the state. Then Hou Jing led his army to the imperial palace . . . and Wudi and Jianwen both died as captives of Hou Jing. When the filial Yuandi was in Jiangling and surrounded by Wan Chou and Yu Jin, he kept reciting the *Laozi* without end. . . . Before long, the city fell and the emperor and his officials were all made prisoner.[41]

太宗謂侍臣曰：「⋯至如梁武帝父子，志尙浮華，惟好釋氏、老氏之教。武帝末年，頻幸同泰寺，親講佛經，⋯終日談論苦空，未嘗以軍國典章爲意。及侯景率兵向闕，⋯武帝及簡文卒被侯景幽逼而死。孝元帝在于江陵，爲萬丑于謹所圍，帝猶講《老子》不輟，⋯俄而城陷，君臣俱被囚繫，⋯」

Here again we see a clear parallel between Taizong's statecraft and the artist's representations of the Liang emperors. Although Taizong respected the famous monk Xuanzang 玄奘 (602–663) and supported his sūtra translation projects, he was not a strong proponent of Buddhism. Nor did he attempt to suppress either Buddhism or Daoism. His dispassionate balance has its negative example in the artist's contrast of Wudi of the Later Zhou and Chen Xuandi.

In other words, the portraits reflect the historical, administrative, and religious attitudes found in *Political Principles of the Zhenguan Reign* and *Principles of Rulership*. The painting, like the texts, was intended as a mirror to the past, a lesson on how to avoid the fates of the emperors portrayed. Although the portraits and their inscriptions may have been based in part on the aforementioned histories of the Liang, Chen, Zhou, and Sui, all of which were completed between 629 and 644, the evidence set forth above suggests a stronger connection with the accounts in *History of the Southern Dynasties* and *History of the Northern Dynasties*. These two texts were completed in 659, which suggests that the portraits were finished sometime shortly after this date. The painter responsible for the portraits was not only a masterful artist, but also a very learned individual, with a solid understanding of both the histories and Taizong's political philosophy. He obviously possessed the substantial imagination needed to produce a subtle visualization of historical data and abstract political theory. Of the artists active during the reigns of Taizong and Gaozong 高宗 (r. 649–683), only two meet these criteria: Yan Liben and Lang Yuling.[42] Scholars disagree on which of them painted the *Thirteen Emperors* scroll.[43] Since Yan Liben, the grandson of Wudi of the Later Zhou,[44] is not likely to

41. *Ibid.*, p. 195.

42. For Yan Liben's biography, see Liu Xu (ca. 10th c.) *et al.*, *Jiu Tangshu (Old Edition of the Book of Tang)*, chap. 77, pp. 13–15 (SKQS, vol. 269, pp. 748–49); Ouyang Xiu (1007–1072) *et al.*, *Xin Tangshu (New Edition of the Book of Tang)*, chap. 100, pp. 20–23 (SKQS, vol. 274, pp. 288–89). For Lang Yuling's biography, see *Jiu Tangshu*, chap. 189, pt. 2, pp. 3–4 (SKQS, vol. 271, pp. 543–44); and *Xin Tangshu*, chap. 199, pp. 1–2 (SKQS, vol. 276, pp. 14–15).

43. Wu Tung suggests that, because most scholars since the Song dynasty have attributed the work to the hand of Yan Liben, this attribution should not be casually overturned. Jin Weinuo and Wu Hung, among others, agree with the theory of Lang Yuling's authorship. See Wu Tung, *Boshidun bowuguan cang Zhongguo guhua jingpin tulu*, vol. 2, p. 14; Jin Weinuo, "'Gu tiwang tu' de shidai yu zuozhe," pp. 151–53; and Yang Xin *et al.*, *Zhongguo huihua sanqian nian (Three Thousand Years of Chinese Painting)* (Taipei: Lianjing chubanshe, 1999), p. 61. Lang Yuling's birth and death dates are unknown, but his biography suggests that his older brother, Yuqing 餘慶, was active early in the reign of Emperor Gaozong. Thus it seems likely that the younger Lang was alive at this time as well. Shih Shou-chien suggests that Lang Yuling was active earlier than Yan Liben, between the years 550 and 630, but cites no evidence for this conclusion. See Shih Shou-chien, "Nan Song de liang zhong guijian hua," p. 97.

44. According to *Zhoushu*, Yan Liben's father, Yan Pi, was married to Princess Qingdu 清都 (the daughter of Wudi of the Later

have painted his grandfather, who died at the age of thirty-six, as an old man, I suggest that the painter was more likely Lang Yuling. Lang is known to have had a thorough education in the traditional classics and histories, and he took part in the editing of *The Book of Sui*. Zhang Yanyuan 張彦遠, in his *Record of Famous Painters Through the Ages* (*Lidai minghua ji* 歷代名畫記; 847), also mentions that he once saw Lang's work entitled *Portraits of Emperors from Ancient Times* (*Zigu diwang tu* 自古帝王圖).[45] However, due to the greater fame of Yan Liben, art historians since the Song dynasty have credited him with painting the *Thirteen Emperors* scroll. Regardless of the painter's identity, these portraits are clearly the work of a master who fits the profile outlined above. The learning and skill of the artist become even more apparent when we contrast these portraits with those on the first section of the scroll (*Fig. 2*).

Questions Concerning the Portraits on the First Section of the Scroll

The monotonous, stiff quality of the portraits in the first section of the scroll demonstrates that the painter of these images lacked the ability of the original artist. Compositionally, he selected the representation of Wudi of the Later Zhou and his servants (*Fig. 8*) as the model for all five of the portraits following the initial image of Han Zhaodi (*Fig. 2*). Each representation is more or less the same, with only minor variations in detail. The emperors' facial expressions are quite uniform, and none succeed at communicating the personality of the subject. The artist seems interested only in expressing the "orthodox" pattern of political succession in earlier dynasties. According to the standard histories, the six emperors portrayed here all played key roles in the transmission of political power during the period spanning the Western Han to Western Jin dynasties.[46] This concept of a single, orthodox lineage of political succession is the only aspect of the original painting successfully reproduced in this section of the scroll. The inscriptions are much simpler, recording only the emperors' names and titles, and lacking even the simplest of historical details. The calligraphy of the inscriptions, written simply in the manner of Ouyang Xun without the stylistic features of Yu Shinan found in the inscriptions on the second part of the scroll, also demonstrates that the calligrapher lacked the extensive training of whoever wrote the original inscriptions.

The first section of the scroll may also have been retouched, particularly in the portrait of Han Zhaodi (*Fig. 22*). For example, the inscription "Emperor Zhaowendi [Zhaodi] of the Former Han (前漢昭文帝)" raises two problems. It is written in rounder and softer brushstrokes, lacking the sharp, angular quality of the other five inscriptions. Apparently

Zhou); see *Zhoushu*, chap. 20, p. 13 (SKQS, vol. 263, p. 567). Thus, if Yan Liben was the son of Princess Qingdu, he was also the grandson of Wudi. Since no mention of this is made in Yan Liben's biography, the question awaits further investigation. For Yan's biography, see *Jiu Tangshu*, chap. 77, pp. 13–14 (SKQS, vol. 269, pp. 748–49); and *Xin Tangshu*, chap. 100, pp. 20–23 (SKQS, vol. 274, pp. 288–89).

45. Zhang Yanyuan, *Lidai minghua ji*, chap. 9, pp. 111–12. For Lang Yuling's biography, see *Jiu Tangshu*, chap. 189, pt. 2, pp. 3–4 (SKQS, vol. 271, pp. 543–44).

46. For discussions of orthodox succession in Chinese history, see Rao Zongyi, *Zhongguo shixue shang zhi zhengtonglun* (*Theories on Political Orthodoxy in Chinese Historiography*) (Shanghai: Yuntong chubanshe, 1996); and Zhao Lingyang, *Guanyu lidai zhengtonglun wenti zhi zhenglun* (*Regarding Debates on the Issue of Orthodoxy Throughout China's Dynastic History*) (Hong Kong: n.p., 1976).

Chen Pao-chen

it was written by another calligrapher. Likewise, the portrait and inscription are on different pieces of silk, suggesting that the inscription was moved from some other location. Also questionable is the identity of the first portrait. Could this portrait of a middle-aged man actually be Han Zhaodi, whom the histories record as dying at the age of twenty-one?[47] The figure wears casual garments, unlike the imperial robes of the other five emperors. In the latter section of the scroll, this casual attire is associated with emperors who are either "unorthodox" or the final rulers of their dynasty. Yet Zhaodi (86–73 BCE) belonged to one of the most historiographically orthodox dynasties in Chinese history, and his reign was followed by a line of prosperous successors. Thus, I believe that this was not originally intended as a representation of Zhaodi, but rather of Wang Mang 王莽 (45 BCE–23 CE), who seized the throne in 9 CE and ruled temporarily in the Xin dynasty that he founded. This conclusion is supported both by the emperor's placement in front of Guangwudi of the Eastern Han, and by the fact that traditional historians did not place Wang Mang in the orthodox imperial succession. Perhaps Wang Mang's identity was misunderstood by the restorer of this scroll.

Attached to the scroll are at least sixty-one identifiable colophons, the earliest by three Northern Song high-ranking officials: Qian Mingyi 錢明逸 (1015–1071) writing in 1058, Han Qi 韓琦 (1008–1075) inscription from 1059, and Fu Bi 富弼 (1004–1083) writing in 1060. This suggests that the former section of this scroll was completed prior to the mid-eleventh century.

Conclusion

The original latter section of the *Thirteen Emperors* scroll can be regarded as synopsizing Tang Taizong's personal judgment of the Liang, Chen, Zhou, and Sui dynasties. Its production is associated with the official historical compilation projects of the early Tang. As far as I know, the early Tang court actively promoted compilations of its predecessors' dynastic histories. The earliest of these was *The Book of Chen*, a project which Yao Silian 姚思廉 inherited from his father Yao Cha 姚察 (533–606), who had been ordered to compile it by Emperor Gaozu:

> In more than two hundred years since the Wei dynasty, the orthodox succession of reigns has been repeatedly revised and historical events left in disarray. Therefore, in the fifth year of the Wude reign (622), Gaozu issued an edict calling for the compilation [of histories]. Silian received his command and thereupon composed *The Book of Chen*. . . .[48]
> 武德五年，高祖以自魏以來二百餘歲，世統數更，史事放逸，乃詔撰次。而思廉遂受詔，為《陳書》，…

After Tang Taizong assumed the throne, he took note of the fact that histories had yet to be compiled for the Liang, Chen, Qi, Zhou, and Sui dynasties. Therefore, in 629, he ordered Wei Zheng to gather a large team of historians and oversee the compilation of histories for each of these dynasties.[49] The results of these efforts were *The Book of Liang* and *The Book of Chen*, compiled by Yao Silian; *The Book of Northern Qi* (Bei Qishu 北齊書), compiled by

47. Ban Gu, *Qian Hanshu* (*Book of the Former Han*), chap. 7, pp. 1–13 (SKQS, vol. 249, pp. 124–30).

48. See Wang Zhu *et al.*, preface to the *Chenshu* (preface 1036), (SKQS, vol. 260, p. 511).

49. For Wei Zheng's biography, see *Jiu Tangshu*, chap. 7, pp. 1–24 (SKQS, vol. 269, pp. 664–676); *Jiu Tangshu*, chap. 97, pp. 1–19 (SKQS, vol. 274, pp. 242–251).

Li Baiyao 李百藥, *The Book of Zhou*, compiled by Linghu Defen 令狐德棻, and *The Book of Sui*, compiled by Wei Zheng himself. *The Book of Chen* itself was finally completed in 634 and presented to the emperor in 636.[50] When Wei Zheng died in 643, the compilation of the remaining dynastic histories was still under way. Completed the following year, the five books totaled 252 fascicles in length.[51] Unlike many of the other dynastic histories, these texts included only annals and biographies. The judgments and critical comments written at the end of each section by the historians themselves were all reviewed and approved by Wei Zheng, who himself ultimately represented Taizong. Taizong's goal in commanding the compilation of these histories, in addition to securing his voice over historical thought, was to understand the successes and failures of previous dynasties and thereby use them as a mirror for reviewing his own policies. It is quite likely that the five histories were originally combined into a single book that was stored in the court library, and that due to its size and extensive content, this text was not widely disseminated.[52]

In 641 Taizong further ordered Wei Zheng and Zhangsun Wuji 長孫無忌 (d. 659) to oversee the compilation of *Historical Treatises of Five Dynasties* (*Wudai shizhi* 五代史志) by a team of historians that included Yu Zhining 于志寧 (588–665), Li Chunfeng 李淳風 (602–670), Wei Anren 韋安仁, Li Yanshou 李延壽, and Linghu Defen. This text, in thirty fascicles, was completed in 656. Between the years 643 and 659, the historian Li Yanshou also revised the official histories of these five dynasties into the abbreviated eighty-fascicle *History of the Southern Dynasties* and hundred-fascicle *History of the Northern Dynasties*.[53] The condensed nature of these texts allowed wider dissemination than the five dynastic histories.[54] Nevertheless, while the content of the *History of the Southern Dynasties* and *History of the Northern Dynasties* is generally more abbreviated than the five histories, there are some places in which it is more detailed.[55] Of particular note is the strong personality manifested in Li Yanshou's critical remarks on the successes and failures of past emperors, which are sharper and more morally absolutist than the historians' comments in the five dynastic histories.[56]

50. Only a limited number of copies of *Chenshu* were originally produced, and it was not reprinted until the early Northern Song. See Zhao Yi, "Ershier shi zhaji (Notes on Reading the Twenty-two Histories)," *Bachaoshi zhi Song shixing* (*From the History of the Eight Dynasties to the Song Beginnings*), chap. 9, pp. 22b–23a.

51. See Liu Zhiji, *Shitong*, chap. 12, pp. 19–20 (SKQS, vol. 685, p. 96); Ji Yun, bibliographic preface to the *Suishu* (SKQS, vol. 264, p. 140). Regarding the compilation of official histories in the Han and Tang, see *Shitong*, chap. 12, pp. 4–22 (SKQS, vol. 685, pp. 88–97).

52. *Ibid.*

53. *Ibid.* See also Wang Shumin, *Shibu yaoji jieti*, pp. 82–88.

54. See Zhao Yi, "Ershier shi zhaji," chap. 9, pp. 22b–23a.

55. An example of such additional detail is the aforementioned description of Liang Jianwendi.

56. See Zhao Yi, "Ershier shi zhaji," chap. 9, pp. 22b–23a. See also Shijie shuju bianjibu, *Ershiwu shi shuyao* (*Narration of Events in Twenty-five Histories*) (Taipei: Shijie shuju, 1970), pt. 2, chs. 13 (*Nanshi*), 14 (*Beishi*), pp. 133–157; Zhang Lizhi, *Zhengshi gailun* (*Summary of the Official Histories*) (Taipei: Shangwu yinshuguan, 1964), pp. 76–80. I again wish to thank Professor Li Donghua for bringing these two works to my attention.

During the Zhenguan years (627–649), in addition to editing *Historical Treatises of Five Dynasties*, Li Yanshou also wrote the thirty-fascicle *Proper Statutes of Taizong (Taizong zhengdian* 太宗正典). Prior to final publication, his *History of the Southern Dynasties* and *History of the Northern Dynasties* were also reviewed by the state historian Linghu Defen. Thus, we may conclude that his opinions were not only accepted by the state historiographic apparatus, but also substantively reflected Taizong's attitudes toward governance.

My research has revealed the close relationship between the original creation of the *Thirteen Emperors* scroll and the compilation of official histories during the reign of Taizong. It has also revealed that the critical representation of some of the rulers featured in the scroll (such as Liang Jianwendi) is based on the *History of the Southern Dynasties* and *History of the Northern Dynasties* of Li Yanshou. Therefore, we may conclude that the painting was finished sometime after the completion of these texts in 659. Whether the original composition included the Northern Qi emperors is impossible to determine. However, reading painting is like reading history—in addition to following the aforementioned histories, the inscriptions and visual representation of the rulers in the latter section of the scroll also give substance to Taizong's critique of the political, cultural, and religious aspects of the Liang, Chen, Zhou, and Sui dynasties, as expressed in *Political Principles of the Zhenguan Reign*, as well as to the principles of rule enumerated by Taizong in *Principles of Rulership*.

In sum, the original painting was probably produced by Lang Yuling on the orders of Tang Gaozong as a commentary on the successes and failures of the Northern and Southern dynasty monarchs, intended to instruct and admonish the emperor's descendents. Its date should lie sometime between the completion of *History of the Southern Dynasties* and *History of the Northern Dynasties* in 659 and the years surrounding the completion of *Political Principles of the Zhenguan Reign* around 720.

圖畫如歷史—
傳閻立本《十三帝王圖》研究

陳葆眞

國立臺灣大學藝術史研究所

　　本文結合風格分析和文獻資料，對傳閻立本(約600-673)《十三帝王圖》(波士頓美術館藏)提出三方面的研究：1）探究畫卷後段圖像和題記的眞僞和文獻根據；2）解釋此段畫面的圖像意涵和文化脈絡；3）討論畫卷前段圖像與題記的相關問題。作者發現，畫卷後段的七組帝王群像和相關題記可分爲原跡，摹補，和添加等三組。原來帝王依序應爲梁簡文帝（原誤爲陳文帝）、梁元帝（原誤爲陳廢帝）、陳宣帝、陳後主、後周武帝、隋文帝和隋煬帝。畫家藉種種圖像上的對比，評論南北朝兩方在政治、文化、和宗教上不同的措施和成效。其觀點正反映了唐太宗在《貞觀政要》(約720成書)和《帝範》(648)二書中所論的前朝得失和治國之道。畫卷前段的六個帝王圖像，除漢昭帝（應爲王莽，題記誤置）之外，全仿後周武帝和侍者的造形。此段畫卷應成於十一世紀中期之前。《十三帝王圖》原畫之製作，與唐太宗時期修撰梁、陳、齊、周、隋等五朝史書的背景關係密切。此畫完成的時間上限應在《南史》與《北史》二書完成(659)之後，下限應在《貞觀政要》成書(約720)的前後。

歴史としての絵画—
伝閻立本「十三帝王図」研究

陳葆真

国立台湾大学芸術史研究所

　本論は閻立本(約600–673)「十三帝王図巻(帝王図巻)」(ボストン美術館蔵)に関する研究で、様式分析と文献資料を結び付け、以下の三つの観点から検討する。

　1）画巻後段の図像・題記の真偽と文献上の根拠

　2）画巻後段の図像・題記の意味と文化的コンテクスト

　3）画巻前段の図像と題記の関係について

　私見では、画巻後段の七帝王を中心とする群像とそれに関連する題記は原本・模本・後補の３つに分類することが出来る。原本としては陳の宣帝・後主、後周の武帝、隋の文帝・煬帝の五帝王が挙げられる。これらの図像は、初唐に流行した古代帝王像、当時流伝していた前朝の帝王の肖像、史書の記述、さらに画家の想像から造られたものである。題記の内容は梁・陳・周・隋各王朝の史書(631–644編纂)、特に『南史』『北史』(659年完成)を根拠としている。書法も虞世南(558–638)と歐陽詢(557–641)の様式から影響を受けている。模本としては「陳文帝」「陳廃帝」があるが、これらは「梁簡文帝」「梁元帝」に相当する。この２帝王の図は元々陳宣帝の前に配置されていたが、後に画像・題記が破損して判断が付かなくなって、模写した者が図像を誤って認識し、題記を誤写し、さらに間違って配置したのである。おそらく五代の頃に起きたことと考えられる。後補部分は、いつ加えられたか断定するのは困難であるが、陳「文」帝の名「蒨」、後周・武帝の題記末尾の「無道」など三カ所が挙げられよう。

　画巻後段の帝王を元の順に復原すれば、上述した南朝の梁・陳と北朝の後周及び隋の帝王がそれぞれ二人ずつ（後周は武帝のみ）となる。帝王の内、南朝と北朝は造形上の対比が明確である。梁・陳諸帝は平服を纏い、榻上に坐し（もしくは輿に乗るか、立っており）、容貌は上品で（或いは物憂げで弱々しく）、如意（或いは短剣）を身に着け、男女の待者を伴い、左方を向いている（梁元帝は右を向く）。陳（宣帝）は仏法に深く帰依した。これに対して、後周・隋の帝王は冕服（煬帝は平服）を身に着け立っており、表情は勇猛（或いは荘重）で、長剣を持ち（煬帝は持っていない）、侍者を伴い、皆右に向いている。後周（武帝）は仏法を破壊した。画家はこれらの対比によって、南北における政治・文化・宗教上の政策及び成果の違いを表している。政治

面では、後周及び隋代の二帝を冕服姿で正統政権を、梁・陳の帝王は平服姿で地方政権を象徴している。文化面では、梁・簡文帝と元帝は文化を好み重視したため身を滅ぼし国を危うくしたとされ、又、後周・武帝は戦争を仕掛け侵攻して北方を統一したが、後継ぎがいなかった。これらから国を治めるのに文章のみによってもうまくいかず、又、武功に頼るだけでも長続きしないことを暗示している。宗教面では、陳（宣帝）は仏法に深く帰依したが、ついに滅亡したのに対して、後周（武帝）は仏法を破壊したが、一時は繁栄を極めた。このことから仏法で国を治めるか否かは国家の盛衰と無関係であることを暗示する。これら三つの評価は、『貞観政要』(約720年成書)『帝範』(648年成書)二書中において唐・太宗が論じた前朝の評価、治世の道をまさに反映したものである。従って、画巻後段の原型が完成したのは、『南史』『北史』が成立した659年を上限とし、下限は『貞観政要』が成った720年頃と推測できよう。

　画巻前段の六帝王の図像は皆後周・武帝と侍者の図像を模したもので、造形は硬化しており、個性に欠ける。題記はそれぞれ王朝名と皇帝の姓名のみが記され、内容は単調で、書風も単に歐陽詢の影響が見られるだけである。画家は画巻後段の手法によっており、これら帝王図を用いて漢代(前206–後220)から西晋(265–316)まで歴代政権の正統性を示した。しかし、巻頭の「前漢昭文帝」は題記と図像の絹質が違うため、他から移して来た可能性もある。又、この皇帝は平服姿で、彼が正統政権の帝王ではないことから、王莽(在位9–23)の可能性が高い。この段は11世紀初期以前に描かれたと考えられる。

Chen Pao-chen

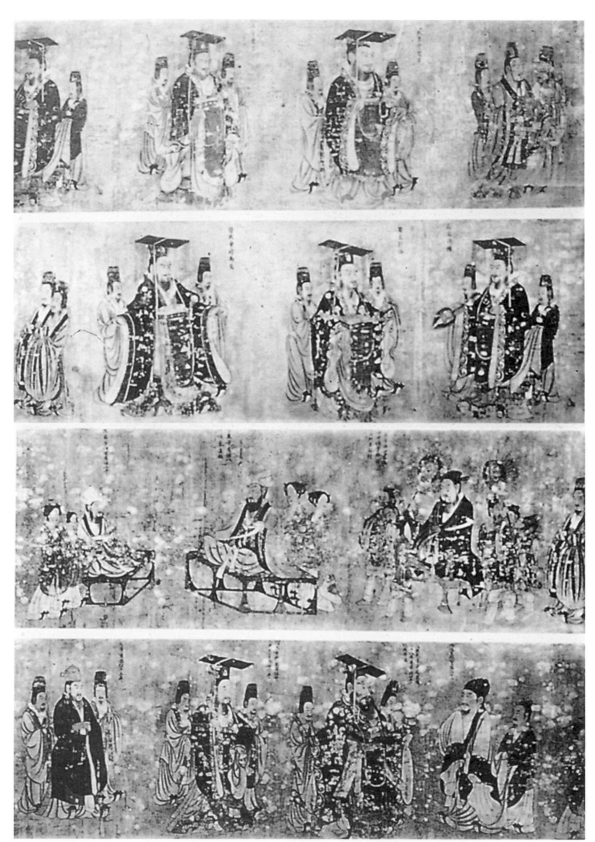

Fig. 1. Attributed to Yan Liben (ca. 600–673). *Thirteen Emperors.* Handscroll, ink and color on silk, 51.3 × 531 cm. Boston Museum of Fine Arts. After Tomita Kōjirō, ed., *Boston Museum of Fine Arts, Portfolio of Chinese Paintings in the Boston Museum of Fine Arts* (Boston: Museum of Fine Arts, 1961), vol. 1, pls. 10, 11.

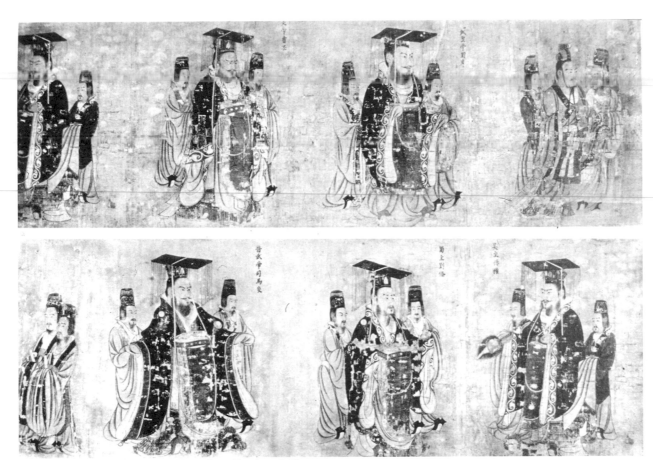

Fig. 2. First section of Figure 1. Photo from Tomita, pl. 10.

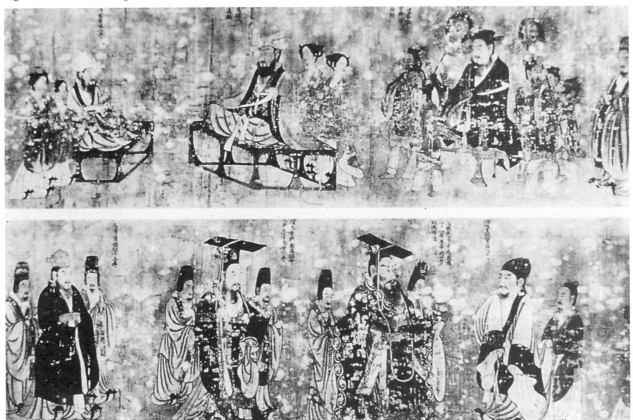

Fig. 3. Second section of Figure 1. Photo from Tomita, pl. 11.

Chen Pao-chen

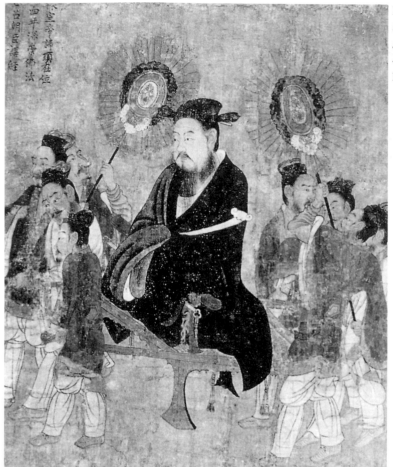

Fig. 4. Portrait of Chen Xuandi. Detail of *Thirteen Emperors*. After Wu Tung, *Boshidun bowuguan cang zhongguo guhua jingpin tulu*, trans. Jin Ying (Tokyo: Ōtsuka Kōgeisha, 1999), vol. 1, pl. 1.

Fig. 4A. Detail of Figure 4.

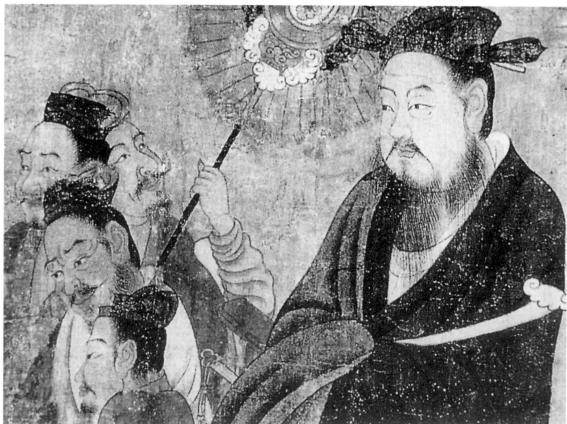

Fig. 4B. Detail of Figure 4.

Fig. 5. Portrait of Chen Wendi.
Detail of *Thirteen Emperors*.
After Wu Tung (1999), vol. 1,
pl. 1.

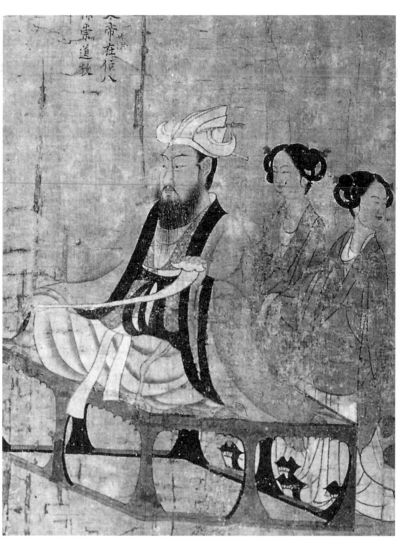

Fig. 5A. Detail of Figure 5.

Chen Pao-chen

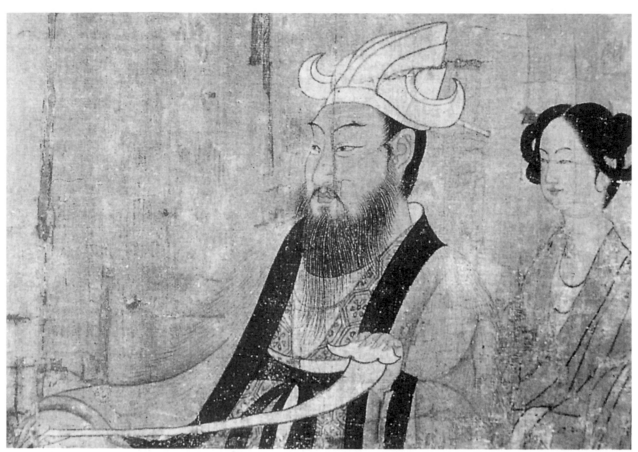

Fig. 5B. Detail of Figure 5.

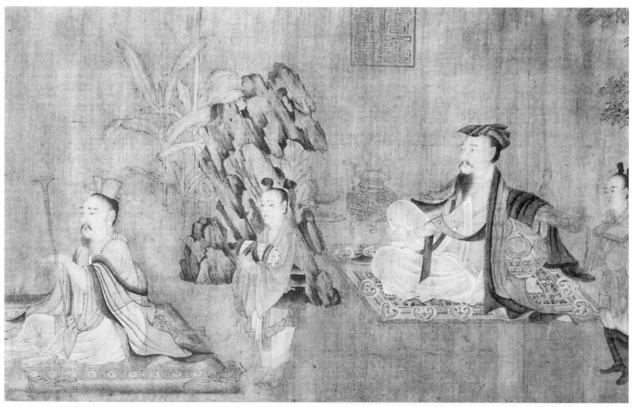

Fig. 5C. Sun Wei (ca. late 9th c.). Detail of *The Seven Worthies*. Ink and color on silk, 45.2 × 168.7 cm. Shanghai Museum. After Zhongguo meishu quanji bianweihui, *Zhongguo meishu quanji* (Beijing: Xinhua shudian, 1988), painting, vol. 2, p. 81.

Fig. 6. Portrait of Chen Feidi.
Detail of *Thirteen Emperors.*
After Wu Tung (1999), vol. 1,
pl. 1.

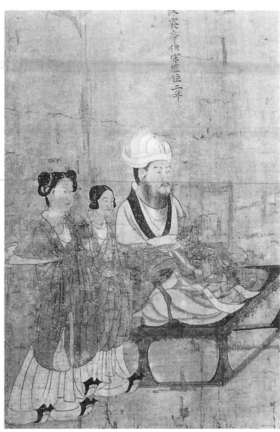

Fig. 6A. Detail of
Figure 6.

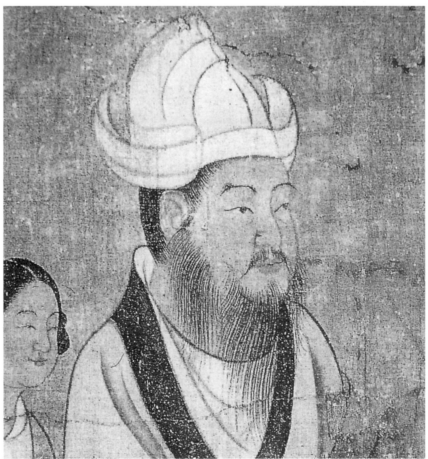

Fig. 6B. Detail of Figure 6.

Chen Pao-chen

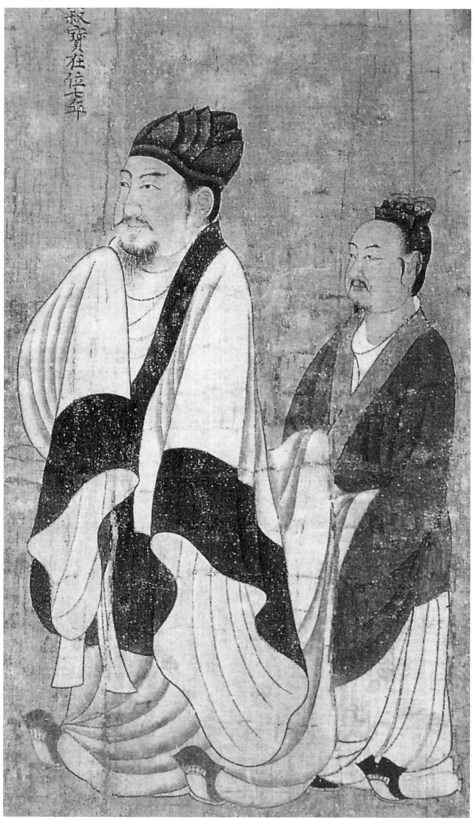

Fig. 7. Portrait of Chen Houzhu.
Detail of *Thirteen Emperors*. After
Wu Tung (1999), vol. 1, pl. 1.

Fig. 7A. Detail of Figure 7.

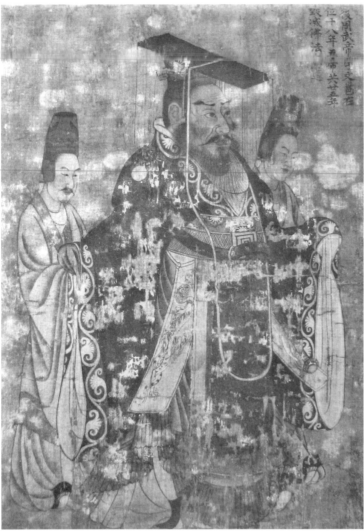

Fig. 8. Portrait of Wudi of the Later Zhou. Detail of *Thirteen Emperors*.
After Wu Tung (1999), vol. 1, pl. 1. *(detail on page 55)*

後周武帝宇文邕在
位十八年五帝共廿五英
毀滅佛法

Fig. 8A. Detail of Figure 8.

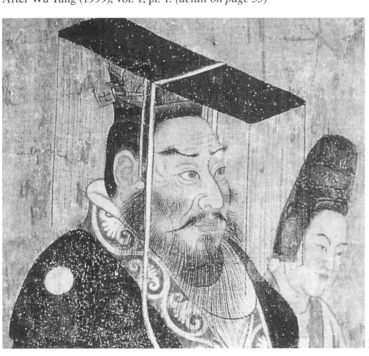

Fig. 8B. Detail of Figure 8.

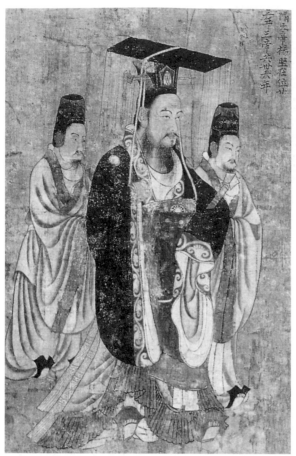

Fig. 9. Portrait of Sui Wendi. Detail of *Thirteen Emperors*. After Wu Tung (1999), vol. 1, pl. 1.

Fig. 9A. Detail of Figure 9.

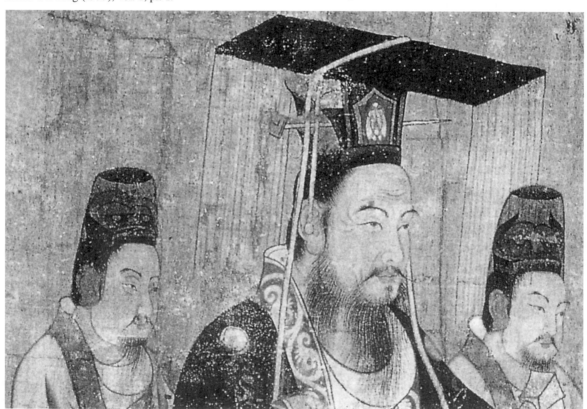

Fig. 9B. Detail of Figure 9.

Fig. 10. Portrait of Sui Yangdi, *Thirteen Emperors*. After Wu Tung (1999), vol. 1, pl. 1.

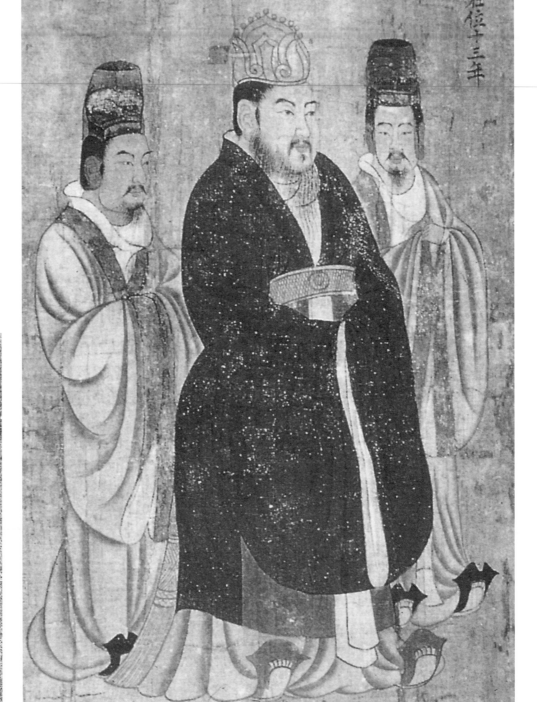

Fig. 10A. Detail of Figure 10.

Chen Pao-chen

Fig. 11. Comparison between the inscriptions on the latter section of the *Thirteen Emperors* scroll (left) and Yu Shinan's calligraphy (right).

Fig. 12. Comparison between the inscriptions on the latter section of the *Thirteen Emperors* scroll (left) and Ouyang Xun's calligraphy (right).

Section I: Studies of Canonical Paintings 87

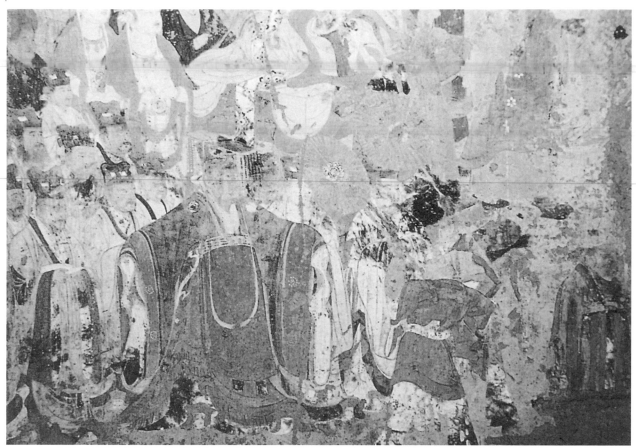

Fig. 13. Detail of the illustration of the *Vimalakīrti Sūtra*, dated to 642. Mural in Cave 220 at Dunhuang, Gansu Province. After Dunhuang wenwu yanjiusuo, ed., *Dunhuang Mogaoku* (Beijing: Wenwu chubanshe, 1987), vol. 3, pl. 33.

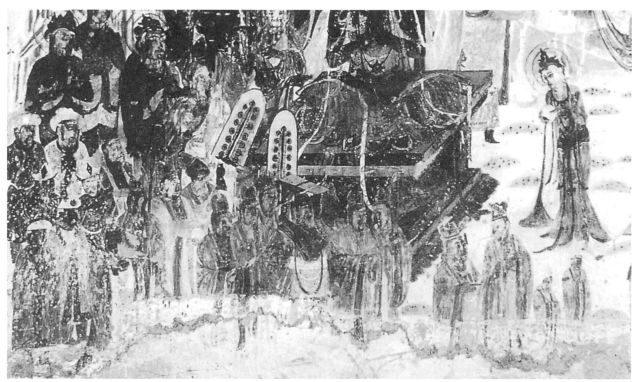

Fig. 14. Detail of the illustration to the *Vimalakīrti Sūtra*, dated 686. Mural in Cave 335 at Dunhuang, Gansu Province. After *Dunhuang Mogaoku* (1987), vol. 3, pl. 61.

Chen Pao-chen

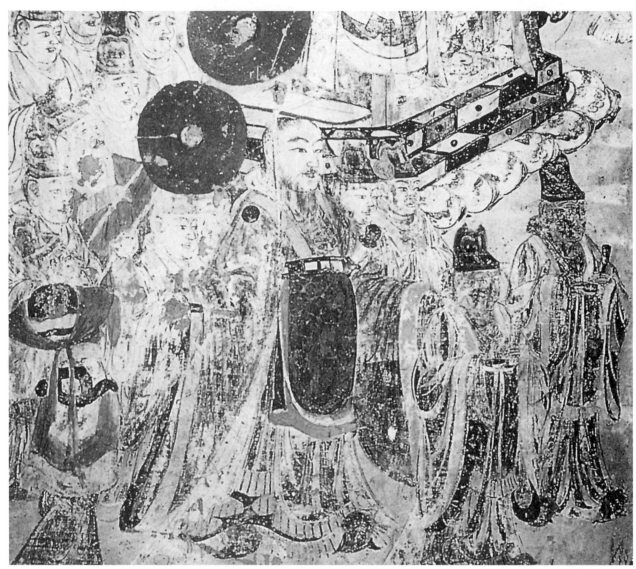

Fig. 15. Detail of the illustration to the *Vimalakīrti Sūtra*, ca. 8th c. Mural in Cave 103 at Dunhuang, Gansu Province. After *Dunhuang Mogaoku* (1987), vol. 3, pl. 154.

Fig. 17. Detailed side-by-side comparison of the inscriptions for Chen Wendi (right) and Hou Zhou Wudi (left).

Fig. 16. Side-by-side comparison of the inscriptions for Chen Feidi (right) and Chen Houzhu (left).

Fig. 18. Side-by-side comparison of the inscriptions for Chen Wendi (right) and Chen Xuandi (left).

Chen Pao-chen

Fig. 19. Reconstruction of the original arrangement of the four initial portraits, second section of the *Thirteen Emperors*. After Wu Tung (1999), vol. 2, p. 13.

Fig. 20. Detail of Figure 19: The four emperors of the Southern Dynasties.

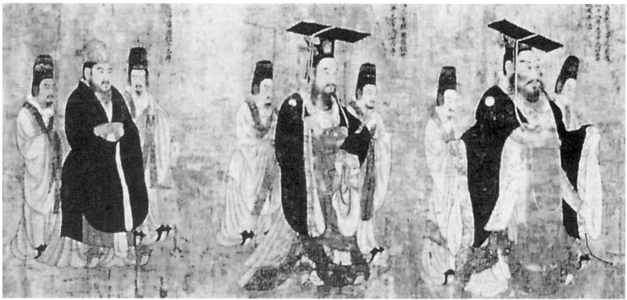

Fig. 21. Detail of Figure 19: The three emperors of the Northern Dynasties.

前漢昭帝

Fig. 22. Detail of *Thirteen Emperors*. Portrait of Han Zhaodi. Museum of Fine Arts, Boston. After Wu Tung (1999), vol. 1, pl. 1.

Chen Pao-chen

Layman Pang and the Enigma of Li Gonglin

Robert E. Harrist, Jr.

Columbia University

Scholarship in recent decades on the Northern Song painter Li Gonglin 李公麟 (ca. 1041–1106) vividly reflects changing methodological and theoretical concerns in the field of East Asian painting studies.[1] In his landmark dissertation on *Illustrations of the Classic of Filial Piety* (*Xiaojing tu* 孝經圖) attributed to Li, as well as in several essays, Richard Barnhart demonstrated in the 1960s and 1970s how "brush-centered" connoisseurship founded on Chinese standards of aesthetic value could be fused with Western concepts of morphology and art historical analysis to determine a corpus of works that continues to define our understanding of Li Gonglin's art.[2] In the 1980s and 1990s, questions of connoisseurship and attribution, though by no means resolved, gave way somewhat to studies that attempted to locate Li's art within the cultural history of the Northern Song period (960–1127) and to shed new light on his approach to the pictorial interpretation of texts.[3] In the past two decades, scholars have investigated also Li's genealogy, his engagement in political life of the late eleventh century, his activities as an art collector, and his affiliation with schools of Buddhism that flourished in the vicinity of the Longmian 龍眠 Mountains of Anhui Province, where the artist lived with his family.[4] Although immune thus far to the full rigors of post-modern debunking,

1. I would like to thank Professor Susan Nelson and Ms. Lara Ingeman, both of Indiana University, for their help in the preparation of this essay. Professor Itakura Masaaki of the University of Tokyo also provided invaluable assistance, for which I am most grateful.

2. Richard M. Barnhart, "Li Kung-lin's *Hsiao-ching t'u,* Illustrations of the Classic of Filial Piety" (Ph.D. diss., Princeton University, 1967), and by the same author, "Li Kung-lin's Use of Past Styles," in *Artists and Tradition,* ed. Christian Murck (Princeton: Princeton University Press, 1976), pp. 51–71; and, with other authors, *Li Kung-lin's Classic of Filial Piety* (New York: Metropolitan Museum of Art, 1993).

3. Among the other doctoral dissertations and Master's theses devoted to Li Gonglin are the following, in chronological order:
 Deborah Del Gais Muller, "Li Kung-lin's *Chiu-ko t'u*: A Study of the *Nine Songs* Handscrolls in the Sung and Yuan Dynasties" (Ph.D. diss., Yale University, 1981);
 Shui Tianzhong, "Li Gonglin he ta de shidai (Li Gonglin and His Times)" (M.A. thesis, Zhongyang meishu xueyuan), in *Shuoshi xuewei lunwenji* (*Collection of Masters' Theses*), ed. Zhongguo yishu yanjiuyuan yanjiu sheng bu (Beijing: Wenhua meishu chubanshe, 1985);
 Robert E. Harrist, Jr., "A Scholar's Landscape: *Shan-chuang t'u* by Li Kung-lin" (Ph.D. diss., Princeton University, 1988);
 Elizabeth Brotherton, "Li Kung-lin and the Long Handscroll Illustrations of T'ao Ch'ien's *Returning Home* (Ph.D. diss., Princeton University, 1992);
 Pan An-yi, "Li Gonglin's Buddhist Beliefs and his 'Lotus Society Picture': An Iconographic Diagram of the Bodhisattva Path" (Ph.D. diss., University of Kansas, 1997).

4. See the following studies by Robert E. Harrist, Jr.: "Li Kung-lin: A Note on the Origins of his Family," *National Palace Museum Bulletin* 25, no. 4 (1990), pp. 1–16; "The Artist as Antiquarian: Li Gonglin and his Study of Early Chinese Art," *Artibus Asiae,* vol. 55, no. 3/4 (Fall 1995), pp. 237–80; and *Painting and Private Life in Eleventh-Century China: Mountain Villa by Li Gonglin* (Princeton: Princeton University Press, 1998). See also the dissertation by Pan An-yi cited above.

the once prevalent vision of Li Gonglin as a "lofty scholar" disengaged from worldly affairs or from the need to make a living has been challenged as part of a more general reexamination of what Joseph Levenson once termed "the amateur ideal."[5]

Despite the increase of knowledge that these studies have achieved, I suspect that, outside a group of diehards, most scholars are content to acknowledge Li Gonglin's importance and then move on to other topics. I myself find, even after years devoted to the study of this artist, that he remains a rather pale, spectral figure whose achievements are lost in a sea of attributed works from which we struggle to find paintings that may really have something to do with his art.

What has not changed much since Richard Barnhart first took up the study of Li Gonglin is a general, though not universal, consensus that among extant paintings, three works deserve to be seriously considered as products of Li's own brush: *Five Horses* (*Wuma tu* 五馬圖; present location unknown), which bears inscriptions by Li's friend Huang Tingjian 黃庭堅 (1045–1105) and was recorded in many historical sources; *Pasturing Horses* (*Muma tu* 牧馬圖; Palace Museum, Beijing), a copy of an eighth-century painting signed by Li Gonglin; and *Illustrations of the Classic of Filial Piety* (Metropolitan Museum of Art), which includes scenes of superbly painted figures and transcriptions of text in calligraphy that has been convincingly identified as the work of Li's period, if not from his own hand. Beyond these three scrolls, copies of Li Gonglin's *Nine Songs* (*Jiuge tu* 九歌圖), *Mountain Villa* (*Shanzhuang tu* 山莊圖), *Returning Home* (*Guiqu laixi tu* 歸去來兮圖), and *Lotus Society* (*Lianshe tu* 蓮社圖) have settled into the scholarly literature as believable reflections of Li's original compositions and fall within the category of "canonical paintings." My goal is to make the case for including another work in this charmed circle.

What may be the most significant recent development in what I will dub "Li xue," or "Li Studies," was the appearance on the New York art market of a painting identified in accompanying colophons of the early Ming dynasty as *Danxia Calling on Layman Pang* (*Danxia fang Pang jushi tu* 丹霞訪龐居士圖; Figs. 1A, 1B). First exhibited at Kaikodo 懷古堂 in 1997 and published in the gallery's spring journal of that year, the painting is executed on silk in ink and light reddish colors now faintly visible on the clothing of the figures.[6] On the painting itself and the adjoining mounting are imperial seals of the Qing dynasty consistent with the documentation of the painting in *Treasured Boxes of the Stone Moat* (*Shiqu baoji* 石渠寶笈), the catalogue of the Qianlong 乾隆 Emperor's (r. 1736–1795) collection, and in Chen Rentao's 陳仁濤 list of paintings dispersed from the palace collection in the early twentieth century.[7] Mounted after the painting, on separate sheets of paper, are colophons and seals of the monk Puxia 溥洽

5. Harrist, *Painting and Private Life*, chap. 1.

6. *Kaikodo Journal* (Spring 1997), pp. 60–62, 214–15. I am indebted to Mr. Howard Rogers, author of the informative catalogue entry on the painting, Mr. Arnold Chang, and the entire staff of Kaikodo who generously facilitated my study of the painting. After this article went to press, the painting entered a collection in Japan.

7. *Shiqu baoji* (*Treasured Boxes of the Stone Moat*), preface dated to 1745 (repr., Taipei: National Palace Museum, 1969), 34: 1046a; Chen Rentao, *Gugong yiyi shuhua mu jiaozhu* (*Annotated Catalogue of Painting and Calligraphy Dispersed from*

(1348–1426) and of the well-known scholar-artist Yao Shou 姚綬 (1423–1495). Seals of the collector Zhu Zhichi 朱之赤 (act. first half of the 17th c.) also appear on the colophons.

It is the colophon by Puxia that identifies the painting as *Danxia Calling on Layman Pang*, which is the title of a work by Li Gonglin recorded in *Catalogue of Paintings in the Xuanhe Collection* (*Xuanhe huapu* 宣和畫譜), the catalogue of Emperor Huizong's 徽宗 (r. 1100–1126) collection: as Puxia notes, however, no seals or inscriptions from the time of Huizong appear on the scroll.[8] Was Puxia correct? Is this actually a painting by Li Gonglin? Before attempting to answer these questions, let us focus on what the painting actually represents. A close reading indicates that it does indeed depict the Buddhist layman Pang Yun 龐蘊 (ca. 740–808) and his family, but the encounter illustrated is not that stated by Puxia in his colophon.

The principal source for information about Pang Yun is a collection of anecdotes and verses titled *Recorded Sayings of Layman Pang* (*Pang jushi yulu* 龐居士語錄), compiled shortly after his death.[9] Also known as Daoxuan 道玄, Pang Yun was born in Hengyang 衡陽 in modern Hunan Province and lived there in a thatched cottage in the mountains with his wife, his son Da 大, and his daughter Lingzhao 靈照. They supported themselves by making and selling bamboo utensils. All four were said to have achieved Buddhist enlightenment, and Lingzhao, a model female Buddhist who figures in many anecdotes in *Recorded Sayings,* reportedly possessed wisdom approaching that of her father.

Layman Pang's friend, the monk Danxia Tianran 丹霞天然 (738–823), was a Confucian scholar as a young man and had intended to become a government official. Travelling to Chang'an 長安 to sit for the *jinshi* 進士 civil service examinations, he encountered a Buddhist who persuaded him to another course. Together with Layman Pang, he set out for Jiangxi 江西 to become a student of the Chan Buddhist master Mazu Daoyi 馬祖道一 (709–788). Mazu accepted Pang as his student but sent Danxia to study with the monk Shitou Xiqian 石頭希遷 (700–790), under whom Danxia was to achieve enlightenment. Stories found in *Recorded Sayings of Layman Pang* circulated widely among Chan monks and lay believers during the Song and Yuan periods. An iconography of the Pang family also developed in paintings known as *Chanhui tu* 禪會圖, or *Pictures of Chan Encounters*. First identified by Shimada Shūjirō 島田修二郎 in a study of the fourteenth-century artist Yintuoluo 因陀羅, four now-lost scrolls titled *Chanhui tu* by unknown artists are recorded in literary collections of thirteenth-century Chan monks.[10] These scrolls consisted of il-

the *Former Palace Collections*) (Hong Kong: Tongying gongsi, 1956), p. 5.

8. *Xuanhe huapu* (*Yishu congbian* ed.), 7: 209. A painting with the same title is recorded also in the supplement, or *xu lu* 續錄, of Chen Kui, *Nan Song guange lu* (*Record of the Southern Song Archives*) (Beijing: Zhonghua shuju, 1998), p. 182.

9. For a translation and critical history of the text, see Ruth Fuller Sasaki *et al., The Recorded Sayings of Layman Pang: A Ninth-Century Zen Classic* (New York and Tokyo: Weatherhill, 1971). For the Chinese text of the *Recorded Sayings of Layman Pang,* I have used the edition annotated by Iriya Yoshitaka, *Hō Koji goroku* (*Recorded Sayings of Layman Pang*) (Tokyo: Chikuma shobō, 1973).

10. Shimada Shūjirō, "Indara no Zen-e-fu (Yintuoluo's *Chanhui tu*)," *Seikan,* 1940; repr. in Shimada's *Chūgoku kaigashi kenkyū* (*Research on the History of Chinese Painting*) (Tokyo: Chūōkōron bijutsu shuppan, 1993), pp. 161–73. See especially page

Robert E. Harrist, Jr.

lustrated episodes from the history of Chan Buddhism in which lay persons visit or seek instruction from Chan masters. Among the scenes included in the scrolls were incidents such as *Huangbo Strikes a Novice* (*Huangbo zhang shami* 黃檗掌沙彌), *Zhaozhou Greets Two Princes Without Rising from his Chair* (*Zhaozhou buxia chanchuang jie er wang* 趙州不下禪床接二王), *Li Ao Visiting Yaoshan* (*Li Ao jian Yaoshan* 李翱見藥山), and *Han Yu Puts Questions to Dadian* (*Han Yu qingyi Dadian* 韓愈請益大顛). Each of the four scrolls concluded with a sequence of scenes illustrating events from the life of Layman Pang and his family: *Layman Pang Visits the Great Master Mazu* (*Pang jushi jian Ma dashi* 龐居士見馬大師), *Lingzhao Meeting Danxia* (*Lingzhao dui Danxia* 靈照對丹霞), *Discussing Birthlessness* (*Shuo wusheng hua* 說無生話), *Lingzhao Sees the Sun's Position in the Sky* (*Lingzhao kan ri zao wan* 靈照看日早晚), *Pang Da Dies Leaning on his Hoe* (*Pang Da yi chu er hua* 龐大倚鋤而化), and (in one scroll only) *The Entire Family of Layman Pang is Gone* (*Pang jushi hejia dou qu* 龐居士合家都去). According to Yoshiaki Shimizu 清水義明 in his study of Yintuoluo, the position of the Pang family scenes as the pictorial climaxes of the *Chanhui tu* scrolls signified that laymen as well as monks could achieve enlightenment.[11]

Shimizu identified a number of extant paintings in Japan that are related iconographically to the first two episodes from the story of Layman Pang. These include an anonymous painting in Tenneiji 天寧寺, Kyoto, datable to the late thirteenth century, showing Pang Yun meeting Mazu Daoyi, and another, formerly attributed to Li Yaofu 李堯夫 (act. early 14th c.) that shows Danxia Tianran meeting Lingzhao on an embankment under a large tree (*Fig. 2*).[12] The encounter in the foreground of the Kaikodo painting can be identified as another representation of Layman Pang's daughter meeting the monk. The details of this episode appear in *Recorded Sayings of Layman Pang*:

> One day, Chan Master Danxia Tianran came to visit the Layman. As soon as he reached the gate, he
> saw [the Layman's] daughter Lingzhao carrying a basket of greens.
> "Is the Layman here?" asked Danxia.
> Lingzhao put down the basket of greens, politely folded her arms [one atop the other] and stood still.
> "Is the Layman here?" asked Danxia again.
> Lingzhao picked up the basket and walked away. Danxia then departed.
> When the Layman returned a little later, Lingzhao told him of the conversation.
> "Is Danxia here?" asked the Layman.
> "He's gone," replied Lingzhao.
> "Red earth painted with milk," remarked the Layman.[13]
> 丹霞天然禪師，一日來訪居士。纔到門首，見女子靈照攜一菜籃。霞問曰，居士在否。照放下
> 菜籃，斂手而立。霞又問，居士在否。照提籃便行。霞遂去。須臾居士歸。照乃舉前話。士
> 曰，丹霞在麼。照曰，去也。士曰，赤土塗牛妳。

In the Kaikodo painting, the encounter takes place in front of a bamboo fence that divides the composition horizontally. On the far left, a young, barefoot attendant carries the monk's oversized straw hat, forked walking staff, and

166 for a chart listing the titles of scenes in the four *Chanhui tu* scrolls.

11. Yoshiaki Shimizu, "Six Narrative Paintings by Yin T'o-lo: Their Symbolic Content," *Archives of Asian Art*, vol. 33 (1980), p. 16. Among the four scrolls studied by Shimada, the titles of the various *Chanhui tu* scenes vary slightly. I follow, with slight alterations, the translations used by Shimizu.

12. These paintings are illustrated and discussed by Shimizu, "Six Narrative Paintings," figs. 14, 23.

13. Translation from Fuller *et al.*, *Recorded Sayings*, p. 51.

fly whisk. The shaven-headed monk (*Fig. 3*), his cheeks and jaws covered with stubble, raises his hands under the long sleeves of his robe to greet Lingzhao (*Fig. 4*); she, as the text of *Recorded Sayings* prescribes, silently crosses her wrists before her. Dressed in a long-sleeved, "V"-necked tunic and high-waisted skirt with long sashes worn over trousers, and shown with her identifying attribute of a bamboo basket, the young woman in the Kaikodo painting can be seen as the prototype for a sizeable group of later works in China and Japan that represent Pang Lingzhao.[14]

Although the story of Danxia's meeting with Lingzhao from *Recorded Sayings* states that Pang was not at home when the monk came to call, the scene on the other side of the fence, in the upper half of the pictorial composition, depicts three figures who can only be Pang Yun with his wife and son (*Fig. 5*). Seated on a mat inside a thatched cottage, which rests on a stone foundation, Pang Yun is shown as a middle-aged man with a luxuriant beard dressed in a scholar's robe and cap. Seated next to him, Pang Da is a younger man whose trouser-clad legs and bare feet are

14. A list of paintings and woodblock prints that depict Lingzhao and other members of the Pang family appears in Fuller *et al.*, *Recorded Sayings*, pp. 33–36. To the list of images recorded and reproduced in this source can be added the following paintings. Works from China precede those produced in Japan; signed or attributed works precede those done by anonymous artists.

Anonymous (formerly attributed to Ma Lin [ca. 1180–after 1256]). *Snowscape with a Standing Woman*. Undated. 13th c. China. Album leaf; ink and light colors on silk; 24.5 x 25.6 cm. Museum of Fine Arts, Boston. See Wu Tung, *Tales from the Land of the Dragon: 1,000 Years of Chinese Painting* (Boston: Museum of Fine Arts, 1997), no. 75, p. 184.

Anonymous. *Mazu Daoyi with the Recluse Pang Yun*. Inscription by Qingzhuo Zhengcheng (1274–1339) dated to 1325. China. Hanging scroll; ink on silk; 37.8 x 28.8 cm. Tenjūin, Myōshinji, Kyoto. See Helmut Brinker, *Zen Meister der Meditation in Bildern und Schriften* (Zurich: Artibus Asiae, 1996), p. 230.

Anonymous. *Portrait of a Woman in White*. 14th c. China. Hanging scroll; ink and color on silk; 93.7 × 43.7 cm. This painting has been tentatively identified as an image of Pang Lingzhao. See Thomas Lawton, *Chinese Figure Painting* (Washington: David R. Godine, in association with the Freer Gallery of Art, 1973), no. 45, pp. 178–81.

Attributed to Kanō Motonobu (1476–1559). *Portrait of Lingzhao*. Undated. Japan. Hanging scroll; ink and color on paper; 100.7 × 45.9 cm. Nara National Museum. See Suzuki Kei *et al.*, eds., *Comprehensive Illustrated Catalog of Chinese Paintings*. Second series (Tokyo: University of Tokyo Press, 1998), vol. 3, no. JM6-005-02.

Attributed to Seikō (16th c.?). *The Three Pangs*. Inscription by Tenshin Chikan dated to 1565. Japan. Hanging scroll; ink and light colors on paper; 44.6 × 68.3 cm. Seikadō bunko Art Museum. See *Kokka*, no. 1231 (1998), p. 53.

Attributed to Chikudō (1776–1853). *Portrait of Lingzhao*. Undated. Japan. Hanging scroll; ink and color on paper; 82.0 × 47.4 cm. Nara National Museum. See Suzuki Kei *et al.*, eds., *Comprehensive Illustrated Catalog of Chinese Paintings*. Second series (Tokyo: University of Tokyo Press, 1998), vol. 3, no. JM6-005-03.

Anonymous. *The Three Pangs*. Inscribed by Shōhan Zenyō (act. early 15th c.). Japan. Handscroll; ink and light colors on paper; 38.7 × 78.8 cm. Masaki Museum, Osaka. See Shimada Shūjirō and Iriya Yoshitaka, eds., *Zenrin gasan* (*Zen Painting Encomia*) (Tokyo: Mainichi shinbunsha, 1987), no. 43, pp. 122–23.

Anonymous. *Layman Pang and Lingzhao*. Inscription by Keishō Genki dated to 1483. Japan. Hanging scroll; ink on paper; 96.5 × 33.2 cm. Ryōsokuin, Kyoto. See Kyoto National Museum, ed., *The Oldest Zen Temple in Kyoto: Kenninji* (Kyoto: Yomiuri shinbunsha, 2002), no. 28, p. 55.

Anonymous. *Avalokitesvara as a Lady of the Ma Family*. Undated. Muromachi period. Japan. Hanging scroll; ink and light colors on silk; 95.7 × 35.7 cm. Kūmyōji, Kyoto. See Tanaka Ichimatsu and Yonezawa Yoshiho, *Suiboku bijutsu taikei* (*Great Synthesis of the Art of Ink Painting*), vol. 4 (Tokyo: Kōdansha, 1975), no. 93, p. 120. This painting of a young woman holding a basket of bamboo utensils may in fact be a representation of Pang Lingzhao.

Anonymous. *Portrait of Lingzhao*. Undated. Muromachi period. Japan. Hanging scroll; ink and color on silk; 100.7 × 45 cm. Nara National Museum. See Suzuki Kei *et al.*, eds., *Comprehensive Illustrated Catalog of Chinese Paintings*. Second series (Tokyo: University of Tokyo Press, 1998), vol. 3, no. JM6-005-01.

Anonymous. *The Mysterious Maiden Lingzhao, Paragon of Filial Piety*. Undated. Early Edo period (ca. 1670). Japan. Hanging scroll; ink, color, and gold on paper; 92.8 × 38.9 cm. Powers collection. See John M. Rosenfield and Shūjirō Shimada, *Traditions of Japanese Art: Selections from the Kimiko and John Powers Collection* (Cambridge: Fogg Art Museum, Harvard University, 1970), no. 142, p. 354.

Robert E. Harrist, Jr.

exposed to view. Across from the two men, Mrs. Pang sits bolt upright with her hands folded in her sleeves. Mother and son listen intently as Pang Yun, gesturing with his raised right hand, speaks. In addition to the bamboo grove in the upper left of the painting, the tools and stalks of bamboo on the floor behind the figures allude to the humble craft by which they made their living. Although the rustic cottage, supported by tree trunks from which branches still extend, is badly in need of repairs—plaster has fallen from the bamboo slats that make up the outer walls—the Pangs are nicely supplied with fresh water channelled through a bamboo pipe into a large vat, next to which are a bird bath and a wooden bucket.

Separated by the fence from Lingzhao's encounter with Danxia, the scene in the thatched cottage recalls another Pang family episode inspired by one of Pang Yun's poems:

> I've a boy who has no bride,
> I've a girl who has no groom;
> Forming a happy family circle,
> We discuss Birthlessness.[15]
> 有男不婚，有女不嫁。大家團圞頭，共說無生話。

Although the poem would seem to demand that a corresponding vignette include all four members of the Pang family, the image of Pang's wife and son listening to the Layman hold forth suggests that what we see in the Kaikodo painting corresponds to the third Pang family scene, *Discussing Birthlessness*, listed in the records of *Chanhui tu*. This episode comes directly after *Lingzhao Meeting Danxia* in three of the scrolls recorded in Chan monks' literary collections, reinforcing the possibility that the two scenes might be conjoined in other renderings; moreover, the literary collection of the monk Xisou Shaotan 希叟紹曇 (act. mid-13th c.) records his colophon for a lost *Chanhui tu* in which he specifically refers to the family discussion represented as taking place in a thatched building.[16] In order to combine two episodes in a single pictorial unit, the artist of the Kaikodo painting sent Lingzhao out to meet the monk, while the rest of the family remains inside, immersed in discussion of Buddhist doctrine. Unlike the meeting of Pang Yun and Mazu Daoyi, or the encounter of Lingzhao and Danxia, which are illustrated in other paintings in China and Japan, the only extant representation of the *Discussing Birthlessness* episode appears to be the one in the Kaikodo painting. The other scenes documented in Song and Yuan records—Lingzhao watching the sun, Pang Da dying while leaning on his hoe, and the complete disappearance of the Pang family (this last illustrated, one imagines, through the representation of an empty thatched cottage)—have yet to be identified.

Returning to Puxia's fourteenth-century colophon for the painting, I believe that his reading of the iconography as *Danxia Calling on Layman Pang* was mistaken. Such a painting by Li Gonglin did exist at one time, as the *Xuanhe Painting Catalogue* entry attests, but it probably included only the figures of the monk and the layman, perhaps in a composition like that of the Tenneiji hanging scroll illustrating Pang Yun's meeting with Mazu Daoyi. Under-

15. Translation from Fuller *et al.*, *Recorded Sayings*, p. 43 (adapted).

16. *Xisou Shaotan chanshi guanglu* (*Comprehensive Record of the Chan Master Xisou Shaotan*), *juan* 7, pp. 145b–146a (*Dai Nihon zoku Zōkyō* [*Buddhist Canon—Japanese Version*], pt. 2, case 27), quoted in full by Shimada, "Indara," p. 167.

stood within the history of Chan imagery, the Kaikodo scroll can be labelled more accurately as *Lingzhao Meeting Danxia* and *Discussing Birthlessness*. Although there are no signs that the painting was once part of a longer scroll or a sequence of pictures separated by sections of texts, the single illustration comprising two Layman Pang episodes might well have been accompanied by others to form *Pictures of Chan Encounters*. A painting with just this title is recorded among Li Gonglin's works in *Catalogue of Paintings in the Xuanhe Collection*, a fact that redirects attention to the question postponed earlier: is the Kaikodo painting by Li Gonglin?

Just as Puxia's identification of the painting as a work by Li Gonglin would indicate, it is through comparison with other paintings attributed to Li that the scroll comes into art historical focus. For example, the scene framed by trees and divided horizontally by a fence with an open gate, the presence of a Buddhist monk in the foreground, and a stone foundation supporting a thatched cottage housing a group of figures—all these elements correspond to Li's image of the Hall of Ink Meditation (Mochantang 墨禪堂) preserved in copies of his *Mountain Villa* (*Fig. 6*). Even the water channelled into a vat and the bird bath outside the Pang home have their equivalents in the *Mountain Villa* scene. The Kaikodo painting resonates also with images of the hermit-poet Tao Yuanming 陶淵明 (365–427) sitting with his family or friends in his thatched cottage, as seen in a handscroll illustration of Tao's "Returning Home" in the Freer Gallery of Art, another work probably copied from an original by Li Gonglin (*Fig. 7*).

The exchanged glances, gestures, and poses of the figures in the Kaikodo painting, as well as the image of an intimate family group, correspond to images in Li's *Illustrations of the Classic of Filial Piety*, a veritable encyclopedia of human relationships bridging classes, generations, and genders. Li's illustration of Chapter Five of the *Classic of Filial Piety* depicts a father and mother seated on a mat on the floor being served a meal by their son and daughter-in-law (*Fig. 8*). The father gestures toward his kneeling son, while the mother, in Barnhart's words, "glances toward her husband, a faint smile on her lips as if she is speaking." As Barnhart notes, "[r]arely in Chinese art had a husband and wife been depicted with such intimacy and apparent affection."[17] What is remarkable about Barnhart's reading of the *Classic of Filial Piety* scene is that his words could describe with equal accuracy the scene of Layman Pang and his wife.

Seated in nearly identical poses and dressed in the same type of clothing—"V"-necked tunics and high-waisted skirts that gather in complex folds on the mats where they sit—the two women could well be sisters (*Figs. 9, 10*). The brushwork in both images displays subtle modulations and fluid changes of direction that successfully model faces and fabric. However, there are significant differences: some passages of the complex and improvisatory drawing in *Illustrations of the Classic of Filial Piety* lack representational clarity. The left sleeve, for example, is difficult to interpret—is there a shawl over the shoulder, as there appears to be on the figure's right side? Outlines intended to show fabric covering the woman's folded legs make the lower part of her body look too small. Some areas in the

17. Barnhart, *Li Kung-lin's Classic of Filial Piety*, p. 98.

Robert E. Harrist, Jr.

Kaikodo painting, such as the folds under Mrs. Pang's right hip, may have been retouched, but these interventions do not obscure what clearly was from its inception a masterful feat of draftsmanship, in which individual brush strokes are fused into a clear, coherent image.

Illustrations of the Classic of Filial Piety seems to be, as Barnhart has suggested, "a first draft, a series of sketches."[18] The Kaikodo painting, on the other hand, is a work completed with exacting care. The greatest contrast between the two paintings appears in the rendering of faces. Those in the Metropolitan scroll, though alert and expressive, are flatter and less substantial than the faces in the Kaikodo painting, which are more finished and volumetric. This effect is especially striking in the face of Layman Pang: the carefully outlined forehead and cheekbones, deep-set and slightly squinting eyes, high nose, and curling nostril powerfully define a calm, intelligent face that wears an expression of intense concentration.

Is, then, the Kaikodo painting by Li Gonglin? It is impossible to be sure. What does seem certain is that the scroll is a work of the Song period, produced close to Li's lifetime, if not by the master himself. Iconographically, the painting fits perfectly into what we know of Li's oeuvre: the inventor of several new iconographic types, such as "Guanyin reclining on a rock" (*Shishang wo Guanyin* 石上臥觀音), Li may also deserve credit for inventing scenes of Chan encounters that gradually were diffused throughout East Asian painting, including images of *Patriarchs Transmitting the Law and the Robe* (*Zushi chuanfa shouyi tu* 祖師傳法授衣圖) and *Tuizhi [Han Yu] Meeting Dadian* (*Tuizhi jian Dadian tu* 退之見大顛圖), both of which became popular subjects in Southern Song Chan painting, the latter corresponding to the scene of *Han Yu Puts Questions to Dadian* recorded among the scenes in *Chanhui tu* scrolls.[19]

Another chain of associations linking the Kaikodo painting to Li Gonglin concerns the Indian sage Vimalakīrti. Visually, the gesture of Layman Pang raising his right hand to signify expostulation or teaching recalls the gesture of Vimalakīrti in a painting attributed to Ma Yunqing 馬雲卿 (act. ca. 1230) that is believed to have been based on an original by Li Gonglin (*Fig. 11*).[20] This visual cue reminds the viewer that any Chinese Buddhist male who remained active in the secular world could be likened to Vimalakīrti, the archetypal Buddhist layman. The bond between Vimalakīrti and Layman Pang, however, was more direct. Statements by Pang himself, as well as comments made about him by his contemporaries, specifically call attention to the parallels between his life and that of the Indian sage. Upon his death, someone declared, "The Layman [Pang] was indeed a Vimalakīrti."[21]

18. *Ibid.*, p. 25.

19. Agnes E. Meyer, *Chinese Art as Reflected in the Thought and Art of Li Lung-mien* (New York, 1923), vol. 2, p. 366. For these subjects in Chan painting, see Shimizu, "Six Narrative Paintings," pp. 11–12, 13–16.

20. Wen Fong and Maxwell K. Hearn, "Silent Poetry: Chinese Paintings in the Douglas Dillon Galleries," *The Metropolitan Museum of Art Bulletin* (Winter 1981/82), p. 28. See also Marsha Weidner, ed., *Latter Days of the Law: Images of Chinese Buddhism, 850–1850* (Lawrence: Spencer Museum of Art, in association with the University of Hawaii Press, 1994), p. 353.

21. See Fuller *et al.*, *Recorded Sayings*, pp. 24–25, 43.

Several centuries later, Li Gonglin, who called himself the Layman of Longmian (Longmian jushi 龍眠居士), probably hoped to be remembered as a latter-day Vimalakīrti as well. Several catalogues, beginning with *Catalogue of Paintings in the Xuanhe Collection*, record Li's paintings of Vimalakīrti, which may be reflected in the Ma Yunqing scroll mentioned above.[22] Besides painting Vimalakīrti, Li Gonglin found other ways to signify an association with that sage. He named one of the sites at his retreat in the Longmian Mountains "Raining Blossoms Cliff" (Yuhuayan 雨花巖) in an allusion to the miraculous descent of blossoms set off by a *deva* during the debate between Vimalakīrti and the bodhisattva Mañjusrī.[23] In a poem that he wrote while grading examination papers in Kaifeng 開封, far from his retreat, Li described memories of living in the mountains, where he carried a sūtra bag that also contained a *zhuwei* 麈尾 fan, an attribute of the Indian sage.[24]

Pursuing other links between Vimalakīrti, Layman Pang, and Li Gonglin leads deep into Li's biography and his artistic practice. We know that Li frequently made informal portraits of his friends, including Su Shi 蘇軾 (1037–1101) and Huang Tingjian, as well as several self-portraits. We know also, as Richard Barnhart was the first to point out, that "it was apparently a common practice in the Song dynasty to disguise eminent personages, a friend or relative, or even oneself, as figures in historical, religious, or genre painting."[25] Viewed in light of these facts, the vivid, portrait-like features of Layman Pang (*Fig. 12*) in the Kaikodo painting invite speculation about the identity of the model. The question might be posed in the following terms: who, among men that Li Gonglin might expect his viewers to recognize, would be a suitable prototype for Layman Pang, a Vimalakīrti-like figure who lived in a thatched cottage in the mountains with his wife, his son, and his daughter? The answer is easy: Li Gonglin himself, the mountain dwelling hermit who was also the father of one son and one daughter.[26]

Is this reckless speculation? It may be, but this is precisely the type of speculation in which viewers from Li's circle of friends, alert to visual allusions and private autobiographical references, could have been expected to indulge as they gazed at the wise, benign features of Layman Pang. There can be no doubt, however, that the artist would become a considerably less "pale, spectral figure," as I somewhat dismissively termed him, if future studies of the Kaikodo painting someday confirm that Li Gonglin is almost literally staring us in the face.

22. For a convenient listing of these paintings, see Meyer, *Chinese Art*, vol. 2, pp. 368–70.

23. Harrist, *Painting and Private Life*, p. 39.

24. Pan, "Li Gonglin's Buddhist Beliefs," pp. 23–24.

25. Barnhart, "Li Kung-lin's *Hsiao-ching t'u*," p. 117.

26. I am grateful to my student Sandrine Larrivé-Bass for pointing out this connection between Li's family and that of Layman Pang. I am grateful also to Chen Li-wei, Jenny Oh, and Xue Lei, also graduate students at Columbia University, for their help with research on Layman Pang.

Robert E. Harrist, Jr.

龐居士和李公麟之謎

Robert E. Harrist, Jr.

哥倫比亞大學

近幾十年來對北宋畫家李公麟(約1041–1106)的研究,已經建立了一小批相信是李公麟親筆或是摹自眞蹟的傳世作品。李公麟研究的最新進展,要屬1997年紐約澄懷堂美術館展出的一張由題跋可定爲《丹霞訪龐居士圖》的作品。基於圖像學及繪畫風格的分析,本文論證這幅畫應爲宋代的重要作品,是一張即使非李公麟親筆,也與其藝術有緊密關係的畫作。

懷古堂的這張畫作的題名與《宣和畫譜》記載的李公麟作品名稱相符,是宋元時期廣泛流傳於禪僧與居士間的《龐居士語錄》中的一段故事。《龐居士語錄》是居士龐蘊(約740–808)話語和文字的集錄。也許是由李公麟創發的龐氏一家圖像,也在如禪會圖一類的畫作中發展著。由現存作品及文獻資料可知,宋代這類禪會圖會由藝術家描繪居士拜會或尋找禪僧教導的禪宗歷史故事。雖然懷古堂的畫作明顯屬於這個類型,但主題並非畫名所題的丹霞訪龐居士,而是表現《龐居士語錄》中另外兩段故事:丹霞與龐居士女兒靈照的相遇,以及龐氏家族成員討論佛教義理的情形。

懷古堂這件作品的圖像,與我們所知發明好幾種新型態佛教圖像的李公麟眞蹟恰恰相符。構圖、人物姿態、衣著,以及畫中的其他元素都反應了我們熟知的李公麟作品如《孝經圖》、《山莊圖》中的形象。另一個將懷古堂畫作與李公麟連接起來的線索與印度聖人維摩居士有關。由龐居士本身聲稱,以及他的同時人對他的評論,都讓人注意到他與維摩居士生平的相似,而維摩居士乃是中國禪宗居士倍受推崇的典型。正如同龐居士,李公麟也喜歡將自己與維摩居士關連起來。除了爲這位聖人畫像,他也自稱居士,並且將他隱居山莊中的某個景點命名爲影射維摩居士生平故事的「雨花巖」。懷古堂畫作中那位栩栩如生、宛若描繪肖像般的龐居士形象,或許不只可以想到維摩居士,由於李公麟會於作品中植入自傳性的參照與影射是廣爲人知的,因此本文以畫中的龐居士有可能是藝術家自身的寫照作結。

龐居士と李公麟の謎

Robert E. Harrist, Jr.

コロンビア大学

北宋画家、李公麟(約1041-1106)に関するここ数十年の研究により、李自身の手による、また李の原画から模写されたと考えられる小作品群が特定されてきた。李公麟研究における近年の重要な進展は、1997年ニューヨークの懐古堂展で、題跋から「丹霞訪龐居士図」と特定される絵画が展示されたことである。本稿は、図像と絵画様式の分析に基づきながら、当絵画が李公麟本人のものでなくとも、その芸術と密接に関連する宋代の重要作品と考えられることを論じる。

懐古堂本の題名は、『宣和画譜』に記載されている李公麟の作品名と一致しており、それは『龐居士語録』中のある逸話を指したものである。『龐居士語録』は仏教居士龐蘊(約740-808)にまつわる故事と詩を集めたもので、宋代、元代の禅僧や居士の間に広く流布した。李公麟が創作したと思われる、龐家族を描いた図像は、後に「禅会図」として知られる絵画において展開された。宋代のこのジャンルの絵画では、現存する作品や文献から分かるように、画家達は禅宗の歴史をもとにした逸話を描いた。そこでは居士が高名な僧を訪ね、その教えを請う姿が描かれた。懐古堂本は明らかにこれに属するものであるが、その主題は、現在の題名が暗示するように、僧丹霞による龐居士の訪問ではない。描かれているのは、『龐居士語録』に収められた二つの異なる逸話、即ち、丹霞と居士の娘霊照との遭遇、娘以外の龐一家による仏教教義の議論である。

李公麟は幾つかの新しい仏教図像の類型の創案者であり、懐古堂本の図像は、李の作品から私たちが知るものと完全に一致する。構図、人物の姿勢、服装、その他の要素も、「孝経図巻」、「山荘図」を含む李公麟の有名な作品と共鳴する。懐古堂絵画と李公麟とを結びつけるもう一つの関連性はインドの聖人、維摩詰に関するものである。同時代人による居士への評言のみならず、龐居士自身の言葉も、彼の人生と、中国仏教居士の崇敬すべき典型、維摩詰の人生との類似点を浮かび上がらせる。龐居士と同じく、李公麟も、維摩詰の逸事と自分自身とを結びつけるのを好んだ。その聖人の絵画を描くことに加え、李は自ら「居士」と称し、維摩詰の生前の故事にちなんで山中の隠棲地を「雨花崖」と名づけた。この画家は作品に自伝的言及、暗示を埋め込んだこ

とが知られており、懐古堂本の生き生きとした肖像画のような龐居士の姿には、維摩詰ばかりでなく、より具体的に、画家自身の特徴を想起させる意図がこめられていたという可能性を提起して本論を終えたい。

Fig. 1A (above). Attributed to Li Gonglin (ca. 1041–1106). *Danxia Calling on Layman Pang.* Undated. Handscroll, ink and light colors on silk, 33 × 50.8 cm (painting only). 1B (below). Colophon. Formerly Kaikodo, New York. *(detail on page 93)*

Robert E. Harrist, Jr.

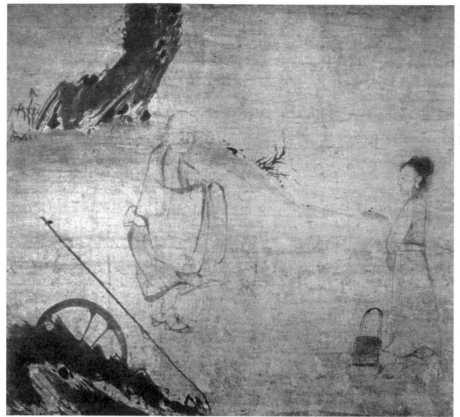

Fig. 2. Formerly attributed to Li Yaofu (act. early 14th c.). *Danxia Meeting Lingzhao*. Hanging scroll, ink on paper, 33.6 × 36.3 cm. Formerly Kawasaki collection, present location unknown. After Kawasaki Yoshitarō, *Chōshun kaku kanshō*, vol. 4 (Kobe, 1914), pl. 36.

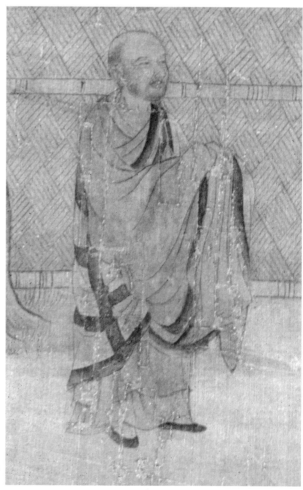

Fig. 3. Detail of Figure 1, the monk Danxia Tianran.

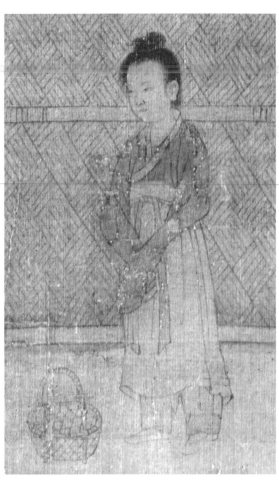

Fig. 4. Detail of Figure 1,
Pang Lingzhao.

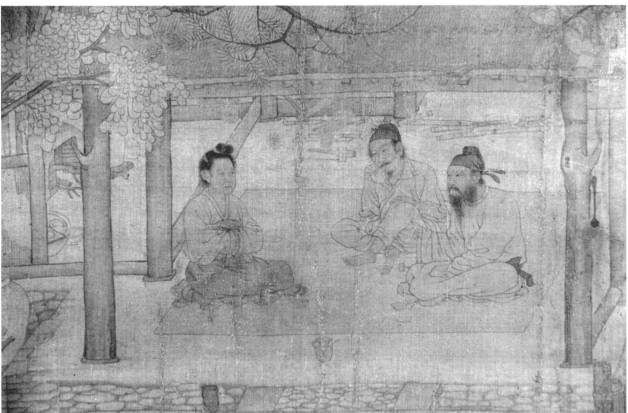

Fig. 5. Detail of Figure 1, showing Pang Yun, his wife, and his son in the family's thatched hut.

Robert E. Harrist, Jr.

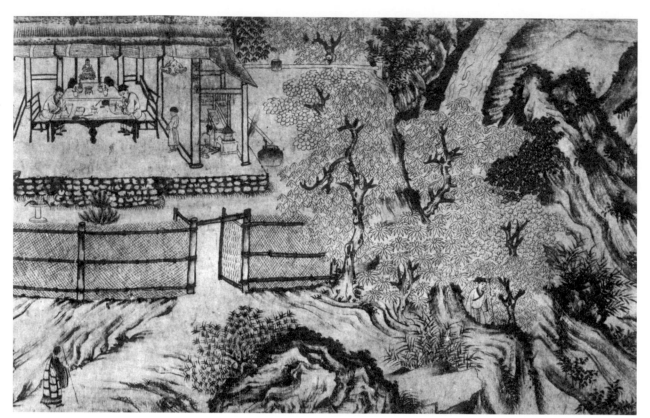

Fig. 6. Copy after Li Gonglin (ca. 1041–1106). *Mountain Villa*. Undated. Section of a handscroll, ink on paper, h. 27.7 cm. Palace Museum, Beijing.

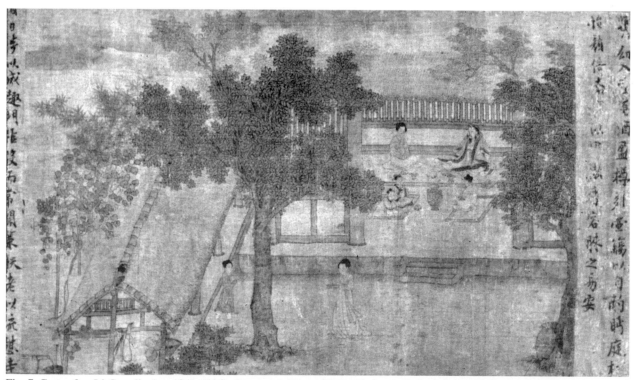

Fig. 7. Copy after Li Gonglin (ca. 1041–1106). *Returning Home*. Undated. Section of a handscroll, ink and colors on silk, h. 37 cm. Freer Gallery, Washington, D.C.

Fig. 8. Li Gonglin (ca. 1041–1106).
*Illustrations of the Classic of Filial
Piety*. Undated. Section of a handscroll,
ink on silk, h. 21.9 cm. Metropolitan
Museum of Art, New York.

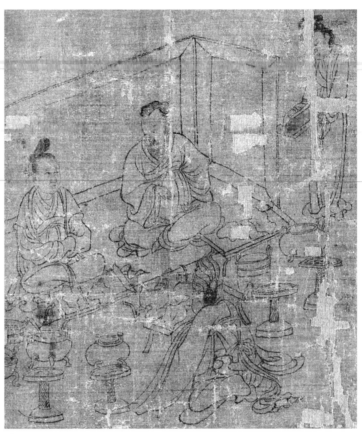

Fig. 9. Detail of Figure 1, Mrs. Pang.

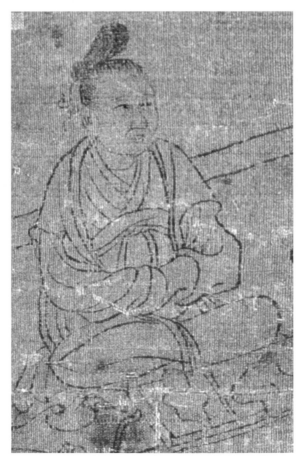

Fig. 10. Detail of Figure 8.

Robert E. Harrist, Jr.

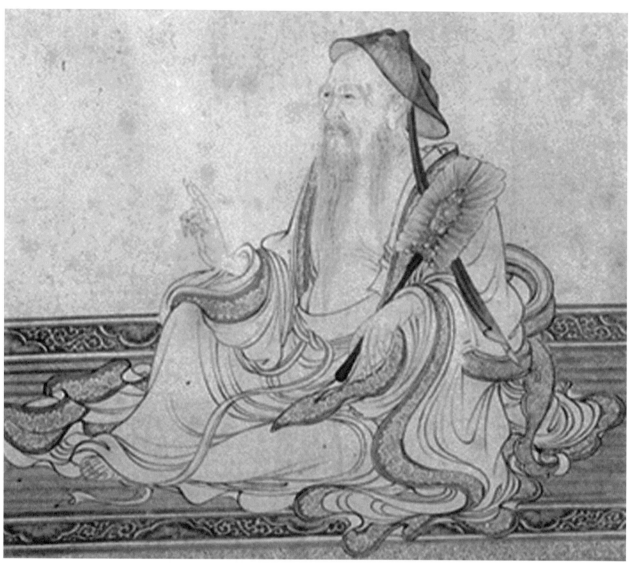

Fig. 11. Ma Yunqing (act. ca. 1230). *Vimalakīrti*. Undated. Section of a handscroll, ink on paper, h. 34.6 cm. Palace Museum, Beijing.

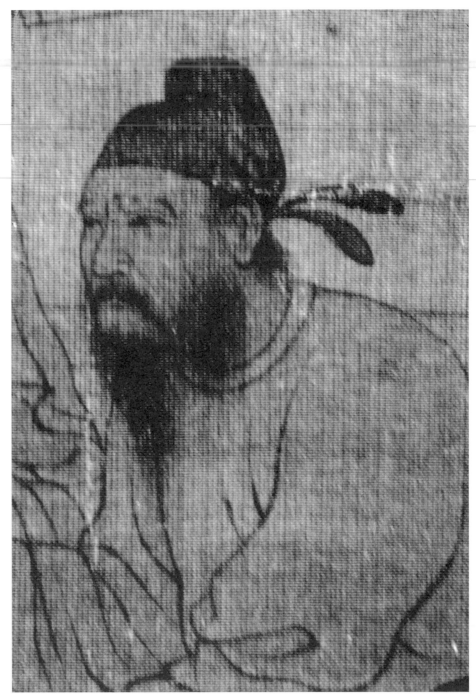

Fig. 12. Detail of Figure 1, face of Layman Pang.

Robert E. Harrist, Jr.

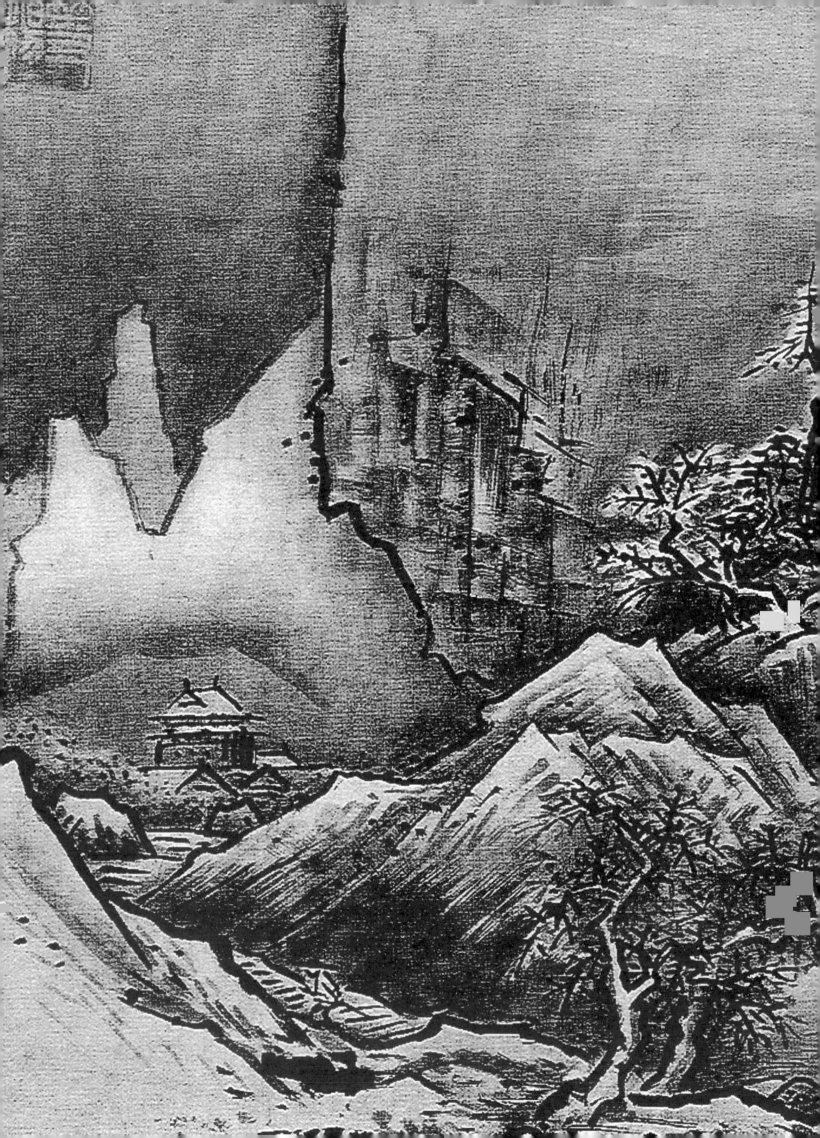

Sesshū's Xia Gui-Style Landscape Paintings in Light of "Comparative Culture Theory"

Shimao Arata

Tama Arts University

In the conclusion to this volume, John Rosenfield, one of the symposium planners, remarks on how recent discourse, including various post-modern theories, has enriched art history. Notwithstanding his inspiringly optimistic summation, I rather sense in present-day art historical research something approaching diffusion, if not outright fissure. Over the last thirty years or so, art history has become a chaotic dance of various critical theories, from the application of semiotics and literary theories to revisionism as well as gender and cultural studies. It would be almost impossible to master thoroughly all these approaches to our field of study.

It goes without saying that most academic disciplines are forms of socially shared illusions, but in its current state, art history seems to have lost this sense of sharing. The osmosis into art history of methodologies from neighboring academic fields has fractured the vantage point from which art is viewed and blurred the nature and scope of art history itself. Therefore, some scholars assert that it is not necessary to look at art objects themselves. Others work on precise, overly confined analyses of "the object" *per se*, such as detailed pigment examination. I do not believe that these diverse discourses have interacted in harmonious balance to form an art history as a whole. Indeed, very few scholars, each responsible for their "parts," have achieved the notion of a unitary discipline.

My stance, which may seem disrespectful to the organizers and other participants in this conference, is an attempt to suggest some remedy for the disjunction that I perceive in our field. For me, the strange and complex entity known as the "work of art" should resist the fissioning of our discipline and link together the many diverse and divergent approaches. I shall touch on this matter at the end of my paper.

The Myth of "Uniformity of Subject"

My topic is the landscape paintings that the Japanese painter Sesshū Tōyō 雪舟等揚 (1420–1506) painted in the style of the Chinese artist Xia Gui 夏珪 (fl. 13th c.), but first I should like to outline what I take to be the questions encompassed in the theme of this symposium and this volume. The following question always arises among scholars of disparate nations studying the same subject: "We think this way in Japan, but how do you view the subject in China or Korea or America?" Such a question perpetuates the fundamental premise of "comparative culture theory": that different locales—meaning academic milieus, subjects of specialization, and kinds of academic training—shape differing opinions about a given art work. That premise, in turn, perpetuates the assumption that scholars who study

the same art work have, in fact, the same subject. Therein, however, lies the myth. A scholar's subject is not the object (the art work) *per se*, but rather the questions he or she asks about it, and these questions are in great part determined by his or her frame of reference.

Taking Sesshū as an example, scholars of Japanese painting history and those of Chinese painting history consider his work from quite different perspectives. A specialist in Chinese art is apt to emphasize comparisons with works of the painter purported to have been Sesshū's teacher in China, Li Zai 李在 (act. 1425–1470). This to which a scholar of Japanese painting, like myself, would counter, "But Sesshū's art far transcends Li Zai's influence." Because we are studying the same body of work, there is a tendency to think that we hold different opinions about the same subject. In fact, however, our subjects are different; that is, we have asked different questions about Sesshū and Li Zai, because our frames of reference to them differ. I shall discuss this matter of diversity of subjects in terms of Sesshū's *Winter Landscape* (one of the paintings from his *Autumn and Winter Landscapes* [*Shūtō sansuizu* 秋冬山水図]) and his *Long Landscape Handscroll* (*Sansui chōkan* 山水長卷).

I have no interest in rehashing the old arguments about the originality of Japanese art versus the importance of Chinese influence. Rather, I seek to suggest how relative is the easily applied term "national identity," mentioned by Ebine Toshio 海老根聰郎 in his comments. Nor do I cleave to the illusion of a unitary "East Asian viewpoint." I intend the phrase "in light of comparative culture theory" found in the title of my presentation to carry a dual meaning. First, since our subjects are not the artworks *per se* but the differing questions we ask about them, we can by no means arrive at a single conclusion. Second, those of us employing comparative culture theory are ourselves subjects of this theory.

I cannot claim a natural visceral understanding of Sesshū simply because both he and I are both Japanese. The culture of present-day Japan is very different from that of the nation five hundred years ago, or, it goes without saying, from that of China. Chinese culture has long been familiar to and revered by the Japanese, but that does not assure that Japanese understanding of it has ever been accurate. Research on cultural topics conducted over the last several decades has made us aware that our conclusions are inevitably molded by our questions, and our questions, in turn, are ineluctably contingent upon our diverse intellectual contexts.

Winter Landscape

Let us turn now to *Winter Landscape*, registered as a National Treasure in Japan and generally considered one of Sesshū's masterpieces (*Fig. 1*). Its remarkable composition has been described as resembling "a camera lens diaphragm," especially the large boulder depicted in the upper right. The verticals that create this boulder have drawn such comments as "[Sesshū] surpassed the discovery of the fundamental straight-line quality of nature."[1] Yet it is not only Sesshū's genius that informs this painting.

1. Kumagai Nobuo, *Sesshū Tōyō. Nihon bijutsu sōsho* (*Japanese Art Series*) (Tokyo: Tokyo University Press, 1958).

Analyzing this painting from three different perspectives will enhance our understanding of it. The first perspective may be called "brush style production" (*hitsuyō seisaku* 筆樣制作), a guideline widely accepted by Muromachi period painters, Sesshū included. The second explains the painting through "stylistic lineage" (*keitō hassei* 系統発生). This approach might be called "stylistic macro-history," for its outlook ranges over the entire corpus of East Asian painting. The third perspective, by contrast, looks at the creative individual (*ningen* 人間) known as Sesshū. The choices that Sesshū made among the diverse stylistic elements created the totality of *Winter Landscape*, though he did not, of course, originate those elements. What, then, did Sesshū include in that totality?

Brush Style Production and Comparative Culture Theory as Seen in *Winter Landscape*

Winter Landscape shows Sesshū working in the style of Xia Gui. We know this because Sesshū himself wrote "Xia Gui" on a fan-shaped painting that closely resembles *Winter Landscape* (*Fig. 2*). As is well known, Muromachi painters sought to paint in the style of such Southern Song Chinese artists of the twelfth and thirteenth centuries as Muqi 牧谿, Ma Yuan 馬遠, Xia Gui, and Liang Kai 梁楷, essentially some of the "top names" in the Japanese painting world of the day. However, they did not strive to make their pictures look exactly like Chinese paintings; instead, each arranged in his own way the elements of a Chinese brush style. Copybooks by Kanō Tsunenobu 狩野常信 (1636–1713), for example, reproduce Sesshū fan paintings that had been done in various Chinese modes. Tsunenobu wrote Sesshū's name within the fans and, in the margins, added the names of Sesshū's Chinese models, such as Xia Gui, Li Tang 李唐 (ca. 1070s–1150s), or Liang Kai. Sesshū's original pictures could have been used like a menu for a patron commissioning a painting. Sesshū could show a composition in the style, say, of Xia Gui and ask, "How about a work like this?" This "brush-style production" system was prevalent in Muromachi Japan, but we know that Li Zai in China used something like it as well. Three of his works, *Returning Home* (*Guiqu lai tu* 歸去來圖; a handscroll illustrating Tao Qian's 陶潛 [365–427] famous ode and now in the Liaoning Provincial Museum; *Fig. 3*) and two currently in the Chuzhou 楚州 Museum in Huai'an 淮安 that were excavated from the tomb of Wang Zhen 王鎭, indicate that Li Zai thought that he painted in the styles of such Song dynasty artists as Li Tang, Liang Kai, and Mi Fu 米芾 (1051–1107).

This brings us back to a point mentioned above. According to Toda Teisuke 戶田禎佑, referring to *Winter Landscape*, "It would not be a mistake to consider that Sesshū absorbed this [brush style] directly from Li Zai."[2] Ogawa Hiromitsu 小川裕充 described Sesshū's borrowings from Li Zai in even greater detail,[3] but we have just seen that Li Zai himself emulated the brush styles of former masters. From this, two questions follow: (1) Was "brush style pro-

2. Toda Teisuke, "Sesshū kenkyū ni kansuru ni, san no mondai (Two or Three Issues Related to Research on Sesshū)," *Nihon kaigashi no kenkyū* (*Research on Japanese Painting*) (Tokyo: Yoshikawa kōbunkan, 1988).

3. Ogawa Hiromistu, "Sesshū to Ajia no sōryo gaka (Sesshū and East Asian Priest-Painters)," *Kokka*, no. 1276 (Feb. 2002).

Shimao Arata

duction" in Japan a reflection of practices in Ming Chinese professional painting circles? and (2) Were Li Zai's and Sesshū's "brush style" borrowings essentially the same?

The point here, of course, is my original one: that our perspectives determine the questions we ask of the art work or the artist, and our questions in turn significantly determine our conclusions. Scholars of Chinese painting history tend to emphasize the transmission of brush styles and stylistic macro-history: "X" learned from "Y" (in this case, Li Zai from the styles of Guo Xi 郭熙 [ca. 1001–ca. 1090], Ma Yuan, and Xia Gui, who in turn also learned from the manner of Fan Kuan 范寬 [ca. 960–ca. 1030]). In other words, great masters of the past created the standards, and their successors adopted/adapted those standards, thus emphasizing continuity, if not virtual uniformity.

I, on the other hand, train my questions on the single painter-priest Sesshū and his world. Sesshū spent his youth in Kyoto, where artists and intelligentsia internalized an ideal image of China and its emphasis on and styles of brushwork. In 1464, he left Kyoto for the patronage of the Ōuchi *daimyō* 大内大名 and a studio in their castle town of Yamaguchi 山口 in far western Honshu. Between 1468 and 1469, under the auspices of the Ōuchi, he travelled to China, landing at Ningbo 寧波 and proceeding to Beijing, where he certainly saw paintings and probably met painters of the Ming court. Thus, in Kyoto, he was absorbed in an atmosphere in which an idealized China and Chinese painting values prevailed, while Yamaguchi afforded him another perspective on that world and its painting values, and in China he finally encountered current actualities.

All three of the perspectives cited above are applicable to a study of *Winter Landscape*, and the insights afforded by any one of them do not invalidate the conclusions derived from the other two. A world map showing a Mercator projection differs vastly from one of a polar projection, but each adds to our knowledge of world geography. Likewise, there is no single "map" of East Asian painting history.

Stylistic Macro-History and the Individual Painter as Exemplified in *Winter Landscape*

The *Fall and Winter Landscapes* are thought to be two scrolls remaining from a set of four seasonal landscapes.[4] This is probably correct, given that the above-mentioned book of copies by Kanō Tsunenobu contains four landscape paintings in the style of Xia Gui that seem to have been painted as seasonal images.

This work by Sesshū fits easily within the "stylistic macro-history," or a "bird's-eye view," of East Asian painting. Though it is a snowy landscape in the style of Xia Gui, we know that Xia Gui's snowy landscapes were in the manner of Fan Kuan, thanks to a comment in *Precious Mirror on Painting* (*Tuhui baojian* 圖繪寶鑑 by Xia Wenyan 夏文彥; 1365) that Xia Gui derived his snowy landscape techniques and style from Fan Kuan. We can imagine what Fan Kuan's snowy landscapes were like from works such as *Cold Forest and Snowy Scene* (*Xuejing hanlin tu* 雪景

4. Shimao Arata, "Sesshū Tōyō no kenkyū (3), (4). Shūtō sansuizu no jōhōgaku (1) (2) (Research on Sesshū Tōyō [3], [4]. Systematic Information on the *Autumn and Winter Landscapes* [parts 1 and 2])," *Bijutsu kenkyū*, nos. 372, 376 (March 1999 and March 2002).

寒林圖) today in the Tianjin Art Museum (*Fig. 4*). The brushwork conveying brittleness in the bare trees and the so-called "chrysanthemum-blossom dotting" (*juhua dian* 菊花點) used on the snowy mountains are particularly striking in this work. These two brushstroke types appear in many snowy landscapes, as if signifying that the latter are lineal descendants. Of these works in the Fan Kuan style, smaller-scale pictures significantly resemble Sesshū's *Winter Landscape*. For example, a painting attributed to Fan Kuan in the Museum of Fine Arts, Boston, shows a bare tree in the right foreground and snowy mountains beyond, with "chrysanthemum-blossom dotting" on the peaks (*Fig. 5*). At the base of the mountain are house roofs surrounded by a bamboo fence with boats at the water's edge and a figure with an umbrella walking in from the left. This set of motifs is standard in Fan Kuan-style snowy landscapes.

We can easily call to mind a roster of Chinese and Japanese paintings that are variants of this basic theme and composition. The snowy landscape in the style of Fan Kuan maintains a loose framework while also evolving into a number of variations. In Muromachi Japan, it was considered simply a Xia Gui style. Frequently, the bare trees were quoted from Liang Kai's snowy landscapes, which also can be traced back to Fan Kuan, but the Japanese of the day thought they derived from Xia Gui.

Sesshū's *Winter Landscape* can also be fitted within this larger "map" of snowy landscape images. We do not know exactly what kinds of paintings he was able to see in person, but we can reasonably surmise based on the snowy landscapes in the Kanō copybooks (*Fig. 6*). The majority of these images were credited to Xia Gui or artists related to him, and although to our eyes Figure 6 seems quite distant from Xia Gui's originals, such paintings would have been perceived in Sesshū's Japan as being by Xia Gui. Bare trees are shown in the foreground, a road stretches from them to the far side of the mountains, and buildings stand in front of the mountain. There is a figure on the road, and water can be glimpsed on both the right and left sides of the scene. The peak of the mountain is covered completely with formalized "chrysanthemum-blossom" dots. The resemblance to *Winter Landscape* by Sesshū is self-evident.

The large boulder painted in the upper right of *Winter Landscape*, however, does not appear in the other snowy landscapes. This kind of boulder precludes the use of "chrysanthemum-blossom" dots. Why did Sesshū put this kind of boulder in his painting? The comparative stylistic perspectives afford no answer to this question. Let us, therefore, consider the third perspective: Sesshū as an individual, as a painter-priest.

As noted earlier, this eye-catching boulder has been described as "discovering the fundamental straight-line quality of nature." Several boulders of this kind, edged by a straight line down from the top of the composition, are present in Sesshū's *Long Landscape Handscroll* (*Fig. 7*). This motif, however, was not exclusive to Sesshū; it can also be found in Chinese handscrolls in the style of Xia Gui. Sesshū, however, made the edge of the boulder itself vertical, and used this motif some six times in *Long Landscape Handscroll*—in various placements and for various purposes. Here, for example, it acts as a compositional turning point, but in Chinese landscape handscrolls the boulder motif is not used in the same way. This boulder was Sesshū's own device placed in his own way in an otherwise

Shimao Arata

Xia Gui-style landscape scroll. For Sesshū, *Long Landscape Handscroll* was the summation of his own Xia Gui-style landscape, painted for presentation to his patron, Ōuchi Masahiro 大内政弘, and this boulder, which appears repeatedly there, was Sesshū's own consolidation of the Xia Gui style—a Xia Gui-style handscroll boulder inserted into a Xia Gui-style hanging scroll. Doing this was simple enough, but no one else had thought to do it before. Nor, once Sesshū had created this composition, were other Japanese painters successful in using it. The boulder in *Landscape* by Shōkō 承虎 (dates unknown), for example, seems somehow pasted into the composition (*Fig. 8*), and even in the Sesshū-style landscapes created by Edo-period Kanō-school painters, similar boulders do not seem to fit properly with the other elements of the composition. It can further be seen as symptomatic that Sesshū's own faithful student, Josui Sōen 如水宗淵, did not use this kind of boulder motif.

As most art historians are aware, neither stylistic macro-history nor brush-style filiation, alone or in tandem, can get to the heart of a painting or an oeuvre. These are phylogenetic approaches, which produce useful schemata. A specific prototype is posited for a given painting, and then a tree-like expanse of variants branches out from this prototype. However, in these schemata the individual artist is lost, becoming simply a label stuck onto the painting. The phylogenetic approaches can help us to decide what questions to pose about *Winter Landscape*, but by themselves they cannot elucidate its unique features.

Long Landscape Handscroll and Ming Period Landscape Handscrolls in the Style of Xia Gui

Whereas *Winter Landscape* is an unusual work, *Long Landscape Handscroll* can be discussed in slightly more general terms (*Fig. 9*). Many similar scrolls, sharing numerous reminiscent passages, remain in both Japan and in China. *Long Landscape Handscroll* has been frequently compared to the National Palace Museum's *Clear and Distant Views over Streams and Mountains* (*Xishan qingyuan tu* 溪山清遠圖) handscroll attributed to Xia Gui. With the introduction in recent years of a number of Ming dynasty landscape handscrolls in the Xia Gui style, we have a better idea of which works actually served Japanese painters as their models. One such work, *Landscape* (*Shanshui* 山水; *Fig. 10*) in the Guangzhou City Art Museum and attributed to Dai Jin 戴進 (1388–1462), is clearly a Zhe school interpretation of a Xia Gui composition. One could note, for example, the coloration and motifs. *Clear and Distant Views over Streams and Mountains* is painted in monochrome ink, whereas *Long Landscape Handscroll* includes considerable color. The work attributed to Dai Jin uses color, particularly a strong blue on the boulders, which is also seen in Sesshū's *Long Landscape Handscroll*. *Landscape Handscroll* (*Sansui zukan* 山水図卷) attributed to Oguri Sōtan 小栗宗丹 (1413–1481) also uses considerable color, with the same striking blue on the boulders (*Fig. 11*).

Landscape Handscroll attributed to Dai Jin, which Sesshū is said to have copied believing it to be a copy of a Xia Gui, is in fact faithful to Xia Gui's composition and brush manner. At the same time, it is also strongly colored, as is Sesshū's *Long Landscape Scroll*. The same motifs also appear in another Sesshū handscroll said to have been

copied directly after a Xia Gui work as well as in a handscroll by Isshi Kii 一枝希維. Isshi Kii's work was painted in Japan and then taken to China by someone on a mission to the Ming court, where it was immediately recognized as "in the style of Xia Gui." The scene at the beginning of this scroll closely resembles scenes in Sesshū's *Short Landscape Handscroll* (*Sansui shōkan* 山水小卷) in the Kyoto National Museum as well as in the above-mentioned *Landscape Handscroll* by Oguri Sōtan. A similar scene also appears in *Landscape Handscroll* by Gei'ai 芸愛 of a slightly later period.

All these works and more are closely similar in style and coloration, and all proceeded from the same source, the landscape handscrolls in the Xia Gui style which artists in the Jiangnan 江南 region in China continued to paint. Many examples of this type of Jiangnan landscape handscroll are extant, and it is not improbable that a number of them came to Japan. Conversely, Song dynasty works such as *Clear and Distant Views over Streams and Mountains* were rare even in Sesshū's day, and surely they would not have been commonly known among Japanese painters. Very few Japanese could have seen Xia Gui landscapes such as the one now in the Hatakeyama 畠山 Museum or *Riverside Town* (*Kōjōzu* 江城圖), the whereabouts of which is unknown. Painters such as Geiami 芸阿弥 (1431–1485), who was in charge of the Ashikaga 足利 shogunate's painting collection, painted Xia Gui-style works, but with considerable color, in contrast to Xia Gui's handscrolls painted only in ink. Only one work by Geiami remains, but he, his pupil Kenkō Shōkei 賢江祥啓 (act. ca. 1478–ca. 1506), and his contemporary Kanō Masanobu 狩野正信 (1434–1530) all shared the characteristic use of color. Paintings such as the handscroll attributed to Oguri Sōtan were probably intermediaries between the Xia Gui style and these later Japanese works. Compared with the somewhat naturalistic appearance of Chinese handscrolls, the Japanese works seem more artful and refined, reflecting the "idealized China" then current among Kyoto intelligentsia.

Conversely, it was the naturalism of Chinese handscrolls which appealed to Sesshū. For example, a source for the zigzagging base of the boulder near the end of *Long Landscape Handscroll* appears in Li Zai's *Returning Home* (see *Fig. 3*). We can see the difference between the way that Geiami in Kyoto interpreted the works he saw and the way Sesshū in Yamaguchi interpreted them. Leaving aside for the moment the special circumstances of Sesshū in Yamaguchi in 1486, we could easily discuss *Long Landscape Handscroll* in terms of its place within a phylogeny of Xia Gui-style landscape handscrolls.[5]

Conclusion: The Molecular Model of a "Work of Art"

Following Ichikawa Hiroshi 市川浩, who asserts that art works are "complex bodies,"[6] I propose that a particular artist (Sesshū) or a particular work (*Winter Landscape*) is perhaps best compared with an atom—an intricate molec-

5. Shimao Arata, *Sesshū no sansui chōkan* (Sesshū's *Long Landscape Handscroll*) (Tokyo: Shōgakukan, 2001).

6. Ichikawa Hiroshi, *'Mi' no kōzō: shintairon o koete* (*The Structure of 'Mi' [Mi Fei Style]: Beyond Body Theory*) (Tokyo: Seidosha, 1985).

Shimao Arata

ular structure of which is formed by the interaction of hundreds of elementary particles, such as electrons, protons, neutrons, and transient mesons. If an atom represents the person known as Sesshū, it was conditioned by the environment in which he was born and moved, the places he passed through (Kyoto, Ningbo, Yamaguchi), the paintings and landscapes he saw, the artists he met (Li Zai), and the styles he studied (Xia Gui).

Since it is difficult to describe molecular structures in words, we find it necessary to use drawings or designs of atoms and molecules in our explanations (*Fig. 12*). Pictures, too, convey things that are not expressible in words, for owing to the linear nature of language, there is no way to capture the essential experience of a fine painting. Works of art are so complex that it is almost impossible to understand them as integral items. Art works—the end products of human intention—are subject to various interpretations, from the circumstances of their production to their symbolic meanings in different social circles and at different times. To define an art work comprehensively is as impossible as to describe a friend's face in a way that differentiates it from billions of other faces. Furthermore, art works come to us enveloped in their past contexts and in discourses about them. We never perceive the work truly by itself, bare of all accretions. We can only express parts of the whole.

Our words describing a work of art arise from the relationship of the "object" (*taishō* 対象) and "speaker" (*katarumono* 語る者). When we ignore this fact, our assertions become false and filled with peril. It is the art work that remains the still center of the flood of diverse discourses, the hub that connects the verbal spokes which radiate outward, each in a different direction.

雪舟的夏珪風山水圖—
爲思考「比較文化論」而作

島尾新

多摩美術大學

　　我以爲特定的畫家（雪舟）或特定的作品（《冬景山水圖》）或可比擬作原子，因其耐人尋味的分子結構是由數以百計的基本微粒，如電子、質子、中子、介子等彼此的交互作用所組成；這種複雜性，好比市川浩先生所謂作品是「錯綜體」的看法。如果原子代表的是雪舟，則他便會爲其出生與活動的環境所制約：如他所經過的地方（京都、寧波、山口）、他曾披閱的畫作、他所遇到的其他藝術家（李在）、以及他所學習的風格（夏珪）等。

　　因爲分子模型難以言傳，故有必要畫出原子與分子圖來解釋（圖12）。同理，由於語言具有線型敘述的性質，自無法完全捕捉畫作的精華意蘊。藝術作品如此錯綜複雜，以至於我們不可能以一個完整的整體來理解它。藝術作品—即人類意念的終極產品—遂能以各種不同的方向詮釋，從製作的情境，到其於不同社群或不同時代的象徵意義等。要徹底地定義一件藝術品，就好像要用言語道出某個朋友的臉如何與其他千百萬張臉不同一般，都是不可能的任務。再者，藝術品本身亦爲其過去的脈絡與論述所包裹，我們根本很難感知到重重建構底下的眞實本體。我們只能道出其中的一部分。

　　用以描述藝術作品的字眼，來自於「對象」與「敘述者」的關係；若忽略這層關係，我們的主張便會有誤並充滿漏洞。藝術作品永遠是各種滔滔論述的中心，也是文字語言自各方輻射而出的軸心。

雪舟の夏珪風山水図—
「比較文化論」を考えるために

島尾新

多摩美術大学

　美術史研究は拡散状況にあるように思う。次々に装いを変えて現れる理論と手法。美術史の語りも、実際に作品を見ることもなく書き上げられた論文から、顕微鏡で覗かなければ分からないような分析にまで広がっている。

　そのような状況に対して、様々な場で活躍する研究者たちは、どのように思っているのか？それが知りたくて、この発表では「比較文化論にただ一つの結論などない」という、やや極端な議論を投げかけてみることにした。具体的には、雪舟による二つの夏珪風の作品、「秋冬山水図」の冬景と「山水長巻」を対象とし、前者については筆様制作・大きな様式史・画家個人の三つ、後者については明時代と室町時代の夏珪風山水図巻というコンテクストから考察した。示したかったのは、私の結論の正しさではなく、コンテクストと呼ばれるものが、対象の置かれた歴史的状況であると同時に、論じる側の描く図式でもあること。それらは対象となる作品に複雑に交錯しており、また描き出される比較文化の「地図」は視座の取り方によって異なってくることだ。そして様々に「作品」を切り取る語りは、果たして相互補完的に調和的な全体をかたちづくっているのだろうか？

　そもそもが複雑な存在である「作品」を、私は分子モデル（あるいはＤＮＡモデルの一部）のようにイメージしている。それを総体としてすっきりと語り得るというのは幻想であり、私たちができるのはその一面を切り取ることにすぎない。そんな「作品」の姿は、様々な視点と理論にもとづいて産み出された言説に纏わりつかれて、更に見えづらいものになっている。しかし、そこが美術史研究の営為の結びつく場であることも間違いはない。そろそろ「作品とはなにか？」という素朴な問いに、もういちど向かい合わねばならないのだろう。

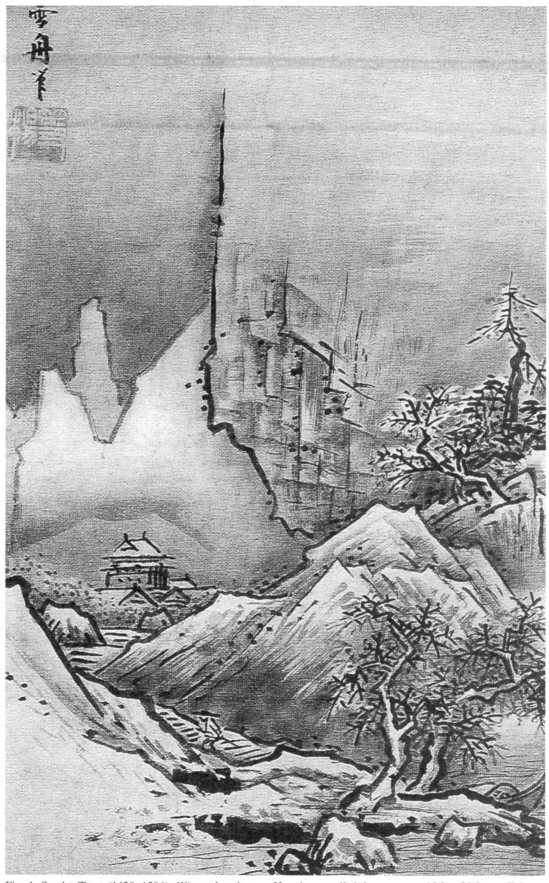

Fig. 1. Sesshū Tōyō (1420–1506). *Winter Landscape*. Hanging scroll, ink on paper, 46.3 × 29.3 cm. Tokyo National Museum. *(detail on page 113)*

Shimao Arata

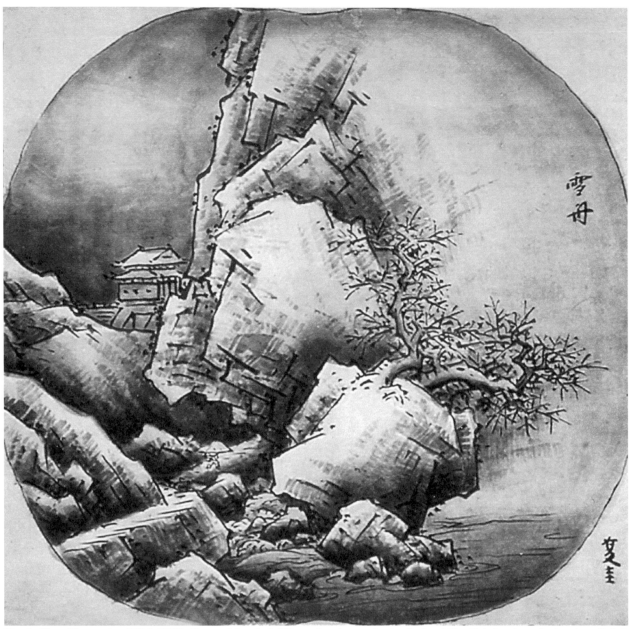

Fig. 2. Kanō Tsunenobu (1636–1713). *Copy of Sesshū's Winter Landscape in the Style of Xia Gui.* Section of a handscroll, ink and colors on paper, 30.0 × 392.5 cm (entire scroll). Tokyo National Museum. *(detail on page 49)*

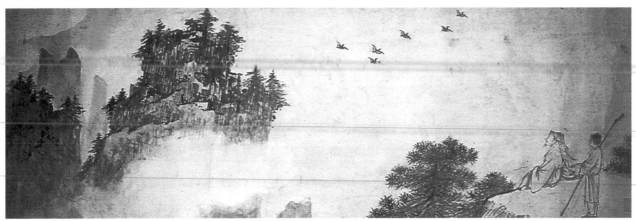

Fig. 3. Li Zai (act. 1425–1470), Ma Shi (act. 1424–1435), Xia Zhi (act. 15th c.). *Returning Home*, dated 1424. Handscroll, ink and light colors on paper, 27.7 × 736.0 cm. Liaoning Provincial Museum.

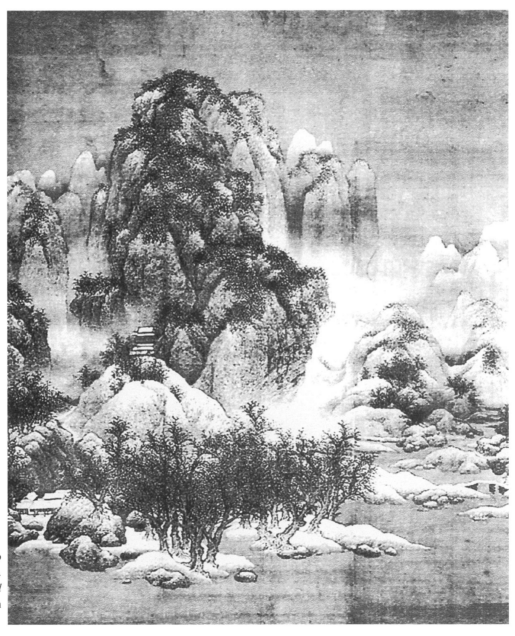

Fig. 4. Attributed to Fan Kuan (ca. 960–ca. 1030). *Cold Forest and Snowy Scene*. Tianjin Art Museum.

Shimao Arata

Fig. 5. Attributed to Fan Kuan (ca. 960–ca. 1030). *Snowy Landscape*. Museum of Fine Arts, Boston.

Fig. 6. Kanō school artist. *Copy of a Snowy Landscape Attributed to Xia Gui*. Tokyo National Museum.

Fig. 7. Sesshū Tōyō (1420–1506). *Long Landscape Handscroll*, dated 1486. Section of a handscroll, ink on paper, 40 × 1585 cm. Mōri Museum, Yamaguchi Prefecture.

Fig. 8. Shōkō (dates unknown). *Land-scape*. Okayama Prefectural Museum.

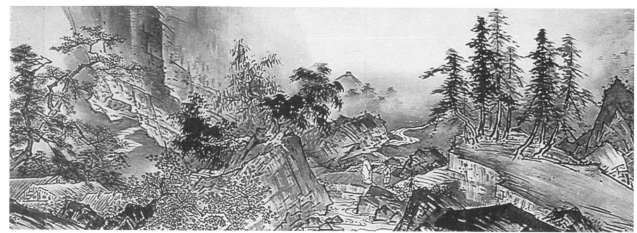

Fig. 9. Sesshū Tōyō, section of *Long Landscape Handscroll*.

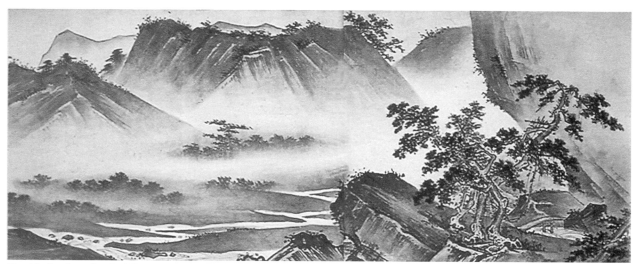

Fig. 10. Attributed to Dai Jin (1388–1462). *Landscape*. Ink and light color on paper. Guangzhou City Art Museum.

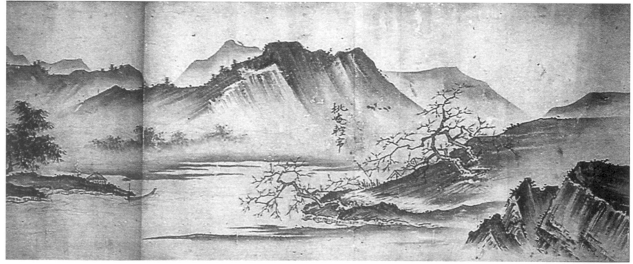

Fig. 11. Attributed to Oguri Sōtan (1413–1481). *Landscape Handscroll*. Ink and light color on paper. Private collection.

Fig. 12. Conjectural models of molecules (left) and of DNA (right).

Shimao Arata

Classic and Colloquial Urban Views:
Yosa Buson's Houses on a Snowy Night

Satō Yasuhiro

University of Tokyo

The Edo period in Japan may be roughly divided into early, middle, and late phases, which roughly correspond to the seventeenth, eighteenth, and nineteenth centuries. The eighteenth century saw the creation of a particularly fascinating and diverse array of paintings and woodblock prints. What was the character of this period? Some scholars of Japanese literature consider that Edo culture included both the "refined" (*ga* 雅) and the "vulgar" (*zoku* 俗), terms that match with the "classical" and the "colloquial," respectively.[1] In the Edo period, the classical referred to traditional culture, while the colloquial designated newly emergent cultural forms. For example, in the theatrical arts, Nō 能 was considered classical, and Kabuki 歌舞伎 as colloquial. In literature, *kanshi* 漢詩 and *waka* 和歌 forms were classical, whereas *haikai* 俳諧 (or *haiku* 俳句) and *gesaku* 戯作 were colloquial. Such distinctions not only differentiated genres but also works within a single genre, with works that tended toward the traditional being considered "classical," while the more innovative were "colloquial."

Edo cultural history can be generally described in terms of the changing relative acclaim and prominence accorded to the classical and the colloquial; they always coexisted, at times mingled or even merged, and in later periods the colloquial became more prevalent than the classical. The mid-Edo period was a point of intersection. Dynamic interactions took place and new art was formed at the points of tension where the classical and the colloquial expanded and met. A variety of new types of painting—i.e., not traditional Kanō 狩野 style—appeared. These presented a new reality, one in which the classical and the colloquial fused and were cross-fertilized. A good example of mid-Edo cultural fusion of the classical and the colloquial is the painting *Houses on a Snowy Night* (*Yashoku rōdaizu* 夜色楼台図; *Fig. 1*) by Yosa Buson 与謝蕪村 (1716–1783), here referred to as *Snowy Night*, which was painted in his later years. Buson, one of the representative artists of this period, was also a superb poet in both *haikai* and free-verse forms. We do not know who this work was painted for, or its provenance prior to entering the collection of its current owners, the Mutō 武藤 family of Hyōgo 兵庫 Prefecture, and thus we can only focus on the painting itself.

1. Two books discussing the classical and the colloquial are Nakamura Yukihiko, *Gesakuron* (*A Theory Concerning Popular Stories*) (Tokyo: Kadokawa shoten, 1966), repr. in *Nakamura Yukihiko chojutsushū* (*Collected Works of Nakamura Yukihiko*), vol. 8 (Tokyo: Chūō kōronsha, 1982); and Nakano Mitsutoshi, *Jūhasseiki no Edo bungei* (*Art and Literature of Eighteenth-Century Japan*) (Tokyo: Iwanami shoten, 1999).

Snowy Night is unique within the many idioms of East Asian landscape painting. Done on a single sheet of paper and measuring 28.0 centimeters high by 129.5 centimeters long, it is too wide for a hanging scroll. Whereas the positioning of the title and the painting suggest a handscroll, it is in fact quite short for this format. In other words, the format falls betwixt and between. It is mostly painted in ink, but with effective use of light color. Furthermore, Buson idealized the lifestyle of the Chinese literati, but was himself a professional painter with continual financial problems.

Also most unusual is the subject of the painting. It is not an anonymous or generic mountain landscape, but rather, presumably, a snowy night scene in Kyoto. This assumption is impossible to prove but highly probable. Because Buson's late name "Sha'in 謝寅" appears in the signature, *Snowy Night* was created sometime after 1778. Buson was then a resident of Kyoto and would have been extremely familiar with the layered rooftops of the city. Likely the painting depicts a section of the Higashiyama 東山 hills, which are described in a famous line of verse by Hattori Ransetsu 服部嵐雪 (1654–1707), a poetry disciple of Matsuo Bashō 松尾芭蕉 (1644–1694). The line, "*Futon kite netaru sugata ya Higashiyama* 布団着て寝たる姿や東山," can be loosely as translated: "Like the shape of someone sleeping under a *futon*—the Higashiyama hills." Buson knew the line and actually referred to it in a verse of his own.[2] In the painting, the Higashiyama hills of Kyoto are shown as undulant forms, indeed like a side view of someone asleep beneath a *futon*.

Before the painting was begun, the surface of the entire piece of paper was coated with powdered shell (*gofun* 古粉). Over that shell white, ink was applied, in some places in multiple coats to create varying darkness, which in turn was here and there dotted with lighter ink in the *tarashikomi* 溜込 puddling method. The resulting extremely complex range of ink tonalities conveys the sense of a night sky heavy with snow-laden clouds. *Gofun* has been scattered liberally across the right edge of the composition, densely in the center portion, and lightly sprinkled over the left side, giving a sense of snowfall.[3] The lines that define the mountain ridges, drawn with quick strokes, irregularly thicken and thin. The straight lines of the rooftops are aligned in echelon at the right and left, creating a "V" shape. At the right, the density of straight rooflines forms strong horizon lines that contrast with the heavy, still weight of the snowy sky. On the left, where the hill rises, the rooflines are curved and disarrayed, and the houses close to the hills are covered with particularly heavy snow. Shell-white pigment brushed onto the roofs indicates their snow

2. In 1775 Buson wrote a poem for the *haiku* poet Itton, who had decided to live at the foot of Higashiyama, that reads as follows: "*Ransetsu to futon hikiau wabine kana* 嵐雪と布団引き合う侘びねかな (You and Ransetsu will be tugging at the same *futon*)." This poem can be interpreted to mean that Itton has decided to live humbly and modestly while refining his taste to make it surpass that of Ransetsu. It is recorded as no. 1318 in Ogata Tsutomu and Morita Ran, ed., *Buson zenshū (Complete Works of Buson)* (Tokyo: Kōdansha, 1992), vol. 1, p. 294.

3. That the entire ground of *Snowy Night* is coated with shell white was first pointed out by Hayakawa Monta in his commentary in the exhibition catalogue *Masterpieces of Yosa Buson* (Nara: Museum Yamato Bunkakan, 1983), p. 92. See also Hayakawa, *Yashoku rōdaizu*, in *E wa kataru (Painting Talks)*, vol. 12 (Tokyo: Heibonsha, 1994), pp. 6–7. The techniques of layered ink and scattered shell-white pigment were probably learned from painters of the Nanpin 南蘋 school. See Satō Yasuhiro, "Jagyoku Sanjin no koto (About Jagyoku Sanjin)," *Kokka* 1085 (1985), pp. 36–37.

cover. Light in the windows and reflected from the walls of the houses is shown in red ochre. To indicate that the lamplight is quite dim, the lightest wash of ink was brushed over the red ochre. But however dim it may be, the light bespeaks of people sheltered in their homes amidst the dark night. *Snowy Night* is a painting that directly appeals to people today. Many questions, however, remain unanswered, such as what layers of imagery gave birth to this painting, and in what aspects the painting was new. I shall attempt to address such questions by discussing concepts of the classical and the colloquial as well as urban scenes.

The Intersection of the Classical and the Colloquial

Snowy Night is a work in which the aforementioned qualities of the classical and the colloquial intersect. The verse written as a title on the right side of the painting can be rendered as "*Yashoku rōdai / banka ni yuki furu* 夜色楼台一万家に雪ふる," which may be loosely translated as "Night colors veiling the pavilion, snow falling on ten thousand houses." Earlier scholarship has indicated that this verse was based on *kanshi* poems by the Edo Zen priest Ban'an Genshi 萬庵原資 (1666–1739).[4] Buson's verse takes a line each from two poems published in Ban'an's anthology, *Collection of Kōryō* (*Kōryōshū* 江陵集; published in 1745) and combines them for his title. One of the two Ban'an poems, about an autumn night, contains the phrase, "*Yashoku rōdai shobutsu no za* 夜色楼台諸仏の座," which literally translates as "Night colors veiling the pavilions, seats of numerous buddhas." The other is entitled "*Tōzan ni asobite rakka wo eizu* 東山に遊びて落花を詠ず" and translates as "Playing in the eastern hills, eulogizing the falling cherry blossoms." One line in this poem reads, "*Kojō no rōdai setsu banka* 湖上の楼台雪万家," which means, "Pavilion above the lake, snow falling on ten thousand houses." The "eastern hills" referred to in Ban'an's poem are not the Higashiyama of Kyoto, but rather the hills in the Ueno 上野 area of Edo, site of Tōeizan Kan'eiji 東叡山寛永寺. Even today, Ueno is famous for its cherry blossoms. This poem likens the falling cherry blossoms to snowfall. In short, Buson created the title for a winter painting by combining elements from an autumn verse with those of one for spring.

Ban'an was a poet of the Kobunji 古文辞 school, originally a Ming-Chinese literary movement (its name translating loosely as "ancient writing") that rejected stylistic elaboration and flowery diction while advocating the simpler and vigorous style of the Classics. An important Edo period Confucian scholar and litterateur, Ogyū Sorai 荻生徂徠 (1666–1728), taught the aesthetics of this school, and the Kobunji style of poetry was extremely popular amongst mid-Edo poets writing in Chinese. Poetry of the Kobunji school carefully imitated that of the High Tang (mid-eighth century), from phrasing down to rhyme schemes. In the latter half of the eighteenth century, however, the Kobunji poetic method was criticized as a form of plagiarism and then discarded, but it was nonetheless an im-

4. Shimizu Takayuki, "Kanshijin Buson (Buson as a Poet in Chinese)," *Haiku* 24 (nos. 11 and 12; 1975), pp. 176–77 of no. 11; Yoshizawa Chū, "Yosa Buson hitsu *Yashoku rōdaizu* ni tsuite (*Houses on a Snowy Night* by Yosa Buson)," *Kokka* 1026 (1979), pp. 9–11.

Satō Yasuhiro

portant element in the history of literature. For example, Ban'an's spring poem refers to cherry blossoms at Ueno, a Japanese urban scene, which the pre-Kobunji poems did not take as a motif. The other poets of the Kobunji school favored motifs of love and eroticism, revelry, and the vivid joys of urban lifestyles.[5] *Kanshi*, or "poetry in Chinese," belonged to the "classical" mode of culture. Although the Kobunji school emphasized elegance of form, in content it tended toward colloquial forms of actual life.

Ban'an's close friend was the famous *kanshi* poet Hattori Nankaku 服部南郭 (1683–1759). Buson spent his youth in Edo and might have even attended Nankaku's lectures. On his paintings, Buson quotes the poems of both Nankaku and Ban'an, and scholars of literature have demonstrated that many of Buson's own poems derive from thoughts and expressions similar to those in contemporary *kanshi*.[6] Since the poems of the Kobunji school were extremely familiar to Buson, commonalities between Kobunji poetic composition and the *Snowy Night* painting are not surprising. Both Sorai and Nankaku created poems that used types of Chinese classical verse to render scenes of Edo as ancient "classical" landscapes. Both of them also wrote poems extolling the cherry blossoms of contemporary Ueno, but likening the scattered blossoms to falling snow, which was an eminently classical trope.[7] Ban'an's verses, from which Buson quarried the title for *Snowy Night*, resemble those earlier examples. Thus, the title poem of *Snowy Night* derives from the Kobunji school's juncture of classical form and colloquial content.

What is the prime requisite in *haikai* and the most difficult to achieve? It was, Buson wrote in 1777, to "distance oneself from the colloquial, all the while using the colloquial."[8] *Snowy Night* exemplifies in painting this method of distancing from the colloquial while using it at the same time. The subject depicted is Kyoto, where Buson lived. The word *rōdai* 楼台, used in Ban'an's verse to connote a Buddhist temple, in Buson's title reverts to its original meaning, that of "pavilion." In *Snowy Night*, the pavilion is a rather noticeable two-story building, with a second-story window in which one could hang a lantern. Let us consider what sort of establishment that pavilion might be. Buson painted plum blossoms on *fusuma* 襖 (interior sliding screens) for the Sumiya 角屋 (*Fig. 2*), an *ageya* 揚屋 famous for its elegance in Kyoto's Shimabara 島原 district.[9] These *fusuma* paintings are inscribed, "*Keika rōjō ni oite utsusu* 京華楼上に於いて写す," which means, "Painted at the top of the pavilion of the flowering capital, Kyoto." Buson enjoyed the entertainment district and was a frequent and well-known patron of teahouses and restaurants—so fre-

5. Hino Tatsuo, *Soraigaku-ha* (*The Sorai School*) (Tokyo: Chikuma Shobō, 1975), pp. 51–75, 85–95.

6. See Shimizu, "Kanshijin Buson"; Hino Tatsuo, "Buson to kanshidan (Buson and the Circle of Poets in Chinese)," *Bungaku* 52 (no. 10: 1984), pp. 53–61; and Morita Ran, "Kanagaki no shijin Buson no haikaisei (*Haikai* Taste in Buson, Who Wrote Chinese Poetry in Japanese Characters)," *Bungaku* 52 (no. 10: 1984), pp. 109–18.

7. Hino, *Soraigaku-ha*, pp. 27–28, 85.

8. In Japanese, the passage reads, "*Zoku wo hanarete zoku o mochiru kotoda* 俗を離れて俗を用いることだ." See Buson, "Shundei Kushū no jo (Preface to the Collection of Haiku by Shundeisha Shōha)," in *Buson zenshū* (*Collected Works of Buson*), ed. Ogata Tsutomu and Yamashita Kazumi (Tokyo: Kōdansha, 1994), vol. 4, pp. 171–74.

9. *Ageya*, conventionally translated as "teahouses," were a combination of elegant restaurant and house of assignation, where clients would be entertained by courtesans and geisha

quent as to earn a reproof from Higuchi Dōryū 樋口道立 (1738–1812), a Confucian scholar who was his student of *haikai*.[10] Many teahouses also bore names ending in *rō*, such as Setsurō 雪楼 ("Snow Pavilion"). Therefore, the *rōdai* in the title of Buson's painting probably refers to an *ageya*.[11] The form we can see in the window of the eye-catching two-story building might be Buson himself, relaxing in such a "pavilion." Possibly Buson even created this work for such an establishment. Given the frequency of *rō* appearing in teahouse names and of Buson's patronage at teahouses, we can reasonably identify *Snowy Night* as a representation of Buson's real, colloquial world.

The theme of the painting itself, snow falling at night over a town, was new; it does not appear in any earlier surviving paintings. Both Chinese and Japanese painting, however, had long included the representation of snowy scenes and night scenes. But both together, and combined with a town scene—in other words, a night snowfall over a town—is unlikely to have been painted before *Snowy Night*. Though Buson's theme is realistic, the painting itself has none of the colloquial feel found in *ukiyo-e* 浮世絵 prints of the "floating world," with their detailed informative depictions. Buson's source of inspiration was the classical culture embodied in Ban'an's Chinese poems. Buson, in embedding contemporary Kyoto within two established tropes of classical culture, was transferring into painting the poetics of the Kobunji school, and in so doing made his townscape acceptable as a landscape. Conversely, one might describe the work as a refined landscape painting that conveys the actual feeling of town life. Classical and colloquial, traditional imagery merged with a depiction of the real and contemporary, this work thus exudes a quite unexpected fascination.

Snowy Night as an Urban Scene

Let us consider in detail the intersection of the classical and the colloquial in *Snowy Night* viewed as a town-scape. A number of prints showing overviews of the city of Kyoto had been published not many years before Buson painted *Snowy Night*. For example, in the 1750s, Maruyama Ōkyo 円山応挙 (1733–1795) created a series of *me-gane-e* 眼鏡絵 (literally, "eyeglass picture") prints composed with assertive linear perspective so as to appear three-dimensional when viewed through an optical device. Included in that series are prints such as *Shijō Riverbank Scene* and *Maruyama Zashiki*, both in the Kobe 神戸 City Museum, which show rows of houses set against a low line of hills. Like *Snowy Night*, these works convey a sense of gazing out over Kyoto. Furthermore, in the print *Uki-e: Perspective View of Kyoto* (*Ukie Kyōjūichimoku saiken no zu* うきゑ京中一目細見の図; *Fig. 3*), thought to have been

10. Teahouses named Sangetsurō, Kikurō and Setsurō appear in the letters of Buson. For Dōryū's reproof, see the letter from Buson to Dōryū in 1780 in *Buson shokan-shū* 蕪村書簡集 (*Collected Letters of Buson*), ed. Ōtani Tokuzō and Fujita Shin' ichi (Tokyo: Iwanami shoten, 1992), pp. 288–90; the letter is recorded as no. 118.

11. That *rōdai* might refer to a teahouse first occurred to the author when in 1982, as a research officer with the Bunkachō (Agency for Cultural Affairs), I studied the Sumiya screens. That insight preceded Yamamoto Kenkichi's essay "Buson no e to haikai (Buson's Painting and *Haikai* Taste)," in which he suggested that the word *rōdai* in *Snowy Night* referred to brothels (*seirō*). See Yamamoto Kenkichi and Hayakawa Monta, *Buson gafu* (*Buson's Paintings*) (Tokyo: Mainichi shinbunsha, 1984), pp. 6–7.

Satō Yasuhiro

published about 1769,[12] the Higashiyama hills are in the foreground, the Nishiyama 西山 hills in the background, and the city of Kyoto seen between from a bird's-eye view. Buson shared that bird's-eye vision of Kyoto, and he voiced it explicitly in a poem of 1771 that reads, "Cuckoo, cutting across Heian City (*Hototogisu Heianjō o sujikai ni* ほとゝぎす平安城を筋違に)."[13] The poem evokes the stationary rectangular grid of Kyoto's streets, intersected by the swift-moving diagonal of the bird's flight, all of which one sees panoramically from a point higher than that of the bird. The flight of the bird, unfettered by the constructs of a town, actually deepens our impression of the urban forms.

The composition of *Snowy Night*, however, is not based on that of perspective prints of the period, or on the kind of bird's-eye view discussed in Buson's poem above. Those kinds of expression were a bit too new and a bit too colloquial; they would have been thought to lower the tone of the picture. In fact, *Snowy Night* is unexpectedly traditional in composition. This kind of composition in Japanese painting, a range of mountains in the background fronted by densely packed house roofs, occurs in works of the Muromachi period attributed to Sesshū Tōyō 雪舟等揚 (1420–1506). Among copies of Sesshū's images of Chinese landscapes, based on his travels there, is a scene of Zhenjiang 鎮江 in Jiangsu Province (*Fig. 4*), which might have been the model for Buson's painting. A painting of Tōfukuji 東福寺 (*Fig. 5*), which is not a genuine work of Sesshū but thought to have some relationship to him, depicts the Higashiyama hills of Kyoto beyond a row of buildings—and in that respect, it resembles Buson's painting. Although we have no unequivocal evidence that Buson knew of these works, he may have known Sesshū's Chinese images from all manner of copies, and he would have had many opportunities to see the above-mentioned *Scene of Tōfukuji* (*Tōfukuji garanzu* 東福寺伽藍図), which was sometimes displayed at that temple. Thus, *Snowy Night* reflects one aspect of the rediscovery and revival of Sesshū-style "true-view picture" (*shinkeizu* 眞景図) type of scenery, which had not been seriously attempted since the Muromachi period.

We can hypothesize a motive or inspiration for this revival. Buson might have seen paintings of actual sites or cityscapes that had been produced in late Ming dynasty Suzhou. The handscroll *Elegant View of the Southern Part of the City* (*Chengnan yayi tu* 城南雅逸圖; *Fig. 6*), created in 1588 by the minor Suzhou artist Qian Gong 錢貢 (act. 1572–1620), shows a row of houses backed by a range of mountains. Buson left three paintings, at the very least, based on Qian Gong's works.[14] He is also thought to have given one of them, *Landscape in the Manner of Qian Gong* (*Hō Senkō sansuizu* 仿錢貢山水圖; *Fig. 7*), to Kan Bogyū 菅暮牛, a *haikai* poet, after creating it at the latter's

12. For the date of publication, see Kishi Fumikazu, "Kikuya-ban *Ukie kyoju ichimoku saiken no zu* ni tsuite—hajimete no 'toshi chōkanzu' (*Ukie: Perspective View of Kyoto*—The Earliest Bird's-Eye Cartograph of a City)," *Kokka* 1214 (1997), pp. 6–10.

13. Ogata and Morita, eds., *Buson zenshū*, vol. 1, p. 194, no. 867.

14. See Ogata Tsutomu, Sasaki Jōhei, and Okada Akiko, eds., *Buson zenshū* (Tokyo: Kodansha, 1998), vol. 6, nos. 105, 191, and 343. Nos. 102 and 524 in the same volume bear inscriptions that refer to Qian Gong, but the works may be copies or forgeries.

home in Kotohira 琴平 on Shikoku.[15] The painting is thought to depict an idealized view of Bogyū and his home. In other words, acquaintance with paintings by Qian Gong inspired Buson to emulate the very subject matter then popular in Suzhou—one's friend together with his house. Therefore, we may plausibly surmise that Buson also had Qian Gong's cityscapes available to him. Moreover, such urban scenes were by no means exclusive to Qian Gong. Shen Zhou 沈周 (1427–1509), one of the originators of the so-called "true-view" form of depiction, was active in Suzhou, and his *Twelve Views of Tiger Hill* (*Huqiu shi'er jing tu* 虎丘十二景圖) includes scenes like this one (*Fig. 8*). Zhang Hong 張宏 (1577–1652?) was also known for his true-view images. One painting in his album of *Twelve Views of Suzhou* (*Sutai shi'er jing* 蘇台十二景; *Fig. 9*), showing a moonlit town, shares certain elements with Buson's picture. In general, Buson's *Snowy Night* belongs to the lineage of "true views" and city views of late Ming Suzhou. Sesshū's "true views" may also have been influenced by Ming dynasty works, but the revival of esteem for Sesshū's paintings on the part of the painters of the mid-Edo period was probably stimulated by later Ming painting—works closer in time to their own period. *Snowy Night* is thus related to the cityscapes considered "classical" in its day, whether those of Sesshū or those of the Ming dynasty.

Even so, this painting recreates its subject with a sense of reality not found in earlier works. Because *Snowy Night* reveals a subtle balancing between the classical tradition and the new colloquial, I do not think that Buson referred merely to the works discussed above. I believe that a work even closer in time and space to Buson provides a definitive hint for the composition and techniques used in *Snowy Night*. This is the *takuhanga* 拓版画, or woodblock print made like a rubbing, entitled *Riding a Boat of Fancy* (*Jōkyōshū* 乗輿舟; *Fig. 10*) by Buson's contemporary Itō Jakuchū 伊藤若冲 (1716–1800). On a spring day in 1767, Jakuchū and Daiten 大典 (Kenjō 顯常, 1719–1801)—a Zen priest, Confucian scholar, and poet—took a boat from Kyoto to Osaka on the Yodo 淀 River. Jakuchū then created in handscroll format a print of the scenes they encountered along the way with accompanying verses in Chinese by Daiten. In format, Jakuchū's *Riding a Boat of Fancy*—a handscroll with *kanshi* inscribed along its length—resembles *Snowy Night*.[16] The sinuous, angled line that Jakuchū used to depict the range of mountains and the combination of mountains with a cluster of foreground houses are both close to Buson's composition. The reverse image characteristic of Jakuchū's printing method, which renders the sky black, the hills, earth, and houses all gray,

15. For a discussion of this painting and its relation to Qian Gong, see James Cahill, "Yosa Buson and Chinese Painting," in Tokyo National Research Institute of Cultural Properties, *International Symposium on the Conservation and Restoration of Cultural Property: Interregional Influences in East Asian Art History* (1982), pp. 253–54; James Cahill, *The Lyric Journey: Poetic Painting in China and Japan* (Cambridge, Mass.: Harvard University Press, 1996), pp. 154–61; and Satō Yasuhiro, "Yosa Buson hitsu Ho Senko sansuizu (Landscape in the Manner of Qian Gong by Yosa Buson)," *Kokka* 1252 (2000), pp. 22–27.

16. The most recent study of the handscroll *Riding a Boat of Fancy* is Satō Yasuhiro, "*Jōkyōshū* shōkai (A Short Discussion on *Riding a Boat of Fancy*)" in *Kagaku Kenkyūhi Hojokin Kenkyū Seika Hōkokusho: Bijutsu no tenkai ni hatashita geijutsuka ni yoru ryokō no igi ni kansuru hōkatsuteki kenkyū* (*Report on the Study Funded by the Japan Society for the Promotion of Science: Comprehensive Study on the Significance of Artists' Travels in Developing Artistic Styles*), ed. Osano Shigetoshi (Tokyo: University of Tokyo, 2002), pp. 111–24.

Satō Yasuhiro

and the trees white, together with the subtle gradations of gray with white dots to indicate sunlight, can be seen to have influenced the similar brush effects in *Snowy Night*. Buson's sky, of course, is full of complex tonal changes, whereas Jakuchū's is an unvaried, intense black. At least four variants of the *Riding a Boat of Fancy* print are extant, and we know that it went through numerous printings. We can surmise that Buson would have seen one of those prints in either Osaka or Kyoto. In addition, just as Buson transformed Ban'an's cherry blossoms of Ueno into falling snow in Kyoto, he might have transformed Jakuchū's spring day on the Yodo River into a wintry city night scene. We also know that Buson wrote a poem about taking a boat down the Yodo River.[17]

By chance, the print-poetry scroll by Jakuchū and Daiten, in its elevation of a Yodo River scene into an elegant artistic realm, contains elements of the Kobunji style. The *takuhanga* rubbing method brought to Japan from Ming China, the Chinese poems by Daiten, and Jakuchū's ink landscape painting style all lessen the colloquial reality of the image and heighten the sense that it belongs to the realm of Chinese culture. In these respects, too, it is similar to *Snowy Night*. Likewise, Ike Taiga 池大雅 (1723–1776), Buson's great contemporary in Kyoto, created a "true-view" image of the Mino'o 箕面 Waterfall of Osaka in 1744 and likened it to the waterfall at Mt. Lu 廬, a famous Chinese scenic spot.[18] Furthermore, Jakuchū's images of roosters, depicted in great detail after careful observation of live birds, are powerfully depicted in compositions like those used for traditional bird-and-flower subjects, such as peacocks or phoenixes.[19] In other words, artists of this period sought to insert Japanese nature into Chinese culture, transforming the "colloquial" into the "classical," and this characteristic links *Riding a Boat of Fancy* with *Snowy Night*. The Chinese and Japanese cityscapes mentioned above would have all been stored in Buson's memory and would have been called forth under the stimulus of *Riding a Boat of Fancy* to lend visual form to his *Snowy Night*.

Conclusion: The Real and Virtual City

Finally, let us consider *Snowy Night*'s construct of the classical and the colloquial in terms of its novelty. To repeat, this painting is thought to be the first of its particular kind in Asian art. Night views had become a popular subject in Edo period paintings and prints, especially views of the pleasure districts with their flourishing nocturnal establishments lit for business with rape-seed oil, which had become relatively inexpensive and therefore widely used. Silhouetted images of figures seen behind *shōji* screens had been depicted in the third scroll of *The Illustrated Life of Saint Ippen* (*Ippen Hijiri-e* 一遍聖絵; Kankikōji 歓喜光寺 and Shōjōkōji 清淨光寺), produced in 1299. However, the artless interest in the effects of night lights as such appears first in genre scenes known as *Pleasures of the Four*

17. Buson, "Denga-ka (Song of Yodo River)," in *Buson zenshū*, ed. Ogata and Yamashita, vol. 4, pp. 11–15.

18. Satō Yasuhiro, "Shinkeizu to mitate (True-view Landscape Painting and Metaphoric Representation)," in The Society for International Exchange of Art Historical Studies, *The 12th International Symposium: Realism in Asian Arts* (Osaka: Osaka University, 1994), pp. 80–87.

19. Satō Yasuhiro, "Jakuchū no niwatori (Jakuchū's Roosters)" in *Kachoga no sekai* (*Bird-and-Flower Paintings of Japan*), ed. Tsuji Nobuo (Tokyo: Gakushū kenkyūsha, 1983), vol. 7, pp. 116–18; Satō Yasuhiro, *Itō Jakuchū* (Tokyo: Shibundō, 1987), p. 40.

Seasons (*Shiki himachi zukan* 四季日待図卷; Idemitsu 出光 Museum of Arts) and *Yoshiwara Gay Quarters* (*Yoshiwara fūzoku zukan* 吉原風俗図巻; Suntory 三得利 Museum of Art) by the seventeenth-century artist Hanabusa Itchō 英一蝶 (1652–1724). Among the eighteenth-century *megane-e* attributed to Maruyama Ōkyo (*Fig. 11*) is an image of crowds enjoying the night scene at Kyoto's premier pleasure quarters, the corner of Shijogawara 四条河原, with lanterns above the heads of the crowd in contrasting perspective. This is a dispassionate depiction of the dark of night somehow distinguished by the qualities of light. I shall omit examples from the *ukiyo-e* genre, merely noting that Ōkyo's observations of lights shining on night streets were more detailed than those found in *ukiyo-e* of the same period.

Buson the city dweller delighted in the lighting of the city's pleasure districts at night. In the Shimabara 島原 district, from the seventh through eighth months, each of the various entertainment houses would hang lanterns adorned with its symbol to attract customers. We know from his letters that Buson enjoyed this spectacle. In a letter to Arita Magohachi, a wealthy farmer of Tanba, he wrote:

> The nightless quarters [i.e., Shimabara] are bustling as usual. The lanterns are considered somewhat inferior this year. They do not appeal to the common taste because Kikyō-ya has not provided a mechanical lantern [which received the most attention]. However, the beauty of the decoration more than offsets this lack.

A letter to his poetry disciple Takai Kitō 高井几董 (1741–1789), inviting Kitō to join him in viewing the ceremony for introducing a new geisha in the Shimabara district, said: "On the first day of the eighth month, in the nightless quarters, . . . the lanterns will be particularly interesting and so we should visit there on that day by all means."[20]

On the other hand, he also wrote poems about the faint light from humble dwellings, and about lanterns betokening lives surrounded by the cold, dark night air:

Yado kasanu	On this snowy night
hokage ya yuki no	warm light flickers in a row of houses.
ietsuzuki	None let me stay overnight.
Koru hi no	On a frosty night
abura ukagau	a mouse secretly searches
nezumi kana	for oil in a lamp.
Sumu kata no	Through the darkness of autumn night
aki no yo tōki	the window of a distant house is
hokage kana	dimly lit.
Zukin kite	Wearing a hood,
tomoshi fukikesu	blowing out a lighted wick,
wabine kana	a lonely sleep begins.[21]

Buson's receptivity to man-made light is expressed in both his poems and paintings. In *Fishing from a Boat on a Dark Night* (*Anya gyoshūzu* 暗夜漁舟図; Itsuo 逸翁 Museum of Art, Osaka), we can see his effective use of the

20. *Buson shokan-shū*, ed. Ōtani and Fujita, pp. 397–98, 418–19, nos. 180 and 196. The first letter is dated the first day of the ninth month, and the second is dated the 27th day of the seventh month; on both, the year is unspecified.

21. These poems are in *Buson zenshū,* ed. Ogata and Morita, vol. 1, nos. 324, 1202, 2083, 2310.

Satō Yasuhiro

fishing torch and the lantern working against the dark. In his poem, "The cherry blossoms' scent, as Saga's lanterns are extinguished (*Hana no ka ya* / *Saga no tomoshibi* / *kiyuru toki* 花の香や嵯峨の燈火消ゆる時)," he extols the scent of the blossoms, presumably most fragrant in the dark. The poem is inscribed on his Saga 嵯峨 fan painting (*Fig. 12*), which does not depict darkness, but does share with *Snowy Night* the image of a row of houses against a range of hills.

The lighting shown in *Snowy Night* is not the attention-getting brightness from the lanterns of the river banks at Shijō or the teahouses of Shimabara; it is the far fainter, softer light of domestic lives. This is the true novelty of *Snowy Night*—that it shows not the brightness of some designated entertainment district, but rather the entire face of the actual city. In all of their paintings and prints for a popular audience, Hanabusa Itchō or Maruyama Ōkyo or Kitagawa Utamaro 喜多川歌麿 (?–1806) depicted man-made light at night only in populated scenes of the urban pleasure quarters.[22] Back in Tang-dynasty China, Li Bai 李白 (701–762) wrote, "The ancients had a good reason to *play* at night with a lamp in their hand" (italics added, from the famous prose "Preface to *A Banquet at the Peach and Plum Garden on a Spring Night*" [*Chunye yan Taoli yuan xu* 春夜宴桃李園序]). *Snowy Night*, however, does not depict but only implies the presence of people, and only the term *rōdai* and the mere sketch of a figure suggest nocturnal "play." With just a bit of light here and there between houses sunk in snow, it mostly implies the long dailiness of urban life. This intimately appealing snowscape centered on buildings can be seen as the predecessor to *Kanbara* 蒲原 from the series *Fifty-three Stages of the Tōkaidō* (*Tōkaidō Gojūsantsugi* 東海道五十三驛站) of 1833 by Utagawa Hiroshige 歌川広重 (1797–1858) and *Kaiun Bridge and First National Bank in Snow* (海軍橋第一国立銀行) of 1876 by Kobayashi Kiyochika 小林清親 (1847–1915). Hiroshige and Kiyochika imbued their pictures with sentiment by placing human figures in the foreground, but Buson's painting creates its lyricism solely through the clustered houses.

The predecessors to Buson's picture all show densely packed houses in a lively urban scene. But Buson's houses are not sites of lively bustle; rather, they are stalwart protectors against the cold of winter and the dark of night. Two Buson poems build on the role of houses as protectors of people against the harshness of nature, and include the motif of houses clustering like people to face the menace of nature:

Kogarashi ya	A wintry wind.
nan ni yo wataru	How in this world
ie goken	are the five houses making their way?
Samidare ya	Early summer rain—
taiga wo mae ni	Two houses
ie niken	Confront a large river.

The first verse, written in 1768, describes five little houses, leaning together against the cold wintry wind. How are the owners to make a living? The second verse implies continual early summer rains swelling the river and the

22. An example of Utamaro's night scenes is the triptych *Pleasure-boating on the Sumida River* (The Art Institute of Chicago).

fear that it will breach its banks. Each of these poems shows human life, symbolized by a row of houses, threatened by the power of nature. Buson wrote the poem on "early summer rain" in two letters dated to 1777, one of them about the breakup of the marriage of his beloved only daughter.[23] His own unease is figured in the image of houses endangered by a river potentially in spate. As it turns out, *Snowy Night* was painted after his daughter's divorce.

In the two poems by Buson quoted above, the small number of houses heightens the sense of their vulnerability, and therefore the tension of the scene. *Snowy Night* depicts some seventy-seven houses, allaying any such sense of tension. Common to Buson's poetry and paintings, however, is the presentation of the houses as home, implying people within, in settings evoking the hardships of nature—in *Snowy Night*, the cold, snow, and darkness. Differences in the method of depiction convey the confrontation between culture and nature. The sky in the painting is boldly brushed in puddled ink, with the mountains and trees depicted in sketchy lines. The falling snow is shown by a scattering of shell-white pigment. In other words, all of these aspects of nature are depicted by techniques that inhibit the artist's control and rely greatly on chance. The houses, on the other hand, are geometrically arrayed to form a gentle "V" shape and indicated by a repetition of straight lines. This method of depiction emphasizes the sense of order in the living space of people. Furthermore, red ochre is used to depict the light shining through the windows and reflected on the walls. Snow (water) versus fire, cold versus heat, and light versus the darkness—these contrasts call forth opposing methods of depiction, which help to emphasize the differences between nature surrounding the town and the homes in which people live. In such places within spaces, we can imagine Buson himself and his fellow Kyoto citizens going about their lives, enduring what must be endured. In light of letters and poems that reveal Buson's later life, we can see that *Snowy Night* exudes a sense of Buson's joys and sorrows of the city, despite the fact that this painting staunchly maintains the most traditional rubrics of classical painting and does not offer explicit information on the joys or sorrows of the dwellers within its houses.

In this respect, certain anomalies appear in the painting. We notice, for example, the strangely indeterminate border. The title and the beginning of the work are separated by a roughly contoured area of black. The top, bottom and left edge of the long composition have been cut, making it appear as if the actual landscape has been trimmed. In the lower left corner, Buson left off both the ink layer and the shell-white ground, so that only the raw surface of paper is visible.[24] The boundaries of the painting are also muted. Like a flashback scene from film or a television program, or reminiscent of a balloon in a comic, this painting seems to exist within a form of quotation marks, like a

23. One letter (*Buson shokan-shū*, ed. Ōtani and Fujita, pp. 198–200, no. 79) is addressed to Yakō, a Kyoto *haikai* poet. The letter telling of his daughter's divorce (*Buson shokan-shū*, pp. 200–203, no. 80) is addressed to Masana and Shunsaku, *haikai* poets in Osaka. The two poems are recorded in *Buson zenshū*, ed. Ogata and Morita, vol. 1, nos. 298 and 1664.

24. Buson similarly omitted the color in one corner of paintings such as *Cuckoo in Flight over New Verdure* (Hiraki Ukiyoe Foundation), *Recluse's Cottage in a Bamboo Grove* and *A Homeward Path under the Shade of Willows* (Yabumoto Kōzō Collection), *Kite and Crows* (Kitamura Museum of Art), and *Mt. Fuji and Rows of Pines* (Aichi Prefectural Museum of Art). *Snowy Night* and these masterful works of his late years have in common a sense of being "unfinished," which emphasizes the transitory reality of the depicted scenes.

雅俗的都市像—
關於與謝蕪村筆《夜色樓臺圖》

佐藤康宏

東京大學

　　關於與謝蕪村(1716–1783)於1788年以降的晚年所描繪的《夜色樓臺圖》，論者的主要觀點多集中於「雅俗」與「都市圖」。這幅畫的題詩「夜色樓台雪萬家」，是根據江戶禪僧萬庵原資的漢詩而來，此事雖已被指出，然而值得注意的是古文辭派的詩人萬庵作詩的重點在於以古典的修辭，將江戶的實景轉換爲唐詩的世界。伊藤若沖於1767年左右制作的拓版畫《乘輿舟》，很可能是啓發此件作品構圖與技法的來源，若沖的畫卷也帶有古文辭派的構思，亦即將淀川景色昇華至風雅詩畫的境界。換言之，在蕪村的時代將現實的都市景觀虛構化是佔優勢的藝術思潮，因此就《夜色樓台圖》的成立而言，這也是必要的一道手續。即便如此，現實景色不單只是標題而已，而是要再現前所未有的眞實感，因而在「雅」的傳統與新式的「俗」之間就產生了絕妙的均衡感。

　　從廣闊的角度而言，《夜色樓臺圖》屬於明末蘇州制作之實景圖、都市圖的系譜。例如張宏《蘇台十二景圖冊》（北京故宮博物院）中的一幅，以籠罩月光的城鎮爲主題，錢貢的《城南逸趣圖卷》（天津市藝術博物館），在橫長的畫面上以山脈爲背景描繪家屋相連的景觀，這些要素都可以在蕪村的畫中見到。從蕪村所作的數件《倣錢貢山水圖》（京都國立博物館）的作品，可以確定他曾見過舶來的錢貢畫，推測在他的所見所聞中，應該也包含這類都市畫。更進一步地考察日本繪畫中描繪都市的先例，及其與京都市民蕪村的實際生活間的關係，那麼這一件特別的畫作到底是產生於何種環境之中呢？結論，如以蕪村歌詠家的意象與《夜色樓台圖》的繪畫表現作爲線索，這件作品可說是所謂「都市的哀歡」之個人情感的流露，在虛實交錯之間表現出來。

雅俗の都市像—
与謝蕪村筆「夜色楼台図」について

佐藤康宏

東京大学

与謝蕪村(1716–1783)が1778年以降の晩年に描いた「夜色楼台図」について、〈雅俗〉と〈都市図〉を主たる論点として論じる。この画の題詩「夜色楼台雪万家」が江戸の禅僧萬庵原資の漢詩に基づくことは既に指摘されるが、古文辞派の詩人萬庵の作詩の眼目が、古典的な修辞によって江戸の実景を唐詩の世界に転じる点にあったことに注意を喚起したい。伊藤若冲が1767年ころに制作した拓版画「乗興舟」が構図や技法の発想源となった蓋然性は高いと考えるが、若冲の画巻がまた淀川の景色を風雅な詩画へと昇華する古文辞派風の構想を持っていた。すなわち、現実の都市の景観を一種虚構化することが、蕪村の時代の芸術思潮では優勢であり、それが「夜色楼台図」の成立にも必要な手続きだったと考えられる。そうでありながら、現実の景色が単なる題目ではなく、従来にない実感をこめて再現されている点に、〈雅〉なる伝統と新しき〈俗〉との絶妙の均衡が認められる。

「夜色楼台図」は、大きくいって明末蘇州で制作された実景図、都市図の系譜に属する。たとえば、張宏の「蘇台十二景図冊」(北京故宮博物院)の中の1図は、月に照らされた夜の町を描くという主題で、銭貢の「城南逸趣図巻」(天津市芸術博物館)は、山並を背景に家屋が並ぶ景観を横長の画面に描く構成で、それぞれ蕪村画に共通する要素を持つ。舶載された銭貢の画を蕪村が見ていたことは、「倣銭貢山水図」(京都国立博物館)など数点の作品によって確かめられるが、見聞の中にこの種の都市図もまた含まれていたのだろう。さらに都市を描く日本絵画の先例や、京都市民蕪村の実際の生活との関係を探って、このユニークな絵画がどのような地層の上に現れたかを考察する。結論として、蕪村の句に詠まれた家のイメージと「夜色楼台図」の絵画表現を手掛かりに、〈都市の哀歓〉というべき私的な感情の発露が、虚実の交錯のうちに表されていることを説く。

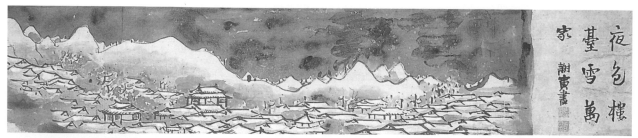

Fig. 1. Yosa Buson (1716–1783). *Houses on a Snowy Night*, ca. 1778-1783. Hanging scroll, ink and light colors on paper, 28 × 129.5 cm. Mutō Haruta collection. *(details on pages 131 and 151)*

Fig. 2. Yosa Buson (1716–1783). *Red and White Plum Blossoms,* ca. 1780. Four-fold screen (originally *fusuma* paintings),ink and colors on gold-leafed paper, 167 × 284 cm. Sumiya Hozonkai.

Fig. 3. Artist unknown. *Uki-e: Perspective View of Kyoto*, ca. 1769. Woodblock and stencil print, 25.5 × 37.5 cm. Kobe City Museum.

Fig. 4. Sesshū (1420–1506?). *Scenic Views of China*, 15th c. Handscroll, ink on paper, 28.2 × 735.7 cm. Kyoto National Museum.

Fig. 5. Attributed to Sesshū (1420–1506?). *Scene of Tōfukuji*, 1505. Hanging scroll, ink and light colors on paper, 83.4 × 153.0 cm. Tōfukuji.

Satō Yasuhiro

Fig. 6. Qian Gong (act. 1572-1620). *Elegant View of the Southern Part of the City*, 1588. Handscroll, ink and light color on paper, 28.5 × 137.8 cm. Tianjin Municipal Museum of Art.

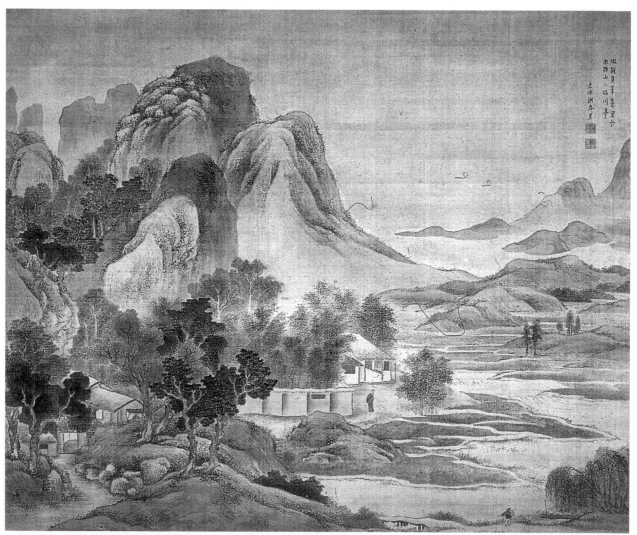

Fig. 7. Yosa Buson (1716–1783). *Landscape in the Manner of Qian Gong*, ca. 1767. Hanging scroll, ink and colors on silk, 113.2 × 133.8 cm. Kyoto National Museum.

Fig. 8. Shen Zhou (1427–1509). Leaf 4 from *Twelve Views of Tiger Hill*, ca. 1490-1509. Album of twelve leaves, ink and light color on paper, 31.1 × 40.2 cm. Cleveland Museum of Art.

Fig. 9. Zhang Hong (1577–1652?). Leaf 9 from *Twelve Views of Suzhou*, 1638. Album of twelve leaves, ink and light color on silk, 30.5 × 24 cm. Palace Museum, Beijing.

Satō Yasuhiro

Fig. 10. Itō Jakuchū (1716–1800). *Jōkyōshū*, ca. 1767. Takuhan print in handscroll format, 28.7 × 1151.8 cm. Kyoto National Museum.

Fig. 11. Attributed to Maruyama Ōkyo (1733–1795). *Shijō Riverbank Scene*, ca. 1750s. Woodblock and stencil print, 20.8 × 27 cm. Kobe City Museum.

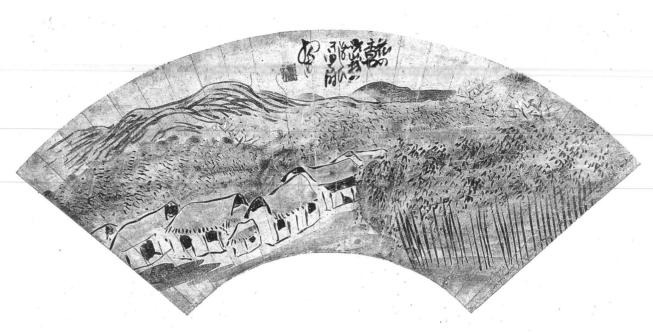

Fig. 12. Yosa Buson (1716–1783). *Scene of Saga with Poem*, ca. 1777 1783. Fan painting mounted as a hanging scroll, ink and light colors on paper, 16.6 × 46.4 cm. Private collection.

Satō Yasuhiro

Section I: Studies on Canonical Paintings
Response

Ebine Toshio

Tokyo National University of Fine Arts and Music

The essays in this section, "Studies on Canonical Paintings," are alike in focusing on major works, but they differ in the questions they ask.

Chen Pao-chen's 陳葆眞 paper on the *Thirteen Emperors* (*Litai diwang tu* 歷代帝王圖) handscroll in the Museum of Fine Arts, Boston, addresses questions of the date (or dates) of the work, the identity of its creators and its subjects, and the iconography and connotations of the portraits.

A colophon on the scroll by the renowned Zhou Bida 周必大 (1126–1208) of the Southern Song notes that this painting was so heavily damaged that he dared not touch it. Only after spending one-fifth of its purchase price to have the work repaired was he finally able to examine it. Of all the thirteen portraits, that of Chen Xuandi 陳宣帝 was the most heavily damaged; Zhou also opined that this image was the only one painted by the famous Tang dynasty artist Yan Liben 閻立本 (ca. 600–673) himself.

Chen Pao-chen has based her inquiry on Tomita Kōjirō's 富田幸次郎 conclusion that the first and second halves of the scroll were produced at different times. She has focused on the second half, noting that its portraits are not the standardized ruler images of the day but rather depictions of specific people. She offers much corollary evidence— the calligraphic style of the inscription preceding each portrait, comparison between the content of those inscriptions and relevant historical documents, and stylistic analysis of the paintings. Chen concludes that the rulers were chosen for inclusion in the scroll on the basis of their didactic historical value as defined by Tang Taizong 唐太宗, whose philosophy of government is visually signified by their presence and their juxtaposition.

Chen's findings and arguments are praiseworthy, but I believe certain troublesome anomalies are still not addressed. For example, if, as the author assumes, the portraits labelled Chen Wendi 文帝 and Chen Feidi 廢帝 are in fact two Liang 梁 dynasty rulers, then their present position within the scroll seems to be incorrect. Certain problems may also have been created by the restoration work. Among the rulers found in the second half of the scroll, Chen Houzhu 後主 seems to me to wear an incongruously stiff expression.

The most striking aspect of this scroll, however, is a singular uniformity within the variety of poses assumed by the rulers. Each is shown in three-quarter view, whereas a figure of great authority and power would customarily be depicted in a full frontal pose. That none of these rulers is so portrayed implies a deliberate choice, and, indeed, the three-quarter pose plays a formative role in the composition. With the face and body in three-quarter view, the de-

picted person appears to be separated from both the picture plane and the background. As a result, the area behind the rulers is enlivened as three-dimensional space rather than left undefined.

Formal portrait paintings are usually taken out of narrative contexts, but the three-quarter pose activates the space into which the figures are placed. Our interaction with the image—seeing the pose, reading the facial expression, receiving information from the inscription—creates a narrative context in the broad sense. I think that, because Chen Pao-chen was subconsciously aware of this, her explication focuses on the narrative context and the character of each ruler. Finally, granting that this handscroll had a didactic function, it was nonetheless likely commissioned for a limited audience, not for a ceremonial purpose.

Robert Harrist discusses a recently discovered painting depicting the family of Layman Pang 龐 (ca. 740–808), clarifying the subject matter and asserting that Li Gonglin 李公麟 (ca. 1041–1106) was the artist. I must note that I have not yet seen this work firsthand, and therefore my comments, based on photographs alone, may be inconsequential. I fully agree, however, with Harris's interpretation of the subject matter of the painting and with his opinion that the work should be retitled *Picture of a Chan Encounter* (*Chan hui tu* 禪會圖), but I still have reservations about his attribution of the work to Li Gonglin.

Reading the account of this scroll in *Kaikodō Journal*, I immediately recalled the Li Gonglin works recorded in *Catalogue of Paintings in the Xuanhe Collection* (*Xuanhe huapu* 宣和畫譜) of 1120 and surmised that the scroll was not of the types listed there. To my mind, it rather recalled the work *Mahāprajāpatī Holding the Infant Buddha* (*Yimu yu Fo tu* 姨母育佛圖) by Wang Zhenpeng 王振鵬 (act. 1280–1329) in the Museum of Fine Arts, Boston. This visual link was suggested by the shapes of trees and buildings in the Layman Pang painting and the depictions of Danxia 丹霞 and his attendant in the first scene. A closer look, however, at the representation of Lingzhao 靈照 and the Pang family ruled out such a close connection. The Layman Pang painting has splendid line work that seems to carve its images out of the page. Still, the line quality alone does not convince me to associate this work with Li Gonglin.

For me, the interest of this work lies in its subject matter, in how this painting relates to the genre of "Chan encounters." First appearing as a type of imagery descriptive of everyday life, "Chan encounters" evolved into a series of didactic compositions employed by some of the schools of Chan Buddhism. Encounters between monks (or between monks and laymen) were compositionally rearranged in order to convey doctrinal instruction. I continue to speculate on how his panting might fit within the "Chan encounters" tradition.

By elucidating Li Gonglin's biography and the artistic practice of his time, and by bringing to bear textual evidence on the painting, Robert Harrist raises the provocative and by no means impossible hypothesis that Li was expressing a direct connection between himself and the two saintly laymen—Vimalakīrti and Pang Yun 龐蘊.

The essay by Shimao Arata 島尾新 reflects on the current state of affairs in art historical research in Japan. Three decades ago, scholars tended to study Japanese painting history solely within the national context, paying little attention to outside influence or stimulus. Over the past twenty to thirty years, the opposite view has gained currency.

Some scholars argue that it is essential to evaluate accurately the role of China in the origins and evolution of Japanese painting, while others consider the history of Japanese art within the broader context of East Asia. These changes have produced extremists on both sides—researchers who find the ultimate source of Japanese art in China, and their antagonists who respond with ever-more emphasis on the unique and indigenous qualities of Japanese art. Outside of Japan, this debate has not aroused much interest, but readers should be aware that it contributes to the context of Shimao's essay.

Shimao examines two paintings by Sesshū Tōyō 雪舟等楊 (1420–1506) from three different perspectives. The first is that of *hitsuyō seisaku* 筆様制作, or "brush-style production." The second is *keitō hassei* 系統発生, or "lineage affinities," while the third is the individual artist—Sesshū in this case—the creative individual whose artistic choices play a crucial role in the final product. As an example of individual invention, Shimao identifies Sesshū's frequent use of a large boulder or cliff face with an outer boundary composed of a strictly vertical line. Though Sesshū was a respectful student of Chinese painting, this feature cannot be found in works by any of the Chinese painters whom he is known to have admired; it must have been Sesshū's own innovation. The three perspectives, rather than being antagonistic, convey different insights into the acts of a single artist.

The essay by Satō Yasuhiro 佐藤康宏 on Yosa Buson's 与謝蕪村 (1716–1783) *Houses on a Snowy Night* (*Yashoku rōdaizu* 夜色楼台図) is composed with such logic, clarity, and completeness that there is virtually nothing for a commentator to add, except to emphasize the significance of his analytical terms. In a previous study, Satō considered early paintings by Ike Taiga 池大雅 (1723–1776) in light of the same contrasting aesthetic principles that he employs here: "*ga* 雅" and "*zoku* 俗," which may be variously translated as classical and colloquial, or elevated and mundane, respectively. As they also imply the contrast between culture and nature, or China and Japan, these principles are of basic importance in understanding the arts and letters of Japan in the Edo period. The discussion of Taiga seemed to focus more on the classical, elevated, and Chinese aspects, while in the current essay on *Houses on a Snowy Night*, Satō gives more emphasis to Buson's use of colloquial, natural, and native Japanese aspects, which resulted in a most innovative and novel work.

Buson painted *Houses on a Snowy Night* in the early 1780s, long after the literati culture that had originated among the Chinese landed gentry had spread beyond the urban elite in Japan to include men and women of all classes and locales—merchants, farmers, fishermen, and country villagers alike. Even while engaging in commerce and labor, Japanese literati were able to engage in Chinese-style poetry, painting, and calligraphy, but they equally wrote verses in native Japanese idioms—*waka* 和歌, *renga* 連歌, and *haiku* 俳句. Was the difference between *Houses on a Snowy Night* and Taiga's early paintings the result of changes in the taste of the increasingly plebeian patrons, or was it due to the personal taste of the artists—Taiga gifted in *kanshi* 漢詩 (Chinese verse) and Buson in *haiku*?

Satō Yasuhiro has pointed out the connection between *Houses on a Snowy Night* and the literary "Ancient Prose-style" (J: *komonji*, C: *guwenci* 古文辭) movement, which encouraged the simple, straightforward style of the clas-

Ebine Toshio

sics. But should we not also take note of the Gongan 公安 school which criticized it? The complete works of Yuan Zhonglang 袁中郎 (1568–1610), the main proponent of the Gongan school, had already been conveyed to Japan by the seventeenth century.

第一節　經典畫作研究
論評

海老根聰郎

東京國立藝術大學

這場「經典畫作研究」的討論中，雖然大家同樣關注重要作品，但是提出的問題有所不同。陳葆眞對波士頓美術館所藏的《十三帝王圖卷》的研究，提出斷代、創作者及主題的歸屬、肖像的圖像學及涵意上的問題。卷末一段十三世紀的題跋提到此卷已嚴重破損，僅剩一幅肖像爲閻立本所繪。

陳葆眞接受此卷前後段作於不同時間，並把焦點放在第二段那些具有高度個人性的帝王像上。她的結論是卷上這些統治者是依唐太宗政治理念、符合其教化價值而被挑選出來的。

陳葆眞的論文值得讚許，但她略過了一些麻煩的例外狀況。如果標爲陳文帝與陳廢帝的肖像作於梁代，那麼他們在卷中的位置似乎不太正確。過往的修復產生了許多問題。例如：陳後主不協調的僵硬表現。

最值得注意的是每位君主均以四分之三側面的角度出現，而通常極具權威的人物都會以全正面的姿態出現。由於面孔與身體均以四分之三側面出現，因此君主後方的區域也成爲立體空間。不像通常都由敘事脈絡中抽離出來的正式的肖像畫，被這四分之三側面的姿態活化出的空間，成爲人物所在之處，而且廣義上創造出一個敘事脈絡。這個手卷因此具有教化意義，是爲某些特定觀衆製作，而非儀式之用。

Robert Harrist 討論新近發現描繪龐居士（ca. 740-808）一家的畫作，澄清畫題並提出此畫爲李公麟所作。我的評論雖然是來自照片的印象，但我完全同意Harrist對畫題的解釋，以及他認爲應將畫名重訂爲〈禪會圖〉的意見，不過我要對他將這件作品歸於李公麟名下提出質疑。

西元1120年《宣和畫譜》記載的李公麟畫作與現存這件作品種類不盡相同。此畫也許與波士頓美術館所藏的王振鵬(act. 1280-1329)《佛母育嬰圖》有關係，不過《丹霞訪龐居士圖卷》筆劃較爲尖利。但即使如此，我還是無法把此作與李公麟關連起來。

本文主要的興趣在於找出此作與「禪會圖」類型畫作的關係。「禪會圖」是一系列禪宗作爲教化之用的作品。我接著的疑問是李公麟的畫作如何會與「禪會圖」傳統有關。Harrist也舉出個很刺激的假設：李公麟將自己與兩位神聖的佛教居士——維摩詰和龐蘊作認同。

島尾新的文章反映了日本當前藝術史研究的狀況。三十年前的學者顯得較具國家主義，對外界加諸於日本藝術的影響不甚在意。近年來則發展出世界性的觀瞻。當一些研究者由中國找到日本藝術的根源時，其他的學者相應地更加強調日本藝術的獨特性。日本之外的地區這種討論並沒有激起多少迴響，但讀者們應該注意到這對島尾新論文產生脈絡的影響。

島尾新採用了三種互補的觀點檢視兩張雪舟的作品：（1）筆樣製作（2）譜系關係（3）獨立藝術家——雪舟個案。島尾新認為雪舟經常運用的巨大卵石或者具有筆直線條輪廓的巖壁是個人創發的例證。雖然雪舟是個對中國畫頗為尊重的學生，但是這個特點尚無法在任何已知受到他推崇的中國畫家作品中找到；因此這必定是雪舟個人的創發。

佐藤康宏關於與謝蕪村《夜色樓台》的論文完整透徹，除了應該強調他分析用語的重要性外，幾乎無可批評。文中佐藤採用他在之前研究文人畫家池野大雅（較與謝蕪村年輕之同時代人）早期作品的用語。他指出瞭解日本美術或江戶時期文字的基礎在於可被描述為「雅」與「俗」的兩種衝突美學傾向中。他們也代表了教養與自然、中國與日本、真實與虛假的對比。佐藤對池田大雅的分析重在其作品的古典、昇華與中國的面向上，而現在這篇《夜色樓台》的論文，則更重視日常的、自然的、以及日本原生的部分。與謝蕪村在1780年代早期畫了《夜色樓台》，遠遲於中國文人地主階級發展出的文人文化，在日本由城市菁英乃至無分性別、地區與階級中擴展開來之後。而《夜色樓台》與池田大雅早期作品的差別，是平民贊助者品味的改變，又或者要歸因於藝術家個人品味——池田大雅長於漢詩而與謝蕪村長於徘句——的影響呢？

佐藤康宏很有道理地指出《夜色樓台》與倡導回歸簡單率直風格的中國古文辭派的關係。我建議注意明代公安派對古文辭派的批評，因為公安派大將袁中郎的文集，在十七世紀時已流傳到日本了。

第一部　經典画作研究
論評

海老根聰郎

東京国立芸術大学

　当セクション作品研究の四つの論文は、主要作品をとりあげている点では同じでも、提起する問題については異なったものである。

　ボストン美術館の「帝王図巻」に関する陳葆真教授の論文は、作品の制作年代、制作者と像主の特定、肖像画の図像と暗示的意味に取り組んでいる。南宋の周必大は、十三人の中で陳宣帝の絹がもっとも痛んで、これだけが閻立本の唯一の真蹟だと述べた。

　陳教授は、この図巻の前段と後段とは制作年代が違うという説に従い、後段を主たる対象として、皇帝の特定の個人像に注目する。教授は、唐の太宗の政治的見解に応じた教訓的価値に基づいて、諸帝がこの図巻に選ばれたと結論づける。

　教授の論考は大変敬服すべきものであるが、いくらか論じられていない点もある。陳文帝、廃帝を梁の二帝と考えるのであれば、現在の位置は正しくない。当然、復元の問題も生じ、陳後主叔宝の硬直した表情が後段の諸帝の中では気にかかる。

　最も特筆すべきは、強大な権力者ならば、正面向きに描かれるはずなのに、すべての皇帝が半側面で描かれていることである。この半側面という構成では、人物は前平面と背景の両方から離れているように見え、皇帝の背後は単なるすき間ではない空間として活性化されているように見えてくる。肖像画とは本来、物語的文脈から切り離された形式と考えられるが、半側面像は、人物の置かれた空間を活性化して、広い意味での物語的文脈を作りあげていく。この画巻は、訓戒的機能をもつといっても、私的な限られた人々の為に作られたものだったのではないだろうか。

　ロバート・ハリスト教授は近年新しく発見された麗居士一家を描いた作品を論じて、主題を明らかにし、作者を李公麟と主張している。以下のコメントは写真からの個人的感想にすぎないが、絵画の主題問題についての教授の解釈には全面的に賛成であり、この作品のタイトルを改めるべきであるという意見にも異論はない。ただ、問題は、この画を李公麟の作品とする第二の論点である。

　私は『宣和画譜』に記される李公麟の作品とこの作品と結びつけようとは思わない。写真を見てすぐ思い浮かべた作品は、ボストン美術館の王振鵬の姨母養育を描い

た作品だった。霊昭女と居士一家の表現は、ボストンの図巻とはまるで異質な、対象を切り出すような見事な線描が見られる。ただ、これだけからこの作品を李公麟と結びつけることは出来ない。

　私の関心は、この作品と禅会図というジャンルとの関係にある。禅会図は北宋時代のはじめに一種の風俗画としておこり、それとは別に、禅会図を構成する各場面が別々に描かれ、それらが禅宗の中である意図のもとに一連のものとして秩序づけられたと考えられるが、この作品は、その中でどんな位置を占めるのかが関心の中心である。ハリスト教授はまた李公麟が二人の高徳の仏教居士、維摩詰と麗蘊に自らを重ね合わせていたという刺激的な仮説も提起している。

　島尾新教授の論文は、日本の美術史研究の現状を反映していると言える。三十年前の研究者はより国家主義的な傾向があり、日本美術への外からの影響を殆ど考慮に入れなかった。近年、世界主義的視野の発達とともに、日本美術の源流を中国に見出す研究者がいる一方で、日本的独自性をことさら強調するというような傾向もある。外国の研究者にとって、この辺の議論は興味のないものではないかと思われる。だが、読者には、島尾教授の論文がこのような現在の研究状況の上にあるということを理解いただきたい。

　さて、島尾教授は雪舟の二点の作品を、一．筆様制作、二．大きな様式史、三．雪舟という一人の画人の営為、という三つのコンテクストから切りとり、冬景山水図の右上から垂直に下りてくる岩について、一つの結論を導きだした。しかし、この結論が前提とし、読みを保証しているのは、先の二つのコンテクスト、すなわち、筆様制作、大きな様式史についての系統発生図ではないか。そのように考えれば、三つのコンテクストとは、次元の違うものでも、対立するものでもなく、一人の画家の営為を考えるための連続した、必要な手続き、方法といいかえられるのではないだろうか。

　与謝蕪村の「夜色楼台図」に関する佐藤康宏教授の論文は、明快で論理的で完璧なため、その分析上の用語の重要性を強調する以外にはコメントの必要がないほどである。教授は、ここで述べられた雅と俗、中国と日本、文化と自然、実と虚の二重構造を池大雅の二十代の作品を材料にすでに論じている。そこで、大雅の作品と、夜色楼台図とを比較してみると、先の二重構造に変化が生じているように考えられる。力点、重心が片方にゆれているのか、両者がより融合していると見るのか判断出来ない、俗、日本、自然、実の方が前面に進出してきたように感じられる。この辺が、教授が結語の部分で言及された新しさというものなのか。

　それを導いたものは何だったのか。「夜色楼台図」の描かれた十八世紀後半は、中国の士大夫文化が都会だけではなく、農・漁村にも広がり、商人、農民など多様な階

層がそれに参加し、地方文化、在村文化を創り出した。彼等は、中国の士大夫のように、一方で実業にたずさわり、他方で文化活動を行っていた。またそこでは、中国文人の詩書画だけではなく、和歌、連歌、俳諧も同一レベルで受容されたといわれる。先の変化は、こうした受け手の側の変化が導いたものなのか。

　あるいは、大雅と蕪村の個性の相違、すなわち、漢詩をもて遊んだ大雅と、俳人であり俳画も描いた蕪村との差なのか。要約すると、大雅と蕪村の受容者の相違が、新しさを導いたモメントとして働いたかどうかということである。もう一つ蛇足ながらつけ加えると、教授は、古文辞派とのつながりですべてを解釈されているようだが、その批判者の公安派も一瞥すべきではないだろうか。公安派の代表者袁中郎の全集は、すでに十七世紀に日本に伝わっていた。

Section II
Buddhist Painting

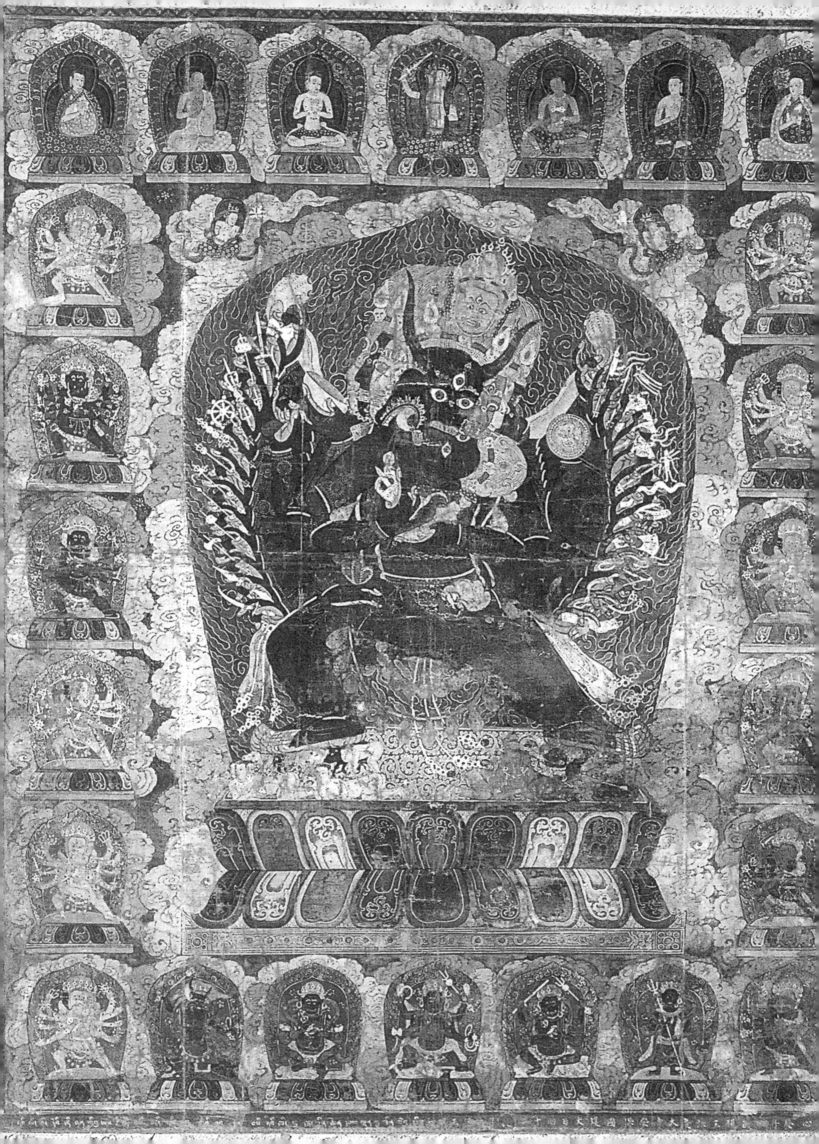

Section II: Buddhist Painting
Introduction

Helmut Brinker

Zürich University, Emeritus

Buddhism, like almost every other world religion, has inspired, invented, and shaped a visual language and material culture to express its faith—including extraordinary, time-honored works that in our age tend to be valued and admired primarily for their artistic qualities. It cannot be stressed enough, however, that works from the vast Buddhist realms were not commissioned, created, and originally appreciated as works of art. Paintings were conceived to be visualizations of the sacred essence of Buddhist faith, sublime expressions of religious ideas and rituals. Individual images as well as multiple configurations and narrative compositions were created and installed for rituals and daily cult activity, for public pilgrimage and private devotion. They were often believed to be invested with miraculous power. Such icons provide focal points for mystic communication with the unseen Sacred. Generally speaking, rituals were addressed to them to solicit the divinities' "loving protection" (C: *jing'ai* 敬愛; J: *keiai*) and support in "stopping calamities" (C: *xizai* 息災; J: *sokusai*) and receiving "well-being."

Buddhist icons were therefore far from being mere artistic representations or aesthetic symbols. They were generally deemed to represent the visible "shadow" (C: *yingxiang* 影像; J: *yōzō*) of divinities or saints empowered to act and respond on their behalf. These visible "shadows" imply an invisible presence and animation rather than inanimate substitution. They constitute the vital link in making "the invisible visible," *invisibilia per visibilia*, to paraphrase a phrase of Saint Paul, who said that visible traces are transitory and invisible things are eternal.[1] Theologians and pious believers alike were deeply concerned with the degree of reality and potency dwelling in a pictorial representation, because sacred icons ensure contact in two directions: on the one hand, they enable the faithful to reach out for the support and salvific power of the unseen Sacred, and on the other hand, they allow the divinity or the venerated *homo religiosus* to respond to the address of the worshipper.[2]

Kūkai 空海 (774–835), the eminent Chinese-trained founder of the chief Esoteric Buddhist school in Japan, the Shingon-shū 眞言宗, in his extensive writings apparently never characterized the production of Buddhist paintings as an artistic performance. That distinguished calligrapher and patron of temple architecture and sculpture consid-

1. Saint Paul in his second letter to the Corinthians, 4: 18. For further aspects of the relationship between *invisibilia* and *visibilia*, see David Freedberg, *The Power of Images: Studies in the History and Theory of Response* (Chicago and London: The University of Chicago Press, 1989), chap. 8: "Invisibilia per visibilia: Meditation and the Uses of Theory," pp. 161–91.

2. Bernard Faure, "The Buddhist Icon and the Modern Gaze," *Critical Inquiry*, vol. 24, no. 3 (Spring 1998), p. 768. Here, Faure sees this spiritual communication as an "asymmetrical exchange of glances that characterizes icon worship."

ered the production of an icon a pious act and the installation of such icons a ritual procedure. For him, the formal aesthetic aspect of a religious work of art seems to have been a *quantité négligeable*, more or less disconnected from the work's ultimate religious significance and experience. He considered art mainly an auxiliary medium through which the meaning of sacred texts could be conveyed and expounded.[3] In his "Memorial on the Presentation of the List of Newly Imported Scriptures" (*Shōrai mokuroku* 請來目録) of 806, he reported to the emperor Heizei 平成 (r. 806–809) on the results of his studies and activities in China:

> The Dharma is beyond speech, but without speech it cannot be revealed. Suchness transcends forms, but without depending on forms it cannot be realized. . . . Since the Esoteric Buddhist teachings are so profound as to defy expression in writing, they are revealed through the medium of painting to those who are yet to be enlightened. The various postures and mudrās [depicted in mandalas] are products of the great compassion of the Buddha; the sight of them may well enable one to attain Buddhahood. The secrets of the sūtras and commentaries are for part depicted in the paintings, and all the essentials of the Esoteric Buddhist doctrines are, in reality, set forth therein. Neither masters nor students can dispense with them. They are indeed [the expression of] the root and source of the ocean-like assembly [of the Enlightened Ones, that is, the world of enlightenment].[4]

Needless to say, Buddhist painting is a sublime expression of religion and art, ennobled equally by spiritual and aesthetic values. The refined artistic embellishment of Buddhist images is termed *alamkāra* (C: *zhuangyan* 莊嚴; J: *shōgon*). This ancient designation joins aesthetic-artistic and religious ideas—splendor and mysterious beauty enhance the sanctity of the image. The two characters, meaning "sanctification by splendor," are exalted to convey the notion of the highest numinous beauty.[5] A religious work of art—like every work of art—always lays claim to be experienced also aesthetically.

Buddhist painting in East Asia is an art form not defined by and confined to national borders; perceptible within its horizons are the differentia that reveal diverse cultural aspirations. It is a subcategory of Asian painting, "itself a rubric within world art, one among the many rooms in André Malraux's famous *musée imaginaire*,"[6] which Ernst H. Gombrich translated as "Museum of the Mind."[7] Basically I agree with Mimi Hall Yiengpruksawan "that the formula of art and nation is a dangerous one in view of the record that nationalism has bequeathed to history."[8] It cannot

3. For Kūkai and his relation to art, see Roger Goepper, "Der Priester Kūkai und die Kunst," in *Religion und Philosophie in Ostasien*. Festschrift für Hans Steininger zum 65. Geburtstag, ed. Gert Naudnorf, Karl-Heinz Pohl, and Hans-Hermann Schmidt (Würzburg: Königshausen & Neumann, 1985), pp. 223–32; and *Kōbō Daishi to mikkyō bijutsu* (*Kōbō Daishi and the Arts of Esoteric Buddhism*), ed. Kyōto kokuritsu hakubutsukan and Tōkyō kokuritsu hakubutsukan (Tōkyō: National Museum, 1983).

4. See Yoshito S. Hakeda, *Kūkai: Major Works* Translated, with an Account of His Life and a Study of His Thought (New York: Columbia University Press, 1972), pp. 145 f.; compare also *Sources of the Japanese Tradition*, comp. Ryusaku Tsunoda, Wm. Theodore de Bary, and Donald Keene (New York: Columbia University Press, 1958), p. 142.

5. Compare Dietrich Seckel, *Buddhistische Kunst Ostasiens* (Stuttgart: W. Kohlhammer, 1957), p. 189.

6. Faure, "The Buddhist Icon and the Modern Gaze," p. 768.

7. Ernst H. Gombrich, "Malraux's Philosophy of Art in Historical Perspective," in *Malraux: Life and Work*, ed. Martine de Courcel (New York: Harcourt Brace Jovanovich, 1976), pp. 169–83.

8. Mimi Hall Yiengpruksawan, "Japanese Art History 2001: The State and Stakes of Research," *The Art Bulletin*, vol. LXXXIII, no. 1 (March 2001), p. 120.

be denied, however, that even with the enduring Buddhist faith as *basso ostinato*, the same religious ideas and concepts, basic iconographical features, forms, and structures manifested themselves differently in different times and regions. Paradigmatic shifts often arose from regional differences or temporal changes in doctrinal emphasis, from spiritual needs of local congregations, or from individual visions and expectations of faithful believers. Despite its ecumenical power throughout the Buddhist world of East Asia, Buddhist painting displayed a subtly differentiated panorama of religious visions, of doctrinal, iconographic, stylistic, and technical features.

When Indian Buddhism reached China and subsequently Korea and Japan, the people in this part of the world encountered a dynamic religion that was able to convince and penetrate all layers of society. Chinese, Koreans, and Japanese had to deal with a foreign system of thought full of blissful promises and salvific prospects. But the creative powers of various regions and periods, peoples and individuals reside precisely in the reflective communion between new ideas and already existing, well-established ones, in the new interpretations growing out of this discourse, and in the final blending-in of the new but now altered system into already existing thought structures and imagery. Let me be clear: I am not advocating a general "Chinese-ness," "Korean-ness," or "Japanese-ness" of Buddhist painting, but I believe that circumspect, penetrating scholarship is, ideally, able to unveil the true identity and life—the origin, history, liturgical function, and perhaps the social or political significance—of a Buddhist painting or monument, by discovering its genuine essentials, its creator, sponsor, donor, audience, affect, and resonance. "If we wish to understand a work of art," writes Rudolf Arnheim, "either by intuitive contemplation or by explicit analysis, we must inevitably start with the pattern of forces that sets its theme and states the reason for its existence."[9]

The study of Buddhist painting in East Asia has been largely a domain of art historians. Most of them were guided by what John Rosenfield called the "gigantic, perhaps overpowering, art historical establishment" of Japan.[10] What is needed now and in the future is a critical exchange beyond disciplinary borders, ideally a close international collaboration of art historians with scholars from related fields such as anthropology, literature, history, history of religion, and especially with Buddhologists. First steps in this direction have been taken in recent years, opening up a broader perspective. Even sophisticated methods and instruments of modern sciences are being employed in art historical research. An increasing reliance on chemical, microscopic, infrared, X-ray, digital, and other sophisticated technologies have greatly aided the meticulous investigation of Buddhist works of art.

It seems to me that art historical studies of Buddhist painting are presently in a "re-" process, a phase of "re-examining," "re-considering," "re-thinking," or "re-vising" the perception and understanding of celebrated monuments or certain aspects of iconography. By skeptics, this may be diagnosed as a serious crisis; to others, "such a

9. Rudolf Arnheim, *Art and Visual Perception: A Psychology of the Creative Eye* (Berkeley and Los Angeles: University of California Press, 1967), p. 424.

10. John M. Rosenfield, "Japanese Art Studies in America since 1945," in *The Postwar Developments of Japanese Studies in the United States*, ed. Helen Hardacre (Leiden: Brill, 1998), p. 163.

Helmut Brinker

crisis should be welcomed with open arms."[11] If the modification of our insight proceeds from a firm grasp of existing knowledge, we may ultimately succeed in "re-envisioning" Buddhist icons, in making them translucent, and in perceiving their wondrous secrets as miracles of the human spirit. Other aspects of the present state of scholarship are the "re-identification" of Buddhist images, the "re-construction" of their original or "shifting identities"—to borrow from one of Sherry Fowler's recent articles[12]—or the discovery of virtually undocumented or unstudied works of Buddhist art, as introduced by Gregory P. Levine under the title "Switching Sites and Identities."[13]

The assumption that historians of East Asian Buddhist art are in a process of "re-discovering" their field and "re-thinking" their subjects is not only corroborated by a number of superb studies in recent years, but—this is my impression—also by the present papers in "Buddhist Painting." Lee Yu-min 李玉珉 in her "A Preliminary Study of the Mural Paintings in Cave 321 at Mogao, Dunhuang" meticulously scrutinizes the iconography and its textual foundations, the historical and political background, and the compositional and stylistic features of the complex murals likely to have been executed during the reign of the zealously Buddhist Tang Empress Wu 武 (624–705; de facto rule 684–705, ascended throne 690). Youngsook Pak 朴英淑 in her paper "Naksan Legend and Water-Moon Avalokiteśvara (Suwŏl Kwanŭm) of the Kŏryŏ Period (918–1392): The Role of Legend in Buddhist Iconography (II)" addresses the intricate interaction of text, image, and function, as well as legend, miracle, and politics. Marsha Weidner in "Portraits and Personalities in the Temples of Ming Beijing: Responses to Portraits of the Monk Dao-yan" unravels the fascinating network of art historical, historical, sociological, political, and religious issues focusing on "one of the most complex personalities of the Ming dynasty." Donohashi Akio 百橋明穂 reconsiders in his paper various aspects of "Portraits of Eminent Priests," re-examining an article that he published more than twenty years ago in *Ars Buddhica* (*Bukkyō geijutsu* 仏教芸術).[14]

Even though spectacular archaeological discoveries of Buddhist paintings are—to my knowledge—far fewer than breath-taking new discoveries of Buddhist sculptures and relic depositories in China, such as the ones at Qingzhou 青州, Shandong Province, or Famensi 法門寺, west of Xi'an 西安 in Shaanxi Province, they also advance our art historical understanding of the visual culture of Buddhism in East Asia. This field, in which remains of Buddhist art and architecture come to light almost every day, is perhaps too important to be left to archaeologists and Buddhologists alone—to counterchange a provocative statement by Bernard Faure.[15]

11. Yiengpruksawan, "Japanese Art History 2001," p. 117.

12. Sherry Fowler, "Shifting Identities in Buddhist Sculpture: Who's Who in the Murōji Kondō," *Archives of Asian Art*, vol. LII (2000–2001), pp. 83–104.

13. Gregory P. Levine, "Switching Sites and Identities: The Founder's Statue at the Buddhist Temple Kōrin'in," *The Art Bulletin*, vol. LXXXIII, no. 1 (March 2001), pp. 72–104.

14. Donohashi Akio, "Tōdaiji kaiga zōkō—Kamakura fukkōki no kaiga seisaku to Kōzō Daishi zō no ichi ni tsuite," *Bukkyō geijutsu* (*Ars Buddhica*), no. 131 (July 1980), pp. 121–26.

15. Faure, "The Buddhist Icon and the Modern Gaze," p. 768.

Let me close with a marginal remark on a personal observation. Among the traces of painting and gilding on the fabulous limestone sculptures unearthed at the Qingzhou site of the putative "Dragon Rise Temple" (Longxingsi 龍 興寺), upon close examination one can discern some tiny remains of cut gold leaf decoration, a technique extensively employed in Buddhist painting of China, Korea, and Japan, where it became known as *kirikane* 切金 (also *kirigane*). It certainly comes as a surprise, that the delicate technique of cutting thin gold leaf into decorative patterns for the adornment of sacred images can now be traced back to the Northern Qi dynasty (550–577), thus lengthening the history of *kirikane* in the Buddhist arts of East Asia by yet another century.[16]

16. The earliest evidence known so far was provided by the impressive Japanese wood sculptures depicting the "Four Heavenly Kings" (Shitennō 四天王), at Hōryūji 法隆寺, Nara, generally dated to the mid-seventh-century. For further information on the polychromed sculptures from Qingzhou, see *The Return of the Buddha: Buddhist Sculptures of the 6th Century from Qingzhou, China*, ed. Lukas Nickel (Zürich: Museum Rietberg, 2002), especially nos. 17 and 19. See also the author's article "Sublime Adornment: *Kirikane* in Chinese Buddhist Sculpture," *Orientations*, vol. 34, no. 10 (December 2003), pp. 30–38.

Helmut Brinker

第二節　佛教繪畫
引言

Helmut Brinker

蘇黎士大學榮譽教授

　　佛教繪畫是宗教與藝術的傑出表現，也由於精神及審美兩方面的價值而顯得尊貴。古老的詞彙「莊嚴」意謂富麗又神秘的妝點有助於塑造形象的尊嚴。與自然的美麗事物對比，宗教藝術品如同所有的人造藝術品，都有權從審美的角度被看待。

　　東亞的佛教繪畫是不能以國家界線定義、限制的藝術形式，它可以容納多種不同文化的想望。即使佛教信仰如基礎低音般持久不變，同樣的宗教概念與觀點、基本的圖象特徵、形式以及結構，在特定的時空內會以獨特的方式呈現出來。

　　佛教繪畫的研究在東亞一般而言屬於藝術史家的領域。現在和未來需要的是跨學科的批評交流。甚至現代科學中複雜的理論和方法也應被用在藝術史的研究中，使用化學、顯微、紅外線、X光、數位以及其他先進技術的情形日漸增加，有助於對佛教藝術品做精細的研究。佛教繪畫的藝術史研究目前處於「重新檢視」的階段，對某些地區或著名的遺跡進行觀念上與認知上的「再發現」、「再定義」、「再探討」、「再判斷」、「再思考」，或者說「更新」。如果只是在已有的學說之上修改我們的觀點，最後會導致對佛教圖象的「再想像」，將其簡化並視其中奧秘為人類精神的奇蹟。

第二部　仏教絵画
序言

Helmut Brinker

チューリッヒ大学名誉教授

　仏教絵画は、信仰と芸術を崇高に表現したものであり、さらに、それは精神的、美的価値観によって高められる。「荘厳」という古代の言葉は、像の神聖な威厳に寄与する壮麗で神秘的な美のオーラを指す。自然の美しい事物とは対照的に、あらゆる人工の芸術作品と同様、宗教的美術作品も美的に鑑賞される権利を主張している。

　東洋の仏教絵画は、国境によって限定され制限されることのない芸術形式である。それは、多様な文化的欲求に共鳴する地平を持つものかもしれない。さらに、永続的な粘り強い仏教信仰を固執低音（basso ostinato）として、同一の宗教思想、宗教概念、基本的な図像学的特徴、形式、構造が、ある時代、ある地域に、具体的に出現してきた。

　東洋の仏教絵画研究は概して美術史家の領域であった。現在、そして将来、必要なことは、学問の領域を越えた批評の交流である。現代科学の精巧な手法や機器も美術史研究にさらに活用されるべきだ。化学、顕微鏡、赤外線、X線、デジタル、その他の高性能な科学技術が仏教美術品の精細な調査に大きく役立っているからである。仏教絵画の美術史的研究は、目下「再生」の途上にある。つまり、ある地域、有名な遺跡に対する認識や理解を、再発見、再確認、再検証、再考、再修正する段階にある。私たちの視線の変化が山積する既存の知識に固く根付いているのなら、それは結局、仏像を再確認し、それを明確なものにし、その驚くべき神秘性を人間精神の奇跡として理解することにつながるかもしれない。

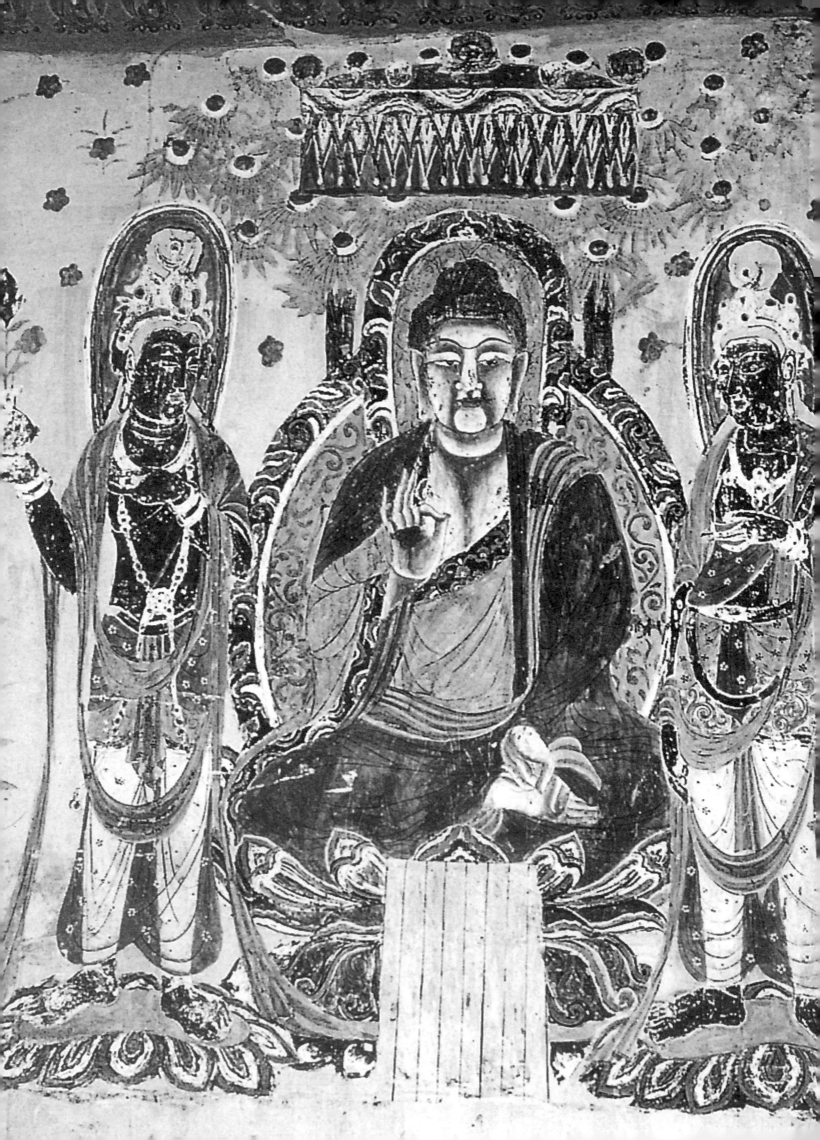

A Preliminary Study of the Mural Paintings in Cave 321 at Mogao, Dunhuang

Lee Yu-min

National Palace Museum, Taipei

Of the existing Mogao 莫高 caves at Dunhuang 敦煌, two hundred and twenty-eight can be dated to the Tang dynasty, forty-four of these to the early Tang period.[1] The early Tang caves can be further subdivided into three phases: (1) from the founding of the Tang to the pacification of Gaochang 高昌 (present-day Turfan, Xinjiang), representing the years 618 to 640; (2) from the pacification of Gaochang to the end of the reign of Gaozong 高宗 (640–684); and (3) thereupon to the period of Wu Zetian's 武則天 political ascendancy (684–704).[2] Caves 321, 323, 332, and 335 are all situated in the first level of the northern end of the southern sector of the Mogao caves. Due to the discovery of inscriptions dating from the reign of Wu Zetian in Caves 323, 332, and 335, it is surmised that Cave 321 was also constructed during Wu Zetian's reign. The Dunhuang Research Academy (Dunhuang yanjiuyuan 敦煌研究院) thus regards Cave 321 as a representative example of Wu Zetian-period cave art and design.[3]

Cave 321 is a medium-sized monastery grotto. Its front is heavily damaged, and only the central Buddha statue remains extant. Fortunately, the Wu Zetian-era murals in the main room are largely intact, allowing Cave 321 to serve as a representative example of Dunhuang cave art from this period (*Diagrams 1 and 2*). This essay will first explore the historical background of the subject matter featured in these murals and then, using them as data, interpret the special characteristics and importance of Dunhuang mural painting during the period of Wu Zetian's rule.

1. Researchers at the Dunhuang Research Academy give different counts of the total number of Tang-period caves. One suggestion is 223 (Shi Weixiang, "Dunhuang Mogaoku de *Baoyu jingbian* [The *Baoyu Sūtra* at the Mogao Grottoes of Dunhuang]," in *1983 nian quanguo Dunhuang xueshu taolunhui wenji: Shiku yishu bian* [*Papers from the 1983 National Dunhuang Academic Conference: Volume on Grotto Art*], ed. Dunhuang yanjiuyuan [Lanzhou: Gansu renmin chubanshe, 1985], vol. 1, p. 80). Another is over 230 (Fan Jinshi and Liu Yuquan, "Dunhuang Mogaoku Tang qianqi dongku de fenqi yu yanjiu [Analysis and Periodization of the Early Tang Grottoes at Mogao, Dunhuang]," in *Dunhuang yanjiu wenji: Dunhuang shiku kaogu pian* [*Research Essays on Dunhuang: Volume on Archaeology of the Dunhuang Grottoes*], ed. Dunhuang yanjiuyuan [Lanzhou: Gansu minzu chubanshe, 2000], p. 143). Ma De writes that there are ". . . approximately 140 caves from the early Tang, fifty from the Tibetan period, and eighty from the period of Zhang clan rule" (see Ma De, *Dunhuang Mogaoku shi yanjiu* [*Research on the Mogao Grottoes at Dunhuang*] [Lanzhou: Gansu jiaoyu chubanshe, 1997], p. 46). Thus, according to Ma De's estimate, the Mogao complex includes as many as 270 caves from the Tang dynasty. The present essay uses the estimate of Duan Wenjie, the former director of the Dunhuang Research Academy. See Duan Wenjie, "Chuangxin yi daixiong: Dunhuang shiku chu Tang bihua gaiguan (Innovation Replacing Majesty: An Overview of Early Tang Wall Paintings at the Dunhuang Grottoes)," in *Zhongguo bihua quanji: Dunhuang 5 (chu Tang)* (*Complete Collection of Chinese Wall Paintings: Dunhuang V [Early Tang]*), ed. Duan Wenjie (Shenyang: Liaoning meishu chubanshe, 1989), p. 3.

2. Duan Wenjie refers to these three phases as the Wude 武德, Zhenguan 貞觀, and Wuzhou 武周 periods, respectively. See Duan Wenjie, "Chuangxin yi daixiong," p. 3.

3. See Ji Xianlin, ed., *Dunhuangxue dacidian* (*Dictionary of Dunhuang Studies*) (Shanghai: Shanghai cishu chubanshe, 1998), p. 52.

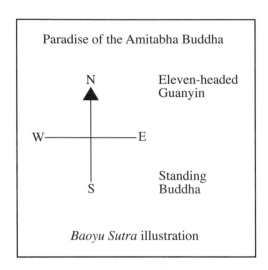

Diagram 1. Arrangement of the murals on
the main walls of Cave 321.

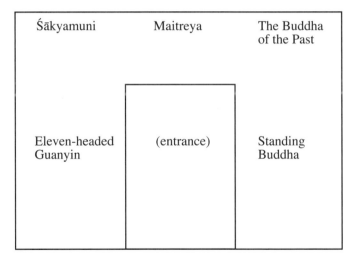

Diagram 2. Arrangement of murals on the east wall of Cave
321. (viewed from the inside, facing the entrance).

Mural Subjects and Religious Content

The most noteworthy mural in Cave 321 is probably the sūtra illustration on the south wall (*Fig. 1*), which is organized into upper and lower sections. In the upper section is a hierarchy of ten preaching divinities. Dividing the two sections is a band of blue clouds, at the center of which is a pair of hands, one holding the sun, the other holding the moon. The lower and primary section of the painting, which constitutes eighty percent of the entire mural, shows a seated Buddha against a background of mountains. The Buddha sits on a lotus throne, his hands in the *dharma-cakra mudrā* (C: *zhuan falun yin* 轉法輪印). Flanking the throne are bodhisattvas, monks, and heavenly kings, all listening intently to the Buddha's preaching. Painted below and to either side of the main subjects are various minor

scenes. The mural is indeed an extraordinary composition, and it is also the only one of its kind found in Dunhuang.

In a 1983 paper, Shi Weixiang 石葦湘 demonstrated that the mural was based on the *Baoyu (Precious Rain) Sūtra (Foshuo Baoyu jing* 佛說寶雨經; S: *Ratnamegha Sūtra*).[4] Bodhiruci (the north Indian missionary-monk also known as Dharmaruci) had translated this sūtra in 693. The central portion of the mural depicts the prelude to the sūtra—the Buddha preaching at Mount Gayā. To the lower right of the lotus throne, wearing luxurious green garments, her palms placed together in prayer, is a female manifestation of the Heavenly Prince of the Sun and Moon (Riyueguang tianzi 日月光天子), who has come to venerate the Buddha. Below the throne is the Zhigai 止蓋 Bodhisattva, head raised in supplication, beseeching the teaching of the Buddha. Over the Buddha's head is a parasol of intertwined flowers decorated with strings of pearls and hanging bells. Surrounding the Buddha are jewels, flowers, and musical instruments, which appear to be drifting down from the heavens. This depiction is entirely consistent with the description in the *Baoyu Sūtra*.[5] Flanking the Buddha on either side are also illustrations of episodes from each of the ten chapters of that sūtra.[6]

The most prominent feature of the *Baoyu Sūtra* illustration in Cave 321 is the band of colored clouds above the main scene. The clouds themselves should illustrate the "Great Dharma Clouds and Rain" (*Dafa yunyu* 大法雲雨) mentioned in the *Baoyu Sūtra*.[7] The clouds, however, also show two massive hands, one holding the sun and the other the moon, an element not found in the sūtra. Shi Weixiang provides a superb explanation of this feature:

> The Chinese ruling classes have long regarded the sun, moon, and sky as symbols of the monarch's unrivalled status. . . . This painting not only expresses the religious content of the *Baoyu Sūtra* but also has clear political implications. The placement of the sun and moon above the sky [in the main scene] can be read as political propaganda when we learn about the Chinese character *kong* ("empty") [is a synonym for "sky"]. The arrangement of these three elements—sun, moon, and *kong* can be found in the character for Wu Zetian's given name [Zhao]. Thus, the design overarching the main scene of the *Baoyu Sūtra* illustration is an emblem for the reign of Wu Zetian.[8]
> 歷來統治階級都把日、月、海天等圖像，認為是帝王「唯我獨尊」的象徵。⋯這條畫除了表現《寶雨經》的宗教含義之外，一定還有它的政治含義。果然，這幅為日月光天子作宣傳的橫條上，海天為「空」，上有日月，正是武則天的聖諱「曌」字的圖解。《寶雨經變》上這一條特殊的飾帶應視為武周王朝的紋章。

From this, it is clear that this sūtra illustration is closely connected with Wu Zetian. In fact, scholars have also determined that Bodhiruci's retranslation of the *Baoyu Sūtra* was intended to glorify Empress Wu's reception of the "Mandate of Heaven" (*Tianming* 天命) in 690.[9]

4. Shi Weixiang, "Dunhuang Mogaoku de *Baoyu jingbian*," pp. 71–83.

5. Dharmaruci, trans., *Foshuo Baoyu jing*, in *Taishō shinshū Daizōkyō* (*The Buddhist Canon Published in the Taishō Era*), ed. Takakusu Junjirō and Watanabe Kaikyuoku (Tokyo, 1924–1932), vol. 16, pp. 284–85.

6. For a discussion of the similarities between this mural and the *Baoyu Sūtra*, see Shi Weixiang, "Dunhuang Mogaoku de *Baoyu jingbian*," pp. 62–70; and Liang Weiying, *Dunhuang shiku yishu: Mogaoku 321, 329, 335* (*Grotto Art at Dunhuang: Mogao Caves 321, 329, 335*) (Nanjing: Jiangsu meishu chubanshe, 1996), pp. 222–28.

7. Dharmaruci, trans., *Foshuo Baoyu jing*, in *Taishō shinshū Daizōkyō*, vol. 16, pp. 296c, 297a, 298c, 299a–b, 303a.

8. Shi Weixiang, "Dunhuang Mogaoku de *Baoyu jingbian*," p. 64.

9. Yabuki Keiki, *Sangaigyō no kenkyū* (*Research on the Three Stages Sect*) (Tokyo: Iwanami shoten, 1927), pp. 748–60; Shig-

Between the sixth and seventh century, three translations of the *Baoyu Sūtra* were produced. The last of these was finished in 693 by Bodhiruci, in residence at the monastery Foshoujisi 佛授記寺 in Luoyang 洛陽.[10] Although the contents of these three translations are largely the same, Bodhiruci's translation contains the following additional text:

> To the east there was then a *deva*, called the Heavenly Prince of the Sun and Moon, who came to visit the place of the Buddha riding on a five-bodied cloud. . . . The Buddha, turning to the *deva*, said: ". . . in the last period following my Nirvāna, in the fourth five-hundred year period, when the Law is about to fade away, you, in the country of Mahācīna in the northeastern region of the Jambudvīpa, will be in the position of *Avaivartika* (one who never recedes). Since in reality you, *Deva*, are a bodhisattva, you will manifest a female body and you will be the sovereign. After many years, the proper Dharma will be ordered and many lives cultivated, as if they were your own children. . . . *Deva*, there are, however, in the body of women Five Impediments (*pancavaranam*). What are they? They will not become a 1) *Cakravartin*, 2) *Sakra Devendra*, 3) *Brahma Devaraja*, 4) *Avaivartika Bodhisattva*, and 5) *Tathagata*. But you, *Deva*, of the five positions will obtain two: the so-called *Avaivartika* and *Cakravartin*.[11]
> 爾時東方有一天子名日月光，乘五身雲來詣佛所。…佛告天曰：…我涅槃後最後時分，第四五百年中法欲滅時，汝於此贍部洲東北方摩訶支那國，位居阿鞞跋致，實是菩薩故現女身爲自在主。經於多歲正法治化。養育眾生猶如赤子。…天子，然一切女人身有五障。何等爲五：一者不得作轉輪聖王、二者帝釋、三者大梵天王、四者阿…跋致菩薩、五者如來。天子，然汝於五位之中當得二位，所謂阿鞞跋致及輪王位。

In the text, the Heavenly Prince of the Sun and the Moon receives a revelation from the Buddha, proclaiming that he would reincarnate in the form of a woman and become the Universal Ruler, *cakravartin* (C: *Zhuanlun shengwang* 轉輪聖王), of the kingdom of China. Wu Zetian viewed this story as a Buddhist "Mandate of Heaven" for her reign and used it as propaganda to legitimize her rule. This story coincidentally resembles a proclamation found in the *Commentary on the Dayun (Great Cloud) Sūtra* (*Dayun jing shu* 大雲經疏), authored by Xue Huaiyi 薛懷義 and other monks in 690. The proclamation reads: "(Wu) Zetian is an incarnation of Maitreya and will serve as the leader of the land of Jambūdvīpa (則天是彌勒下生，作嚴浮提主)."[12] Thus, it appears that Bodhiruci's retranslation of the *Baoyu Sūtra* did not come about spontaneously but rather as a result of political manipulations by Wu Zetian. The list of translators (*yichang liewei* 譯場列位) found in Stein 2278 (a manuscript copy of the ninth *juan* 卷 of the *Baoyu Sūtra*) includes the following names: Xue Huaiyi 薛懷義, Chuyi 處一, Degan 德感, Zhijing 知靜, Xinggan 行感, Huiyan 惠儼, Faming 法明, and Huiling 惠稜. These same individuals were not only active in Empress Wu's

enoi Shizuga, "Hōkyō o meguru jakkan no kōsatsu (An Examination on the *Baoyu Sūtra*)," *Yindogaku Bukkyōgaku kenkyū* (*Studies on Buddhism and Hinduism*), vol. 20, no. 1 (1971.12), pp. 41–51; Antonino Forte, *Political Propaganda and Ideology in China at the End of the Seventh Century* (Naples: Instituto Universitario Orientale, 1976), pp. 125–77; Rong Xinjiang, "Tulufan chutu 'Wuzhou Kangjushi xiejing gongdeji bei' (Stele Record Unearthed in Turfan of the Dedication of Sūtra Writing by Layman Kang of Wuzhou)," *Minda shixue* (*Minda Historical Studies*), vol. 1 (1996); repr. Rong Xinjiang, *Zhonggu Zhongguo yu wailai wenming* (*Medieval China and External Civilizations*) (Beijing: Shenghuo, dushu, xinzhi sanlian shudian, 2001), pp. 204–21.

10. Mingquan *et al.*, *Da Zhou kanding zhongjing mulu* (*Catalogue of Sūtras from the Great Zhou*), in *Taishō shinshū Daizōkyō*, vol. 55, pp. 396b–c.

11. Dharmaruci, trans., *Foshuo Baoyu jing*, in *Taishō shinshū Daizōkyō*, vol. 16, p. 284b.

12. Liu Xu *et al.*, *Jiu Tangshu* (*Old Book of the Tang*), chap. 183 (*Xue Huaiyi zhuan* [*Biography of Xue Huaiyi*]) (Beijing: Zhonghua shuju, 1974), p. 4742.

inner court but also responsible for drafting the *Commentary on the Dayun Sūtra*, and thus for fabricating the notion of Wu Zetian as an incarnation of Maitreya, the Buddha of the Future. Research by Antonino Forte further reveals that the story of the female reincarnation of the Heavenly Prince of the Sun and Moon found in the translated *Baoyu Sūtra* was most likely composed by the same people who wrote the *Commentary on the Dayun Sūtra*.[13]

Further evidence for the prevalence of these two texts can be found in a passage from the *Stele of the Cave Constructed by Mr. Li at Mogao* (*Lijun Mogaoku fokan bei* 李君莫高窟佛龕碑), dating from the year 698, which states that "because of the beginning of the True Dharma, the great clouds (*dayun*) and precious rain (*baoyu*) extended over all (更紹眞乘，初隆正法，大雲遍布，寶雨滂流)."[14] This wording demonstrates the familiarity of the Mogao cave builders with the *Dayun* and *Baoyu* sūtras, which in turn shows that these two texts had reached western China, despite the remoteness of the Mogao caves from the Tang metropolitan region. The depiction of the female manifestation of the Heavenly Prince of the Sun and Moon venerating the Buddha, found in the *Baoyu Sūtra* illustration in Cave 321, therefore had the propagandist function (among other more pious ones) of legitimating Wu Zetian's reign.

Of the six extant copies of the *Baoyu Sūtra*, four were originally recovered from Dunhuang. According to research by Rong Xinjiang 榮新江, it is quite likely that the new translation of the *Baoyu Sūtra* produced under the reign of Wu Zetian was, like the *Commentary on the Dayun Sūtra*, distributed to temples throughout the empire, where it was recited on imperial order. For example, it appears that Stein 2278 is an imperially commissioned copy of the *Baoyu Sūtra* that was sent from the court to the palace at Shazhou 沙州 (present-day Dunhuang).[15] Its presence in Shazhou would make the existence of *Baoyu Sūtra* illustrations at Cave 321 thoroughly plausible.

The northern wall, directly opposite the *Baoyu Sūtra* mural, bears a grand illustration of the paradise of Amitābha Buddha (*Fig. 2*). It is composed of three horizontal sections. The middle section contains three platforms constructed of brick and interconnected by bridges, symbolizing the land of the seven jewels. The Triad of the Western Paradise (Xifang [jile shijie] sansheng 西方[極樂世界]三聖)—Amitābha, Avalokiteśvara, and Mahāsthāmaprāpta sits on the middle platform. Many other bodhisattvas surround the platform. Two strolling Buddhas are found close to the two flanking platforms, followed by ten bodhisattvas who represent the various followers coming to listen to Amitābha preach. The lower section is a magnificent dance scene, with two dancers and a band of musicians, behind whom are bodhisattvas holding banners. The upper section of the mural illustrates a blue sky, filled with clouds that take the form of extravagant pavilions and pillars. Four groups of Buddhas are riding clouds in the midst of flying instruments. Their graceful movements and billowing clothes harmonize well with the fluent clouds. The scene of the lotus pond, seen in the middle and bottom sections of the illustration, is populated with pea-

13. Antonio Forte, *Political Propaganda and Ideology in China*, pp. 72–79, 134–36.

14. Su Bai, *Zhongguo shikusi yanjiu* (*Research on Grotto Monasteries of China*) (Beijing: Wenwu chubanshe, 1996), p. 265; Ma De, *Dunhuang Mogaoku shi yanjiu*, p. 276.

15. Rong Xinjiang, "Tulufan chutu 'Wu Zhou Kangjushi xiejing gongdeji bei'," pp. 213–14.

Lee Yu-min

cocks, mandarin ducks, and other fauna. Flanking the lotus pond stand a pair of pavilions, occupied by many heavenly deities. The whole mural thus illustrates the joys associated with the Western Paradise.

Six sūtras concerning the Western Paradise existed in China during the reign of Wu Zetian: three translations of the *Large Sukhāvatī-vyūha Sūtra* (*Sutra of the Land of Bliss*; C: *Da Amituo jing* 大阿彌陀經), two of the *Small Sukhāvatī-vyūha Sūtra* (*Xiao Amituo jing* 小阿彌陀經) and one of the *Amitāyus-dhyāna Sūtra* (*Sūtra on Visualizing the Buddha of Infinite Life*; C: *Guan Wuliangshoufo jing* 觀無量壽佛經). The many subjects found in the paradise tableau on the northern wall, such as the Triad of the Western Paradise, the seven-jewelled towers, and the many musical instruments, can be found in both *Sukhāvatī-vyūha* sūtras, and the work has therefore been termed a *Sukhāvatī-vyūha Sūtra* illustration. Close observation of this mural, however, reveals that many of the subjects do not belong to either *Sukhāvatī-vyūha Sūtra*. For example, the nine classes of the afterlife are not described in the *Sukhāvatī-vyūha Sūtra*, but figure importantly in the *Amitāyus-dhyāna Sūtra* instead. Another example is the image of two trees standing beside the two strolling Buddhas on the flanking platforms of the north wall in Cave 321. Above the trees is a magnificent five-storied compound, composed of many palaces and decorated with countless jewels and precious objects. This obviously illustrates the "Meditation on the Precious Tree" (Baoshuguan 寶樹觀), which forms part of the *Amitāyus-dhyāna Sūtra*.[16] It is thus evident that the illustrations in Cave 321 drew upon both the *Sukhāvatī-vyūha* and the *Amitāyus-dhyāna* sūtras.

Master Shandao 善導 (613–681), regarded as a reincarnation of Amitābha,[17] was a great promoter of the Pure Land (C: *Jingtu* 淨土) faith, created many artistic depictions of the Western Paradise, and greatly advanced popular belief in the Western Paradise in the early Tang dynasty. The Japanese monk Nichien 日延, who travelled to China in the tenth century and wrote *Records of Divine Miracles Seen on Travels to the Western Paradise* (*Ōjō seihō Jōdo zuiōden* 往生西方淨土瑞應傳; 958), mentioned that Master Shandao produced two hundred Pure Land sūtra illustrations during his lifetime.[18] Nichien's text, however, does not describe these illustrations. Shandao, in his *Contemplation of the Various Virtues and Merits of Amitābha Buddha* (*Guannian Amituofo xianghai sanmei gongde famen* 觀念阿彌陀佛相海三昧功德法門), comments that, if believers continuously contemplated the scenes of the sixteen meditations depicted in illustrations of the *Amitāyus-dhyāna Sūtra*, they could nullify all the sins accumulated over their many past lives.[19] Shandao's text also indicates that illustrations based on the *Amitāyus-dhyāna Sūtra* were referred to as Western Paradise sūtra illustrations. Thus, it can be speculated that Shandao's Western Paradise sūtra illustrations all drew on the *Amitāyus-dhyāna Sūtra*.

16. See Huang Xinghui, "Tangdai chuqi Dunhuang Mogaoku de Xifang Jingtu bian (The Western Paradise of the Pure Land at Early Tang Mogao Caves of Dunhuang)" (M.A. thesis, Chinese Cultural University, Taipei, 1991), pp. 123–24.

17. Zhipan, *Fozu tongji* (*Overall Record of the History of Buddhism*), chap. 26, in *Taishō shinshū Daizōkyō*, vol. 49, p. 260c.

18. Nichien, *Ōjō Seihō jōdo zuiōden*, in *Taishō shinshū Daizōkyō*, vol. 51, p. 105c. *Fozu tongji*, by contrast, gives a figure of 300 Pure Land sūtra illustrations. See Zhipan, *Fozu tongji*, p. 263b.

19. See Shandao, *Guan nian Amituofo xianghai sanmei gongde famen*, in *Taishō shinshū Daizōkyō*, vol. 47, p. 25a.

Use of the *Amitāyus-dhyāna Sūtra* as a basis for illustrations of the Western Paradise was not an innovation of Shandao. Earlier traces of the *Amitāyus-dhyāna* nine classes of the afterlife can be seen in mural illustrations at Mogao Cave 220, created in 642, when Shandao was still a student monk and not yet influential. Therefore, the Western Paradise illustration found in Cave 220 (*Fig. 3*) could have been based on paradise ideologies that existed prior to Shandao's writings.[20] Although the *Amitāyus-dhyāna Sūtra* was used as a source for Western Paradise illustrations before Shandao, it was, however, the monk's influence that cemented the popularity of these illustrations. Wang Huimin 王惠民 has pointed out that, according to *Inventory of the Contents Found in the Dunhuang Mogao Caves* (*Dunhuang Mogaoku neirong zonglu* 敦煌莫高窟內容總錄), in the early Tang dynasty only two Western Paradise illustrations were based on the *Amitāyus-dhyāna Sūtra*, as opposed to sixteen on the *Sukhāvatī-vyūha Sūtra*. In over ten of the illustrations based on the *Sukhāvatī-vyūha Sūtra*, however, he found traces of the *Amitāyus-dhyāna Sūtra*.[21] This demonstrates that, from at least the early Tang, Western Paradise illustrations were influenced by the *Amitāyus-dhyāna Sūtra*.

A fact worth noticing is that out of the twelve (according to Fan Jinshi 樊錦詩 and Liu Yuquan 劉玉權) surviving early Tang *Sukhāvatī-vyūha Sūtra* illustrations in the Mogao caves,[22] half were painted during the reign of Wu Zetian,[23] possibly due to enthusiastic support from the empress. The Japanese monk Miyoshi Kiyoyuki 三善清行 records in his *Biography of the Monk Enchin at Enryakuji* (*Tendaishū Enryakuji zasu Enchin den* 天台宗延曆寺座主圓珍傳; 902) that:

> In the ninth year of the Jōgan reign of Seiwa Tennō (867), the Tang monk Deyuan, a native of Wenzhou who served in the imperial temple of Emperor Seiwa, presented to Zhan Jingquan, a native of Wuzhou, a Western Paradise sūtra illustration from a set of four hundred embroidered by Empress Wu Zetian. [It was given as a farewell gift upon] Zhan's return to his country.[24]
> 清和天皇貞觀九年，唐溫州內道場供奉德圓座主付婺州人詹景全向國之便，贈則天皇后縫繡四百幅之內《極樂淨土變》一鋪。

20. Katsuki Genichiro has noted that in 642 Shandao was merely twenty-nine *sui* 歲 (approximately twenty-eight years old) and had yet to complete his representative work, *Guanjing sitie* (*Four Writings on the Visualizing Sutra*). Thus, the Western Paradise illustrations in Cave 220 were definitely based on Pure Land philosophy which preexisted Shandao, possibly the thought of Huiyuan 慧遠 (of Jingyingsi 淨影寺; 523–592) or Master Jiaxiang 嘉祥. See Katsuki Genichiro, "Tonkō Bakkōkutsu dainihyakunijūkutsu Amida jōdo hensō zōkō (Research on the Transformation Illustrations of the Pure Land of Amitabha at Mogao Cave 220 at Dunhuang)," *Bukkyō geijutsu* (*Ars Buddhica*), vol. 202 (1992.5), p. 85.

21. Wang Huimin has noted that, of the sixteen *Sukhāvatī-vyūha Sūtra* illustrations, fourteen do not contain representations of the stories of Prince Ajātaśatru and the complete set of sixteen meditations. These illustrations are located in Caves 71, 78, 123, 124, 205 (north wall), 211 (north wall), 220, 321, 322, 329, 335, 338, 341, and 392. See Wang Huimin, "Dunhuang Sui zhi Tangqianqi de *Guan jing* tuxiang kaocha (Examination of Sui to Early Tang Illustrations of the *Visualizing Sūtra* at Dunhuang)" (unpublished, 1996), pp. 9–15. According to the *Mogaoku neirong conglu* and Fan Jinshi and Liu Yuquan ("Dunhuang Mogaoku Tang qianqi dongku de fenqi yu yanjiu"), however, Caves 123 and 124 both date from the High Tang, and thus there are only a total of twelve early Tang *Sukhāvatī-vyūha Sūtra* illustrations.

22. *Ibid.*

23. These illustrations are located in Caves 321, 329, 335, 338, 341, and 372.

24. Miyoshi Kiyoyuki, *Tendaishū Enryakuji zasu Enchin den*, in *Dainihon Bukkyō zensho* (*Complete Book of Buddhism in Japan*) (Kyoto: Bussho kankōkai, 1918), p. 1372.

According to this record, then, Wu Zetian had produced four hundred embroidered Western Paradise sūtra illustrations while she was empress.

Record of the Vairocana Niche at the Fengxian Monastery Cave in Longmen (*Longmen Fengxiansi Dalushe'na-xiang kan ji* 龍門奉先寺大盧舍那像龕記),[25] dated to 672, notes that Wu Zetian donated twenty thousand cash that had been allotted for cosmetics to support the construction of the Fengxian Cave. Master Shandao was overseer of the construction, which would have entailed contact between Shandao and the empress. Therefore, Shandao may well have been a motivating force behind the large-scale production of Western Paradise sūtra illustrations during the Wu Zetian era. Given the circumstantial evidence for close contact between the monk and the empress, Wu Ze-tian's embroidered versions of the Western Paradise sūtra illustrations probably drew upon elements in the *Amitāyus-dhyāna Sūtra*.

The eastern wall of Cave 321 bears three paintings of seated Buddhas. Each image is accompanied by an inscription that is now indecipherable. The painting above the door depicts Maitreya as the Buddha of the Future (*Fig. 4*). Flanking the Buddha on each side are two bodhisattvas. Two monks and two bodhisattvas attend the Buddha on Maitreya's north side (*Fig. 5*), indicating that the subject is Śākyamuni, the Buddha of the Present. The central figure in the illustration on Maitreya's south side (*Fig. 6*), by contrast, is flanked only by a pair of bodhisattvas, and thus quite likely it is a representation of a Buddha of the Past. In sum, this mural depicts the Buddhas of the Past, Present, and Future.

Flanking the entrance on the north is a triad of bodhisvattas (*Fig. 7*), the central one an Eleven-headed Guanyin 觀音 (S: Ekādaśamukha Avalokiteśvara) crowned with an image of Amitābha Buddha. This Guanyin has six arms, the two uppermost upward curved, forming a mudrā gesture. The middle right arm extends outward in front of the chest, forming the *vitarka mudrā* (*anwei yin* 安慰印), a gesture of appeasement. The middle left arm is pendent. In the lower right hand is a willow branch, and in the lower left hand a water vase. Currently extant are only five Elev-en-headed Guanyin illustrations in early Tang Mogao caves.[26] Since all were completed during the reign of Wu Ze-tian, we may surmise that this particular representation of Guanyin was a very important subject during Wu's reign.

Although a sūtra concerning the Eleven-headed Guanyin, *Ekādaśamukha-Avalokiteśvara-mantra Sūtra* (C: *Shi-yimian Guanshiyin shenzhou jing* 十一面觀世音神咒經), was translated as early as the reign of Wudi 武帝 of the Northern Zhou 周 (r. 560–578), it was Wu Zetian who most promoted the popularity of the Eleven-headed Guanyin. *Biography of the Great Monk Facang of the Great Tang Dynasty* (*Tang Dajianfusi gusizhu fanjing dade Facang*

25. For a complete account of the images in this cave, see Liu Jinglong, Li Yukun, and Longmen shiku yanjiusuo, eds., *Long-men shiku beike tiji huilu* (*Catalogue of Carved Records and Steles at the Longmen Grottoes*) (Beijing: Zhongguo dabaike quanshu chubanshe, 1998), vol. 2, p. 381.

26. In addition to the example in Cave 321, the other four early Tang Eleven-headed Guanyin images are found above the entrances of Caves 334 and 340, and on either side of the seated Buddha above the entrance of Cave 341. For reproductions of these images, see Duan Wenjie, ed., *Zhongguo bihua quanji: Dunhuang 5 (chu Tang)*, pls. 165, 196, 197.

heshang zhuan 唐大薦福寺故寺主翻經大德法藏和尚傳) records that, in the year 697, a Tang military expedition was ordered against the insubordinate Khitan. To ensure military success, Empress Wu Zetian ordered Facang to build a *daochang* 道場 (ritual performance area) dedicated to the Eleven-headed Guanyin. It was completed, and the Khitan were subsequently defeated,[27] thereby reinforcing the belief in the protective power of Guanyin over the state. Worth noting in this connection is that Degan, who participated in translating the *Baoyu Sūtra* and drafting the *Commentary on the Dayun Sūtra*, had a statue of the Eleven-headed Guanyin made in the year 703. The inscription on this statue records: "For the sake of the state, we respectfully created this statue of the Eleven-headed Guanyin in the hope that the Empress and her reign will live and prosper forever (奉爲圀敬造十一面觀音像一區，伏願皇基永固，聖壽遐長)."[28] This also clearly demonstrates a strong belief in the protective power of the Eleven-headed Guanyin. Further evidence of these protective associations can be seen in the placement of Eleven-headed Guanyin paintings close to the eastern entrances of Mogao caves from the era of Wu Zetian's rule.[29]

In fact, Wu Zetian was promoting the veneration of the Eleven-headed Guanyin well before 697. The colophon to *Vows to Make Bodhisattva Statues* (*Zao pusa yuanwen* 造菩薩願文), preserved at the Shōsōin 正倉院 in Japan, states:

> On the fourth day of the twelfth month of Chuigong (686), the Tang dowager empress had a thousand embroidered copies of the "Eleven-headed Guanyin Bodhisattva" and a vow (*yuanwen*) made on behalf of Emperor Gaozong; and had an Eleven-headed Guanyin Bodhisattva and a vow made on behalf of the former kings and concubines.[30]
> 垂拱二年十二月四日，大唐皇太后奉爲高宗大帝，敬造繡《十一面觀世音菩薩》一千鋪、願文一首。奉爲先王、先妃，造十一面觀世音菩薩、願文一首。奉爲（後闕）。

Wu Zetian also ordered eight relief images of the Eleven-headed Guanyin carved on the Seven Treasures Pagoda (Qibaotai 七寶台), which she erected in the Guangzhaisi 光宅寺 (seven of which survive today).[31] Such large numbers of images demonstrate not only Wu Zetian's firm belief in the Eleven-headed Guanyin but also her predilection for icons of this bodhisattva. Given the already-noted strong allusion to Wu Zetian in the *Baoyu Sūtra* illustration in Cave 321, the presence in the cave of an Eleven-headed Guanyin should come as no surprise.

Flanking the entrance on the south is a standing Buddha (*Fig. 8*). His right hand is pendent, and his left hand is extended in a mudrā. Shaded by a parasol, the Buddha is striding across lotus blossoms, accompanied by a pair of bodhisattvas. Caves dating from the second phase of the early Tang dynasty often feature depictions of a standing

27. Cui Zhiyuan, *Tang Dajianfusi gusizhu fanjing dade Facang heshang zhuan*, in *Taishō shinshū Daizōkyō*, vol. 50, p. 203c.

28. Quoted in Yen Chüan-ying, "Wu Zetian yu Tang Chang'an Qibaotai shidiao foxiang (Wu Zetian and the Stone Buddhist Sculptures from the Seven Jewels Pagoda in Chang-an)," *Yishuxue* (*Study of the Arts*), vol. 1 (1987), p. 58.

29. See Chuan-ying Yen, "The Sculpture from the Tower of Seven Jewels: the Style, Patronage and Iconography of the Monument" (Ph.D. diss., Harvard University, 1986), p. 72; Wang Huimin, "Wu Zetian shiqi de mijiao zaoxiang (Esoteric Sculptures of the Wu Zetian Era)," *Yishushi yanjiu* (*Studies in Art History*), vol. 1 (1999), p. 258.

30. Ikeda On, ed., *Chūgoku kodaishahon shikigo shūroku* (*Collection of Texts from Written Sources in Ancient China*) (Tokyo: Tōkyō daigaku tōyō bunka kenkyūsho, 1990), p. 235.

31. See Yen Chüan-ying, "Wu Zetian yu Tang Chang'an Qibaotai shidiao foxiang," p. 57, pls. 5–11.

Buddha (or Buddha triad or quintet) flanking either side of the entrance. Sometimes, the Buddha is depicted holding a cane and a medicine bowl,[32] which has earned it the name "Medicine Buddha" (C: Yaoshifo 藥師佛). The present triad, however, is as yet unidentified.

Stylistic Analysis

Not only do the caves reveal new subject matter, they also present new mural styles. The Wu Zetian murals exhibit much more complexity and richness of coloring than that found in earlier works. Most noticeable is the dramatic increase in the use of blue pigment in the halos, mandorlas, lotus thrones, and clothes of the Buddha and bodhisattva figures in the murals. The upper section of the Western Paradise sūtra illustration on the north wall (see *Fig. 2*) and the top of the niche in the west wall were painted with copious amounts of blue, creating a color scheme that graces the whole cave.

Due to the drastic decay of the sūtra illustrations on the northern and southern walls, it is very difficult to picture the original look of these murals. Fortunately, the two preaching Buddhas found on the upper panels over the entrance are well preserved, thereby allowing plausible speculation about the unique style of figure painting in the Wu Zetian period. The colors in the painting of Śākyamuni preaching (see *Fig. 5*) are bright and lively; the Buddha has a full, round face, with large, elongated eyes. Compared with the Amitābha Buddha in the Western Paradise sūtra illustration depicted in Cave 220 (*Fig. 9*), this Buddha is fuller in figure, with broad and fleshy shoulders. His attendant bodhisattvas have bare torsos, with long skirts of translucent gauze and upper garments decorated with floral motifs, showing the curves of their realistically rendered bodies. This style, already evident in Cave 220, was influenced by Indian art. However, the contrapossto postures (S: *tribhaṅga*) of the bodhisattva figures accompanying Maitreya on the east wall in Cave 321 (see *Fig. 4*) are, by comparison, even more realistic and animated. The long, graceful forms of the *apsarā* celestial maidens (*Fig. 10*) in Cave 321 are magnificent. Against the blue sky, the motions of their flight seem effortless and fluid, particularly in contrast with similar images that are found from the second phase of the early Tang (*Fig. 11*).

In early Tang caves of the second phase, figures are depicted with protruding features shaded and recessed areas left uncolored. The painters of Cave 321 adopted Central Asian shading techniques to render the contours of the facial features and achieve a more three-dimensional effect. Known as the "inner-outer" (*aotu* 凹凸) technique in Chinese, this method was used extensively at Mogao beginning in the Northern Dynasties period. The technique had evolved greatly by the time it was used in Cave 321, where the shading is more delicate and refined than in early caves. At the same time, the painters responsible for Cave 321 also described the figures' clothing with fluid and dense parallel lines, which, for their even thickness and wiry strength, are known as "iron wire-strokes" (*tie xian* 鐵

32. See Duan Wenjie, ed., *Zhongguo bihua quanji: Dunhuang 5 (chu Tang)*, pl. 30; Liang Weiying, *Dunhuang shiku yishu: Mogaoku 321, 329, 335*, pl. 181.

線) in the language of traditional Chinese figure painting. This fusion of Central Asian and Chinese painting styles was unprecedented at Mogao. It is highly unlikely that these features could have developed independently within the Mogao Cave system. As mentioned above, the subject matter of the murals in Cave 321 also reveals Tang metropolitan influence. Can the same be said of their style?

During the early Tang dynasty, many famous painters were active in Chang'an 長安 and Luoyang. The styles of these painters can be divided into two schools.[33] One was the traditional Chinese style, represented by Yan Liben 閻立本 (d. 673), while the other was the Central Asian style, led by Yuchi Yiseng 尉遲乙僧 (act. ca. 650–710).[34] Yan, who inherited from the painting traditions of the Six Dynasties, was particularly skilled at representing noble figures. He used even colors and simple lines to delineate the forms, facial features, and characteristics of his subjects. His clothing folds are succinct, rendered with upright brush strokes at once even and strong—the classic iron-wire strokes of Chinese aesthetic discourse. Suzuki Kei 鈴木敬 regards Yan Liben's work as in the conservative style of the early Tang.[35] Yuchi Yiseng, a member of the Khotan royal family, had gained access to the court through his outstanding painting skill. He was famous especially for his paintings of foreign figures, such as Buddhas, bodhisattvas, and other divinities. Duan Chengshi's 段成式 Record of Monasteries and Pagodas (Sita ji 寺塔記) of 853 states that the Subjugation of Demons (Jiangmo bian 降魔變) that Yuchi Yiseng painted in the Samantabhadra Hall (Puxiantang 普賢堂) at Guangzhaisi 光宅寺, Chang'an, featured "three demon daughters being transformed [from beautiful girls into ugly old women], which seemed to leap out from the wall (變形三魔女，身若出壁)."[36] Such a description suggests that the three female figures appeared very three-dimensional. In Examination of Painting (Huajian 畫鑑; 1329), Tang Hou 湯垕 describes Yuchi Yiseng's painting as having "thick and heavy color built up [by many washes] like piled silk (用色沉著，堆起絹素)."[37] In other words, Yuchi Yiseng's extensive use of color enabled him to make two-dimensional depictions appear volumetric, and his skillful use of color and shading was probably perfected during his Central Asian training in Khotan. What makes Yuchi Yiseng so remarkable is his successful fusion of these Central Asian influences with traditional Chinese brushwork. Zhang Yanyuan 張彥遠 in a section of his Record of Famous Paintings of All Dynasties (Lidai minghua ji 歷代名畫記; 847) mentions that when Yuchi Yiseng "painted foreigners and bodhisattvas, he depicted small subjects with strong, tight brush strokes, like twisting iron and winding silk. For large subjects, he worked with casual elegance and spirit (畫外國及菩薩，小則用筆緊勁，如屈鐵盤絲，

33. Jin Weinuo, "Yan Liben yu Yuchi Yiseng (Yan Liben and Yuchi Yiseng)," in Zhongguo meishushi lunji (Collected Essays in Chinese Art History) (Taipei: Mingwen shuju, 1984), p. 125; Duan Wenjie, ed., Zhongguo bihua quanji: Dunhuang 5 (chu Tang), p. 17.

34. Duan Wenjie, ed., Zhongguo bihua quanji: Dunhuang 5 (chu Tang), p. 17.

35. See Suzuki Kei, Zhongguo huihuashi (The History of Chinese Painting), vol. 1, trans. Wei Meiyue (Taipei: Guoli gugong bowuyuan, 1987), p. 60.

36. Duan Chengshi, Sita ji, chap. 1, in Taishō shinshū daizō kyō, vol. 51, p. 1023c.

37. Tang Hou, Huajian, in Jingyin wenyuange siku quanshu (Facsimile Reproduction of the Wenyuan Pavilion Complete Treasury of the Four Libraries) (Taipei: Taiwan shangwu yinshuguan, 1983–86), vol. 814, p. 424a.

大則灑落有氣慨)."[38] The term "twisting iron and winding silk" has many formal connotations, referring not only to Yuchi Yiseng's use of an upright brush to render strong, unmodulated lines, but also to the long, winding, unbroken quality of these lines—a quality distinct from that of the succinct, summary brushwork of traditional Chinese style. It was his masterful fusion of brushwork and color that earned Yuchi Yiseng a prominent place within the large artistic community of Chang'an.

No mention of Yan Liben ever painting Buddhist murals in monasteries can be found in such Tang and Northern Song records as Zhu Jingxuan's 朱景玄 *Famous Tang Paintings* (*Tangchao minghua lu* 唐朝名畫錄), *Record of Famous Paintings of All Dynasties*, *Record of Monasteries and Pagodas*, and *Chang'an Gazetter* (*Chang'an zhi* 長安志). On the other hand, many documents record the Buddhist murals of Yuchi Yiseng. Even more noteworthy is the fact that all of his mural projects—at the Chang'an Daciensi 大慈恩寺, Guangzhaisi, Anguosi 安國寺, and the Luoyang Dayunsi 大雲寺—were patronized by the imperial family. Thus, it is apparent that Yuchi Yiseng was not only the most influential Buddhist mural painter of the latter half of the seventh century, but also one of the expert muralists employed by the court to adorn Buddhist temples. Unfortunately, none of his original works, nor any reliable copies, survive.

The preaching Buddha illustrations visible today on the east wall of Mogao Cave 321 (see *Figs. 5, 6*) feature rich, heavy colors applied in multiple washes in the aforementioned *aotu* fashion of Central Asia. The varying intensity and brightness of the tones clearly accentuate the facial features and musculature of the figures. The folds of the Buddhas' robes are described with dense and flowing iron-wire strokes of even thickness, which twist and wind with tensile strength like strands of silk. These lines not only express the softness of the garments, but also, by means of their winding turns and varying density, convey the musculature and movements of the figures within. In fact, they are just like the terms "twisting iron" (*qutie* 屈鐵) and "winding silk" (*pansi* 盤絲). Consequently, in both washes and brushwork, the illustration closely matches the stylistic qualities attributed to Yuchi Yiseng in texts. These records, however, contain no mention of Yuchi Yiseng ever working at the distant outpost of Dunhuang, and it is naturally impossible that the mural in Cave 321 should have come from the hand of this famous metropolitan Buddhist painter. Clearly, though, the flourishing east-west transportation routes of the era would have brought a large number of central Chinese immigrants to the Dunhuang area. These immigrants probably carried Yuchi Yiseng's richly colorful Central Asian style, then popular in the Chinese heartland (particularly the metropolitan area of the twin capitals), to Dunhuang, where it exerted a powerful influence on the Mogao mural painting of the Wu Zetian era. Therefore, although nothing survives of Yuchi Yiseng's own work, the murals of Cave 321 may suggest at least one aspect of his style.

38. Zhang Yanyuan, *Lidai minghua ji*, chap. 9, in *Huashi congshu* (*Collectanea of Painting History*) (Taipei: Wenshizhe chubanshe, 1974), vol. 1, p. 110.

A Western Paradise sūtra illustration, massive in scope, makes an early appearance during the second phase of the early Tang dynasty. Occupying the entire southern wall of Cave 220, the illustration is divided into three sections: The top section is the sky, the middle a lotus pond, and the bottom the holy Buddhist land. The sky section occupies only the upper border of the wall, the smallest portion of the mural. The middle and lower sections are detailed and complex, giving the mural a dense and compact quality. The Western Paradise sūtra illustration in Cave 71[39] is located on the northern wall of the cave. Its lower section has deteriorated completely, but the sky, as in the mural in Cave 220, appears relatively small. In comparison, the Western Paradise sūtra illustration in Cave 321, from the third phase of the early Tang, has a proportionally larger sky area. Almost one third of the mural is composed of the sky, contrasting clearly and brightly with the middle and lower sections. Similar proportions and compositions can be found in other caves dated to the same period, such as Caves 335 and 341.[40] This type of composition for Western Paradise sūtra illustrations first appeared under Wu Zetian and persisted through the High Tang period (705–780). An example of this is the Western Paradise illustration in Cave 445,[41] which dates from the middle of the High Tang (ca. 750s).

On the other hand, the *Baoyu Sūtra* illustration focuses on the theme of Śākyamuni Buddha preaching on Mount Gayā. The preaching scene occupies the central zone, while illustrations from the rest of the chapters in the sūtra surround the central area, forming a combination of landscape and figure painting. Although the composition is detailed and complex, the main subject is still distinct. This type of composition is not seen in the first and second phases of the early Tang, and it remained rare even during the reign of Wu Zetian. By the High Tang period, however, the composition was becoming popular. For example, the *Lotus Sūtra* illustration found in Cave 217 and the *Guanyin Sūtra* illustration found in Cave 45[42] are all similar in composition to the *Baoyu Sūtra* illustration in Cave 321. It can be thus surmised that the layout of early Tang *Baoyu Sūtra* illustrations laid the foundation for later High Tang paintings.

Conclusion

Mogao Cave 321 is a representative cave of the later phase of Wu Zetian's reign, a time which saw the rapid economic development of the Dunhuang area. Historical records indicate that, during the suzerainty of Empress Wu, the court, following the recommendation of Chen Zi'ang 陳子昂, increased military defenses in the regions west of

39. Duan Wenjie, ed., *Zhongguo bihua quanji: Dunhuang 5 (chu Tang)*, pl. 174.

40. Liang Weiying, *Dunhuang shiku yishu: Mogaoku 321, 329, 335*, pl. 165; Shi Pingting, ed., *Dunhuang shiku quanji 5: Amituo jing huajuan (Complete Collection of Dunhuang Grottoes V: Paintings on the Amitabha Sūtras)* (Hong Kong: Shangwu yinshuguan, 2002), pl. 28.

41. Dunhuang wenwu yanjiusuo, ed., *Zhongguo shiku: Dunhuang Mogaoku (Grottoes in China: The Mogao Caves at Dunhuang)* (Beijing: Wenwu chubanshe, 1987), vol. 3, pl. 171.

42. *Ibid.*, pls. 100, 131.

the Yellow River and expanded the military colony (*tuntian* 屯田) system.[43] These policies spurred the development of agriculture in the Western regions. Wu Zetian's policy of promoting immigration to the borderlands brought large allocations of human and material resources to the Dunhuang area. This helped stabilize the region and promoted commercial growth, which in turn facilitated the increase in the construction of grottoes at Mogao. Many of the military colonists came from the metropolitan regions of the northern plains, bringing not only more advanced methods of agricultural production but also culture of the metropolitan area. This introduced new ingredients into the culture of Dunhuang and opened a new phase in the development of Dunhuang art.

Dunhuang mural paintings of the late Wu Zetian era were, in terms of the human forms depicted, composition, technique, and subject matter, closely related to Buddhist paintings found in the monasteries of the Chang'an and Luoyang metropolitan regions. No Tang-era Buddhist murals survive in either of these cities, but evidence in Mogao Cave 321 at Dunhuang offers at least an indication of what once adorned the monastery walls of the twin capitals. Furthermore, the artistic mode of the Wu Zetian era expressed in the murals of Cave 321 was nourished by the arrival of new intellectual trends and painting techniques from the Chinese heartland. The Dunhuang artists of the era expanded upon this foundation, initiating a new and significant phase in the history of mural painting. Empress Wu Zetian's reign was therefore a critical period in both the broad scope of Chinese painting and specific developments in Dunhuang art.

43. See Wu Tingzhen and Guo Houan, *Hexi kaifashi yanjiu* (*Study on Developments West of the Yellow River*) (Lanzhou: Gansu jiaoyu chubanshe, 1996), pp. 194–205.

敦煌莫高窟第三二一窟壁畫初探

李玉珉

國立故宮博物院，臺北

　　莫高窟第三二一窟是武則天時期的一座代表窟。其中，南壁的寶雨經變和東壁的十一面觀音都是敦煌新出的壁畫題材，皆與武則天關係密切；特別是寶雨經變，不但繪有武則天聖諱「曌」字的圖解，更將武則天實乃「授記神皇」的政治意圖表露無遺。北壁西方淨土變的圖像雜揉阿彌陀經和觀經兩經的圖像特徵，很可能又受到中原善導大師所作淨土變相的影響。此外，莫高窟第三二一窟的壁畫無論在暈染或是線描上，也都與文獻所述譽滿兩京的尉遲乙僧畫風特徵相近。由於此窟的壁畫題材、人物造型、經變構圖等，可能都與兩京的佛寺壁畫不分軒輊，足見在武則天移民實邊的政策下，來自內地的屯田士兵所帶來豐富多彩的中原文化，為敦煌壁畫注入了新的養分。

敦煌莫高窟第321窟壁画初探

李玉珉

国立故宮博物院、台北

　　およそ695年から699年までの間に開窟された莫高窟第321窟は、敦煌石窟の中でも則天武后期を代表する窟の一つである。窟内の塑像の大部分は後代の改修を経ており、あまり見る価値がないが、窟主室の壁画は則天武后期の当初の姿をほぼ留めている。本論では莫高窟第321窟壁の画題材と図像内容が生まれた歴史背景を探求し、さらに、この窟の壁画から則天武后期の仏教壁画の特色を考察したい。

　　この窟の南壁には伝世した中で唯一の「宝雨経変」が残っており、北壁には「西方浄土変」、東壁の門上に「三世仏説法図」、門北側に「十一面観音」、門南側に「三尊立像」が描かれている。中でも「宝雨経変」と「十一面観音三尊像」は敦煌ではそれまでにない壁画題材で、どちらも則天武后と密接な関係があり、特に「宝雨経変」がそうである。この経変は武周・長寿2年(693)に南天竺僧・菩提流支が訳した『仏説宝雨経』を画いたもので、菩提流支訳で付加された、仏より授記を得、未来に女身として現れ、摩訶支那国（中国）の転輪聖王となった日月光天子が描かれている。のみならず、この経変上部の彩雲の中に日・月を分け持った大きな両手が描かれており、則天武后の諱「瞾」の図解に相当する。すべてに則天武后が「授記神皇」であるという政治的意図を余すところなく表しているのである。北壁の「西方浄土変」の図像は「阿弥陀経」と「観経」両方の図像の特徴が入り交じっており、それは又、中原の善導大師が作った「浄土変相」の影響を受けている可能性がある。

　　第321窟の壁画は色彩が豊富で、石青の割合が大幅に高くなっており、色彩の変化もますます豊富になっている。この他、画家は低い部分を色付けし、高い部分を色付けしないという西域の凹凸法を用いて、人物の立体感を表現しており、さらに、鉄線描で衣紋を表し、その線描は緻密で流麗である。それらは身体の動き、肉体の構造と呼応している。これらの特徴はそれまでの莫高窟壁画には見えず、むしろ画史に記載される長安・洛陽で活躍した尉遅乙僧(639-711年頃に活躍)の画風に合致している。尉遅乙僧は于闐王（ホータン）族の一員で、貞観(627-649)初に画が巧みであることから推挙され朝廷に入り、外国人物や仏像、菩薩、鬼神などの画を善くして有名であった。厚い色彩を施した彼の作品は、西域式の凹凸画法の暈染で人物の立体感を十分に表し

た、異国風の強いものだった。『歴代名画記』には、彼が外国人物や菩薩を描く際、「小は則ち用筆緊勁にして、鉄を屈し絲を盤まらせるが如く、大は則ち灑落にして気概あり」（「小画面では筆使いは緊密で強く、鉄を曲げて糸をからませたようであり、大画面では洒脱で気概がある」）とある。彼は中原の伝統的な筆法を巧みに用いたことも確かである。壁画の様式を見れば、莫高窟第321窟の壁画は暈染においても線描においても、文献に記載される尉遅乙僧の画風の特徴に近い。しかし、史料中に尉遅乙僧が遠く敦煌に赴いたという記載が発見されるはずもなく、莫高窟第321窟の壁画が、都で著名な仏画の大家、尉遅乙僧の手によるはずもない。しかしながら、則天武后の移民を辺境に送り込む政策で、内地からの屯田兵がもたらした豊富で多彩な中原文化は、敦煌壁画に新しい養分を注入した。多くの中原移民が敦煌に転入し、中原、特に長安・洛陽に流伝した西域色の強い尉遅画派の特徴も敦煌にもたらされ、則天武后期の莫高窟壁画に大きな影響が現れたのである。

Lee Yu-min

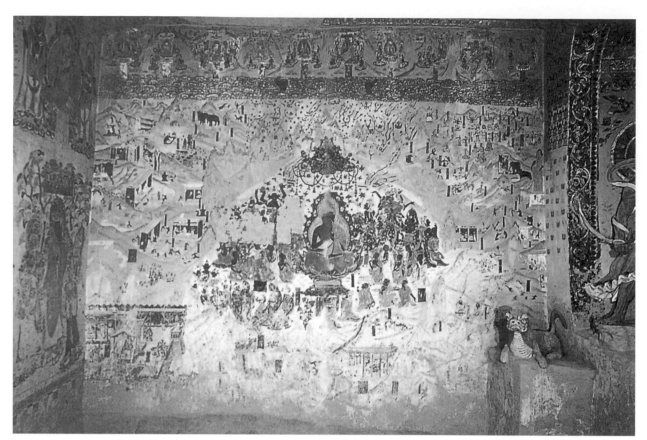

Fig. 1. *Baoyu Sūtra* illustration, late 7th–early 8th c. Mogao Cave 321, main room, south wall. From *Zhongguo shiku: Dunhuang Mogaoku*, vol. 3, pl. 53.

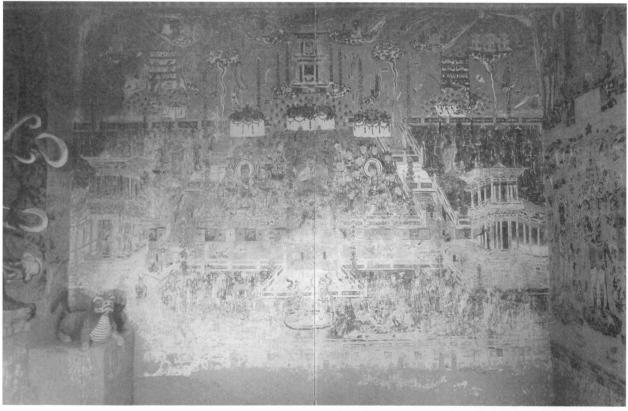

Fig. 2. Illustration of the Western Paradise, late 7th–early 8th c. Mogao Cave 321, main room, north wall. From *Dunhuang shiku yishu: Mogaoku 321, 329, 335*, pl. 60.

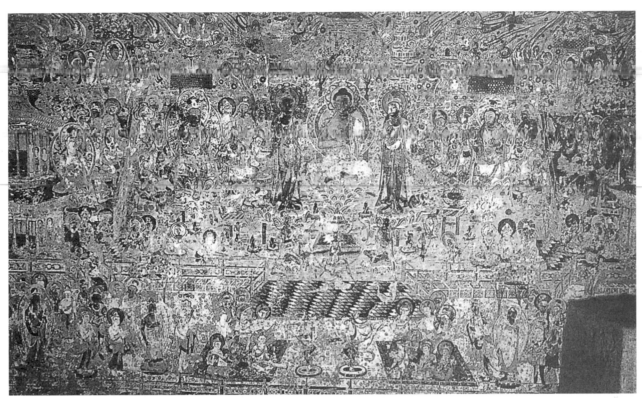

Fig. 3. Illustration of the Western Paradise, dated to 642. Mogao Cave 220, main room, south wall. From *Zhongguo shiku: Dunhuang Mogaoku*, vol. 3, pl. 24.

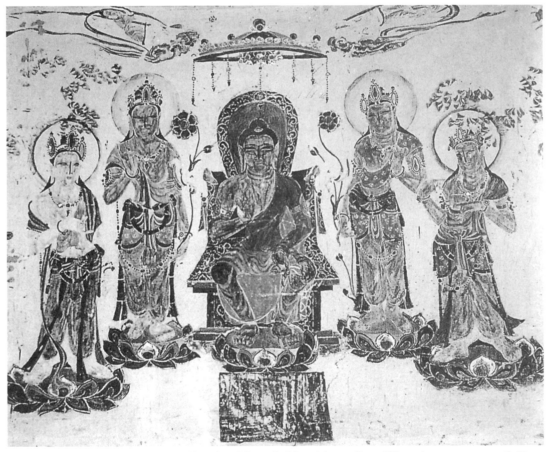

Fig. 4. Illustration of Maitreya preaching, late 7th–early 8th c. Mogao Cave 321, main room, east wall. From *Dunhuang shiku yishu: Mogaoku 321, 329, 335*, pl. 53.

Lee Yu-min

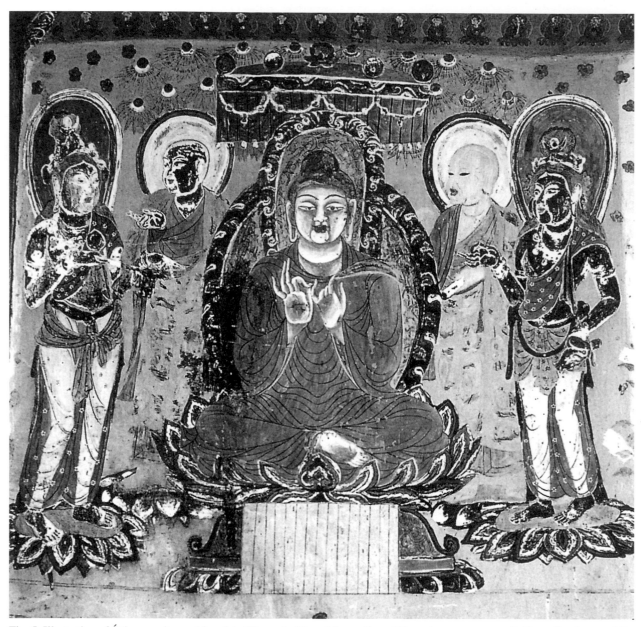

Fig. 5. Illustration of Śākyamuni preaching, late 7th–early 8th c. Mogao Cave 321, main room, east wall. From *Dunhuang shiku yishu: Mogaoku 321, 329, 335*, pl. 50.

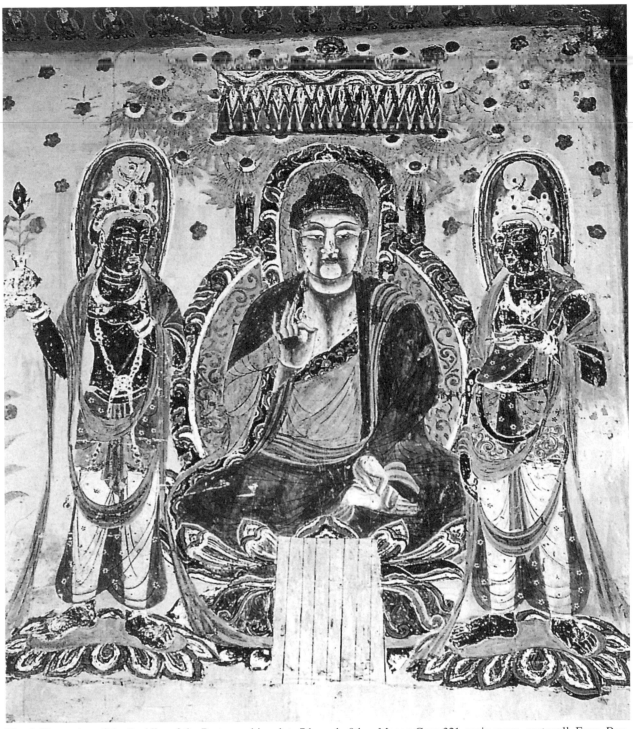

Fig. 6. Illustration of the Buddha of the Past preaching, late 7th–early 8th c. Mogao Cave 321, main room, east wall. From *Dun-huang shiku yishu: Mogaoku 321, 329, 335*, pl. 55. *(detail on page 171)*

192 *Lee Yu-min*

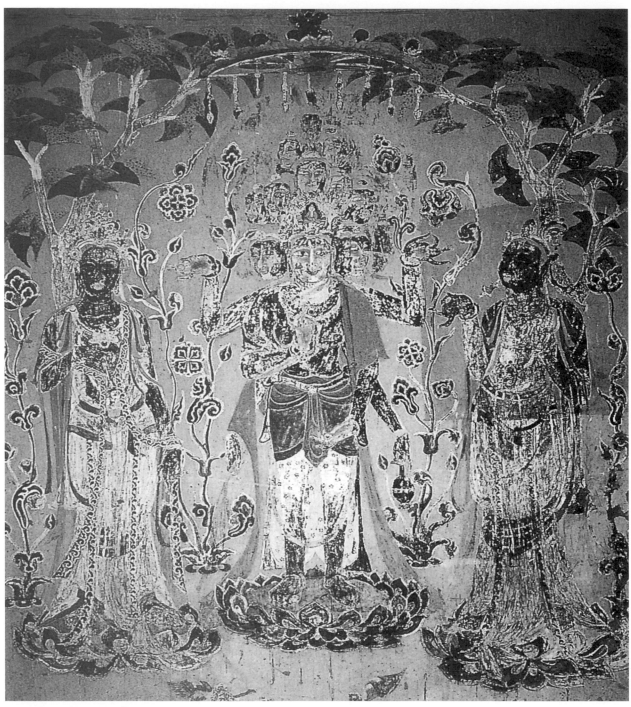

Fig. 7. Illustration of an Eleven-headed Guanyin triad, late 7th–early 8th c. Mogao Cave 321, main room, north side of east wall. From *Dunhuang shiku yishu: Mogaoku 321, 329, 335*, pl. 59.

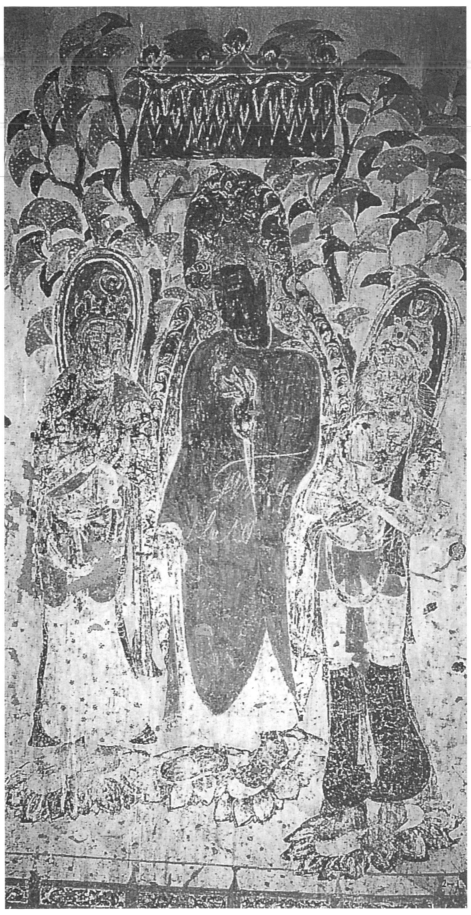

Fig. 8. Standing Buddha triad, late 7th–early 8th c. Mogao Cave 321, main room, south side of east wall. From *Dunhuang shiku yishu: Mogaoku 321, 329, 335*, pl. 58.

Lee Yu-min

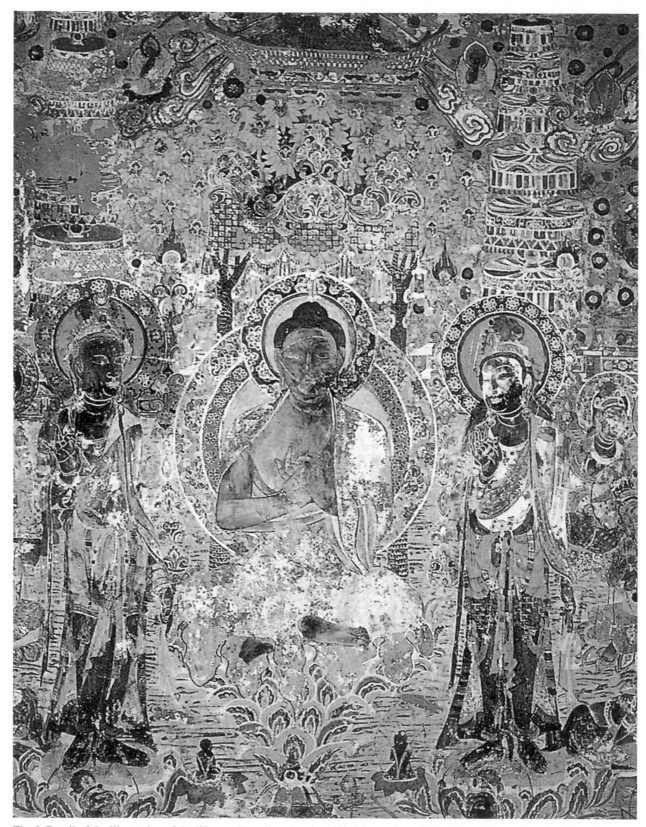

Fig. 9. Detail of the illustration of the Western Paradise, dated to 642. Mogao Cave 220, main room, south wall. From *Zhongguo shiku: Dunhuang Mogaoku*, vol. 3, pl. 26.

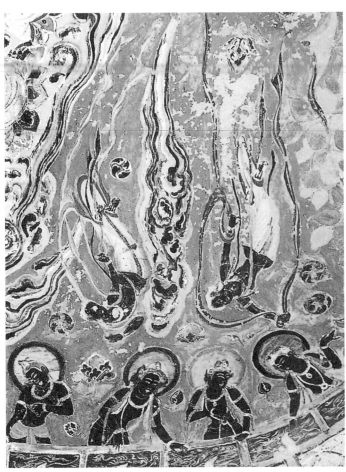

Fig. 10. Apsarās, late 7th–early 8th c.
Mogao Cave 321, main room, west wall
niche pediment. From *Dunhuang shiku
yishu: Mogaoku 321, 329, 335*, pl. 7.

Fig. 11. Apsarās, ca. 640–684. Mogao Cave 322, main room, west wall niche pediment. From *Zhongguo bihua quan-ji: Dunhuang 5 (Chu Tang)*, pl. 32.

Lee Yu-min

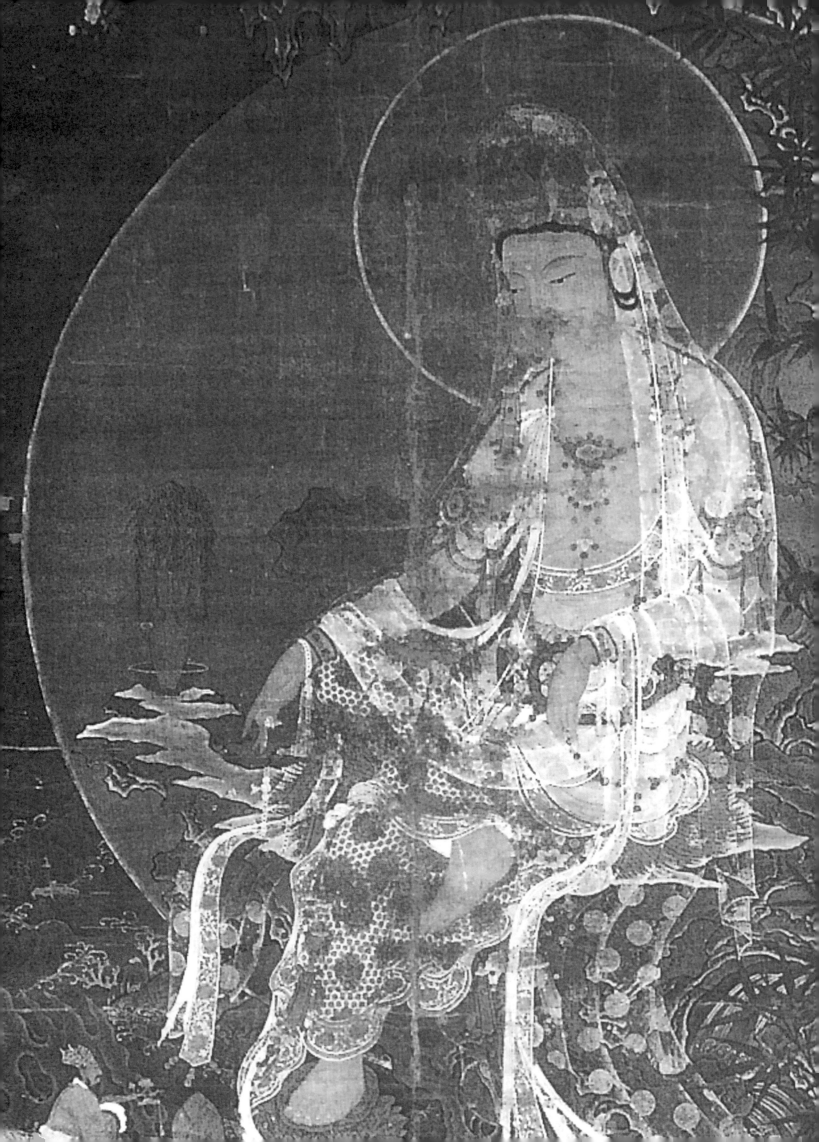

Naksan Legend and Water-Moon Avalokiteśvara (Suwŏl Kwanŭm) of the Koryŏ Period (918–1392): The Role of Legend in Koryŏ Iconography (II)*

Youngsook Pak

School of Oriental and African Studies, University of London

Samanta-mukha-parivarta (C: Pumenpin 普門品; K: Pomunp'um; "Chapter on the Universal Gate"), the twenty-fifth chapter of the *Saddharma puṇḍrīka sūtra* (*The Lotus Sūtra*; C: *Miaofa lianhua jing* 妙法蓮華經),[1] describes the bodhisattva Avalokiteśvara's (C: Guanshiyin 觀世音 or Guanyin 觀音) infinite means of salvation to rescue sentient beings from all imaginable mundane forms of distress and peril, such as water, fire, thieves, fearsome wild animals, malicious spirits, imprisonment, or violent death. The appearance of the indigenous *High King Avalokiteśvara Sūtra* (*Gaowang Guanshiyin jing* 高王觀世音經)[2] in sixth-century China further popularized the faith in Avalokiteśvara.[3] Many Avalokiteśvara paintings of the Tang and Five Dynasties period prominently and graphically depict scenes of perils based on *The Lotus Sūtra*,[4] but only a few Koryŏ 高麗 Avalokiteśvara paintings from Korea illustrate such peril scenes, and even in those the scenes are so small as to be hardly visible (*Fig. 1*). Instead, the majority of Koryŏ Avalokiteśvara images, amounting to one third of the entire corpus of Koryŏ Buddhist paintings, are of Suwŏl Kwanŭm (C: Shuiyue Guanyin 水月觀音), the Water-Moon Avalokiteśvara. Suwŏl Kwanŭm

*The author's first article on this topic was published as "The Role of Legend in Koryŏ Iconography (I)—The Kśitigarbha Triad in Engakuji" in *Function and Meaning in Buddhist Art*, ed. K. R. van Kooij and H. van der Veere (Grőningen: Egbert Forsten, 1995), pp. 157–65.

1. *Taishō shinshū Daizōkyō* (*The Buddhist Canon Published in the Taishō Era*; hereafter, *T.*), ed. Takakusu Junjirō and Watanabe Kaikyuoku (Tokyo, 1924–1932), vol. 9, pp. 56–58.

2. *T.* 85, p. 1425.

3. The pioneering study of Avalokiteśvara iconography is Marie-Thérèse de Mallmann, *Introduction à l'Etude d'Avalokiteśvara* (Paris: Annales du Musée Guimet, 1948). On *Gaowang Guanshiyin jing*, see *Dai Nippon kōtei zōkyō* (*Japanese Revised Version of the Canon*, also known as the *Manji zōkyō* (*The Manji Canon Continued*) (Kyoto, 1902-1905) 87, pp. 571–74. This compilation includes several stories of Avalokiteśvara's salvific efficacy. About this *sūtra*, see Chün-fang Yü, *Kuan-yin. The Chinese Transformation of Avalokiteśvara* (New York: Columbia University Press, 2001), pp. 110–18. Hayashi Susumu ("Kōrai jidai no Suigetsu Kannonzu ni tsuite (On Water-Moon Avalokiteśvara Paintings of the Koryŏ Period)," *Bijutsushi* (*Journal of Art History*) 102 [1977], pp. 101–17; see esp. p. 115, n. 9) mistakenly ascribed some phrases, which describe the abode of Avalokiteśvara, to this *sūtra*. Kikutake Jun'ichi ("Kōrai jidai no Kannon Bosatsu (Avalokiteśvara Bodhisattva of the Koryŏ Period)," *Kannon zonsō to hensō* [*The Art of Bodhisattva Avalokiteśvara: Its Cult Images and Narrative Portrayals*], International Symposium of Art Historical Studies 5, [The Taniguchi Foundation, 1986], p. 59) also wrote that Potalaka is described as the abode of Avalokiteśvara in *Gaowang Guanshiyin jing*, but this description does not in fact appear in that text. Harrie Vanderstappen likewise made the same mistake ("Water-Moon Avalokiteśvara and its Appearance in Chinese Song Sculpture," *Kannon zonsō to hensō*, p. 79f.).

4. Roderick Whitfield, *The Art of Central Asia: The Stein Collection in the British Museum* (Tokyo: Kodansha International, 1984), vol. 2., pls. 18, 21, 25; Jacques Giès, *Les arts de l'Asie centrale. La collection Pelliot du Musée Guimet* (Tokyo: Kodansha, 1994), vol. 1, pls. 72, 73.

was the most frequently produced subject in Koryŏ Buddhist paintings, especially during the latter part of the Koryŏ period—the thirteenth and fourteenth centuries.[5]

Images of the Water-Moon Avalokiteśvara, seated on a rock holding a rosary and with a nearby vase containing a branch of willow, began to appear in China in the tenth century, closely connected in their iconography with the already existing esoteric image of the Thousand-armed Avalokiteśvara (Qianshou Guanyin 千手觀音; such as a Five Dynasties painting, dated to 943, in the Musée Guimet). In fact, an apocryphal sūtra, *Water-Moon Avalokiteśvara Sūtra* (*Shuiyue Guanyin jing* 水月觀音經; dated to 958) was discovered among other Dunhuang manuscripts in the Tianjin Art Museum. This sūtra instructs devotees to recite it in order to gain wisdom, avoid various kinds of pain, and escape from the three evil paths as quickly as possible. Wang Huimin's 王惠民 study has shown that this very short sūtra is taken almost word for word from the Tang dynasty version of *Thousand-Armed Avalokiteśvara Sūtra* (*Qianshou jing* 千手經), translated by Bhagavatdharma (C: Jiafan Damo 伽梵達摩).[6]

As it turns out, both water and moon have specific connotations in Buddhist teachings. On the one hand, the reflection of the moon in water is a metaphor for all living things, which are "illusory and transient"; on the other, the full moon dispelling darkness is likened to the words of the Buddha, which dispel ignorance and afford enlightenment. The cool, clear features of the moon are analogous to the wisdom of the Buddha or a bodhisattva. In *Dhāraṇī of Divine Transformation of the Amoghapāśa Avalokiteśvara* (*Bukongjuansuo shenbian zhenyan jing* 不空胃索神變眞言經; *T.* 20, no. 1092, 314c), the great compassion and mercy of Avalokiteśvara is likened to the moon shining on every creature.[7] In the *Thousand-Armed and Thousand-Eyed Avalokiteśvara Dhāraṇī* (*Nilakanta-sūtra*; C: *Qianshou qianyan Guanshiyin Pusa dabeixin tuoluoni* 千手千眼觀世音菩薩大悲心陀羅尼) that was translated by Amoghavjra (C: Bukong 不空; 705–774), the moon has the power of cooling and willows the power of healing. Willows indeed have healing power, being a natural source of salicin and salicylic acid, ingredients used to make aspirin: "For thousands of years, willow bark has been used to treat fevers and arthritis."[8] In the same *dhāraṇī* (mystic incantation), devotees are instructed to pray to the hand holding a rosary, if they wish to encounter the Buddhas of all directions.[9]

5. For other Koryŏ Suwŏl Kwanŭm paintings, see *Koryŏ sidae ŭi pulhwa* (*The Buddhist Paintings of the Koryŏ Dynasty*), ed. Chung U-tak and Kikutake Junichi (Seoul: Sigongsa, 1996), pls. 67–99.

6. Wang Huimin, "Dunhuang xieben *Shuiyue Guanyin jing* yanjiu (Research on the Manuscript Copy of *Shuiyue Guanyin jing*)," *Dunhuang yanjiu* (*Dunhuang Studies*) 3 (1992), pp. 96–98. On the *Thousand-Armed Avalokiteśvara Sūtra*, see Chünfang Yü, *Kuan-yin. The Chinese Transformation of Avalokiteśvara*, p. 233ff.

7. Yen Chih-hung 嚴智宏 refers to all the relevant Tripitaka sources on this topic in his outstanding Ph.D. dissertation (*Bhaisajyāguru at Dunhuang* [University of London, 1997], pp. 60–63). Chün-fang Yü, in *Kuan-yin. The Chinese Transformation of Avalokiteśvara*, p. 235ff., also provides other canonical sources, but indicates there is no scripture that describes the metaphor of Avalokiteśvara and the moon (*ibid.*, p. 238).

8. Richard Mabey, ed., *The Complete New Herbal* (London: Penguin Books, 1991), p. 109ff.

9. *T.* 20: 117b, 117c.

The appearance of the Water-Moon Avalokiteśvara in the Buddhist pantheon is but a logical development of the growing popularity of Avalokiteśvara in East Asia that took place about the tenth century. The earliest Korean record on the Water-Moon Avalokiteśvara of the Koryŏ period is found in *Literary Collection of the National Preceptor of Great Awakening (Taegak Kuksa munjip* 大覺國師文集) by Ŭich'ŏn 義天 (1056–1083). Unfortunately, this record consists only of a title, "Eulogy on the Newly Painted Water-Moon Avalokiteśvara"; the relevant text is lost,[10] but the title attests to the fact that Suwŏl Kwanŭm appeared in Koryŏ as early as the eleventh century. Thereafter, judging from the entries in *History of Koryŏ (Koryŏsa* 高麗史, compiled in 1451), images of this bodhisattva were continuously produced. *History of Koryŏ* records that in the twentieth year of the reign of Euijong 毅宗 (r. 1146–1170; 1166), the powerful eunuch Paek Sŏn-yŏn 白善淵 commissioned forty Kwanŭm paintings. It is unknown whether these were paintings of Suwŏl Kwanŭm or of some other form of Avalokiteśvara. Unfortunately, few Koryŏ paintings dating prior to the thirteenth century have survived.

Already in the eleventh century, Chinese observers noted how keenly people in Koryŏ sought Song paintings, as recorded by Guo Ruoxu 郭若虛 (act. ca. 1080) in *Account of My Experiences in Painting (Tuhua jianwen zhi* 圖畫見聞誌), *juan* 卷 (fascicle or chapter) 6, on Koryŏ:

> In refinement of artistic skill, other lands have seldom [produced anything] comparable to its marvels of painting. . . . In the *jiayin* year of the Xining era [1074], they sent an envoy with tribute, one Jin Liangjian [K: Kim Yanggam], who was on the lookout for Chinese pictures. He was a very keen buyer, and purchased some three hundred works. . . . In the *bingchen* year [1076], they sent another envoy with tribute, Cui Sixun [K: Ch'oe Sahun], who brought in his train several painters and sought permission for them to make copies of the wall paintings at Xiangguosi to take back [to Korea]. An edict was issued granting the request, whereupon they made copies as completely as possible to carry home. The copyists employed showed a good deal of refinement in their methods of working.[11]
> 至於伎巧之精，他國罕比，固有丹青之妙。⋯熙寧甲寅歲，遣使金良鑒入貢，訪求中國圖畫。銳意購求，稍精者十無一二，然猶費三百餘緡。⋯丙辰冬復遣使崔思訓入貢，因將帶畫工數人奏請模寫相國寺壁畫歸國。詔許之，於是盡模之持歸。其模畫人頗有精於工法者。

In *Record of the Xuanhe Envoy to Koryŏ (Xuanhe fengshi Gaoli tujing* 宣和奉使高麗圖經; 1123), *juan* 17, Xu Jing 徐兢 (1091–1153) records that the Xiangguosi wall paintings were copied in the Hŭngwangsa 興王寺 in Kaegyŏng 開京 (present-day Kaesŏng 開城), the Koryŏ capital. Another Chinese commentator, Tang Hou 湯厚 (act. ca. 1322–1329), wrote admiringly in his *Examination of Painting (Huajian* 畫鑑) that Koryŏ paintings of Avalokiteśvara were "exceptionally elaborate."[12] The spectacular Water-Moon Avalokiteśvara painting in Kagami Jinja 鏡神社 in Saga 佐賀 Prefecture, Kyushu, dated to 1310, confirms the accuracy of such comments (*Fig. 2*). Its

10. *Taegak Kuksa munjip*, bk. 18 (The Academy of Korean Studies, 1989), p. 72.

11. Alexander C. Soper, *Kuo Jo-Hsü's Experiences in Painting (Tuhua jianwen zhi)* (Washington, D.C.: American Council of Learned Societies, 1951), p. 102f. For the original text, see *Huashi congshu 1 (Collectanea of Painting History 1). Tuhua jianwenzhi* (Shanghai: Renmin chubanshe), p. 93. The romanization in Soper's title has been changed to the *pinyin* system.

12. Tang Hou is quoted by Hayashi, "Kōrai jidai no Suigetsu Kannonzu ni tsuite," p. 115, n. 4.

Youngsook Pak

enormous size (419.5 × 254.2 centimeters), majestic appearance, and refinement of rendering in every detail strongly suggest that this painting must have been used in a special court ceremony.[13]

A particularly noticeable feature of Koryŏ Avalokiteśvara paintings is the exquisite depiction of fine fabrics, contributing an aura of refined splendor. The white transparent shawl is decorated with gold in Figure 3, which on actual fabrics may have been patterned with gold thread (K: *chikgŭm* 織金) or printed with gold leaf (K: *kŭmbak* 金箔 or *inkŭm* 印金). The portrayal of this transparent shawl as stiff and sharp-edged has led a Korean scholar to suggest that the fabric represented was not silk, but a very fine ramie (K: *sep'o* 細布).[14] Koryŏ craftsmen excelled in this textile technique, as the visiting Song scholar Xu Jing recorded in 1123:

> Koryŏ people plant ramie and hemp, making clothes of them. The finest [material] is called *shi* 絁, its purity and whiteness like those of jade. The width is narrow. Royalty and aristocrats wear clothes made of these [textiles].[15]
> 其國自種紵麻，人多衣布。絕品者爲之絁，潔白如玉而窄邊幅。王與貴臣皆衣之。

Few pieces of actual fabric have survived from the Koryŏ period, but Water-Moon Avalokiteśvara paintings vividly depict what the finest products of such famed craftsmanship must have looked like.

One of the largest and most remarkable Koryŏ Buddhist paintings of the thirteenth century is the so-called *Suwŏl Kwanŭm I*, one of two paintings of the Water-Moon Avalokiteśvara in Daitokuji 大德寺, Kyoto (*Fig. 4*). For reasons that will become clear in this essay, I shall refer to it hereafter as *Naksan Suwŏl Kwanŭm* 洛山水月觀音, so as to avoid confusion with *Suwŏl Kwanŭm II*. The *Naksan Suwŏl Kwanŭm* painting has been stored in Daitokuji for several hundred years. During this time, like most Koryŏ paintings in Japanese collections, it has seldom been shown to the public. Perhaps as a result, it remains in excellent condition.[16] Since Hayashi Susumu 林進 first published his study on this painting, there has been considerable discussion about *Naksan Suwŏl Kwanŭm*. I briefly mentioned it in discussing the *Water-Moon Avalokiteśvara* in The Metropolitan Museum of Art, which shows similar iconography.[17] Here I

13. The complex method of painting and the pigments of this painting have been thoroughly investigated by Ide Seinosuke and Shirono Seiji in an unpublished paper given at the international conference on Koryŏ art at the Chong-Moon Lee Center for Asian Art and Culture in San Francisco on 9 October 2003. See also Hirata Yutaka, "Kagami Jinja shozō yonjū Kannon gazō saikyū (Reexamination of the Willow Avalokiteśvara painting in the collection of the Kagami Jinja)," *Yamato Bunka* 72 (Feb. 1984), pp. 1–14, and Ide Seinosuke's article on Koryŏ Water-Moon Avalokiteśvara in *Goryeo Dynasty: Korea's Age of Enlightenment, 918–1392,* ed. Kumja Paik Kim (San Francisco: Asian Art Museum, 2003), p. 35f.

14. Jang Kyung-hee, "A Study on the White Shawl of the Water-Moon Avalokiteśvara of the Koryŏ Dynasty" (in Korean), *Misulsa Yŏn'gu,* no. 8 (1994), pp. 33–62, esp. p. 49.

15. Xu Jing, *Xuanhe fengshi Gaoli tujing,* book 23, in the section on "Tuchan 土產 (Local Products)."

16. About 130 Koryŏ Buddhist paintings have been identified to date, of which only ten are in Korea. Seventeen are in Western collections, and the great majority, over one hundred paintings, are in Japanese collections. The Daitokuji *Naksan Suwŏl Kwanŭm* is published in the following works: *Hanguk ŭi mi 7: Koryŏ pulhwa (The Art of Korea 7: Koryŏ Buddhist Painting),* ed. Yi Tong (Seoul: Chungang ilbosa, 1981), pl. 30; *Kōrai Butsuga (Koryŏ Buddhist Painting),* ed. Kikutake Jun'ichi and Yoshida Iroshi (Tokyo: Asahi shimbunsha, 1981), pl. 32; and *Koryŏ sidae ŭi pulhwa (Koryŏ Period Buddhist Painting),* ed. Kikutake Jun'ichi and Chung U-tak (Seoul: Sigongsa, 1997), vol. 1, pl. 69.

17. Pak Youngsook, "The Korean Art Collection in the Metropolitan Museum of Art," *Arts of Korea,* ed. Judith Smith (New York: The Metropolitan Museum of Art, 1998), pp. 433–36.

intend to explore the following questions: Is this iconography unique among all known Water-Moon Avalokiteśvara paintings in East Asia? If there were prototypes, what did the Koryŏ painter of *Naksan Suwŏl Kwanŭm* borrow from them? What motivated Koryŏ Buddhists to produce so many paintings of the Water-Moon Avalokiteśvara during the second half of the Koryŏ dynasty?

In the *Naksan Suwŏl Kwanŭm*, the bodhisattva, splendidly attired, holds a red rosary and sits in a grotto canopied with overhanging rocks. His head is haloed and a large moon-like aureole encircles him. Two stout bamboo culms grow on the right, while a blue bird with a flowering twig in its beak glides down from the top left toward the bodhi-sattva. Kwanŭm looks down on a group of humans and demonic figures, led by an elderly man (*Fig. 5*). These are de-picted quite small compared with the bodhisattva. Two white horns protrude from the headgear of the leading figure, who wears official robes and holds an elaborate incense burner of cast bronze in the form of a lotus stem bearing one bud and leaf, very similar to a Koryŏ censer (dated to 1077) in the National Museum of Korea, Seoul (*Fig. 6*). The horns identify this anthropomorphic figure as the Dragon King of the Sea (C: Longwang 龍王; K: Yongwang). Court ladies, officials, and half-naked grotesque creatures follow immediately behind him. Each of them carries precious offerings; coral, a fan, flaming jewels, or a lacquer box. One young man in noble outfit rides on the back of a dark-faced demon and holds aloft a red pearl (the wish-granting *cintāmaṇi*); another demon carries a drum under his arm; a third thrusts forward with a silk banner (*Fig. 7*). Two smaller demons bring up the rear, one carrying a huge vase with triple jewels and another a single jewel on an offering dish. At the extreme right, a young boy has just arrived on a large lotus leaf and bows toward the bodhisattva with his palms pressed together in a respectful gesture of the *anjāli mudrā*. The ends of his long red scarf float before him, and white-crested waves surround his lotus leaf vehicle (*Fig. 8*).

Both the iconography and style of *Naksan Suwŏl Kwanŭm* display intrinsic meaning and vividly demonstrate the artistic achievement of the Koryŏ painters, who were able to convey the magnificent spiritual presence of the bodhi-sattva through the refinement of every detail (*Fig. 9*). The bodhisattva's translucent veil with gold medallions, his red skirt in honeycomb and double-lotus design, the jewelery, and the willow branch in a *kuṇḍikā* (pure-water bottle) are all found in other well-documented Koryŏ Buddhist paintings.

The representation here of Avalokiteśvara Bodhisattva and a young boy doing reverence is taken from the text *Entering the Dharma Realm* (*Gaṇḍhavyūha*; C: *Ru Fajie pin* 入法界品), the forty-fascicle version of *The Avatamsaka Sūtra* (C: *Huayan jing* 華嚴經; K: *Hwaeom-gyeong*), which was one of the principal scriptures of both the Meditation (Sŏn 禪) and the Orthodox (Kyo 教) schools in the Koryŏ Buddhist community.[18] "Entering the Dharma Realm" is the story of the boy Sudhana (C: Shancai 善財), who set out on his journey to obtain enlightenment with the aim of sav-ing sentient beings from suffering. His journey took him to fifty-three saints, monks, and pious laymen. His twenty-eighth destination was Mt. Potalaka, the abode of Avalokiteśvara Bodhisattva. According to the original Sanskrit text,

18. *Gaṇḍavyūha*, translated by Prajñā in 795–810 (*T*. 10, no. 293), was the most popular of the three translations of *The Avatam-saka Sūtra* current during the Koryŏ period.

Youngsook Pak

Potalaka would be located somewhere off the South Indian coast. East Asian devotees located it variously on islands or peninsulas near their own homelands; thus, the name of the mountain was rendered into Chinese as Guangmingshan 光明山 (Radiant Mountain) in Buddhabhadra's (C: Juexian 覺賢) sixty-fascicle translation of *The Avatamsaka Sūtra* from 418 to 420, and as Putuoluojiashan 普陀洛迦山 (Mt. Potalaka) in Śikṣānanda's (652–710; C: Shichanantuo 實叉難陀) eighty-fascicle translation of 695 to 699. Sudhana found the Bodhisattva amid springs, in a dense forest carpeted with soft grass.[19]

The Koryŏ painters of the Water-Moon Avalokiteśvara depicted the rocks with shimmering gold, a visual reference to the bodhisattva's Diamond Cave (C: Jingangku 金剛窟) abode as described in *The Avatamsaka Sūtra*.[20] This method of painting Potalaka rocks in gold must have influenced the landscape painting of Song dynasty China. For example, Deng Chun 鄧春 wrote as follows in his *Painting Continued* (*Huaji* 畫繼; compiled in 1167) about Wang Shen 王詵 (1048–1104), the prominent Song scholar-painter:

> He learned his landscape painting from Li Cheng's [919–967] *cun* ("texture method"). Wang also used gold and green for them, they are similar in shape to Guanyin's treasured Mt. Putuo in old and contemporary paintings.[21]
> …其所畫山水學李成皴法。以金碌爲之，似古今觀音寶陀山狀。

The gold-shimmering rocks, which evoke a numinous world, ultimately derive from the Chinese Daoist concept of the ideal landscape. On Han dynasty *boshanlu* 博山爐 censers, the contours of the spirit mountains were often picked out in gold. From Daoism, this way of signifying a sacred mountain must have come to influence Buddhist painting and was most prominently applied to Water-Moon Avalokiteśvara paintings.[22]

Avalokiteśvara is represented in *Naksan Suwŏl Kwanŭm* in three-quarter view, with the rosary and a willow branch in a pure-water bottle. In the background grow a pair of tall bamboo culms. The iconography is similar to that of the Water-Moon Avalokiteśvara in the paintings of the Five Dynasties and the early Northern Song now in the British Museum and in the Musée Guimet (including the aforementioned 943 painting).[23] The earliest known example of a rosary as an attribute of Avalokiteśvara is a Northern Song sculpture in Yanxiadong 煙霞洞, an eleventh-century cave temple in Hangzhou. In Koryŏ paintings of Avalokiteśvara, the rosary is a standard attribute.

Neither in "Entering the Dharma Realm" nor in *The Lotus Sutra* do we find any textual source for the iconography of Avalokiteśvara Bodhisattva in *Naksan Suwŏl Kwanŭm*. Instead, the textual source can be traced to the miracle in the story of the founding of Naksan 洛山 Temple in Kangwŏn 江原 Province. The legend is recounted in *Memorabilia*

19. *T.* 9: 718; *T.* 10: 366.

20. *T.* 10: 733c and 735.

21. *Huashi congshu* 1, *Huaji* 2 (Shanghai: Renmin meishu chubanshe, 1963), p. 9.

22. Shi Mingfei, "Li Po's Ascent of Mount O-mei: A Taoist Vision of the Mythology of a Sacred Mountain," *Taoist Resources*, vol. 4, no. 1 (Jan. 1993), p. 39.

23. Whitfield, *The Art of Central Asia: The Stein Collection in the British Museum*, vol. 2, pl. 15; Giès, *Les arts de l'Asie centrale. La collection Pelliot du Musée Guimet*, vol. 1, pl. 96.

of the Three Kingdoms (*Samguk yusa* 三國遺史), compiled by the eminent Koryŏ monk Iryŏn 一然 (1206–1289).[24]

The story reads as follows:

> When the [Silla 新羅] monk Ŭisang [625–702] returned from Tang China, he heard that the True Body of the Great Compassionate One (i.e., Bodhisattva Avalokiteśvara) dwelled in a cave by the seashore. He therefore named that place Naksan [after Potalaka]. Mt. Potalaka is located in the Western regions [in India]. The reason why this place is also called Small White Flower is because the Venerable One in a White Robe [i.e., White-robed Avalokiteśvara] dwelled here. After keeping observances for seven days, Ŭisang threw himself into the early morning tide. [At this moment] Eight Devas [saved him and] led him into the cave. He paid homage to the heavens. [Thereupon] a crystal rosary was bestowed on him. Ŭisang received it and retreated. The Dragon of the Eastern Sea also offered him a *cintāmaṇi*. Master (Ŭisang) accepted it. After repeating observances for seven days, Ŭisang could encounter the True Countenance. He told the monk, "On the mountain peak will grow a couple of bamboo stalks. On that spot you should build a hall." The master heard this and retreated from the cave. [When he went to the peak, he saw] indeed a pair of bamboo culms was there. He built a golden [image] hall and enshrined a carved image [of the bodhisattva]. The graceful countenance of the image was as if it were alive. The bamboo disappeared. The master knew that was the place of the True Body abode, and hence he named the temple Naksan. The master enshrined the two "pearls" [i.e., the rosary and *cintāmaṇi*] that he had received, and left the temple. . . . In the middle of a field there was a pine tree on which a blue bird was perched.[25]
>
> 昔義湘法師，始自唐來還，聞大悲眞身住此海邊崛內，故因名洛山，蓋西域寶陀洛伽山。此雲小白華，乃白衣大士眞身住處，故借此名之。齋戒七日，浮座具晨水上。龍天八部侍從引入崛內參禮。空中出水精念珠一貫給之。湘領受而退。東龍海亦獻如意寶珠一顆。師捧出。更齋七日，乃見眞容。謂曰，於座上山頂，雙竹湧生，當其地作殿宜矣。師聞之出崛。果有竹從地湧出。乃作金堂塑像而安之。圓容麗質，儼若天生。其竹還沒，方知正是眞身住也，因名其寺曰洛山。師以所受二珠，鎭安於聖殿而去。⋯時野中松上有一青鳥。

The detailed iconography of *Naksan Suwŏl Kwanŭm* coincides quite remarkably with this legendary account of the founding of Naksan. Avalokiteśvara holds the crystal rosary, while the young man on the back of the dark-faced demon carries the *cintāmaṇi*. The Dragon King (identified by the white horns emerging from his headdress) and the blue bird are also represented in this painting.

The Chinese located Potalaka, which they also abbreviated as Putuoshan, somewhere off the coast of Zhejiang Province.[26] Naksan in Kangwŏn Province is the Korean equivalent of the name Potalaka, and it was situated on the east coast of the Korean peninsula. According to Buddhist cosmology, which ultimately derives from traditional Chinese "Five Elements" (*wuxing* 五行) theory, east is the direction in which Avalokiteśvara resides. In the center of this cosmology abide Vairocana (C: Piluzhena 毘盧遮那) and Mañjuśrī (C: Wenshushili 文殊師利); in the west Amitāyus (C: Wuliangshoufo 無量壽佛) and Mahāsthāmaprāpta (C: Dashi 大勢); in the south, the Eight Great Bodhisattvas (C: Bada pusa 八大菩薩) and Kśitigarbha (C: Dizang 地藏); and in the north Śākyamuni (C: Shijiamouni 釋迦牟尼) and arhats (C: *luohan* 羅漢).[27] Naksan became firmly established as the Korean Potalaka. It was a sacred and a secret

24. Hayashi Susumu, "Kōrai jidai no Suigetsu Kannonzu ni tsuite," pp. 101–17, especially p. 14.

25. *Samguk yusa*, compiled by Iryŏn (1208–1289) (Chōsen shigakkai edition, 1928), book 3, p. 47f.

26. See Chün-fang Yü, "P'u-t'o Shan: Pilgrimage and the Creation of the Chinese Potalaka," in *Pilgrims and Sacred Sites in China*, ed. Susan Naquin and Chün-fang Yü (Berkeley: University of California Press, 1992), pp. 190–245; repr. in Chün-fang Yü, *Kuan-yin. The Chinese Transformation of Avalokiteśvara*, pp. 353–406.

27. *Samguk yusa*, book 3, "Taesan oman chinsin (The Fifty Thousand True Bodies on Mt. Odac)."

place, in which were stored the Koryŏ national treasures of the *cintāmaṇi* and crystal rosary. Historical records and literary sources of the Koryŏ and Chosŏn periods testify to the importance of these objects; for example, in *Newly Enlarged Gazetteer of the Scenic Sites of the Eastern Country* (*Sinjŭng tongguk yŏji sŭngnam* 新增東國輿地勝覽) compiled in 1530, we find that:

> When our King T'aejo [r. 918–943] founded this country, every spring and autumn he sent envoys to the [Naksan] Temple to pray for three days with utmost sincerity. He made this as a rule to observe [and ordered] the crystal rosary and *cintāmaṇi* to be passed down as temple treasures. In the *kyech'uk* year (1253), [Yuan Chinese] armies invaded our country. A fortress was built on Mt. Sŏrak to protect the nation, but the castle fell to the enemy. Temple slaves buried the rosary and *cintāmaṇi* and ran away to report [this] to the palace. When the invaders retreated, [the palace] dispatched envoys [to the temple] to collect the rosary and *cintāmaṇi* and kept them in the inner court of the palace.[28]
> 我太祖立國春秋遣使設齋三日以致敬焉。厥後書於甲令以爲恒規，水精念珠及如意珠藏於是寺，傳寶之。癸丑歲天兵闖入我疆。是州於雪嶽山築城守禦，城陷寺奴，取水精念珠及如意珠埋於地而亡走。上告於朝兵，退遣人取之藏於內殿。

The Dragon King is not an unfamiliar image in relation to Avalokiteśvara scriptures. He is referred to as a tutelary spirit of those who recite the *Thousand-Armed and Thousand-Eyed Avalokiteśvara Dhāraṇī*.[29] The Heavenly Dragon (Tianlong 天龍) and Eight Devas (Babuzhong 八部衆) are also mentioned as the protectors of Avalokiteśvara in *Account of Mt. Potalaka* (*Putuoluojiashan zhuan* 普陀洛迦山傳), compiled by Sheng Ximing 盛熙明 during the Yuan dynasty.[30]

In Korea, the dragon has been worshipped as a nation- and dharma-protecting deity since the Silla period. King Munmu 文武 (r. 661–681), who unified the Three Kingdoms, was said to have been transformed into the Dragon of the Eastern Sea after his death in order to continue protecting his kingdom.[31] The construction of Hwangnyongsa 皇龍寺, the Temple of the Imperial Dragon in the center of the Silla capital Kyŏngju 慶州, was begun in 553 after the reported appearance of a dragon on that site.[32] A number of stories related to protective dragons and renowned Silla monks, including Ŭisang, the founder of the Avatamsaka school in Korea, testify to the significant dragon cult in Korean antiquity. Ŭisang's biography is immortalized in the set of illustrated scrolls entitled *Founding Legends of the Kegon Sect* (*Kegon engi* 華嚴緣起) in Kamakura Japan; the last scroll shows his return to his native Silla, after his period of study in Tang China, under the protection of a dragon (a transformation of the girl Shanmiao 善妙 who had befriended Ŭisang in China) that saved his ship from a storm.

Like the dragon, the "blue bird" (K: *ch'ŏngjo* 青鳥) also appears in Buddhist texts as the *utpala* ("blue lotus") bird, an inhabitant of paradise that dwells in the human world of Jambudvīpa (C: Yanfuti 閻浮提), south of Mt. Sumeru (C:

28. *Sinjŭng tongguk yŏji sŭngnam,* bk. 44, "Paeyang. Puru (temples) Naksansa."

29. *T.* 20: 108b.

30. *T.* 51: 1138c.

31. *Samguk yusa,* book 2, "Munho wang, Pŏmmin."

32. *Ibid.,* book 3, "Hwangnyŏngsa chang yuk."

Xumi 須彌).[33] Birds also commonly appear in Chinese Water-Moon Avalokiteśvara paintings. On the western wall of Yulin 榆林 Cave 2 (12th c., Xixia 西夏 state), in Anxi 安西, Gansu Province, Water-Moon Avalokiteśvara is accompanied by flying birds (*Fig. 10*). Yü Chün-fang 于君方 identifies the birds in Chinese Water-Moon Avalokiteśvara paintings as white parrots. Furthermore, the parrot in Buddhist *jātaka* stories demonstrates filial piety and is depicted as an intelligent creature that became an attendant to Avalokiteśvara.[34]

In Korean sources, the mysterious blue bird with a floral spray in Naksan is also recorded in the epitaph for Yu Cha-ryang 庾資諒 (1150–1229), written by the eminent Koryŏ literatus Yi Kyu-bo 李奎報 (1168–1241), himself a devout Buddhist. Yu Cha-ryang was a respected Koryŏ scholar-official who became a Buddhist in his old age. His epitaph reads:

> As Commander, he [Yu] went to Kwandong [Kangwŏn 江原 Province]. Arriving in Naksan, he paid homage to Avalokiteśvara. Two blue birds brought a flower and dropped it on his garment. Also a plume of seawater surged up and wet his forehead. It is said that there is a blue bird, but not everyone among those who pray to the Buddha can see it. [Yu Cha-ryang] could see it only because he was such a virtuous and religious man.[35]
> 其帥關東也。到洛山禮觀音。俄有二青鳥含花落衣上。又海水一掬許，湧灌其項。世傳此地有青鳥，凡謁聖者非其人則不見。此公之惇德至信所致然也。

This auspicious event appears to have been widely reported, as it is further recorded in the above-mentioned *Newly Enlarged Gazetteer of the Scenic Sites of the Eastern Country* as follows:

> It was said that if a person earnestly prayed in front of the [Naksan] cave, a blue bird would appear. In the year *chŏngsa* of King Myŏngjong (1197), he [Yu Cha-ryang] became Army Commander. In the tenth month, he came to the [Naksan] cave, offered incense and prayed [to the bodhisattva]. A blue bird brought a flower and dropped it on his headgear. People said this was a remarkable incident.[36]
> 世傳有人到窟前至誠拜稽則青鳥出現，明宗丁巳庾資諒爲兵馬使至十月到窟前焚點拜稽，有青鳥含花飛鳴，落花於襆頭上，世以爲稀有云云。

These records of Yu Cha-ryang's encounter with the divine blue bird at Naksan Temple are significant for the interpretation of the *Naksan Suwŏl Kwanŭm*. Quite possibly, Yu Cha-ryang, or his family after his death, commissioned this painting to commemorate these strikingly auspicious incidents.

Even before the thirteenth century, the Avalokiteśvara Bodhisattva at Naksan Temple was famous for its miraculous powers. *History of the Koryŏ* (book 10; first year of Hŏnjong's 獻宗 reign [1095]) records that the Song merchant Huang Chong 黃沖, with thirty other Chinese laymen and the Ci'en 慈恩 school monk Huizhen 惠珍 requested in

33. See *Saddharmasmṛtyūpasthāna sūtra* (*T.* 17, no. 721: 157b, 407a), translated by Prajñaruci (C: Panruoliuzhi), who came from India to Luoyang in 516 during the Northern Wei period. I am grateful to Dr. Yen Chih-hung for drawing this text to my attention.

34. Chün-fang Yü, *Kuan-yin. The Chinese Transformation of Avalokiteśvara*, pp. 443ff, 540, n. 2.

35. *Tongguk Yi Sangguk jip*, book 36, in *Han'guk munjip ch'onggan* 2, p. 74.

36. *Sinjŭng tongguk yoji sŭngnam*, book 44, "Paeyang. Puru (temples) Naksansa."

Youngsook Pak

vain to visit the sacred grotto of Avalokiteśvara. In the third year of King Wŏnjong's 元宗 reign (1262), the queen wanted to see the *cintāmaṇi* of Avalokitcśvara in Naksan Temple, and her wish was granted.[37]

For the "eye-opening" ceremony of a painting of the Water-Moon Avalokiteśvara, Yi Kyu-bo wrote a prayer imploring the deity to expel the straggling remnants of Khitans who had invaded Koryŏ between 1216 and 1218. The prayer, written on behalf of the powerful military leader Ch'oe Ch'ung-hŏn 崔忠獻 (1150–1219), is heartrending to read:

> In *Dhāranī of the Great Compassionate Avalokiteśvara*, it is said: "If threat occurs, foreign enemies invade, an epidemic spreads, or evil devils menace, one ought to make the image of the Great Compassionate One, pray with utmost sincerity, decorate [the image] with banners and canopies, and make offerings of incense and flowers; then the enemies will surrender and all menace will cease." Taking these words is like hearing your own teaching. Now through the painter's hand, [we] draw the image of Water-Moon. His painting is like a White-robed image. With our utmost sincerity, we add the dots [i.e., the pupils] to [Your] lotus eyes. We bow down and pray to You. May You bestow on us Your wonderful powers. Like the benevolent and yet frightful Virūpāksa, may You defeat the enemies. [Faced with Your] unabashed divine power, let them retreat to their own den.[38]
> 謹案大悲陀羅尼神咒經云，若患難之方起，有怨敵之來侵，疾疫流行，鬼魔耗亂，當造大悲之像，悉傾至敬之心，幢蓋莊嚴，香花供養，則舉彼敵而自伏。致諸難之頓消。奉此遺言，如承親囑。茲倩丹青之手，用摹水月之容。吁哉繪事之工，肖我白衣之相。聲披霞懇，仰點蓮晬，伏願遣借丕庥，仍如妙力。如至仁廣大，憚令醜類以盡劉。以無畏神通，俾反舊巢而自卻。

Yi Kyu-bo composed another eulogy, this one on behalf of Ch'oe U 崔瑀 (also called Ch'oe I 崔怡, d. 1249), the son of Ch'oe Ch'ung-hŏn, when restoration work was finished on the sculpted image of Avalokiteśvara in Naksan Temple. This famous image had evidently been vandalized during the Mongol invasion, probably in 1235, when the most famous Silla temple, Hwangnyongsa, and other treasures on the Korean peninsula were destroyed.

> On the top of Mt. Naksan on the east coast is outstanding scenery. It is pure and without a speck of dust. It is said this is the place where the majestic appearance of Water Moon [Avalokiteśvara] dwelled. Alas! The barbarians were obstinate and hostile, and their ignorance without limit. When they ran rampant and robbed, even the temples and Buddhist images could not escape their cruelties. Our Great Holy Image succumbed to the same fate. Only his form remained, for they [the Mongol armies] took all the precious treasures concealed in His stomach out and made it empty. But since the realm of the One can not be measured by that of sufficiency and insufficiency [waxing and waning, or profit and loss] and can not be dispersed or added to, how can there be destruction of his Diamond-like True Body? How could an ordinary man not be saddened by this [sight]? Moreover, when one, like this disciple, who has always revered the Holy One, now hears that the contents of its belly have been lost and dispersed, how could one not feel twice as much bitterness as an ordinary man and bravely undertake to restore this?[39]
> 洪惟東海之濱洛山之上，有一勝境。清靜無塵。水月晬相，於是乎寄焉。嗟乎，憬彼頑戎，無之莫甚。方其橫行寇掠也。至於佛宇梵相，無不披其殘毀者。我大聖尊軀亦爾。雖形體僅存，而腹中之珍藏，盡爲蒐露散頓。拐然其空矣，且至人境界，本絕盈虛消息之理，則金剛眞體，寧且有毀滅耶。然在凡夫所睹，得不愴然傷心哉。況如弟子者，仰止之心，自昔滋切，乃今聞腹藏潰散之事。

Thus, in the first half of the thirteenth century in Koryŏ, prayer and Buddhist ceremonies including readings of the *Dhāraṇī of Thousand-Armed Thousand-Eyed Avalokiteśvara* were offered to the Naksan Water-Moon

37. *Koryŏsa sega*, book 27, "Wŏnjong, 3rd year."

38. *Ibid.*, book 41, in *Han'guk munjip ch'onggan* 2, p. 125.

39. *Tongguk Yi Sangguk jip*, book 25, in *Han'guk munjip ch'onggan* 1, p. 554.

Avalokiteśvara image, seeking peace or the expulsion of foreign invaders, and an end to all calamities. The Water-Moon Avalokiteśvara in Naksan was thus seen as crucial for the protection of the nation during turbulent and perilous times.

When the Koryŏ finally surrendered to the Mongols in 1257 after long struggles, the Water-Moon Avalokiteśvara paintings acquired an additional function. Besides being entreated to protect the state, they were also invoked by individuals to eliminate disease or to assure the well-being of superiors or deceased relatives. The historical record in *History of Koryŏ* (book 28) reveals that in 1275 King Ch'ungnyŏl 忠烈 apparently commissioned twelve Avalokiteśvara paintings as an offering for the welfare of the Mongol Yuan dynasty emperor Khubilai Khan.[40]

The Mongol invasion was a humiliating experience for many Koryŏ intellectuals. Some Korean historians have pointed out that Iryŏn's intention in compiling *Memorabilia of the Three Kingdoms*, a collection of miraculous tales of Buddhist temples, images, and monks and other worthy individuals, was to uplift national pride by showing that the people of Koryŏ were culturally superior to the Mongols, and that it was moreover a divine Buddha Land chosen by Buddhas and bodhisattvas. Hence, it is not surprising that the majority of Koryŏ Avalokiteśvara images portray the miraculous Water-Moon Avalokiteśvara of Naksan, where his "True Body" is said to have dwelled.

The Naksan legend and the Avalokiteśvara image retained their reputation for efficacy well into the sixteenth century, as is recorded further in the aforementioned *Newly Enlarged Gazetteer of the Scenic Sites of the Eastern Country*:

> Naksan Temple is located on Mt. Obong and was built by the Silla monk Ŭisang. The image of Avalokiteśvara is enshrined on the altar of the Hall of the Great Hero and has been revered by generation after generation. Various miracles have happened. Our King Sejo 世祖 [r. 1418–1450] visited this temple, and ordered it to be enlarged after seeing that the monastery was small and narrow.
> 洛山寺在五峰山，新羅僧義相所建。殿上安栴檀觀音一軀，歷代崇奉。頗有靈異。我世祖幸此殿，以殿舍隘陋，命新之極宏壯。

Naksan Suwŏl Kwanŭm exemplifies the significance of iconography for the correct interpretation of an image. A similar case in Western art history is Piero della Francesca's (1412?–1492) little-known fresco *Madonna del parto* in Monterchi (*Fig. 11*). In Christian tradition, the representation of the Madonna about to give birth symbolizes Christ's birth in human form. In Florence, there existed a long devotional tradition of praying to the Madonna for ease of childbirth. The German art historian Ingeborg Walter, however, has discovered an important hidden political and social meaning in this painting: the red and green of the angels' clothes and wings are the colors of the Guelph coat of arms, which makes this painting an expression of the political hegemony of the Florentines over the Monterchians.[41] Therefore, Piero's *Madonna del parto* in Monterchi reveals a complex layering of meaning. The artist portrayed the

40. Quoted by Kamata Shigeo, "Buddhism during Koryŏ," in *Buddhism in Koryŏ: a Royal Religion* (Korea Research Monograph 22), ed. Lewis R. Lancaster, Kikun Suh, and Chi-shin Yu (Berkeley: The Regents of the University of California, 1996), p. 56.

41. Ingeborg Walter, *Piero della Francesca: Madonna del Parto. Ein Kunstwerk zwischen Politik und Devotion* (Frankfurt am Main: Fischer Taschenbuch Vlg., 1992), p. 38ff.

continuing tradition of prayers to the Madonna by female devotees, while the patron intended to signal the change of political circumstances in this area. Religion, in both East and West, has always been closely intertwined with society and with political life, and religious art was used in the service of the rulers. This was particularly the case with Koryŏ Buddhist paintings: paintings and sculptures, especially such works as *Naksan Suwŏl Kwanŭm*, were seen not just as devotional images, but as vital forces in repelling the invasions of the Mongols and asserting Koryŏ independence.

At the beginning of his monumental study *Bild und Kult*, Hans Belting defined the devotional meaning of the iconic image, the focus of worship in medieval Europe, and stressed that it should not be confused with narrative or historical pictures of holy events or of saints' lives, which were meant to be pictorial readings for the observer.[42] He also pointed out that the image, or *Bild* ("picture"), in medieval Europe was not a work of art *per se*, but primarily an object of devotion. I also have always regarded Buddhist images primarily as religious icons, the focus of worship; and precisely because this was their paramount purpose, their significance can be discovered only by knowing the textual sources of the iconography. It is also important, as Dietrich Seckel has pointed out, to understand that what is seen as aesthetic and artistic refinement in Buddhist paintings is rather the use of splendor, or adornment (*zhuangyan* 莊嚴; K: *changôm*), to manifest the divinity of Buddhas and bodhisattvas.[43]

Buddhist scriptures offer a rich literature of legends and miracles relating to sacred images, a powerful instrument to excite the imagination of devotees and to enhance the narration of events with a supra-mundane character. Miracle gives to religion an entity and a divine perpetuity. Known in Chinese as *ganying* 感應 ("influence response"), *lingxian* 靈顯 ("efficacious response"), or *lingyi* 靈異 ("efficacious wonders"), the retelling of miracles and legends assisted in the promulgation and popularization of particular doctrinal teachings.[44] They helped to establish the status of the divinity in question, and supplemented the canonical scriptures already in existence about the sacred figure. When a particular place, such as Naksan in Korea, became known as the sanctuary of a bodhisattva, legends and miracles concerning the deity came to be associated with that sacred place. At the same time, legends and miracles ascribed to these deities provided new elements in the iconography of the expanding pantheon of Mahāyāna Buddhism. Thus, for the proper interpretation of a Buddhist painting, should the iconography not follow the formal description provided by the doctrinal scriptures, as in the case of *Naksan Suwŏl Kwanŭm*, it is vital to identify the relevant non-canonical literary sources and to consider the historical circumstances, if we are to interpret correctly the inherent meaning of such an image.

42. Hans Belting, *Bild und Kult—eine Geschichte des Bildes vor dem Zeitalter der Kunst* (Munich Vlg. C. H. Beck, 1990), p. 9. Note that the point of this important sentence was entirely lost on the translator in the English edition; see Hans Belting, *Likeness and Presence. A History of the Image before the Era of Art,* trans. Edmund Jephcott (Chicago: University of Chicago Press, 1994), p. xxi.

43. Dietrich Seckel, *Buddhistische Kunst Ostasiens* (Stuttgart: W. Kohlhammer Vlg., 1957), p. 189ff. English translation by Ulrich Mammitzsch, *Buddhist Art of East Asia* (Bellingham: Western Washington University Press, 1989), p. 182ff.

44. Chün-fang Yü, *Kuan-yin. The Chinese Transformation of Avalokiteśvara,* pp. 25, 153ff.

高麗時代 (918–1392) 的洛山傳奇與水月觀音——
傳奇在高麗圖像學中的角色

朴英淑

倫敦大學亞非學院

六世紀時出現的《高王觀世音經》，不僅是中國的原生典籍，亦帶動了觀音信仰的流行，許多唐、五代時期的觀音圖都明確而詳盡地描繪《妙法蓮華經》內觀音救難的場景；然只有少數的高麗觀音圖有救難場景的圖繪，即使有，這些場景也小得難以辨識。高麗的觀音圖像通常是水月觀音，爲高麗佛畫中最常見的題材，佔總數的三分之一，尤盛行於十三、十四世紀高麗時代的末期。

水月觀音的形象在十世紀時出現於中國，乃當時觀音信仰盛行於東亞地區的表徵。倚坐岩石的觀音，手持念珠，旁有一盞淨瓶插柳枝，此形象與既存的密宗千手觀音關係密切。在佛的教法中，水與月皆有深意。而韓國最早提到高麗時代水月觀音之文獻爲義天 (1056–1083) 的《大覺國師文集》，該文雖已佚失，然因題爲〈和國原公讚新畫成水月觀音〉，故知早在十一世紀時高麗便出現水月觀音的圖像。而從1451年編修的《高麗史》來看，此類觀音像日後仍持續製作，可惜十三世紀之前的高麗畫幾乎不存。

然自當時的紀錄而觀，那些現已無存的水月觀音像應相當地華麗精巧；成於1310年的九州左賀縣鏡神社水月觀音像，即可證明此類評述的正確性。而高麗觀音圖上最值得注意的特色，即是對觀音所著細緻織物的精心描繪。高麗織工技藝卓絕，來訪的宋代文人徐兢亦於1123年爲文記載。高麗時代的織品現雖罕見，然水月觀音圖上所繪的巧工織品，必定與此相仿。

現存十三世紀最巨大出眾的高麗佛畫，即是所謂的《水月觀音》，爲京都大德寺所藏二幅水月觀音像的其中之一。在本文中，我將此圖稱爲《洛山水月觀音圖》，並欲探討其圖像在東亞水月觀音圖中的特出之處。若眞有水月觀音的原型，則《洛山水月觀音圖》自原型處取用了什麼？而高麗的佛教信徒何以在高麗時代後期繪製如此眾多水月觀音像？

《洛山水月觀音圖》圖中，菩薩盛裝並以四分之三側面示人，坐於懸岩爲蓋的巖穴裡，手裡的紅色念珠，乃高麗觀音像裡的典型持物。畫家描繪的岩石鑲有金邊，指射著《法華經》裡菩薩所居的金剛窟。這樣的處理方式實源於道教描繪聖山的作法；佛教繪畫不僅受其影響，也普遍地應用於水月觀音像的製作。

我們無法在《華嚴經》或《妙法蓮華經》中找到任何關於《洛山水月觀音圖》的圖

像文本，其文本應來自於江原道洛山寺的開山故事。《洛山水月觀音圖》上的圖像細節，與《三國遺事》所載幾乎吻合。觀音手持水晶念珠，在黯面鬼背上的年輕人則捧著如意寶珠。龍王（頭冠伸出白角雙角者）與青鳥亦出現於圖中。在觀音塑像裡，龍王並不是個令人陌生的角色；青鳥亦經常出現於中國的水月觀音圖，如甘肅省安西榆林窟第二洞（十二世紀，西夏）裡，水月觀音即與飛鳥一同出現。韓國文獻裡有篇「庾資諒墓誌」，亦提及洛山神秘的啣花青鳥。此文由李奎報(1168–1241)所撰，李氏本人亦為虔誠的佛教徒；而庾資諒(1150–1229)則是德高望重的高麗文人官員，晚年皈依佛門，並曾至洛山朝拜觀音。

在十三世紀之前，洛山寺的觀音菩薩便以其神力著稱。李奎報便曾書一水月觀音開眼疏文，祈求驅逐1216–1218年間曾入侵高麗的契丹餘黨。在混亂而危殆的年代裡，洛山寺的水月觀音扮演著重要的護國角色。

當高麗歷經長期奮戰後終於在1257年臣服於蒙古時，水月觀音圖亦有了新的功能。自《高麗史》(28冊)可知，1275年忠烈王命人繪製12幅水月觀音圖，顯然是為了幫元世祖忽必烈祈福。《洛山水月觀音圖》一例顯示圖像學對於正確地解釋畫面形像有多麼重要；而洛山傳奇與觀音圖像的靈驗直至十六世紀依然聲名不衰。

洛山伝説と高麗期(918–1392)の水月観音—高麗図像における伝説の役割

朴英淑

ロンドン大学東洋アフリカ研究学院

6世紀に中国固有の観音経、『高王観世音経』が現れたことにより、観音信仰が流行した。唐と五代の多くの観音図は傑出して『妙法蓮華経』に基づいた危機的場面を図像化して描いているが、高麗の観音図で危機的状況を描いたのはごくわずかであり、その場面も非常に小さく描かれていてほとんど見えない。これに対し高麗仏画の全体の三分の一を占める高麗観音像の大多数は水月観音である。特に13世紀から14世紀の高麗後期に、水月観音は高麗仏画で最も頻繁に制作される主題だった。

傍らの花瓶に柳の枝を挿し、数珠を手にして、岩の上に座る水月観音は10世紀に中国に現れ始めた。これは当時、東アジアで観音の流行が高まっていたことを表わす。その図像は既存の千手観音の密教像と密接に関連している。水と月は仏教教義において特別な意味合いを持つものである。高麗期の水月観音の最も古い記録は、義天(1056–1083)の『大覚国師文集』に見られる。残念ながら、「新たに描かれた水月観音への讃辞」という標題しか残っておらず、本文は失っている。しかし、これから明らかなのは、水月観音が11世紀には高麗に現れていたことである。1451年編纂の『高麗史』の記述によれば、その後、この菩薩像が制作し続けられたとある。残念ながら、13世紀以前の高麗の絵画はほとんど現存していない。

しかしながら、同時代の文献は、失われた水月観音図をきわめて精妙にして優れた出来栄えであると記している。九州佐賀県の鏡神社にある1310年制作の壮麗な「水月観音図」はその評論の正確性を裏づけるものである。高麗観音画に顕著な特色は、菩薩の衣装の服地の細密な描写である。その地を訪れた宋の文人、徐兢が1123年に記しているように、高麗の織物技術は非常に優れたものであった。高麗期の織物はほとんど残っていないが、「水月観音図」はそうした最高品質の工芸技術を鮮やかに物語っている。

13世紀高麗仏画の最大にして最も注目すべき作品の一つは、京都大徳寺の水月観音図2点のうちの片方、「水月観音一」と称されるものである。本稿では、「水月観音一」を「洛山水月観音」と呼ぶことにし、次の問題を探ってゆく。東アジアで知られるすべての水月観音図の中でこの図像は独自性を持つものであろうか。もし原型が存在し

たとすれば、洛山水月観音を描いた高麗の画家はどの部分を借用したか。高麗王朝期の後半、高麗の仏教徒があれほどまで多くの水月観音図を描いた動機は何であったか。

　「洛山水月観音」では、菩薩は天蓋のように突き出した岩下の洞窟に四分の三側面像で座している。盛装姿で、赤い数珠を手にしている。この数珠は高麗観音図の標準的な属性である。水月観音を描いた高麗画家たちによる金色に光る岩の描写は、究極的には道教に由来するものであるが、『華厳経』に記される菩薩の住まい、金剛窟を視覚化したものである。道教由来の神聖な山をこのように表わす手法は、仏教絵画に影響を及ぼすようになったにちがいなく、水月観音画に最も顕著に適用された。

　『華厳経』にも、『妙法蓮華経』にも、洛山水月観音における観音菩薩図像を読み解く文献を見出すことはできない。だが、その典拠は江原道洛山寺の奇跡の建立物語に遡ることができる。「洛山水月観音」の図像の細部は、『三国遺事』に記された寺院建立の逸話の記述と明らかに一致するものである。観音は水晶の数珠を手にし、暗い顔をした鬼の背上の若者が如意宝珠を持っている。龍王(頭冠から突き出す二本の白い角から特定できる)と青い鳥もこの絵画に描かれる。龍王は観音経ではよく知られるものであり、鳥も中国の水月観音図一般に現れる。甘粛省安西の楡林窟、第二窟(12世紀西夏)の西壁では、水月観音は飛んでいる鳥を伴っている。韓国の文献によると、洛山の嘴に花の枝をくわえた神秘的な青い鳥は、敬虔な仏教徒であった高麗の著名な文人、李奎報(1168–1241)が書いた庾資諒の墓碑銘にも記されている。庾資諒(1150–1229)は尊敬を受けた高麗の文官で、晩年に仏教徒となり、洛山の洞窟の観音に敬意を表した。

　13世紀以前から、洛山寺の観音菩薩はその奇蹟の力で有名であった。その水月観音図の開眼法要の際に李奎報は、1216年から1218年に高麗に侵攻した契丹の残党を駆逐する力を嘆願する祈文を執筆した。洛山の水月観音は、不穏で危機的な時期に、鎮護国家という重要な役割を担っていた。

　長い戦乱の後、1257年に高麗がモンゴルに降伏すると、水月観音絵画はさらに異なる役割を果すようになる。『高麗史』(第28巻)によると、1275年に忠烈王は元のフビライの繁栄を願い捧げ物として観音画12幅を制作させた。「洛山水月観音」は、仏画の正確な解釈における図像学の重要性を実証するものである。洛山伝説と観音像は16世紀になっても霊験の名を保持し続けた。

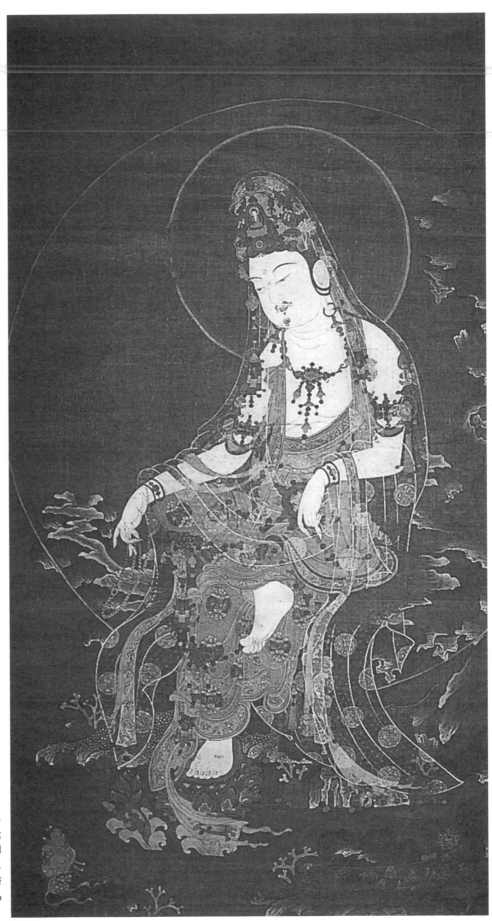

Fig. 1. *Suwŏl Kwanŭm*. Koryŏ, 14th c. Hanging scroll, colors and gold on silk, 109.5 × 57.8 cm. Tanzan Jinja. From *Kōrai Butsuga* (Nara: Yamato Bunkakan, 1978).

Youngsook Pak

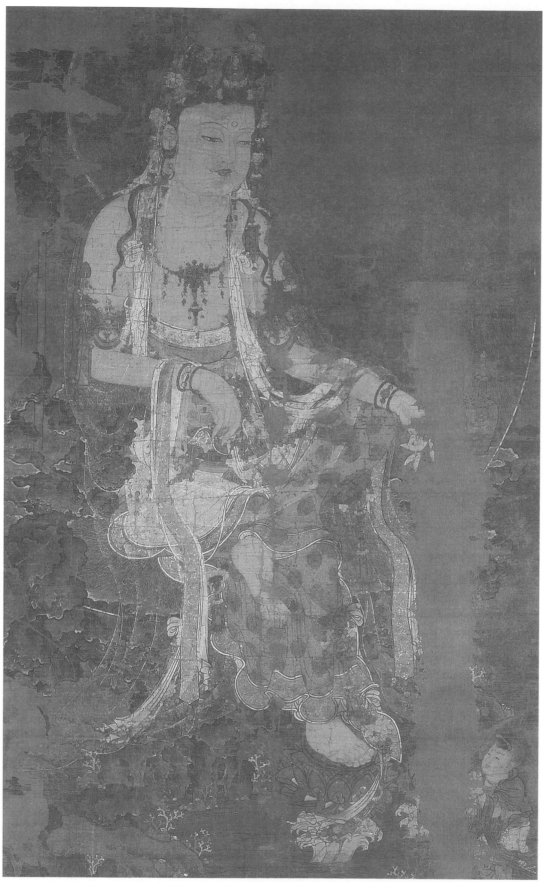

Fig. 2. *Suwŏl Kwanŭm*. Koryŏ, dated to 1310. Hanging scroll; colors and gold on silk, 419.5 × 254.2 cm. Kagami Jinja. From *Goryeo Dynasty: Korea's Age of Enlightenment, 918–1392* (San Francisco, 2003), pl. 8.

Section II: Buddhist Painting 215

Fig. 3. Detail of Figure 2. Photo credit: Roderick Whitfield.

Youngsook Pak

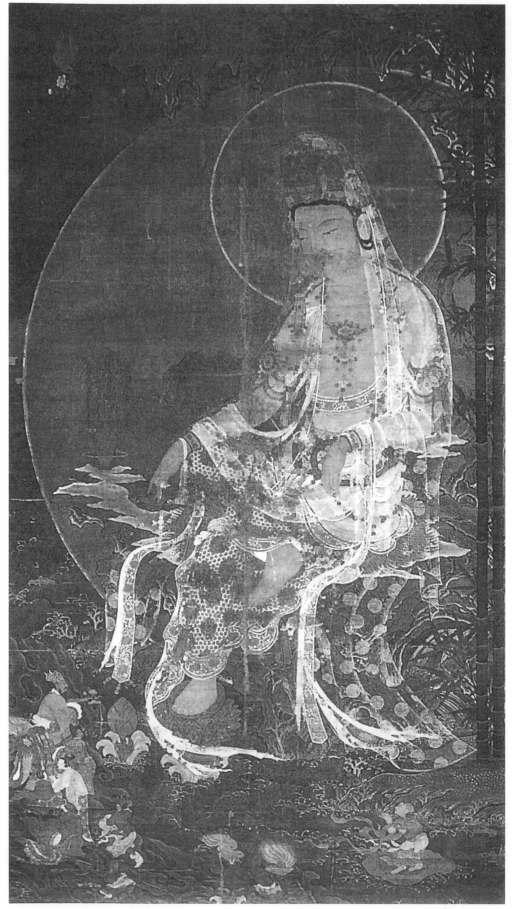

Fig. 4. *Naksan Suwŏl Kwanŭm*. Koryŏ, 13th c. Hanging scroll, colors and gold on silk, 227.9 × 125.8 cm. Daitokuji, Kyoto. From *Kōrai Butsuga* (Nara: Yamato Bunkakan, 1978). *(detail on page 197)*

Fig. 5. Detail of Figure 4: Dragon King and his entourage.

Youngsook Pak

Fig. 6. Censer in lotus shape, Koryŏ, dated to 1007. Gilt bronze. National Museum of Korea, Seoul. Photo credit: Roderick Whitfield.

Fig. 7. Detail of Figure 4: Small boy and demons.

Fig. 8. Detail of Figure 4: Sudhana.

Youngsook Pak

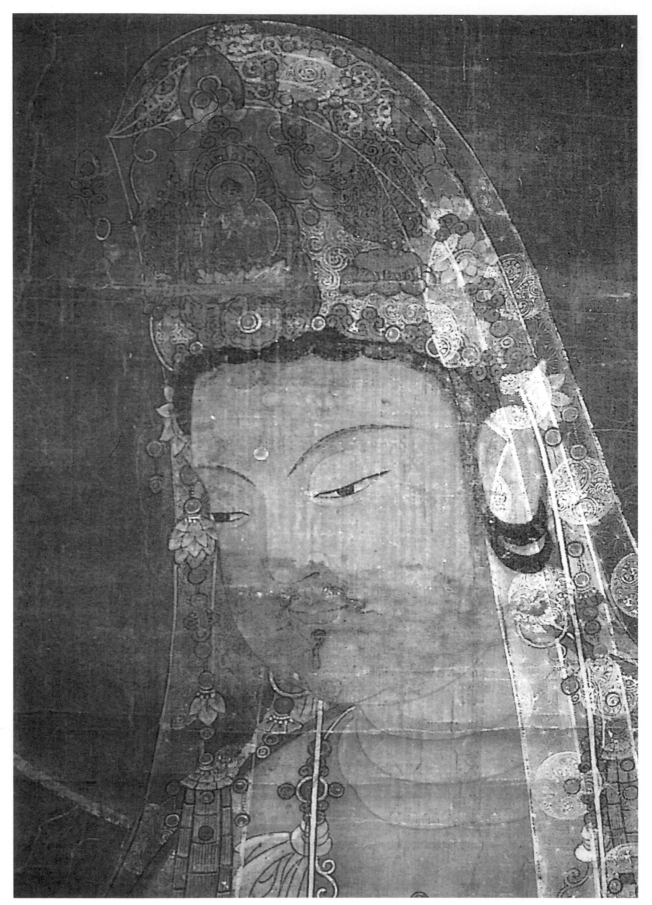

Fig. 9. Detail of Figure 4: Head of Kwanŭm.

Fig. 10. *Water-Moon Avalokiteśvara*, Xixia period, 12th c. Wall painting on the west wall of Yulin Cave 2. China, Gansu Province. From *Anxi Yulinku* (Beijing: Wenwu chubanshe, 1997), pl. 137.

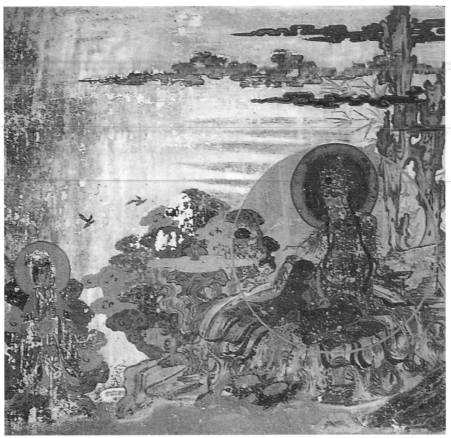

Fig. 11. Piero della Francesca (1412?–1492), *Madonna del Parto*, Monterchi. From Ingeborg Walter, *Piero della Francesca: Madonna del Prato: Ein Kunstwerk zwischen Politik und Devotion* (Frankfurt a. Main, 1992).

Youngsook Pak

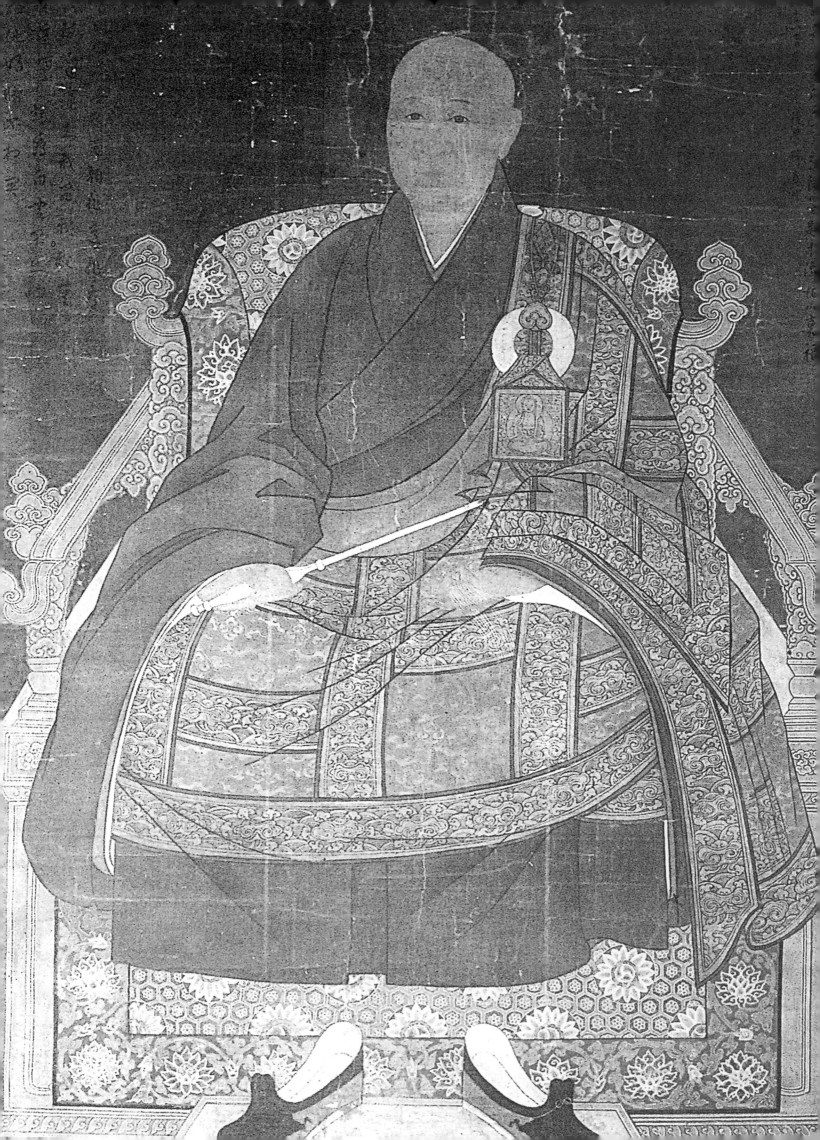

Portraits and Personalities in the Temples of Ming Beijing: Responses to Portraits of the Monk Daoyan

Marsha Weidner

University of Kansas

One of the most complex personalities of the Ming dynasty is best known today by his secular name, Yao Guangxiao 姚廣孝 (1335–1418), yet from his teenage years until his death at the age of eighty-three, he was a Buddhist monk. He shaved his head, wore Buddhist robes, and lived in Buddhist monasteries. In death, he was given a Buddhist burial, and monasteries became guardians of his spirit tablet and images. Therefore, it seems fitting to call him by his clerical name, Daoyan 道衍. Daoyan was born under the Yuan dynasty, but is remembered as a man of the Ming. He was an important cleric, author of Buddhist books, abbot of one of the great monasteries of Beijing, and associated with leading southern literati. He was also a canny political adviser and military strategist who helped Zhu Di 朱棣 usurp the throne to become the Yongle 永樂 Emperor (r. 1403–1424). Daoyan held official positions, won a biography in *History of the Ming* (*Ming shi* 明史), and was depicted in portraits that attracted the attention of prominent individuals for centuries after his death in 1418.[1]

The only portrait of Daoyan that seems to have survived was once at Tanzhesi 潭柘寺 in the Western Hills (Xishan 西山) of Beijing, then entered the Qing imperial collection, and is now in the Palace Museum in Beijing (*Fig. 1*).[2] After introducing this painting and its subject, I shall turn to recorded portraits of Daoyan and episodes in the history of their reception. A critical element in this history was setting: responses to these portraits were substan-

1. Zhang Tingyu *et al.*, eds., *Ming shi* (1739; repr. Beijing: Zhonghua shuju, 1995), 145: 4079–4082. The contemporary scholar Bu Liansheng 步連生 maintains that there were at least four painted images of Daoyan in Beijing, one showing him in court costume and three depicting him dressed as a monk; Bu Liansheng, "Ming Xuande shi nian diaozao de Bandan Zhashi xiang (The Image of Bandan Zhashi Carved in the Tenth Year of Xuande of the Ming Dynasty)," *Wenwu*, no. 7 (1979), pp. 83–84.

2. Bu Liansheng, "Ming Xuande shi nian diaozao de Bandan Zhashi xiang," p. 84. I am grateful to Chang Qing of the University of Kansas for helping me make the contacts necessary to secure a color photograph of the portrait. This portrait was formerly in the Nanxundian 南薰殿 managed by the Storage Office of the Imperial Household Department. It is recorded and described in Hu Jing, *Nanxundian tuxiang kao* (*Study of the Portraits in the Nanxundian*), (1816; repr. Shanghai, 1924), *shang*, pp. 30a–31a. (Pan An-yi was kind enough to find the latter book in the Cornell University library and send me copies of relevant pages.) A portrait of Yao Guangxiao is also listed in the inventory of the portraits in the Nanxundian in *Da Qing huidian* (*Collected Statutes of the Great Qing*), *juan* 卷 (fascicle) 90. It is not, however, recorded with the other portraits in this hall in *Shiqu baoji san bian* (*Treasured Boxes of the Stony Moat* [the catalogue of painting and calligraphy in the Qing imperial collection], Part 3), comp. Hu Jing *et al.*, nor was it included when the cream of the imperial collection was skimmed for transport to Taiwan. This historical record is recounted in Jiang Fucong, "Guoli gugong bowuyuan Nanxundian tuxiang kao (Study of the Portraits from the Nanxundian in the National Palace Museum)," *Gugong jikan* (*National Palace Museum Quarterly*), vol. 8, no. 4 (Summer 1974), pp. 4, 6. The condition of the portrait may have something to do with its being left behind. The photograph (I have not seen the painting in person) shows a simple white mounting (not the red satin mounting lined in blue given to portraits of meritorious officials when they were remounted on imperial order in 1748); see Hu Jing, *Nanxundian tuxiang kao*, preface, p. 1. The painting also seems to have been significantly trimmed, probably due to damage.

tially affected by the monastic environments in which most were seen. Monasteries, temples, and shrines were primary contributors to visual culture and major sites of aesthetic experience in the Ming dynasty, as in earlier and later periods. They provided visually and intellectually complex viewing environments, and their institutional histories were entwined with the personal histories of individuals portrayed within their walls. Other factors that influenced responses to these images included Daoyan's biography, theories of physiognomy, historical and art historical precedents, popular stereotypes, and legends, as well as each viewer's own social, political, and religious perspectives. We find these factors at work in reports by notable Ming individuals on their encounters with portraits of Daoyan.

The portrait in the Palace Museum is a large hanging scroll, about two meters high, done in ink and rich colors on silk. Written in gold, from right to left across the top, is the following inscription: "The true countenance of Lord Yao Guangxiao, [imperially] titled Junior Preceptor, [posthumously] ennobled as Duke of Rongguo [named] Gongjing (*Chi feng Rongguo Gongjing gong zeng Shaoshi Yao Gong Guangxiao zhenrong* 敕封榮國恭靖公贈少師姚公光孝真容)."[3] The opulence of the color and quality of the drawing, as well as the subject's close ties with the Ming court, suggest that this portrait came from the hand of a court painter (or painters). Its size and formality indicate that it was made for use in a memorial image hall. The composition follows the familiar "portrait-in-a-chair" formula favored in the depiction of Song and Yuan Chan 禪 Buddhist abbots,[4] with modifications that echo characteristics of formal portraits of Ming emperors and officials. Like Chan masters in earlier portraits, such as the Song master Wuzhun Shifan 無準師範 (1177–1249),[5] Daoyan sits on a chair, his legs folded and his shoes placed on a low step below. The chair is draped with a brilliantly colored lotus-pattern cloth. The master holds and fingers a delicately drawn flywhisk (*fuzi* 拂子), a standard abbot's implement, and wears full ceremonial robes. White and turquoise under-robes are visible at his neck and the edges of his sleeves. His brown outer robe, with wide neckband and long heavy sleeves, wraps across the front to fasten on his right side. His surplice, or *kasāya*, (C: *jiashaye* 袈沙野) is patchwork to evoke the patched robes worn by mendicant monks, but made of delicately patterned turquoise silk with gold borders and bands filled with *ruyi* 如意 ("as-you-wish") fungus-shaped cloud designs. It fastens with an ornately knotted turquoise cord through a *ruyi*-shaped button and a ring (*huan* 環) on the upper left side of his chest. Suspended below the ring is a square gold badge with an image of a seated Buddha, perhaps designating Daoyan's position as a high-ranking Buddhist official.

3. The late Qing seal in the middle reads: *Xuantong yulan zhi bao* 宣統御覽之寶 (Treasure Imperially Viewed by the Xuantong Emperor [r. 1908–1911]).

4. On the formula for depicting abbots, see Helmut Brinker and Hiroshi Kanazawa, *Zen Masters of Meditation in Images and Writings* (Zurich: Artibus Asiae Publishers, Supp. 40, 1996), p. 161; also T. Griffith Foulk and Robert H. Sharf, "On the Ritual Use of Ch'an Portraiture in Medieval China," *Cahiers d'Extrême-Asie*, vol. 7 (1993–1994), pp. 156–57.

5. A hanging scroll in ink and color on silk, this often-reproduced portrait of Wuzhun Shifan, dated to 1238, belongs to the Tōfukuji in Kyoto. See Jan Stuart and Evelyn S. Rawski, *Worshiping the Ancestors, Chinese Commemorative Portraits* (Washington, D.C.: Freer Gallery of Art and Arthur M. Sackler Gallery, Smithsonian Institution, in association with Stanford: Stanford University Press, 2001), pp. 77–80, fig. 3.3; also Brinker and Kanazawa, *Zen Masters of Meditation in Images and Writings*, pp. 163–64.

The master turns slightly to his right, recalling the three-quarter views of Song and Yuan master portraits, but his chair is seen straight on, like the symmetrical throne in the fully frontal portrait of the Hongzhi 洪治 emperor (r. 1488–1505).[6] Daoyan's broad, square, light green chair is also much more ornate than those of earlier Chan masters, inviting comparison with thrones like the one occupied by the Yongle Emperor in the famous portrait in the National Palace Museum, Taipei.[7] Where the back and armrests of the emperor's throne are ornamented with dragons, those of Daoyan's chair are decorated with repeated *ruyi* designs.

Daoyan's face is sensitively rendered in fine lines and soft washes of color. A high forehead suggests his intelligence. His face is full, even a bit pudgy. Below a broad nose, his small, pink mouth is firmly set, lips slightly pursed. The eyes, his most often noted physical feature, are dark-rimmed with pale irises and black pupils. His eyelids lift just a bit in the middle, giving his eyes a slightly triangular shape. Small, thin eyebrows do little to soften his expression, which can be read as cool and calculating.

By some accounts, Daoyan's character and destiny were written on his face. According to *History of the Ming*, when the physiognomist Yuan Gong 袁珙 (1335–1410) encountered Daoyan at Songshansi 嵩山寺, Yuan exclaimed: "What kind of strange monk are you? Your eyes are triangular, your form like a sickly tiger. Your nature must be bloodthirsty. You are the same sort of person as Liu Bingzhong (是何異僧，目三角，形如病虎，性必嗜殺，劉秉忠流也)." Daoyan, we are told, was "greatly pleased."[8] In a slightly different version of the story, the physiognomist exclaims: "You are such a fat monk (寧馨胖和尚乃爾耶)!" He describes Daoyan's eyes as flashing or glittering as well as triangular, and, when he compares Daoyan with Liu Bingzhong, Daoyan responds with a "great laugh."[9] Liu Bingzhong (1216–1274) was a Chan monk who served as a key adviser to Khubilai Khan (1215–1294), much as Daoyan served Zhu Di. There were many parallels between their lives, and Daoyan is said to have taken Liu as his hero.[10]

6. On the frontal orientation of the portrait of the Hongzhi emperor and the transformation of the Ming imperial image into an iconic representation, see Wen C. Fong and James C. Y. Watt, *Possessing the Past: Treasures from the National Palace Museum, Taipei* (New York: Metropolitan Museum of Art; Taipei: National Palace Museum, 1996), pp. 331–32; Wen C. Fong, "Imperial Portraiture in the Song, Yuan, and Ming Periods," *Ars Orientalis*, vol. 25 (1995), pp. 47–59; and Mette Siggstedt, "Forms of Fate: An Investigation of the Relationship Between Formal Portraiture, Especially Ancestral Portraits, and Physiognomy (*Xiangshu*) in China," in *International Colloquium on Chinese Art History, 1991, Proceedings, Painting and Calligraphy*, part 2 (Taipei: National Palace Museum, 1992), pp. 721–23. Stuart and Rawski respond to Fong and others in discussing the "iconic pose" with reference to ancestor portraiture; see *Worshiping the Ancestors*, pp. 83–88. A frontal orientation is also characteristic of seventeenth-century "chair" portraits of Ōbaku 黃檗 Zen Japanese masters; see Stephen Addiss, *Obaku: Zen Painting and Calligraphy* (Lawrence, Kansas: Spencer Museum of Art, 1978), cat. nos. 4, 5, 10; *The Art of Zen: Paintings and Calligraphy by Japanese Monks, 1600–1925* (New York: Harry N. Abrams, 1989), pp. 79–81.

7. An anonymous hanging scroll, ink and color on silk, 220 by 150 centimeters; for a color reproduction, see Fong and Watt, *Possessing the Past*, p. 329, pl. 161.

8. Zhang Tingyu *et al.*, eds., *Ming shi*, 145: 4079.

9. *Shishi jigu lue xuji* (*Followers of Buddha, a Brief Account of Investigating the Past, Continued*), in *Taishō shinshū Daizōkyō* (*The Buddhist Canon Published in the Taishō Era*), ed. Takakusu Junjirō and Watanabe Kaikyoku (Tokyo, 1924–1932), no. 2038, 3: 940.

10. Hok-lam Chan, "Liu Ping-chung (1216–74): A Buddhist-Taoist Statesman at the Court of Khubilai Khan," *T'oung-pao*, vol. 53 (1967), pp. 110–11.

Marsha Weidner

Although Liu Bingzhong eventually accepted the trappings of secular officialdom, for most of his life he served in monk's costume,[11] as did Daoyan. This physiognomic reading of Daoyan's character surely influenced perceptions of his portraits, and, as will be shown below, what he wore was clearly an issue for some who viewed these images.[12]

Daoyan's life is a study in contradictions. He was born into a family of physicians in Xiangcheng 相成 (Changzhou 長州 County, Suzhou Prefecture) but rejected the family calling, reportedly saying that he wished to study to become an official or, if this proved impossible, then he would like to follow the Buddha as "a traveller beyond this world." He left home at the age of thirteen (fourteen *sui* 歲) to pursue a religious vocation at Miaozhi'an 妙智庵 in Xiangcheng and was tonsured four years later.[13] By the time he was pulled into the orbit of the Ming throne as a middle-aged man, he had become a prominent figure in Buddhist circles, residing for a period at Jingshansi 徑山寺, serving as abbot of several other southern monasteries and authoring texts on Pure Land (Jingtu 淨土) Buddhism.[14] He was also known for his Confucian studies, poetry, calligraphy, and painting.[15] He was a good friend of the Suzhou poet Gao Qi 高啓 (1336–1374), and at one time his travelling companion.[16] He added poetic inscriptions to paintings by Wang Meng 王蒙 (ca. 1308–1385), one of the so-called "Four Great Masters of the Yuan" (*Yuan si dajia* 元四大家) who likewise associated with Gao Qi's circle in the 1360s.[17] The literary side of Daoyan's person-

11. *Ibid.*, p. 140.

12. On the influence of physiognomy on portraiture, see Mette Siggstedt, "Forms of Fate," pp. 713–48. After the symposium, the author was kind enough to send me copies of relevant sections of illustrated texts on physiognomy.

13. Wang Ao, *Zhenze jiwen* (*Records of Things Heard by Zhenze [Wang Ao]*), 11: 4b–6a, in *Ming Qing shiliao huibian* (*Collection of Ming and Qing Historical Materials*), ed. Shen Yunlong, sect. 1, no. 3 (Taipei: Wenhai chubanshe, 1967), pp. 1206–9; Eugene Feifel and Hok-lam Chan, "Yao Kuang-hsiao," *Dictionary of Ming Biography* (hereafter, *DMB*), ed. L. Carrington Goodrich (New York: Columbia University Press, 1976), pp. 1561–65; Shang Chuan, "Ming chu zhuming zhengzhijia Yao Guangxiao (The Early Ming Famous Statesman Yao Guangxiao)," *Ming Qing shi* (*Ming and Qing History*) 3 (1985), pp. 17–26. (I am indebted to Chang Qing for drawing my attention to this article.)

14. Leng Xiao, *Hangzhou fojiao shi* (*History of Buddhism in Hangzhou*) (Hangzhou: Hangzhou shi fojiao xiehui, 1993), p. 228; Shang Chuan, "Ming chu zhuming zhengzhijia Yao Guangxiao," 19; *DMB*, pp. 1561–65; Zhang Tingyu *et al.*, eds., *Ming shi*, 145: 4081.

15. *DMB*, p. 1561; Yu Jianhua, *Zhongguo meishujia renming cidian* (*Biographical Dictionary of Chinese Artists*) (Shanghai: Shanghai renmin meishu chubanshe, 1981), p. 590. Chinese catalogues record paintings of ink bamboo and plum blossoms by Daoyan; see John C. Ferguson, *Lidai zhulu hua mu* (*Index of Recorded Paintings of Successive Dynasties*) (Taipei: Zhonghua shuju, 1968), *shang* 上: 188b. A hanging scroll of ink bamboo, signed "Yao Huangxiao" and dated to 1409, is published in *Zhongguo guhua ji* (*Collection of Ancient Chinese Paintings*) (Hong Kong, 1966), pl. 148. A landscape handscroll with a inscription dated to 1382, signature, and seal of Daoyan, was acquired by the San Antonio Museum in 1987; see Alice R. M. Hyland, "Chinese Paintings in Texas Museum Collections," *Ars Orientalis*, vol. 25 (1995), pp. 151–54.

16. *DMB*, p. 696; Frederick W. Mote, *The Poet Kao Ch'i, 1336–1374* (Princeton: Princeton University Press, 1962), pp. 104–06, 194, 199–201.

17. *DMB*, p. 1393. In 1369 Daoyan added a colophon to Wang Meng's famous *Listening to the Rain Pavilion* (*Tingyu lou* 聽雨樓) handscroll painted four years earlier; see Zhang Chou, *Qinghe shuhua fang* (*Boat of Painting and Calligraphy on a Pure River*; 1616) in *Zhongguo shuhua quanshu* (*Complete Texts on Chinese Painting and Calligraphy*), vol. 4 (Shanghai: Shanghai shuhua chubanshe, 1992), p. 349. A poetic inscription by Daoyan appears on Wang Meng's *Bamboo, Rock and Flowing Stream* (*Zhu shi liuquan* 竹石流泉), a hanging scroll in the National Palace Museum, Taipei. This inscription is not dated, but it has been suggested that the painting was done in 1364. Wang Xing 王行, another member of the circle of Gao Qi, also inscribed the painting. See Chang Kuang-pin, *Yuan si dajia* (*The Four Great Masters of the Yuan*) (Taipei: National Palace

ality is highlighted in his biography composed by the eminent statesman Wang Ao 王鏊 (1450–1524), also of the Suzhou area. Wang Ao's account also suggests that the monk was initially reluctant to engage in court politics, as he declined two imperial invitations to serve before responding to an imperial summons in 1382.[18]

Daoyan was one of the prominent monks called to Nanjing in that year to participate in the funeral of Empress Ma 馬 (Xiaoci Gao Huanghou 孝慈高皇后; 1332–1382). The founding Ming emperor Taizu 太祖 (the Hongwu 洪武 Emperor; r. 1368–1399) then assigned him to serve Zhu Di, then Prince of Yan (Yanwang 燕王), in Beijing. Daoyan served his prince well, eventually helping him wrest the throne from his nephew, the Jianwen 建文 Emperor (r. 1399–1402). Daoyan has been identified as one of Zhu Di's principal military advisers in this bloody usurpation.[19] Although sixty-seven years old when his prince took the throne in 1402, Daoyan continued to serve. He was first made "Left Buddhist Patriarch" (*zuo shanshi* 左善世) of the Central Buddhist Registry (Senglusi 僧錄司).[20] Then, in 1404, the emperor returned to Daoyan his original surname, Yao, presented him with the name Guangxiao, and appointed him "Grand Master for Assisting with Goodness" (*zishan dafu* 資善大夫) and "Junior Preceptor of the Heir Apparent" (*taizi shaoshi* 太子少師). Henceforth he became known as "Junior Preceptor Yao (Yao Shaoshi)." His literary skills were again in demand, in part for the revision of history necessary to legitimize the new reign.[21] History, however, has not been kind to Daoyan, characterizing him as "an evil man" whose own sister found him lacking in Buddhist compassion and "fond of killing."[22] Still, as Chün-fang Yü has pointed out, he had admirers, including, surprisingly, the eminent late Ming Buddhist master Yunqi Zhuhong 雲棲袾宏 (1535–1615).[23] The complexity of Daoyan's historical persona always affected the reception of his portraits.

Museum, 1975), (English section) pp. 34–35, 80–81, no. 406. In 1417, near the end of his life, Daoyan composed a colophon for Wang Meng's *Mount Taibai* (*Taibaishan* 太白山). The painting and colophons are reproduced in *Liaoning bowuyuan cang hua* (*Painting Collection in the Liaoning Museum*), ed. Yang Renkai and Dong Yanming (Shanghai: Shanghai renmin meishu chubanshe, 1986), no. 31; also Zhang Zhao *et al.*, *Shiqu baoqi chubian* (1745), 22: 25a–30a. This scroll is the subject of an excellent seminar paper (which includes translations of most of the colophons) by Ling-en Lu, a Ph.D. candidate at the University of Kansas and Assistant Curator at the Nelson-Atkins Museum in Kansas City. Daoyan was also among the scholars who inscribed poems on Wang Fu's 王紱 (1362–1416) *Farewell Meeting at Fengcheng* (*Fengcheng jianyong* 鳳城餞詠), a hanging scroll in the National Palace Museum, Taipei; reproduced in James Cahill, *Parting at the Shore: Chinese Painting of the Early and Middle Ming Dynasty, 1368–1580* (New York and Tokyo: Weatherhill, 1978), pl. 23.

18. Wang Ao, *Zhenze jiwen*, 11: 4b.

19. David B. Chan, "The Role of the Monk Tao-yen in the Usurpation of the Prince of Yen (1398–1402)," *Sinologica*, vol. 7, no. 2 (1959), p. 83.

20. Translations of official titles follow Charles O. Hucker, *A Dictionary of Official Titles in Imperial China* (Stanford: Stanford University Press, 1985).

21. Zhang Tingyu *et al.*, eds., *Ming shi*, 145: 4079–4081; *DMB*, pp. 1561–64; Chan, "The Role of the Monk Tao-yen," pp. 92–94; Chün-fang Yü, "Ming Buddhism," in *The Cambridge History of China*, vol. 8, *The Ming Dynasty, 1368–1644*, Part 2, ed. Denis Twitchett and John K. Fairbank (Cambridge: Cambridge University Press, 1998), pp. 915–18; Shih-shan Henry Tsai, *Perpetual Happiness: The Ming Emperor Yongle* (Seattle: University of Washington Press, 2001), pp. 43–45, 140.

22. *DMB*, p. 1563, citing Tan Qian 談遷 (1594–1658) for the characterization of Daoyan as an "evil man." See also Yü, "Ming Buddhism," p. 916.

23. *Ibid.*, pp. 916–17.

Marsha Weidner

Despite the fame (or notoriety) of its subject, Daoyan's portrait has received relatively little attention from art historians, presumably because it falls outside the traditional range of art historical interest.[24] For Chinese connoisseurs, such relatively late, anonymous, functional paintings were not "art" in the sense of expressive or collectible objects. Japanese scholars have taken great interest in Buddhist master portraits, but have seldom extended their inquiries to Chinese works postdating the Yuan, and, in general, Western scholars have followed suit. Recent studies, however, have begun to move beyond canonical categories, entrenched value systems, and standard interpretations. Accepted explanations of the functions of Chan master portraits, for example, have been challenged, permitting us to see these images in a broader context of East Asian memorial portraiture and calling greater attention to their ritual function.[25] At the same time, we have begun to recognize the pursuit of the hand of the canonical master as just one of many ways to "do art history," and to admit a broader range of visual culture into the art historical context. The exhibition of Chinese ancestor portraits held in 2001 at the Arthur M. Sackler Gallery in Washington, D.C., was vivid testimony to our expanding visual horizons.[26]

The door is now open to talk about portraits like this one in a variety of ways, some more rewarding than others. Because this portrait depends heavily on long-established pictorial conventions and comes from the hand of our familiar painter known collectively as "Anonymous," traditional art historical approaches focusing on its point of production yield comparatively few rewards. Such portraits had lives of their own, tied to those of their subjects to be sure, but rarely to those of their makers. Attention to their ritual function, as called for by historians of religion, may tell us something of the concerns of patrons and ritual practitioners, but little about the power of these portraits as images. We learn much more in this regard from those who saw them. Formal portraits were living things, imbued with the spirit of and empowered to stand in for their subjects not only in rituals, but also in the popular imagination. Their power becomes apparent when we follow them down through time and recognize the fascination they held for generations of viewers.[27]

Portraits of Daoyan were actors in the drama of Beijing well into the seventeenth century. The stages upon which they appeared were Buddhist monasteries. If we look for places where people of the Ming (and other periods) went to see things that afforded escape from the mundane, places where art intensified experience, we will find none

24. It was reproduced in *Gugong* (February 1930), no. 5; *Gugong zhoukan* (19 September 1931; bound in vol. 5), and *Zhongguo lidai mingren tujian* (*Pictorial Handbook of Famous Men of Successive Dynasties of China*) (Shanghai: Shanghai shuhua chubanshe, 1989), p. 49. Bu Liansheng introduces the painting primarily to support his argument concerning the erroneous identification of a sculptural portrait as Yao Guangxiao; "Ming Xuande shi nian diaozao de Bandan Zhashi xiang," pp. 83–84.

25. Foulk and Sharf, "On the Ritual Use of Ch'an Portraiture in Medieval China."

26. See Stuart and Rawski, *Worshiping the Ancestors*. Siggstedt's study of physiognomy and ancestor portraits, "Forms of Fate," was also a pioneering work in this area.

27. My thinking on these subjects was influenced by David Freedberg, *The Power of Images: Studies in the History and Theory of Response* (Chicago: University of Chicago Press, 1989), and Richard Brilliant, *Portraiture* (London: Reaktion Books, 1991).

more important than the monasteries.[28] It has become common to compare monasteries to museums.[29] Like modern museums, the big Chinese monasteries were treasure houses, with imposing architecture and prominent displays of patrons' names. They offered respite from the "dusty world" and shaped aesthetic experience through their physical and social spaces. They possessed functional equivalents to the spaces found in museums: permanent galleries, special exhibition halls, storage rooms, and curatorial offices. Ritual activities, ritual manuals, lectures, and mural cartouches provided interpretation, and in this regard can be compared to museum talks, catalogues, and gallery labels. Treasures were kept and further explained by clerical counterparts to museum curators—monks and nuns who also had it within their gift to make certain treasures available to certain guests. Clerical curators, of course, lived in their museums. They were the main audience for the art in their homes, and they interpreted these objects in light of their religious vocations. They acquired, examined, and wrote about objects. Yet we seldom take their perspectives into account, perhaps because, as outsiders ourselves, it is easier for most of us to identify with monastery visitors than with the residents.[30] Usefully, both visitors and clerics left written responses to portraits of Daoyan.

Visitors, drawn by popular lore, gazetteers, and the writings of prominent literati, went to monasteries to see marvelous things and were prepared to have certain responses. Some went to commune with the ancients through stelae engraved with calligraphy from famous hands. Some were fascinated by exotic, if sometimes repellent, images from foreign countries. Some savored experiences like those offered by national portrait galleries: face-to-face encounters with famous people of the past.

Wang Ao, whose biography of Daoyan was mentioned above, reported on such an encounter with the master in a poem simply titled "Portrait of Junior Preceptor Yao." Wang wrote:

> Dismounting my horse, I touch and read the old stone tablet,
> Wishing to inquire into past affairs that no one knows.
> All that remains is a portrait in a full-moon niche,
> With the bearing of [the figures of] the Lingyan Pavilion.
> On his jaw are the "three hairs" indistinct but still recognizable;
> That he achieved eminence "coming out six times" was fundamentally unsurprising.

28. Two books in particular suggested this approach: Frank Burch Brown, *Religious Aesthetics: A Theological Study of Making and Meaning* (Princeton: Princeton University Press, 1989), and Susan A. Crane, ed., *Museums and Memory* (Stanford: Stanford University Press, 2000).

29. Timothy Brook, *Praying for Power: Buddhism and the Formation of Gentry Society in Late-Ming China* (Cambridge, MA: Harvard University Press, 1993), p. 111; Marsha Weidner, "Buddhist Pictorial Art in the Ming Dynasty (1368–1644): Patronage, Regionalism, and Internationalism," in *Latter Days of the Law: Images of Chinese Buddhism, 850–1850*, ed. Marsha Weidner (Lawrence, Kansas: Spencer Museum of Art; Honolulu: University of Hawaii Press, 1994), p. 70; Susan Naquin, *Peking, Temples and City Life, 1400–1900* (Berkeley: University of California Press, 2000), pp. 93–99; Marsha Weidner, "Imperial Engagements with Buddhist Art and Architecture: Ming Variations on an Old Theme," in *Cultural Interactions in Later Chinese Buddhism*, ed. Marsha Weidner (Honolulu: University of Hawaii Press, 2001), p. 119.

30. Exceptions to this generalization include Amy McNair's "Buddhist Literati and Literary Monks: Social and Religious Elements in the Critical Reception of Zhang Jizhi's Calligraphy," in *Cultural Intersections*, ed. Weidner, pp. 73–86, and a dissertation in progress; Lara Ingeman, "Meditations on Painting: Inscriptions on Paintings Collected in the Discourse Records of Southern Song (1127–1279) Chan Masters," Indiana University.

Marsha Weidner

> One day the country returned to a true ruler,
> Because of this ascetic old monk.[31]

下馬摩挲讀古碑，欲詢往事沒人知。獨留滿月龕中像，便是凌煙閣上姿。頰隱三毛還可識，功高六出本無奇。一朝社稷歸眞主，還是朧然老衲師。

The historical and art historical references in this poem reflect Wang Ao's engagement with both government and art.[32] In comparing the portrait to those of the Lingyan Pavilion (Lingyange 凌煙閣), Wang Ao likened Daoyan to the twenty-four meritorious subjects painted for this memorial hall by Yan Liben 閻立本 (ca. 600–674) on imperial order. In referring to the "three hairs," Wang recalled Gu Kaizhi's 顧愷之 (ca. 344–ca. 406) portrait of Pei Kai 裴楷, wherein the artist reportedly conveyed the intelligence of his subject by adding three hairs to his jaw, a subtle but telling detail. The phrase "coming out six times" is probably a reference to the six battles of Zhuge Liang 諸葛亮 (181–234), a hero with whom Liu Bingzhong was also compared. Thus, with marvelous poetic economy, Wang Ao likened Daoyan to admirable men of the past portrayed by old masters. Art embraced politics, with man and portrait praised simultaneously. Wang Ao, however, did not indicate where he saw this portrait. This poem simply appears in his collected writings as one of several inspired by the shrines of famous men that formed something of a literati tourist trail in the capital.[33] By the late Ming, the poem was associated with Chongguosi 崇國寺, where a memorial hall (yingtang 影堂) for Daoyan had been established.[34]

Daoyan's home in the capital, however, was another venerable Buddhist establishment, Qingshousi 慶壽寺. Founded in the Jin dynasty, Qingshousi was one of the major Buddhist establishments of the Yuan capital, when it was located just south of the palace on the west side of the city.[35] Daoyan was appointed abbot of Qingshousi when he was sent to Beijing to attend Zhu Di in 1382. The Central Buddhist Registry, in which Daoyan served as Left

31. Wang Ao, *Zhenze ji*, *Siku quanshu zhenben wu ji* edition, pp. 305–8 (Taipei: Shangwu yinshuguan, 1974), 1: 25b. A somewhat different version is quoted in Liu Tong and Yu Yizheng, *Dijing jingwu lue* (*Description of the Scenery of the Imperial Capital*; hereafter *DJ*) (1635; repr. Taipei: Guangwen shuju, 1969), 1: Chongguosi, p. 6b; and *Rixia jiuwen kao* (*Study of "Ancient Accounts Heard in the Precincts of the Throne"*) (ca. 1785; repr. Bejing: Guji chubanshe, 1983), 53: 847. I am much indebted to Chang Qing for his assistance in translating this poem and other texts used in the preparation of this essay. Whatever mistakes remain in the translations are, of course, strictly my own.

32. *DMB*, pp. 1343–47; on Wang Ao as an art collector and patron, see Anne De Coursey Clapp, *The Painting of Tang Yin* (Chicago: University of Chicago Press, 1991), pp. 27–39.

33. Wang Ao, *Zhenze ji*, 1: 25b. Wang also wrote poems on visiting the shrine of Wen Tianxiang 文天祥 (1236–1283) and the grave of Yelü Chucai 耶律楚材 (1190–1244), 25a–26a. About literati visits to these sites and tourism in Beijing, see Naquin, *Peking*, pp. 115, 176–77, 249–72.

34. The poem is attached to the entry for Chongguosi in *DJ*, 1: 62b (Chongguosi, 6b). Since Wang Ao died over a decade before Daoyan's memorial rites were moved to this monastery, either Chongguosi had a portrait of the master prior to that time, or Wang Ao saw a portrait at another site, perhaps Qingshousi or Tanzhesi.

35. See the map of Yuan Dadu 大都 in *Beijing lishi ditu ji* (*Collection of Historical Maps of Beijing*), ed. Hou Renzhi (Beijing: Beijing chubanshe, 1988), pp. 27–28. In 1448 the monastery was restored and renamed Da Xinglongsi. A pair of pagodas for Haiyun and Ke'an stood just to the west of the compound, giving the site its later name, Twin Pagoda Temple (Shuangtasi 雙塔寺); see *Rixia jiuwen kao*, 43: 680, 684. Among the famous artistic and literary personalities who stayed at Qingshousi were Zhao Mengfu 趙孟頫 (1254–1322) and Wen Zhengming 文徵明 (1470–1559).

Buddhist Patriarch, was established there in the Yongle period.[36] Counted among the monastery's treasures were portraits of Haiyun 海云, the famous thirteenth-century monk-adviser to the early Mongol rulers and abbot of Qingshousi, and his successor at the monastery, Ke'an 可庵. Haiyun's portrait carried a eulogy by his follower and Daoyan's hero, Liu Bingzhong.[37] Eventually, a portrait of Daoyan also came to hang in a memorial hall in the monastery.

Daoyan's biographers make much of his insistence on living in a monastery. Despite the Yongle Emperor's attempts to entice him back into the secular world with titles, names, gifts (including palace women), and entreaties, Daoyan continued to shave his head and live as a monk. He did, however, accept ceremonial court dress. He reportedly donned the dress of a scholar-official, "cap and belt" (*guandai* 冠帶), when he went to court, and then returned to his monk's robes when he withdrew.[38] Portraits, too, showed him in different guises. Jiang Yikui 蔣一葵, writing in the late sixteenth century, reported on two paintings of the "Junior Preceptor" then in the capital—one showing him dressed in a red robe with a jade belt and wearing a Tang 唐 cap on his bald head, and the other in a monk's robe.[39] Like his names and titles, these costume changes signified the tension between his secular and sacred roles, and this tension was critical to perceptions of the man and his images in later times.

This tension played out over the fifteenth and sixteenth centuries, as later emperors became custodians of Daoyan's memory. Zhu Di's son, Zhu Gaozhi 朱高熾 (the Hongxi 洪熙 Emperor; r. 1424–1425) installed Daoyan's spirit tablet in the hall of meritorious officials in the Taimiao 太廟, the Imperial Ancestral Temple, in recognition of Daoyan's service to the emperor's father.[40] There, along with other worthies, Daoyan received offerings until 1530, when a zealous official, Liao Daonan 廖道南 (d. 1547), took exception to the monk's presence in the heart of the imperial cult. This episode, although fairly minor in the context of the larger controversies on rites roiling at the time,[41] testifies to the role a portrait could play on the national stage. When he petitioned to have Daoyan's spirit tablet removed from the Taimiao, Liao called the portrait of Daoyan at Qingshousi (by then renamed Da Xinglongsi 大興隆寺), figuratively, as a witness. Because this image portrayed Daoyan with a shaven head and monk's robe, Liao argued, Daoyan could not be compared with the other meritorious officials in the hall. Liao's petition was referred to the Board of Rites, the officials of which agreed that it was improper for one with a shaven head and monk's robe to receive sacrifices in the Taimiao, but they also recommended a compromise. They proposed moving his spirit tablet

36. *Da Ming huidian* (*Collected Statutes of the Ming Dynasty*) (1587; repr. Beijing: Zhonghua shuju, 1989), 226: 1110.

37. *DJ*, 4: 17b–18a (Shuangtasi, 2b–3a); Sun Chengze, *Chunming meng yu lu* (*Record of a Remembered Dream of the Capital*) (1761, repr. in *Siku quanshu zhenbian liu ji*, vols. 224–34; Taipei: Shangwu yinshuguan, 1976), 66: 8a–b.

38. Zhang Tingyu *et al.*, eds., *Ming shi*, 145: 4081; *DMB*, p. 1563; David B. Chan, "The Role of the Monk Tao-yen," p. 94.

39. Jiang Yikui, *Chang'an kehua* (*A Visitor's Remarks on the Capital*) (ca. 1603[?]; repr. Beijing: Beijing guji chubanshe, 1980), p. 20.

40. Zhang Tingyu *et al.*, eds., *Ming shi*, 52: 1340; 145: 4082.

41. *The Cambridge History of China*, vol. 7, *The Ming Dynasty, 1368–1644*, Part I, ed. Frederick W. Mote and Denis Twitchett (Cambridge: Cambridge University Press, 1988), pp. 457–61; Deborah A. Sommer, "Images into Words: Ming Confucian Iconoclasm," *National Palace Museum Bulletin*, vol. 29, nos. 1, 2 (March–April, May–June 1994), p. 15.

to Da Xinglongsi and sending officials to make regular offerings there. The emperor approved and dispatched a message to Daoyan in the spirit world, advising him of the change. This proved to be only a temporary solution, however. Da Xinglongsi burned down five years later and was not rebuilt.[42] Even then, the Board of Rites did not abandon Daoyan. His spirit tablet was moved again, along with the Central Buddhist Registry, to Chongguosi in Beijing.[43] It is assumed that the portrait was lost in the fire.[44]

If the thought of a cleric receiving offerings in the Taimiao offended certain officials, the idea of a Buddhist monk serving as a government official did not sit well with all Buddhist monks, either—Yunqi Zhuhong's approval of Daoyan notwithstanding. The celebrated master Zibo Zhenke 紫柏眞可 (1543–1603) was one who found Daoyan's political career problematic, or at least this is indicated by the inscription he added to the upper right corner of the portrait of Daoyan now in the Palace Museum. Zhenke wrote:

> A monk's robe but serving as an official, [this is like] flies dotting an ice-pure face.
> To go against what is constant on behalf of the Dao, how broad are the waves of compassion?
> Whether one understands or blames this gentleman, the stars have their fixed pattern. Why!
> He obtained [Master] Wuchu's transmission of the orthodox line,
> [But] illumination and darkness never mixed with one another.
> 染衣而官，蠅點冰顏。以道反常，慈波奚寬。知公罪公，星有定盤。咦！接得無初傳正脈，
> 從來明暗不相參。

Zhenke composed this inscription in 1592 at the Yiyin tang 一音堂 ("One-Sound Hall"), his retreat at Tanzhesi.[45]

Tanzhesi was known for the beauty of its setting, its antiquity and its antiquities, which included a "forest" of stupas and portraits of secular and religious notables.[46] Daoyan had a meditation house just to the northeast of this

42. *Rixia jiuwen kao* (43: 684–685), citing *Ming huidian* (*Ming Statutes*), dates the fire to 1535; *DJ* (1: 18a; Shuangtasi, 3a) to 1538.

43. Zhang Tingyu *et al.*, eds., *Ming shi*, 50: 1306; 52: 1340; 145: 4082; *Jiajing sidian* (*Rites and Ceremonies of Jiajing*), quoted in *Rixia jiuwen kao*, 43: 684; Naquin, *Peking*, p. 14.

44. Bu Liansheng, "Ming Xuande shi nian diaozao de Bandan Zhashi xiang," p. 83.

45. Hu Jing, *Nanxundian tuxiang kao, shang*, pp. 30a–b. On the left side of the portrait is a matching encomium by Layman Xinyuan of Jiangyou:
 > An official in monk's clothing; a face without shame.
 > There is neither Dao nor constancy (*chang*); the sea of Dharma is itself vast.
 > Understand me or blame me, I have no fixed pattern. Ha-ha!
 > Try to see the peak emerging from the white clouds;
 > Let the bright moon act as it will, [the two are] unrelated.
 > Xinyuan jushi of Jiangyou eulogized in response in the autumn of *xinchou* (1601?).
 > 官爾緇衣無覥爾顏。非道非常法海自寬。知我罪我我無定盤。呵呵。試看白雲開出岫，任他明月不相
 > 關。辛丑秋江右心源居士和贊。

 Readings by Daniel Stevenson of the University of Kansas contributed substantially to the translation of both of these inscriptions. Stevenson pointed out, for instance, the probable connection between the references to Dao and *chang* in these poems and the opening line of *Laozi*: "The Way that can be spoken of as a 'way' is not the constant Way (*Dao ke dao, fei chang dao* 道可道，非常道)."

46. By the seventeenth century, the portraits included an ink painting of the founding patriarch riding a dragon and life-size statues of Khubilai Khan, his wife, son, and daughter, Princess Miaoyan 妙嚴, who had become a nun at the temple. *DJ*, 7: 50a–b (Tanzhesi, 2a–b); Susan Naquin, "Sites, Saints, and Sights at the Tanzhe Monastery," *Cahiers d'Extrême-Asie*, vol. 10 (1998)," p. 185. I am grateful to Susan Naquin for sending me references to Yao Guangxiao in various sources.

monastery and was close friends with the abbot, the master Wuchu 無初 mentioned in Zhenke's inscription.[47] Wuchu (Deshi 德始; J: Musho Tokushi) was a Japanese monk who visited China twice, the second time arriving at Qingshousi in Beijing, where he met Daoyan. In 1412, Daoyan recommended him to the emperor, who then appointed Wuchu abbot of Tanzhesi. Daoyan and Wuchu pursued their friendship at this secluded site.[48] After Daoyan's death, Tanzhesi established a portrait hall for Daoyan with a painted image, presumably the surviving painting bearing Zhenke's inscription.[49] According to Qing dynasty sources, however, Daoyan's meditation house held a sculpted portrait of the master.[50] A late Ming source quotes a poem by Airong 艾容 of Jiangning titled "Lodging at Tanzhesi and Viewing the Portrait of Junior Preceptor Yao" (Su Tanzhesi zhan Yao Shaoshi xiang 宿潭柘寺瞻姚少師像).[51] It is unclear which portrait Airong saw, but the last line of his poem echoes a line in a self-eulogy Daoyan composed for his portrait kept at Chongguosi in Beijing.[52] Such cross-referencing of images indicates the impact they had on visually and intellectually receptive viewers.

Chongguosi was the place that received the Central Buddhist Registry and Daoyan's spirit tablet when Da Xinglongsi (Qingshousi) burned. His spirit tablet was paired with the portrait bearing his self-eulogy in a memorial hall, where officials from the Court of Imperial Sacrifices (Taichangsi 太常寺) maintained his rites until 1586.[53] According to a late Ming guidebook, the "image was stern, with a full-moon face, eyes bright and piercing, a bare head, monk's robe, and seated in cross-legged posture."[54] Presumably it looked very much like the surviving portrait.

Located northwest of the Forbidden City, Chongguosi is another venerable, imperially patronized institution with an impressive Yuan pedigree. In 1429, during the Ming, it was renovated and renamed Da Longshansi 大隆善寺. The designation huguo 護國 ("protecting the nation") was added in 1472, at the time of another restoration, making it Da Longshan Huguosi, but "people of the capital" apparently preferred to call it by its old name, Chongguosi.[55]

47. Shen Mude and Shi Yi'an, Tanzhe shan Xiuyunsi zhi (Gazetteer of Xiuyunsi of Mt. Tanzhe; hereafter Tanzhe zhi) (18th c.; repr. in Zhongguo fosi shizhi huikan [Collection of Historical Gazetteers of Chinese Buddhist Monasteries] [Taipei: Zongqing tushu chuban gongsi, 1994]), pp. 69–72, 150–51. Daoyan's poem "Travelling to Mt. Tanzhe to Venerate the Patriarch's Stupa on an Autumn Day" is quoted in DJ, 7: 51b (Tanzhesi 3b), and Tanzhe zhi, pp. 92–93.

48. Yuan Shusen, Tanzhesi (Beijing: Beijing shi Tanzhesi guanli chu, n.d.), pp. 11, 13, 86; Tanzhe zhi, pp. 69–72.

49. Yuan Shusen, Tanzhesi, p. 86.

50. Tanzhe zhi, pp. 150–51; Li Zongwan, Jingcheng guji kao (Investigation of Ancient Traces in the Capital) (1745; repr. Beijing: Beijing guji chubanshe, 1981), p. 23.

51. DJ, 7: 55b (Tanzhesi, 7b).

52. This connection is pointed out in Tanzhe zhi, pp. 150–51.

53. DJ, 1: 58a–b (Chongguosi, 2a–b); Shen Bang, Wanshu zaji (Miscellaneous Notes About My Office at Wanping) (1593; repr. Beijing: Beijing guji chubanshe, 1983), 18: 219–20; Naquin, Peking, p. 148.

54. DJ, 1: 58b (Chongguosi, 2b). Others recorded this portrait in the seventeenth century, including Sun Chengze 孫承澤 (1592–1676) and Tan Qian. See Sun Chengze, Chunming meng yu lu, 66: 9a–b. Sun does not describe the image, but transcribes Daoyan's self-eulogy. Tan Qian, Beiyou lu (Record of a Journey North) (1654; repr. Beijing: Zhonghua shuju, 1960), p. 79. Tan's description of the image follows that of DJ.

55. DJ, 1: 57a–62b (Chongguosi, 1a–6b); Beijing lishi ditu ji, 27–28. For a careful description of what remained at the monastery

Marsha Weidner

Stelae in Chinese and Tibetan, wall paintings, and sculptures bear witness to its antiquity and cosmopolitan character.[56] The largest Tibetan Buddhist center in the capital in the Yuan and Ming periods, it was home to Tibetan clerics who served and enjoyed the support of the Ming court.[57] It was also a place congenial to thoroughly Chinese literary gatherings, a favorite haunt of scholars such as Yuan Hongdao 袁宏道 (1568–1610) and his brothers. Their literary club, the Grape Society (Putaoshe 葡萄社), met there from 1598 to 1600, to talk about Chan Buddhism, write poetry, and drink wine—the monastery is often mentioned in their poems.[58]

Yuan Hongdao saw Daoyan's portrait during a visit to the monastery on a spring day in 1599. He had set out with his elder brother and some friends for a destination west of the city, but a sandstorm forced them to take refuge in the monastery. As luck would have it, his younger brother and another friend were already there, so they joined forces and drank happily all day long. They also took advantage of the opportunity to see some of the sights of the monastery. In a short essay recounting highlights of the day,[59] Yuan Hongdao wrote:

> A monk of the monastery led us to view the portrait of Junior Preceptor Yao [Guangxiao, Daoyan]. [His] appearance is natural and unrestrained; the pupils of his eyes flash with the brilliance of lightning. The words of the portrait eulogy are those of a true Chan monk. It was inscribed by the Junior Preceptor himself.
> 寺僧引觀姚少師像，姿容瀟洒，雙睛如電光之爍。像贊蓋本色衲子語，少師自題也。

For Yuan Hongdao, a devout lay Buddhist, Daoyan's Chan identity was clearly a positive thing. Yuan does not quote the revealing self-eulogy, but it can be found in other sources. The aforementioned Jiang Yikui, writing about the same time, described Daoyan's appearance in words nearly identical to Yuan's, and then goes on to report:

> The portrait encomium says:
> "Observing the broken plantain and leaning on my staff,
> I am careless to the bone and 'flow with dew and breeze' [adopting an unconventional air].
> At times I wave the tortoise-hair whisk,
> And if you directly obtain the void, I laugh and nod my head."

in the early twentieth century, including a ground plan and photographs, see Liu Dunzhen, "Beiping Huguosi can ji (Remaining Traces of Huguosi in Beijing)," in *Liu Dunzhen wenji* (*The Collected Writings of Liu Dunzhen*), vol. 2 (Beijing: Zhongguo jianzhu gongye chubanshe, 1982), pp. 211–50, reprinted from *Zhongguo yingzao xueshe huikan* (*Bulletin of the Institute for Research in Chinese Architecture*) 6, no. 2 (December 1935).

56. These include stelae composed and written by Zhao Mengfu and Wei Su 危素 (1295–1372) in 1312 and 1364, respectively. For an account of the Tibetan Buddhist cultural relics at the site, see Huang Hao, *Zai Beijing de Zangzu wenwu* (*Tibetan Cultural Relics in Beijing*) (Beijing: Minzu chubanshe, 1993), pp. 10–14. A wooden seated figure of a monk was previously misidentified as Daoyan (see Liu Dunzhen, "Beiping Huguosi can ji," pp. 212, 229, 235), but is now recognized as an image of a fifteenth-century Tibetan cleric, Grand Preceptor of State Bandan Zhashi 班丹札釋; see Bu Liansheng, "Ming Xuande shi nian diaozao de Bandan Zhashi xiang," pp. 82–86.

57. *DJ*, 1: 57a (Chongguosi, 1a); Huang Hao, *Zai Beijing de Zangzu wenwu*, p. 10.

58. Yuan Hongdao, *Yuan Hongdao ji jianjiao* (*Annotated Collection of Works by Yuan Hongdao*), ed. Qian Bocheng (Shanghai: Shanghai guji chubanshe, 1979), pp. 628, 641, 646, 657–58, 661, 664. A number of poems by Yuan Zongdao 袁宗道 (1560–1600) and Yuan Hongdao are cited in *DJ*, 1: 60a–62a (Chongguosi, 4a–6a).

59. "Chongguosi you ji (Record of Travelling to Chongguosi)," *Yuan Hongdao ji jianjiao*, 687; Jonathan Chaves, *Pilgrim of the Clouds: Poems and Essays from Ming China* (New York and Tokyo: Weatherhill, 1978), pp. 105–6. (My translation differs slightly from Chaves'.)

These are the words of a true Chan monk. The postscript says: "Inscribed by Du'an Laoren himself."
Du'an Laoren was the Junior Preceptor's alternate sobriquet.[60]
像贊云：「看破芭蕉柱杖子，等閒徹骨露風流。有時搖動龜毛拂，直得虛空笑點頭。」蓋本色
衲子語。跋云獨安老人自題。獨安，少師別號也。

After viewing the portrait, Yuan Hongdao's party continued to tour Chongguosi, following their clerical guide through the Tibetan monks' dormitory to view a "transformation image" (*bianxiang* 變相) of Mañjuśrī and other bodhisattvas. Yuan describes it as a terrifying image, short and fat, with a blue face, boar's head, sixteen feet shown side by side, hung with human heads, and holding military implements. His description generally matches a *thangka* of Vajrabhairava, a wrathful manifestation of Mañjuśrī, dated to 1512, now in the collection of the University Art Museum in Berkeley (*Fig. 2*). It has been suggested that this painting was made for Chongguosi.[61] The monk told Yuan that Tibetans presented many images of this sort, and this led to discussion of the customs of that country and its remoteness.

Yuan Hongdao's narrative, though spare, tells us a good deal about viewing art in monasteries. It reminds us that not all images were readily accessible. To see some objects required, or was at least facilitated by, helpful monks who might also be knowledgeable guides. Moreover, such viewings were not necessarily inspired by religious motives. Yuan's account suggests a range of religious and secular reasons for looking at art in monasteries. He was interested in Daoyan's portrait as an image of a Chan monk, but he was also interested in features of the picture itself. He provides quite specific descriptions of both the portrait and the Tibetan image. Viewing was also a form of entertainment, in this case one of many pleasures of a day that mixed drinking and intellectual pastimes. Finally, there is in his account a hint of fascination with the exotic and perhaps even an implied comparison between Daoyan and the terrifying Tibetan image. Neither figure was strange in the sense of unfamiliar. Tibetan images had been part of the religious landscape of the capital for centuries, and Daoyan was one of the most famous personalities in Ming imperial history. At the same time, both were beyond the pale from an orthodox historical perspective, representing Buddhist incursions into Chinese political territory and best seen safely behind monastery walls.

60. Jiang Yikui, *Chang'an kehua*, p. 20. Here again, Daniel Stevenson provided helpful suggestions on the translation. He also notes that the stalk of plantain mentioned in the first line of the poem is probably a metaphor for the insubstantiality of existence and self.

61. Chaves anticipated this comparison with his identification of Yuan Hongdao's essay as containing "one of the earliest detailed descriptions of a Tibetan work of art by a Chinese writer" and his observation of the general correspondence between the iconography of Vajrabhairava and the figure described by Yuan Hongdao. See *Pilgrim of the Clouds*, pp. 135–37. The link between this painting and Chongguosi was made by David Kidd in "Tibetan Painting in China, Author's Postscript," *Oriental Art*, vol. 21, no. 2 (Summer 1975), pp. 158–60. See also *Latter Days of the Law*, entry no. 11 by Amy McNair. The painting inscription identifies the donor as the Great Felicitous Dharma King Rimpoche dPal-ldan (Daqing Fawang Lingzhan Bandan 大慶法王嶺占班丹). This Tibetan cleric and others took up residence at Chongguosi in 1512 on imperial order. See *DJ*, 1: 57a (Chongguosi, 1a). The inscription also names Da Huguo Bao'ansi 大護國保安寺, which may provide another link with Chongguosi. The latter was renamed Da Longshan Huguosi in the fifteenth century. However, I have yet to connect the name "Bao'an 保安" with this temple.

Marsha Weidner

Through his portraits, Daoyan took his place among notables of past generations in the halls of famous Beijing monasteries. These portraits, in turn, were part of a network of images that linked the monasteries, the court, and official culture, as well as the itineraries of cultural tourists in the capital. Admittedly the portraits of Daoyan were exceptional. They depicted an exceptional man and attracted commentary from other exceptional men, but they were by no means unique. Guidebooks list numerous images in monasteries that the indefatigable tourist or pilgrim might enjoy. The Palace Museum's handsome portrait of Daoyan thus represents a class of works and range of viewing situations familiar to Ming dynasty audiences, but too seldom addressed in our studies of Ming art. This painting is an invitation to further exploration of the roles Buddhist monasteries played in Ming visual culture.

北京明代寺院之肖像與名人——
對僧道衍肖像畫的反應

Marsha Weidner

堪薩斯大學

以姚廣孝之名廣爲人知的著名政治顧問、軍事策略家、佛教僧侶道衍的肖像畫在他於1418年死後，幾世紀以來吸引眾名人關注。道衍的唯一現存肖像畫，收藏於北京故宮博物院，是張以墨與豐富色彩描繪於絹本上的大型掛軸。此像是舉行儀式時的盛裝姿態，並遵循初期畫禪宗住職時好用的習慣，描繪像主坐在椅子上的姿勢。儘管這是張優秀的作品，但卻甚少受到注目；由於此畫爲一晚期、作者不明、實用性的作品，因此被排除於傳統美術史家關心的領域之外。在以製作面爲焦點的傳統美術史學方法中，關於這類繪畫有許多不明之處。若注意其儀式性質的實用層面，或許可以闡明其關護者或進行儀式者，但卻幾乎無法說明肖像畫作爲一種圖像的力量。然而，吾人可從鑑賞者的反應學到許多這種力量的內涵。

本稿期待以故宮博物院所藏繪畫和諸多文獻解明對道衍肖像畫的接受狀況。此接受狀況之重要因素是肖像畫在寺院被鑑賞的背景。把寺院比作美術館是很平常的，如同現代美術館一般，寺院是具備展示空間、解說方案、館員（知識豐富的僧侶）等要素的寶庫，更重要的是，寺院是審美經驗的場域。幾張曾經存在的道衍肖像畫和其他有名的肖像、文化遺產一併被放置於北京莊嚴的寺院中。像主傳記、人像學理論、歷史或美術史先例、因襲與傳說，以及鑑賞者自身的社會、政治、宗教見地，則更進一步影響對肖像畫的反應。

身爲佛教僧侶，也是王位篡奪者朱棣的政治顧問，道衍的雙重經歷廣爲有教養的鑑賞者所知，常常影響他們對肖像畫的反應。一位觀相家在道衍的臉上看出殘虐本性，將之比擬作忽必烈的顧問僧侶劉秉忠，這種風評應該影響了很多人。另一方面，明代偉大政治家王鏊作了道衍傳記，他在被某張肖像畫引發而賦的詩中對道衍表示肯定。王氏在詩中引用過去名家描繪的歷史人物之肖像畫，不但褒揚道衍的個性，也讚許肖像本身。嘉靖朝(1522-1566)宮廷中積極信奉儒教的官員談及著僧侶袍服的道衍肖像，嘆願希望可從祭祀天子祖靈的太廟之功臣殿取下道衍牌位，他主張穿僧服者不可與其他功臣並列。此外，也不是所有佛教僧侶都認同道衍的經歷，明代後期的著名佛僧紫柏眞可在故宮博物院藏的肖像畫上題贊，將出仕任官的僧人比作黏附在清白顏面上的蒼蠅。

虔誠的佛教居士袁洪道在崇國寺舉行的社交雅集中看到其肖像，被道衍寬大的眼睛注

視，道衍的風貌自然而不抑鬱，畫上題的自贊被認為是「真禪僧」之言。袁氏在此場合也對可怖的西藏影像感銘深刻，他的解說提供在寺院進行的藝術鑑賞活動之說明。例如這不見得會被賦予宗教動機，而也可以是一種娛樂。

這種事例顯示故宮博物院藏之端正的道衍像，不僅被編入北京有教養的觀光客之旅程中，也是把寺院、宮廷、官僚文化結合之網絡的一部分。

北京明代寺院の肖像と著名人―
僧道衍肖像画への反応

Marsha Weidner

カンサス大学

　姚広孝として広く知られる著名な政治顧問、軍事策略家、仏教僧、道衍の肖像画は、1418年の彼の死後、数世紀にわたり著名人の関心を惹きつけた。道衍の唯一現存する肖像画は、北京の故宮博物院に収蔵される絹本地に墨と豊富な色彩で描かれた大きな掛軸である。儀式の際の盛装姿で、初期の禅宗住職を描く際に好んで使われた慣習に従い、椅子に腰掛ける姿が描かれている。優れた絵画であるにもかかわらず、比較的、注目されなかったのは、晩年の作者不明の実用的絵画であったため、伝統的な美術史家の関心の領域から外れていたからである。制作面に焦点を当てる伝統的な美術史的アプローチでは、この種の絵画について明らかとなるものが少ない。儀式的な実用性に注目すれば、その庇護者や儀式を取り行なった人物に関しては判明することもあるだろうが、肖像画のイメージとしての力についてはほとんど語られない。だが、その鑑賞者の反応から、われわれはその力についてより多くを学ぶことができる。

　本稿では故宮博物院所蔵の絵画と、数々の文献を用いて、道衍の肖像画の受容について明確にしたい。この受容における重要な要素は、肖像画が鑑賞された寺院という背景であった。寺院を美術館にたとえるのは一般的なことで、現代の美術館と同様、寺院は、展示空間、解説プログラム、学芸員（知識豊富な僧侶）などを備えた宝庫であった。さらに最も重要なのは、寺院は美的経験の場であったことである。いくつか存在した道衍の肖像画は、他の有名な肖像や文化遺産と一緒に、北京の荘厳なる寺院に置かれていた。こうした肖像画に対する反応にさらに影響を与えたのが、像主の伝記、人相学理論、歴史的また美術史的先例、因習と伝説、そして、鑑賞者各人の社会的、政治的、宗教的見地であった。

　仏教僧、かつ王位篡奪者、朱棣の政治顧問という道衍の二重の経歴は、教養ある鑑賞者にはよく知られたことで、しばしば肖像画への反応に影響を及ぼした。ある観相家が道衍の顔に残虐な本性を見出し、フビライハンの顧問にして僧侶であった劉秉忠にたとえたという風評もおそらく多くの者に影響しただろう。一方、明の偉大な政治家、王鏊は、道衍の伝記を創作し、ある肖像画に触発されて書かれた詩の中で彼の

肯定的な面に目を向けた。その詩で王は、過去の大家が描いた歴史的人物の肖像画を引き合いに出しながら、道衍の人間性、肖像をともに褒め称えている。嘉靖期(1522–1566)宮廷のある熱心な儒教信奉者だった役人は、僧侶の服装をした道衍の肖像に言及し、天子の祖先の霊を祀る太廟の功臣殿から道衍の位牌を取り除くよう嘆願した。僧衣をまとった者を他の功臣達と並べるわけにはいかないと彼は主張した。また道衍の経歴はすべての仏教僧に認められたわけではない。明代後期の著名な仏僧、紫柏真可は、故宮博物院の肖像画に賛を記し、役人として仕える僧侶を、清らかな白い顔にたかる蠅とたとえた。

敬虔な仏教居士、袁宏道は、崇国寺での社交の集まりの折にこの僧の肖像画を見て、道衍により寛大な目を向けている。道衍の風貌は自然にして屈託がなく、絵画に記された自賛の言葉は「真の禅僧」の言葉だとされた。同じ機会に袁は、恐ろしいチベットの影像に感銘を受ける。彼の解説は寺院で芸術を鑑賞することに関して多くを物語る。それは必ずしも宗教的に動機づけられたものでなくてもよく、一種の娯楽でもありえた。

こうした事例は、故宮博物院の道衍の端正な肖像画が、北京の教養ある観光客の旅程に組み入れられていたばかりでなく、寺院、宮廷、官僚文化を結びつけるネットワークの一部であったことを示している。

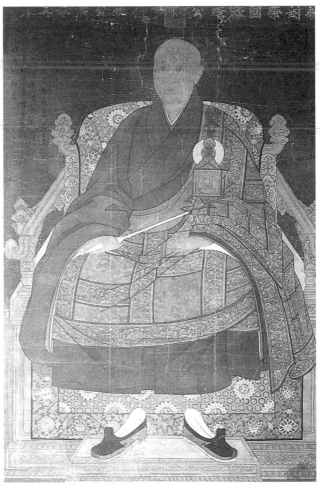

Fig. 1. Anonymous, *Portrait of Yao Guangxiao (Daoyan)*, Ming dynasty. Hanging scroll, ink and colors on silk, approx. 200 × 134 cm. Palace Museum, Beijing *(detail on page 223)*

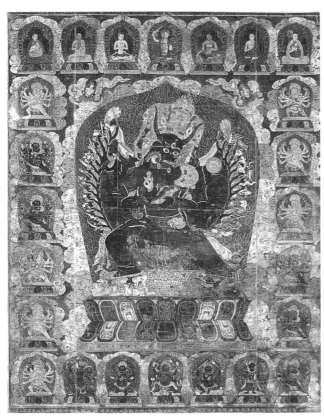

Fig. 2. Anonymous. *Vajrabhairava in Yab-yum*, Ming dynasty. Hanging scroll, ink and color on cotton, 122 × 93 cm. University Art Museum, University of California, Berkeley, 1982.13. Gift of Dorothy and James Cahill. (detail on page 163)

Marsha Weidner

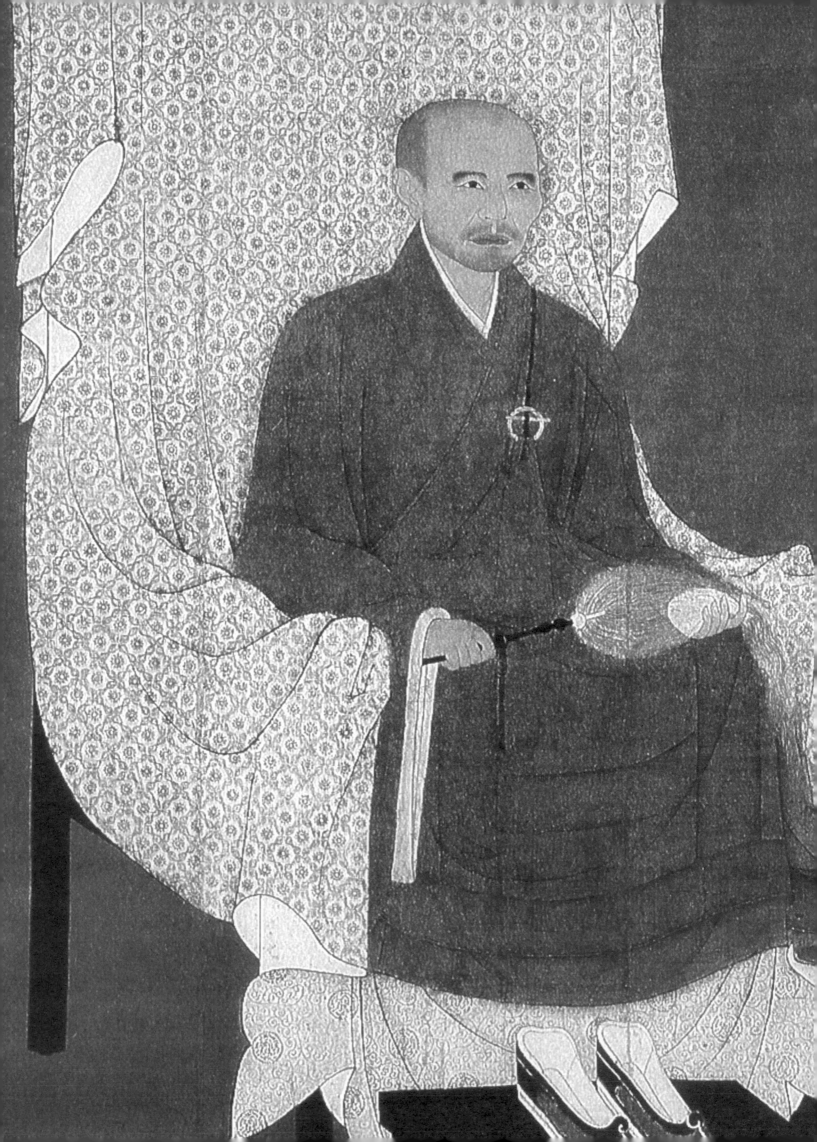

Portraits of Eminent Priests

Donohashi Akio
Kobe University

Japan's absorption of the high-level cultures from both the Korean peninsula and the Chinese continent took place through much of their shared past and involved the efforts of vast numbers of people. Similarly, Buddhism was brought to Japan through the perseverance of numerous high-ranking priests over a long span of time. Buddhism—both its practice and its sūtras—were, in the end, brought to Japan by "people." Furthermore, in keeping with the original traditions of Buddhism, its teachings were handed down from person to person.

Many high-level Japanese Buddhist clerics at some time in their lives travelled to the continent for religious training. Those who went to the continent might travel with a diplomatic mission, whether as part of an ambassadorial retinue or simply as passengers, or they might take passage on a merchant ship. Before returning to Japan, these priests often had portraits made of their teachers as proof of transmission of their training. Such portraits were also created in Japan and similarly handed down to disciples as proof of doctrinal lineage. These portraits would also be copied and then distributed to other followers, to be handed down in turn to their disciples. The portrait of one's teacher was thus among a cleric's most important possessions.

This essay concerns portraits brought to Japan by high Buddhist clerics—both Chinese and Japanese—who travelled between Japan and the continent, as well as those created in Japan. In particular, it is concerned with signed inscriptions that explain where they were created and where the subjects of the portraits were actually located. The following discussion involves some notable examples.

Jianzhen 鑑眞 (J: Ganjin, 689–763) came to Japan by imperial invitation in 753. The mission of this famous cleric of the Damingsi 大明寺 in Yangzhou, Jiangsu Province, was to establish in Japan orthodox procedures of monastic life (J: *ritsu* 律) and especially of ordination. The portrait sculpture of Jianzhen now at Tōshōdaiji 唐招提寺 (which he founded) is famous for its lifelike verisimilitude. This portrait was created immediately after Jianzhen's death, ten years after his arrival in Japan, and there is no questions as to its Japanese origin or Nara period date.

During the Heian period, Saichō 最澄 (767–822) and Kūkai 空海 (774–835) both went to China for training and returned to Japan with portraits of the founding teachers of the Tendai 天台 and Shingon 眞言 sects, respectively. Saichō arrived in China in 804 and returned to Japan the following year, bringing with him, among other materials, a portrait of Zhiyi 智顗 (J: Chigi, 539–597), the great master of the Tiantai sect, as indicated in the inscription that

was added beneath the painted image.[1] The inscription states that the portrait is a true likeness of the teacher, and that it was presented to Saichō on the thirtieth day of the first lunar month of the twenty-first year of the Zhenyuan 眞元 reign (805), on the occasion of his return trip to Japan. The original version of this work is thought to have been lost, however, and the work nowadays preserved at Enryakuji 延暦寺, which includes this dated inscription, is considered to be a Japanese Kamakura copy of the original (*Fig. 1*). From this inscription, we can infer that the original portrait was painted at Mt. Tiantai in Taizhou 台州, Zhejiang Province.

Kūkai went to Chang'an, also in 804, and returned to Japan in 806. Through the offices of his teacher Huiguo 惠果 (J: Keika, 746–805) of Qinglongsi 青龍寺 (J: Seiryūji), he was given "Mandalas of the Two Spheres" (J: *Ryōkai mandara* 両界曼陀羅) by the painter Li Zhen 李眞 (act. ca. 780–ca. 804). He returned to Japan with these mandalas and portraits of the Five Patriarchs of Shingon, as recorded in the accounts of his journey.[2] Five of the seven portraits of Shingon patriarchs preserved at Tōji 東寺 are these works brought to Japan by Kūkai. They were created in Chang' an in 804, the same year that Saichō travelled to China. These, with the addition of Kūkai's posthumous portrait, have been often copied and distributed in Japan. The above afford various instances of portraits of Buddhist masters, painted in China and carried back to Japan by Japanese priests, preserved in Japan, and there copied and distributed.

Some priest portraits bear dated inscriptions, which are not necessarily proof of time or place of origin. On the portrait of Shandao 善導 (J: Zendō, 613–681) handed down at Chionji 知恩寺, for example, the inscription includes the Southern Song reign date "*Xinsi* year of Shaoxing" (*Shaoxing xinsi* 紹興辛巳) and mentions the "*Bhikhsu* disciple Tanxing of Siming (*Siming chuanlü biqiu Tanxing* 四明傳律比丘曇省)," purporting that this picture was created in 1161 in Ningbo 寧波, Zhejiang Province. In fact, this famous portrait of the Pure Land (C: *Jingtu* 淨土) patriarch and evangel has been identified as a copy made in Japan during the Kamakura period (*Fig. 2*).[3] The style of cut gold-leaf (*kirigane* 切金) designs on the single-layer robe, as well as other elements, indicate its Japanese origins, the inscription as well as the painting itself copied from the now-lost original brought by unknown hands from China.

1. See the exhibit catalogue *Shozō gasan, Hito no sugata, Hito no kotoba (Inscribed Portraits, Human Forms, Word Forms)* (Osaka Municipal Museum of Art, 2000). *Dengyō Daishi shōrai Taishō roku (Taizhou Record of Materials Brought to Japan by Dengyō Daishi)* contains *Tendaisan Chisha Daishi reiozu itchō (Album of the Spirit Image of Zhizhe Dashi of Mt. Tiantai)* and *Tendaisan Kokuseiji kabe no Daishi seppō eizō narabini Butchō oyobi Yuima shitennō roku sōzō ikkan (Scroll of the Image of Daishi's Sermon on the Law, with Yuima, the Four Kings, and the Six Patriarchs on the Wall of Guoqingsi, Mt. Tiantai)*. These images of Chisha Daishi 智者大師 (C: Zhizhe Dashi) share the same iconography as that seen in the later image of Chisha Daishi among the portraits of Tendai high clerics owned by Ichijōji 一乗寺, Hyōgo 兵庫 Prefecture. In other words, Chisha Daishi wears a headcloth and holds his hands in the *dhyāna* (concentration) mudrā; the Ichijōji image presses his palms together in prayer. The figure sits with eyes closed on a pedestal with a backing screen, indicating that he is in the realm of the Tendai practice known as *shikan* 止観 (S: *samatha vipasyana*).

2. Kūkai's *Record of Materials Brought from China (Goshōrai mokuroku* 御請來目録) lists: Kongōchi 金剛智 (S: Vajrabodhi) ajari (S: acārya; or senior monk), "painting made with three pieces of silk"; Zenmui sanzō 善無畏 (S: Subhakarasimha) ajari, "one painting made with three pieces of silk"; Daikōchi 大廣智 (C: Daguangzhi, or Amoghavajra), "one painting made with three pieces of silk"; Seiryūji Keika (C: Huiguo) ajari, "one painting made with three pieces of silk"; Ichigyō Zenshiō 一行禪師 (C: Yixing Chanshi), "one painting made with three pieces of silk." All of these remain intact.

3. See *Goshōrai mokuroku.*

Another work, this one a portrait said to be of Master Tiantai (Tiantai Dashi 天臺大師 [Zhiyi, J: Tendai Daishi]) and handed down at Saikyōji 西教寺, bears a signature that reads, "Zhang Sixun of Qingyuan in the Great Song (Da Song Qingyuan fu Zhang Sixun 大宋慶元府張思訓)" and claims to have also been created at Ningbo in Zhejiang Province (*Fig. 3*). This is a so-called "Ningbo Buddhist" painting, made by one of the many professional painters of religious themes in that trade port. Unlike the previous work, this one is thought to have originated in Southern Song.[4] The bearers of these two works from China to Japan cannot be identified, but Eisai 榮西 (1141–1215) and Chōgen 重源 (1121–1206) were two of the priests who travelled to Song China about this time, both returning to Japan in 1168. Both also travelled through Ningbo (then Mingzhou 明州) in Zhejiang, enhancing the possibility that one or both brought the lost Shandao and the extant Tendai Daishi originals to Japan. Style, therefore, is the criterion that may enable us—regardless of the inscription—to determine whether a given portrait is the Chinese original that the inscription claims it to be or rather a copy made in Japan.

Now I should like to focus on the portrait of Fazang 法藏 (643–712), also called Xiangxiang Dashi 香象大師 (J: Kōzō Daishi), today in the collection of Tōdaiji 東大寺 (*Fig. 4*).[5] In the Central Asian town of Kangu 康居, Xiang-xiang Dashi achieved fame for his commentaries on the Avatamsaka (C: Huayan 華嚴, J: Kegon) sūtras and for creating a hierarchy of Buddhist teachings with Huayan at the top. He was greatly respected by Empress Wu Zetian 武則天 (625-705). It is said that when he lectured on the sūtras, the ground shook and flower petals fell from the heavens, as is shown in the Tōdaiji painting. Unlike the static patriarch portraits discussed above, this portrait incorporates one of the legends related to its subject. According to the inscription, it was painted in "the *yisi* year of Dading (*Dading yisi* 大定乙巳)," in 1185, but not in Southern Song China. Rather, the Dading reign-period belonged to the Jurchen Jin dynasty that had conquered northern China at the time. The inscription is written with sharp brushwork in thin characters closely resembling the "slender gold" (*shoujin* 瘦金) style of the Northern Song emperor Huizong 徽宗 (1082–1135). It is said that the "slender gold" style was also popular in the Jin dynasty.

Sharply angled characters, as appearing in the cartouche in Figure 4 like those of the "slender gold" style (*Fig. 6*), are not to be found in Japanese medieval calligraphy. Figure 4 is characterized as well by a strong color contrast, detailed depiction of the motifs, pigment applied to the back of the silk, and realistic skin tones, as well as vividly depicted lips (*Fig. 7*)—characteristics that differ greatly from those of Japanese copies (*Fig. 8*). The box containing this Chinese painting bears an ink inscription dated to the tenth year of the Tenshō 天正 reign (1582), stating that circa the second year of the Kengen 乾元 reign (1303) this work was transferred from Chikuzen 筑前 Province to Tōdaiji. In

4. Similar examples are the Kōzanji 高山寺 image of Fukū Sanzō 不空三藏 (Amoghavajra) and the Nison'in 二尊院 image of Five Pure Land Jōdo 淨土 Patriarchs.

5. Regarding the Kōzō Daishi portrait, see Donohashi Akio, "Tōdaiji kaiga zakkō: Kamakura fukkōki no kaiga seisaku to Kōzō Daishi zō no ichi ni tsuite (Miscellaneous Thoughts on Paintings at Tōdaiji: Painting Production During the Kamakura Restoration Period and the Place of the Kōzō Portrait)," *Bukkyō bijutsu* (*Quarterly Journal of Buddhist Art*) 131 (July 1980), pp. 121–26. A portrait of Xuanzang 玄奘 (J: Genjō) in a closely related style is in the Tokyo National Museum; this work is dated to either the Kamakura or Nambokuchō period.

other words, about the end of the Kamakura period, the painting was moved from the Hakata 博多 region of Kyūshū to Tōdaiji in Nara. The work in Figure 5, a Japanese copy of the Chinese painting in Figure 4, is thought to have been made at that temple during the Muromachi period. Comparing these two works, their differences are clearly apparent. Although it is sometimes claimed that the painting in Figure 4 was made in Japan in either the early or middle Kamakura period, it is much more likely to have originated in northern China when that region was controlled by the Jin dynasty.

During the Kamakura period, Japanese priests travelled to Song and Yuan dynasty China in even greater numbers. One of the them, Shunjō 俊芿 (1166–1227), went to Song China in 1199, and after about eleven years there returned to Japan in 1211, bringing with him portrait paintings of Daoxuan 道宣 (596–667; *Fig. 9*) and Yuanzhao 元照 (1048–1116), both today preserved at Sennyūji 泉涌寺, Kyoto. These works bear inscriptions by "Lou Lun of Siming (四明樓鑰)" dated to the third year of the Jiading 嘉定 reign (1210). Shunjō's biography, entitled *Biography of Master Fukaki* (*Fukaki hōshiden* 不可棄法師傳),[6] also clearly notes that when Shunjō returned from China, he brought with him works inscribed by Lou Lun, a literatus from the Ningbo region and active in the Southern Song period. Stylistically, the works bear out origins in that region: their detailed realistic depiction and cool-toned, somewhat frigid and mysterious overtones, also characterize a number of works from Ningbo and accord with Chinese painting tendencies of this period.

But what about the portrait of Shunjō himself, also handed down at Sennyūji (*Fig. 10*)? According to its inscription, the portrait was made just before the sitter died in the third year of the Karoku 嘉禄 reign (1227) at the age of sixty-two; moreover, the painting bears an inscription by Shunjō himself. However, according to *Biography of Master Fukaki*, this painting was made by the Song dynasty painter Zhou Tanzhi 周擔之.[7] Indeed, it reveals the same qualities found in the portraits of Daoxuan and Yuanzhao: cool in tone, detailed in depiction, and back-painted for the flesh tones, which all contribute to a remarkably lifelike portrayal. However, it is self-inscribed by the subject, a Japanese priest then in Japan. Its strong Song dynasty style suggests a Song painter then resident in Japan. Thus, the problem becomes more complicated. Is this a Song Chinese painting or a Japanese work? Does its Song style make it a Chinese painting, or its Japanese reign date make it a Japanese painting?

Into the thirteenth century, during the Kamakura period, the number of Zen priests travelling to China increased further. Enni Ben'en 圓爾辨圓 (Shōichi Kokushi 聖一国師; 1202–1280) went to China in 1235 and returned to Japan in 1241, carrying with him a portrait of his teacher, Wujun Shifan 無準師範 (1177–1249) as proof of having received Buddhist teachings. That portrait, held at Tōfukuji 東福寺, the Kyoto temple founded by Enni, bears an inscription by Wujun dated to "Jiaxi *wuxu* 嘉熙午戊", equivalent to the Southern Song date of the second year of the Jiaxi reign

6. Shunjō's *Biography of Master Fukaki* includes a passage regarding the portraits of Nanshan Dashi 南山大師 (Daoxuan) and Dazhi (Yuanzhao) and the inscriptions on them.

7. See the Japanese text for the quotation from *Biography of Master Fukaki*.

(1238), when the subject was sixty-one years old. Wujun Shifan was born in Sichuan and primarily active in propagating the Linji 臨濟 (J: Rinzai) sect of Zen in Zhejiang and Jiangsu. Starting from 1232, his activities centered at the Wanshousi 萬壽寺 on Jingshan 徑山, near Hangzhou. This means that he was already at Jingshan when Enni Ben'en arrived in China, and this painting then was created there. Undoubtedly this portrait was painted during the lifetime of the subject, who exudes a penetrating alertness and perceptiveness. This is a splendid Song dynasty priest portrait, technically superb and richly evocative, perhaps being the finest extant portrait of a Zen cleric. In the visual and tactile qualities conveyed by the detailed depiction of the sitter's robes and in the lively realism of the flesh tones, too, it far surpasses Japanese portrait paintings.

By contrast, consider a posthumous, memorial portrait of Wujun Shifan, also at Tōfukuji, on which an inscription was added by the priest Shigu 師古, dated "Baoyou *jiayin* 寶祐甲寅," corresponding to the second year of the Southern Song Baoyou reign period, 1254. The two portraits reveal major stylistic differences, the Japanese work apparently deficient in conveying a sense of life.

Lanqi Daolong 蘭溪道隆 (J: Rankei Dōryū, Daikaku Zenji 大覚禪師; 1213–1278) arrived in Japan from Song China in 1246, bringing with him the "pure" form of Song dynasty Chan Linji sect, unmixed with Tiantai or Jingtu 浄土 (Pure Land) elements. He spent the rest of his life in Japan and had an enormous influence on Japanese Zen. A portrait of Lanqi preserved at Kenchōji 建長寺, Kamakura, inscribed by the subject with the reign date for the eighth year of Bun'ei 文永 (1271), gives a sense of the austere Zen style (*Fig. 11*). This painting was, of course, produced in Kamakura, where its subject had settled not long after arriving in Japan. In style, however, it closely resembles the realism of Song dynasty priest portraits. There were then many émigré Chinese Chan priests living in Japan's various Zen temples, and quite likely there would have been some talented painter-priests among them. As with the portrait of Shunjō, this work might well have been created by a Chinese Chan painter-priest in Japan.[8]

Another portait of Lanqi, also at Kenchōji, was commissioned in Japan by the Rinzai priest Taikyo Genjū 太虚元寿, a later disciple in the Lanqi lineage (*Fig. 12*). The portrait was then taken to China, where an inscription was added by Lingshi Ruzhi 靈石如芝, a Chinese Yuan dynasty priest. The painting style is undoubtedly that of the Nambokuchō period in Japan. Compared with the painting made during Lanqi's lifetime, this one offers a gentler, more refined, and elegant image.

In conclusion, portraits of patriarch priests were valued as highly as the priests they depicted. They witnessed the transmission of the Dharma from master to disciple; they were handed down through succeeding generations, and copies of the originals were distributed widely. By carefully studying a portrait's style as well as its inscription and relevant information from external sources, we may hope to arrive at a just notion of where it was made and when, and whether its painter was Chinese or Japanese.

8. This finely depicted and detailed fierce expression makes it hard to imagine this work as the creation of a Japanese painter.

Donohashi Akio

關於高僧肖像畫的製作

百橋明穗

神戶大學

　　日本文化是受到外來文文化的刺激和影響發展而成的。其古代、中世、近代是受到亞洲之中國、朝鮮、印度的影響，近代則受到歐美的影響。當今，被視爲亞洲的時代，這種價值觀也勢必有待改變。在近代美術史學的發展過程中，特別是自明治時期開始以來，一方面對於作品有嚴密而實證性的研究，一方面又受到國民國家成立的意識形態影響，因此，近代的國家意識觀念往往會反映在對古代、中世的美術作品評價和判斷中。即作品的國籍問題，常成爲爭論的焦點。再與外來文化交流中發展而來的日本美術，也屢屢被捲入其論戰之中。

　　日本的古代、飛鳥、白鳳、奈良時代，從朝鮮半島、中國大陸輸入了先進的美術作品，重複地摹仿和臨摹的過程。無需論證，這一階段主要是接受和吸收。積聚了亞洲各國文物的正倉院，不正告訴了我們日本曾經是絲綢之路終點的事實嗎？那段期間應該是一個文化無國界、比現在更加自由的時代。但是，從古代到中世，隨著日本美術水準的提昇，便出現了一些微妙的問題。即前面提到的「國籍」問題。其中如再摻入些近代的國家意識，問題就變得愈發複雜起來。於此，我想就日本平安至鎌倉時代的肖像畫，並以高僧像爲實例，來和大家一起探討。藉以證明不同文化的交流並非一樁簡單的事情，而是以「人」爲媒介的一部既複雜又微妙的交流史；並圍繞在那些被認爲是從中國大陸乃至朝鮮半島傳來的繪畫作品，和日本臨摹作品之間的「國籍」問題，而展開論述。現存日本的作品，究竟是哪個國家的作品？至今，一般傾向認爲：精湛而具有大陸表現手法的是中國大陸的作品，形式上稍顯板滯的是朝鮮半島的作品，不具寫實性但極其溫和華麗的是日本作品。由此，可以明顯地看出近代日本人的國家觀念影響了對作品的評價，因而導致了混亂。此回發表的要點，就在於對此觀點進行再次檢討。

　　如年表所示，日本現存中國大陸的高僧像中，有的具有紀年銘，有的從畫讚中可以看出肖像畫的製作年代及題讚的年代。逐一查看這些於今被鑑定爲何時、何地的作品，對其製作地點和製作年代重新進行認定。美術史學最精采的展開，便在於作品的判斷。這些作品的繪製是基於何種理由？由誰帶到日本？以及它們在日本又是如何地受到臨摹和傳承的？驗證這一過程時，我們將會發現，亞洲美術史中不同文化的交流比起我們所認知的更爲深廣。

高僧肖像画の制作について

百橋明穂

神戸大学

　日本文化は外国からの刺激や影響を受けて発展した。古代、中世、近世においてはアジア、中国、朝鮮、さらにインドであり、近代においては欧米であった。近代美術史学の発展の中で、特に明治期以降、一方で作品の厳密な実証研究があり、一方で国民国家成立のイデオロギーを受け、近代における国家意識を古代中世にまで反映させた作品評価や作品判定が行われてきた。つまり、しばしば作品の国籍問題が論議の的であった。異文化交流の中に発展してきた日本美術もたびたびその論争に巻き込まれた。古代において飛鳥、白鳳、奈良時代の美術は朝鮮半島、中国大陸からの先進的な美術作品の輸入をまって、模倣、転写を繰り返して、接収、吸収したものであることはろんを待たない。本来はもっと大らかなボーダーレスの時代であった。しかしやがて古代から中世にかけて、日本美術の水準が向上してくると、微妙な問題が登場する。先の国籍問題である。今回は日本でいえば平安から鎌倉時代に至る時代の中で、特に肖像画、しかも高僧画像にしぼって実例をお話ししたい。異文化の交流はそれほど簡単な事ではなく、人を介した複雑で、微妙な交流の歴史であったことを証明したい。中国大陸ないし朝鮮半島から日本に伝わってきたとみられる絵画作品と日本での転写模倣による作品との間で国籍問題は紛糾する。現在日本に伝来する作品をいったいどこの国の作品とするかが問題となる。これまでは優れて大陸的な表現をもつ作品を中国大陸の作品とし、やや形式的な重苦しい作品を朝鮮半島の作品とし、写実性のない極めて穏やかな華やかな作品を日本製とするのが、一般的な傾向であった。つまりそこにはあきらかに日本人の近代における国家観が作品の価値評価にまで投影して混乱を生じてきた。この視点を再検討するのが今回の要点である。

　年表に示したように、日本に現存する中国大陸の高僧画像の紀年銘を有するもの、また着賛があって描かれた年代や賛の年代がわかるもの、などを列記した。これらの作品が今どこの作品として、また何時の時代の作品として鑑定され、評価されているかを追ってみることにする。つまり制作地を、国家ではなく、もっと厳密にどの地域とし、また何時の時代の作品として認定するかである。そしてそれらの作品がいついかなる理由で、誰によって日本に将来されたかを、さらに日本で転写され伝承されてゆく過程を検証するとき、アジア美術史の中に、従来考えたより遙かに広い異文化の交流の歴史が見えてくるのである。

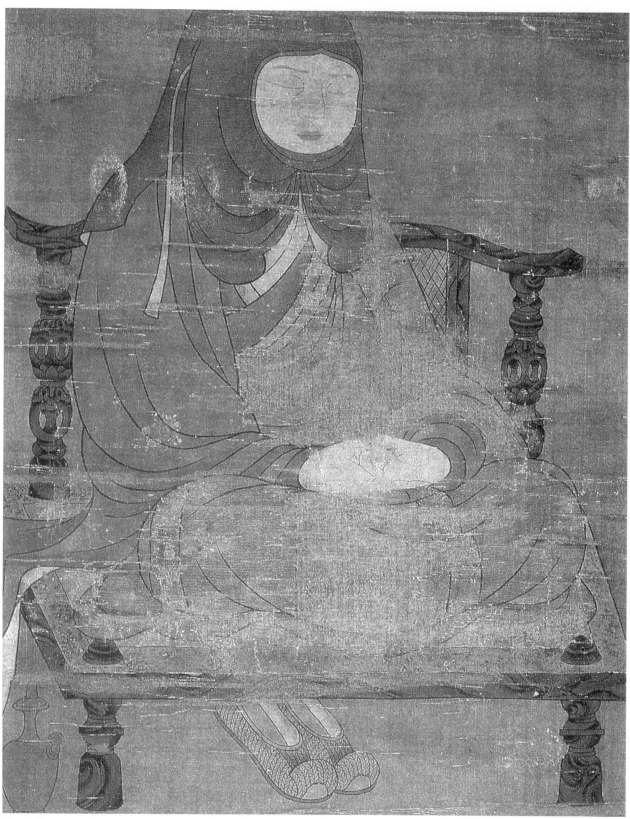

Fig. 1. *Portrait of Tientai Zhiyi*. Hanging scroll, ink and colors on silk, 53.2 × 31.4 cm. Enryakuji, Shiga Prefecture.

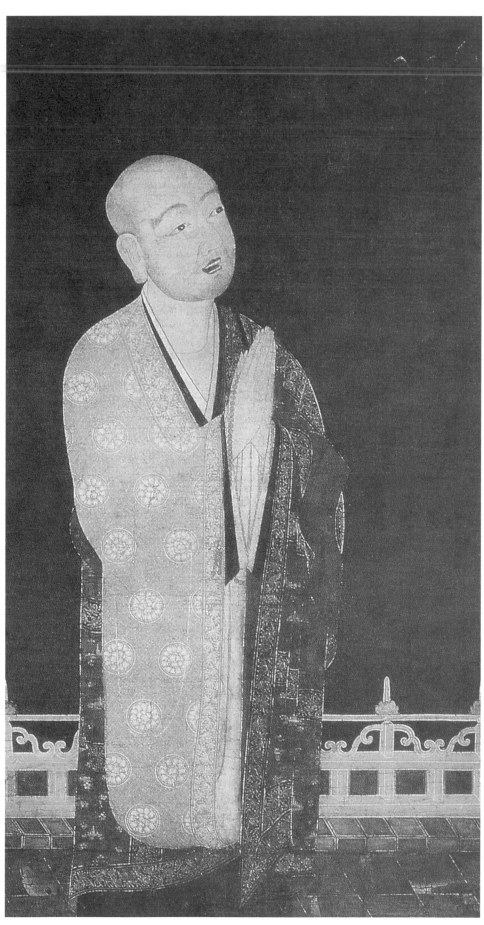

Fig. 2. *Portrait of Shandao*, detail. Hanging scroll, ink and colors on silk, 141.0 × 55.0 cm. Chionji, Kyoto.

Donohashi Akio

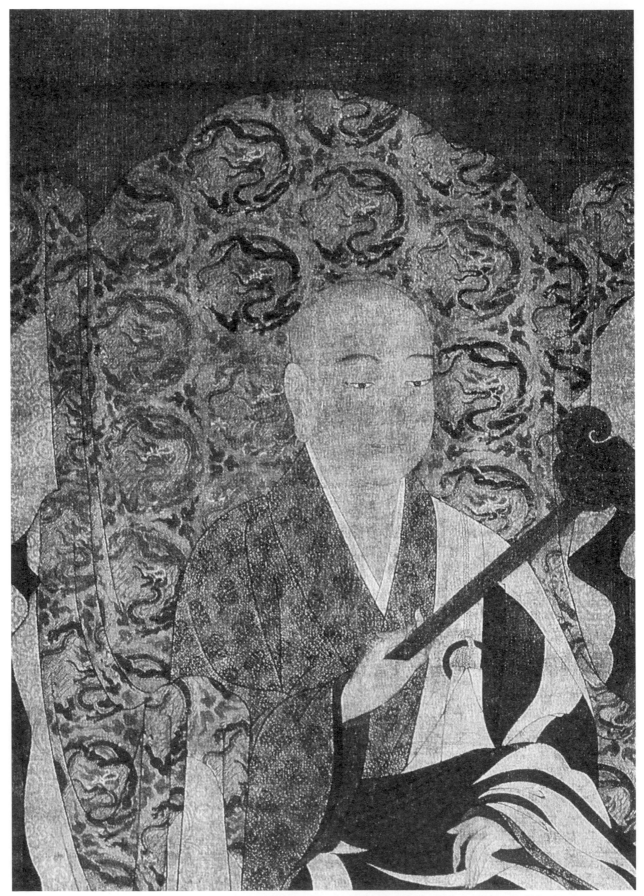

Fig. 3. *Portrait of Tiantai Dashi*, detail. Hanging scroll, ink and colors on silk, 116.7 × 58.2 cm. Saikyōji, Shiga Prefecture.

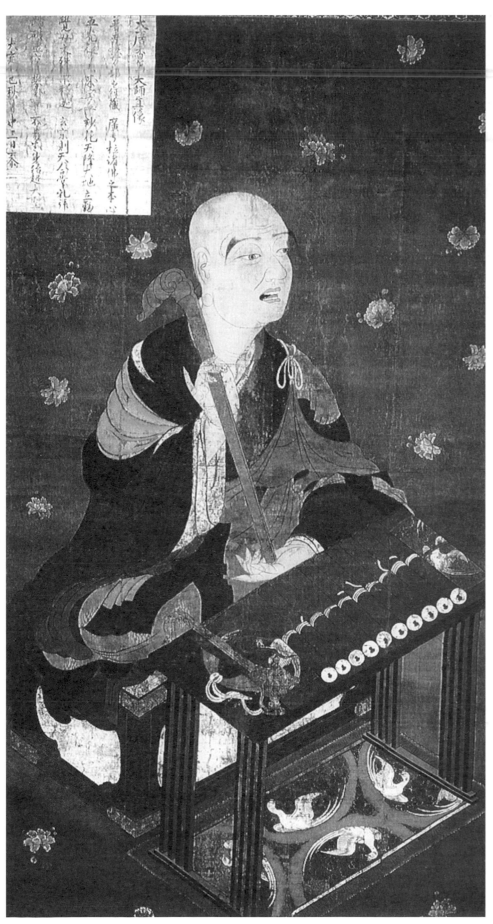

Fig. 4. *Portrait of Xiang-xiang Dashi*. Hanging scroll, ink and colors on silk, 152.5 x 81.4 cm. Todaiji, Nara.

Donohashi Akio

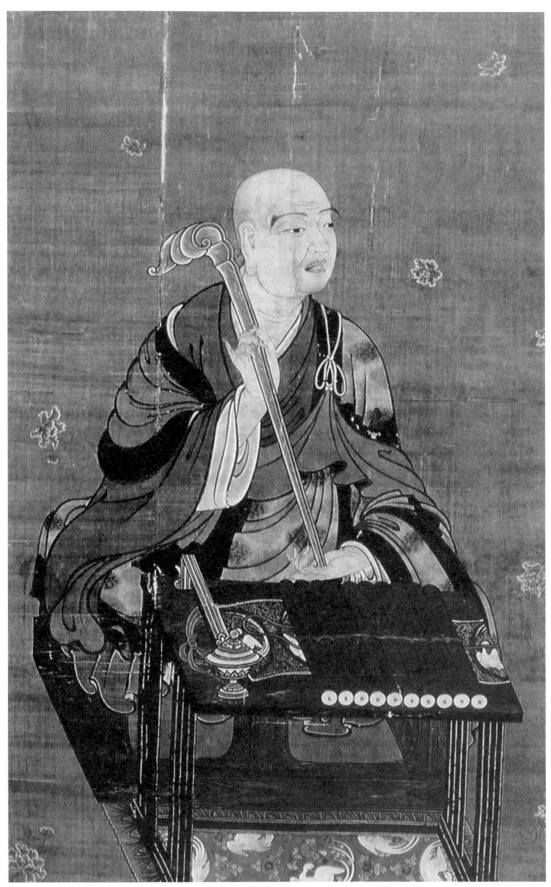

Fig. 5. *Portrait of Xiangxiang Dashi*. Japanese copy of the painting in Figure 4. Hanging scroll, ink and colors on silk. Tōdaiji, Nara.

大唐忝為大師真像

Fig. 6. Detail of Figure 4.

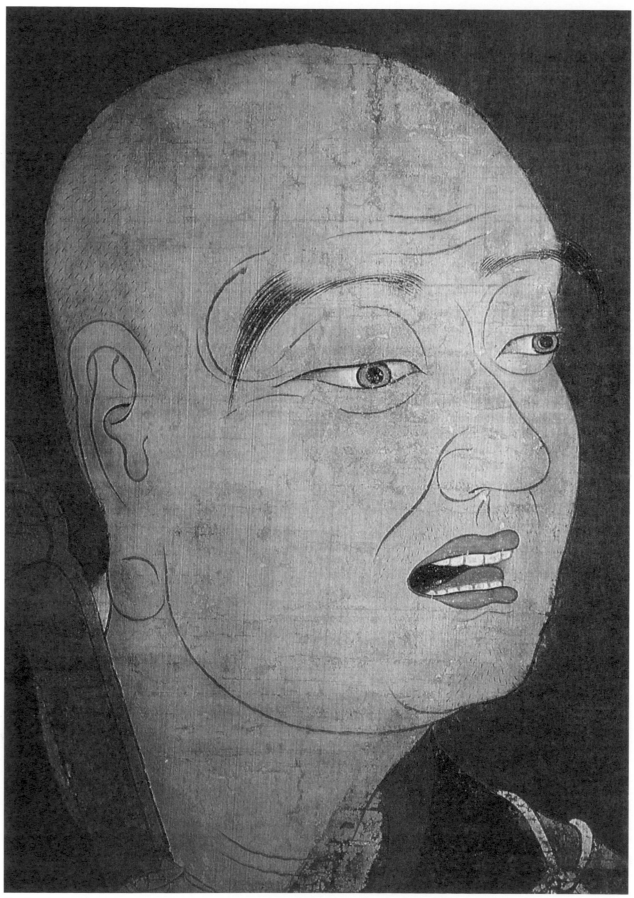

Fig. 7. Detail of Figure 4.

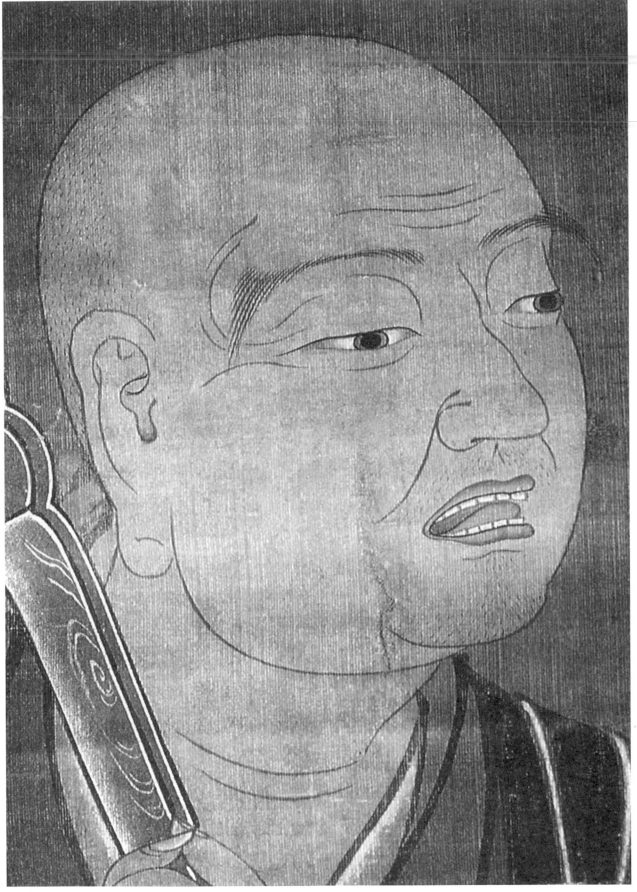

Fig. 8. Detail of Figure 5.

Donohashi Akio

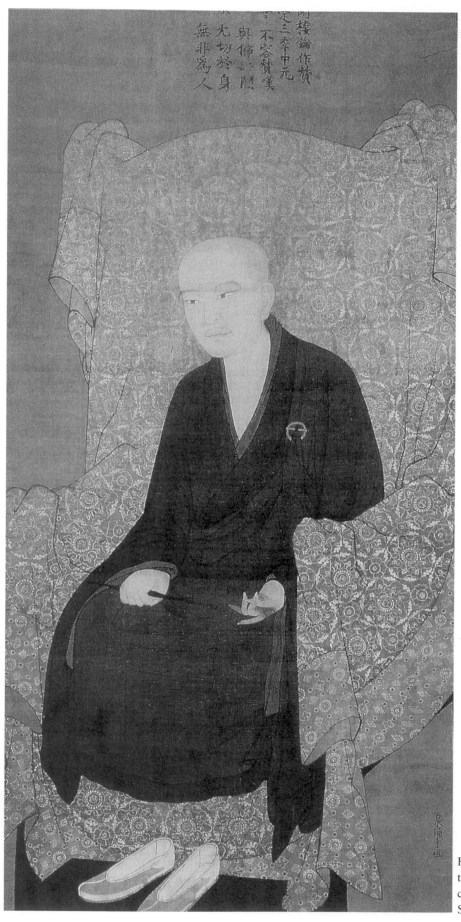

Fig. 9. *Portrait of Daoxuan*, dated to 1210. Hanging scroll, ink and colors on silk, 171.0 × 81.7 cm. Sennyūji, Kyoto.

Fig. 10. *Portrait of Shunjō*, dated to 1227. Hanging scroll, ink and colors on silk, 177.0 × 92.0 cm. Sennyūji, Kyoto. *(detail on page 243)*

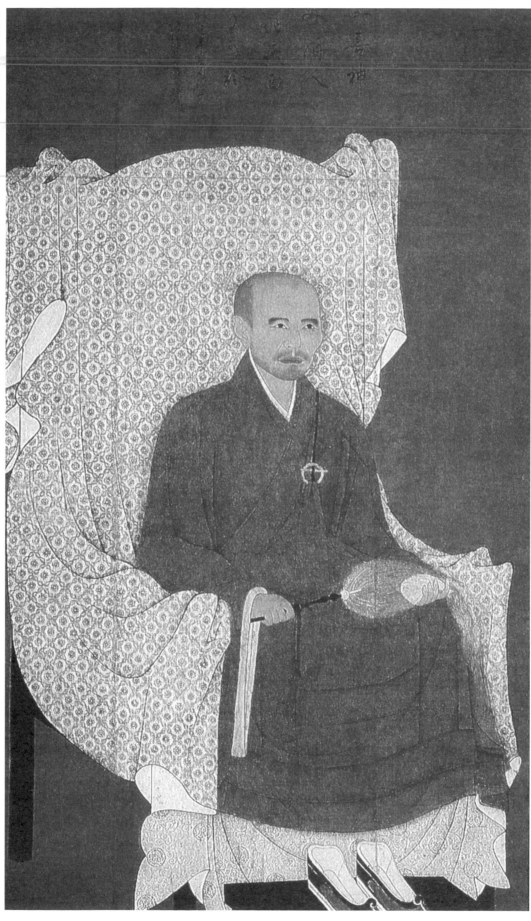

Donohashi Akio

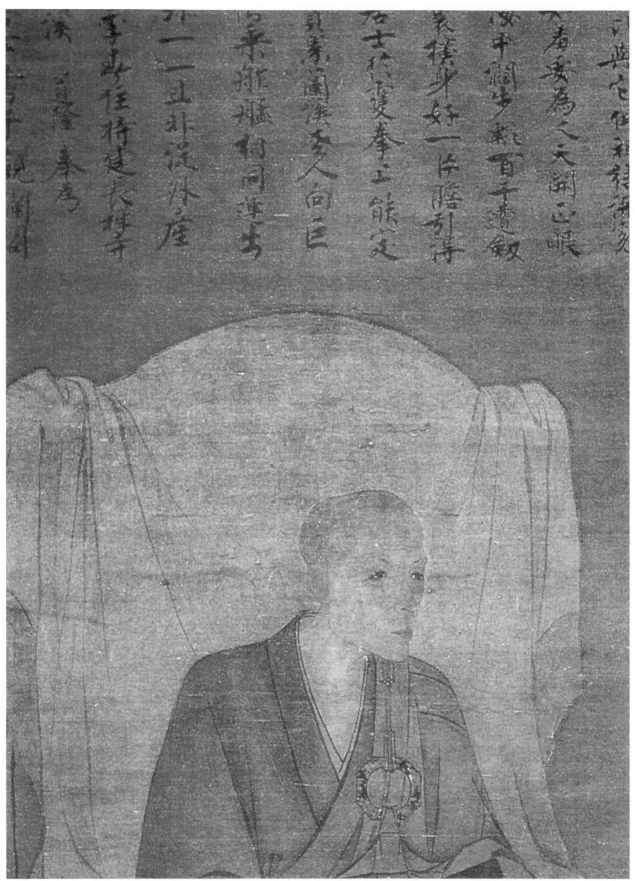

Fig. 11. *Portrait of Lanqi Daolong*, detail, dated to 1271. Hanging scroll, ink and colors on silk, 104.8 × 46.4 cm. Kenchōji, Kanagawa. *(detail on page 263)*

Section II: Buddhist Painting　　　　　　261

Fig. 12. *Portrait of Lanqi Daolong.*
Hanging scroll, ink and colors on silk,
124.3 × 52.3 cm. Kenchōji, Kanagawa.

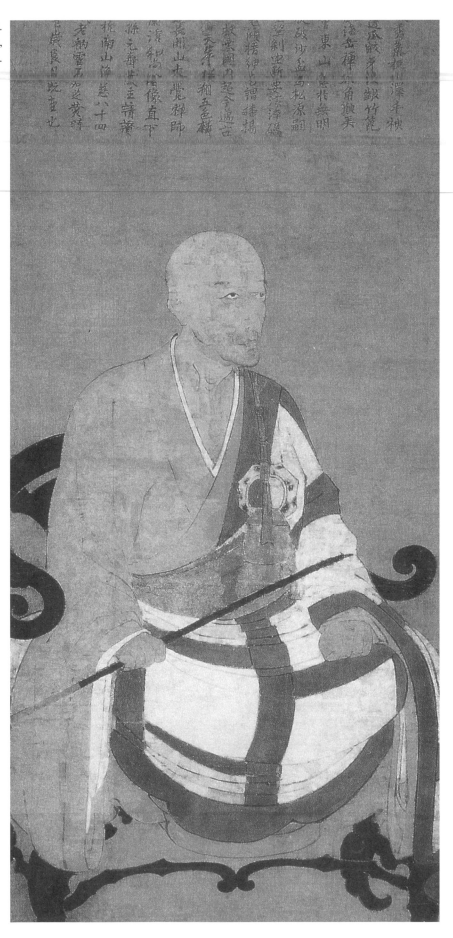

Donohashi Akio

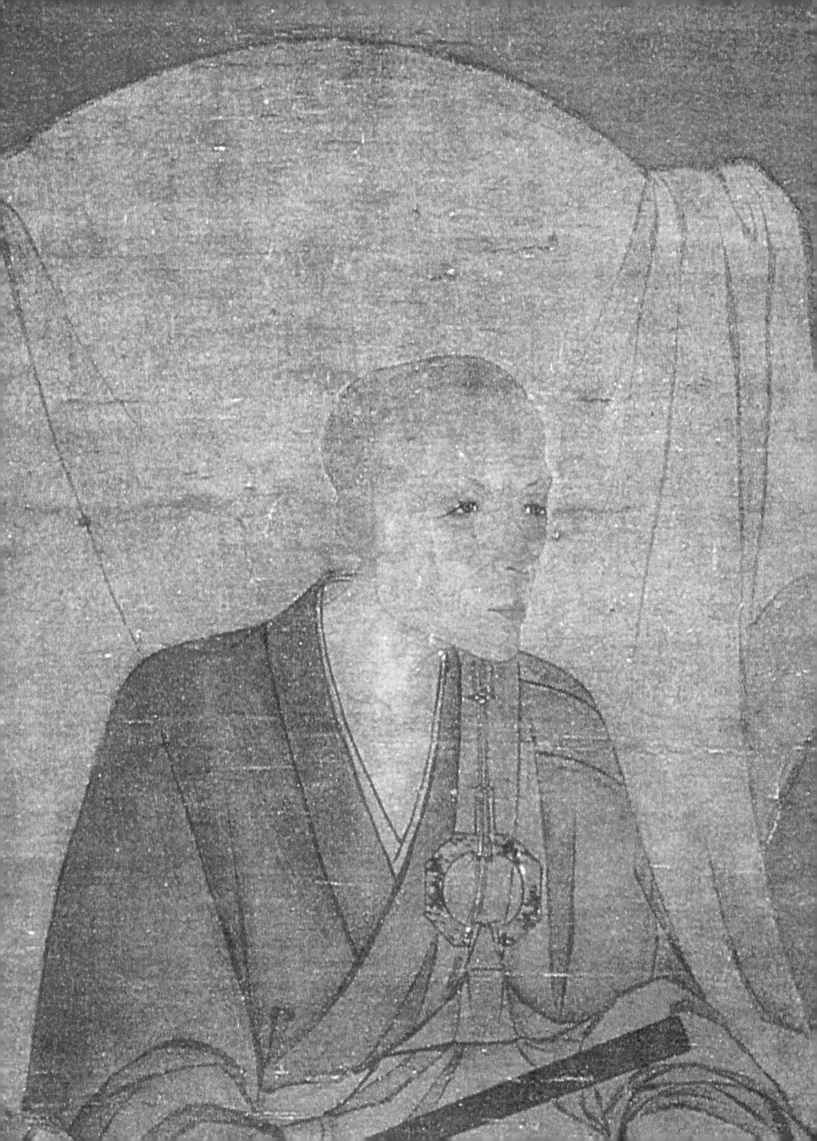

Section II: Buddhist Painting
Response

Lothar Ledderose
Heidelberg University

In commenting on the four preceding essays, I shall follow a simple scheme. I will discuss the papers in sequence, first summarizing and then raising two or three issues which seem to me most intriguing or relevant. Finally I shall offer some comments on the importance of these four papers for the study of Buddhist painting and the study of painting in general, in accordance with one of the stated aims of our conference, which is to assess the state of the field.

Lee Yu-min

The essay by Lee Yu-min 李玉珉 concentrates on one single grotto in Dunhuang 敦煌, Cave 321, which is believed to have been made between 695 and 699. Lee's detailed analyses of iconography and style, as well as of the political situation, allow her to define precisely the characteristics of Dunhuang mural painting during the reign of Wu Zetian 武則天 (624–705).

The systematic essay begins with a preface, in which Lee briefly identifies the unique characteristics of the murals in Cave 321 in comparison with those in other contemporary caves. The bulk of the essay consists of an extensive discussion of the iconography followed by a shorter treatment of style. The conclusion gives an overview of political and artistic developments in the century before Cave 321, culminating in an overall assessment of the artistic achievements embodied in its murals.

I shall give a fairly detailed account of Lee's discussion of the iconography, in order to bring out her argument that the subject matter of the cave reflects the political impact of the empress Wu Zetian.

The author starts with the most noteworthy theme, the preaching Buddha on the south wall. In 1983, Shi Weixiang 石葦湘 identified this particular representation of the preaching scene as being based on the *Baoyu* 寶雨 (*Precious Rain*) *Sūtra* in its translation of 693. This new translation was done on imperial order of Wu Zetian. It includes passages that could be interpreted as revelation that Wu Zetian was an incarnation of the bodhisattva Maitreya and a *cakravartin* ruler by the "Mandate of Heaven." The sun and moon in the band of colored clouds above the mural can likewise be read as an emblem of Wu Zetian.

The scene opposite, on the northern wall, is an Amitābha paradise. Lee argues that the scriptural basis for this illustration is found not only in the *Sukhāvatī-vyūha Sūtra* (*Amituo jing* 阿彌陀經), as previously thought, but also in

the *Amitāyus-dhyāna Sūtra* (*Guan wuliangshoufo jing* 觀無量壽佛經) as well. The nine grades of rebirth in the lotus pond are described in the *Amitāyus-dhyāna Sūtra* but not in the *Sukhāvatī-vyūha Sūtra*. In this theme, too, Lee finds a connection to Wu Zetian.

Monk Shandao 善導 (613–681), the Pure Land (C: Jingtu 淨土) evangelist, oversaw the construction of the monastery Fengxiansi 奉先寺 in Longmen 龍門, which Wu Zetian sponsored in 672. Shandao may also have prompted, Lee suggests, Wu Zetian's order for four hundred embroideries illustrating the "Western Paradise." Those were likely also based on the *Amitāyus-dhyāna Sūtra*.

A third remarkable iconographic feature is the Eleven-headed Guanyin 觀音 at the northern side of the eastern entrance of Cave 321. As Lee observes, four other early Eleven-headed Guanyin representations in Dunhuang are all found in caves constructed during Wu Zetian's reign. The empress believed in the tutelary power of the Eleven-headed Guanyin in military matters and ascribed the victory over the Khitan (Qidan 契丹) in 697 to Guanyin's help. She also ordered one thousand embroidered copies of the Eleven-headed Guanyin to be made.

In her stylistic analysis of the murals in Cave 321, Lee Yu-min suggests that they represent the style of Yuchi Yiseng 尉遲乙僧 (act. ca. 650–710). This painter from Khotan (Hotan, or Hotian 和田) was the most influential muralist in the Chinese capital, Chang'an, in the late seventh century. He enriched the metropolitan style with Central Asian elements, by combining serene facial features with swinging curves in the garments, and by meshing the iron-like brushwork of the Central Plains in China with the Central Asian shading technique for rendering volumes. His new style was swiftly taken up in Cave 321, and this in turn paved the way in Dunhuang for the succeeding style of the High Tang.

This well-researched and well-argued essay admits few substantial additions. Two specific points caught my attention in particular. The first is the martial role of Guanyin. We are accustomed to seeing Guanyin as a benevolent deity, preserver of the faithful from calamities and mishaps. Guanyin as military protector of the state, however, is less well known.

Pak Youngsook 朴英淑 equally demonstrates in her essay that Guanyin in Korea not only protected individual believers from personal misfortune, but also acted as protector of the state. By way of a revealing analogy, Pak points to a similarly dual-roled icon in early Renaissance painting. Historically close to the Korean case is the role of Guanyin in the Liao dynasty of the Khitan, the very people who later invaded the Koryŏ kingdom. The Khitan prayed to Guanyin for military help, especially in their struggles with the Song. The giant Guanyin image of 984 in the double-storied hall of Dulesi 獨樂寺, east of present-day Beijing, for example, had precisely this function of ensuring military superiority. Apparently, a tradition of the martial Guanyin can be traced from the Tang through the Liao and into Korea.

The second notable point is the vast number of religious embroideries. We hear of four hundred paradise scenes and of one thousand images of the Eleven-headed Guanyin. Hardly any Tang embroidery is extant today, which

gives an idea of the scale of loss. Despite their abundance, embroideries were much more highly valued than paintings; they constituted a truly munificent imperial donation.

Further attesting to the value ascribed to embroideries, Emperor Taizong 太宗 (599–649) of the Tang dynasty once bestowed on Xiao Yu 蕭瑀 (574–647), the fervent advocate of Buddhism at his court, "an embroidered Buddha icon as well as an embroidered portrait figure of Xiao Yu himself in the pose of a donor next to the Buddha icon. He also presented him with one copy of the *Larger Prajñāpāramitā Sūtra* (*Dapin boruo jing* 大品般若經), written out by Wang Bao 王褒 (513–576) as well as with a monk's robe and all the other clothing needed for preaching and reciting."[1] The emperor intended his generous gifts as a broad hint that the time had come for Xiao Yu to retire from office.

To us, the story signifies that embroideries were ubiquitous and most visible ingredients of visual culture in the Tang dynasty. They also remained so in later times.

Pak Youngsook

The essay by Pak Youngsook likewise studies one single painting, a Korean Water-Moon Guanyin (Suwŏl Kwanŭm 水月觀音) now preserved in Daitokuji 大德寺 in Kyoto, which Pak rightly so claims to be "one of the largest and most remarkable Koryŏ Buddhist paintings of the thirteenth century." Based on an analysis of the particular iconography of this painting, the paper offers a well-substantiated hypothesis about its patron, the circumstances of its production, and its political function.

Pak starts by discussing the textual sources for the Water-Moon Guanyin iconography, including the apocryphal *High King Avalokiteśvara Sūtra* (*Gaowang Guanshiyin jing* 高王觀世音經) in sixth-century China. Still by way of an introduction, the essay then briefly traces the appearance of Water-Moon Guanyin iconography in Korea. The earliest record dates from the period 1056 to 1083, about a century later than the first extant paintings from Dunhuang.

The main part of the essay is a detailed discussion of the Daitokuji scroll, centering on its iconography. The painting shows the bodhisattva sitting on Mt. Potalaka. The pilgrim boy Sudhāna approaches him from below, as described in the *Avatamsaka Sūtra*. Pak identifies the iconographic attributes that were current in Five Dynasties and early Northern Song paintings of the subject, such as the pure-water bottle, willow branch, bamboo stems, and rosary. In addition, she then singles out three features that are unique in this painting, namely the *cintāmaṇi* jewel, Dragon King, and blue bird. The textual basis for these idiosyncrasies is found in the *Memorabilia of the Three Kingdoms* (*Samguk yusa* 三國遺事) by the eminent monk Iryŏn 一然 (1206–1289). There, the *cintāmaṇi* jewel, dragon king, and blue bird occur in Iryŏn's account of the origin of Naksan 洛山, the holy mountain on the east coast

1. See *Jiu Tangshu* (*Former History of the T'ang*), 63: 2402.

of Korea. Like the mountain island Putuoshan 普陀山 off the east coast of Zhejiang in China, Naksan is the Korean version of Mt. Potalaka in India.

Already in 1977, Hayashi Susumu 林進 had cited the quotation from Iryŏn in his article on Korean Water-Moon Guanyin paintings in *Bijutsushi* 美術史.[2] Hayashi's main line of inquiry, however, was stylistic (he first established the Korean identity of this group of paintings mainly on stylistic grounds), whereas Pak Youngsook pursues iconographic allusions. She adduces more texts on the *cintāmaṇi*, Dragon King, and blue bird, and she demonstrates convincingly that beyond being a savior of individuals in jeopardy, the Kwanŭm in Naksan functioned as a protector of the state. In particular, she adduces quotations demonstrating that military men turned to the Naksan Kwanŭm as savior of the kingdom during the Khitan invasion (1216–1218) and the Mongol invasion two decades later. She even suggests that the army commander Yu Cha-ryang 庾資諒 (1150–1229) or his descendants may have commissioned the Daitokuji painting.

I should like to comment on two points in this essay, one concerning the *High King Avalokiteśvara Sūtra*, and the second on the transferral of a sacred space from one country to another. The earliest extant version of the *High King Avalokiteśvara Sūtra* is engraved in Leiyindong 雷音洞 ("Thunder-Sound Cave") at the monastery Yunjusi 雲居寺, in the Fangshan 房山 district seventy kilometers southwest of Beijing. Thunder-Sound Cave was finished in 616 CE, and *High King Avalokiteśvara Sūtra* is one of nineteen texts chiselled on the stone slabs of its walls. This shows that the sūtra, not composed until the mid-sixth century, was by 616 already popular in north China. It was one of the texts that the designers of Thunder-Sound Cave chose to preserve in the face of imminent apocalypse in Buddhism, the so-called "Decline of the Law" (C: *mofa* 末法). At the time of this sūtra's composition, the state-protecting powers encountered in the essays by Lee and Pak had not yet been ascribed to Guanyin.

The creation of sacred space by adopting features of a particular site from one country to another is, again, a phenomenon well known in Christian art. Some places made holy by Christ's presence, such as Calvary mountain in Jerusalem, have been recreated again and again in the Christian realm. Similarly, we find in Buddhist monasteries replicas of the sites of activity of the Buddha and the bodhisattvas in India. The establishment of a sacred site for Guanyin on Putuoshan in China, followed by one on Naksan in Korea, exemplifies this borrowing of the numinous.[3]

A precondition for the replica of a sacred space is apparently some kind of physical substrate. On Naksan mountain, this is the *cintāmaṇi* jewel offered to the founder by the Dragon King, as well as a particular rosary. Of further necessity is a proper foundation legend, and it is obviously helpful if the name is the same. Naksan is the Korean pronunciation of the Chinese for Luoshan 洛山, an abbreviation of the name Butuoluojiashan 補陀洛迦山, which

2. Hayashi Susumu, "Korai jidai no Suigetsu Kannonzu ni tsuite (On the Water-Moon Kannon of the Koryŏ Period)," *Bijutsushi* (*Journal of Art History*) 102 (1977), pp. 101–117.

3. See Chün-fang Yü, "P'u-t'o Shan: Pilgrimage and the Creation of the Chinese Potalaka," in *Pilgrims and Sacred Sites in China*, ed. Susan Naquin and Chün-fang Yü (Berkeley: University of California Press, 1992), pp. 190–245.

in turn is one of the transliterations of the Indian mountain Potalaka. Equally important for a proper replica is some topographical similarity. In this case, it is the geographical situation at the eastern shore, and, possibly, some similarities in the shape of the cave in which Guanyin is purported to dwell. Exact verisimilitude in the recreation of a sacred space is not required.

The essay thus opens up fascinating roads for further inquiry into such fundamental questions as what makes a copy, what constitutes a sacred space, and—most intriguing of all—what is virtual reality.

Marsha Weidner

The essay by Marsha Weidner likewise concentrates on one single painting, the Ming dynasty portrait of the Buddhist clergyman Daoyan 道衍 (1335–1418). Using reception theory as one of her methods, Weidner discusses when and under what circumstances the portrait was viewed, and what kind of responses it evoked.

She starts with a detailed description and identification of the painting type, which combines the traditional slightly three-quarter view of the figure, as in portraits of Song and Yuan dynasty abbots, with a frontally-seen chair, as in portraits of emperors. Weidner quotes a contemporary description of Daoyan's unusual physiognomy, continues with biographical information about the sitter, and then spells out her methods of inquiry. She proposes that these portraits should be viewed as "living things," and she draws attention to their ritual function. In particular, she notes that Buddhist monasteries "shaped aesthetic experience through their physical and social spaces."

Weidner then adduces three later personalities who encountered the portrait and wrote about it, the statesman Wang Ao 王鏊 (1450–1524), the monk Zibo Zhenke 紫柏眞可 (1543–1603), and the literatus Yuan Hongdao 袁宏道 (1568–1610). Wang Ao dwelled on the tension between Daoyan's secular and sacred roles. A century later, Zibo Zhenke, one of the four great monks of the Ming dynasty and, incidentally, the Chan Buddhist master of Dong Qichang 董其昌 (1555–1636), equally questioned the sitter's double role as monk and official. Zibo Zhenke composed his poem in the conducive surroundings of the monastery Tanzhesi 檀柘寺, west of Beijing, where the portrait probably hung in a portrait hall, and he wrote on the portrait itself. Only a few years later, Yuan Hongdao saw the portrait in the monastery Chongguosi 崇國寺 and mused about the physiognomy and the character of the sitter. The circumstances of his viewing the portrait perfectly exemplify the role of monasteries as a setting for art viewing and as a center of aesthetic experience.

With regard to this thought-provoking paper, I should like to discuss Ming period applications of physiognomy and commentary. Weidner quotes several descriptions of Daoyan's physiognomy—one of his appearance in his biography in the official history of the Ming (*Mingshi* 明史), a description of one of Daoyan's portraits in a late Ming guidebook, and Yuan Hongdao's response to the portrait in Chongguosi.

All of these descriptions emphasize the unusual features of the sitter, yet I suspect that one could nevertheless find tropes here. In particular, it might be revealing to compare the wording used in these descriptions with the ter-

minology found in physiognomic treatises and books. These, as we know, categorize various types of facial features and name them, so that by these features the reader can recognize character; the books can also be used for fortune telling. Illustrated handbooks of physiognomy circulated widely. Almost everyone knew them, including painters and viewers of portraits. It is therefore likely that the act of viewing portraits included the identification of types of facial features and their physiognomic meaning. These identifications, in addition, may have been reflected in the inscriptions.

The intriguing question also arises as to how inescapable the relation between character and physiognomy was perceived to be. Would outward appearance put certain expectations on a young individual, in the sense of a self-fulfilling prophecy? And, on the other hand, would the known character and fate of a sitter require the painter to depict that person with physiognomically corresponding features?

The genre "commentary" figures importantly in Chinese literature. Entire intellectual traditions have been formed and handed down in the medium of commentaries, be it in the exegesis of the Confucian classics or of Buddhist sūtras. Using methodology developed in literature studies, one could treat portrait inscriptions, as well as later painted versions of a portrait, as commentaries, and analyze how they interpret the original work and how they direct and channel the perception of the viewer. Inscriptions on the painting itself convey additional information through the style of the calligraphy and their placement within the original layout.

Donohashi Akio

The last essay, by Donohashi Akio 百橋明穗, gives an overview of portraits of Buddhist priests in China and Japan. In particular, Donohashi has chosen portraits with inscriptions that inform us where they were produced and how they were handed down. What emerges is a fascinating range of places, styles, and functions.

The essay proceeds chronologically, and one can identify two main phases in the development of the genre. The first phase (dated by Donohashi as 754 to 1126) comprises the Tang, Five Dynasties, and Northern Song in China and the Heian period in Japan. Within this first period, one finds three remarkable examples of works that are somewhat unusual by comparison with the cases in the second period.

The earliest example, the portrait sculpture of Jianzhen 鑑眞 (J: Ganjin, 689–763) in Tōshōdaiji 唐招提寺, is unusual, by virtue of its dry-lacquer medium (J: *kanshitsu* 乾漆). This indicates that the genre of religious portrait sculpture in China has its roots in an earlier tradition of mummification, as had already been observed by Kosugi Kazuo 小杉一雄 in 1937.[4] Mummies of early Buddhist patriarchs could be preserved by covering them in lacquer. Seen in this perspective, priests' portraits are aestheticized mummies.

4. Kosugi Kazuo, "Nikushinzō oyobi yukazō no kenkyū (A Study on Mummified Images and Ash-Relic Images)," *Tōyō gakuhō* (*Reports of the Oriental Society*) 24, no. 3 (1937), pp. 93–124.

In this early period, a remarkable number of Japanese priests brought back from China portraits of long-deceased patriarchs, sometimes more than one. In 805, Saichō 最澄 (767–822) returned with a portrait of the Tendai 天台 patriarch Zhiyi 智顗 ("Great Master Tiantai" [Tiantai Dashi 天台大師]; 531–597). Kūkai 空海 (774–835) brought back portraits of five former patriarchs of the Shingon 眞言 school. Whereas later priests each established their personal authority through a portrait of their own teacher, those priests who brought back several portraits of ancient patriarchs established the authority of an entire tradition.

In 987, Chōnen 奝然 (938–1016) returned from China not only with paintings, but with a sculpture as well. This, however, was not a portrait sculpture of a historical figure, but of Sākyamuni Buddha. It raises the question as to why portrait sculptures were not brought from China more often, especially since sculptures ranked higher than paintings in the hierarchy of icons. Transportation difficulties were not insurmountable, as Chōnen proved.

Donohashi's second phase mainly concerns the period from 1161 to 1329, which includes the Southern Song and Yuan dynasties in China, and the Kamakura period in Japan. During this phase, Japanese Zen priests returned from China with portraits of their own teachers. Tendai priests, however, seem to have continued to bring portraits of ancient patriarchs, such as of Shandao, preserved in a Kamakura period copy, or of Tiantai Dashi.

Testimony to the wide locus of production of priest portraiture in this period is the portrait of Great Master Xiangxiang 香象 in Tōdaiji 東大寺, which according to its inscription was painted under the Jin dynasty in 1210. The inscription is written in the so-called "slender gold" (C: *shoujin* 瘦金) script, which was created by the Song emperor Huizong 徽宗 (r. 1101–1126) and emulated by the Jin emperor Zhangzong 章宗 (r. 1190–1208).

In Donohashi's essay, I should like to single out the matter of style and of the range of production. Donohashi demonstrates once again that the ultimate criteria for dating a painting, and for determining its nationality, are stylistic. In some cases, those are even more reliable than inscriptions. He also demonstrates the amazing stylistic variety in the portraits he discusses. This raises old questions: was there a typical Zen Buddhist style, and what were the reasons for choosing a particular style? When Donohashi discusses the portrait of Lanqi Daolong 蘭溪道隆 (1213–1278) at Kenchōji 建長寺, dated to 1271, he speaks about the "austere Zen style." By contrast, in his discussion of a portrait from Ningbo 寧波, Donohashi talks about "detailed realistic depiction and cool-toned, somewhat frigid and mysterious overtones." The output of thirteenth-century Ningbo workshops included paintings with iconography that was not particularly Chan 禪, such as sets depicting Yama (the Kings of Hell; C: Yanwang 閻王) and nirvana (C: *niepan* 涅槃) scenes. This would appear to cast doubt on the idea of a typical Zen style.

The same applies to the calligraphy of the inscriptions. Huizong's slender gold script hardly has a Zen quality. As argued by Max Loehr and Yoshiaki Shimizu 清水義明 long ago, a specific Zen style may not exist at all. Zen art can be defined iconographically or functionally, but hardly stylistically.

The second question concerns the range of this body of works—its boundaries, so to speak. As Donohashi says at the beginning, "Many high-level Japanese Buddhist clerics at some time in their lives travelled to the continent

Lothar Ledderose

for religious training." Which clerics did not travel? Were portraits made in all Buddhist schools—in later Shingon, for example? The frontality in Daoyan's portrait, as Weidner shows, owes to a formula used in imperial portraits. What other typological or stylistic developments took place after the Yuan and in later periods in Japan? Did portrait sculpture in Japan continue to follow Chinese prototypes, even if no examples were imported from China? Did the practice of making portraits ever stop? What is present practice? When are portraits replaced by photographs? All these questions and many others are raised by Donohashi's stimulating paper.

State of the Field

First let us note that this volume contains a complete section on Buddhist painting. In earlier conferences of the sort that generated this book, Buddhist subjects were but scantily treated. Among the fourteen papers in the "International Symposium on Chinese Painting" (*Zhongguo guhua yantaohui* 中國古畫研討會) held in the National Palace Museum in 1970, only one paper dealt with religious art (incidentally, with Chan portraits). Of the twenty-seven papers given in the art section of the "International Conference on Sinology at Academia Sinica" (*Zhongyang yanjiuyuan guoji Hanxue huiyi* 中央研究院國際漢學會議) in 1981, four dealt with religious art, two of them with Dunhuang. Ten years later, in 1991, the "International Colloquium on Chinese Art History" (*Zhonghua minguo jianguo bashinian Zhongguo yishu wenwu yantaohui* 中華民國建國八十年中國藝術文物研討會) was held in the National Palace Museum. Its thirty-seven papers in the painting and calligraphy section included only one on a Buddhist subject, presented, incidentally, by Lee Yu-min. The wealth of papers on Buddhist paintings in the present conference demonstrates how the field has expanded in recent years. Together with nineteenth- and twentieth-century painting as well as archaeologically discovered pictorial art, religious painting is today one of the frontiers of our discipline. Here, the boundaries of our knowledge about the history of painting in East Asia are being enlarged.

Boundaries are also expanding within the area of Buddhist painting itself. Studies on Korean paintings have increased dramatically in recent years, as have studies on Buddhist painting of the Ming dynasty. Professors Pak and Weidner have both been instrumental in this attainment. Not long ago, a painting such as the portrait of Daoyan would scarcely have been found worthy of scholarly attention. It is, for example, not even contained in the lavish, eight-volume publication of paintings in the Beijing Palace Museum.[5]

It is further remarkable that no painting discussed in this section is kept in a Western collection. One reason why the study of East Asian painting could thrive in the West in the last half century was the availability of first-class original works in Western public and private collections. Many of these scrolls left East Asia only after World War II, and many of them were works of the Chinese literati tradition, which were relatively easy to remove from their original social and spatial context. Refugees and art dealers could carry them conveniently into other countries.

5. *Zhongguo lidai huihua: Gugong bowuyuan canghuaji* (Chinese Paintings of Successive Periods in the Palace Museum) (Beijing: Renmin meishu chubanshe, 1978–1991).

Section II: Buddhist Painting 271

The paintings studied in this section, however, are by and large still in their original contexts, from whence they are unlikely to leave, be it the caves at Dunhuang or the temples in Japan (the Daoyan portrait in the Palace Museum in Beijing being the only exception). This body of religious art thus directs our view back to the treasure troves in East Asia, where many discoveries are still to be made. In this sense, too, Buddhist painting is a field of the future.

In terms of methodology, the original setting in which much of Buddhist art still survives is of considerable significance. It allows substantial and well-founded research about the function of these works. There is ample literary evidence on traditional ritual and liturgy, and contemporary practice can further elucidate ancient usage. A famous example for a study in this direction is the article by T. Griffith Foulk and Robert H. Sharf that demolishes the often repeated notion that Zen portraits were certificates of enlightenment.[6]

Part of the issue of function is functional change. Here again, Buddhist works of art can offer rich evidence, as Marsha Weidner's essay demonstrates. When tracing how the perception of a Buddhist painting evolves through decades and centuries, one perceives the changes in its social setting and in society at large. Buddhist paintings thus offer great opportunities for precise insights into the role of art in society.

Moreover, studying the function of a work of religious art more often than not implies studying its political function. As it is increasingly realized, much religious art carried a precise political message. The murals in Cave 321, the Naksan Kwanŭm, and the portrait of Daoyan are revealing examples. Buddhist paintings thus offer another opportunity for precise insights, namely about the role of art in politics.

In comparison with these major issues, questions of authenticity and style, which figure so prominently in the study of literati painting, tend to pale in significance. The authenticity of the Dunhuang murals, the Naksan Kwanŭm, or the Daoyan portrait is not in question. Style, as religious paintings remind us, is not an end in itself, but—up to a point—deliberately chosen in order to add to the message of the painting and enrich its structure. In religious paintings, style is only one well-embedded facet among the many that together make up artistic creativity.

In summing up, we might say that the study of Buddhist painting is an expanding field. Rich material in East Asia still awaits discovery and research. Of prime methodological interest is the function of these works. Because Buddhist paintings are still part of a living tradition, their functions can be studied more easily. Modern methodologies such as reception theory and literary criticism can be tested by applying them to the analysis of religious art in East Asia. This body of works also offers superb opportunities to understand more precisely the role of art in society and in politics. Questions of authenticity and style, but even more importantly, such fundamental inquiries into the nature of a replica, a sacred space, and creativity, can profitably be investigated. The field of Buddhist painting studies thus will substantially enrich, modify, and—I may add—correct our present perception of the history of art in East Asia.

6. T. Griffith Foulk and Robert H. Sharf, "On the Ritual Use of Ch'an Portraits in Mediaeval China," in *Cahiers d'Extrême-Asie* 7 (1993–94), pp. 149–219.

第二節　佛教繪畫
論評

Lothar Ledderose
海德堡大學

首先讓我們注意這本書包含了佛教繪畫的完整場次。以往編輯成這類論文集的會議中，佛教主題只微略地被討論。1970 年在故宮博物院舉行的中國繪畫國際研討會，十四篇論文中，只有一篇討論宗教藝術（正好是禪宗肖像畫）。1981 年中央研究院國際漢學會議論文集，在 27 篇藝術論文中，有四篇討論宗教藝術，其中兩篇討論敦煌。十年後，1991 年，國立故宮博物館舉行中華民國建國八十年中國藝術文物討論會。繪畫與書法場次的 37 篇論文中只有一篇佛教題目而且正好是由李玉珉所發表的。現今呈現在會議裡，豐富的佛教繪畫論文表示了這個領域近幾年來如何地擴展。如今宗教畫與十九、二十世紀的繪畫以及考古發掘的繪畫藝術，皆成為我們學科中的範圍之一。在上述範圍裡，我們對於東亞繪畫史的知識的領域正在逐漸擴大。

佛教繪畫自身的領域也在擴展中。近年來，韓國繪畫的研究急劇地增多，明朝佛教繪畫的相關研究亦復如是。朴與 Weidner 教授在這方面已有示範性的成就。不久之前，像道衍師肖像這類的繪畫幾乎完全沒有學術性的價值。比方說，它並沒有被收入內容豐富，共有八冊的《中國歷代繪畫：故宮博物院藏畫集》（北京，1978-1991）。

更值得注意的是，此場次所討論的所有繪畫都不在西方收藏之內。上半世紀的西方的東亞繪畫研究興盛的原因在於西方公私收藏著一流原作，提供研究的可能。許多畫卷直到二次大戰後才離開東亞，而這其中有許多為中國文人傳統下的作品，這些作品相對地容易脫離原來的社會與時空背景。難民和古董商人很容易攜帶它們到其他國家。然而，此場次所研究的繪畫，仍大致上保存在原來的環境中，這些作品不太可能離開原地，不論敦煌石窟，或者日本的寺院（北京故宮的道衍師肖像是唯一的例外）。這些宗教藝術將我們的視線導回仍有許多等待發掘的東亞珍貴寶藏。從這個角度來看，佛教繪畫是明日之星。

許多的佛教藝術仍然保存在原來配置的環境下，後者在方法論上相當重要。原有的配置使我們能充分而有依據來研究其功能。文獻方面保存了豐富的傳統儀式與禮拜的資料，而當代的實踐也能夠用來進一步推斷古代的方法。在這方面，有名的研究例子便是 T. Griffith Foulk 和 Robert H. Sharf 發表在 *Cahiers d'Extrême-Asie* 7 (1993-94) 的「On the Ritual Use of Ch'an Portraits in Mediaeval China」（中古世紀中國禪畫的儀軌），此文推翻了一般的說法，即禪宗肖像畫是開悟的證書。

功能議題的重點之一是功能的變遷。如 Marsha Weidner 的論文所示，佛教藝術作品也可以提供這方面豐富的證據。若追溯在數十年與數個世紀之間一件佛教繪畫的意義如何演變，便可以察覺其社會環境與社會全體的巨大變遷。因此，佛教繪畫提供絕佳的機會可以洞察藝術在社會的角色。

其次，研究宗教藝術的功能往往牽涉到政治功能。如我們逐漸瞭解，許多宗教藝術帶有明確的政治訊息。321 窟的壁畫，洛山觀音以及道衍禪師像都是明顯的例子。因此，佛教繪畫提供另一個洞察藝術在政治裡的角色很好的機會。

相較於這些重要議題，真偽與風格這些在文人畫研究中關鍵問題的重要性，便顯得黯然失色。敦煌壁畫、洛山觀音，或道衍肖像畫的真偽問題並不存在。風格，如同宗教繪畫所提示的，並不是終極目的，而是，在某個程度上，刻意被選取來傳達畫中的意涵，並且豐富其結構。在宗教繪畫裡，風格不過是構成藝術創造力的許多不可或缺的條件之一。

總之，我們可以說，佛教繪畫的研究是個正在拓展的領域。東亞豐富的材料仍有待發掘與研究。方法學上的重要旨趣就在於這些作品的功能。因為佛教繪畫仍屬於現存宗教文化傳統的一部份，它的功能更容易被研究。現代方法論中，例如覺知理論和文獻批判，都可以運用在東亞宗教藝術的分析與測試。這些作品也提供極佳的機會，更明確地瞭解藝術在社會與政治上的地位。真偽與風格的問題，甚至於更重要的問題例如，何謂複製品？何謂神聖空間？以及何謂創造性等等一些基本的問題，都值得充分探討。佛教繪畫研究的範疇將因此而更為豐盛，同時，容我指出，將會改變我們目前對於東亞藝術史的觀念。

第二部　仏教絵画
論評

Lothar Ledderose

ハイデルベルク大学

　本書において仏教絵画に完全な一章が割り当てられたことは注目に値する。以前のこうした学会で仏教のテーマが扱われることは少なかった。1970年に故宮博物院で開催された中国絵画の国際シンポジウムの十四の発表のうち、宗教美術に関するものはわずか一つ、ちなみに禅の肖像画に関するものだった。1981年の中央研究院国際漢学会議論文集に寄稿された二十七編の論文の中で、宗教芸術を扱ったものは四編で、そのうち二篇が敦煌についてのものだった。十年後の1991年、中華民国建国八十年中国芸術文物討論会が故宮博物院で開かれた。書画のセクションの三十七の発表のうち仏教絵画に関するものはただ一つで、それは李玉珉教授によるものであった。本学会の仏教絵画の発表の充実ぶりは、近年におけるこの分野の拡大を示している。十九世紀、二十世紀絵画や、考古学的に発見される絵画芸術とともに、宗教画は今日、我々の研究分野の最前線の一つとなっている。ここに東洋絵画史に関する我々の知の境界線はさらに押し進められているところである。

　仏教絵画の領域においても境界線が拡大している。近年、明代の仏画研究と並んで、韓国絵画研究が長足の進歩を遂げている。朴、ウェイドナー両教授がここで有益な貢献をされている。つい最近まで、道衍の肖像画のような絵画は学問的研究にふさわしいものとはまず考えられなかった。たとえば、豪華な八巻本から成る北京故宮博物院の『中国歴代絵画故宮博物院蔵画記』(北京、1978-1991)にその肖像画は掲載されていない。

　さらに注目すべきは、本章で議論された絵画で、西洋に所蔵されているものが一つもないということである。東洋絵画研究が過去半世紀に西洋で隆盛した理由の一つに、第一級のオリジナル作品が公私を問わず西洋に所蔵されていたことがある。そうした画巻の多くは第二次世界大戦後に東洋を離れていった。その多くは中国の文人画の伝統を継ぐ作品であったが、元来の社会的、空間的なコンテクストからそうした作品を切り離すことは比較的容易だった。亡命者、美術品商により作品は容易に他国へ流出した。しかし、本章で扱われた絵画は、敦煌の洞窟であれ、日本の寺院であれ、概して元来のコントクストから離れることなく、今なおそこにとどまっている（故宮博物院所蔵の道衍の肖像画だけは例外だが）。こうした宗教芸術作品のおかげで、多くの発見が今なお続いている東洋の発掘物へと私たちの視線がまた向けられることに

なる。この意味でも、仏教絵画は未来のある分野なのである。

　仏教芸術の多くがなお現存するところの当初の環境は、方法論的に相当大きな意味を持つ。作品の機能について実質ある十分に根拠のある研究を行なうことが可能となる。伝統的な儀式や祈祷に関する文献も豊富にあり、同時代の習慣から古代の習慣が説明できることもある。この方面の研究の有名な実例は、『極東研究7』(1993-94)に収められたT・グリフィス・フォークとロバート・H・シャーフの「中世の中国における禅肖像画の儀式的な使用について」である。そこでは、禅の肖像画は悟りに達した証であるという、よく繰り返される考えが完全に否定されている。

　機能に関する問題点の一つは、機能の変化である。ここでもまた仏教芸術作品は、マーシャ・ウェイドナー教授の論文が示すように豊富な証拠を提供する。仏教絵画の受容が数十年、数世紀を通していかに進化したかを辿ってみると、それが置かれた社会環境の変化、また社会全般の変化が認められる。このように仏教絵画は社会における芸術の役割を正確に洞察する大きな機会を提供してくれる。

　さらに、宗教芸術作品の機能の研究は、多くの場合、その政治的な機能の研究をも暗に意味する。我々の認識が深まるにつれて、宗教芸術の多くは明確な政治的メッセージを伝えてくる。第321窟の壁画、洛山の観音、道衍の肖像画は啓発的な実例である。このように仏教絵画は、政治における芸術の機能について正確な洞察の機会をも提供する。

　こうした大きな問題と比べると、文人画研究において重要な位置を占める真偽の問題、様式の問題は影を潜める。敦煌の壁画、洛山の観音、道衍の肖像画にとって真偽は問題ではない。宗教絵画が我々に教えてくれるように、様式はそれ自体が目的なのではなく、ある程度まで慎重に選択され、絵画のメッセージ性を高め、絵画の構造を豊かにするためのものである。宗教絵画における様式とは、芸術的創造力を構成する多種多様な面の中に埋め込まれたごく一面にしかすぎない。

　要約すれば、仏教絵画研究は拡大しつつある領域であると言える。東洋の豊かな資源はなお発見と研究を待っている。方法論的に最も大きな関心があるのはそうした作品の機能である。仏教絵画は今なお生きた伝統の一部であるため、その機能の研究は比較的容易に行なうことが可能だ。受容理論や文学批評といった現代の方法論は、東洋の宗教芸術の分析に応用することによってその有効性を検証することができる。この作品群はまた、社会、政治における芸術の役割をより正確に理解する機会を提供してくれる。真偽や様式の問題もある。しかし、はるかに重要なのは、複製とは何か、聖地とは何か、創造性とは何かといった根本的な問題が、実り豊かな研究対象となりうることだ。この仏教絵画研究という分野は、我々の東洋美術史についての現在の理解を大きく充実させ、変容させ、さらには、修正してゆくことにもなるであろう。

Lothar Ledderose

Section III
Literati Painting

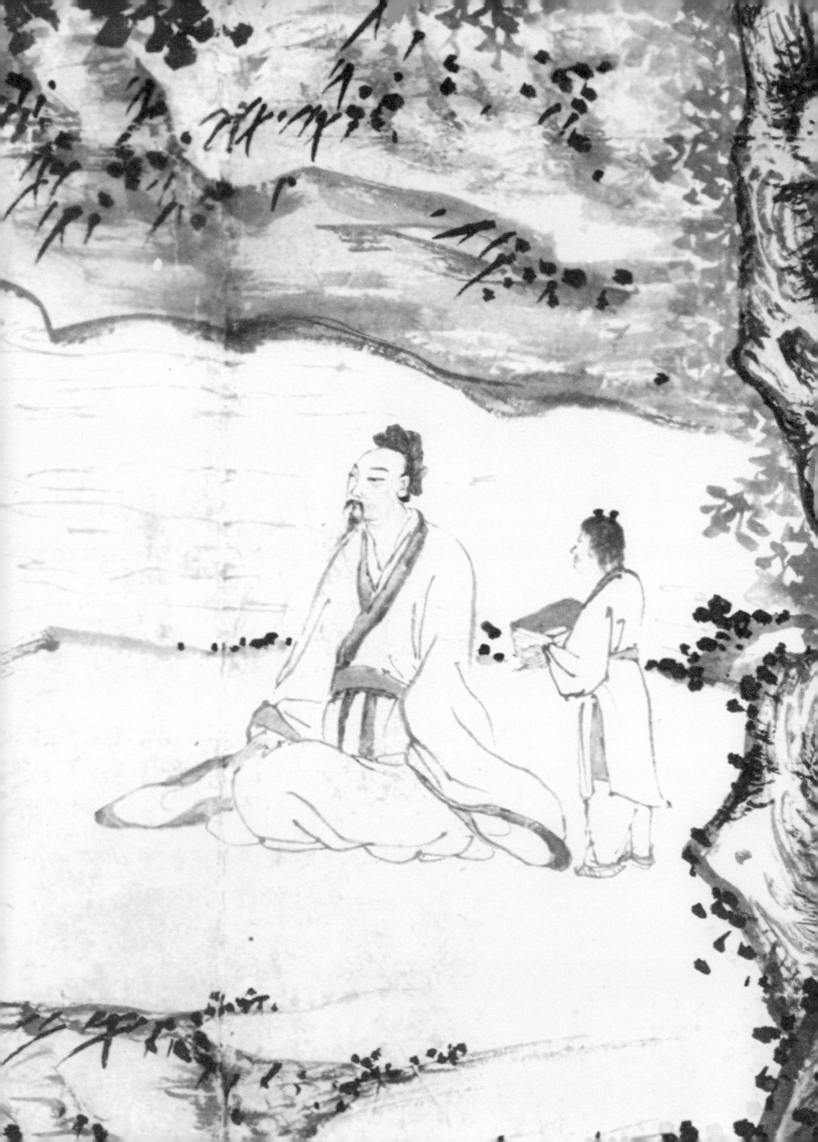

Section III: Literati Painting
Introduction

Fu Shen

Graduate Institute of Art History, National Taiwan University

Literati culture is one of the unique features of Chinese civilization. It has not only constituted a dominant trend of the last thousand years, but it also serves as a feature common to the cultural traditions of East Asia. Because of its centrality, the study of literati painting has long been an important subject in China, Japan, and Korea—and more recently in the West.

Some of the best-known early studies include Ōmura Seigai's 大村西崖 *Renaissance of Literati Painting* (*Bunjinga no fukkō* 文人画の復興) in Japan and Chen Hengke's 陳衡恪 *Studies of Chinese Literati Painting* (*Zhongguo wenrenhua zhi yanjiu* 中國文人畫之研究) in China from earlier in the twentieth century as well as James Cahill's "Confucian Elements in the Theory of Painting" (in *The Confucian Persuasion*) from 1960. Following these, Susan Bush's *The Chinese Literati on Painting: Su Shih to Tung Ch'i-ch'ang* of 1971 provided a comprehensive and systematic sourcebook for the study of literati painting theory beginning in the Song dynasty and laid an indispensable foundation for further research. In 1982, Nakata Yūjirō 中田勇次郎 published *Collection of Literati Painting Theory* (*Bunjinga ronshu* 文人画論集), drawing from both Chinese and Japanese sources.

Over the subsequent decades, numerous studies of individual painters have appeared, including literati artists of the Song, Yuan, and Ming periods. Yet in a 1996 paper, Shih Shou-chien 石守謙, a contributor to the present volume, was still able to ask, "What really is Chinese literati painting?"

Yi Song-mi 李成美 of the Academy of Korean Studies, the author of the first essay in this section, entitled "Ideals in Conflict: Changing Concepts of Literati Painting in Korea," has conducted research in both Korean and Chinese literati painting. Her 1983 doctoral dissertation completed at Princeton University, entitled "Wu Chen's 'Mo-Chu P'u': Literati Painter's Manual on Ink Bamboo," demonstrates her thorough training in Chinese art history. Her deep understanding of Chinese literati painting theory has enabled her to discover that, after the adoption of the concept of literati painting by Korean artists in the Koryŏ period, cultural differences and the passage of time led to the emergence, in the Chosŏn dynasty, of so-called "true-view landscape" (K: *chin'gyong sansuhwa* 眞景山水) painting.

The remaining three essays in this section focus, from different perspectives, on the Ming literati painter Wen Zhengming 文徵明 (1470–1559). An excellent foundation for these present efforts has been laid in individual studies on such major literati painters of the late Song and Yuan dynasties (13th and 14th century) as Zheng Sixiao 鄭思肖, Gong Kai 龔開, Qian Xuan 錢選, Zhao Mengfu 趙孟頫, Huang Gongwang 黃公望, Wu Zhen 吳鎮, Ni Zan 倪瓚, and

Wang Meng 王蒙. Not only did they provide groundwork for understanding literati painting in the Ming, the previous generation of scholars has also worked extensively on Ming literati painting itself. As early as 1954, Nelson Wu was researching Dong Qichang 董其昌 that led to his article "Tung Ch'i-ch'ang (1555–1636): Apathy in Government and Fervor in Art" published in *Confucian Personalities* in 1962. In that same year, Richard Edwards published a study on Shen Zhou 沈周 (1427–1509) entitled *The Field of Stones* that helped him and his students trace the origins of Wen Zhengming. The subsequent years saw a surge in the study of Wen Zhengming, spurred both by research in the United States and by Chiang Chao-shen's 江兆申 study of the Wu 吳 school, published in conjunction with a major exhibition and conference at the National Palace Museum, Taipei. From 1968 to 1969, Chiang also presented the results of his research on the Ming painter Tang Yin 唐寅 (1470–1524). After being invited by Professor Edwards to participate in a research project on painting in sixteenth-century Suzhou, Chiang then, from 1973 to 1974, held a three-part exhibition at the National Palace Museum entitled *Ninety Years of Wu School Painting* (*Wupaihua jiushinian zhan* 吳派畫九十年展). In 1975, he released a catalogue of the exhibition and a chronology of Wen Zhengming's painting. In 1974, Marc Wilson and K.S. Wang jointly prepared an exhibition entitled *Friends of Wen Cheng-ming*, while Anne Clapp published in 1975 a study entitled *Wen Cheng-ming: The Ming Artist and Antiquity*. These were followed in 1976 by Richard Edwards's major exhibition and catalogue, *The Art of Wen Cheng-ming,* and an international conference, which signified a peak of interest in the artist. In 1978, Chiang Chao-shen culminated this phase of his research with an expanded version of his Wen Zhengming chronology entitled *Wen Zhengming and Suzhou Painting* (*Wen Zhengming yu Suzhou huatan* 文徵明與蘇州畫壇). These various studies laid the foundation for subsequent research on the Wu school, including examinations of such artists as Qiu Ying 仇英 (ca. 1494–1552), Chen Chun 陳淳 (1484–1544), and Wen Boren 文伯仁 (1502–1575), as well as additional studies on Wen himself. Twelve years ago, the Palace Museum in Beijing held an international conference on the Wu school, followed by the publication in 1993 of *Studies of Wu School Painting* (*Wumen huapai yanjiu* 吳門畫派研究).

The three essays in this volume build on such solid foundations. The first, Craig Clunas's "Commodity and Context: The Work of Wen Zhengming in the Late Ming Art Market," is in part related to past studies of Wen Zhengming, but it owes more to Clunas's own extensive studies of decorative art and material culture, which represent a new topic in the field of art history. Clunas uses the theories of anthropologists and economic historians to examine both the objectification and commodification of paintings in a socio-economic context, and to recognize that works of art have "lives" that extend long beyond the circumstances of their inception. He studies the history of the Chinese art market within a commercial context. Here Clunas focuses on *Diary from the Water Tasting Studio* (*Weishuixuan riji* 味水軒日記), by the late Ming artist and connoisseur Li Rihua 李日華 (1565–1635), plumbing this account for references to paintings by Wen Zhengming. He uses these references to discuss how, fifty years after the painter's death, Wen's works were valued and given life as commodities in the art market.

Jonathan Hay's "Wen Zhengming's Aesthetic of Disjunction" discusses two of Wen's works, the hanging scroll *Cascading Falls in a Pine Ravine* and the handscroll *Heavy Snow on Mountain Passes*. Wen spent four to five years working on these landscapes, both of which he then presented to his young friend Wang Chong 王寵 (1494–1533) Hay addresses two questions, the first on why Wen Zhengming worked for so long on these paintings, and the second on why he presented them to the same person. Because Wen Fong and Shih Shou-chien have previously presented an opposing explanation to these questions, Hay hopes that his perspective will initiate dialogue on the subject.

In "Wen Zhengming, Zhong Kui, and Popular Culture," Shih Shou-chien offers a continuation of his ongoing research, having previously presented a series of four articles on the artist. Here he focuses on the work *Zhong Kui in a Wintry Forest* (*Hanlin Zhong Kui tu* 寒林鍾馗圖) to demonstrate how Wen Zhengming took a subject from popular culture—in this case, the auspicious image of Zhong Kui—and transformed it into a sophisticated image suitable for a scholar's study.

I wish to emphasize here that the previous generation of art historians, responding to the needs of their day, took on the difficult task of elucidating Wen Zhengming's personal history and establishing a chronology of his surviving and recorded works. They also clarified issues of authenticity and discussed the origins and development of Wen's style, his place in history, and his unique characteristics. Now younger scholars have the freedom to build on the foundations of their predecessors, and are moving forward and raising new questions. Not only are they analyzing the political, social, cultural, and economic contexts of art, they are also exploring artists' psychology—their feelings, thoughts, and emotions. They are even probing matters of physiology, anthropology, linguistics, and material culture. Whether they seek to adopt, modify, or discard the work of their predecessors, this new generation of art historians takes advantage of a wide variety of disciplines and modes of investigation, a trend apparent in the essays of Clunas and Hay. Such new perspectives are gradually forming the basis for new theories.

The new generation of art historians practices "diverse art history" in what perhaps might be called the era of "post-modern art history." The evolution of these interpretations of works of art reflects the evolution of Chinese painting itself in the Ming and Qing periods, which the famous art historian Max Loehr categorized as "art-historical art." I believe that art history as a field is moving in the same direction to become what I call "art-historical art history," and I believe that this new era is already upon us.

Fu Shen

第三節　文人畫
引言

傅申

國立臺灣大學藝術史研究所

　　文人畫在中國繪畫史上成爲中國的主流繪畫之一，也成爲東亞文化圈內共有的繪畫品類，在西方找不到等量齊觀的繪畫品種及歷史地位。文人畫在本世紀的研究，中國、日本、韓國或近代的西方都開始得很早。如大村西崖、陳衡恪。在西方有James Cahill等開啓了對文人畫之研究。Susan Bush的著作，爲了解自宋以來的文人畫論最重要及最有系統的參考書。中田勇次郎及石守謙各在1980及1990年代參加文人畫的討論。

　　本組首篇論文是韓國精神文化研究院的李成美＜理想的對立：韓國文人畫中觀念的變化＞，李成美研究中國及韓國的文人畫背景，基於其博士論文：《吳鎭的墨竹譜》，檢視當中國文人畫觀念被韓國畫家在高麗時代引進並接納後，因地區文化上的差異，在李朝時期有所轉化而產生了韓國的「眞景山水」畫。其他三篇論文都集中在明代文人畫大家文徵明身上。過去對宋末元初以來的文人畫家作過不同程度的研究，有助於學者對明代繪畫史的研究。1954年吳納遜研究了董其昌，1962年Richard Edwards發表了沈周的研究，爲日後文徵明研究的前奏。同時，台灣故宮的江兆申的吳派畫研究配合大型展覽及研討會，爲吳派畫及文徵明研究的盛期。1968-69年，江兆申發表了唐寅的研究，並從事「十六世紀蘇州地區畫家活動情形」研究。1973-74年，在故宮舉辦了三期的＜吳派畫九十年展＞，1975年出版該展的圖錄以及《文徵明畫繫年》。美國由Marc Wilson及黃君實在1974年舉辦了＜文徵明及其友人＞展。1975年，Anne Clapp發表《Wen Cheng-ming: The Ming Artist and Antiquity》一書，1976年Richard Edwards舉辦了文徵明大展並發表圖錄：《The Art of Wen Cheng-ming》。同時也有一場國際的文徵明研討會，將文徵明的研究推向了高潮，1978年江兆申發表《文徵明與蘇州畫壇》。北京故宮也舉行了「吳門繪畫國際學術研討會」，並在1993年出版《吳門畫派研究》。石守謙自1988年起陸續發表四篇有關文徵明的研究。

　　此次研討會有三篇關於文徵明的研究，都是上述背景下的產物。關於裝飾藝術與物質文化的研究，是藝術史研究中的新課題，運用藝術人類學及經濟史學家的理論。Craig Clunas一文的研究是將中國藝術市場放進商業脈絡，以李日華的《味水軒日記》爲主，整理出文徵明在去世五十年後，其書畫作品在文物市場上的生命及價值。Jonathan Hay一文，討論文徵明的立軸《松壑飛泉圖》及長卷《關山積雪圖》，希望對文徵明爲什麼要

花費這麼長的時間為王寵畫這兩幅畫提出解答。石守謙及方聞曾提出對此的看法，於是Hay與二位進行了一場對話，並提出個人的觀點。石守謙一文，以《寒林鍾馗》圖來闡述文人如何將大眾文化中能驅邪迎福的圖騰，引入文人畫中而被書齋文化所接受的這一現象。

　　當今的藝術史家，在既有的成果上，往前推進逐步揭出不同的議題，不但從政治經濟、社會文化等角度，亦從藝術家的心理、思想、情感，及人類學、語言學，甚至物質文化等理論來探討。後來者在援引、修正、異議前人的理論時，須與各種理論及藝術史的先進或同儕們進行對話。新一代的藝術史學者，正進入所謂的「後現代藝術史時代」。我想再借用Max Loehr的著名詞彙，他將明清時代的繪畫歸類為「art historical art」(藝術史的藝術)。在美術史研究的中，對藝術品詮釋的理論化、主觀化，似也走入「藝術史的藝術史」(art historical art history)。個人認為，這樣的時代也已來臨。

第三部　文人画
序言

傅申

国立台湾大学藝術史研究所

　　中国絵画史上、文人画は一つの主流をなしており、同時に東アジア文化圏で共有される絵画の一ジャンルである。西洋には文人画に相当する絵画ジャンル、史的位置は見出せない。20世紀における文人画の研究は、中国・日本・韓国のみならず、近代の欧米において早々に開始された。大村西崖・陳衡恪、米国のジェームズ・ケーヒル氏らの名が挙げられよう。スーザン・ブッシュ女史の著作は宋代以来の文人画論を解くための、最も重要かつ最も系統だったものといえる。中田勇次郎氏、石守謙氏は1980年代及び1990年代において重要な文人画研究を発表されている。

　　本セクションの初めの論文は韓国精神文化研究所の李成美「理想の対立：韓国文人画における観念の変化」である。李成美氏は中国・韓国両国の文人画の背景を研究しており、博士論文「呉鎮の墨竹譜：文人画家の墨竹画譜」における文人画論の理解を基にして、韓国では中国文人画の観念が高麗時代に導入され、その後、地域性に応じて朝鮮時代に変化を来し、韓国に「真景山水」画が生み出されたことを考察している。

　　他の3本の論文はすべて明時代文人画壇の領袖、文徴明に集中している。現在の明時代絵画史研究は、これまでの宋末元初以来の文人画家に関する様々な研究が基礎となっている。1954年に発表されたネルソン・ウー(呉納遜)氏の董其昌研究、1962年のリチャード・エドワーズ氏による沈周研究等は文徴明研究の前提となった。また、江兆申氏の呉派画研究は台湾故宮博物院の大展覧会及びシンポジウムの開催と相俟って、呉派画及び文徴明の研究の最盛期をもたらした。1968・69年、江兆申氏は唐寅に関する研究を発表し、その後「十六世紀蘇州の画家の活動状況」の研究に携わった。1973・74年、故宮博物院では三期に渡る「呉派画九十年展」を開催、1975年に展覧会図録及び『文徴明画系年』を出版した。米国ではマーク・ウィルソン氏・黄君実氏による「文徴明とその友人」展が1974年に開催された。アン・クラップ女史は1975年に研究書『Wen Cheng-ming: The Ming Artist and Antiquity』を発表、リチャード・エドワーズ氏はその翌年(1976年)文徴明の大展覧会を開催、図録『The Art of Wen Cheng-ming』を発表、文徴明の国際シンポジウムも開かれ、文徴明研究は活況を呈した。江兆申氏は1978年に『文徴明と蘇州画壇』を発表した。北京故宮でも「呉門絵画国際学術討論

会」を開催し、1993年にはそれに基づく『呉門画派研究』を出版した。石守謙氏は1988年から次々に文徴明に関する研究を4本発表した。今シンポジウムにおける3つの文徴明に関する研究はみな上述した背景の産物といえよう。装飾芸術と物質文化に関する研究は芸術史研究中の新たな課題であり、芸術人類学・経済史学者の理論が用いられている。クレイグ・クルーナス氏の研究は、中国芸術市場を商業のコンテクストで理解し、李日華『味水軒日記』を中心に、文徴明が没して五十年後の文物市場における文徴明の書画のあり様と価値を整理している。ジョナサン・ヘイ氏は、文徴明の「松壑飛泉図」軸と「関山積雪図」巻を論じ、文徴明が王寵のために、どういう理由で、どのくらいの時間を費やしてこの2作品を描いたかという問題に対して解答を試みている。石守謙氏と方聞氏はかつてこうした見方とは異なる意見を提出しており、ヘイ氏は二人に対話を挑む形で個人的な見方を提示したといえよう。石守謙氏は「寒林鍾馗」図において、文人がいかに大衆文化におけるトーテムとしての駆邪迎福を文人画中に引き入れ、書斎文化の中に受け入れたかという現象を詳述している。

　現在の美術史家は、既存の成果の上に、いろいろと異なる議題を提出して前進していく。政治経済・社会文化といった角度からアプローチするばかりではなく、芸術家の心理・思想・感情に入り込んで分析し、人類学・言語学、さらには物質文化等の理論まで用いて検討するようになって来ている。後進の者が前人の理論を引用・修正・反論する際には、様々な理論に触れ、芸術史の先輩・同輩らと対話せねばならない。新世代の美術史学者はまさに「ポストモダン美術史」の時代に入っている。ここでマックス・ロア氏の有名な言葉を再び引用しよう。彼はまさに明清時代の絵画を「art historical art (「芸術史の芸術」)」と分類した。つまり、美術史研究において芸術作品を解釈し理論化・主観化する行為は、「芸術史の芸術史 (art historical art history)」に踏み込んでいくようでもある。こうした時代もすでに到来している、と私は考える。

Ideals in Conflict:
Changing Concepts of Literati Painting in Korea

Yi Sŏng-mi

Academy of Korean Studies, Emeritus

Korean literati painting has developed in close relationship with that of China since the Koryŏ period. This essay examines the literary evidence and extant paintings in order to explore the changing concepts and understanding of literati painting in Korea from the Koryŏ through the late Chosŏn period.

Diplomatic and scholarly exchanges between the Northern Song and Koryŏ courts seem to have naturally resulted in the transmission of Song literati painting theories and practices to Koryŏ. Although only a handful of paintings remain from this period, many poems and colophons from ink bamboo paintings by Koryŏ scholars are recorded and attest to their knowledge and understanding of Song literati painting. They reveal that Koryŏ scholars enthusiastically absorbed the literati painting theories of Su Shi 蘇軾 (1037–1101) and his circle and painted ink bamboo in the manner of Su Shi and Wen Tong 文同 (1019–1079).

The strong tradition of literati painting was set back, however, by the fall of the Koryŏ and founding of the Chosŏn dynasty. The advisors who helped the dynasty to power had a strong commitment to austerely Neo-Confucian world views and moral standards, which included a disdain for the arts as frivolous and selfish pursuits. If a ruler showed an unusual degree of interest in the arts, high officials promptly admonished him, citing Chinese and Korean rulers whose predilection for the arts (they said) caused the downfall of their respective dynasties. This climate hindered the development of literati painting during the early to middle Chosŏn period and blocked the transmission of literati painting styles from Ming dynasty China. Even during the late Chosŏn period, scholar-painters were reluctant to publicly reveal their artistic talent.

From the mid-seventeenth century, the introduction to Korea of Chinese painting manuals such as *Master Gu's Painting Compendium* (*Gushi huapu* 顧氏畫譜) and the *Mustard Seed Garden Painting Manual* (*Jiezi yuan huazhuan* 芥子園畫傳) prompted a revival of interest in Chinese literati painting. In the late eighteenth and early nineteenth century, even professional artists at court did paintings in the "Southern School" (C: *Nanzong* 南宗) brush idioms of this tradition. Some, though, due to their incomplete knowledge of Chinese literati painting, misunderstood its ideals and misinterpreted its practices.

Koryŏ Scholar-Painters

A well-known scholar-official and ink bamboo painter, Yi Inro 李仁老 (1152–1241), composed the following poem:

The resonance [of your ink bamboo painting] reached my beautiful bamboo.
In my former life I must have been Wen Xiaoxiao [Tong].[1]
餘波猶及碧琅玕，自恐前身文笑笑。

This poem was addressed to Sukŏsa 睡居士, "The Sleeping Recluse," the sobriquet of An Ch'imin 安置民 (dates unknown), whose ink bamboo painting Yi had long been emulating. It is a neatly turned compliment, suggesting that only a former incarnation as the patriarch of ink bamboo painting would have enabled Yi to approach Sukŏsa's ink bamboo.

On the surface, Yi's conjectured link with Wen Tong conveys admiration for that Northern Song painter. Beneath the surface, Yi is also invoking solidarity with Song dynasty literati who took Wang Wei 王維 (701–761), the Tang poet-painter and high official, as their inspiration. Song formulations of literati painting theory, particularly that of the near identity of poetry and painting, frequently cited Wang's stanza, "In my former life, I must have been a painter (*Qianshen ying huashi* 前身應畫史)." To fellow literati, the allusion in Yi Inro's second verse would have been immediately apparent.

Another scholar-official, Yi Kyubo 李奎報 (1168–1241), upon viewing An Ch'imin's ink bamboo painting, composed the following poem:

Kiam Kŏsa [An Ch'imin]
Through [his] bamboo [painting] equals the immortals.
When wielding the brush [to paint ink bamboo],
Instinctively the painter's spirit accords with nature.
His hand performs as his mind directs,
Always his thoughts are conveyed by his mind.
His mind directs while his hand responds,
So how can anything escape [such concentration]?[2]
棄庵居士，於竹通仙。一掃其眞，暗契自然。手爲心使，常以心傳。心指手應，物何逃焉。

This poem by Yi Kyubo expresses one of the most fundamental theories of Chinese literati painting: that is, if the painter has become one with the Dao (or "Way"), he is *ipso facto* one with nature and can trust his hand (C: *xin shou* 信手) when painting ink bamboo. This set of linked concepts was expounded upon by Su Shi in his famous *Record of Wen Yuke's Painting of Bent Bamboo at Yundang Valley* (*Wen Yuke hua Yundang gu yanzhu ji* 文與可畫篔簹谷偃竹記).

One of the best scholar-painters of the Koryŏ period was Chŏng Hongjin 丁鴻進 (dates unknown; style name Yi'an 而安, official title Pisŏgam 秘書監 [Director of the Palace Library]). Chŏng was not only good at ink bamboo, but also well known as a portrait painter. Yi Kyubo judged Chŏng's ink-bamboo painting far superior to that of the Tang

1. Yi Inro, *P'a-han jip* (*Broken Fence Collection*), quoted in O Sech'ang, *Kŭnyŏk sŏhwajng* (*Biographical Dictionary of Korean Calligraphers and Painters*) (Korean trans. by the Oriental Classics Society) (Seoul: Sigongsa, 1998), vol. 1, p. 89.

2. See "In praise of An Ch'imin's ink bamboo painting" in Yi Kyubo, *Tongguk Yi Sangguk chŏnjip* (*Complete Collection of Prime Minister Yi of the Eastern Country*), vol. 19, "Miscellanea" (Korean trans. by the Committee for the Promotion of Korean Culture, 1978/1982), vol. 3, pp. 161–62.

bamboo painter Xiao Yue 蕭悅[3] and of Wen Tong. Upon receiving two ink bamboo hanging scrolls along with his portrait, all painted by Chŏng, Yi composed a long rhyming poem in ancient style. The following is the middle section of the poem:

> When you take up your brush [to paint ink bamboo],
> Your elegant brush is aided by the spirits.
> At the very moment of calm spiritual concentration,
> You would not notice the fall of a huge mountain.
> The force of the ten thousand feet [tall bamboo stalks] stored in your heart,
> Has already risen above the high clouds.
> I would hate to compare you with Xiaolang,
> Even more with Yuke.[4]
> 想子下筆時，神鬼助軒欹。方其靜凝神，寧顧大山墮。中有萬尺勢，雲外已迥跨。
> 猶嫌比蕭郎，況更論與可。

The three poems quoted above attest to the admiration of Koryŏ scholars for Song literati painters, and to their deep immersion in the spirit of Song literati culture and painting theories, such as "oneness of painting and poetry" (*shihua yilü* 詩畫一律), "spiritual concentration" (*ningshen* 凝神) when painting ink bamboo, "hand and mind responding to each other" (*xinshou xiangying* 心手相應), or "storing the force of tall bamboos in one's heart" (*zhongyou wanchishi* 中有萬尺勢). At the same time, they were confident of the Koryŏ painters' superiority over even the semi-legendary Chinese masters of bamboo painting.

The Chosŏn Period: Art Disdained as Lowly Craft

The extreme moral rigor of Chosŏn society condemned the arts, including painting, as pleasure-seeking activities. Only calligraphy, traditionally considered the highest art form in China as well as in Korea, was exempt from this censure.[5] As a result, extant works by scholar-painters of the early Chosŏn period are very rare. It is recorded that Kang Hŭian 姜希顏 (1418–1465), a scholar-official famous for calligraphy and painting, ordered his sons to destroy his paintings, as he did not wish to be remembered in history for his painting, which he termed a "lowly craft" (*ch'ŏn'gi* 賤技).[6] A handful of extant paintings attributed to him, including *Scholar Gazing at a Waterfall* (*Fig. 1*), a small painting with a seal reading Injae 仁齋 (his sobriquet), were all done in the Zhe 浙 school style. In 1462, Kang went as an envoy to the Ming capital, where, presumably, he was exposed to the contemporary Zhe school style of professional

3. Xiao Yue is recorded in Zhang Yanyuan, *Lidai minghua ji* (*Record of Famous Paintings of All Dynasties*), chap. 9, p. 113. Also see "Huazhu ge (Song on a Bamboo Painting)" by Bo Juyi (772–846), in which he praises the natural, graceful look of Xiao's bamboo painting. This poem is in Sun Shaoyuan, *Shenghua ji* (*Collection of Paintings with Voice*), which is included in *Lianting shierzhong* (*Twelve Volumes of Lianting*), comp. Cao Yin (1706; reprint, Shanghai, 1921).

4. Yi Kyubo, *Tongguk Yi sangguk chŏnjip* (*hujip* [addendum], chap. 5), in Yi Kyubo, vol. 6, p. 44–45.

5. See Chŏng Yangmo, "Chosŏn chŏngi ŭi hwaron (Painting Theories of the Late Chosŏn Period)," in An Hwi-joon, ed., *Sansu-hwa* (*Landscape Painting*), vol. 1, pp. 177–190, for an overview on the art of painting by early Chosŏn members of the ruling class.

6. Kang Hŭimaeng, *Chinyang sego*, quoted in O Sech'ang, *Kŭnyŏk Sŏhwajing*, vol. 1, p. 222.

court painters in China. Chinese scholar paintings of the early Ming period were mostly done in the Wu 吳 school style, which was markedly and indeed purposefully different.

Several of the Chosŏn rulers are known to have been talented painters and calligraphers. For example, King Sejong 世宗 (r. 1418–1450), while crown prince, painted a screen of bamboo and orchid that he later gave to his minister Sin Inson 辛引孫.[7] Unfortunately, that painting is no longer extant. King Sŏnjo 宣祖 (r. 1567–1608) is also known to have painted orchids and bamboo. In addition to a small painting of ink bamboo now in the National Museum of Korea,[8] Sŏnjo's orchid and ink bamboo paintings are included in the woodblock-printed book *Album of Calligraphies by Several Kings* (*Yŏlsŏng Ŏp'il* 列聖御筆).[9] King Chŏngjo's 正祖 (r. 1776–1800) paintings and calligraphy are now kept in the Tongguk 東國 University Museum (*Fig. 2*) and the National Museum of Korea. The case of King Sŏngjong 成宗 (r. 1469–1494), a painter of ink orchid and bamboo, reflects the attitude of the early Chosŏn ruling class toward art.[10] He retained his favorite painters at the palace and ordered birds captured so that his painters could observe them firsthand and represent them correctly. Sŏngjong's love of painting, however, elicited grave admonitions from court officials.[11] For example, Ch'oe Pan 崔潘 and Yi Segwang 李世匡 feared that a love of painting would lead the king to overindulgence in material goods. As precedent for their reproof, they cited the seven officials said to have admonished the legendary Emperor Shun 舜 for commissioning lacquer wares. King Sŏngjong then overreacted by ordering court officials to abolish the Painting Bureau, or Tohwasŏ 圖畫署. The officials finally persuaded the king to annul his order, pointing out that the painting of royal portraits and creation of designs, such as for the embroidery of official robes, necessitated the Painting Bureau.[12] Another entry in the official records of Sŏngjong's reign relates that Hyŏn Sŏkkyu 玄碩圭, his secretary, reminded the king of the story of the Five Dynasties ruler Liu Chang 劉鋹 (958–971) of the Southern Han, whose indulgence in the arts is said to have brought about the downfall of his kingdom.[13]

7. *Sejong sillok* (*Veritable Records of King Sejong*), chap. 109 (25th day of the seventh lunar month, 1445), and *Munjong sillok* (*Veritable Records of King Munjong*), chap. 8 (first day of the sixth lunar month, 1451), in *Chosŏn wangjo sillok misul kisa charyojip* (*Compilation of Art-related Articles from the Veritable Records of the Chosŏn Dynasty*), ed. Yi Song-mi, vol. I (Songnam: The Academy of Korean Studies, 2001: hereafter, CWSMKC), pp. 191, 223, and also p. 268.

8. A small leaf of ink bamboo, measuring 31 by 19.3 centimeters, is now mounted as the first leaf of a five-volume set of albums entitled *Collected Garden of Paintings* (*Hwawŏn pyŏlchip* 畫苑別集). This set consists of 79 paintings ranging in date from late Koryŏ to Late Chosŏn. See Lee Wonbok, "Hwawŏn pyŏlchip ko (A Study on *Collected Garden of Paintings*)" in *Misulsahak yŏn'gu* (*Studies in Art History*), vol. 219 (Sept. 1997), pp. 57–79.

9. See *Yŏlsŏng ŏp'il* (Changsŏgak Library, The Academy of Korean Studies, no. 3: 499), which is a volume containing calligraphy and paintings of the five Chosŏn kings, namely Sŏnjo, Injo 仁祖, Hyojong 孝宗, Hyŏnjong 顯宗, and Sukchong 肅宗. Illustrated in *Chosŏn wangsil ŭi ch'aek* (*Books Belonging to the Chosŏn Royal Family*) (Sŏngnam: The Academy of Korean Studies, 2002), p. 109.

10. Poetic inscriptions on his own ink orchid and bamboo paintings are collected in *Yŏlsŏng ŏje* (*Compositions by Several Kings*) quoted in O Sech'ang, *Kŭnyŏk sŏhwajing*, pp. 259–261.

11. *Sŏngjong sillok* (*Veritable Records of King Sŏngjong*), chap. 95 (fourth day of the eighth lunar month, 1478), in CWSMKC, pp. 466–462 and pp. 463–466.

12. *Ibid.*, p. 465.

13. *Sŏngjong sillok*, chap. 60 (23rd day of the tenth lunar month, 1475), in *ibid.*, pp. 374–375.

Section III: Literati Painting

Two centuries later, in 1681, scholars at the Sŏnggyungwan 成均館, the hall of the Directorate of Education and the highest educational institution in the kingdom, went so far as to warn King Sukchong 肅宗 (r. 1674–1720) not to indulge in any of the five traditional gentlemanly arts, that of playing the *qin* 琴, the game of *qi* 棋, poetry, painting, and archery. Their term of reproof was "*wanmul sangji* 玩物喪志," which means "losing one's principle by treasuring [useless] things." This warning, which originated in the *Book of History* (*Shujing* 書經),[14] became a guiding principle of conduct among Neo-Confucian Chosŏn scholars. The famous late Chosŏn scholar of the School of Practical Learning (*Sirhak* 實學), Yi Ik 李瀷 (1681–1763), also considered ancient paintings depicting exotic landscapes and bird-and-flower scenes to be mere objects of "*wanmul*" and warned that gentlemen should not possess them.[15] In sum, the acts of painting and treasuring paintings were considered equally culpable, and Korean literati seem to have exercised utmost restraint in both at the time.

In fact, however, the term "*wanmul sangji*" as used in the *Book of History* had nothing to do with painting. It merely warned the ruler to refuse as non-customary the gift of a dog from the tribe of Lü 旅. No doubt, earlier Chosŏn scholars were aware of the Northern Song Neo-Confucian thinker Cheng Hao's 程顥 (1032–1085) warning based on the story from the *Book of History*, but the story seemed to have acquired added strength once told by Yi I 李珥 (1536–1584), Korea's most respected Neo-Confucian scholar.[16]

Cho Yŏngsŏk's 趙榮祏 (1686–1761) rare album of paintings entitled *The Deer's Navel* (*Saje-chŏp* 麛臍帖), consisting of sketches from the daily life of commoners (*Fig. 3*), remained buried among the Cho family's documents for nearly two and a half centuries after Cho's death, and only recently was uncovered by art historians. The title implies that the album, as with a deer's navel, should be absolutely hidden from public view. Like Kang Hŭian of the fifteenth century, Cho, also a scholar-official, did not wish his talent in painting to be known. It is recorded that in 1735 Cho was jailed for refusing the order of King Yŏngjo's court to participate in the copying of King Sejo's portrait.[17] However, Yun Tŏkhŭi 尹德熙, also a scholar-painter, complied with the court's order.

In this connection, the story of Kang Sehwang 姜世晃 (1713–1791), the famous critic and painter, destroying all his painting brushes when he decided to quit painting for good is also illuminating. At age fifty-one, Kang was advised by King Yŏngjo 英祖 (r. 1725–1776) not to let the world know of his talent for painting, which he believed would bring

14. From the "Lü ao (Lü Dog)" section of the "Zhoushu" (Book of Zhou) chapter in *Shujing*.

15. *Sŏngho sŏnsaeng chŏnjip* (*Complete Writings of Sŏngho [Yi Ik]*), quoted in Hong Sŏnp'yo, "Chosŏn hugi ŭi hoehwagwan (Views on Painting in the Late Chosŏn Period)," in Ahn Hwi-joon, ed., *Sansuhwa*, vol. 2, p. 222.

16. *Yulgok chŏnsŏ* (*Complete Writings of Yulgok*), chap. 21, "Sŏnghak chipyo (Abstracts from the School of Practical Learning)," 3, cited in Hong Sŏn-p'yo, *Chosŏn sidae hoehwasaron* (*Collection of Essays on Chosŏn Period Painting*) (Seoul: Munye chulpan-sa, 1999), p. 196.

17. See Yi Sŏng-mi, "Chosŏn wangjo ŏjin kwan'gye togam ŭigwe (Chosŏn Palace Documents Concerning the Painting and Copying of Royal Portraits)," p. 77, in *Chosŏn sidae ŏjin kwan'gye togam ŭigwe yŏn'gu* (*Studies on Chosŏn Palace Documents Concerning the Painting and Copying of Royal Portraits*), ed. Yi Sŏng-mi, Kang Sinhang, and Yu Songok (Academy of Korean Studies, 1997).

Kang disrepute. Before burning all his brushes, Kang cried for three days and nights until his eyes were swollen. He did not take up the brush again for at least ten years.[18]

King Sŏngjong's determination to promote Ch'oe Kyŏng 崔涇 and An Kwisaeng 安貴生 to the level of "third rank senior" (*tangsanggwan* 堂上官), after the two had served as royal portrait painters, met with stiff opposition from officials in the Censorate.[19] The officials forced the king to consent that doing a royal portrait was merely a duty of the painters at the Painting Bureau, and that "third rank senior" must not be bestowed upon painters, who are mere artisans and of lowly origins, not belonging to the same class as scholar-officials (*saryu* 士類). They went so far as to admonish the king that such a promotion would set a precedent, leading every other artisan who served the court in doing a similar task to request higher rank, thereby devaluing the prestige of higher ranks and of scholar-officials.[20] Their arguments indicate how paltry, even ignoble, the art of painting seemed to scholar-officials of the Chosŏn period. Late in the Chosŏn period, when King Yŏngjo wanted to promote the famous "true-view landscape" (*chin'gyong sansuhwa* 眞景山水) painter Chŏng Sŏn 鄭敾 (1676–1759), he encountered similar arguments from high officials, but in this case he was not swayed by them.[21]

From the above discussion, we can discern the complex and partly contradictory psychological, ideological, and practical views of the Chosŏn ruling class towards the art of painting. On the one hand, scholar-officials felt a strong historical and psychological attachment to the literati painting theories and ideals formulated in Northern Song China. On the other, however, with few exceptions they denigrated painting as a lower-class activity and feared to acquire a reputation for painting. Their ambivalence also appears in their encounters with Chinese painting styles introduced to Korea through painting manuals and other illustrated books.

The Role of Chinese Painting Manuals and the Idea of Brush-Style Lineages in the Late Chosŏn

From the early seventeenth century, painting manuals such as *Master Gu's Painting Compendium* (1603; hereafter GSHP), *Ten-Bamboo Studio Calligraphy and Painting Manual* (*Shizhuzhai shuhuapu* 十竹齋書畫譜; 1627; hereafter SZZSHP), and *Mustard Seed Garden Painting Manual* (1679, 1701; hereafter JZYHZ), or such illustrated printed books as *Tang Poetry and Painting Compendium* (*Tang shi huapu* 唐詩畫譜; Wanli reign [1573–1620]; hereafter TSHP) began to be published in China. Korean scholar-painters, who quickly came to have access to these books,

18. See *P'yoam Yugo* (*Posthumous Collection of Writings by P'yoam [Kang Sehwang]*), pp. 494–495, quoted by Pyun Young-sup, "On Kang Sehwang: The Lofty Ideals of a Literati Artist," in *The Fragrance of Ink: Korean Literati Paintings of the Chosŏn Dynasty (1392–1910) from Korea University Museum*, p. 206.

19. *Chosŏn Law Code* (*Kyŏngguk taejŏn*) explicitly states that the highest rank a court painter could reach is the sixth grade.

20. There are more than ten entries on this subject in *Sŏngjong sillok*, beginning from the 26th day of the fifth lunar month to the ninth day of the seventh lunar month, 1472. See CWSMKC, vol. I, pp. 330–359.

21. *Yŏngjo sillok* (*Veritable Records of King Yŏngjo*), fifth day of the fourth lunar month, 1754, in *ibid.*, vol. II, p. 411.

avidly absorbed the styles and techniques of Chinese painters whose works were illustrated in them.[22] Although the degree of emulation varied among artists and even within the oeuvre of an individual artist, Korean painting after the introduction of these illustrated books was never the same.

By the early seventeenth century, when these manuals appeared on the scene, Korean painting had become somewhat stagnant. In the fifteenth century, An Kyŏn 安堅 (active mid-15th c.) and his followers had introduced and popularized the Li Cheng 李成 and Guo Xi 郭熙 school of Chinese painting, while the scholar-official Kang Hŭian and such sixteenth-century royal clansmen as Yi Kyŏng'yun 李慶胤 (1545–?) and Yi Yŏng'yun 李英胤 (1561–1611) adapted the Zhe painting style in the so-called "Korean Zhe school" manner, which was taken up by other scholar-painters as well as by professional painters.[23] However, by the seventeenth century, the Korean-ized Li-Guo and Zhe school styles of painting seemed to have played out.

The 106 model compositions of Chinese painters contained in *Master Gu's Painting Compendium*, which was introduced to Korea as early as 1608, offered fresh stimuli to Korean scholar-painters, such as Yun Tusŏ 尹斗緒 (1668–1715), searching for new models.[24] In the Yun Tusŏ Memorial Museum, established by his descendants in their hometown of Haenam 海南, South Chŏlla Province, a copy remains of the painting manual that the painter had studied and copied. Several extant paintings by Yun clearly show the artist's dependence on the model compositions in *GSHP*. *Landscape* (*Fig. 4*), one of the leaves from an album of paintings transmitted in the Yun family and now kept in the Yun Tusŏ Memorial Museum, shows his debt to the right half of a Ni Zan 倪瓚 (1301–1374) composition in *GSHP* (*Fig. 5*) as well as to another page of a Ni Zan composition in *TSHP*, entitled *Streamside Pavilion among Bamboo and Trees* (*Zhushu qiting tu* 竹樹谿亭圖).[25]

Beginning in the seventeenth century, many Korean paintings are compositionally identical to paintings reproduced in the abovementioned Chinese manuals. Some Korean painters would reverse the composition, creating a mirror image of the model in the Chinese manuals. In neither case is the compositional source mentioned on the Korean painting. Still other Korean painters combined compositional elements from several models into their own compositions. For example, an undated landscape painting by Cho Sok 趙涑 (1595–1668), *Gathering Mist in a Village by a Lake* (*Hochon yeonŭi do* 湖村煙凝圖; *Fig. 6*), in the Kansong 澗松 Art Museum in Seoul, is almost exactly based on the composition in *GSHP* (vol. 3) attributed to Gao Kegong 高克恭 (1248–1310), which also appears in *TSHP* entitled *After Gao Kegong's Brush Idea* (*Fang Gao Kegong biyi* 仿高克恭筆意; *Fig. 7*). Zhang Lu's 張路 (ca. 1490–ca. 1563)

22. There are several studies on this subject in Korean. These will be cited where relevant.

23. See Ahn Hwi-joon, "Han'guk Chŏlp'a huap'ung ŭi yŏn'gu (Studies on the Korean Zhe-school Painting Style)" in *Misul Charyo* (*National Museum of Korea Art Magazine*), no. 20 (June 1977), pp. 24–62.

24. As for evidence concerning the entry of *GSHP* into Korea in 1606 at the time of Zhu Zhifan's 朱之蕃 visit to Korea as an envoy to King Sŏnjo's court, see an unpublished M.A. thesis by Song Hyegyŏng, "Kossi Hwabo wa Chosŏn hugi hwadan (*Gushi huapu* and the Art Scene of the Late Chosŏn Period)" (Hong'ik University, June 2002), p. 62.

25. Illustration no. 7, vol. 5, *TSHP*.

composition in *GSHP* is emulated in Hyŏn T'aesun's 玄泰純 (1727–?) *Mounted on a Lame Donkey Looking for Plum Blossoms* (*Geonryeo simmae* 蹇驢尋梅), also in the Kansong Art Museum. Even Chŏng Sŏn, considered one of the most original Korean painters, based his *Squirrel* (*Fig. 8*), now in the Seoul National University Art Museum, on a composition by Tao Cheng 陶成 (act. ca. 1480–ca. 1532) in *GSHP* (*Fig. 9*).

The painter who depended most heavily on *GSHP* and *TSHP* was Sim Sajŏng 沈師正 (1707–1769). Sim was descended from an illustrious and artistically gifted family from Ch'ŏngsong 青松, which had produced high officials since the late Koryŏ period.[26] His own advancement into officialdom, however, was foreclosed by the involvement of his grandfather, Sim Ikch'ang 沈益昌 (1652–1725), in the unsuccessful attempt to kill the crown prince, who later became King Yŏngjo.[27]

Sim, debarred from an official career but artistically talented, worked almost like a professional painter. His numerous landscape paintings echo model compositions found in *GSHP*, often combined with trees or rock formations taken from *JZYHZ*. He also painted landscapes in the styles of both the Wu and Zhe schools.[28] In his undated landscape painting *Overnight on the Riverboat* (*Gangsang yabak* 江上夜泊圖; *Fig. 10*), Sim adopted tree types and mountain peaks in the Mi style associated with Mi Fu 米芾 (1051–1107) and Mi Yuren 米友仁 (ca. 1072–1151) from *JZYHZ* (*Fig. 11*). Another of his landscapes specifies Ni Zan as his model (*Bang Ye Un lim beob* 倣倪雲林法) and almost exactly transcribes the Ni Zan composition in *GSHP*.

By Sim Sajŏng's time, Korean painters had a fairly firm notion of the basic stylistic idioms of Chinese Southern School painting. Augmenting the painting manuals, they now had access to actual Chinese paintings, or at least to eyewitness accounts of these, brought to Korea by emissaries returning from Yanjing 燕京 and spreading knowledge of Southern School styles among scholar as well as professional painters.[29] Sim, being a member of a scholarly family and yet working in the capacity of a professional painter, was versatile and eclectic; he painted in both the scholarly and professional manners.

Although the Korean tradition of painting in allusion to certain Chinese old masters can be traced back to painting by Yi Yŏng'yun, artists of the late sixteenth to early seventeenth century[30] did not generally acknowledge their models.

26. For Sim Sajŏng's life and a history of his family, see Yi Yesŏng, *Hyŏnjae Sim Sajŏng yŏng'gu* (*Studies on Sim Sajŏng's Paintings*) (Seoul: Ilchisa, 2000), pp. 12–42.

27. *Ibid.*, p. 17.

28. For a period-by-period development of Sim Sajŏng's landscape painting styles, see *ibid.*, pp. 64–168.

29. See Ahn Hwijoon, "Han'guk namjong-hwa ŭi pyŏnch'ŏn (The Vicissitudes of Korean Southern School Painting)" in his *Han'guk hoehwa ŭi chŏnt'ong* (*Traditions of Korean Painting*) (Munye Ch'ulp'ansa, 1988), pp. 250–309; and Yi Sŏng-mi, "Southern School Literati Painting of the Late Chosŏn Period," in *The Fragrance of Ink: Korean Literati Paintings of the Chosŏn Dynasty (1392–1910) from Korea University Museum*, pp. 117–91.

30. In his landscape in the National Museum of Korea, he wrote that he did the painting in Huang Gongwang's early style ("*Daeŭi chonyeon yeok you cha pil* 大癡初年亦有此筆").

Sim Sajŏng, on his numerous paintings, explicitly wrote that they were done in allusion to "so-and-so" painter, and this practice seemed to have marked the beginning of a new era.

It seems that after the introduction of GSHP, Korean painters were able to study various Chinese masters of both the Southern and Northern Schools of painting. It was definitely after the mid-seventeenth century, however, that the practice of doing paintings in imitation of certain masters (C. *fang biyi* 倣筆意) began to appear in Korea. This apparently was due to the introduction to Korea of *TSHP* and *Book of Poems with Complementary Paintings* (*Shiyu huapu* 詩餘畫譜; hereafter, *SYHP*), both published slightly later than *GSHP* and both reaching Korea sometime in the mid-seventeenth century. Unlike *GSHP*, many compositions in these two painting manuals are marked as "in imitation of 'so-and-so'." For example, the first illustration in *TSHP* of a five-character poem by the Tang emperor Taizong 太宗 (599-649) is labeled "After Xia Gui's brush idea" (*Fang Xia Gui biyi* 倣夏珪筆意; *Fig. 12*); the second illustration, "After Ma Hezhi 馬和之," and another illustration, this one of a poem on chrysanthemums by Chen Shuda 陳叔達 (act. ca. 573–635), is labeled "after Chen Daofu's 陳道復 [Chun 淳, 1484–1544] brush idea."

The percentage of illustrations in the manner of named masters in *SYHP* is much greater than in *TSHP*: 26 out of a total of 97 illustrations, or roughly 26 percent.[31] Most of the compositions in *TSHP* and *SYHP* marked "After so-and-so's brush idea" are directly based on those in *GSHP*.[32] In *GSHP*, none of the paintings are marked as being "After so-and-so's brush idea," but all 106 illustrations are allegedly based on works by earlier painters whose concise biographical information follows the painting itself. When these painting manuals or illustrated books reached Korea in the middle to late seventeenth century, Korean painters were able to learn the basics of Chinese paintings of the past and also to develop the practice of doing paintings after an individual master's brush manner.

From the late eighteenth century, Korean painters began to identify earlier Korean masters instead of Chinese ones as the models they were following. Although Kim Ŭnghwan 金應煥 (1742–1789) on his *Complete View of Mt. Kŭmgang* (*Kŭmgang jeon do* 金剛山全景) of 1772 (*Fig. 13*) simply wrote, "Painted in the manner of *Complete View of Mt. Kŭmgang*, he was unquestionably referring to Chŏng Sŏn's *Complete View of Mt. Kŭmgang* of 1734 (*Fig. 14*), or possibly another of the extant versions of this composition. One leaf of an eight-leaf album by Yun Chehong 尹濟弘 (1764–after 1840) is marked as "After Yi Nŭngho 李陵壺" (*Fig. 15*), referring to the scholar-painter Yi Insang 李麟祥 (sobriquet Nŭnghogwan 陵壺館; 1710–1760). Many more nineteenth-century paintings crediting a former Korean master as model can also be found.

From the late seventeenth to the late eighteenth century, Koreans eloquently expressed their independence from China in all aspects of culture, including painting. "True-view" landscape and genre painting of Korean life developed

31. In all, twenty-two out of 149 poems, or about fifteen percent of *TSHP* poem illustrations, were labeled as after the "brush idea" of old masters. Of the fifty illustrated five-syllable poems, twenty-one indicate as being "after so-and-so's brush idea," while only one out of forty-nine illustrations for six-syllable poems are indicated as so, and none of the fifty illustrations for seven-syllable poems.

32. For specific examples, see Song Hyegyŏng, pp. 50–51.

and flourished. Even in this age of distinctively Korean painting, however, Chinese literati painting continued to cast its shadow. The two paintings cited in the above paragraph are "true-view" landscapes, and yet their creators followed the Chinese literati tradition of painting in forming a previous master's brush idea.

Kang Sehwang, the critic and painter considered a master of "true-view" landscapes as well as literati painting, affords a fine example of Korean painters embracing the two seemingly conflicting ideals of "true-view" representation and literati brush styles. Kang composed *Clear Summer Day under a Paulownia Tree after Shen Shitian* (*Bang Sim Seokjeon byeok o cheong seo do* 倣沈石田碧梧清暑圖, referring to Shen Zhou 沈周, 1427–1509; *Fig. 16*), based on a model of the same title in *JZYHZ*.[33] Although Kang's painting differs slightly from the *JZYHZ* model, the dependence is considerable. Kang Sehwang also wrote the following colophon on Kang Hŭiŏn's 姜熙彦 (1738–1784) "true-view" landscape painting, *Mt. Inwang* (*Inwang san do* 仁王山圖):

> Painters of true-view landscapes always worry that their paintings might look like maps. This painting, however, successfully captures the resemblance [to real scenery] without sacrificing the [old] masters' methods.

The painting indeed contains many traditional Mi-style dots to render the earthen texture and to shape the areas of Mt. Inwang.

In his famous "true-view" painting, *Approach to Yŏngt'ongdong* (*Yŏngt'ongdong gu* 靈通洞口; *Fig. 17*), one leaf from his *Album of a Journey to Songdo* (*Songdo gi haeng cheob* 松都紀行帖), Kang Sehwang himself applied Mi-style dots profusely to create the effect of crevices in the mountain peaks behind the huge rocky boulders. The two above-mentioned paintings and colophon tellingly demonstrate that Kang, notwithstanding his commitment to the new "true-view" landscape manners, considered it most crucial in a painting to correctly observe the methods of the old masters. To him, the "old masters" meant Chinese masters.

Chŏng Sŏn provides yet another instance of contradiction in the styles he adopted for his "uniquely Korean" paintings. Although Chŏng created his own brush methods, such as "vertical texture strokes" (K: *sujikchun* 垂直皴) to represent the characteristic formations of the rocky peaks of Mt. Kŭmgang in his *Complete View of Mt. Kŭmgang* (see *Fig. 14*), he also adopted Mi-style dots to depict the soft turf of earthen peaks that surround the rocky peaks. In addition, Chŏng used a variation of "hemp-fiber texture strokes" (known as *liemacun* 裂麻皴 in Chinese), as noted by Kang Sehwang in his comparisons of "true-view" landscapes by Chŏng Sŏn and Sim Sajŏng.[34] To conclude, it seems that for eighteenth-century Korean landscape painters, Chinese literati brush conventions were considered adoptable for whatever purposes, whether true literati painting or "true-view" landscapes. The brush idioms associated with Chinese Southern School painting were no longer the monopoly of scholar-painters.

33. See *JZYHZ*, vol. 1. on *Landscapes*, section on "Compositions after various masters."

34. See *P'yoam Yugo*, p. 261. Kang Sehwang considered Chŏng's use of the hemp-fiber texture stroke confusing in the lack of resemblance to actual scenery.

By the late nineteenth century, there was renewed interest in returning to the original ideals and practices of Chinese literati painting. This was largely due to the dominant influence of Kim Chŏnghŭi 金正喜 (1786–1856), who insisted that literati painting should emit a "scholarly atmosphere" (sŏgwŏn-gi 書卷氣) and "literary fragrance" (muncha-hyang 文字香). His *Landscape* (*Fig. 18*), inscribed as "Done after a Yuan master's *Cold and Desolate Small Scene*" (*Bang Wonin hwanghan sogyeong* 倣元人荒寒小景; in the Sŏnmun 鮮文 University Museum), shows faithful adherence to Ni Zan's brush idioms.

During the nineteenth century, new groups of people began to participate in cultural life that had hitherto been an upper-class monopoly. *Chung'in* 中人 ("middle people"), comprising technical officials[35] as well as merchants, aspired to emulate the elite cultural life of the *yangban* 兩班 scholar-official class, forming poetry societies and doing painting and calligraphy for their own enjoyment. As a result, professional painters, scholar-painters, and "middle people" all practiced the styles associated with Southern School painting. Some officials, especially official interpreters, also had direct contact with the contemporary culture of Qing dynasty China by virtue of their trips to Yanjing.

Yim Hŭiji 林熙之 (1765–?), an interpreter of Chinese and a typical technical official, wrote the following on his *Orchid, Bamboo, and Rocks* (*Fig. 19*), now in the collection of the Art Museum of Korea University:

> The rocks of Yuanzhang [Mi Fu], the bamboo of Ziyu [Wang Huizhi 王徽之],[36] and the orchids of Zuoshi 左史 [Qu Yuan 屈原], I give these all to you in one morning. And what will you give me in return?
> 元章之石，子猷之竹，左史之蘭，一朝贈君，何以報之。

The painting, however, displays no signs of dependence on Chinese models; its dynamic composition, powerful brush strokes, and varying tones of ink all contribute to create for an original painting.

Chang Sŭng'ŏp 張承業 (1843–1897), a famous nineteenth-century professional painter, was said to have had no formal education either in painting or in the Classics. Nonetheless, he claimed to have painted almost exclusively in various Chinese masters' styles.[37] However, close comparison of Chang's paintings with those of the Chinese masters whom he purportedly emulated reveals that Chang's versions of their styles are at best inconsistent. Such a discrepancy is not limited to Chang Sŭng'ŏp. Another renowned professional painter of the last days of the Chosŏn dynasty, An Chungsik 安中植 (1861–1919), wrote that he painted *Autumn Feelings among Streams and Mountains* (*Gyesan*

35. "Technical official" is a translation of the Korean term *kisulgwan* 技術官 as used by high ranking civil officials. It refers to those middle ranking officials who passed the miscellaneous division of the government examination called *chapkwa* 雜科. Such technocrats specialized in such fields as the interpretation of foreign languages, medicine, law, geomancy, arithmetic and astronomy.

36. The following anecdote established Wang Huizhi (d. 388) as initiator of a cult concerning bamboo (as exemplar of the perfected gentleman). Wang ordered his servants to plant bamboo around his temporary residence. When asked why he bothered to plant bamboo there, he answered with a laugh, "How can I live even one day without this gentleman (*junzi* 君子 [i.e., bamboo])?"

37. See Yi Sŏng-mi, "Chang Sŭngŏp hoehwa wa Chungguk hoehwa (Chinese Painting and Paintings of Chang Sŭngŏp)," in *Chŏngsin Munhwa Yŏn'gu* (*Korean Studies Quarterly*), vol. 83 (Summer 2001), p. 30, chart 1, for a list of Chang's paintings done in the styles of various Chinese masters.

Yi Sŏng-mi

chǔyi 溪山秋意), now in the Seoul National University Museum (*Fig. 20*), in the "general [brush] idea of Huang Dachi (Gongwang; *Ŭi Huang Daechi dae ŭi* 擬黃大癡大意)." The painting, however, more closely resembles the works of Ni Zan than Huang Gongwang. Specifically, the painting is a combination of the two Ni Zan compositions illustrated in *TSHP* and *JZYHZ,* both of which are marked as "after Yunlin 雲林," that is, Ni Zan.

Conclusion

Korean scholar-painters since the Koryŏ dynasty and even through the late Chosŏn period mostly subscribed to the lofty ideals of literati painting formulated by Northern Song literati painters and tried to assimilate various styles and brush idioms developed in China. Inevitably, however, both the ideals and the practices altered in their transmission from one culture to the other. The early Chosŏn ruling class, seeking to impose a strict Neo-Confucian morality of duty, condemned painting as a "pleasure-seeking" activity, an attitude which naturally cramped the development of literati painting. Scholar-painters hesitated to let their talent be known, sometimes hiding or even destroying their paintings. This tendency was by no means unique to Korea, but it seems to have been more prevalent there than elsewhere in East Asia.

Periodically, renewed contacts with Chinese literati culture, and the influx of Chinese books and paintings into Korea, significantly influenced the development of literati painting in the Chosŏn period. So overwhelmingly popular did Southern School painting styles become among literati and professional painters that even the painters of "true-view" landscapes, the most Korean of all genres of painting, freely adopted certain literati brush conventions, such as Mi-dots or hemp-fiber texture strokes. Often, professional painters simply adopted certain techniques normally associated with literati painting without understanding the history and ideals behind them. The resulting paintings, supposedly "after the style of" a certain Chinese master, tend to reveal this failure to understand.

Further complicating the history of literati painting in the later Chosŏn period are changes in society, especially the movement of the "middle people" class (technical officials and merchants) into the world of high culture hitherto reserved for the *yangban* scholar-official class. Some officials, especially interpreters, being far more versed than professional painters in the Chinese Classics, therefore came to understand much better the world of literati painting. All of the above conditions came to operate on and mold late nineteenth-century Korean literati painting.

理想的對立—
韓國文人畫中觀念的變化

李成美

韓國精神文化研究所榮譽教授

　　韓國文人畫自高麗時期便與中國文人畫有極密切的關係。本文透過檢視文字證據及現存畫作，探索韓國自高麗時代到朝鮮時代，對文人畫概念與瞭解的轉變。

　　高麗及朝鮮時期的韓國文人畫家，大多認同北宋文人畫家形塑出的文人畫清高的理想，而且試著模仿中國發展出的各種風格與筆墨語彙。無論是理想或是操作方式無疑會在文化傳播的過程中受到改變。早期朝鮮統治階級試著強加嚴刻的理學道德責任，將繪畫貶為尋歡的活動。這種態度必然阻礙了文人畫的發展。文人畫家們猶豫著是否要顯現才能，有時他們隱藏甚至毀棄自己的畫作。這種傾向無疑是韓國獨有的，但在韓國境內卻是非常普遍的現象。

　　由於經常與中國文人文化保持接觸，當十七世紀初期中國畫譜湧入時，便大大地影響了朝鮮文人畫的發展。許多十七世紀以後的朝鮮繪畫顯示出對中國畫譜構圖的依賴。職業畫家經常單純地取用某些原與文人畫有關的技巧，而不問其背後的歷史與理想。最後由畫作被歸為仿某位中國畫家風格的假定中，很容易看出理解上的失敗。

　　另外社會轉型更加複雜化朝鮮時代後期文人畫的歷史，特別是中人－官員與商人－朝原本一直專屬於上層階級世界移動的狀況。部分官員，特別是翻譯人員，比起專業畫家更精通中國古典文化，因此對文人畫的世界也有更佳的掌握。以上所有狀況似乎都對十九世紀晚期韓國的文人畫有所影響。

葛藤する理想—
韓国文人画の概念の変化

李成美

韓国精神文化研究所名誉教授

　高麗期以降、韓国の文人画は、中国の文人画との密接な関係のうちに発展した。本論では、文献証拠と現存する絵画の検証を通して、高麗期から朝鮮後期に至る韓国の文人画の概念と理解の変遷を考察する。

　高麗・朝鮮王朝期の韓国学究画家達は、北宋の文人画家の公式化した文人画の崇高な理想を支持し、中国で発展した様々な様式や筆法を吸収しようと努めた。だが、必然的に、ある文化から他の文化への伝達を通して、理想も実践も変容することになる。朝鮮初期の支配者階級は、義務の道徳観に基づく厳格な新儒学を課し、絵画を「快楽を求める」活動として批判した。こうした態度は当然ながら文人画の発展を妨げた。学究画家は自分の才能を公表するのをためらい、しばしば自らが描いた絵画を隠し、破棄した。この傾向は決して韓国だけのものではなかったが、他国よりも大きな広がりを見せたようだ。

　定期的に更新される中国文人文化との接触、17世紀前半からの中国絵画教本の流入が、朝鮮の文人画の発達に重要な影響を与えた。17世紀以後の多くの朝鮮絵画も中国の絵画教本の構図を手本にしている。しばしば職業画家は、背後にある歴史や理想を理解することなく、文人画の技法を採用した。ある中国の大家の「様式に倣って」という形で描かれた絵画は、そうした理解不足を露呈するものだった。

　朝鮮後期の文人画の歴史をさらに複雑にしたのは社会変化、特に、技術官吏や商人といった「中人」が、それまでは上流階級の独占していた高尚な文化の世界へと流入してきたことだった。そうした官吏、特に通訳の中には、職業画家よりもはるかに中国の古典に精通しており、それゆえ、はるかに文人画の世界を理解していた者もいた。このような状況すべてが19世紀後半の韓国文人画に影響を及ぼしたと考えられる。

Fig. 1. Kang Hŭian (1418–1465). *Scholar Gazing at a Waterfall*. Album leaf, ink on paper, 23.4 × 15.7 cm. National Museum of Korea. *(detail on page 287)*

Yi Sŏng-mi

Fig. 2. King Chŏngjo (r. 1776–1800). *Plantain.* Hanging scroll, ink and light color on paper, 84.6 × 51.5 cm. Tongguk University Museum, Seoul.

Fig. 3. Cho Yŏngsŏk (1686–1761). *Women Sewing*, detail. Album leaf from *The Deer's Navel*, ink and light color on paper, 27 × 22.5 cm. Private collection.

Fig. 4. Yun Tusŏ (1668–1715). *Landscape*. Album leaf, 16.8 × 16.0 cm. Yun Tusŏ Memorial Museum, Haenam, South Chŏlla Province.

Fig. 5. Landscape in the Style of Ni Zan. Page from *Master Gu's Painting Compendium*.

Yi Sŏng-mi

Fig. 6. Cho Sok (1595–1668). *Gathering Mist in a Village by a Lake*. Album leaf, ink and light color on paper, 38.5 × 27.6 cm. Kansong Art Museum, Seoul.

Section III: Literati Painting 305

傲高克恭筆意

Fig. 7. Page from the *Tang Poetry and Painting Compendium*, entitled *After Gao Kegong's Brush Idea*.

Yi Sŏng-mi

Fig. 8. Chŏng Sŏn (1676–1759). *Squirrel.* Album leaf, ink and light color on paper, 16.3 × 16.0 cm. Seoul National University Museum.

Fig. 9. Tao Cheng (act. ca. 1480–ca. 1532). *Squirrel.* Page from *Master Gu's Painting Compendium.*

Fig. 10. Sim Sajŏng (1707–1769). *Overnight on the Riverboat.* Dated 1734. Hanging scroll, ink on silk, 153.2 × 61.0 cm. National Museum of Korea.

Fig. 11. Page from *Mustard Seed Garden Painting Manual* (1679, 1701) on Huang Gongwang's and Ni Zan's method of painting trees.

Yi Sŏng-mi

Fig. 12. Illustration of Tang Taizong's poem, *After Xia Gui's brush idea.* Page from *Tang Poetry and Painting Compendium.*

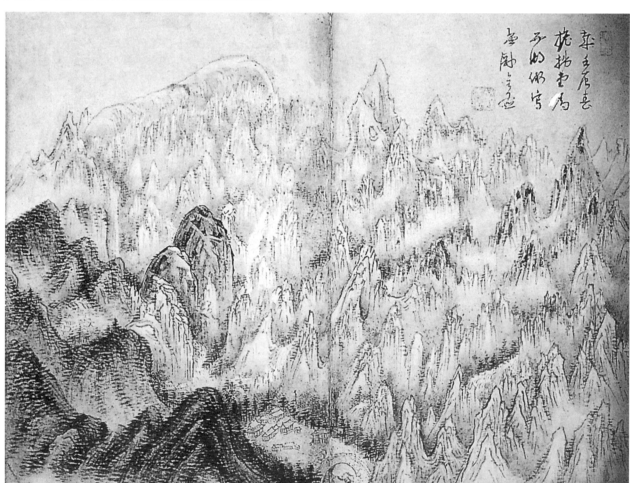

Fig. 13. Kim Ŭnghwan (1742–1789). *Complete View of Mt. Kŭmgang,* dated 1772. Album leaf, ink and light color on paper, 22.3 × 35.2 cm. Pak Chuhwan collection, Seoul.

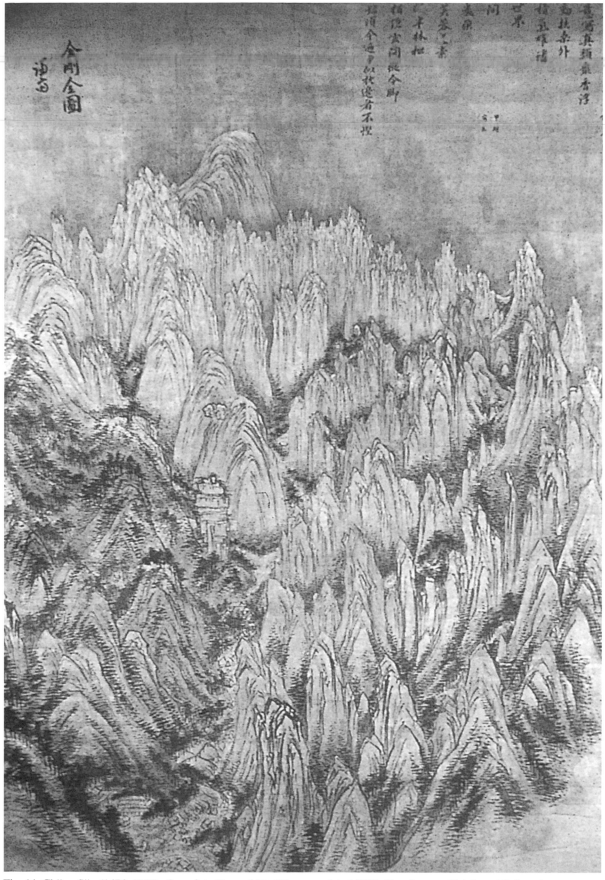

Fig. 14. Chŏng Sŏn (1676–1759). *Complete View of Mt. Kŭmgang*, dated 1734. Hanging scroll, ink and light color on paper, 130.6 × 94.1 cm. Ho-am Art Museum, Yong'in.

Yi Sŏng-mi

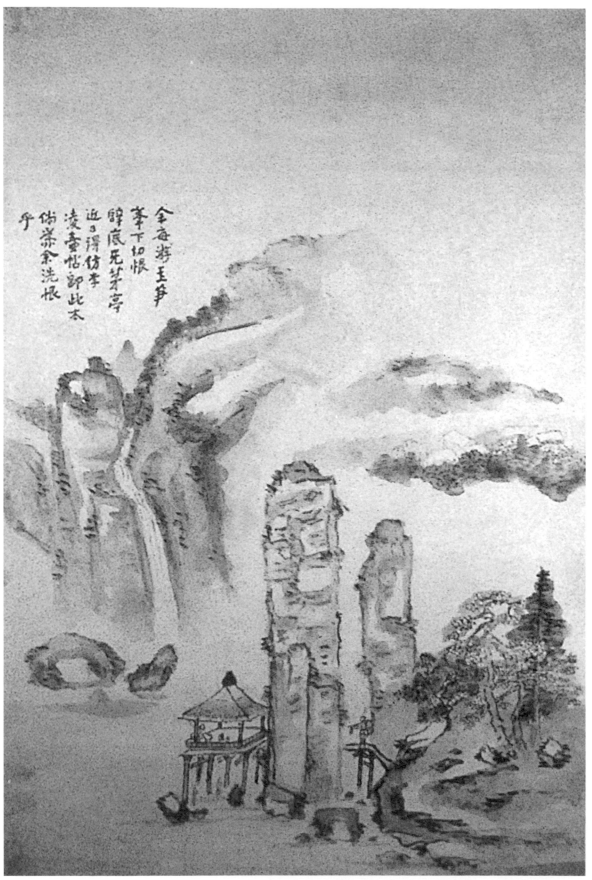

Fig. 15. Yun Chehong (1764–after 1840). *Jade Bamboo Shoot Peak*. Marked as "painted in the manner of Yi Nŭngho," i.e., Yi Insang. Hanging scroll, ink on paper, 67.0 × 45.5 cm. Ho-am Art Museum, Yong'in.

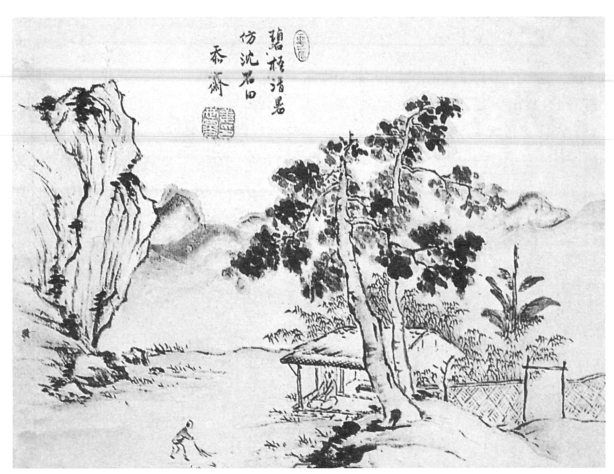

Fig. 16. Kang Se-hwang (1713–1791). *Clear Summer Day under a Paulownia Tree after Shen Shitian*. Album leaf, ink and light color on paper, 30.5 × 35.8 cm. Private collection.

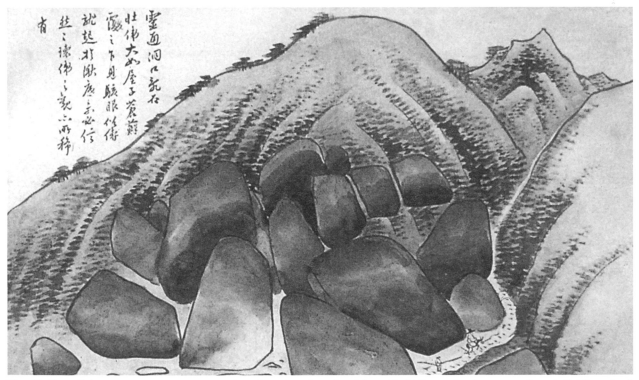

Fig. 17. Kang Sehwang (1713–1791). *Approach to Yŏngt'ongdong*. Leaf from his "Album of a Journey to Songdo." Album leaf, ink and light color on paper, 32.8 × 54.0 cm. National Museum of Korea.

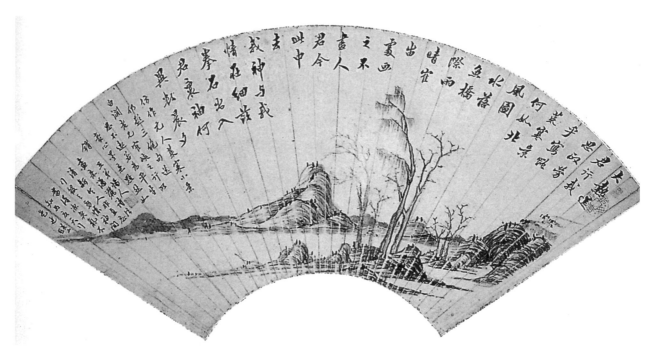

Fig. 18. Kim Chŏnghŭi (1786–1856). *Landscape*. Marked as "after a Yuan Master's *Cold and Desolate Small Scene*." Fan, ink on paper, 13.3 × 61.0 cm. Sŏnmun University Museum.

Fig. 19. Yim Hŭiji (1765–?). *Orchid, Bamboo, and Rocks*. Hanging scroll, ink on paper, 87.0 × 42.3 cm. Korea University Art Museum.

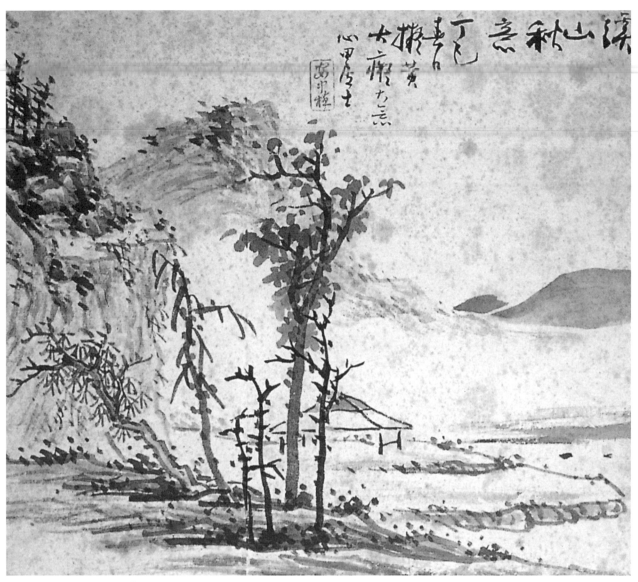

Fig. 20. An Chungsik (1861–1919). *Autumn Feelings among Streams and Mountains*, dated 1917. Album leaf, ink on paper, 25.8 × 28.3 cm. Seoul National University Museum.

Yi Sŏng-mi

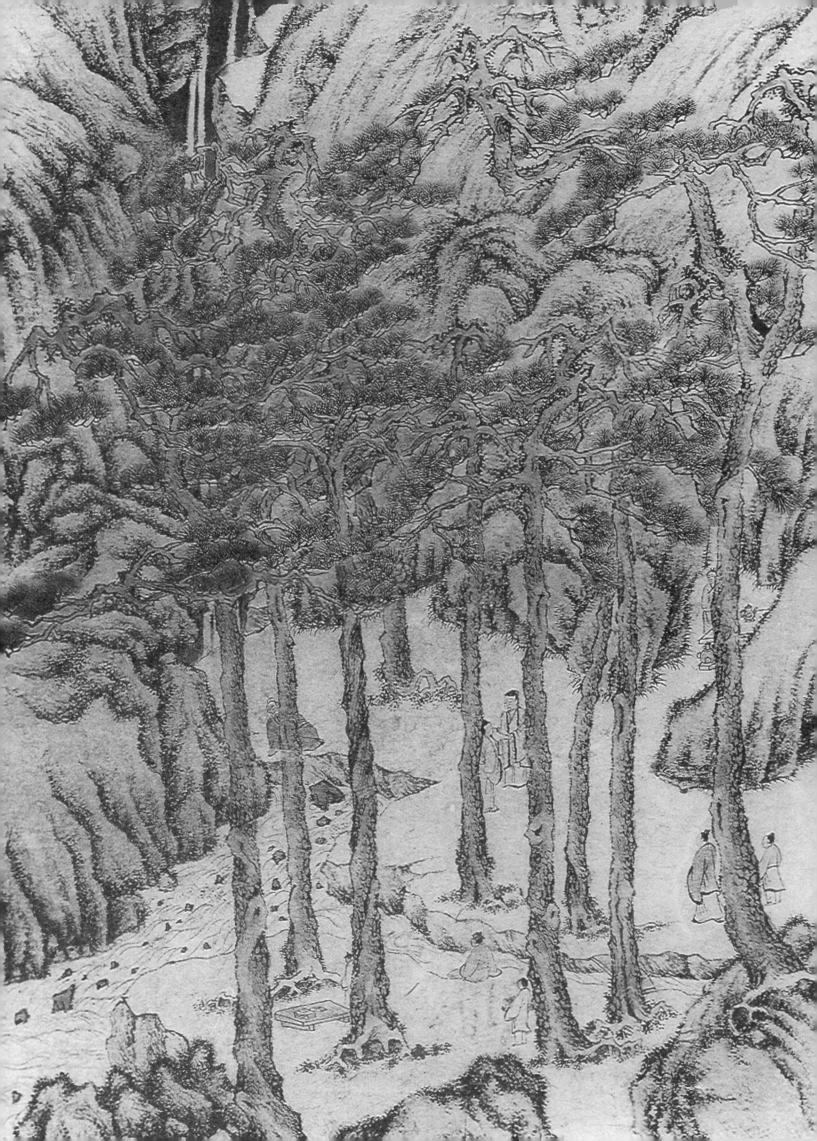

Commodity and Context:
The Work of Wen Zhengming in the Late Ming Art Market

Craig Clunas

University of Oxford

Pictures, although they are images, are at the same time things. They have a material presence and form part of a wider world of material culture, even if customarily assigned to more delimited and highly valued categories as "painting" or "art." Since the work of R. H. van Gulik nearly fifty years ago,[1] relatively little study has been devoted to the Chinese painting as a physical object, although recent years have seen a growing interest in it as an object of consumption. This essay looks at the "social life" of works of painting and calligraphy in Ming China, principally those of Wen Zhengming 文徵明 (1470–1559), and at ways in which consideration of that life can disclose how these very distinctive types of things functioned as indexes of the social personae of their creators and owners.

Common sense dictates that people and things are two different categories. This is so, as much in a common sense grounded on the Confucian idea of the "humane," with its dictum that "The superior man is not a utensil (*junzi bu qi* 君子不器)," as it is in a Western common sense grounded on Aristotelian concepts. However, some recent anthropological theory would question both of these two local "common senses," by drawing attention to contexts in which things behave "as if," or are treated by others as if, they were *not* inanimate matter but were instead active in their own right. One of these theories is the concept of "the social life of things," associated principally with Arjun Appadurai and Igor Kopytoff, and expressed in a book of that title published in 1986.[2] Appadurai asserts that "in many historical societies, things have not been so divorced from the capacity of persons to act and the power of words to communicate. . . ."[3] His collaborator Igor Kopytoff advances slavery as one extreme but by no means uncommon historical case in which people are made to behave as things.[4] At the end of this essay, I shall return to a more complex proposition regarding people in the role of things, if of a special kind. My present concern, however, is the ways in which things behave like people, and in which one class of objects—calligraphy and painting in scroll form—behaved in the complex, socially diverse, and highly commoditized society of mid- and late-Ming China.

1. R. H. van Gulik, *Chinese Pictorial Art as Viewed by the Connoisseur* (Rome: Instituto Italiano per il Medio ed Estremo Oriente, 1958).

2. Arjun Appadurai, ed., *The Social Life of Things: Commodities in Cultural Perspective* (Cambridge: Cambridge University Press, 1986).

3. Arjun Appadurai, "Introduction: Commodities and the Politics of Value," in Appadurai, *The Social Life of Things*, pp. 3–63 (p. 4).

4. Igor Koptyoff, "The Cultural Biography of Things: Commodization as Process," in Appadurai, *The Social Life of Things*, pp. 64–91 (p. 64).

I draw here also on the work of another anthropologist, Alfred Gell, whose *Art and Agency* explores the ways in which a truly anthropological theory of art would be one which "considers art objects as persons."[5] Gell demands a reorientation away from what objects "mean" to what they "do," and his conscious "methodological philistinism" will not be to every taste. Art history may nevertheless gain insights from his rigorous direction of attention to agency, particularly in a context, like that of Ming China, where so many surviving works either actually or potentially functioned as part of gift exchange between members of the elite.[6]

This methodological shift is perhaps made more palatable by Gell's "exclusively relational" concept of agency.[7] That concept fits well with recent work on selfhood and agency in Confucian thought, such as the statement that "male and female, Confucian subjects always appeared as part of something else, defined not by essence but by context, marked by interdependency and reciprocal obligation rather than by autonomy and contradiction."[8] Similarly for David Hall and Roger Ames, the self in Chinese constructions is a unique place, but this uniqueness is "immanent and embedded within a ceaseless process of social, cultural and natural changes."[9] Context is all.

Counter to Western notions of passive matter worked on by an active human or divine creator, the active agency of *things* is an idea widespread in Chinese painting theory. To take just one example, when Wang Lü 王履 (ca. 1332– ca. 1395) writes that "I take my heart-mind to be my teacher. It takes as its master my eyes, which in turn revere Mount Hua as their teacher (*Wu shi xin, xin shi mu, mu shi Huashan* 吾師心，心師目，目師華山)," he is acknowledging the agency of Mount Hua in the creation of its own pictorial image—the mountain is ultimately responsible for the painting of itself.[10] Elsewhere the Western obsession with the "hand" of the artist is replaced by a more dispersed idea of agency, in which the brush is credited as the all-important possessor of method (*bi fa* 筆法) or of force (*bi li* 筆力).

What, in Ming terms, do calligraphy or pictures, as indexes of the agency of the brush, actually do? Clearly one of the things they do most easily is move between people, and in so doing they both "presence" those people (they do not "re-present" them, an idea too indebted to its Platonic roots to be helpful in the Chinese context) and at the same time they make (*not* "reflect") all sorts of connections between them. Much of Ming connoisseurial theory is

5. Alfred Gell, *Art and Agency: An Anthropological Theory* (Oxford: Oxford University Press, 1998), p. 9.

6. This forms the major theme of Craig Clunas, *Elegant Debts: The Social Art of Wen Zhengming, 1470–1559* (London: Reaktion Books, 2004).

7. Gell, *Art and Agency*, p. 22.

8. Tani Barlow, "Introduction," in Tani Barlow and Gary Bjorge, eds., *I Myself Am a Woman: Selected Writings of Ding Ling* (Boston: Beacon Press, 1989), cited in Mayfair Mei-hui Yang, *Gifts, Favors, and Banquets: The Art of Social Relationships in China* (Ithaca and London: Cornell University Press, 1994), p. 44. See also the introduction to Angela Zito and Tani Barlow, eds., *Body, Subject and Power in China* (Chicago: University of Chicago Press, 1994).

9. David L. Hall and Roger T. Ames, *Thinking from the Han: Self, Truth and Transcendence in Chinese and Western Culture* (Albany: State University of New York Press, 1998), p. 27.

10. Kathlyn Liscomb, *Learning from Mt. Hua: A Chinese Physician's Illustrated Travel Record and Painting Theory*, Res Monographs on Anthropology and Aesthetics (Cambridge: Cambridge University Press, 1993), p. 62.

predicated on the idea of the presence of the maker in the work, of the piece of calligraphy or painting as the "true trace (*zhen ji* 眞跡)" of that maker, and of brushwork as a visible presencing of that person across place and time. Works of calligraphy and painting here operate in a realm of what has been called "fractal personhood," in which "any individual person is 'multiple' in the sense of being the precipitate of a multitude of genealogical relationships, each of which is instantiated in his/her person;" this is an idea designed "to overcome the typically 'Western' opposition between individual (ego) and society, parts and wholes, singular and plural. . . ."[11] This seems to me a helpful concept in dealing with works of art that were almost all produced for specific occasions, that are highly mobile and not permanently visible, and that are the material remains of relationships which are necessarily social—hence the notion of the *shen hui* 神會, or "spiritual meeting," which the viewer of a work can have with its maker even after that maker's bodily demise.[12] Thus, when Wen Zhengming viewed a picture by his teacher Shen Zhou 沈周 (1427–1509), he was moved to write on it:

> The master has departed this life, and I am old and withered; in truth the years cannot be stayed for, but the place where he lodged his spirit is still here. Surely this encounter with it was predestined![13]
> 先生去世，余亦老朽，信乎年不可待，而寄意者尤存；然會偶豈非前定歟。

It is not some disinterested aesthetic force within the work which compels a response, but rather it is the work as index of Shen Zhou's bodily presence which is understood as the active agent in generating overpowering emotion. Yet this agency is relational, since it only operates if someone is there to see it. It is not some essence of Shen Zhou which is constantly present in the scroll, even when rolled up.

In his writings, Wen Zhengming gives plenty of evidence for things in motion, and for the different ways in which they might pass from one owner to another. Gift-giving was one of the most widespread of these. Despite a certain delicacy in speaking about such matters, Wen also includes occasional allusions to what Appadurai would call the three aspects of "commodity-hood": "commodity candidacy" (calligraphy and painting could be commodities), "commodity phase" (they could move in and out of a market situation), and "commodity context," defined as "the variety of social arenas, within or between cultural units, that help link the commodity candidacy of a thing to the commodity phase of its career."[14] The history of the art market in China, one important commodity context, is as yet a relatively under-researched field, perhaps surprisingly since it developed so early.[15] There is nothing to match the

11. Gell, *Art and Agency*, p. 140.

12. Richard Vinograd, "Private Art and Public Knowledge in Later Chinese Painting," in *Images of Memory: On Remembering and Representation*, ed. Susanne Küchler and Walter Mellon (London and Washington: Smithsonian Institution Press, 1991), pp. 176–202 (p. 184).

13. Wen Zhengming, *Wen Zhengming ji* (*Collected Works of Wen Zhengming*), ed. Zhou Daozhen, 2 vols. (Shanghai: Shanghai guji chubanshe, 1987), vol. 2, p. 1374.

14. Appadurai, *The Social Life of Things*, p. 15.

15. Work is, however, beginning in this neglected field. See, for instance, Ankeney Weitz, "Notes on the Early Yuan Antique Art Market in Hangzhou," *Ars Orientalis*, vol. 27 (1997), pp. 27–38; and Craig Clunas, *Superfluous Things: Material Culture and Social Status in Early Modern China* (Cambridge: Polity Press, 1991), pp. 116–40.

Craig Clunas

collections of essays about art markets in early modern Europe, often collaborative studies between economic and art historians.[16] The sources Europeanists have at their disposal direct the enquiry in very different ways from that which is possible for China, which has in compensation a denser texture of "biography" around individual surviving objects. These biographies are inscribed both on the surfaces of objects themselves and also in the writings of those who, like Wen Zhengming, were the social agents whose identities were bound up with the objects-in-motion they produced, circulated, and consumed.

As well as the abundant evidence for the social life of Wen Zhengming's works of calligraphy and painting during his own lifetime, there survive from later in the Ming a number of pieces of textual and material evidence for the ways in which his "fractal personhood" was dispersed through elite culture by the circulation of these same works in the art market. One of the richest of these sources is the *Diary from the Water Tasting Studio* (*Weishuixuan riji* 味水軒日記) of Li Rihua 李日華 (1565–1635).[17] This is a detailed account of Li's life from 1609 to 1616, when he was living in retirement in his native city of Jiaxing 嘉興. It is a useful (and entertaining) source on the lifestyle of the Ming elite, including those aspects ignored in more formal literary genres. Although the *Diary from the Water Tasting Studio* hardly qualifies as unmediated "raw data," it does seem to have undergone relatively little in the way of editing and polishing. It details the social round of funerals, visits to the inauguration of a new piece of Buddhist sculpture, birthdays, parties in studios, and parties on boats. It mentions presents received from a stream of disciples, and the paintings (mostly fans) which Li did for them in return. Of constant concern are the weather and his health (eye trouble and earache are continual presences). Prominent in the diary are the operations of the art market, and in particular the procession of dealers who visited Li with works to sell or pawn, or simply for his authentication.[18] Quantities of bronzes, jades, inkstones, and ceramics are noted, often in great detail, in addition to calligraphy and painting. Some of these are works of great antiquity, others are more recent.[19] Extremely numerous among the latter are works by or purportedly by Wen Zhengming.

Li Rihua did not admire Wen's works without reservation. He omits Wen from the short list of those whom he credits with a loose and sketchy style that reached the level of the "marvelous (*miao* 妙)."[20] Li was closely associated

16. See, for example, Michael North and David Ormrod, eds., *Art Markets in Europe, 1400–1800* (Aidershot: Ashgate Press, 1998), or Neil De Marchi and Craufurd D. W. Goodwin, eds., *Economic Engagements with Art* (Durham and London: Duke University Press, 1999).

17. On Li's life, see *Dictionary of Ming Biography*, ed. L. Carrington Goodrich and Chaoying Fang, 2 vols. (New York and London: Columbia University Press, 1976), vol. 1, pp. 826–30.

18. Craig Clunas, "The Art Market in 17th-century China: The Evidence of the Li Rihua Diary," in *History of Art and History of Ideas*, 1 (2003), pp. 201–24.

19. For Li's views on "ancient" paintings, see Craig Clunas, "Images of High Antiquity: The Prehistory of Art in Ming Dynasty China," in *Die Gegenwart des Altertums: Formen und Funktionen des Altertumsbezugs in den Hochkulturen der Alten Welt*, ed. Dieter Kuhn and Helga Stahl (Heidelberg: Edition Forum, 2001), pp. 481–91 (p. 485).

20. Li Rihua, *Weishuixian riji*, Song Ming Qing xiaopin wenji jizhu (Annotated compilation of essays and literary collections of the Song, Ming, and Qing) (Shanghai: Shanghai Yuandong chubanshe, 1995), p. 224 [Wanli 萬曆 40th year / 3rd month / 4th

with the circle of Dong Qichang 董其昌 (1555–1636), and with the Songjiang 松江 school, for whom Wen might be a revered old master, but one who was safely a part of history, not a living presence or a guide to current practice. Wen Zhengming was there to be surpassed, and to be praised up to a point so that surpassing him might be the greater achievement.[21] It is significant that Wen Zhengming figures much less prominently in the three collections of Li's edited "brush notes" (*bi ji* 筆記), *Brush Notes from the Six Inkstones Studio* (*Liuyanzhai biji* 六研齋筆記), than in the earlier diary. In the "brush notes" we find colophons by Wen,[22] plus transcriptions of poems about him, and an anecdote about the birth of his son.[23] However, there is nothing like the flood of references to dealers bringing Wen's works for Li to assess, suggesting that Wen's pervasive presence in the diary reflects not so much Li's particular taste for this artist, as the simple fact that works attributed to him were circulating in great quantities. Not all, of course, were what they purported to be. In 1613 Li writes:

> Dealer Xia came with a fake version of Wen Zhengzhong's [Zhengming] *Picture of Preserving Chrysanthemums*, very proud of himself. I said nothing for a long time, then slowly produced the real one from my collection for inspection, at which the dealer fled without ado. With the real one present, he was panicked to death! How laughable. (I bought this scroll some twenty years ago.)
> 夏賈以文徵仲存菊圖僞本來。意態甚驕。余不語。久之。徐出所藏眞本併觀。賈不覺斂避。所謂眞書在側。慚惶殺人者耶。可笑。

He then quotes the inscription on the version that he owned, concluding that this is "a fine work of Hengshan's [Wen Zhengming] youth, not the kind of thing a hack could successfully imitate (乃衡山少年精工之作，斷非凡子所能效抵掌也)."[24] As Xu Bangda 徐邦達 points out, discrepancies between the inscription quoted by Li and that on the *Picture of Preserving Chrysanthemums* now in the Palace Museum prove that the latter scroll (itself highly problematic) and that seen by Li Rihua cannot be the same object.[25] There were therefore at least two and probably several more versions of this composition in circulation. The original was produced by Wen under specific circumstances for a particular individual, the doctor Wang Wen 王聞, cousin of his pupil Wang Guxiang 王穀祥 (1501–

day]. In Li's opinion, only Shen Zhou and Chen Chun had attained that pinnacle.

21. Wai-kam Ho and Dawn Ho Delbanco, "Tung Ch'i-ch'ang and the Transcendance of History and Art," in *The Century of Tung Ch'i-ch'ang, 1555–1636*, ed. Wai-kam Ho and Judith G. Smith, 2 vols. (Seattle and London: The Nelson-Atkins Museum of Art and the University of Washington Press, 1992), vol. 1, pp. 2–41 (pp. 17–18); Xu Bangda, "Tung Ch'i-ch'ang's Calligraphy," in *ibid.*, pp. 104–32 (p. 107). For a list of Dong Qichang colophons on Wen works, see Shi-yee Liu Fiedler, "Dong Qichang shuhua jianzang tiba nianbiao (Chronology of Dong Qichang Colophons on Painting and Calligraphy in his Collection)," in *The Century of Tung Ch'i-ch'ang, 1555–1636*, vol. 2, pp. 487–575 (p. 559).

22. Li Rihua, *Liuyanzhai biji*, four *juan* 卷, preface dated to 1627 (contemporary [?] woodblock ed. in SOAS Library), *juan* 1, pp. 39a–43a. This text is also transcribed in Wen Zhengming, *Wen Zhengming ji*, vol. 2, pp. 1387–8.

23. Li Rihua, *Liuyanzhai biji*, *juan* 3, pp. 8b–9b; Li Rihua, *Liuyanzhai erbi* (*Second of notes from the Six Inkstones Studio*), 4 *juan*, preface dated to 1630 (contemporary [?] woodblock ed. in the SOAS Library), *juan* 2, p. 1a. On this text, see Hin-cheung Lovell, *An Annotated Bibliography of Chinese Painting Catalogues and Related Texts*, Michigan Papers in Chinese Studies no. 16 (Ann Arbor: Center for Chinese Studies, The University of Michigan, 1973), pp. 27–28.

24. Li Rihua, *Weishuixuan riji*, p. 417 [Wanli 42/10/18].

25. Xu Bangda, *Gu shuhua wei'e kaobian* (*Studies in Authenticating Fakes in Ancient Painting and Calligraphy*), 4 vols. (Nanjing: Jiangsu guji chubanshe, 1984), *xia* 下 *juan*, text portion, vol. 2, pp. 126–127.

1568). The inscription on *Picture of Preserving the Chrysanthemums*, a portrait-image incorporating allusions to the subject's *biehao* 別號, or self-chosen sobriquet, is dated to 1508 and states that the picture was done for Wang in the same year.[26] The *biehao* name Cunju ("Preserving Chrysanthemums") had specific family connotations, of which Wen was aware at the time of making the image. The subject, however, held broader cultural resonances which made it very marketable even when (or especially when) divorced from its original context. Every educated or even semi-educated person would associate chrysanthemums with the poet Tao Qian 陶潛 (Yuanming 淵明; 365–427) and thence with the ideal of retirement from office to a life of cultivated leisure.[27] A work that bore the powerful double imprint of two cultural icons, namely Tao Qian and Wen Zhengming, was going to command a wide audience and a high price. This dramatizes in its starkest form the transformation which Wen Zhengming's works underwent after his death—originating as media of obligated and situated transactions, they became objects which floated free of their circumstances of production, to be redefined above all as "works by Wen Zhengming." Wen was well on his way to becoming a famous artist, a process in which the art market was central.

Li Rihua's diary illustrates this by giving us a picture of what was circulating under Wen's name in the art market some fifty years after his death. A typical diary entry reads in its entirety: "Dealer Xia brought Wen Hengshan's *Ancient Trees and Cold Stream* for me to look at, its old trunks and frosted roots particularly rich in vitality (*shengqi*) (夏賈持文衡山古木寒泉圖來，作老幹霜根，甚有生氣)."[28] Certainly Wen's is the most frequently encountered name of any artist in the text. Whether these works were genuine or fake matters less for our purposes than the sheer number mentioned, although Li himself was very conscious of fakery. On a visit to Suzhou in the summer of 1615 he commented, "Met with Master Dai and looked at his painting and calligraphy. Lots of miscellaneous Wen and Shen (Zhou), but all fakes and not worth looking at (遇戴生者邀看書畫。多文沈雜蹟，但贋物不足屬目)."[29] However, the twenty pieces of calligraphy and fifty-six pictures by Wen (plus twelve works by others with Wen colophons) that he saw in other hands and considered to be genuine far outnumbered the fakes (of course, this tells us nothing about their actual status).

Of the fifty-six pictures, thirty-three were definitely in their commodity phase when Li Rihua saw them, many in the hands of dealers whom he names. Not all of these dealers were in Suzhou. Thirteen were shown to him by

26. For a masterly handling of the connoisseurship problems surrounding the *Cunju tu*, see Xu Bangda, *Gu shuhua wei'e kaobian*, vol. 2, pp. 125–127, and also Liu Jiuan, "Wumen huajia zhi biehaotu jianding juli (Examples of Authenticating *Biehao* Pictures of Wu School Painters)," in *Wumen hua pai yanjiu* (*Research on the Wu School of Painting*), ed. Gugong bowuyuan (Beijing: Zijincheng chubanshe, 1993), pp. 35–46 (p. 44). The 1537 scroll is in Liu Jiuan, *Song Yuan Ming Qing shuhuajia chuanshi zuopin nianbiao* (*Chronology of Surviving Works by Sung, Yuan, Ming, and Qing Painters and Calligraphers*) (Shanghai: Shanghai shuhua chubanshe, 1997), p. 197.

27. Susan E. Nelson, "Revisiting the Eastern Fence: Tao Qian's Chrysanthemums," *Art Bulletin*, vol. 83.3 (2001), pp. 437–60.

28. Li Rihua, *Weishuixuan riji*, p. 7 [Wanli 37/1/14].

29. *Ibid.*, p. 454 [Wanli 43/4/11]. For other references to Wen Zhengming fakes, see *ibid.*, p. 187 [Wanli 39/8/18]; p. 237 [Wanli 40/6/2]; and p. 340 [Wanli 41/9/10]. Master Dai is the Suzhou-based dealer Dai Zhibin 戴稚賓.

"Dealer Xia (Xia gu 夏賈)," his main source for works of art and who significantly seems never to have dealt in works of calligraphy.[30] In addition to him and to Master Dai, those offering Li works by Wen included "Dealer Xu 許" and "Dealer Gao 高,"[31] the Suzhou dealer Zhang Tiren 張體仁,[32] and a certain Shen Cuishui 沈翠水.[33] In 1612 the Hangzhou dealers Pan Qintai 潘琴臺 and Wu Qingyun 吳卿雲 came to see him with a number of items, including a version of the *Record of the Garden of the Artless Official* (*Zhuozheng yuan ji* 拙政園記) and also poems composed and written by Wen in fine standard script.[34] In the same year Fang Qiaoyi 方樵逸 and Wu Yazhu 吳雅竹 came by, with a piece of Wen calligraphy among their stock.[35] After Dealer Xia, the most frequently encountered dealer in Wen Zhengming works is a certain Hu Yazhu 胡雅竹, who may be the same person as Wu Yazhu. This Hu (or Wu) Yazhu is seen acting in 1614 as a broker, bringing someone from Changshu 常熟 who wants to sell Li Rihua some pictures, including a Shen Zhou with a Wen Zhengming colophon.[36] In the same year he brought on his own account a Tang Yin 唐寅 (1470–1523) work, again with a Wen inscription, and early the following year he had a collection of calligraphy to pawn, writings by "the famous hands of Suzhou."[37] In 1615 he came out with an album of pictures for authentication, of which Li notes, "the only fine one was a Wen Zhengzhong *Waiting for the Ferry at a River in Spring*, which had the manner of a Song artist (止文徵仲春江待渡一圖精妙有宋人法)."[38] Our understanding of the structures of the art market is enhanced by another diary entry, which reveals that Hu Yazhu was also in business as a mounter of pictures, a highly skilled profession which must have granted access to collectors and collections, and hence provided its practitioners with the knowledge of who had what, an essential part of the specialist information on which the "bazaar economy" of the art market depends.

In addition to these shadowy figures, with whom Li Rihua clearly dealt more than once, are the numerous un-named "merchants," "Suzhou merchants," "Anhui merchants," "Huizhou dealers," or just "merchants" who process across the pages of the diary. Not only did numerous dealers come to his door, Li Rihua also went out shopping for works of art, strolling with friends on one occasion to the shop of the dealer Shen Tu'nan 沈圖南, who showed him among other things a small Wen Zhengming landscape after Huang Gongwang 黃公望 (1269–1354).[39] To get some sense of the company in which a Wen Zhengming work might find itself in the art market, it is worth noting what

30. On Dealer Xia, see Clunas, "The Art Market in 17th-Century China."

31. Li Rihua, *Weishuixuan riji*, p. 48 [Wanli 37/10/14] and p. 484 [Wanli 43/9/4].

32. *Ibid.*, p. 74 [Wanli 38/1/13].

33. *Ibid.*, p. 125 [Wanli 38/8/27].

34. *Ibid.*, p. 219 [Wanli 40/2/19].

35. *Ibid.*, p. 275 [Wanli 40/11/14].

36. *Ibid.*, p. 373 [Wanli 42/2/19].

37. *Ibid.*, p. 421 [Wanli 42/11/7] and p. 437 [Wanli 43/1/14].

38. *Ibid.*, p. 475 [Wanli 43/8/14].

39. *Ibid.*, p. 222 [Wanli 40/2/24].

else Shen Tu'nan showed his clients on this occasion. They saw an image of Śākyamuni by Zhao Mengfu 趙孟頫 (1254–1322) with an inscription by Ni Zan 倪瓚 (1301–1374), a small landscape by Ni Zan himself, and a snowscape by Shen Zhou. They also saw works by Wang Qihan 王齊翰 (act. 961–975) and Li Gonglin 李公麟 (ca. 1041–1106), both dismissed with the words "neither of them was genuine (*ju bu zhen* 俱不眞)." Paintings were only part of Shen Tu'nan's stock, however, as Li notes, "Among the ceramics there was only a white Ding 定 box, the lid with a branch of plum; very nice (諸瓷中止一白定盒蓋面，作疏梅一枝甚好)."

During the period of his diary (covering the years 1609 to 1616), Li Rihua on six occasions acquired works of calligraphy by Wen Zhengming. In 1609 an album of Sima Guang's 司馬光 (1019–1086) essay on his Garden of Solitary Delight (Duleyuan 獨樂園), written by Wen in running script calligraphy, formed part payment for composing a funerary inscription; the payment also included four porcelain cups of the Jiajing 嘉靖 period (1522–1566) and a flower-and-rock painting by Wen's associate Chen Chun 陳淳 (Daofu 道復, 1483–1544).[40] Li also acquired such works by purchase, and as pledges from their owners to whom he advanced money.[41] A closer look at some of these acquisitions shows the extent to which works produced for very specific contexts were now circulating shorn of any such significance. A few works are described simply as "an album leaf in running script," with no subject specified. Some, like *The Garden of Solitary Delight*, or *The Pavilion of the Prince of Teng* (*Tengwangge* 滕王閣), are classics of Chinese literature, and the copies acquired by Li may not have had situation-specific meanings at the time of writing, but most of them refer to specific occasions and obligations for which they were produced. In 1615 Li was able to acquire the *Biography of Assistant Yi* (*Yi Qianshi zhuan* 伊僉事傳), one of a group of writings by "famous masters of Wu" (*Wuzhong minggong* 吳中名公).[42] Neither the content nor the copy in question survive today (a reminder of how many Wen Zhengming works are lost to us). Li's interest in the piece had nothing to do with the otherwise unknown Assistant Yi and everything to do with the calligraphic style of Wen Zhengming, which he compares in the diary to another classic work of the past. In the same year he was able to buy Wen's writing of a famous sequence of "Fallen Flowers" (*Luohua* 落花) poems, the composition of which was initiated by Shen Zhou, a work of calligraphy with an accompanying picture by Lu Zhi 陸治 (1496–1576) and a colophon by Wen's student Peng Nian 彭年 (1505–1566). Contexts of discipleship and transmission across generations had brought the object into being, but in terms of Li's acquisition of the object they were irrelevant. In the following year Li bought a handscroll by "the famous hands of the present dynasty" (*benchao mingshou* 本朝名手). Its text is a farewell poem by Shen Zhou, addressed to "Prefect Lin," who was probably Lin Shiyuan 林世遠, prefect of Suzhou from 1499 to 1507.[43] The handscroll carries

40. *Ibid.*, p. 54 [Wanli 37/11/3].

41. *Ibid.*, p. 436 [Wanli 43/1/13]; p. 518 [Wanli 44/2/28]; p. 552 [Wanli 44/11/1] (purchases); and p. 437 [Wanli 43/1/14] and p. 484 [Wanli 43/9/3] (both occasions of pawning).

42. *Ibid.*, p. 437 [Wanli 43/1/14].

43. Li Mingwan, ed., *Suzhou fuzhi* (*Gazetteer of Suzhou*), 1883 ed., *Zhongguo fangzhi congshu* (*Collectanea of Regional Gazetteers in China*), *Huazhong difang* (*Huazhong Region*), number 5, 6 vols. (Taipei: repr., Chengwen chubanshe, 1970), *juan* 52.

additional inscriptions by Xu Zhenqing 徐禎卿 (1479–1511) and by Wen Zhengming, the latter dated to 1517. Thus, a work produced to honor the local ranking official had become entirely detached from the obligations of deference and reciprocity that acted at the point of its creation. It had become, in short, a work of art. Li Rihua elsewhere noted that ". . . Wen Hengshan's small regular script was of such excellence that scholar-officials of the Zhengde (1506–1521) and Jiajing eras all wanted his handwriting to be engraved in stone for all sorts of tomb inscriptions (文衡山小楷精妙，德靖間士大夫阡表墓銘必乞其手書濬石以行)." Li goes on to claim that those stonecutters who had Wen's manuscripts were making money off the back of his art.[44]

Li Rihua was therefore conscious of the original context of the production of things like funerary inscriptions (he did them for payment himself), and at the same time as he was also well aware that such things were now commodities, shorn of their original agency and re-inscribed in a context of circulation, sale, and connoisseurship. Here agency has been relocated from the dedicatees of the works (magistrates and seniors) to their maker (Wen Zhengming). This relocation was made all the easier because the work in this reoriented state is capable of projecting the agency of the artist in a very salient manner (this, after all, is what "brushwork" is all about).[45] In another, similar case, a transcription of the *Record of the Garden of the Artless Official*, produced by Wen for his patron Wang Xianchen 王獻臣, was shown to Li by two "Hangzhou merchants" in 1612.[46] Although the text came into being as an index of the agency of Wang Xianchen, in his role as Wen's patron, it performs no such task in 1612, and Wang Xianchen has become of relatively little interest. Even the private letters of the prominent were now available on the market—in 1610, Li Rihua was offered letters from Zhu Yunming 祝允明 (1461–1527) to Wen Zhengming, and one from Wen to his favorite disciple, Wang Chong 王寵 (1494–1533).[47]

Li Rihua's diary also shows him buying three Wen Zhengming paintings: in 1609 he acquired *Amusing Myself with a Fishing Pole in an Empty Belvedere* (*Xuge nonggan* 虛閣弄竿) and *Linked Bridles on the Willow Embankment* (*Liuti lianpei* 柳提聯轡) from the Suzhou dealer Dai Zhibin 戴稚賓 (the "Master Dai" referred to above with the fakes), and in 1611 he acquired *Reeds and Crabs* (*Lu xie* 蘆蟹) from an unknown source.[48] Of the fifty-six Wen paintings mentioned in total throughout the diary, sixteen of them have their titles by Li, six of them are dated, and only seven carry dedications. These include works done for and dedicated to men called Yang Fusheng 楊復生, Wu Jingfang 吳敬方, Lüyue 履約, Bu Yiquan 卜益泉, and Wu Shanquan 吳山泉.[49] These are now simply names, not identifiable today as men with whom Wen had any ongoing connection. Their agency in the creation of the pictures

44. Li Rihua, *Weishuixuan riji*, p. 531 [Wanli 44/5/4].

45. Gell, *Art and Agency*, p. 35.

46. Li Rihua, *Weishuixuan riji*, p. 219 [Wanli 40/2/19].

47. *Ibid.*, p. 125 [Wanli 38/8/27]. For another instance of Wen letters for sale, see *ibid.*, p. 409 [Wanli 42/9/4].

48. *Ibid.*, p. 61 [Wanli 37/11/16] and p. 182 [Wanli 39/7/15].

49. *Ibid.*, p. 58 [Wanli 37/11/12]; p. 238 [Wanli 40/6/11]; p. 484 [Wani 43/9/4]; and p. 490 [Wanli 43/10/4].

is murky and unrecoverable, but the list also includes a piece done for Yuan Yongzhi 袁永之 (1502–1547), one of Wen's major patrons, and one for Xu Jin 徐進 (1479–1545), son-in-law of the Suzhou grandee Wang Ao 王鏊 (1450–1524) and someone for whom Wen did a number of works.[50]

The relative rarity of dated or dedicated works circulating in the market could make attractive a hypothesis along these lines: the ones which made it out of their original context of production were fairly perfunctory or generic things, and dedicated works were more likely to stay with the families of their original recipients at least until the end of the Ming dynasty. This, however, may be overly simplistic. If private letters were circulating as commodities, it seems likely that specifically destined pictures were, too. We have to bear in mind that often the content of the picture indicates little or nothing about the context of its production, and that the numerous variations on the "lofty scholar" (*gaoshi* 高士) composition which make up much of Wen Zhengming's output may have been produced in circumstances that are no long recoverable, either because they were never inscribed on the picture or because the inscription was trimmed off in the process of transmission. Thus, we cannot assume that the seventeen pictures Li Rihua describes simply as "landscapes" (*shanshui* 山水) or "views" (*jing* 景) had no specific context of dedication of their own in Wen's lifetime.

Although Li Rihua recorded any dedicatory context that formed an integral part of the inscription he was transcribing, this was not the focus of his interest. Instead, he almost always commented on the manner of the work. The most frequent category he used to describe Wen's works was the "blue-green" (*qinglü* 青綠) style, but he also noted occasions of "fine" (*xi* 細) or "coarse" (*cu* 粗) brushwork (an early critical distinction for dividing Wen's output), and he used the terms *xiaosa* 瀟灑 ("free and easy"), *shenpin* 神品 ("divine class") and *yi* 逸 ("untrammeled"). These are all terms with distinguished histories in the critical literature on painting, part of the vocabulary of educated connoisseurship, but they are not the principal way in which Li discussed individual Wen Zhengming works. In keeping with the largely situational aesthetics of such writing, he describes them not so much as *possessing* certain qualities as being *like* the work of other figures of the canon. He did this for thirty of the fifty-six pictures. Of these paradigms, the most commonly cited is Zhao Mengfu, mentioned as Wen's model for seven pictures. Then comes Huang Gongwang, cited six times, and Wu Zhen 吳鎮 (1280–1354) three times. Lu Hong 盧鴻 (act. 713–742), Li Cheng 李成 (ca. 919–ca. 967), and Ni Zan are each mentioned twice, and Zhao Boju 趙伯駒 (d. ca. 1162), Li Tang 李唐 (b. 1050s–after 1130), Li Sixun 李思訓 (651–716), Dong Yuan 董源 (act. ca. 937–975) and Mi Youren 米友仁 (1075–1151) once. Li offers a degree of close discrimination by describing a work as bisecting two other contiguous manners, as in "Li Tang or Huang Gongwang," "Jing Hao 荊浩 (act. late 9th–early 10th c.) or Li Cheng," or "in between Zhao Boju and Zhao Mengfu." What such correlations did was to write Wen Zhengming into history *as a painter*, associating him with those leading painters of the past who were becoming normative models in the critical

50. *Ibid.*, p. 260 [Wanli 40/9/2] and p. 402 [Wanli 42/7/24].

writing of Dong Qichang, Li Rihua's friend. Now most of his output could be spoken of only in terms which exclude the agency of those for or through or on behalf of whom the pieces were brought into existence. This is how Wen Zhengming became "an artist"—audiences such as Li Rihua conceived of his works as materializing the agency of these great names of the past. It was the "commodity context" of the art market that made possible this redirection of agency

Alfred Gell's concept of the work of art as an index of agency, useful as it may be, runs into difficulties when it engages with the concept of "style," largely because it is still entrapped in a binary opposition between "the individual style of the artist" (in the West) and the tribal/collective production of work in "traditional" contexts, where a collective cultural consciousness is predominant. Gell writes, "This is one of the reasons that we esteem Picasso so much; however much his manner transforms itself, he maintains a consistent stylistic identity, difficult though this is to pin down."[51] The casual invocation of what "we" esteem cannot go unchallenged here. His model of the artist's oeuvre is weakened by presupposing the Western model of the individual artist, and of the isomorphism between an individual artist and his work, a premise which has been criticized by Donald Preziosi.[52] I do not think that one can see Wen Zhengming's total oeuvre as similar to (for example) Rembrandt's, in any meaningful sense. Indeed, I think that the concept of "oeuvre," as a coherent and autonomous "body of work," may not be helpful to the study of Chinese painting at all. The idea of "oeuvre" has tied art historians in knots trying to account, through terms like "eclecticism," for many pictures attributed to the same person, but in no way resembling one another. It is certainly a concept hard to square with the eleven different painters of the past whom Li Rihua invokes in stating what the works of Wen Zhengming he has seen are "like."

Better attention to the case of China may provide a way out of individual "Western" versus collective "tribal" binaries. This is so because it involves in turn an attention to ways other than "Western" concepts whereby to construe individuality. If a central idea in Gell's work is that a work of art can behave like a person, then one of the equally striking ideas in the work of David Hall and Roger Ames is that in the Chinese context we can consider a person as a work of art. They claim this in the course of a complex discussion which seeks to contrast Western and Chinese notions of the self, and in particular of individuality, and to argue against what they see as a deep-rooted but fundamentally mistaken Western understanding of Chinese culture as self-abnegating, collectively orientated, and indeed "self-less." They argue for different conceptions of the individual in China. In Western notions of a selfhood which is separate and distinct,

> "individual" can refer to a single, unitary, separate and indivisible thing that, by virtue of some essential property or properties, qualifies as a member of a class.

They contrast this with the Chinese concept:

51. Gell, *Art and Agency*, p. 162.

52. Donald Preziosi, *Rethinking Art History: Meditations on a Coy Science* (New Haven: Yale University Press, 1989), p. 31.

Craig Clunas

Individual can also mean *unique*. A unique individual has the character of a single and unsubstitutable particular, *such as a work of art* [my emphasis], that might be formally comparable to other such works, but that remains, nonetheless, qualitatively unique. This sense of individual does not entail assumptions about class membership. . . . It is this sense of "unique individuality" that is helpful in understanding the traditional Confucian conception of self.[53]

If Gell's work is undermined to a degree by universalist assumptions about "the artist," then Hall and Ames can perhaps be criticized for ahistoricism, for assuming a "traditional Confucian conception of the self" that was at all times the same. Their work may be helpful to art historians trying to understand why Wen Zhengming worked in what to our eyes are so many different "styles"—these may perhaps be taken as material and visual traces of a "fractal," contextual personhood. However, as Jonathan Hay has shown in his recent book on Shitao 石濤 (1642–1707), in the period following the death of Wen Zhengming, social and political change on a cataclysmic scale generated new forms of subjectivity associated with "modernity" in the Chinese context, along with "the emergence of a modern field of consciousness [which] articulated and embodied not only new possibilities but also dehumanizing insecurities and pressures. . . ."[54] More work on the role of the marketplace in creating new contexts, in which objects could circulate and identities be advanced and contested, should prove fruitful in tracing the trajectory which leads from a Wen Zhengming to the very different field of consciousness in which a Shitao had to operate.

This essay has attempted only a single focused study of the ways in which social and artistic personae interacted through the mediums of painting and calligraphy. The study of Chinese painting across its full trajectory, and a better understanding of the ways in which the social life of its creators and of their work were mutually constituted, may lead to deeper insights into the historically specific forms of selfhood which operated through China's long history. This in turn can lead to a more effective challenge to simplistic binaries of West/Other within the discipline of art history as a whole. As is now well studied, such pairs as "idea/form" are part of the heritage of European philosophy bequeathed to the discipline of art history in oppositions like "drawing/color" in the writings of Giorgio Vasari (1511–1574), or "linear/painterly" in those of Heinrich Wölfflin.[55] Their appro-

53. Hall and Ames, *Thinking from the Han*, p. 25. However, also see Gell, *Art and Agency*, p. 153, for the following quotation related to this subject:

> While I hold that where each individual work of art (index) is concerned, anthropological analysis is always going to emphasise the relational context at the expense of artistic or aesthetic form, the network of agent/pattern relations "in the vicinity" of the work of art—the same does not apply when we come to consider artworks not "individually" but as collectivities of artworks. . . . Artworks are never just singular entities; they are members of categories of artworks, and their significance is crucially affected by the relations which exist between them, as individuals, and other members of the same category of artworks, and the relationships that exist between this category and the other categories of artworks within a stylistic whole, a culturally or historically specific art-production system.

54. Jonathan Hay, *Shitao: Painting and Modernity in Early Qing China*, Res Monographs on Anthropology and Aesthetics (Cambridge: Cambridge University Press, 2001), p. 25.

55. David Summers, "Form and Gender," in *Visual Culture: Images and Interpretations*, ed. Norman Bryson, Michael Ann Holly, and Keith Moxey (Hanover and London: Wesleyan University Press and the University Press of New England, 1994),

priateness to an expanding field of study is no longer to be quite so lightly taken for granted, and even the most "common sense" of oppositions, like that between things and people, must be seen as requiring investigation. Only a close attention to the widest possible number of objects and contexts, and a cautious skepticism about what constitutes art historical common sense, will enable us to move to a richer understanding of the myriad ways in which people, things, people-as-things, and things-as-people have been mutually constitutive of the worlds they all inhabit.

pp. 384–411.

Craig Clunas

商品與脈絡—
晚明藝術市場中的文徵明作品

Craig Clunas

牛津大學

　　本文將透過檢視文徵明(1470-1559)作品在其死後於藝術市場的流通情形，來探討明代書畫作品的「社會生活」。李日華(1565-1635)的《味水軒日記》中對於文徵明的書畫作品，有著極爲詳盡的描述(共有56張畫作及20件書法作品)。《味水軒日記》的內容提供我們約於文徵明歿後五十年藝術市場文徵明作品流通情形的景像。這些作品被置於各類不同的商賈間，以及混雜於廣布而被視爲貴重商品的贗品之中。李日華不僅對文徵明創作時的各種社會交易形態有興趣，也關心作品外觀的形式特點，或是個別作品於畫史流派的位置。透過這些藝術市場的操作，使得文徵明(由文人)變成藝術家。

　　本文使用了一些新的人類學理論，特別是Arjun Appadurai與Igor Kopytoff兩位關於「物品社會生活」的著作，以及Alfred Gell的藝術「能動性」(agency)概念。但將中國的例子放入考慮，理論卻顯示了它們的侷限。此理論認爲深入檢視明代藝術市場的運作，可以提供更好的視角來看待明代自我與個體特性的概念。它依次地顯示了藝術史作爲一個學科準則，若以歐洲歷史發展的觀念作爲標準，便會限制了它對於個體的了解。中國繪畫的研究，與繪畫這個實物在社會角色間移動的能力，扮演了這些社會角色特性的指標，可以擴展(藝術史)學科準則，並幫助藝術史更能處理人與物之間多樣化的關係。

商品とコンテクスト―
明代後期の美術市場における文徴明の作品

Craig Clunas

オックスフォード大学

　本稿は、文徴明(1470-1559)の作品が彼の死後どのように美術市場に流通したかを検証し、明代の書画の「社会的生活」を考察する。李日華(1565-1635)の『味水軒日記』に記された文徴明の作品（全部で56点の画と20点の書）に関する多くの記述に着目した。この文献は文徴明の死後およそ50年間に美術市場で入手可能であったものを豊富かつ詳細に紹介している。当時そうした作品が置かれていたコンテクストには、様々な種類の専門美術商のみならず、すでに貴重な商品となっていた作品の贋作の流行も含まれた。李日華の興味の対象は、文徴明が本来、作品を制作した複雑な社交上の贈答制度ではなく、作品の外見的な形式的特徴、個々の作品と過去の大家の手法との関係であった。美術市場の機能を通して文徴明は「芸術家」になった。

　本論は、様々な文化人類学理論、主としてArjun AppaduraiとIgor Kopytoffの「事物の社会的生活」に関する業績と、Alfred Gellの芸術の「作用力」に関する概念を利用した。しかし、ここでは、それらの理論が中国での検証を考慮に入れていないため制約が生じていることを示す。明代中国の美術市場の機能に注目すると、自我と個性という明代の概念のよりよき洞察が得られる。学問としての美術史が「個性」の理解にいかに乏しかったかを、歴史的にヨーロッパの概念を規範とすることによって示したい。中国絵画の研究、また、社会の行為者間を移動する能力を持った事物が、その行為者の個性の指標として働く様態の研究は、この学問全体を拡大し、人間と事物との多様な関係に対してより敏感な美術史を創造することに寄与することであろう。

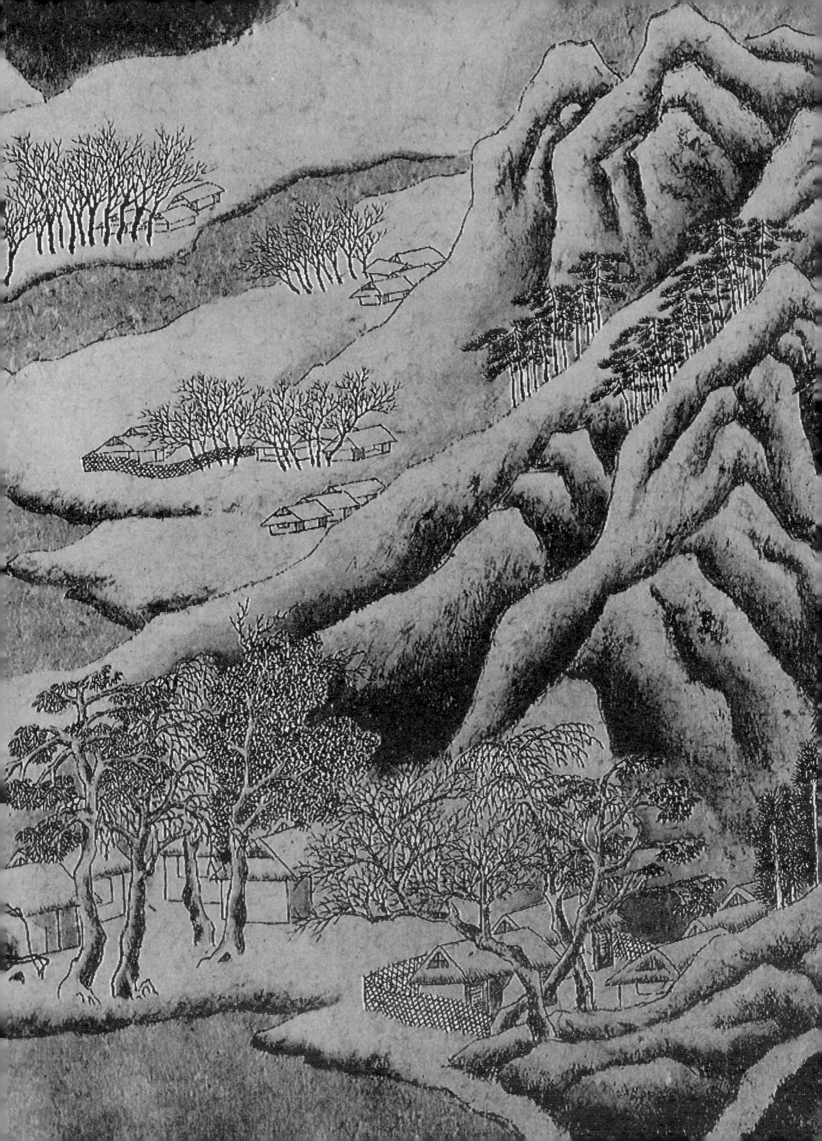

Wen Zhengming's Aesthetic of Disjunction

Jonathan Hay

Institute of Fine Arts, New York University

Two paintings by Wen Zhengming 文徵明 (1470–1559) were included in the exhibition of artwork sent by the National Palace Museum to the United States in 1996. One was a hanging scroll, *Cascading Falls in a Pine Ravine* (*Songhuo feiquan tu* 松壑飛泉圖; 1527–31; *Fig. 1*), the other a handscroll, *Heavy Snow on Mountain Passes* (*Guanshan jixue tu* 關山積雪圖; 1528–32; *Fig. 9*).[1] Both works were unusually ambitious projects, took several years to paint, and were completed at the beginning of the 1530s. Connecting the two scrolls more directly are their dedications to the same man, Wang Chong 王寵 (1494–1533). There was, therefore, a somewhat long period—1527 to 1532—when Wen Zhengming was working intermittently on two important paintings for a single recipient. Why did they take so long, and what was the relationship between the two men that led to such ambitious works?

Straightforward as they are, these questions cannot be satisfactorily answered without bearing in mind several contexts, all interrelated. The first is Wen's friendship with his student Wang Chong, which has been little explored in the modern literature, yet was without any doubt one of the most important friendships of Wen Zhengming's long life. When Wang Chong died in 1533, at the age of only forty *sui* 歲, Wen was little less than heartbroken. Friendship of this intensity already explains a great deal, but Wen's relationship to Wang also had a significant art-world dimension. Wen's relationship to his public was conditioned by the lack of any form or system of public exhibition for secular paintings. The proving ground for his art lay at a precise point within the highly differentiated field of particular artist-audience relationships. There were certain viewers, certain recipients of his paintings, whose approval of his art Wen Zhengming desired. These individuals cannot ever have been many, but Wang Chong, I am certain, was one of them.[2] So great a challenge did an important work for Wang represent (as against several other known, less ambitious paintings for him) that Wen took five years to complete each of these two. These were paintings in which Wen Zhengming tested his own limits, knowing that his friend and student expected nothing less of him.

Also important is the physical and social context provided by a particular place, Stone Lake (Shihu 石湖), located to the south of the city of Suzhou. The importance of Stone Lake in mid-Ming Suzhou culture has been obscured by a modern fixation on two other places, Tiger Hill (Huqiu 虎丘) and Lake Tai (Taihu 太湖). Its particular significance

1. Wen C. Fong and James C.Y. Watt, *Possessing the Past: Treasures from the National Palace Museum, Taipei* (New York: The Metropolitan Museum of Art and The National Palace Museum, Taipei, 1996), pp. 388–94.

2. For a related discussion of "inside" versus "outside" publics, see Jonathan Hay, *Shitao: Painting and Modernity in Early Qing China* (New York: Cambridge University Press, 2001), pp. 230–36.

for Wen lay in its being the center of activity of a group of like-minded artists and intellectuals, including Wang Chong and Wen himself, whom I shall refer to as the "Stone Lake Group."[3] Yet another context, which has been explored by Shih Shou-chien 石守謙 in an important, densely argued article, is the impact on Wen Zhengming's art of his unhappy experience of politics in Beijing at the beginning of the Jiajing 嘉靖 reign, between 1523 and 1526.[4] A final context to take into account is Wen Zhengming's engagement in the art market. Although neither of the two paintings for Wang Chong was produced as a commercial item, part of their meaning derives precisely from their privileged status as a financially disinterested investment of labor. Moreover, in analyzing the attitude toward moral practice and public responsibility in early sixteenth-century Suzhou that is articulated in the two scrolls, it is misleading to cite the artist's political disaffection without also taking into account his attention elsewhere to the material rewards of cultural mastery.

In the article just mentioned, Shih Shou-chien has argued that *Cascading Falls in a Pine Ravine* marked a decisive break in Wen Zhengming's practice of art, involving a sharp shift toward a stance of deliberate disengagement from politics—what might be termed an activist form of reclusion. This essay builds on Shih's thesis by expanding the interpretation beyond the narrowly political to include a wider range of considerations, and by relating *Cascading Falls in a Pine Ravine* to a different set of paintings, including *Heavy Snow on Mountain Passes*; clarifying the relation between these two works in particular is essential to understanding the full significance of each. My discussion will therefore have different emphases from Shih's, and in the end a different, not entirely compatible, thrust. Wen Zhengming's two great paintings for Wang Chong initiated—so I shall propose—an artistic exploration of disjunction that would preoccupy Wen and Suzhou artists close to him throughout the 1530s, 1540s, and 1550s. It is no exaggeration to say that these two paintings helped to change the course of Chinese painting history, if only because what Wen first achieved here opened the way for the later achievement of Dong Qichang 董其昌 (1555–1636). A further theme of this essay, therefore, is the role and significance of an aesthetics of disjunction in early modern Chinese painting. In the author's view, its significance lies partly in a reassessment of moral and cultural authority that relativized the importance of the values associated with the hierarchical imperial cosmos by confronting them with the more fluid values of the commercial city.

Cascading Falls in a Pine Ravine

Wen Fong, following Shih Shou-chien, has described *Cascading Falls in a Pine Ravine* as "a lyrical and expressionistic projection of the reclusive life [Wen Zhengming] led in his later years." In support of this idea, Fong sug-

3. The longer version of the present essay that was distributed at the Taiwan 2002 Conference includes a discussion of the literati coterie associated with Stone Lake to which Wen Zhengming and Wang Chong belonged, and identifies twenty-eight paintings attributed to Wen that can be linked to this "Stone Lake Group."

4. Shih Shou-chien, "Jiajing xinzheng yu Wen Zhengming huafeng zhi zhuanbian (The Jiajing Ritual Controversy and the Transformation of Wen Zhengming's Painting Style)," *Yishu xue*, 1988, no. 2, pp. 111–40.

gests that the upper half of the composition derives from the composition of the "mind landscape" of Xie Kun 謝鯤 (280–322), as painted by Zhao Mengfu 趙孟頫 (1254–1322).[5] Shih proposes a different (and to my eyes more plausible) connection, with Shen Zhou's 沈周 (1427–1509) *Lofty Mount Lu* (*Lushan gao tu* 廬山高圖; *Fig. 2*) of 1467, painted for his teacher, which shares a similarly involuted mountain structure and, like *Cascading Pines in a Pine Ravine*, is also in the Wang Meng 王蒙 (ca. 1308–1385) style. Shih also convincingly argues, and here is joined by Fong, that the lower half of the composition incorporates an allusion to Wang Xizhi's 王羲之 (303–361) "Gathering at the Orchid Pavilion (Lanting 蘭亭)" of 353—a common mid-Ming theme in its own right (see Wen Zhengming's *Gathering at the Orchid Pavilion* [*Lanting xiuqi tu* 蘭亭修禊圖]; *Fig. 3*).[6] Wen Zhengming is unarguably deploying a rhetoric of reclusion in this painting; however, his relationship to reclusion as an ideal seems to me to be rather more distanced and ambiguous than has been suggested by Shih and Fong.

In the first place, Wen Zhengming's inscription to *Cascading Falls in a Pine Ravine* presents the painting as the memory of a memory—his memory now in Suzhou of his memory a few years before in Beijing of his previous life of reclusion in Suzhou. This layering of memory in his inscription highlights the distance he feels from his pre-Beijing life, so it is not surprising that the inscription goes on to insist on the enormous difficulty of making contact again with his past self:

> When I lived in the capital, I would often recall how, among the ancient pines and waterfalls, my spirit and feelings wandered. In the *dinghai* year [1527], after returning to get old in Suzhou and speaking of this to Lüji [Wang Chong], I began to paint this picture for him. Several times I started, then stopped. Only after five changes of season, in the year of *xinmao* [1531], did I finally finish the work. Some say it takes five days to paint water and ten days to paint a rock; my pictures seem to take a hundred times longer! Painting is no easy pursuit. How it resists being hurried! Only after [such a long struggle] can I make Lüji appreciate my music. On the tenth day of the fourth month, signed by Zhengming.[7]
> 余留京師，每憶古松流水之間，神情渺然。丁亥歸老吳中，與履吉話之，遂爲寫此；屢作屢輟，迄今辛卯，凡五易寒暑始就。五日一水，十日一石，不啻百倍矣。是豈區區能事，眞不受促迫哉！於此有以見履吉之賞音也。四月十日徵明識。

This text speaks not only to the divide that had opened up within Wen Zhengming himself between his pre-Beijing past and his post-Beijing present, but also to the parallel divide that now intervened between him and Wang Chong, which it was the purpose of the painting to overcome. Wen Zhengming places himself in a deferential position. Wang Chong, who has never gone to Beijing and who would take the provincial examination for the last time that same year of 1531, is the one whom Wen has to please; Wang is also the one who, by implication, is as yet untainted by the experience of politics and is thereby able to judge the value of Wen's evocation of the ideal of reclusion. The evocation itself, however, is far from idealistic—the painting is a troubled one, with trees that function as barriers and a mountain that twists with tortured energy.

5. Fong and Watt, *Possessing the Past*, p. 392.

6. Shih, "Jiajing xinzheng," pp. 129–33; Fong and Watt, *Possessing the Past*, pp. 388–92.

7. Translation partly based on Fong's in Fong and Watt, *Possessing the Past*, p. 389.

Jonathan Hay

The upper section is centered on a solitary figure contemplating the waterfall (*Fig. 4*); the lower shows a group of five literati, accompanied by three servants (*Fig. 5*). Because the painting is so clearly and problematically divided between top and bottom, it does not seem quite natural to see the solitary figure and the group as making up a larger group of six. In the five literati figures below, I believe we must see a specific reference to the "inner" circle of the Stone Lake group, comprising Wen Zhengming, Wang Chong, Wang Shou 王守, Cai Yu 蔡羽 (d. 1541), and Tang Zhen 湯珍.[8] Of the five figures in the painting, one seems particularly important—a standing figure facing in the viewer's direction and engaged in conversation with another man. This figure is not only centrally placed and exposed to our view, but is neatly framed by two tree trunks. This standing figure and the solitary figure high in the mountains can perhaps be understood as alter egos of each other; the recluse in conversation with his friends below and in solitary communion with nature above, illustrating the two sides of the recluse ideal. Tellingly, given the iconography of court paintings contemporary with this one, the recluse is not approached here by any emissary of the state.[9] Although it seems certain that these two focal figures, one above and one below, have some connection to the real-life figures of Wen Zhengming and Wang Chong, it is not at all clear what the connection was intended to be. Was one the artist and the other Wang Chong? Were both figures potentially to be identified with both Wen and Wang Chong, or would Wen have wanted us to see in them either only himself or only Wang Chong? The rather abstracted representation does not give the viewer any clues to decide—which might itself be interpreted as a deliberate openness to different interpretations or, on the contrary, as something an artist could permit himself to do because the rules of decorum operative in his world would have specified the proper direction of interpretation for his audience. I sense that mid-Ming decorum would have countenanced a teacher presenting a student with a painting that places the teacher (Wen Zhengming) at the center, but also that a recipient of the long-expected gift of a painting from a painter-friend might with equal propriety have expected to occupy the painting's center. Since Wen and Wang were linked by something "between a teacher-student relationship and friendship" (*shi you zhi jian* 師友之間), decorum does not seem to point toward the meaning, which I therefore conclude was deliberately left open.

In fact, the image as a whole relates as easily to one man as to the other. In order to see the painting as basically self-referential, one need only bring to mind Wen Zhengming's reference in his inscription to his spirit and feelings wandering "among the ancient pines and waterfalls," a formulation that neatly summarizes the two parts of this figure-in-landscape composition. The painting also, however, resonates with a passage in the epitaph that Wen Zhengming later wrote for Wang Chong:

> By temperament he disliked promoting himself and did not care to live in a commercial environment. When he was young, he studied with Mr. Cai Yu, staying at Lake Dongting for three years. Then he

8. What makes this identification almost unavoidable is the central place of *Cascading Falls in a Pine Ravine* within a larger group of works related to the Stone Lake group. See above, Note 3.

9. Scarlett Ju-yu Jang, "Issues of Public Service in the Themes of Chinese Court Painting" (Ph.D. diss., University of California Berkeley, 1989).

studied at Stone Lake for twenty years, coming into town only rarely and at odd times. When he encountered fine scenery, he would always lose himself listening. On occasion he would lie down in the forests and the high grass. He would burn incense and compose poems and, leaning on his seat, would sing. Carried away with thousand-year-old thoughts, how could his acts be those of some commonplace and ordinary scholar?[10]

性惡喧囂，不樂居廛井。少學於蔡羽先生，居洞庭三年。繼而讀書石湖之上二十年，非歲時省侍，不數數入城。遇佳山水，輒忻然忘去，或時偃息於長林豐草間，含醺賦詩，倚席而歌，邈然有千載之思。跡其所為，豈碌碌尋常之士哉！

Nor is the symbolic (self-) portrait dimension of the painting exhausted by the figure-in-landscape theme. This is suggested by its connection to Shen Zhou's *Lofty Mount Lu*. In that painting, the landscape itself, or rather the mountain, was meant to be read as a metaphoric portrait of Shen's teacher, and from this point of view the title could also be translated as *Lofty as Mount Lu*.[11] The example of Shen Zhou's earlier landscape helps to explain the most striking formal features of Wen Zhengming's painting—the anthropomorphic character of the mountain, with its reminiscences of bodily forms and overall suggestion of a bodily presence. One way of interpreting this would be to say that *Cascading Falls in a Pine Ravine* incorporates a mountainscape portrait of the recipient, Wang Chong. But the precedent of Shen Zhou's painting also authorizes a reading of the mountain as self-portrait, since Wen Zhengming was Wang Chong's teacher. Either way—and I believe that both interpretations are valid—this was an extremely bold move for Wen Zhengming to make, Shen Zhou's precedent notwithstanding. Traditionally, mountains were reserved metaphorically for the representation of the emperor, scholars being represented as trees. Here, I believe, the trees are indeed in play symbolically, and correspond to the five literati in their shade; correspondingly, the mountain corresponds to the tiny figure in its shade—at its heart, so to speak. Where, then, is the emperor in this monumental metaphoric landscape? One may well ask, for he is absent. Only the Stone Lake group, and what the painting implies to be certain shared values of its members, are monumentalized here.

What justified this form of treatment? *Cascading Falls in a Pine Ravine* was, I think, in part an attempt by Wen Zhengming not just to visualize Wang's qualities but also to make of those qualities, and his own empathetic identification with them, an emblem of something much larger—a kind of moral alternative to what he had seen at the capital. Shih Shou-chien has related the painting to Wen's experience of the Great Ritual (*dali* 大禮) controversy of the early 1520s, in which his lack of sympathy with both the opposing factions cost him the chance of promotion.[12] According to Shih, the view of reclusion advanced by Wen Zhengming in *Cascading Falls in a Pine Ravine* gives lyrical form to his troubled psychological state of disillusionment in the post-Beijing years. In Wen Fong's words, "In 1526, Wen returned to Soochow, where he lived as a retired scholar-artist, viewing art as a moral anchor in an age

10. *Wen Zhengming ji (Collected Works of Wen Zhengming)*, vol. I, pp. 713–15.

11. Indirect confirmation of the connection comes from the fact that earlier, in 1508, Wen had painted a landscape for a teacher of his own, entitled *Lofty Leisure in Hills and Valleys*, which Shen Zhou inscribed with a poem on the *Lofty Mount Lu* theme. See *Wen Zhengming ji*, vol. I, pp. 67–68.

12. Shih, "Jiajing xinzheng."

of political cynicism."[13] I would go even further than either Shih or Fong—I believe that in Wen's eyes the nation's best talent was being wastefully ignored, and his post-1527 paintings were to stand both as a condemnation of that situation and as a manifesto for an alternative. In other words, this is not an escapist vision. Wen's aims—his theme, his underlying "idea" (yi 意)—had everything to do with who Wang was, and what he represented. *Cascading Falls in a Pine Ravine*, I believe, is an attempt to monumentalize in the most uncompromising fashion a certain concept of the moral individual, which Wen himself aspired to and, along with other members of the Stone Lake group, saw embodied in Wang Chong.[14]

In post-structuralist terms, *Cascading Falls in a Pine Ravine* can be said to announce a shift of subject position. Before and after Beijing, Wen Zhengming was in the position of a literatus whose gentry heritage did not prevent the need to supplement his income by the commercial exploitation of his cultural skills. The principal change brought about by his Beijing sojourn was a rise in both his social status and his reputation, which made his writing and art commercially more desirable. His basic social profile, however, remained the same—he continued to be a combination of property owner and cultural professional.[15] The more important change lay in the way he interpreted for himself his dual circumstances. At the start of his career, he had followed Shen Zhou in presenting himself in his paintings as a member of the local gentry elite, someone who was socially inscribed in an order that was above question. This type of self-presentation can still be seen in the 1516 painting *Thatched Cottage in Green Shade* (*Luyin caotang tu* 綠蔭草堂圖; *Fig. 6*). But very soon after this, in works such as *Deep Snow over Mountains and Streams* (*Xishan shenxue tu* 溪山深雪圖; *Fig. 7*), dated to 1517, and *Gathering for Tea at Mount Hui* (*Huishan chahui tu* 惠山茶會圖; *Fig. 8*), circa 1518, a theatricality crept into his work that implies the arrival of distance and doubt. The self-consciously mannered, archaistic style creates an effect of staginess, so that we see not scholars in a landscape but "scholars" in a "landscape." They seem to be playing a gentry role. Subsequently, in *Cascading Falls in a Pine Ravine* and other post-Beijing paintings, Wen Zhengming took up a far more ambiguous position in relation to the social order promoted by Shen Zhou's work. While continuing to inscribe himself within it, he also assumed a critical distance, affirming an independent, critical individuality quite different from the socially networked individuality analyzed by Craig Clunas in a recent article.[16] To see this critical distance simply as disillusionment or doubt is to characterize it negatively, by what it rejects, without taking into account its more positive rooting in a particular social experience. As I would instead tentatively describe his new stance, after 1527 Wen Zhengming began to present himself—doubtless reluctantly—as someone whose social identity was not straightforwardly clear, but was instead

13. Fong and Watt, *Possessing the Past*, p. 389.

14. See Wen's epitaph for Wang Chong in *Wen Zhengming ji*, vol. I, pp. 713–15.

15. On Wen Zhengming's post-Beijing professionalism, see the discussion by Howard Rogers in *Masterworks of Ming and Qing Paintings from the Forbidden City*, ed. Howard Rogers and Sherman E. Lee (Lansdale, Pa.: International Arts Council, 1989), pp. 128–29.

16. Craig Clunas, "Artist and Subject in Ming Dynasty China," *Proceedings of the British Academy*, vol. 105 (2000), pp. 43–72.

socially complex and defined by the negotiation of different pressures and desires. Disillusionment with the state freed him to acknowledge as one part of his identity his urban condition of self-reliance and insecurity.[17]

This is why it is so important to resist the notion that the economics of Wen Zhengming's art are somehow irrelevant to its deeper meaning. Shih Shou-chien has recently made an elaborate attempt to marginalize the significance of Wen's commercial practice as an artist. In an article on Wen Zhengming's calligraphy that incidentally increases the evidence for his engagement in commerce, Shih ingeniously presents Wen's professionalism as little more than a by-product of the larger social practice of creating artworks as gifts within an economy of reciprocal gift exchange.[18] By characterizing as gifts rather than commercial products even those art works for which the reciprocal gift is likely to have been money or the equivalent, Shih is able to present Wen Zhengming as being essentially disinterested in financial gain—thereby confirming the Confucian self-image that Wen claimed and deflecting attention from the unpalatable fact that widespread market demand for his art, reflected in his use of ghost painters, helped to make Wen Zhengming rich in later life. Those of us less scandalized by commerce may see the disinterestedness of Wen's "reclusion" as a rhetorical posture; the money to support his comfortable recluse lifestyle had to come from somewhere, and if it was not coming significantly from calligraphy and painting, why then did he produce so many works for people with whom his personal acquaintanceship was slight or nonexistent? Clunas argues that Wen Zhengming's *qing gao* 清高 ("pure and lofty") recluse behavior represents a symbolic refusal of social engagement "that functions to create opportunities for re-engagement, for reintervention in the mundane sphere."[19] Taking this argument a step further, reclusion was a synonym for independence, and the "wilderness" ideally inhabited by the "recluse" was often in real life the open market, which provided income outside of government service. A work like *Cascading Falls in a Pine Ravine* was presumably created with no thought of commercial gain, but commerce is nonetheless part of the painting in the sense that its particular quality of critical distance affirms a self-reliance that bespeaks Wen's acceptance of his engagement in commercial activity. Wen Zhengming could repress this acceptance at the rhetorical level of recluse iconography, but the power and historical importance of *Cascading Falls in a Pine Ravine* come from the fact that he allowed it to surface in the very structure of the painting.

Heavy Snow on Mountain Passes

Heavy Snow on Mountain Passes (*Fig. 9*) has, if anything, an even more fascinating inscription than *Cascading Falls in a Pine Ravine*:

17. I have explored the relevance of this hybrid social identity to painting in *Shitao*, pp. 19–25, 205–9, 282–86.

18. Shih Shou-chien, "Calligraphy as Gift: Wen Cheng-ming's (1470–1559) Calligraphy and the Formation of Soochow Literati Culture," in *Character and Context in Chinese Calligraphy*, ed. Cary Y. Liu, Dora C.Y. Ching, and Judith G. Smith (Princeton: The Art Museum, Princeton University, 1999), pp. 254–83.

19. Clunas, *Fruitful Sites: Garden Culture in Ming Dynasty China* (Durham: Duke University Press, 1996), pp. 106–7.

Jonathan Hay

The lofty scholars and recluses of the past often liked to take up the brush and paint landscapes for their own pleasure, but when they chose snow scenes it was usually to embody a feeling of noble loneliness, of freedom from vulgarity. For example, Wang Mojie's [Wang Wei 王維; 699–759] *Snow Along the River*, Li Cheng's [919–967] *Flying Snow in Ten Thousand Mountains*, Li Tang's [ca. 1050–after 1130] *Pavilions in Snowy Mountains*, Guo Zhongshu's [ca. 910–977] *Along the River in Clearing Snow*, Zhao Songxue's [Zhao Mengfu] *Yuan'an Sleeping in the Snow*, Huang Dachi's [Huang Gongwang, 黃公望; 1269–1354] *Clearing Snow in Nine Mountains*, and Wang Shuming's [Wang Meng] *Planked Roads in Sword Mountains*—all of these are works famous past and present, their names on everyone's lips, and I have been fortunate to see them all. In every case, I have wanted to copy them, but to my shame I have been unable to set brush to paper. In the winter of *wuzi* [1528], while Wang Chong and I lodged at a priest's cottage on Mt. Lengjie [i.e., Zhiping Temple], snow was piled up several feet deep, a thousand mountain peaks had turned from emerald to white, and myriad trees lay frozen and prostrate. Chong brought out some fine paper and asked me to paint. Contentedly, moistening my brush, I started this composition, *Heavy Snow in Mountain Passes*. Unable to complete the work, I took it home. I worked on it on and off for five changes of season before it was completed. My brushwork is awkward and flawed, and I have been incapable of capturing more than a ten-thousandth of the ancients; still, my intention to convey feeling and illuminate moral purity is probably not completely unachieved.

古之高人逸士，往往喜弄筆作山水以自娛，然多寫雪景者，蓋欲假此以寄其孤高拔俗之意耳。若王摩詰之《雪谿圖》、李成之《萬山飛雪》、李唐之《雪山樓閣》、閻次平之《寒巖積雪》、郭忠恕之《雪霽江行》、趙松雪之《袁安臥雪》、黃大癡之《九峰雪霽》、王叔明之《劍閣圖》，皆著名今昔，膾炙人口，余幸皆及見之，每欲效倣，自歉不能下筆。曩於戊子冬同履吉寓於楞伽僧舍，值飛雪幾尺，千峰失翠，萬木僵仆，履吉出佳紙索圖，稱興濡毫，演作關山積雪，一時不能就緒，嗣後攜歸，或作或輟，五易寒暑而成，但用筆拙劣，不能追蹤古人之萬一，然寄情明潔之意，當不自減也。

Wen is seemingly quite explicit about the problem that preoccupied him during the five years it took him to paint the scroll; but it might be more accurate to say that he is explicit about one problem that preoccupied him, since the real difficulty of the project may have lain elsewhere—the talkativeness on one point may, in other words, have as part of its purpose to distract our attention from a reticence on some other, perhaps more important issue. The point on which he is forthcoming is one of ancients and moderns. He tells us that he took Wang Chong's request as an opportunity to come to terms with a genre of painting that went back to the Tang dynasty, of which he had been able to see seven examples that in his time were considered to be masterpieces. The genre was that of the snowy landscape; he apparently had the history of this genre in his mind from the moment he started the composition in 1528. On the surface at least, it was the difficulty of doing justice to the tradition of snow-covered landscapes that dragged out the project.

There is nothing inherently improbable in this. The antecedent paintings that Wen lists, insofar as they are knowable today, are very diverse, and it would have been no easy matter for him to develop a new work that spoke to this diversity. At the simplest level, some are handscrolls, others hanging scrolls; some are works on paper, others on silk; most are landscapes, but at least one is a genre painting; and the styles, covering several centuries, are necessarily widely divergent. One may be sure, therefore, that Wen saw the snow-covered landscape tradition as a challenge, yet one for which he found a straightforward solution. Despite the variety of models he cites, his own composition is clearly based on one attributed to Wang Wei, which he would have known through one of several versions entitled *Riverbank After Snow, After Wang Wei* (*Mo Wang Mojie Jianggan xueji tu* 摹王摩詰江干雪霽圖); these purported

to be copied by Yan Wengui 燕文貴 (fl. ca. 970–1030) of the Wang Wei original (*Fig. 10*). No fewer than three of these are today in the collection of the National Palace Museum, Taipei.[20] It is not surprising, therefore, that the first artist he cites is Wang Wei. In fact, in 1539, when Wen Zhengming came to make a second version of his painting for Wang Shou, he added an inscription to the new painting that presents it specifically as a response to Wang Wei without mentioning any other artists.[21] Although in both cases Wen specifically mentions a composition entitled *Snow Along the River* (*Xuexi tu* 雪溪圖), this title corresponds to none of the surviving Wang Wei snowscape attributions, and judging by the visual evidence should probably be taken as a reference to the *Riverbank After Snow* (*Jianggan xueji tu* 江干雪霽圖) compositional type.

Wen Zhengming's greatest challenge lay outside the realm of style. Early in his inscription, he obliquely mentions this. Introducing the masterpieces of the past, he attributes to them a shared purpose: "to embody a feeling of noble loneliness, of freedom from vulgarity." Then, toward the end of the inscription, he returns to this idea when he assesses, with understated but unmistakeable pride, the results of his efforts: "still, my intention to convey feeling and illuminate moral purity [*jiqing mingjie zhi yi* 寄情明潔之意] is probably not completely unachieved." This articulates the concept of the moral individual that was a central concern of the Stone Lake group.[22] Wen's comments are not only relevant to the style of the painting; they also speak to the iconography and to the theme of the painting. Consider what is represented: isolated houses, temples, villages, a city, iced-in boats, hermits, and, above all, travellers. All of these are knit together into a narrative. The first section (*Figs. 9-1, 9-2*) is built around a solitary rider passing over a planked bridge; this is followed by a second section, the thematic center of which is a second rider emerging from the lakeside forest (*Fig. 9-3*). The third section is dominated by three riders setting out across the ice (*Fig. 9-4*); the fourth is keyed to the solitary rider arriving at the other side (also in *Fig. 9-4*) A fifth section has two riders, following different paths (*Fig. 9-6*); a pair of intertwined trees ahead suggests a friendship between them, interrupted by separation—are these trees a symbol for the friendship of Wen Zhengming and Wang Chong? The figures of the sixth section are not travellers but inhabitants of the homes shown (*Fig. 9-8*). The seventh section has figures on foot, near a city gate (*Fig. 9-9*). The eighth and last section (*Figs. 9-10, 9-11*) takes us back out into the wilderness, here sheer mountains. The heroes of this painting wander, for the most part, through the wilderness; not aimlessly, but toward the city. What kind of metaphor is this?

The terms of the argument I have been developing here suggest a layered interpretation. The protagonists of the narrative can be taken to be, on one level, members of the Stone Lake group, and on another level some wider community of literati, whether of Suzhou alone or the region or even the nation. The pines and other trees and bamboo,

20. *Gugong shuhua tulu (Illustrated Catalog of Painting and Calligraphy in the National Palace Museum)*, vol. 15 (Taipei: Guoli gugong bowuyuan, 1997), pp. 209–12, 219–21, 223–25.

21. National Palace Museum, *Ninety Years of Wu School Painting* (Taipei: Guoli gugong bowuyuan, 1975), pp. 266–67.

22. For Wen Zhengming's moral credo written in 1542, see *Wen Zhengming ji*, vol. II, p. 1307.

Jonathan Hay

growing amid the snow and ice, function as symbolic doubles and multiplications of the few human figures. In a number of cases, figures and trees are brought into a conspicuously close formal relationship, as if to underscore the point. The wilderness landscape through which the men move is thematically ambiguous in a way that complements the ambiguity of the figures. One can equally and easily read it as a local landscape outside the protective walls of the city, or as a national landscape on the model of monumental Song landscape compositions. Interpretation has to include both, and ultimately depends on one's understanding of the wintry wilderness as social metaphor. Few will disagree, I think, that the wilderness here alludes not only to the travails of the examination process, but also to the disappointments of "success." As such, it is a far bleaker commentary on contemporary life than Wen's pre-Beijing (1517) snowscape for Cai Yu, *Deep Snow over Streams and Mountains* (see *Fig. 7*), which he constructed as a metaphor of the arduous circumstances resulting from repeated failure in the examinations, in which the gentlemen-protagonists nevertheless pursue their study undaunted.

The above bleak interpretation of the wilderness, however, to my mind coexists in the handscroll with the second and rather different one that I suggested earlier for *Cascading Falls in a Pine Ravine*. "Wilderness" was not simply the opposite of the "state's" orbit—*ye* 野 was not simply the opposite of *chao* 朝. Wilderness was equally a space of independence and self-reliance, and in the world of Wen Zhengming and his circle, that space was fundamentally urban and commercial. It seems reasonable, therefore, to characterize the protagonists of this narrative as engaged in a difficult moral journey in which they had to balance their attraction to what the state and the city each had to offer them with their inability to wholeheartedly embrace the values of either. Here, too, Wen Zhengming was seeking to exalt a type of moral integrity that he believed Wang to embody, and was seeking to embody himself. The hanging scroll of the previous year monumentalizes reclusion; its concern is with social and moral positioning. The handscroll shifts the emphasis onto the passage of time; it monumentalizes the moral journey through life. It also—and this is no small feat—places that journey on the stage of history. This is why the elaborate art historical references were necessary, even though in strict art historical terms they might easily have been dispensed with. The lineage that they establish is ultimately one of literati as moral actors.

The Aesthetic of Disjunction

In conclusion, let us consider the two paintings within a larger art historical context. Their lasting significance for the history of Chinese painting lies, I believe, in their structural experimentation, and more specifically in Wen Zhengming's introduction of disjunction as a structural principle. In *Heavy Snow on Mountain Passes*, the disjunctiveness is partly a matter of scale, which is not nearly monumental enough for its subject. Moreover, as one proceeds through the scroll, one becomes aware of a second type of disjunction as well. The spatial structures of the successive sections making up the landscape are willfully contrasted, in some places almost to the point of incoherence. As a result, the narrative continuity centered on the figures is given a troubled and troubling psychological

undercurrent. In *Cascading Falls in a Pine Ravine*, the compositional structure is itself disjointed: treetops visibly suture the break between the upper and lower sections, but the unity of the whole remains in question. Moreover, the artist uses tree trunks both to frame and to separate the figures in the foreground, thereby simultaneously binding the figures together and alienating them from one another. What should be a vision of contentment is instead shaded by anxiety. Traditionally, of course, the kinds of stylistic feature to which I am pointing have been explained as archaistic. Archaism, however, cannot account for their psychological effects, which would necessarily have been felt as contemporary—or, if one wishes—modern. In both paintings, it is as if the project of monumentalizing a certain ideal could only be achieved at the price of keeping the ideal at a psychological distance. The formal disjunctions are thus symptomatic of a still deeper disjunction in the thematics of the works. *Heavy Snow on Mountain Passes* and *Cascading Falls in a Pine Ravine* together mark the point at which Wen Zhengming's practice expanded from one that was still basically affirmative in the Shen Zhou mode, although a certain self-consciousness had already crept in by the late 1510s, toward one that was more complex, accommodating also a new type of painting in which he tried *both* to affirm *and* to face up to the limits of possibility of its realization. From 1527 until his death in 1559, the latter, conflicted approach would characterize his most ambitious works.

Since pictorial structure is fundamentally concerned with order, much was at stake in Wen Zhengming's experimentation. Painting in China, on the model of the *shi* 詩 form of poetry, had an age-old function of revealing the underlying order of the world.[23] This function was only rarely thematized explicitly; rather, it provided the substratum of meaning on which all the other specific thematic work of painting was undertaken. Visually, the revelatory work took form in the deep structure of the picture, governing aspects as basic as the use of the primary axes, relations of scale, integration of space and time, and narrative relation of figures to their environment. Elsewhere, I have suggested that what is involved is a cosmology specific to painting; by this I mean the capacity of painting to articulate a social and metaphysical cosmology in its visual structure.[24] To create pictorial order had ramifications far beyond the internal logic of picture-making. The many accounts of Chinese painters approaching the act of painting as a ritual activity are bound up with this issue, for to *reveal* was either to externalize or to internalize an order in which much more was at stake than merely formal concerns.

Down the centuries, the revelatory function of Chinese painting was radically reconceived several times, and therefore was very different in 1550 from what it had been in, say, 950, when Li Cheng was painting. By the sixteenth century, order was starting to become explicitly tied to subjectivity.[25] A particular aspect of this problem con-

23. Stephen Owen, *Traditional Chinese Poetry and Poetics: Omen of the World* (Madison, Wis.: University of Wisconsin Press, 1985).

24. Hay, *Shitao*, pp. 279–80.

25. On this historical development, see John Hay, "Subject, Nature, and Representation in Early Seventeenth-Century China," *Proceedings of the Tung Ch'i-ch'ang International Symposium*, ed. Wai-ching Ho (Kansas City, Mo.: Nelson-Atkins Museum of Art, 1992), pp. 4.1–4.22.

Jonathan Hay

cerns the place that is held within the pictorial order by the human figures that signify subjectivity iconographically. With Shen Zhou's work, we are still in a world where the experiencing subject aligns itself with, or at least situates itself in relation to, a stable and coherent pre-existing order—an order that can be traced directly back through Ni Zan 倪瓚 (1301–1374), Huang Gongwang, and Wang Meng to the monumental landscapes of the tenth and eleventh centuries (see *Walking with a Staff* [*Cezhang tu* 第杖圖]; *Fig. 11*). Of course, there are important historical differences between the Ming painter and his Yuan predecessors. The visual order of Shen Zhou's paintings is more intimate and local, though this has its origins in what Richard Vinograd has called the "landscape of property" of Wang Meng.[26] It functions as a visual counterpart to a social order centered on a gentry class that assumed paternalistic responsibilities toward its tenants and toward the land of which it had the stewardship. Nonetheless, the emphasis on stability and unity is symptomatic of an underlying continuity with the pre-Ming past. Only the prominence of the self-referential figure, seen in its centrality and scale, quietly announces the arrival of a world in which the subject will claim the right to reinvent in its own image the order it inhabits.

This reinvention first becomes visible in the early sixteenth century, in the more dynamic of Tang Yin's 唐寅 (1470–1524) landscapes and the more theatrical of Wen Zhengming's figure-in-landscape compositions. However, Wen Zhengming post-1527 paintings for Wang Chong opened the way for the far more radical exploration of new aesthetic territory in the increasingly disjunctive of the artist's late works. In these paintings, the psychological center as defined by the focal human figure or figures, which in Shen Zhou's work had always been a safe position, is transformed by Wen Zhengming into a position of insecurity and anxiety. The figural embodiments of subjectivity in the paintings are either marginalized, as in a work for Wang that I have not discussed here, *Farewell at the Halting Clouds Lodging* (*Tingyun guan yanbie tu* 停雲館言別圖) of 1531; or they are left exposed (*Heavy Snow on Mountain Passes*); or they are placed under spatial pressure from the surrounding environment (*Cascading Falls in a Pine Ravine*). This exploration of insecurity reaches an extreme in such late masterpieces as *Verdant Pines by a Clear Stream* (*Maosong qingquan tu* 茂松清泉圖) of 1542 (*Fig. 12*) and *A Thousand Cliffs Contend in Splendor* (*Qianyan jingzhu tu* 千巖競秀圖) dated to 1548–1550 (*Fig. 13*). In the latter paintings, the problematization of the psychological center is echoed in the larger formal structure of the landscape, which in several places takes a disjunctive pictorial vision to the edge of incoherence and instability. There seems to be an inescapable connection between this pictorial disquiet and the fact that the real-life referents of the protagonists of Wen Zhengming's paintings were often elite males who did not have the security of a stable gentry existence. To one degree or another, theirs was instead either the literati insecurity of surviving on the symbolic capital of their education and culture, or the equivalent mercantile insecurity of knowing their social privilege to depend on commerce. These men played a gentry role, but self-consciously, knowing there to be—to one degree or another –a disjunction between image and reality. By giving

26. Richard Vinograd, "Family Properties: Personal Context and Cultural Pattern in Wang Meng's *Pien Mountains* of 1366," *Ars Orientalis*, vol. 13 (1982), pp. 1–29.

their insecurity (which was also his own), visual form as disjunction, Wen Zhengming may be said to have problematized the ideological assumptions of literati painting as he had inherited them from Shen Zhou.

Modern art history has tended to associate formal disjunction with the seventeenth century, presenting Dong Qichang as its paradigmatic exponent. Dong went much further than Wen Zhengming—not surprisingly, in terms of the argument presented here, since he lived out a much sharper dichotomy between engagement in state values and urban professionalism.[27] His paintings achieve coherence through the relations among autonomous and sometimes unstable elements—relations which must be established by a participatory viewer (see *Poetic Feeling at the Qixia Monastery* [*Qixiasi shiyu tu* 棲霞寺詩意圖]; *Fig. 14*). As for the center (in the sense of an organizing focal point), it is abandoned in Dong's work: there are no figures to embody subjectivity, and no central position to accommodate such figures if they had existed. Instead, subjectivity is divided between a *nomadic* presence, potentially occupying any spot within the picture either as trace or as narrative implication, and a *somatic* presence, embodied in the totality of the form as landscape image.[28] Dong Qichang's debt to Wen Zhengming is so great that the relative silence with which Dong passes over the debt can only be explained as the result of an anxiety of influence. It was Wen Zhengming's late experiments in disjunction that made possible Dong Qichang's more radically disjunctive art. The fundamental contribution of Wen Zhengming's late work was the dismantling of the hierarchical cosmology that had descended in painting from the Song to the mid-Ming. For Dong Qichang, that dismantling was no longer enough— it was necessary to constitute a new coherence. Dong succeeded, as we know, but only at the price of establishing disjunction as the very principle of subjectivity.

Behind these questions of disjunction and subjectivity lurks the issue of authority. In *Snow on Mountain Passes* and *Cascading Falls in a Pine Ravine*, Wen Zhengming took the decisive first step in a longlasting pictorial reassessment of moral and cultural authority, without which Dong Qichang's later iconoclasm would have been unimaginable. At the beginning of this study, I wrote that this reassessment, in its broad lines, relativized the importance of the values associated with the hierarchical imperial cosmos by confronting them with the more fluid values of the commercial city. In effect, Wen used his paintings for Wang Chong to assert Wang Chong's practice and his own, and more generally the practice of the Stone Lake group, as embodiments of a moral and cultural authority that claimed relative autonomy with regard to both the state and the market. This authority looked for no legitimation other than its own claim and the resonance that this claim inspired in his contemporaries—a precedent that was not lost on Dong Qichang.[29]

27. Dong's intense engagement in painting as a commercial activity is now beyond doubt. See Shan Guoqiang, "The Tendency toward Mergence of the Two Great Traditions in Late Ming Painting," in *Proceedings of the Tung Ch'i-ch'ang International Symposium*, ed. Wai-ching Ho, pp. 3.9–3.10.

28. As John Hay has written ("Subject, Nature, and Representation in Early Seventeenth-Century China," pp. 4.15–4.16): "Tung Ch'i-ch'ang uses both trees and mountains as a body, and a physiological representation is essential to both."

29. See Richard M. Barnhart, "Tung Ch'i-ch'ang's Conniosseurship of Sung Painting and the Validity of His Historical Theories:

Jonathan Hay

Consider, for example, Dong Qichang's connoisseurship, which Richard Barnhart has demonstrated to be deeply flawed. Yet Dong's opinion had authority, essentially because he claimed this authority with unparalleled effectiveness, asserting his ability to recognize the true masterpieces of the past, and to know how the masters of the past were related to each other historically. By incorporating these claims into his practice of painting, he was also to legitimize his own art and reinforce his reputation as a connoisseur. Masterpieces by definition had authority, to which one gained access by being able to recognize or, better still, to own them. But what one notices, reading Dong Qichang's writings or his inscriptions, is that every painting that ever inspired him was by definition a masterpiece: *because* it had inspired him, it had to have that status. In other words, Dong's collecting, connoisseurship, theorizing, and practice of painting all mutually supported each other in asserting his general claim to an authority that was not only cultural but ultimately moral as well. Dong was helped, of course, by the extremely limited circulation of putatively early paintings. Few other individuals of the time had his opportunities to see so many of them, and by his later years, he had owned more of them at one time or another than any of his contemporaries. Increasingly, he was able to appeal to his *own* authority, and did. Finally, without trying to decide whether it functioned as a catalyst or a by-product, we should note that authority had value—it was desirable and profitable. In his paintings and calligraphy, Dong was selling not only the private creativity that we so admire today, but also a self-created guarantee that his own creative engagement with cultural tradition was significant for society. If the claims made by Wen Zhengming seem by comparison to be understated and relatively restrained, they nonetheless opened the road to Dong's more extravagant ambition.

Depending on the historical prism through which we view Wen Zhengming's art, different characteristics emerge. We have long known him to be a key figure in the history of "post-classical" Chinese painting, and as such a major "later" Chinese painter working in a context of cultural belatedness. More recently, Shih Shou-chien has viewed Wen Zhengming's painting through a dynastic prism and demonstrated in new ways that he also occupied a central place in the art history of the Ming dynasty. In this study, I, like Craig Clunas in some of his writing on the artist, have chosen the historical prism of modernity. Without suggesting that a view of Wen Zhengming's art through this prism in any way exhausts its significance, this essay has made the claim that certain important features of his painting can only be explained within a history of early modern painting in China. Our ultimate goal must be to integrate this type of explanation, like those offered by other kinds of analysis, into a broader, multifaceted history of Chinese painting that does justice to the manifold historical frames of reference in which painting was implicated at any moment.[30]

A Preliminary Study," in *Proceedings of the Tung Ch'i-ch'ang International Symposium*, ed. Wai-ching Ho, pp. 11.1–11.20.

30. For more detailed discussions of the theoretical problems involved in creating a multifaceted history of Chinese art along the lines suggested, see Jonathan Hay, "Toward a Disjunctive Diachronics of Chinese Art History," *Res: Anthropology and Aesthetics*, vol. 40 (Autumn 2001), pp. 101–12; and "The Diachronics of Early Qing Art: Palaces, Porcelain, Painting," in *The Qing Formation in World-Historical Time*, ed. Lynn Struve (Cambridge, Mass.: Harvard University Press, 2004).

文徵明「斷裂」的審美特質

Jonathan Hay

紐約大學藝術學院

　　文徵明(1470–1559)兩件最有名的作品《松壑飛泉圖軸》(1527–1531)與《關山積雪圖卷》(1528–1532)，皆爲亦徒亦友的王寵(1494–1533)而作。本文欲提出這兩件作品在文徵明轉而探索「斷裂」之審美特質的關鍵地位，因爲此番探索是1530、40至50年代時縈繞著文徵明與文派蘇州畫家的藝術追求。這兩幅畫可說改變了中國繪畫史的走向，因爲文氏在此處的成就很可能爲後來的董其昌(1555–1636)鋪路。故本文的另一主題即是探討「斷裂」的審美特質在早期現代（early modern）中國畫裡所扮演的角色與重要性。依筆者之見，其重要性有部分在於對道德與文化權威的重新評估；他們以更具流動性的商業城市價值，來因應具有強烈位階性格的帝國秩序，進而將帝國價值的重要性給相對化。

　　本文並不認爲透過「現代性」的歷史透析便足以窮盡文徵明藝術的一切意義，而是主張文氏繪畫中某些重要的特色只有從中國早期現代繪畫史（history of early modern painting）的觀察角度才得以解釋。我們的終極目標必得要整合這種類型的解釋，就像我們去整合其他分析方法而得的詮釋一樣，要將它們匯成更寬廣多面的中國繪畫史，才得以全盤了解這些畫作無時無刻不暗示著的多元歷史架構。

文徴明の分裂の美学

Jonathan Hay

ニューヨーク大学美術院

　文徴明(1470–1559)の最も有名な絵画の二点は、画軸「松壑飛泉図」(1527–1531)と長巻「關山積雪図」(1528–1532)である。どちらも弟子であり友人であった王寵(1494–1533)のために描かれた。本論では、文徴明が芸術的な分裂の探求に移行する上でこの二作品が決定的な位置を占めることを論じる。その分裂の探求とは1530、1540、1550年代を通して文徴明とその周囲の蘇州の画家達の心を満たしていたものと思われる。文徴明がここで達成したものが後の董其昌(1555–1636)の功績の道を開いたと言えるにしても、この二点の絵画は中国絵画史の方向を変えるのに貢献した。したがって本稿のさらなるテーマは、近代初期中国絵画における分裂の美学の役割と重要性である。筆者の見解では、その重要性は一つには道徳的、文化的権威の再評価にある。その再評価は、階層的な王室の秩序に関連する価値観の重要性を、商業都市のより流動的な価値観に直面させることにより相対化させた。

　本論では、近代という歴史的プリズムを通して見ると文徴明の芸術の意義が解消されるとは決して言うことなく、彼の絵画のいつくかの重要な特徴は、中国近代初期絵画史においてのみ説明可能であると主張する。われわれの最終的な目的は、他の種類の分析から提示されるものと同様、こうした説明をより広く多角的な中国絵画史へと統合することでなければならない。そうした絵画史とは、何時であれ絵画が関係した多様な歴史的視座を公平に評価するものである。

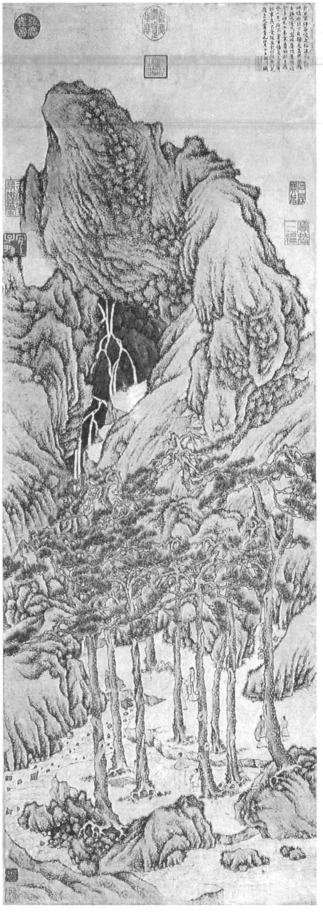

Fig. 1. Wen Zhengming (1470–1559).
Cascading Falls in a Pine Ravine, dated to
1527–1531. Hanging scroll, ink and color
on paper, 108.1 × 37.8 cm. National Palace
Museum, Taipei. *(detail on page 315)*

Jonathan Hay

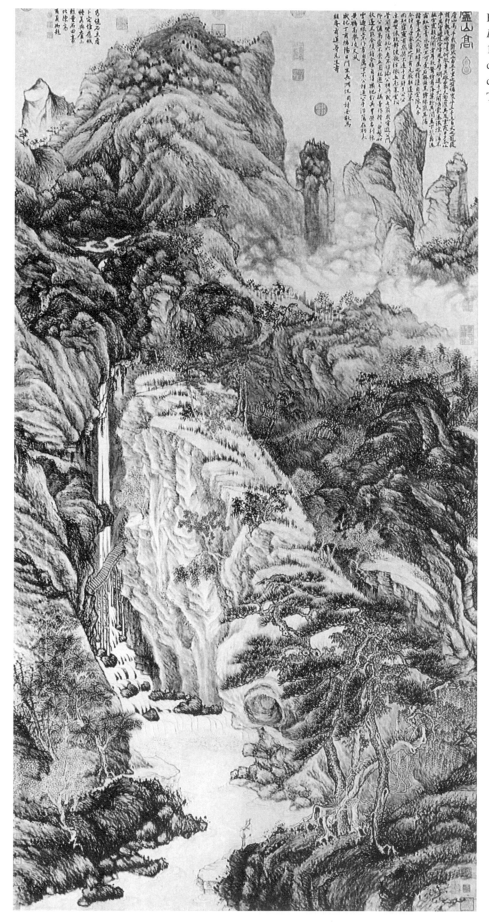

Fig. 2. Shen Zhou (1427–1509). *Lofty Mount Lu*, dated to 1467. Hanging scroll, ink and color on paper, 193.8 × 98.1 cm. National Palace Museum, Taipei.

Fig. 3. Wen Zhengming (1470–1559). *Gathering at the Orchid Pavilion*. Handscroll, ink and color on gold paper, 24.2 × 60 cm. Palace Museum, Beijing.

Fig. 4. Detail of Figure 1.

Fig. 5. Detail of Figure 1.

Jonathan Hay

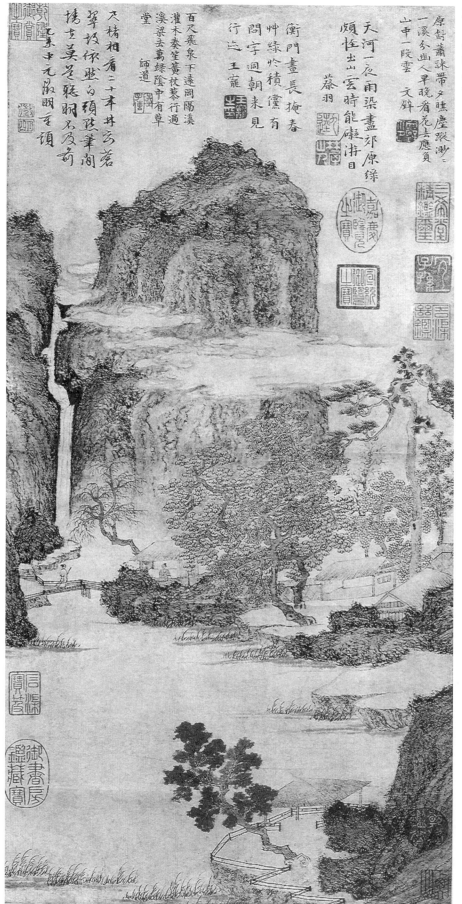

天河一夜雨染盡郊原綠
頗性出山雲時能礙游目
行述王寵
衡門晝長掩春
艸綠於積懨有
問宇迴朝未見
堂
百尺飛泉下遠岡隔溪
灌木奏笙黃枝蔡行過
溪梁去萬綠陰中有草
師道

原斷蕭誄帶夕暝塵蹤沙二
一溪分幽人早晚看花去應負
山中一段雲 文辭

蔡羽

翠枝依墜白頰泚筆間
楊去吳盡馳睨名及前
天椿相看二十年井玄茗
元末元皉明至頃

Fig. 6. Wen Zhengming (1470–1559). *Thatched Cottage in Green Shade*, ca. 1516. Hanging scroll, ink and color on paper, 58.2 × 29.3 cm. National Palace Museum, Taipei.

Section III: Literati Painting 351

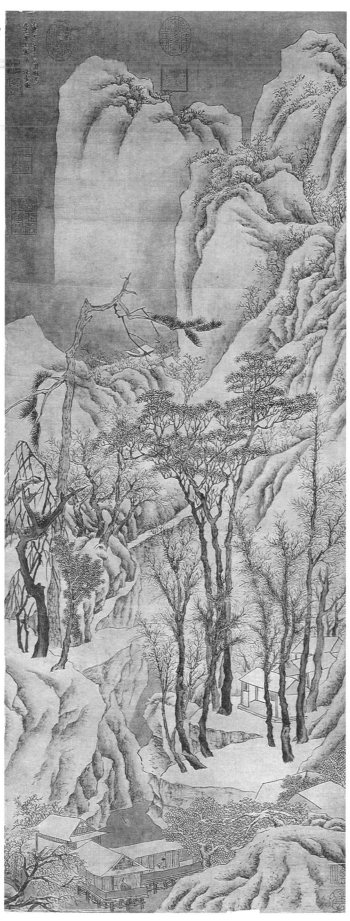

Fig. 7. Wen Zhengming (1470–1559). *Deep Snow over Mountains and Streams*, dated to 1517. Hanging scroll, ink and color on silk, 94.7 × 36.3 cm. National Palace Museum, Taipei.

Jonathan Hay

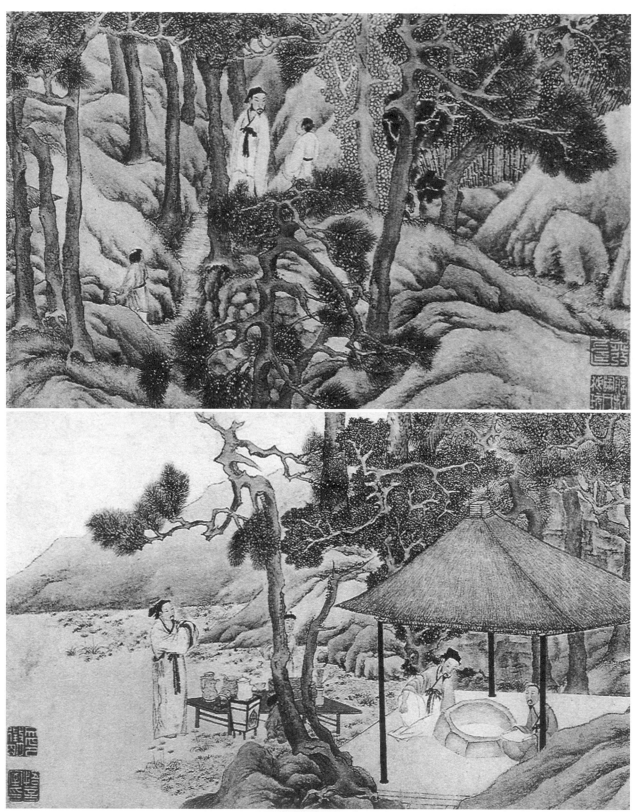

Fig. 8. Wen Zhengming (1470–1559). *Gathering for Tea at Mount Hui*, ca. 1518. Handscroll, ink and color on paper, 21.8 × 67 cm. Palace Museum, Beijing.

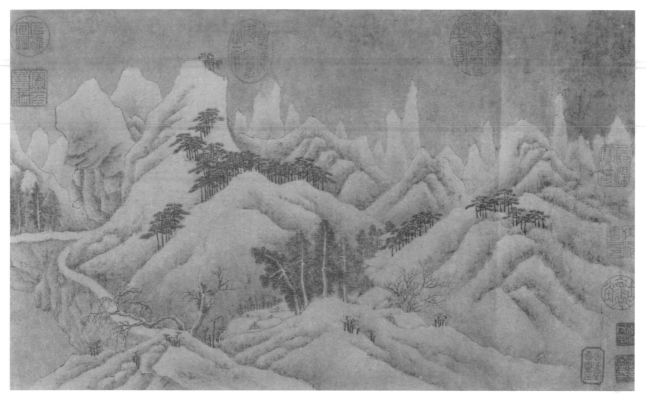

Fig. 9-1. Wen Zhengming (1470–1559). Section 1 of *Heavy Snow on Mountain Passes*, dated to 1528-1532. Handscroll, ink and color on paper, 25.3 × 445.2 cm. National Palace Museum, Taipei.

Fig 9-2. Section 2 of *Heavy Snow on Mountain Passes*.

Jonathan Hay

Fig 9-3. Section 3 of *Heavy Snow on Mountain Passes. (detail on page 331)*

Fig. 9-4. Section 4 of *Heavy Snow on Mountain Passes.*

Fig. 9-5. Section 5 of *Heavy Snow on Mountain Passes.*

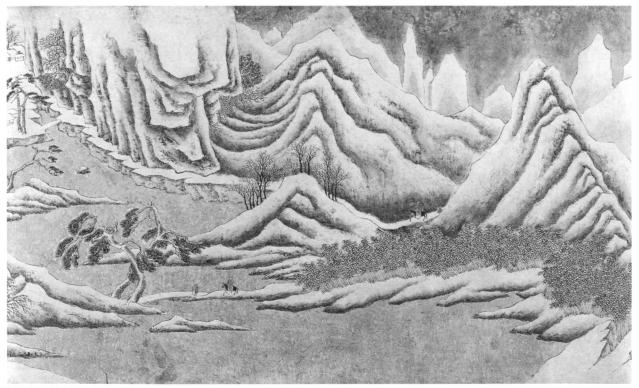

Fig. 9-6. Section 6 of *Heavy Snow on Mountain Passes.*

Jonathan Hay

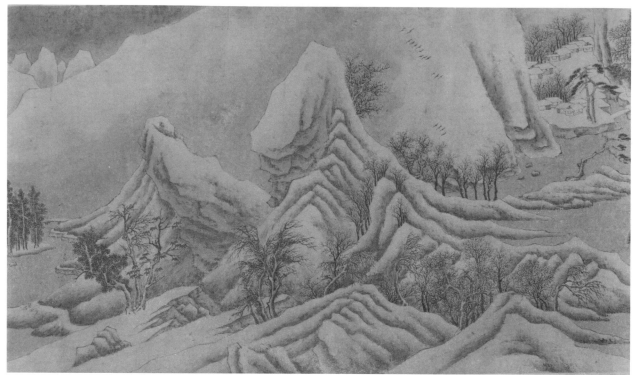

Fig. 9-7. Section 7 of *Heavy Snow on Mountain Passes.*

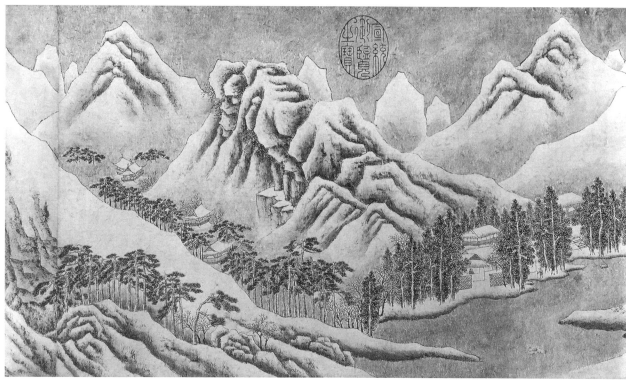

Fig. 9-8. Section 8 of *Heavy Snow on Mountain Passes.*

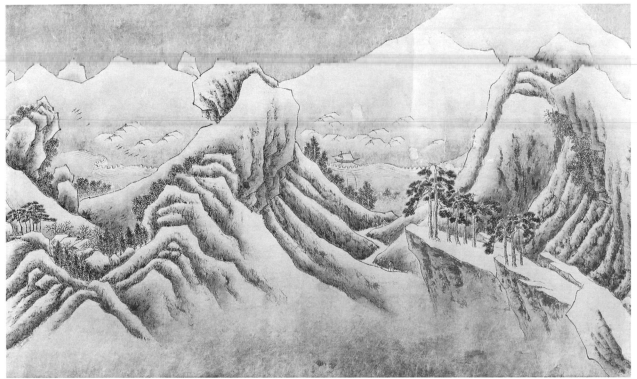

Fig. 9-9. Section 9 of *Heavy Snow on Mountain Passes*.

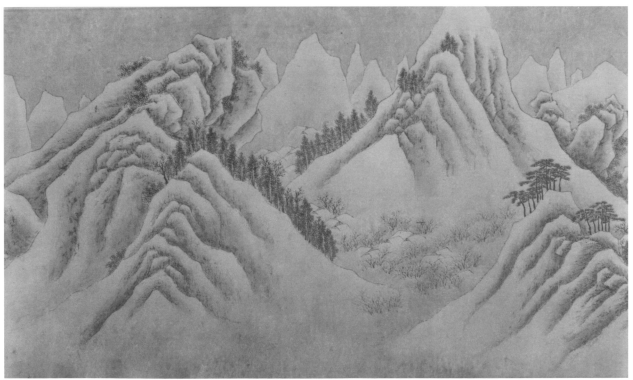

Fig. 9-10. Section 10 of *Heavy Snow on Mountain Passes*.

Jonathan Hay

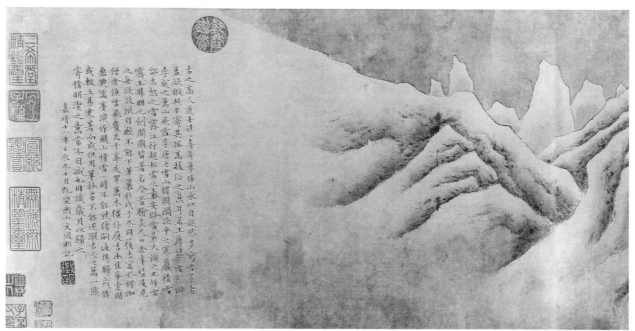

Fig. 9-11. Section 11 of *Heavy Snow on Mountain Passes*.

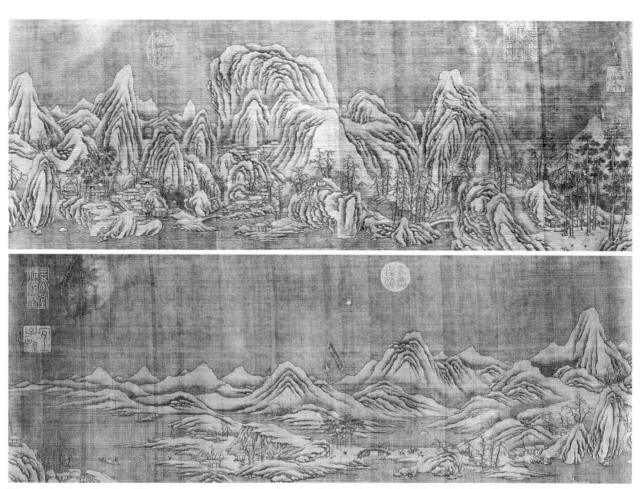

Fig. 10. Attributed to Yan Wengui (act. ca. 980–1010). *Riverbank After Snow, After Wang Wei*. Handscroll, ink and color on silk, 24.8 × 151.1 cm. National Palace Museum, Taipei.

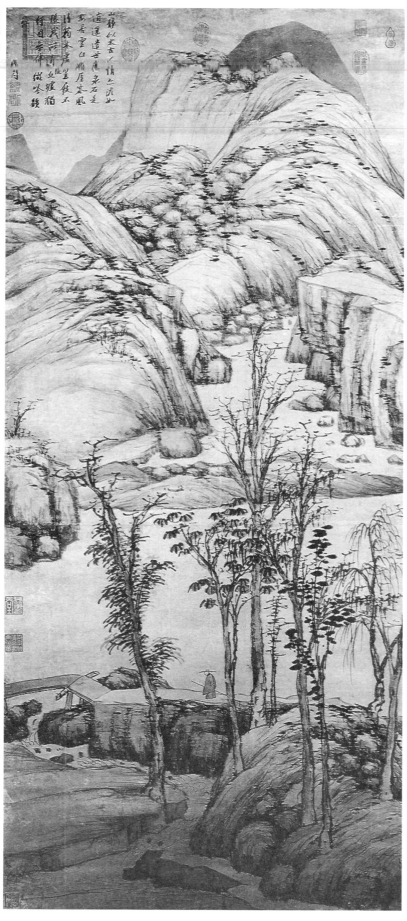

Fig. 11. Shen Zhou (1427–1509). *Walking with a Staff*, ca. 1485. Hanging scroll, ink on paper, 159.1 × 72.2 cm. National Palace Museum, Taipei.

Jonathan Hay

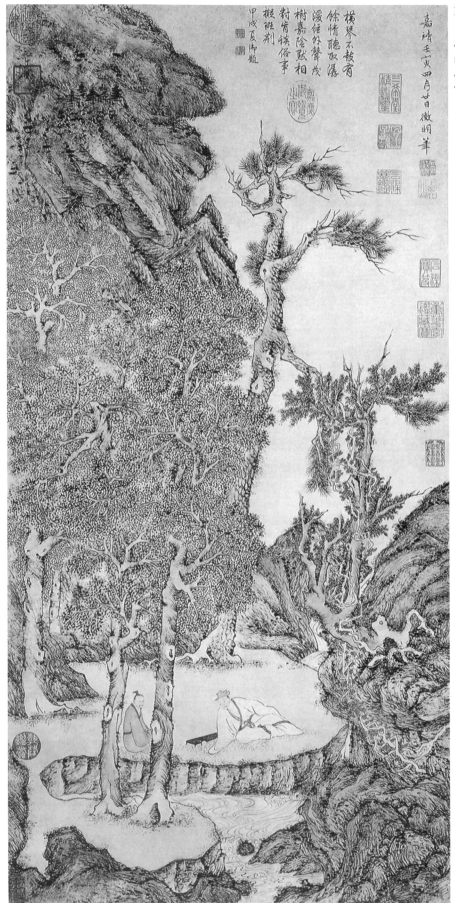

橫琴不疲有
餘情聽取潺
湲往知聲茂
樹嘉陰默相
對肯徇俗事
擬擬荊
甲戌夏御題

嘉靖壬寅四月十日徵明筆

Fig. 12. Wen Zhengming (1470–1559). *Verdant Pines by a Clear Stream*, dated to 1542. Hanging scroll, ink and color on paper, 89.9 × 44.1 cm. National Palace Museum, Taipei.

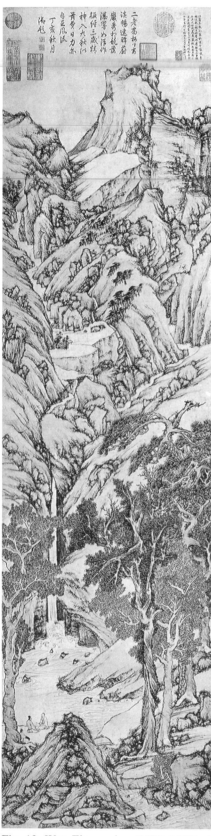

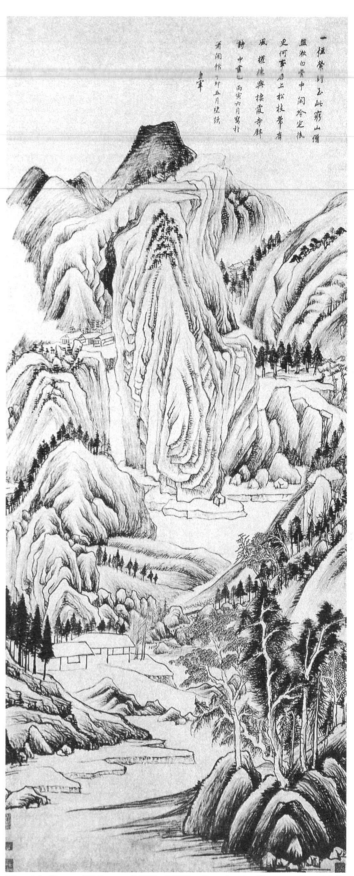

Fig. 13. Wen Zhengming (1470–1559). *A Thousand Cliffs Contend in Splendor*, dated to 1548-1550. Hanging scroll, ink and color on paper, 132.6 × 34 cm. National Palace Museum, Taipei.

Fig. 14. Dong Qichang (1555–1636). *Poetic Feeling at the Qixia Monastery*, dated to 1626. Hanging scroll, ink on paper, 133.1 × 52.5 cm. Shanghai Museum.

362 *Jonathan Hay*

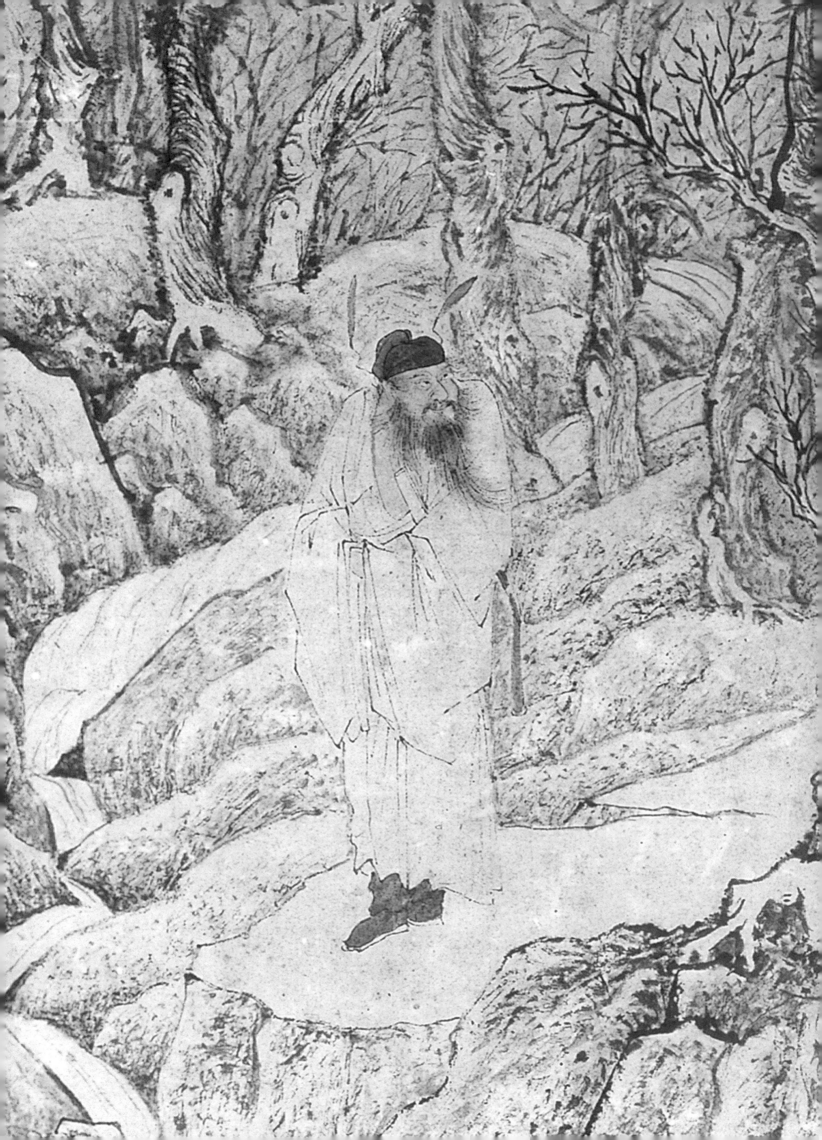

Wen Zhengming, Zhong Kui, and Popular Culture

Shih Shou-chien

Institute of History and Philology, Academia Sinica, Taipei

As the historical bearers of power and academic learning, members of the elite class in China have traditionally held little regard for those they considered beneath them and for the popular culture by which such commoners lived. In an effort to assert their social preeminence and simultaneously to increase it by widening the social gap between themselves and the general public, the privileged often resorted to censure of popular culture as a means of demonstrating their superiority. At the same time, their condemnations of popular culture also effectively served to bulwark them against its attractions. Such vehement disdain reveals their underlying anxiety and vulnerability, for ultimately they were not only unable to suppress popular culture but even to resist its allure. This contradiction informs the tension that characterized the attitudes of the Chinese elite class toward popular culture.

In the late eleventh century, the defining interests and attitudes of literati culture began to coalesce in China, and by the sixteenth century the literati had become fully self-aware and viewed their class as a separate entity. Along with the scholars' wish to distinguish themselves utterly from commoners came the acute fear of assimilating in any way to popular culture. Social advancement and the respect of the masses awaited those who mastered the scholarly role, and these rewards affirmed the scholar's place among the elite class. Commoners who managed to acquire extensive education and then to pass the civil service examinations emerged thereby from the commoner class to the possibility of political and economic power and a lifestyle vastly different from their previous one.

Nonetheless, attractive as the newly acquired elite values, perquisites, and ways might appear to be, the old values and ideals of the commoner ethos were pervasive and persistent. Therefore, throughout its evolution, the relationship of the literati class with popular culture was continually changing. As popular culture was formed by the masses, based on their ideals, it was easily accepted and understood by them. It also possessed great power to insinuate itself into higher culture and thereby transcend social divides, and for this reason it constituted a continual perceived threat to elite culture. In addition, the literati were never a hereditary caste. Acquisition of learning could promote one to an elevated status, but it did not guarantee maintenance of that status. Political or economic vicissitudes could easily result in exile from the scholar class and a return to the life of the commoner.[1] This two-way bridge between the classes furthered the scholars' need to build and affirm their own culture as a distinct entity. At the beginning of the sixteenth

1. For a detailed discussion of the Chinese scholar-elite and related problems of social mobility, see Ho P'ing-ti's classic study, *The Ladder of Success in Imperial China: Aspects of Social Mobility, 1368–1911* (New York: Columbia University Press, 1962).

century, which marked the pinnacle of such efforts, an established canon of style and expression developed in literati painting.

Wen Zhengming 文徵明 (1470–1559) may be considered the instigator and leader of this movement, steadily and deliberately working to advance a culture specific to the literati. Approved forms of artistic expression included plays, poetry, and novels, but painting emerged as the medium most valued by the scholar-official. Therefore, the creation, appreciation, bestowal, and exchange of paintings were adopted as defining acts of scholarly life, emblematic of and prized by the elite class. The immediate identification of these activities as being solely symbolic of the literati further crystallized their unique culture, while also distinguishing it absolutely from that of others.[2]

For much of his life, Wen Zhengming was the leader of literary and art circles in the Jiangnan 江南 region. He served as a paragon for his peers, and his paintings, whose subjects included gardens, literary gatherings, travel, friendship, and art appreciation, were viewed as depictions of the ideals of scholarly life. So influential were his works on contemporaries and succeeding generations that such productions of the Wu 吳 school have been considered the zenith of sixteenth-century Chinese painting.[3] For centuries, Wen Zhengming and his preferred painting subjects endured as epitomes of scholarly life and continued to be emulated in real life. As embodiments of elite ideals, both the man and his works exercised enormous influence over social realities in traditional China.

Nevertheless, despite persevering efforts to adopt principles and activities defined as elite, the literati could never completely sever themselves from the commoners' way of life. This proved especially true for customs that transcended social class, including the celebration of such holidays as the Chinese New Year. The occasion represents not only a holiday but also a time when bad luck is ushered out and good fortune welcomed. This generally accepted belief was reflected in the activities that marked the celebrations. Although these rites and rituals were primarily practiced by commoners, even scholars participated to some degree. An example of a universally accepted cultural phenomenon, associated with the imminent arrival of good fortune in the new lunar year, is the legendary figure of Zhong Kui 鍾馗. By investigating the attitudes of scholars toward Zhong Kui, we can illustrate the relationship that existed between the elite class and popular culture.

Examination of a sixteenth-century painting, Wen Zhengming's *Zhong Kui in a Wintry Forest* (*Hanlin Zhong Kui tu* 寒林鍾馗圖; *Fig. 1*), can shed light on the intricacies of this relationship. The inscription on the painting reveals that it was playfully created on New Year's eve of the *jiawu* 甲午 year, a date that corresponds to 1 February 1535, when the artist was sixty-five years old. As the celebrated leader of literati life and staunch proponent of a unique elite culture, Wen Zhengming would have shunned themes and subjects popular among commoners. In support of this as-

2. Shou-chien Shih, "The Landscape Painting of Frustrated Literati: The Wen Cheng-ming Style in the Sixteenth Century," in *The Power of Culture: Studies in Chinese Cultural History,* ed. Willard J. Peterson *et al*. (Hong Kong: The Chinese University Press, 1994), pp. 218–46.

3. Anne De Coursey Clapp, "Wen Cheng-ming: The Ming Artist and Antiquity," *Artibus Asiae* Supp. XXXIV (Ascona, 1975), pp. 89–94.

sertion, his repertory holds no other large figure paintings. Yet this work, which is quite large by his standards, has for its subject a folk figure.

Two questions can help to elicit what this painting reveals about the interrelationships between the elite and commoner cultures and classes. First, what are the specific peculiarities of this painting, and, second, why would Wen Zhengming have chosen to paint this subject?

Zhong Kui in a Wintry Forest: A Question of Authorship

As the title indicates, this work comprises two main parts: a wintry forest background and the figure of Zhong Kui. Measuring 69.6 centimeters tall by 42.5 centimeters wide, this is not an especially large hanging scroll, but the figure of Zhong Kui measures twenty centimeters in height and occupies a significantly large portion of the space depicted therein. Figures in Wen Zhengming's paintings are often seen as minute details within much vaster landscapes. Rarely did he depict a full-length figure of such size and degree of detail as seen here to serve as the focal point of a painting.

Among Wen Zhengming's extant works, the only other example of a such focal figure occurs in a painting dated to 1517 and entitled *Goddesses of the Xiang River* (*Xiang jun Xiang furen tu* 湘君湘夫人圖; *Fig. 2*). In this painting, however, the figures are neither especially large nor rendered with much detail. This is Wen's only surviving female figure painting, and its somewhat casual rendition would seem to suggest that figure painting was not Wen Zhengming's specialty. This conclusion, however, seems contradicted by Wen Zhengming's painting of Zhong Kui. In the figure in *Zhong Kui in a Wintry Forest*, both facial and bodily features are depicted in intricate detail. Moreover, pose and gesture are carefully rendered so as to suggest the character and temperament of the subject. These qualities imply an artist skilled in figure painting. The contrast with *Goddesses of the Xiang River* leads us to question whether Zhong Kui in fact was painted by Wen Zhengming.

Turning our attention to the rest of the Zhong Kui painting, the landscape portion is very much characteristic of Wen Zhengming's style, for the same bare trees and sinuous river appear in his painting of 1542 entitled *Wintry Forest after Li Cheng* (*Fang Li Cheng hanlin tu* 仿李成寒林圖; *Fig. 3*). In addition to the overall composition, similarities in brushwork and the use of ink also reinforce the opinion that the two landscapes were painted by the same hand. The rugged appearance of the rocks and hills surrounding Zhong Kui was produced using a series of dry brush strokes that are also evident in the foreground rocks of Wen Zhengming's painting *Yingcui Pavilion* (*Yingcui xuan tu* 影翠軒 圖) in the National Palace Museum, Taipei. A wetter brush and rapid strokes created the bare, curvilinear branches of the trees around the figure of Zhong Kui. These effects appear also in the trees of the 1519 painting *Scholar of the Lofty Mountains* (*Juehuo gaoxian tu* 絕壑高閑圖; *Fig. 4*) and other works that were done by Wen Zhengming from the 1530s, such as *Forest, River, and Fisherman after Dong Yuan* (*Fang Dong Yuan Linquan jing diao tu* 倣董源林 泉靜釣圖).[4]

4. *Ibid.*, pp. 77–88.

Shih Shou-chien

From these comparisons, it is evident that the background landscape of *Zhong Kui in a Wintry Forest* was indeed painted by Wen Zhengming, but the figure of Zhong Kui himself was most likely by another hand. It was sometime during the 1530s that Wen Zhengming began to foster relations with Qiu Ying 仇英 (ca. 1494–1552), a professional painter from Suzhou. Unlike literati artists, whose repertoire was often restricted, Qiu Ying was skilled in a wide variety of genres. He excelled especially in figure painting, as demonstrated by his keen observation and skilled naturalistic renderings in *Spring Evening Banquet at Taoli Garden* (*Chunye yan Taoli yuan tu* 春夜宴桃李園圖; *Fig. 5*). In this painting, a scholar seen in profile raises his head while stroking his beard thoughtfully (*Fig. 5A*). His position and pose are such that one shoulder is angular, the other curved, resembling in this respect the figure of *Zhong Kui in a Wintry Forest*. More parallels appear in such details as the folds of the clothing. The hem of the right sleeve forms a lowercase "n" shape, and linear elements below indicate where the forearm rests. Although these two paintings differ in the thickness of the lines, both their general manner and specific details point to Qiu Ying as author of the Zhong Kui figure in Wen Zhengming's *Zhong Kui in a Wintry Forest*.[5]

To confirm this assertion, we must consider other aspects of the painting. Comparing Wen Zhengming's Zhong Kui in a wintry forest with the one in Qiu Ying's painting of *Boy from the Heavens* (*Tianjiang lin'er tu* 天降麟兒圖; *Fig. 6*), showing a child sitting on the shoulders of Zhong Kui, certain discrepancies between the two Zhong Kui figures appear. *Boy from the Heavens* illustrates an auspicious narrative which embodies movement, whereas in *Zhong Kui in a Wintry Forest* all is still and motionless. In *Boy from the Heavens*, Zhong Kui also has a prominent aquiline nose to symbolize his special status, while in *Zhong Kui in a Wintry Forest* it is lacking.

Qiu Ying often used this aquiline nose to identify singular individuals. For example, in his painting of 1540 entitled *Two Horses* (*Shuangjun tu* 雙駿圖; *Fig. 7*), the nomadic attendant has an aquiline nose to differentiate him from the Han Chinese figure. Compared with these two renderings, Zhong Kui in the wintry forest appears somewhat refined and elegant. These discrepancies may also point toward the particular relationship between Wen Zhengming and Qiu Ying, for Wen Zhengming perhaps may have directed Qiu Ying to paint the Zhong Kui figure as shown here. In fact, according to the inscription on *Goddesses of the Xiang River*, the collaboration between these two artists was not one of equals. Based on seniority and social status, Wen Zhengming was emphatically the superior figure in this artistic relationship. Accordingly, Qiu Ying would paint what Wen Zhengming wished, both in subject and in manner. This would thus account for the significantly different appearance of Zhong Kui seen in the wintry forest here.

The Tradition of Painting Zhong Kui

Why should a particular depiction of Zhong Kui have been so important to Wen Zhengming that he would enlist the collaboration of a celebrated figure painter but also prescribe exactly how that figure should look? Studying the

5. For Qiu Ying's style and his Zhong Kui painting, see Stephen Little, "The Demon Queller and the Art of Qiu Ying," *Artibus Asiae*, vol. XLV1, 1/2 (1985), pp. 5–79.

tradition of Zhong Kui paintings can help to disclose the unique qualities of the Wen-Qiu collaborative work, and may reveal for what purpose it was painted. It is generally acknowledged that the traditional image of Zhong Kui began with an eighth-century painting by Wu Daozi 吳道子 (act. ca. 710–760), made for the Tang emperor Xuanzong 玄宗 (r. 712–756). That painting is said to have been based on the appearance of a demon queller whom Emperor Xuanzong saw in his sleep.[6] The Zhong Kui legend itself dates even earlier. In surviving texts from the Six Dynasties period, we find quite a few people who adopted the personal name Zhong Kui for its auspicious connotations; one of these even dates from the fifth century. This practice would indicate that the Zhong Kui legend as we know it may have originated prior to the Tang dynasty.[7]

Zhong Kui and other ancient demon quellers, such as Fangxiang 方相, Shentu 神荼, and Yulu 鬱壘, constituted a subset of the category for protective deities. Sharing similar roles and traits, they likely originated within the same very distant past. As each region tended to cultivate its own pantheon of protective deities, even very widely known spirits took on differing local attributes and characteristics. Such thematic variations make it difficult to ascertain which early images of demon quellers in fact represent Zhong Kui. Wu Daozi's painting is thus significant for having established a canonical image of Zhong Kui—one that distinguishes him from other demon quellers.

Although Wu Daozi's painting no longer survives, we can still surmise its major components from related literary references. Of these, accounts of Emperor Xuanzong's dream of Zhong Kui are the most important source. To create his prototypical Zhong Kui, Wu must have started from an existing image-type of demon queller, such as representations of guardian figures in Buddhism, which would have been familiar elements of his repertoire. This figure he clothed as in the emperor's dream—in blue, with hat and boots, and one arm sleeveless. Its actions also illustrated the legend of the emperor's dream—attacking demons, gouging out their eyes, and eating their limbs. This demonic-looking subjugator of demons thus became the established iconography of Zhong Kui and the earliest mode of distinctive Zhong Kui painting.

By the middle of the Tang dynasty (about the period of Wu Daozi's activity), images of Zhong Kui as a demon queller were extremely popular. At the New Year, the emperor commonly bestowed Zhong Kui pictures with calendars on officials of the court. This custom became even more common during the succeeding Five Dynasties and Northern Song period.[8] Literary records document that artists at this time often sought new ways to depict Zhong Kui. Zhong

6. Shen Gua, *Mengxi bitan* (*Brush Talks from the Dream Stream*) (Taipei: Dingwen shuju, 1977), pp. 320–21. Translated into English in Mary Fong, "A Probable Second 'Chung K'uei' by Emperor Shun-chih of the Ch'ing Dynasty," *Oriental Art*, vol. XXIII, no. 4 (1977), pp. 427–28.

7. Hu Wanchuan, *Zhong Kui shenhua yu xiaoshuo zhi yanjiu* (*Studies on the Legend and Fiction of Zhong Kui*) (Taipei: Wenshizhe chubanshe, 1980), pp. 31–49.

8. Examples could be found in Ouyang Xiu, *Xin Wudai shi* (*New History of the Five Dynasties*) (Taipei: Dingwen shuju, 1980), p. 842; Su Che, *Luancheng ji* (*Collective Works of Su Che*) (*Sibu congkan chuanbian* edition) (Taipei: Taiwan shangwu yinshuguan, 1965), *chi* 3, *juan* 1, pp. 13a–b.

Shih Shou-chien

Kui's precise demon-quelling tactics were much debated, even discussing, for example, which finger he would have used for gouging out eyes.[9]

Withal, the Wu Daozi iconography of Zhong Kui persisted largely unchanged through the thirteenth century. During the reign of the Southern Song emperor Lizong 理宗 (r. 1224–1264), a scholar by the name of Chen Yuanjing 陳元靚 reported that some Zhong Kui paintings found on walls and doors also featured a female—Zhong Kui's younger sister. Her presence was a literary-artistic pun, since the character *mei* 魅 ("demon") has the same pronunciation as the character *mei* 妹 that means "younger sister." The images of Zhong Kui made at this time were said to be so frightening that they would not be hung during rites of ancestor worship, for fear they would frighten away the ancestral spirits.[10] An example of this type of image can be seen in *Illustration of Zhong Kui* (*Zhong Kui tu* 鍾馗圖, *Fig. 8*). Possibly produced in a workshop in Ningbo 寧波 around the thirteenth to fourteenth century, this figure is also shown as a guardian spirit wearing Zhong Kui's typical dress and attacking a demon.

As this formulaic image became increasingly widespread, its symbolism and style began to evolve. Still especially popular around the Chinese New Year, images of Zhong Kui were gradually imbued with greater auspicious meaning. From being a vanquisher of evil, Zhong Kui became also, by a natural progression, a summoner of good. The image of *Summoning Fortune* (*Zhijian laifu tu* 執劍來福圖, *Fig. 9*), found in the *Pantheon of Deities of the Three Teachings* (*Sanjiao yuanliu shoushen daquan* 三教源流搜神大全), is derived from a Yuan dynasty book of prints. In this print, the seated Zhong Kui figure resembles the pose of that of the spirit Erlang 二郎 in another work entitled *Investigating the Mountain* (*Soushan tu* 搜山圖), which also symbolizes the dispelling of evil. *Summoning Fortune*, however, also includes two bats (the word for which in Chinese is pronounced *fu* 蝠, a homonym for the character meaning "happiness" [福]), thereby further augmenting the auspicious symbolism that can be associated with the work.

A later image of a standing Zhong Kui with bats attests to the persistence of this symbolism. In the Ming dynasty painting *All Things Providential* (*Paishi ruyi tu* 百事如意圖) by Emperor Xianzong 憲宗 (the Chenghua 成化 emperor; r. 1465–1488) (*Fig. 10*), Zhong Kui appears here intent on capturing the bat that is seen flying in front of him. This portrayal lends a new urgency to the symbolism of Zhong Kui with bats, indicating the pursuit and acquisition of good fortune. Fortune-bidding and fortune-chasing Zhong Kui pictures reached a height of popularity during the fifteenth century and remained equally well-received thereafter.

Like hanging scrolls, the handscroll format was also popular during the Song and Yuan dynasties. Many handscrolls of that time depict Zhong Kui en marche. Two works, one by Yan Hui 顏輝 (*Fig. 11*) and the other by Yan Geng 顏庚, both active in the thirteenth century, are typical of such. In these paintings, Zhong Kui is accompanied

9. Huang Xiufu, *Yizhou minghua lu* (*Catalogue of Famous Painters of Yizhou*) (*Zhongguo shuhua quanshu* edition) (Shanghai shuhua chubanshe, 1993), vol. 1, p. 195.

10. Chen Yuanjing, *Suishi guangji* (*Extensive Record at the Time of the New Year*) (*Biji xiaoshuo daguan* edition) (Taipei: Xinxing shuju, 1978), *juan* 40, pp. 6b–7a.

by a troupe of demonic soldiers playing musical instruments and performing powerful feats of strength. Their actions illustrate the rites of exorcism (*danuo yi* 大儺儀) that were performed in the capital on New Year's Eve.

What did the rites of exorcism entail? According to Meng Yuanlao's 孟元老 *The Eastern Capital: A Dream of Past Splendors* (*Dongjing menghua lu* 東京夢華錄) of 1147 and Wu Zimu's 吳自牧 *Record of Dreams* (*Meng Liang lu* 夢梁錄; thirteenth c.), this ritual involved thousands of people, including performers enacting demon quellers, divine soldiers, demon messengers, and Zhong Kui. Marching to the beat of the drums, the parade of players would make their way to the city gates to drive out evil spirits.[11]

Although this custom was originally imbued with strong religious import, the paintings by Yan Hui and Yan Geng emphasize its theatricality; they present ritual as drama. In this drama, Zhong Kui no longer figures as the central demon-quelling figure, but is overshadowed by the demonic musicians and strongmen who accompany him.

This merger of the ceremonial and theatrical into a new genre, termed *nuoxi* 儺戲 (exorcism play), is also present in Gong Kai's 襲開 (1221–ca. 1307) *Zhongshan on an Outing* (*Zhongshan chuyou tu* 中山出遊圖). Gong Kai, born a subject of Southern Song, lived during the Yuan dynasty as a self-exiled Song loyalist, finding an outlet in his painting for political sentiments dangerous to express in words. Many of his paintings, such as *Zhongshan on an Outing* (*Fig. 12*), carried pointed political implications, which can be interpreted as satirical of Mongol rule over China.[12] The painting features Zhong Kui and his younger sister, both carried in sedan chairs, and an assortment of attendant demons. All *appear* eccentric, but their *actions* are not eccentric or violent in the least, thereby lessening the sense that this is an illustration of drama. Instead, the reference to theater appears in the sister's makeup, the flowers in the demons' hair, and all the costumes. The dress and makeup derive from a type of Yuan dynasty drama called *zaju* 雜劇 ("miscellaneous drama"). Dai Jin's 戴進 (1388–1462) *Night Travels of Zhong Kui* (*Zhong Kui yeyou tu* 鍾馗夜遊圖; *Fig. 13*) likewise shows the demons with flowers in their hair. Although Gong Kai's painting is a handscroll and Dai Jin's a hanging scroll, they are similar in their positioning and depiction of Zhong Kui. Both artists show him seated in a sedan chair carried by demons. Approximately a century separated the two artists, and whether or not Dai Jin borrowed from Gong Kai, it is evident that their manner of presenting Zhong Kui had continued current during that century.

The function of these Zhong Kui *nuoxi* paintings is still unclear. Possibly they served as a substitute for actual ceremonial parades, especially as few locales had the means to arrange such an enormous event. The actual parades also became simplified. For example, the Ming dynasty *zaju* entitled *Five Raucous Demons and Zhong Kui at the Celebratory Harvest* (*Qing fengnian wugui nao Zhong Kui* 慶豐年五鬼鬧鍾馗) required a cast of only six people.[13]

11. Meng Yuanlao, *Dongjing menghua lu* (Taipei: Guting shuwu, 1975), p. 620. Wu Zimu, *Meng Liang lu*, in *ibid.*, pp. 181–82.

12. Thomas Lawton, *Chinese Figure Painting* (Washington, D.C.: Smithsonian Institution, 1973), pp. 142–49.

13. Anonymous, *Qing fengnian wugui nao Zhong Kui*, in *Quan Ming zaju* (*Collection of Zaju Drama in the Ming Dynasty*), ed. Chen Wannai (Taipei: Dingwen shuju, 1979), vol. 10, pp. 6190–6253.

Shih Shou-chien

This type of processional piece would have been performed during the New Year or on specific occasions when demon quelling was necessary. The novel of life during the late Ming, *Plum in a Golden Vase* (*Jinping mei* 金瓶梅), relates one such occasion: five demons create a ruckus before the grave of Li Ping'er 李瓶兒 and are then subdued by Zhong Kui.[14]

A simplified *nuoxi* performance is depicted in the work *Five Rowdy Demons* (*Wugui naopan* 五鬼鬧判, *Fig. 14*). Discovered in the tomb of Wang Zhen 王鎮 (1424–1496), in Huai'an 淮安 Prefecture of Jiangsu Province, this scroll could have served a number of functions. It might have been only a prized possession of the deceased, but it could also have been placed in the tomb as a substitute for an apotropaic ritual. When Wang Zhen died, the collection of paintings entombed with him, including *Five Rowdy Demons*, consisted mainly of works by professional artists. *Five Rowdy Demons* was painted by Yin Shan 殷善 (act. 1410s–1460s), a painter attached to the Ming court, as were his son Yin Xie 殷偕 (ca. 1430s–1504) and grandson Yin Hong (1460s–1520s).

It is worth noting here that Yin Shan and Dai Jin were near contemporaries. They also seem to have employed similar symbolic references as well as pictorial modules in their painting practices. For example, the image of a demon carrying two buckets on a shoulder yoke appears in both paintings. At this time, a wide range of motifs pertaining to Zhong Kui seems to have been available, and no strict prescriptions fixed the imagery or composition of *nuoxi* paintings. So long as the iconographic meaning of the work was clear, artists were free to improvise as well as to repeat. For example, a stone engraving, dated to 1500, of an anonymous painting entitled *Zhong Kui at the End of the Year* (*Suimu Zhong Kui* 歲暮鍾馗) contains an image of Zhong Kui on a donkey.[15] A work attributed to Dai Jin (*Fig. 15*) from *Collection of Illustrations by Master Gu* (*Gushi huapu* 顧氏畫譜), a printed book containing reproductions of works of famous painters compiled by Gu Bin 顧炳 and published in the late sixteenth century, also shows Zhong Kui riding a donkey as well as the stock image of a demon carrying two buckets across his back on a shoulder yoke. The latter motif also shows up in Gong Kai's *Zhong Kui on an Outing*, in which Zhong Kui is not riding a donkey but carried in a sedan chair. By the end of the sixteenth century, a wide variety of "mix-and-match" images reliably evoked Zhong Kui and his entourage and kept their appeal fresh in the popular imagination.

Paintings of Zhong Kui could be used in two ways—to dispel evil and bring in good fortune. They could be hung on doors and walls to expel malevolent forces, or they could substitute for ceremonial processions. The paintings for doors and walls would act as guardians, and whether Zhong Kui was shown attacking demons or pursuing good fortune, the most important element was Zhong Kui himself. In the paintings that substituted for processions, the emphasis was on plot and narrative progression; Zhong Kui was a main character but no longer the sole focus, as the demons and their actions were used to convey the theatrical storyline.

14. Hu Wanchuan, *Zhong Kui*, p. 154.

15. *Zhongguo meishu quanji huihua bian* (*A Complete Collection of Masterpieces of Chinese Art: Painting Section*) (Shanghai: Renmin meishu chubanshe, 1988), vol. 19, p. 94.

Further forms and functions for Zhong Kui paintings arose over time. For example, the Qiu Ying painting *Boy from the Heavens* is a transformation of Zhong Kui paintings as door guardians who expel evil. In this painting, Zhong Kui's resemblance to a judge introduces a play on words, as the Chinese term for judge, *pan* 判, combines with the Chinese term for child, *zi* 子, to form a homonym for the phrase *panzi* 盼子, which means "blessing for sons." The images serving as procession substitutes evolved into a genre called *jiamei* 嫁妹, which refers to betrothing a younger sister; that phrase is also a homonym for "chasing away demons." Such rebus-puns, no doubt, lent even more interest to Zhong Kui and allowed such images to become the most sought-after illustrations of the New Year.

Returning to Wen-Qiu's *Zhong Kui in a Wintry Forest*, the differences between this and the paintings from the Zhong Kui apotropaic-auspicious tradition become evident. Thus, the question remains, what is the meaning of the Wen-Qiu painting, and why did Wen Zhengming invite someone else to paint part of his scroll?

The "Useless" Zhong Kui

Although the Wen-Qiu painting did develop in part from popular examples of traditional Zhong Kui imagery, several distinct differences set it apart. Perhaps the most exceptional aspect of the painting is its lack of activity—no quelling of demons or pursuing of fortune. The Zhong Kui figure here is not only motionless but stands with arms folded and hands hidden in his sleeves. What could have been the meaning—or use—of a Zhong Kui who was not fighting, or travelling, or even holding any kind of implement?

Further emphasizing its difference from earlier popular paintings is the omission of demons, soldiers, and auspicious creatures. Their absence has stripped Zhong Kui of his superhuman strengths and attributes. Zhong Kui's face lacks the characteristic frightening features and expression, and against the setting of a wintry forest he takes on the pensive and contemplative air of a scholar, as in Wen Zhengming's *Searching for Inspiration* (*Konglin miju tu* 空林覓句圖; *Fig. 16*) and Du Jin's 杜菫 (act. ca. 1465–1509) *Lin Hejing Viewing Plum Trees in the Forest* (*Lin Hejing guan mei tu* 林和靖觀梅圖).[16] The Zhong Kui figure's only movement seems to be the upward tilt of his head. The smile is also completely atypical of the demon queller and quite rare among depictions of scholars. Freed of all superhuman traits, this new smiling Zhong Kui is the most significant aspect of the painting.

During the early Ming dynasty, Ling Yunhan 凌雲翰 wrote a poem entitled "An Illustration of Zhong Kui" (*Zhong Kui hua* 鍾馗畫). Although it is not inscribed on the present painting, it does appear on Wen Zhengming's hanging scroll of 1542 also entitled *Zhong Kui in a Wintry Forest*.[17] His son, Wen Jia 文嘉 (1501–1583), who often copied his

16. For the illustration of Du Jin's painting, see Wai-kam Ho *et al.*, *Eight Dynasties of Chinese Painting: The Collections of the Nelson Gallery-Atkins Museum, Kansas City, and the Cleveland Museum of Art* (Cleveland: The Cleveland Museum of Art, 1980), p. 191.

17. Ling's poem is recorded in his *Zhexuan ji* (*Collected Works by the Master of Zhexuan*) (*Wenyuange siku quanshu* edition) (Taipei: Taiwan shangwu yinshuguan, 1986), *juan* 3, pp. 39a–b. Wen Zhengming's 1542 painting is recorded in Lu Shihua, *Wu Yue suojian shuhua lu* (*Painting and Calligraphy Seen in Jiangsu and Zhejiang*) (*Zhongguo shuhua quanshu* edition), *juan* 4, p. 22a.

father's works, also completed a painting of the same name in 1548 (*Fig. 17*). This one is inscribed with the poem. These two paintings help to establish a concrete relationship between Ling's poem and Wen Zhengming's painting. They also introduce the possibility that although the present painting lacks the poem, its subject matter may reflect the poem's content.

Ling Yunhan's poem describes Zhong Kui as one who dispels evil and brings in fortune, but for purposes of interpreting Wen's untraditional painting, the most significant couplets are the first and last—"Eyes strain to see as sand sweeps through the air; wind blows across the willow trees as plum blossoms open in full bloom (朔風吹沙目欲眯, 官柳搖金梅綻蕊)" and "People run from firecrackers, wishing for bright spring luminance across ten thousand miles (一聲爆竹人盡靡, 明日春光萬餘里)." The Zhong Kui figure in the Wen-Qiu painting—which was created on New Year's Eve and therefore evokes the anticipation of spring—may be looking up into the bare trees for the plum blossoms. He is no longer a violent demon queller or one of a procession of grotesques, but rather a refined invocation to spring and the center of a tranquil painting suitable for a scholar's studio.

The great difference in size between Dai Jin's *Night Travels of Zhong Kui* and Wen Zhengming's *Zhong Kui in a Wintry Forest* lends credence to the above interpretation of Wen's painting. Dai Jin's painting measures 189.7 by 120.2 centimeters. Including the full mounting, its total height is approximately three meters. Such a huge painting would most likely have been hung in a large hall. Wen Zhengming's much smaller work is not even two-fifths the size of Dai Jin's painting, and therefore it probably was meant for more intimate viewing in a studio. There, the ruckus typical of the holiday for which apotropaic-auspicious Zhong Kui images were made could not be heard. The quietude of such an environment matched the tranquility of Wen Zhengming's painting and emphasized the subtlety of its purpose—to picture, and perhaps also to invoke, the blessings of spring.

Scholars often considered unseemly the single-minded pursuit of goals, even positive ones, such as success or longevity. They considered unbridled ambition hazardous to the individual as well as to society. Having witnessed, and experienced, albeit briefly (1523–1527), the realities of official life and power politics, Wen Zhengming strongly rejected whatever smacked of personal striving for conventional goals. It was an attitude shared by most of his peers. Therefore, the lack of auspicious functionality in the painting expresses yet another element of the literati ethos. Visual serenity and avoidance of program were two critical components of the literati painters' aesthetic and of their self-distinction from professional painters. As Wen's painting embodies this evolving spirit, it serves as a critical reminder of the principles and lifestyle of literati.

At the same time that *Zhong Kui in a Wintry Forest* imparts the distinctive qualities of the literati's lifestyle, it also reveals the impossibility of a complete separation between scholars and commoners. The very creation of the piece on New Year's Eve and its subsequent use during this time are clear evidence that scholars also felt impelled to observe Everyman's holidays, even as the entirely different style of depiction signals the scholars' need to set themselves apart and higher. As political and economic power did not entirely suffice to guarantee their unbreachable elevation, the

identity of literati became an immense source of anxiety. Works such as *Zhong Kui in a Wintry Forest* reveal one way in which they resolved this dilemma. Wen Zhengming's painting demonstrates how literati artists could follow secular tradition while also imposing on it innovations that proclaimed their self-image.

As many scholars hung this type of painting during the New Year, it is apparent that the literati took to this new approach. Besides the 1535 painting, Qing dynasty writings record four other paintings by Wen Zhengming also entitled *Zhong Kui in a Wintry Forest*, two of them said to have been painted in collaboration with Qiu Ying.[18] If authentic, these paintings were most likely given as gifts and must have been well received by his peers. Wen's followers also continued the trend. For example, his son Wen Jia and his student Qian Gu 錢穀 (1508–1578) both painted several similar pieces bearing the same title.[19] Thus, by the end of the sixteenth century, this type of refined cultural expression was already used widely by scholars during the New Year.

Conclusion

The popularity enjoyed by *Zhong Kui in a Wintry Forest* is evidence of the power of the literati to shape a distinctive way of life and thence to affect the artistic trends of future generations. Additionally, the innovative aspects of the painting and its enduring popularity attest to a literati aversion to the lure of popular culture, while the subject attests to the literati's inability to insulate themselves completely from popular culture. Paintings of Zhong Kui in conjunction with the Chinese New Year are but one instance of the literati adoption and depiction of folk figures in conjunction with the celebration of holidays.

Paintings such as *Zhong Kui in a Wintry Forest* became popular only among the literati, and even within that class, their appeal was not universal. Wen Zhengming's own great-grandson, Wen Zhenheng 文震亨 (1585–1645), in his *Treatise on Superfluous Things* (*Changwu zhi* 長物志), recommended the more traditional demon-quelling and fortune-bidding imagery of Zhong Kui.[20] Needless to say, outside literati circles, this type of painting was even less acknowledged, and the more traditional representations of Zhong Kui continued to be fashionable.

Indeed, the popular imagery continued so strong that its influence flowed back into the literati type of Zhong Kui painting. Li Shida 李士達 (act. ca. 1580–1620), a professional painter from Suzhou and a contemporary of Wen Zhenheng, also created a work entitled *Zhong Kui in a Wintry Forest* (*Fig. 18*). To elements of Wen Zhengming's painting, such as Zhong Kui's raised head as he looks up at the leafless branches, Li added a demon's face peeking out of the trees. Thus, the figure of Zhong Kui is once more infused with the demon-quelling spirit.

18. Zhou Daozhen, *Wen Zhengming shuhua jianbiao* (*A Brief List of Wen Zhengming's Painting and Calligraphy*) (Beijing: Renmin meishu chubanshe, 1985), pp. 94, 98, 104, 141.

19. For the discussion of Wen Jia's Zhong Kui paintings, see Stephen Little, "The Demon Queller and the Art of Qiu Ying," pp. 18–22. For the illustrations of Qian Gu's Zhong Kui paintings, see *Gugong shuhua tulu* (*Illustrated Catalog of Painting and Calligraphy in the National Palace Museum*) (Taipei: Guoli gugong bowuyuan, 1991), vol. 8, pp. 101–4.

20. Wen Zhenheng, *Changwu zhi*, *juan* 5 in *Meishu congshu* (*Collectanea of Fine Art*), ed. Huang Binhong and Deng Shi (Shanghai: Shenzhou guoguangshe, 1929), III: 9, p. 184.

Shih Shou-chien

Li Shida's painting shows the limits of literati culture and the strength of popular tradition, while Wen Zheng-ming's *Zhong Kui in a Wintry Forest* represents the literati self-image and the literati aesthetic. We do not know whether Wen had hoped that his painting would change the direction of popular tradition, but even if he did, we know that it did not do so. We know, too, that to further our understanding of Chinese society and culture, we must continue to identify and analyze the tensions that marked the relationship between elite and popular culture.

文徵明、鍾馗與大眾文化

石守謙

中央研究院歷史語言研究所，臺北

　　文徵明是中國文人文化在十六世紀獨立成形發展過程中的代表性人物。透過繪畫的製作、欣賞、投贈與交換等活動，文徵明不僅建立了所謂「吳派」文人畫的具體典範，而且形塑了文人這個精英階層的特有生活風格，以使其有別於一般的庶民。文人文化除了試圖與大眾文化劃清界限外，同時也呈現了害怕爲其同化的焦慮，這在伴隨著歲時禮俗而來的生活行事上，尤其如此。文徵明爲新年而作的鍾馗圖便是一個有代表性的個案，可以藉之探討精英文化與大眾文化間久被忽略的這層緊張關係。

　　存國立故宮博物院的《寒林鍾馗》雖歸爲文徵明之作，其實還有深入探究的必要。它的寒林背景確爲文氏手筆，但是主角人物的鍾馗卻有著講究的姿勢、細緻的表情，顯示出畫者對人物畫科專業技巧的高超掌握，絕非文徵明所能爲。它的作者應是與文氏素有交往的職業畫師仇英。然而，此鍾馗的特爲文雅，又與仇英一般所作不同，顯示了文氏在背後的指授。

　　鍾馗畫的傳統起自唐代吳道子，後世迭有衍化。擊鬼式可能即是吳道子所創，稍晚則有祈福式的變體。兩者皆屬如門神的辟邪圖象的演化，形式亦都採單幅立軸。另一種出行鍾馗則與儺戲的搬演有關，鍾馗通常沒有誇張的表現，戲劇的張力倒全置於可隨時添加的各段落鬼卒之上。而其形式則以手卷爲主。但是，不論是辟邪或出行鍾馗，驅凶納福的功能性都很強。與此流行圖像相較，文仇合作的《寒林鍾馗》則以無所事事的文雅姿態，剝除了原有的神聖性與功能性。

　　文仇合作鍾馗形象的新意在於其臉上的微笑與輕揚的轉首。這個設計來自對明初詩人凌雲翰鍾馗詩中「明日春光萬餘里」的詮釋，意在將此形象的意涵由世俗的功利轉成對春天的單純期待。在此同時，畫的尺幅也被縮小，適於懸掛在私人性較高的文人畫齋之中。如此被移入書齋的鍾馗圖，其「無用性」特受強調，正是構築文人生活空間的要件。然而，「無用」的鍾馗在扮演著文人形塑其自我生活風格之角色外，同時也透露出文人文化不願也不能完全與大眾文化隔絕的焦慮；爲新年而創製的鍾馗圖的新模式，可謂針對這種焦慮的有效紓解。

　　文徵明所規畫的寒林鍾馗雖在當時的文人圈中頗受歡迎，但並不能眞正地改變以驅邪納福爲訴求的流行圖像。職業畫師李士達即曾將此無用的鍾馗重新賦予傳統的功能。這個現象意謂著文人文化面對大眾文化時，永遠揮之不去的焦慮之存在。

文徴明と鍾馗、大衆文化

石守謙

中央研究院歴史語言研究所、台北

　文徴明は16世紀、独自に発展していった中国文人文化における代表的な人物である。絵画の制作・鑑賞・贈与や交換等の活動を通して、文徴明は所謂「呉派」文人画の規範を確立したのみならず、一般庶民とは異なる、文人エリート階層特有の生活様式を形成した。文人文化は、大衆文化とはっきり一線を引こうとしたが、完全に断絶することができず、両者の同化を畏れていた。特に歳時の儀礼風習や生活行事の習慣において顕著であった。文徴明が新年を祝って作った「鍾馗図」はそうした状況がよく現れた作例で、この作品を通じて、長い間見落とされてきた、エリート文化と大衆文化の間における緊張関係を見てみたい。

　「寒林鍾馗図」(台湾・国立故宮博物院）は文徴明作とされるが、さらなる検討が必要である。背景の寒林は確かに文徴明自身の筆によるが、大変凝った姿勢で緻密な表情をした主役の鍾馗は、優れた人物画の優れた技量の持ち主によるもので、文徴明ではあり得ない。その画家は文徴明と以前から交遊のある職業画家の仇英に違いない。が、この鍾馗は極めて文雅で、仇英の標準的な作品とは異なり、文徴明の指示・指導があったことを示している。

　鍾馗画の伝統は唐・呉道子から始まった後、進展し変化していった。鬼を退治する型は呉道子によって創造された可能性があり、やや遅れて福を祈る型も登場した。両者は共に門神のような辟邪図となり、みな一幅の軸物の形式であった。別の系統の出行鍾馗は主として画巻形式で、儺戯（鬼やらい）の役と関係があり、鍾馗は通常誇張表現されず、戯劇の力点は自在に加えることの出来る各段落の鬼卒に置かれている。但し、辟邪鍾馗であれ出行鍾馗であれ「駆凶納幅（災いを祓い、幸福に暮らす）」といった機能性が重視された。これらの流行した図像と比較すれば、文徴明・仇英合作「寒林鍾馗図」は何もしていない文雅な姿で、元々あった神聖性や機能性が失われている。

　文徴明・仇英合作の鍾馗像の新たな意味は、微笑した顔と軽く顔を上げて首を傾げていることにある。この格好は明初の詩人、凌雲翰の鍾馗詩中の「明日春光萬余里」の解釈から来たもので、この図像における世俗の功利から春に対する純粋な期待に転

化したことを意味している。同時に、画の大きさが小さくなり、私的な性格の強い文人の書斎の中に掛けるのに適している。こうして書斎に移された鍾馗図の無用性（役に立たないこと）が特に強調されたのは、まさに文人の生活空間を構築する上で重要な条件であった。しかし、「無用」鍾馗は文人が形成した自らの生活様式の役割を演じているばかりでなく、文人文化が大衆文化と完全に隔絶したくないし、できないという苦慮を明示している。新年を祝って作られた鍾馗図の新しいモデルは、こうした緊張を解き緩めるのに有効だったといえよう。

　文徴明が考案し描いた「寒林鍾馗図」は当時の文人に非常に受け入れられたが、駆邪納福を求める流行した図像を実際に変えることはできなかった。職業画家の李士達は、かつてこの無用鍾馗に改めて伝統的な機能を付与した。この現象は、文人文化が大衆文化と直面する際、永遠にこの苦慮の存在をぬぐい去れないということを意味している。

Shih Shou-chien

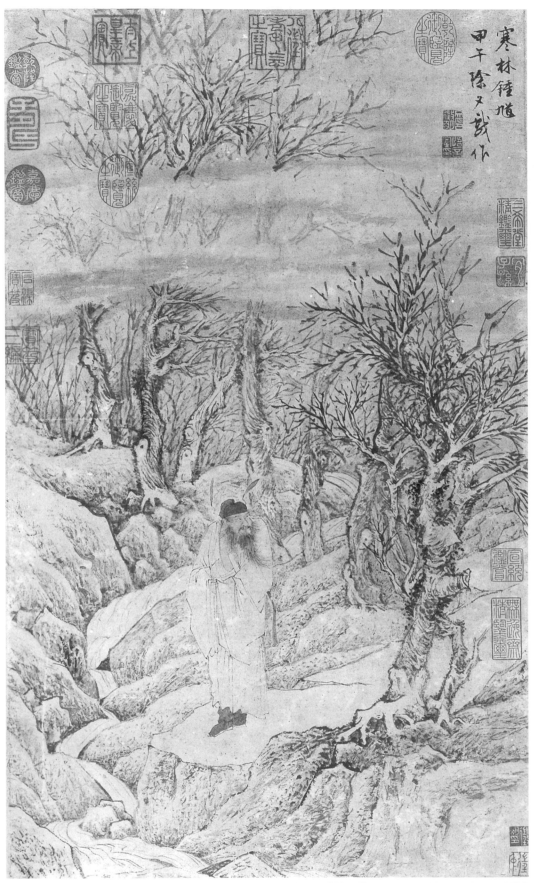

寒林鍾馗
甲午除夕戲作

Fig. 1. Wen Zhengming (1470–1559) and Qiu Ying (ca. 1494–ca. 1552). *Zhong Kui in a Wintry Forest*, 1535. Hanging scroll, ink on paper, 69.9 × 42.5 cm. National Palace Museum, Taipei. *(detail on page 363)*

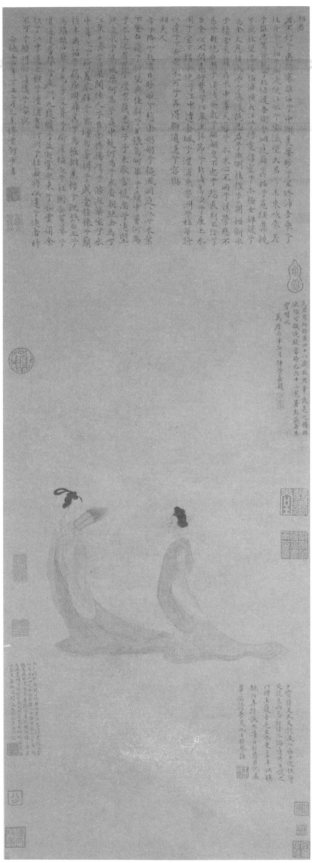

Fig. 2. Wen Zhengming (1470–1559). *Goddesses of the Xiang River*, 1517. Hanging scroll, ink and color on paper, 100.8 × 36.6 cm. Palace Museum, Beijing.

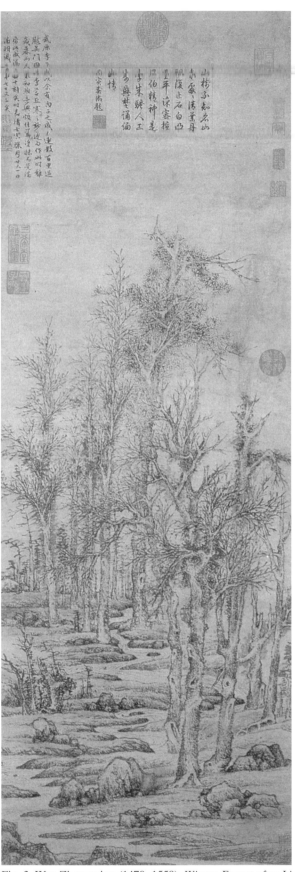

Fig. 3. Wen Zhengming (1470–1559). *Wintry Forest after Li Cheng*, 1542. Hanging scroll, ink and color on paper, 60.5 × 25 cm. British Museum, London.

Shih Shou-chien

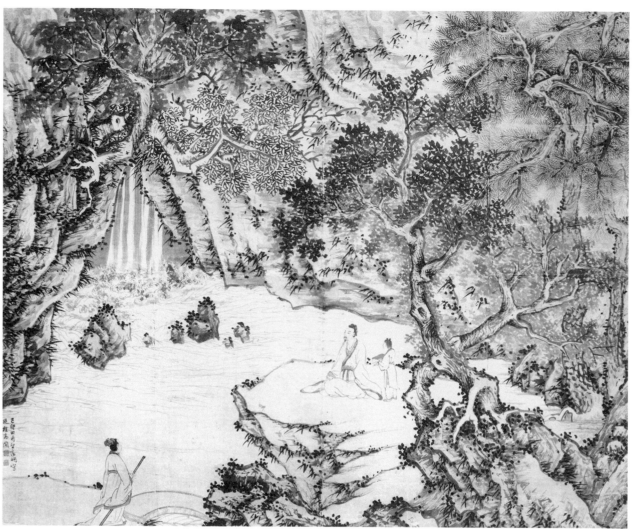

Fig. 4. Wen Zhengming (1470–1559). *Scholar of the Lofty Mountains*, 1519. Hanging scroll, ink and color on paper, 148.9 × 177.9 cm. National Palace Museum, Taipei. *(detail on page 279)*

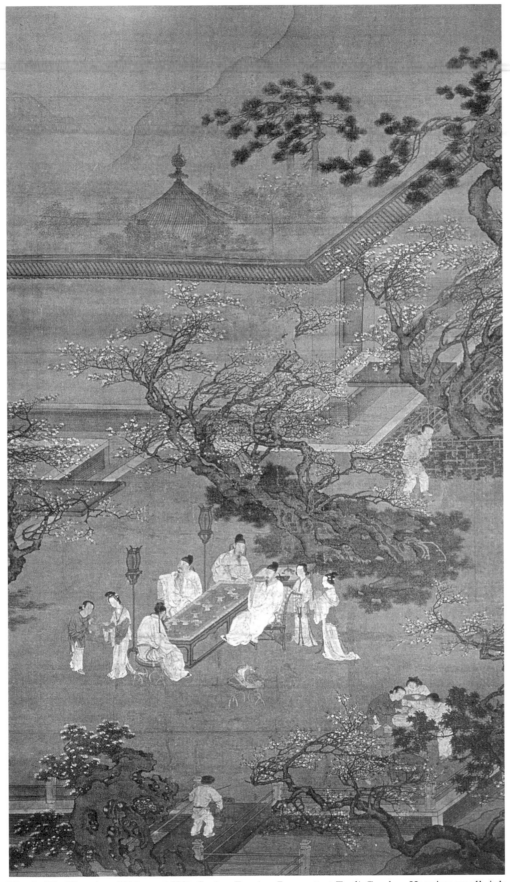

Fig. 5. Qiu Ying (ca. 1494–ca. 1552). *Spring Evening Banquet at Taoli Garden*. Hanging scroll, ink and color on silk, 224 × 130 cm. Kyoto National Museum.

Shih Shou-chien

Fig. 5A. Detail of Figure 5.

Fig. 6. Qiu Ying (ca. 1494–ca. 1552). *Boy from the Heavens*. Collection unknown. From *A Hundred Paintings Concerning Zhong Kui* (Guangzhou: Lingnan Art Publishing House, 1990), pl. 4.

Fig. 7. Qiu Ying (ca. 1494–ca. 1552). *Two Horses*, 1540. Hanging scroll, ink and color on paper, 109.5 × 50.4 cm. National Palace Museum, Taipei.

Shih Shou-chien

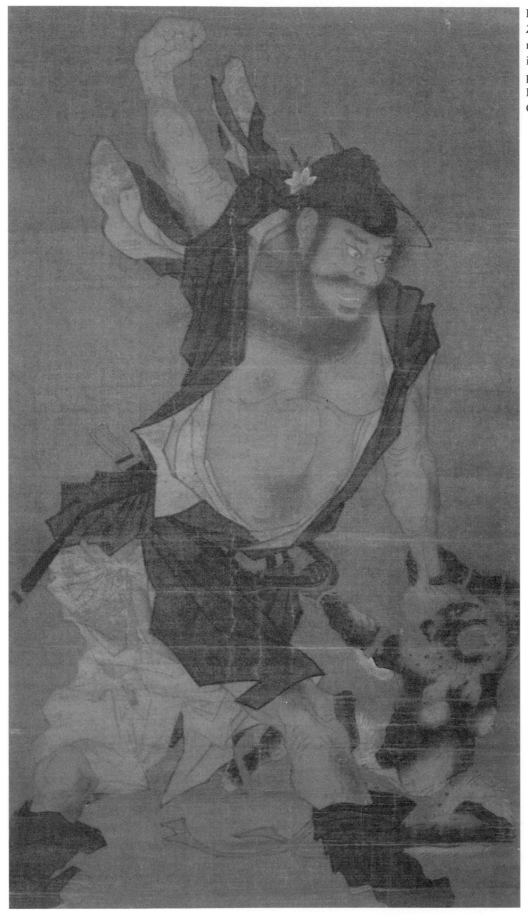

Fig. 8. *Illustration of Zhong Kui.* Yuan dynasty. Hanging scroll, ink and color on paper, 96.7 × 52 cm. Kuboso collection, Osaka.

Fig. 9. *Summoning Fortune*. Ilustration in *Pantheon of Dieties of the Three Teachings* (*Huitu sanjiao yuanliu souchen daquan*) (Taipei: Linking Press, 1980), *juan* 3, p. 24.

Shih Shou-chien

栢
抑
必
忿

一
脈
春
回
暖
氣
通

風
雲
萬
里
伍
明
時

畫
圖
今
日
來
佳
兆

如
意
年
年
百
事
宜

Fig. 10. Emperor Xianzong (the Chenghua Emperor; r. 1465–1488). *All Things Providential.* Palace Museum, Beijing. From *A Hundred Paintings Concerning Zhong Kui* (Guangzhou: Lingnan Publishing House, 1990), pl. 3.

Section III: Literati Painting 387

Fig. 11. Yan Hui (act. 1297–1308). *Zhong Kui en Marche*. Handscroll, ink and slight color on paper, 24.8 × 240.3 cm. The Cleveland Museun of Art.

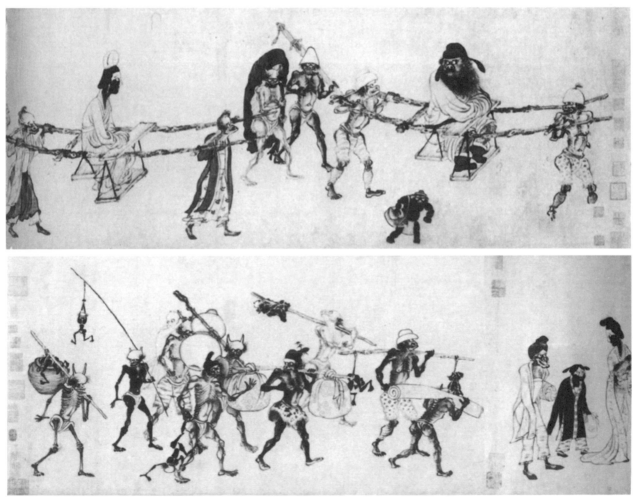

Fig. 12. Gong Kai (1221–ca. 1307). *Zhongshan on an Outing*. Handscroll, ink on paper, 32.8 × 169.5 cm. Freer Gallery of Art, Smithsonian Institution, Washington, D.C.

Shih Shou-chien

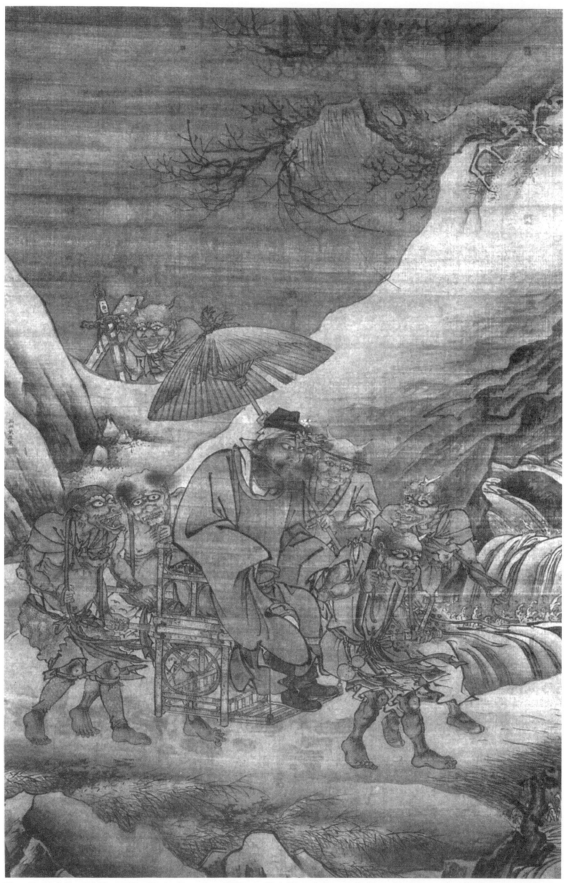

Fig. 13. Dai Jin (1388–1462). *Night Travels of Zhong Kui*. Hanging scroll, ink and color on silk, 189.7 × 120.2 cm. Palace Museum, Beijing.

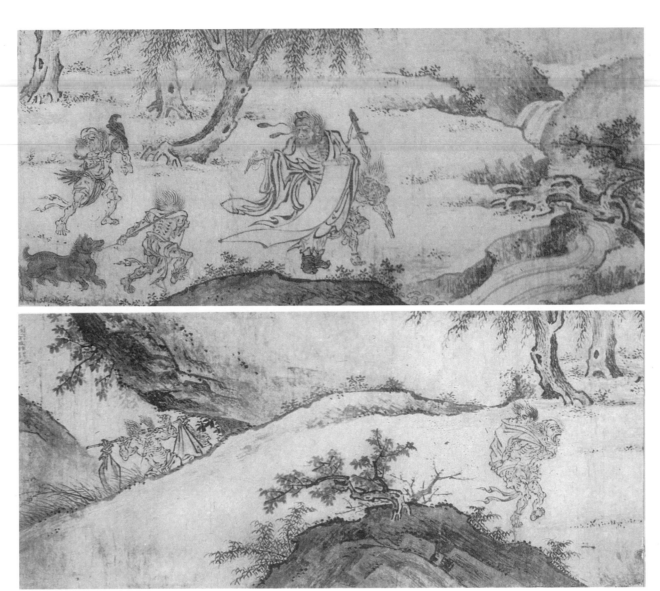

Fig. 14. Yin Shan (act. 1410s–1460s). *Five Rowdy Demons.* Discovered in the tomb of Wang Zhen (1424–1496) in Huaian Prefecture, Jiangsu Province. Handscroll, ink and color on paper, 24.2 × 112.8 cm. Huaian County Museum.

Fig. 15. Attributed to Dai Jin (1388–1462). *Zhong Kui*. Illustration in *Collection of Illustrations by Master Gu* (*Gushi huapu*) (Beijing: Wenwu, 1983).

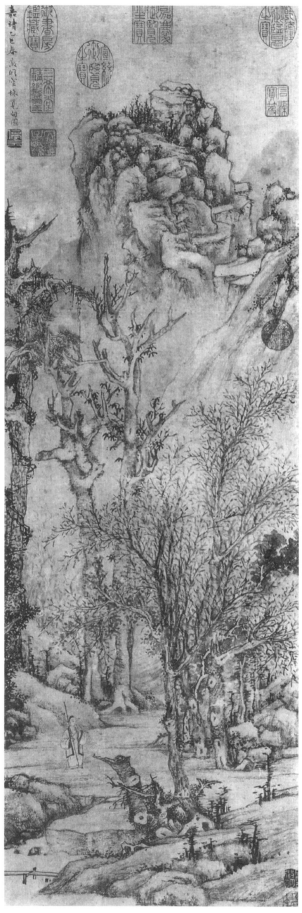

Fig. 16. Wen Zhengming (1470–1559). *Searching for Inspiration*, 1545. Hanging scroll, ink on paper, 81.2 × 27 cm. National Palace Museum, Taipei.

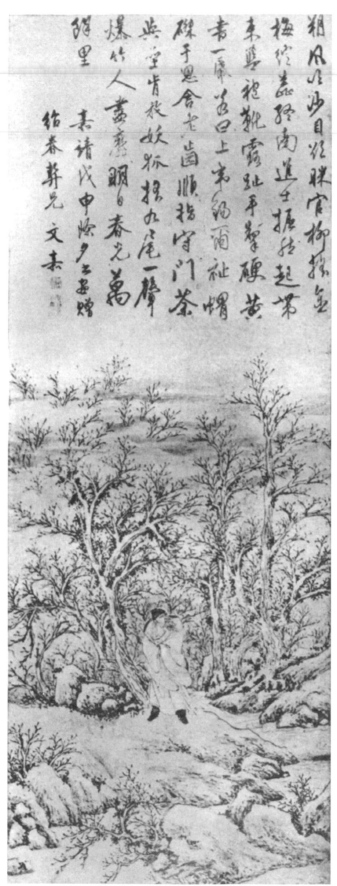

霜風峭峭目怒睜官柳搖金
梅絲嫋嫋嘉經南進士揚挺起第
束褁槌靴露趾平肇硬黃
書一簾荷日上未紗雨祗帽
傑手愚含老齒順指守門茶
與堂肯秋妖狐揖九尾一聲
爆竹人畫應明日春光萬
獅里　春請戊申除夕之筆贈
　　　為春群先文嘉

Fig. 17. Wen Jia (1501–1583). *Zhong Kui in a Wintry Forest*, 1548. Hanging scroll. Collection unknown.

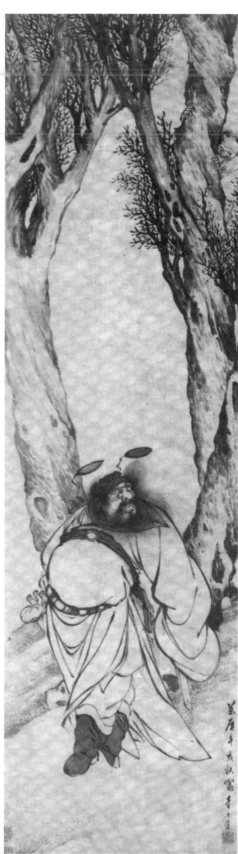

Fig. 18. Li Shida (1550–1620). *Zhong Kui in a Wintry Forest*. Hanging scroll, ink on paper, 124.1 × 31.6 cm. Osaka Municipal Museum of Art.

Shih Shou-chien

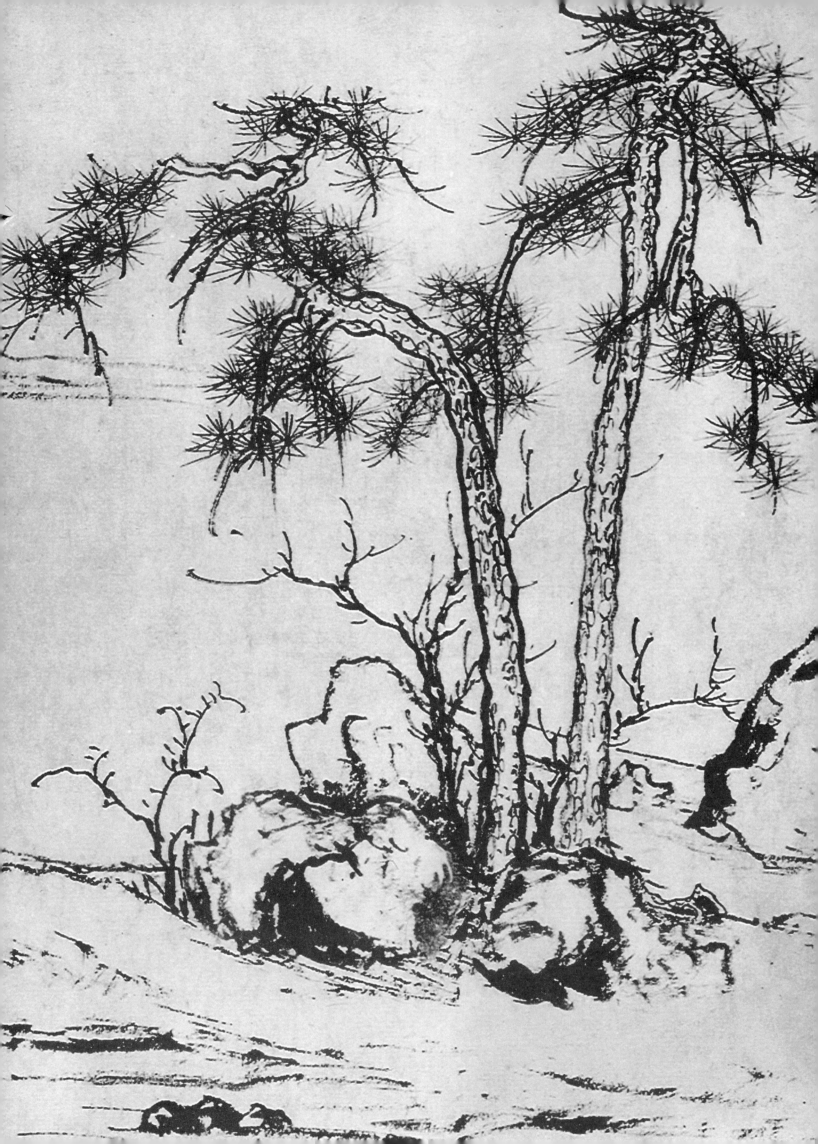

Section III: Literati Painting
Response

Wen C. Fong

Princeton University, Emeritus

Implicit in the ambitious program of the present volume, which embraces the "History of Painting in East Asia," is the recognition of the complexity of a culturally diverse East Asia, where no single narrative of art history ever existed. Our difficulty in defining Asian art histories—Chinese, Japanese, or Korean—from a Eurocentric point of view began in the early nineteenth century, when Georg Wilhelm Friedrich Hegel (1770–1831) first regarded a "changeless" East as the cultural "Other" that lay "still outside the World's History."[1] The average museum-goer in Europe and the United States understands "fine arts" as comprising exclusively European and American paintings, prints, and sculpture; "archaeology" as encompassing the ancient world of Egypt, Mesopotamia, Greece, and Rome; and "anthropology" and "ethnography" as introducing the material cultures and artifacts of non-Western peoples of China, Japan, India, and the rest of the world to a multicultural public. However, ethnography, the last of these categories, has no art history and is relativist.[2]

Yet for Asian art historians, the visuality of Chinese, Japanese, and Korean painting must provide insights into human cultures as deep and valuable as those afforded by the painting of the West. In order to offer approaches and insights distinctly different from those provided by Western art historiography, modern Asian art historians must engage styles and expressive contents from Chinese, Japanese, or Korean art historical perspectives, and from these perspectives interpret how the visual expressions of East Asian painting reflect and describe their diverse cultural and historical contexts.

Stimulated by ethnographic theories of "thick description" and "practice," recent art scholarship in Taiwan has made significant strides in studying interregional (notably, Japan/China) links in the creation of a "modern" Chinese painting style.[3] However, as Satō Dōshin's 佐藤道 essay "'History of Art': The Determinants of Historicization" in

1. Georg W. F. Hegel, *The Philosophy of History* (New York: Dover, 1956), p. 116.

2. According to Michel Foucault in *The Order of Things: An Archaeology of the Human Sciences* (New York: Vintage Books, 1973), p. 376;

 It is no doubt difficult to maintain that ethnology has a fundamental relation with historicity since it is traditionally the knowledge we have of peoples without histories; in any case, it studies (both by systematic choice and because of lack of documents) the structural invariables of cultures rather than the succession of events. It suspends the long 'chronological' discourse by means of which we try to reflect our own culture within itself, and instead it reveals synchronological correlations in other cultural forms.

3. See Lai Yu-chih, "Surreptitious Appropriations: Japanese Networks in Shanghai in the 1870s and Ren Bonian's Contemporary Assimilation of Japanese Visual Conventions," in *Taida Journal of Art History*, no. 14 (March 2003), pp. 159–242; also Chen Pao-chen, ed., *Quyu yu wanglu* (*Regions and Connections*) (Taipei: Graduate Institute of Art History, National Taiwan

the present volume points out, in order to relate Japanese, Chinese, and Korean art to a larger Asian art historical narrative, we need a "weather map" of a larger region "that transcends national boundaries." In studying interregional and cross-cultural developments in East Asian art, the principal concerns are the processes of reception. Context is all. Precisely because all cultural borrowings become significant in the context of identity and self-definition, the historian must determine where the borrowings end and the borrower's own heritage begins.

We may begin by examining the different concepts of "literati painting"—a unique East Asian genre of style and expressivity that appeared first in China in the late eleventh century—as practiced in different regions of East Asia: China, Japan, and Korea. The first essay in this section, entitled "Ideals in Conflict: Changing Concepts of Literati Painting in Korea," by Yi Sŏng-mi 李成美, shows how the Korean practice of "literati" painting was essentially different from that in China. Professor Yi first documents the influence of contemporaneous Chinese "literati" ideals of the Song dynasty in Korea during the Koryŏ period, through three poems on the subject of ink bamboo paintings written by two well-known early thirteenth-century Korean scholar-officials, Yi Inro 李仁老 (1152–1241) and Yi Kyubo 李奎報 (1168–1241). After the founding of the succeeding Chosŏn dynasty in 1392, artistic activities were often discouraged by court officials on moralistic grounds that "playthings were detrimental to [Confucian] ambitions" (K: *wanmul sangji* 玩物喪志). Beginning in the early seventeenth century, when Chinese "literati painting" vocabularies became widely available through Chinese woodblock-printed painters' manuals and encyclopedias, Chosŏn painters, both professional and "literati," enthusiastically based their artistic creations on the codified brush idioms and model compositions illustrated in these manuals. It was from the late eighteenth century onward, when the "Koreans eloquently expressed their independence from China in all aspects of culture, . . ." writes Professor Yi, that "'true-view' [*meaning scientifically 'realistic'*] landscape painting and genre painting of Korean life developed and flourished" (italics mine).

The development of the realistic, "true-view landscape" (K: *chin'gyong sansuhwa* 眞景山水) in both late Chosŏn Korea and Edo period Japan in the eighteenth century is a fascinating case study of intercultural cross-fertilization (by misapprehension). Melinda Takeuchi, in her excellent monograph *Taiga's True Views: The Language of Landscape Painting in Eighteenth-Century Japan*, has shown how the concept of *shinkeizu* 眞景図, or "true-view" pictures, developed within the context of the changing social status of the painter and the adoption of empirical learning in late eighteenth-century Japan.[4] Under the impact of the newly imported European concept of scientific realism, Japanese and Korean artists borrowed the term *zhen shanshui* 眞山水 (K: *chin sansu*), used by the tenth-century Chinese Neo-Confucian master Jing Hao 荊浩 (act. ca. 870–ca. 930) to mean the perfect expression of the "inner truth" of a scene—a "truth" that only a superior person could grasp. This they conflated with realistic "true-view" landscape,

University, 2001).

4. Melinda Takeuchi, *Taiga's True Views: The Language of Landscape Painting in Eighteenth-Century Japan* (Stanford: Stanford University Press, 1992), p. 142.

created according to Western scientific principles of linear perspective and modeling. In writing about "true-view" landscape paintings in Korea, Professor Yi quotes the scholar Yi Ik 李瀷 (1681–1763), whose father, Ha-jin 夏鎭 (1628–1682), a high-ranking official, went to China in 1679 and brought back with him many books of Western learning that had been translated into Chinese. Yi Ik writes:

> When looking at [European-style] paintings, one should close one eye . . . so that the buildings and the walls reveal their "true shapes" [*chinhyong*]. . . . These days I am reading Euclid's *Geometry* translated into Chinese by Ri Madu [Matteo Ricci]. There it says: "The method of painting lies in seeing things with one's eyes. . . . One should be precise about measurements of distances and things in order to represent their degrees and true shapes."[5]
> 市西洋畫掛在堂上，始閉一眼⋯而殿角宮垣皆突起如眞形⋯今觀利馬竇所撰幾何原本，序云其術有目視⋯以遠近正邪高下之差，照物狀可畫立圓立方之度數於平版之上。

In the end, both Japanese and Korean "literati" painters understood "true-view landscapes" to mean paintings of actual sites, imbued with their own experiences and feelings.

The other three essays in this section are devoted to the leading Ming dynasty literati painter Wen Zhengming 文徵明 (1470–1559). Craig Clunas, by looking at Chinese literati paintings as material *things* in a social and economic context, has not only made significant headway toward a new social history of Chinese art, but has also helped to break down the traditional divide between Chinese painting and calligraphy and Chinese decorative arts and popular culture.[6] His essay, "Commodity and Context: The Work of Wen Zhengming in the Late Ming Art Market," establishes a clear methodological basis for his approach. Professor Clunas begins with the idea of the "social life of things," drawing attention to historical contexts in which *things* function as if they were active *agents* in their own right. Clunas proposes to study the ways "in which one class of objects—calligraphy and painting in scroll form—behaved in the complex, socially diverse, and highly commoditized society of mid- and late-Ming China [ca. 1450–1644]." His essay, part of a larger project that explores the history of the Chinese art market, uses evidence from the well-known *Diary from the Water Tasting Studio* (*Weishuixuan riji* 味水軒日記), by Li Rihua 李日華 (1565–1635), a literatus and contemporary of Dong Qichang 董其昌 (1555–1636), to study "the ways in which [Wen's] 'fractal personhood' was dispersed through elite culture by the circulation of these same works in the art market." Clunas's earlier work, most notably his book *Superfluous Things: Material Culture and Social Status in Early Modern China*, has won valuable corroboration and support from the economic historian Timothy Brook in his recent volume *The Confusions of Pleasure: Commerce and Culture in Ming China*.[7] This is a major step toward fruitful collaboration between art historians and economic historians.

5. Yi Sŏngmi, "Artistic Tradition and the Depiction of Reality: True-View Landscape Painting of the Chosŏn Dynasty," in *Arts of Korea*, ed. Judith G. Smith (New York: The Metropolitan Museum of Art, 1998), pp. 341–42.

6. See, for example, Craig Clunas's *Superfluous Things: Material Culture and Social Status in Early Modern China* (Cambridge: Polity Press, 1991); *Art in China* (New York: Oxford University Press, 1997); and *Pictures and Visuality in Early Modern China* (Princeton, N.J.: Princeton University Press, 1997).

7. Timothy Brook, *The Confusions of Pleasure: Commerce and Culture in Ming China* (Berkeley: University of California Press, 1998).

Wen C. Fong

Equally stimulating is Jonathan Hay's essay, "Wen Zhengming's Aesthetic of Disjunction," which grapples conceptually with the impact of a consumer economy on what the author believes to be the beginning of a new visual "modernity" in Wen Zhengming's art. Professor Hay sees Wen as an early-modern Chinese painter who, in his works executed after 1527, following his return to Suzhou from Beijing, "began to present himself . . . as someone whose social identity was not straightforwardly clear, but was instead socially complex and defined by the negotiation of different pressures and desires." Hay observes that, in these late works by Wen,

> commerce [was] nonetheless part of the painting in the sense that its particular quality of critical distance affirms a self-reliance that bespeaks Wen's acceptance of his engagement in commercial activity. Wen Zhengming could repress this acceptance at the rhetorical level of recluse iconography, but the power and historical importance of [these works] come from the fact that he allowed it to surface in the very structure of the painting.

Hay identifies Wen Zhengming's introduction of disjunction in landscape composition as his epochal contribution to early-modern Chinese painting:

> The spatial structures of the successive sections making up the landscape are willfully contrasted. . . . As a result, the narrative continuity centered on the figures is given a troubled and troubling psychological undercurrent. . . . The formal disjunctions are thus symptomatic of a still deeper disjunction on the level in the thematics of the works.

By contrasting Wen Zhengming's post-1527 works with those of his teacher, Shen Zhou 沈周 (1427–1509), whose "emphasis on stability and unity is symptomatic of an underlying continuity with the pre-Ming past," Hay argues that

> the fundamental contribution of Wen Zhengming's late work was the dismantling of the hierarchical pictorial cosmology that descended in painting from the Song to the mid-Ming. . . . [Wen's] reassessment of moral and cultural authority . . . relativized the importance of the values associated with the hierarchical imperial cosmos by confronting them with the more fluid values of the commercial city.

In his recent book on Shitao 石濤 (1642–1707), Hay has also shown how the cataclysmic social and political changes in the early Qing dynasty generated new forms of subjectivity associated with modernity in the Chinese context, along with "the emergence of a modern field of consciousness [that] articulated and embodied not only new possibilities but also dehumanizing insecurities and pressures."[8] For Jonathan Hay, the crucial question of a social and materialist history of Chinese painting is: "Where, in the work, do the person and the social process meet?"[9]

The last essay of this section, entitled "Wen Zhengming, Zhong Kui, and Popular Culture," by Shih Shou-chien 石守謙, is a thoughtful study of identity and differentiation between elite scholar-literati culture and popular culture in Ming China. Through careful stylistic analysis, Professor Shih first establishes that the painting *Zhong Kui in a Wintry Forest* (*Hanlin Zhong Kui tu* 寒林鍾馗圖), dated to the eve of the Chinese New Year in 1535 and traditionally considered a work by Wen Zhengming, is in fact a collaborative effort on the part of Wen and the professional artist Qiu Ying 仇英 (ca. 1494–1552), who painted, presumably under Wen's direction, the carefully rendered figure

8. Jonathan Hay, *Shitao: Painting and Modernity in Early Qing China,* Res Monographs on Anthropology and Aesthetics (Cambridge: Cambridge University Press, 2001), p. 25.

9. *Ibid.*

of the apotropaic "demon-queller" Zhong Kui, with Wen adding the landscape setting of wintry branches, rocky slopes, and winding stream. Turning to earlier traditions of popular Zhong Kui images in the Tang, Song, and Yuan periods, Shih associates narrative handscroll illustrations on the theme of "Zhong Kui travelling" (such as in the Freer Gallery of Art, The Cleveland Museum of Art, and The Metropolitan Museum of Art) with popular theatrical performances celebrating New Year's eve from the Song dynasty onward. He then contrasts these popular renditions of the figure with Wen and Qiu's literati rendition, which he describes as the "useless" Zhong Kui, linking the image to an early Ming poem by the literati scholar Ling Yunhan 凌雲翰 (act. ca. 1359–1381), the last line of which reads, "Wishing for bright spring luminance across ten thousand miles (明日春光萬餘里)." "The Zhong Kui figure in the Wen-Qiu painting–which was created on New Year's Eve," writes Shih, "evokes the anticipation of spring. . . . [Zhong Kui] is . . . the center of a tranquil painting suitable for a scholar's studio." Shih concludes:

> Paintings such as *Zhong Kui in a Wintry Forest* became popular only among the literati, and even within that class, their appeal was not universal. . . . To further our understanding of Chinese society and culture, we must . . . identify and analyze the tensions that marked the relationship between the elite and popular culture.

In returning to Craig Clunas's essay, when my book *Images of the Mind* first appeared in 1984,[10] the traditional literati expression "lodging one's mind in painting" (*jiyu* 寄寓) was sometimes discounted as a meaningless conventional phrase or merely an excuse for bad painting. Some of my colleagues, who looked for a social analysis of the artistic process, apparently found it difficult to accept my assertion that, in Chinese painting theory, representation is linked through calligraphic brushwork to the artist's *presence*—that Chinese painting is both representational and presentational, expressing a state of mind and body that reflects the painter's *selfhood*.[11] Clunas has now shown how the practice of calligraphy and painting, in particular the presence of the physical "trace" of the artist, can be specifically described and situated in the cultural fabric of a new social art history. As he writes:

> Much of Ming connoisseurial theory is predicated on the idea of the presence of the maker in the work, the piece of calligraphy or painting, as the "true trace" (*zhen ji* 眞跡) of that maker, and of brushwork as a visible presencing of that person across place and time. . . . This seems to me a helpful concept in dealing with works of art that were almost all produced for special occasions, that are highly mobile and not permanently visible, and that are the material remains of relationships which are necessarily social—hence the notion of the *shen hui* [神會], or "spiritual meeting," which the viewer of a work can have with its maker even after that maker's bodily demise.

Fortunately for the efforts of Craig Clunas, we are now able to locate the *mind* in both a social and a historical context.

10. Wen C. Fong *et al.*, *Images of the Mind: Selections from the Edward L. Elliott Family and John B. Elliott Collections of Chinese Calligraphy and Painting at The Art Museum, Princeton University* (Princeton, N.J.: The Art Museum, Princeton University, 1984).

11. See also Wen C. Fong, *Beyond Representation: Chinese Painting and Calligraphy 8th–14th Century* (New York: The Metropolitan Museum of Art, 1992), p. xiv; and Wen Fong, "Chinese Calligraphy: Theory and History," in *The Embodied Image: Chinese Calligraphy from the John B. Elliott Collection*, ed. Robert Harrist, Jr. and Wen C. Fong (Princeton, N.J.: The Art Museum, Princeton University, 1999), p. 29.

The terms *biji* 筆跡 and *moji* 墨跡, respectively "brush trace" and "ink trace," connote that a work of calligraphy or painting represents the physical mark of its maker. Chinese calligraphy and painting, which are based on graphic conventions, functioned as diagrammatic signs (*tu zai* 圖載) that signified meaning. Works by or attributed to the legendary calligraphic master Wang Xizhi 王羲之 (303–361; *Fig. 1*) are, in Clunas's words, "material remains of relationships which are necessarily social." Because great calligraphy, as the physical trace of the writer, was thought to embody material proof of genius, even immortality, the works or *things* by or attributed to Wang Xizhi achieved, in Clunas's terms, an "active agency" in their own right; and in "commodity contexts," then or later, they became not only "indexes of the social personae" of their creator but also potentially lucrative commodities.

Clunas has also called our attention to recent anthropological work on selfhood and agency in Confucian thought. In contrasting Western and Chinese notions of selfhood and individuality, he leads us to recent discourse on East-West comparative philosophy, in particular the respective value of causal and analogical—or correlative—thinking, questions that have a direct bearing on Chinese artistic creativity.[12] He observes, for example, how "Wen Zhengming worked in what to our eyes are so many different 'styles'"—those of the ancient masters, such as Zhao Mengfu 趙孟頫 (1254–1322), Huang Gongwang 黃公望 (1269–1354), and Wu Zhen 吳鎮 (1280–1354)—which he takes as "material and visual traces of a 'fractal,' contextual personhood." The idea of a fractal personhood, according to Alfred Gell, was designed "to overcome the typically 'Western' oppositions between individual (ego) and society, parts and wholes, singular and plural." "The notion of genealogy," writes Gell, "is the key trope for making plurality singular and singularity plural":

> Any individual person is "multiple" in the sense of being the precipitate of a multitude of genealogical relationships, each of which is instantiated in his/her person; and conversely, an aggregate of persons, such as a lineage or tribe, is "one person" in consequence of being one genealogy: the original ancestor is now instantiated, not as one body but as the many bodies into which his one body has transformed itself.[13]

Zhao Mengfu was the first literati painter to turn to a systematic analysis of ancient painting styles, translating them into an abstract vocabulary of calligraphic brush patterns or idioms and using them to represent different art historical and emotional associations. In landscape painting, as we all know, Zhao began with the archaic linear idiom of Gu Kaizhi 顧愷之 (ca. 344–ca. 406), which he re-created with the iron-wire technique of seal-style calligraphy (*Fig. 2*). He went on to experiment with both Dong Yuan's 董源 (act. ca. 937–976) hemp-fiber (*pima* 披麻) brush idiom and the Li Cheng 李成 (ca. 919–ca. 967) and Guo Xi 郭熙 (ca. 1000–ca. 1090) idiom of devil-face (*guilian* 鬼臉) and crab-claw (*xiezhua* 蟹爪) brush patterns (*Fig. 3*). Depending on the specific contexts of his works, most of which were produced for special occasions, the language of received painting traditions served as a pictorial sign which Zhao manipulated into forms that expressed his intent or meaning.

12. See also David L. Hall and Roger T. Ames, *Anticipating China: Thinking through the Narratives of Chinese and Western Culture* (Albany: State University of New York Press, 1995).

13. Alfred Gell, *Art and Agency*, p. 140.

Zhao Mengfu's mastery of his genealogy of classical landscape styles is expressed by his metamorphosis of a variety of calligraphic brush idioms into a new and unified visual structure. In his colophon to *Elegant Rocks and Sparse Trees* (*Xiushi shulin tu* 秀石疏林圖; *Fig. 4*), done about 1310, Zhao explains how he structures his brushwork in painting by combining different calligraphic scripts:

> [I paint] rocks as in flying white, and trees as in seal script;
> When painting bamboo, I use the spreading-eight [later clerical] method.
> Only when one masters this secret
> Will he understand that calligraphy and painting have always been one.
> 石如飛白籀，寫竹還於八法通。若也有人能會此，方知書畫本來同。

In transforming landscape styles into calligraphic idioms and by manipulating their syncretic markings—round and square, centered and oblique, internal and external—to create a fused, illusionistic pictorial surface, Zhao mastered both nature and history: his painting *Elegant Rocks and Sparse Trees* establishes not only a new correspondence of different kinds of calligraphic brush strokes with forms of nature, but also an all-embracing grid of art historical associations that imposed a central authority over all forms of representation. Zhao's art fits well not only with Clunas's notion of the literati painter's "'fractal' contextual personhood," as seen through the "material and visual traces" of the maker, but also with Gell's concept (which Clunas draws upon) of art as agency, as something "exclusively relational."

The significance of the "literati painting aesthetic" (*shidafu hualun* 士大夫畫論), which arose in late Northern Song China, was that it led to a permanent shift in Chinese painting from mimetic representation, as seen in imperially sponsored Academy paintings of the court, to calligraphic self-expression, as practiced by literati painters. As Jonathan Hay has argued in his essay, Wen Zhengming's late works show a total "dismantling of the hierarchical pictorial cosmology that had descended in painting from the Song to the mid-Ming." What evolved beyond mimetic realism was *xieyi* 寫意, or the "writing of ideas and feelings," which expressed the literati artist's own subjective realities. Indeed, the essence of literati painting was to *write* rather than to *paint* a painting, which brings us back to the concept of the traces of brush and ink.

In his article "The 'Visual Arts' and the Problem of Art Historical Description," David Summers has contrasted the Western tradition of optical naturalism—that is, the conception of painting as representing the visual world—with an alternative proposition of the "planar structure [that] in fact absolutely establishes and qualifies images and is a major condition of making visible their meaning."[14] Chinese painting, which is based on graphic schemata and conventions, assumes a planar, rather than an optical, structure. Early Chinese pictorial representation, using graphic symbols, reads both horizontally along register lines and vertically along the entire picture plane. In a wall painting from a tomb in Holingol, Inner Mongolia (*Fig. 5*), dating from the Eastern Han period, a map-like depiction of a series of courtyard scenes, created by diagonal lines that form parallelograms against the horizontal picture surface,

14. David Summers, "The 'Visual Arts' and the Problem of Art Historical Description," *Art Journal* (Winter 1982), p. 303.

Wen C. Fong

presents a bird's-eye view of enclosed spaces filled with rows of piled-up figures and buildings. To position the figures in space, similar parallelograms are used to represent the edges of a floor mat or the sides of a building. Over the years, I have used three diagrams (*Figs. 6A, 6B, 6C*) to illustrate how, between the eighth and fourteenth century, Chinese painters mastered visual realism in painting.[15] It was through the arranging and rearranging of triangular mountain motifs into parallelograms, also known as *parallel* perspective, that Chinese painters learned to master illusionism in landscape painting by suggesting continuous recession beyond the picture plane. In contrast to Cartesian perspectivalism and other scopic regimes in Western painting,[16] Chinese landscape painters presupposed a moving focus, or travelling point of view. Rather than viewing a scene from a fixed, monocular vantage point, composing it within the picture frame like a "window on the wall," early Chinese artists *positioned* and *placed* (*jing ying weizhi* 經營位置) the elements of nature *additively* in an expanded field of vision that, owing to its dynamic moving focus, transcended the physical boundaries of the picture frame and turned the landscape into a symbolic form— what Jonathan Hay calls the "hierarchical pictorial cosmology"—as an "image of the mind." As a mode of seeing or representation, classical Chinese landscape follows, in Norman Bryson's terms, the logic of the "Glance" rather than the "Gaze."[17] This suggests that the way Chinese painters *read,* rather than *look at,* landscape painting may imply, again in Bryson's words, a different kind of "politics of vision . . . in an expanded [visual] field."[18]

After spatial representation was mastered in landscape painting, in about 1300, Chinese literati painters turned again to the flat picture plane. In *Wang Xizhi Watching Geese* (*Wang Xizhi guan'e tu* 王羲之觀鵝圖; *Fig. 7*), dating from about 1295, Qian Xuan 錢選 (ca. 1235–before 1307) paints by *writing* archaic graphic conventions of schematic mountain motifs and tree foliage and then covering them with flat mineral colors. Bringing Song illusionism to an end, the literati painter inscribes his own physical presence onto the flat picture plane with the traces of his brush and ink. As John Hay has stated:

> The outcome . . . is a tangible medium, or substrate, which runs through the entire work, including the inscription. This substrate is, quite concretely, the surface on which Ch'ien Hsüan [Qian Xuan] paints his forms, writes his poem, and in which he leaves his voids. His medium is the paper, and its surface is consistently and uninterruptedly present.[19]

Like Zhao Mengfu's *Elegant Rocks and Sparse Trees* (see *Fig. 4*), Qian's return to the flat picture plane, in which the artist validates the simultaneous practice of calligraphy, painting, and poetry as a single art form, is expressive of the

15. See Fong, *Images of the Mind*, pp. 21–22.

16. For discussions of Western "scopic regimes," see Martin Jay, "Scopic Regimes of Modernity," in *Vision and Visuality*, ed. Hal Foster (New York: The New Press, 1988), pp. 3–27.

17. See Norman Bryson, *Vision and Painting: The Logic of the Gaze* (New Haven: Yale University Press, 1983).

18. For discussion of "the discovery of a politics of vision," see Norman Bryson, "Gaze in an Expanded Field," in *Vision and Visuality*, ed. Hal Foster, p. 107.

19. John Hay, "Subject, Nature, and Representation in Early Seventeenth-Century China," in *Proceedings of the Tung Ch'i-ch'ang International Symposium*, ed. Wai-kam Ho *et al.* (Kansas City, Missouri: Nelson-Atkins Art Museum, 1992), pp. 188–89.

radical shift in Yuan dynasty literati painting, from mimetic representation to self-expression. Treating his composition as a manuscript page, Qian reifies calligraphy and poetry as preeminent art forms of expressive intent.

Finally, the lasting significance of Wen Zhengming's *Heavy Snow on Mountain Passes* (*Guanshan jixue tu* 關山 積雪圖; *Fig. 8*), as Jonathan Hay in his essay points out, lies "in [its] structural experimentation, and more specifically in [the] introduction of disjunction as a structural principle." Here Wen reverted to the flat picture plane, rearranging the diagonally receding mountain ranges into a series of interlocking parallelograms not unlike those of the second-century wall painting at Holingol (see *Fig. 5*). By replacing the additive principles of the Song, which depict a vast, hierarchically ordered universe (see *Figs. 6A, 6B* and *Fig. 9*), with physically compacted but spatially disjunctive forms, Wen Zhengming's sharply disjunctive triangular mountain formations, again in Jonathan Hay's words, impart to the painting's narrative "a troubled and troubling psychological undercurrent." The dwarfed travellers in Wen's scroll journey through a hallucinatory world of fantastic mountain forms and disorienting passages, all snow-clad and relentlessly bleak.[20]

In conclusion, I return briefly to Professor Satō Doshin's essay in the present volume and the idea of a larger "weather map" for writing East Asian painting histories. If we ask how the study of Chinese, Japanese, or Korean art histories can contribute to a post-modern history of world art, I am reminded of what the noted Islamic art scholar Oleg Grabar has written:

> What is required of the historian [now] is to discover the national or ethnic culturally *discrete meanings* of *a certain kind of visual language*. . . . The history of art required by new countries in old worlds is not one that relates them to the West but one that proclaims their differences" (italics mine).[21]

However, can old histories of art, or Professor Satō's "determinants of historicization," be meaningful, or even useful, to the making of new, post-modern art? On the face of it, the answer would appear to be an emphatic "no." Contemporary Chinese art, from constructs of "contemporaneity" in mainland China as described by Wu Hung 巫 鴻 in his essay to cross-cultural "fusion" works in contemporary music, is attracting unprecedented attention in the international arts scene. I nevertheless cannot help but be attracted to Satō Doshin's notion of a "weather map" of a larger region "that transcends national boundaries." Is it possible that by digesting and recapturing the art historical legacies of a culturally diverse East Asian world—those that transcend the boundaries of China, Korea, Japan, or Taiwan—modern East Asian artists will be empowered, finally, to create new, post-modern art histories with discrete cultural identities and meanings?

20. See Wen C. Fong, in *Possessing the Past: Treasures from the National Palace Museum, Taipei* (New York: The Metropolitan Museum of Art, 1996), pp. 393–94.

21. Oleg Grabar, "On the Universality of the History of Art," *Art Journal,* vol. 42, no. 4 (Winter 1982), p. 282.

Wen C. Fong

第三節　文人畫
論評

方聞

普林斯頓大學榮譽教授

　　這本以涵蓋整個東亞繪畫史爲宏旨的論文集，實肯定了東亞地區文化紛呈的複雜性，畢竟這裡從未出現過單一的藝術史論述。在研究東亞藝術跨區域與跨文化的發展時，文化的接受過程始終是最主要的關懷。脈絡就是一切。然而，正如著名的伊斯蘭藝術史學者 Oleg Grabar 所言：「[今日] 藝術史家的當務之急，是發掘各國家或各民族在文化上對*某種視覺語言的不同意義……舊世界中的新興國家，需要的不是將他們與西方世界聯繫起來的藝術史，而是要能夠展現其獨特性的藝術史。*」[1]

　　本節首先是李成美教授的「理想的對立－韓國文人畫觀念的變遷」，她指出韓國的「文人畫」實與中國的大異其趣。十七世紀初期，中國的文人畫語彙藉由來自中國的木刻畫譜與日用類書開始大量流通；朝鮮畫家們不分職業畫師或文人畫家，皆熱切地運用畫譜中的筆墨程式與構圖模式創作。之後，歐洲十八世紀的理性主義思潮傳入，帶來科學寫實的新觀念，日本與韓國畫家遂將中國十世紀新儒學大師荊浩（約活動於870-930年）的「眞山水」觀念（認爲唯有超群之士，方能掌握景致的「內在眞實」並將之轉化爲紙上的眞山水的觀念），與西方科學原則下線性透視與塗敷手法所繪成的寫實性「眞景山水」結合。

　　「文人畫」是中國特有的畫科與表現手法，初興於十一世紀末期的北宋王朝，其重要性在將中國繪畫之發展從「再現」外在世界，永遠轉向書法性的自我「表現」；前者之例可見於宮廷院畫，後者即如文人畫家所爲。這主題下的另三篇論文，皆不約而同地將焦點放在明代文人畫的領導人物文徵明(1470–1559)身上，並自中國藝術史的角度給予我們更深刻的認識。Craig Clunas 教授在〈商品與脈絡－明末藝術市場中的文徵明作品〉一文中建立了明確的方法學基礎，將中國文人畫視爲社會經濟脈絡下流通的物質商品。[2]他觀察到「文徵明在我們眼前展演了各種不同的風格」－尤其是古代大師的風格，像是趙孟頫(1254–1322)、黃公望(1269–1354)、與吳鎮(1280–1354)－而 Clunas 則將這些風格視爲「破碎的、脈絡下之個人的物質與視覺殘跡」。[3] 趙孟頫的藝術與 Clunas 所引 Alfred

1. Oleg Grabar, "On the Universality of the History of Art," *Art Journal*, vol. 42, no. 4 (Winter 1982), p. 282. 斜體字是本人所標示。

2. Craig Clunas, "Commodity and Context: The Work of Wen Zhengming in the Late Ming Art Market."

3. 同書。

Gell將藝術視爲代理者（agency）、視爲某種獨家關聯物（exclusively relational）的觀念相合。[4]

而Jonathan Hay教授之「文徵明『斷裂』的審美特質」，則在觀念上緊抓著消費經濟對文徵明藝術的衝擊，認爲它促成文徵明畫作中新的視覺「現代性」的開展。Hay更指出文徵明山水畫中所採用的斷裂構圖是對早期現代（early modern）之中國畫的劃時代貢獻。Hay將文徵明1527年之後的作品與其師沈周（1427–1509）的畫作相比，認爲：「文徵明晚期作品的根本貢獻，在打破自宋代至明中葉以來具有位階性的繪畫宇宙觀（pictorial cosmology）……「文徵明]對道德與文化權威所進行重新評估……便是以更具流動性的商業城市價值，將具有強烈位階性之帝國秩序的重要性給相對化。」[5]

最後，是石守謙教授所撰〈雅俗的焦慮：文徵明、鍾馗與大眾文化〉。這是關於明代菁英文人與俗文化之間有關認同與區別的深思力作。石教授首先證明歷來歸屬於文徵明名下的1535年《寒林鍾馗》，實爲文徵明與職業畫家仇英(約1492–1552)的合作畫；畫裡具有辟邪功能的驅鬼鍾馗，很可能是仇英在文徵明的指授下繪成的。其次，他又比較鍾馗圖像的通俗版本與文仇合作的文人版本，以爲文人版的鍾馗是「無用的」鍾馗，且與明初詩人凌雲翰（約活動於1359–1381年）的詩句「明日春光萬餘里」有關。最後，石教授總結道：「《寒林鍾馗》的流行大致不出文人圈的範圍，即使在文人中，也不能保證所有成員都會捨流行的鍾馗相而採用新樣・・・欲更深刻的地了解中國社會與文化，我們必須辨明與分析文人在面對大眾文化時所生的焦慮。」[6]

4. Alfred Gell, *Art and Agency: An Anthropological Theory* (Oxford: Clarendon Press, 1998), p. 140.

5. Jonathan Hay, "Wen Zhengming's Aesthetic of Disjunction."

6. Shih Shou-chien, "Wen Zhengming, Zhong Kui, and Popular Culture."

第三部　文人画
論評

方聞

プリンストン大学名誉教授

　東洋絵画史を包括する本書を出版しようという意欲的な計画には、単一の美術史の物語が存在することのなかった、多様な文化をもつ東洋の複雑性の認識が暗示されている。東洋美術の異なる地域間、異なる文化間の発展を研究する上で、主たる関心事は受容の過程である。コンテクストが重要となる。だが、イスラム美術の著名な研究者Oleg Grabarが指摘するように「（今日の）歴史家に必要なのは、ある種の視覚言語の国家的、民族的に独立した意味を発見することである。旧世界における新しい国々が要求する美術史とは、西洋に結びついたものではなく、差異を明確に示すものである。」[1]

　最初の論文、李成美氏による「葛藤する理想――韓国文人画の概念の変化」では、韓国の「文人」画の慣習が中国とは本質的に異なっていることが示される。木版刷りの画家入門書や百科辞典を通して中国文人画の表現法が広く入手されるようになった17世紀初頭から、朝鮮の職業画家も「文人」画家も、こうした入門書の解説による体系化された画法、構図の手本を彼等の芸術創作の基礎とした。そして、18世紀になると、新たに移入されたヨーロッパの科学的リアリズムの概念の影響のもとに、日本と韓国の芸術家達は、10世紀中国の新儒学の大家、荊浩(870–930年頃に活動)が用いた中国語の「真山水」を採用したが、それは情景の「内なる真実」の完全な表現を意味し、その「真実」は優れた人物にしか把握できないものとされた。彼等はこれを、西洋の遠近法や塑像術の科学的原理を応用して創作したリアリスティックな「真景」図と融合させていった。

　11世紀後半の北宋時代に最初に現れた中国独自の様式や表現性を持つジャンル「文人画」の重要性とは、宮廷が後援した画院絵画に見られる模倣表現から、文人画で実践された書による自己表現へと、中国画の永続的な転換を導いたことである。本セクション内の三つの論文は、いずれも明代を代表する文人画家、文徴明(1470–1559)を論じたものであり、中国美術史の観点からその主題の理解に大きく貢献してくれている。「商品とコンテクスト――明代後期の美術市場における文徴明の作品」でCraig

1. Oleg Grabar, "On the Universality of the History of Art," *Art Journal*, vol. 42, no. 4 (Winter 1982), p. 282. 強調は筆者。

Clunas教授は、中国の文人画を社会的、経済的コンテクストにおける「物質的事物」としてみるための明確な方法論的基礎を確立している。[2]教授はいかに「文徴明が私たちの目に異なって見える実に多くの様式の作品を残したか」を考察する。たとえば趙孟頫(1254–1322)、黄公望(1269–1354)、呉鎮(1280–1354)といった昔の大家の様式は、「『フラクタル』でコンテクスト的な個性の具体的、視覚的な形跡」とみなされる。[3]趙孟頫の芸術は（Clunas教授が参考にした）Alfred Gellの美術は作用力であり、「きわめて関係的な」ものであるという概念にうまく適合する。[4]

Jonathan Hay教授の「文徴明の分裂の美学」は、文徴明の芸術の新たな視覚的「近代性」の始まりと筆者が考えるものに消費者経済が及ぼした影響について理論的に取り組んだ論文である。教授は、文徴明が山水図の構図に分裂を導入したことを近代初期中国絵画への画期的貢献であると特定する。文徴明の1527年以後の作品と彼の師、沈周(1427–1509)の絵画を比較して次のように論じている。「文徴明の後期作品の根本的貢献とは、宋代から明代中期へと引き継がれた階層的な絵画のコスモロジーを解体したことである。・・・（文徴明の）道徳的、文化的権威の再評価により、商業都市のより流動的な価値観と直面することによって、階層的な王室の秩序に関連する価値観の重要性は相対化された。」[5]

最後の論文、石守謙教授による「文徴明、鍾馗、大衆文化」は、明代中国の学者・文人のエリート文化と民衆文化間の相違とアイデンティティーに関する思慮深い研究である。まず1535年の文氏の作品と考えられてきた「寒林鍾馗図」が実は、文氏と職業画家、仇英(1494–1552年頃)との合作であったことが立証される。仇英がおそらく文氏の指示により、厄除けの「鬼やらい」の像を描いたものとされる。教授は、民間の絵画での鍾馗の描かれ方と、文氏と仇氏の文人画的描写とを比較する。最終行に「遥か万里の春の日の光を見る」とある学者、凌雲翰(1359–1381年頃に活動)が書いた明代初期の詩と関連させて考えると、後者は「無用の」鍾馗であると説明される。教授の結論は次の通りである。「『寒林鍾馗図』のような絵画は文人の間のみで流行し、その階級の内ですら広く訴えかけるものではなかった。・・・中国の社会と文化をさらに理解するためには、エリート文化と大衆文化の間の関係を特徴づける緊張を特定し分析しなければならない。」[6]

2. Craig Clunas,"Commodity and Context: The Work of Wen Zhengming in the Late Ming Art Market."

3. 同書。

4. Alfred Gell, *Art and Agency* (New York: Oxford University Press, 1988), p. 140 を参照。

5. Jonathan Hay, "Wen Zhengming's Aesthetic of Disjunction."

6. Shih Shou-chien, "Wen Zhengming, Zhong Kui, and Popular Culture."

Wen C. Fong

Fig. 1. Wang Xizhi (303–361). *Ritual to Pray for Good Harvest*, 7th c. Detail of a tracing copy. The Art Museum, Princeton University.

Fig. 2. Zhao Mengfu (1254–1322). *The Mind Landscape of Xie Youyu*, ca. 1275. Section of a handscroll, ink and color on silk, 24.7 × 117 cm. The Art Museum, Princeton University.

Fig. 3. Zhao Mengfu (1254–1322). *Twin Pines and Level Distance*, ca. 1310. Section of a handscroll, ink on paper, 26.9 × 107.4 cm. The Metropolitan Museum of Art, New York. *(detail on page 393)*

Wen C. Fong

Fig. 4. Zhao Mengfu (1254–1322). *Elegant Rocks and Sparse Trees*, ca. 1310. Handscroll, ink on paper, 26.9 × 107.4 cm. Palace Museum, Beijing.

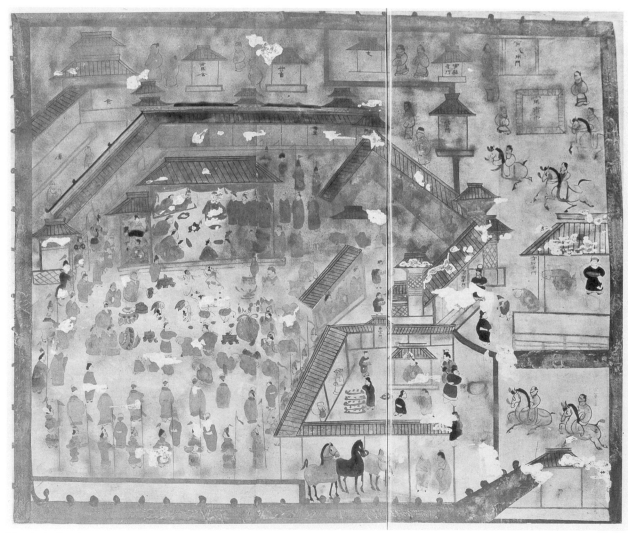

Fig. 5. Wall painting, late 2nd c. From a tomb in Holingol, Inner Mongolia.

Fig. 6. Three diagrams of works illustrating how Chinese painters mastered visual realism in painting.

 A: Anonymous, *Hawks and Ducks*, 8th c. Painting on lute plectrum guard showing additive mountains receding in three separate states. Shōsōin Treasury, Nara.

 B: Lisheng, *Dream Journey on the Xiao and Xiang Rivers*, ca. 1170. Painting showing overlapping mountain motifs receding in a continuous space. Tokyo National Museum.

 C: Zhao Mengfu (1254–1322). *Autumn Colors on the Qiao and Hua Mountains*, dated to 1296. National Palace Museum, Taipei.

Wen C. Fong

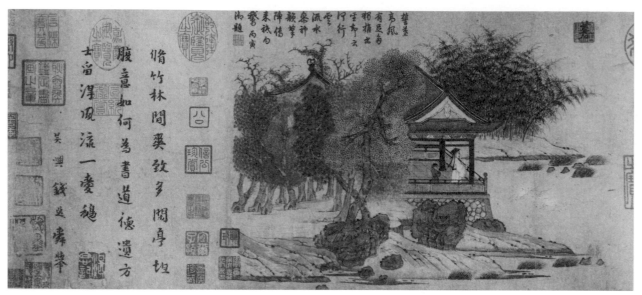

Fig. 7. Qian Xuan (ca. 1235–ca. 1307). *Wang Xizhi Watching Geese*, ca. 1295. Section of a handscroll, ink and color on paper, 23.2 × 92.7 cm. The Metropolitan Museum of Art, New York.

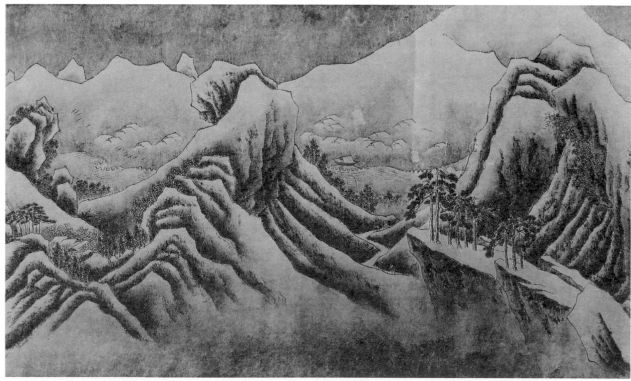

Fig. 8. Wen Zhengming (1470–1559). *Heavy Snow on Mountain Passes*, dated 1528–1532. Section of a handscroll, ink and color on paper, 25.3 × 445.2 cm. National Palace Museum, Taipei.

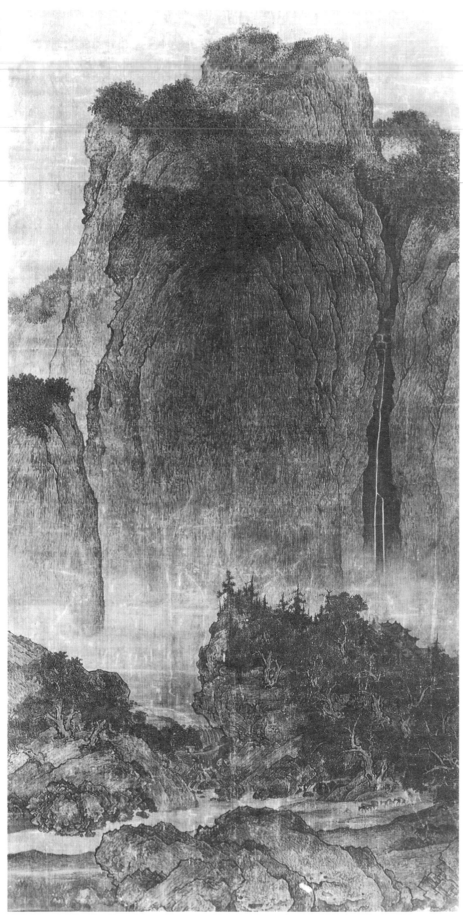

Fig. 9. Fan Kuan (ca. 960–ca. 1030). *Travellers amid Streams and Mountains*, ca. 1000. Hanging scroll, ink and color on silk, 206.3 × 103.3 cm. National Palace Museum, Taipei.

Wen C. Fong

Section IV
Art Historical Methodology

Section IV: Art Historical Methodology
Introduction

John Rosenfield

Harvard University, Emeritus

This section deals with the goals and study methods of art historians. Here we hope to demonstrate some of the debates about method that have been taking place in our field. Indeed, in the 1970s and the aftermath of the Vietnam War, an intellectual movement loosely labeled "Post-Modern Critical Theory," or "New Critical Theory," swept through the developed world. Reflecting the loss of confidence in long-established cultural and political values, it was based mainly on writings by such French thinkers as Jacques Derrida, Michel Foucault, Roland Barthes, and Jacques Lacan. Dissident ideas gained a strong foothold among all branches of the humanities and among historians of Asian art in all English-speaking nations and, to a lesser extent, in Japan.[1]

When applied to the visual arts, the movement has produced what is called the "New Art History." Claiming that the old methods had become stagnant, it seeks to revitalize art history by applying insights from fields such as sociology, economics, anthropology, psychology, and linguistics. It questions the importance given to old standards (or canons) of quality, such as the extreme veneration of great masters—of painters such as Michelangelo or Rembrandt in the West; in China, the painters Guo Xi 郭熙 or Ma Yuan 馬遠; in Japan, Sesshū 雪舟 or Tan'yū 探幽; in Korea, Ankyon 安堅 or Yi In-mun 李寅文. It opposes scholarly focus on periods called "golden ages" (Southern Song China, for example, or late Heian Japan). It injects ethical issues into the study of art, saying that art historians should pay more attention to the fate of the oppressed classes: women, the silenced poor, colonial peoples, people of color, and people who are repressed because of their sexual orientation. It believes that the art market and private collecting remove works of art from their original and proper settings, thereby depriving poorer nations of their cultural heritage and making art a plaything of the rich.

This is not the place to explore the conflict in detail; I will return to it briefly in the concluding remarks at the end of this volume. However, I must mention here that a major point of dispute is the "craft of connoisseurship." This can be defined as the ability to determine the authorship, conditions of origin, physical state, authenticity, record of ownership, and relative quality of a work of art. The older generation insisted that connoisseurship was the foundation skill of the art historian; many younger scholars feel that the art market has fatally contaminated the craft, and they ignore it and follow other avenues of study. Some younger scholars are bewildered and vacillate between the two views.

1. Countless books and articles have been published on this subject. For introductions, see Margaret A. Rose, *The Post-Modern and the Post-Industrial: A Critical Analysis* (Cambridge; Cambridge University Press, 1991); and Charles Jencks, *What is Post-Modernism?* 3rd rev. ed. (New York: St. Martine's Press, 1989).

The first two essays in this section demonstrate the opposite positions in this debate. Itakura Masaaki 板倉聖哲 of the University of Tokyo, in the conservative role, analyzes a handscroll painting in the Nelson-Atkins Museum of Art in Kansas City that is probably the oldest surviving illustration of the "Later Ode on the Red Cliff" (*Hou Chibi fu* 後赤壁賦) by the Song poet Su Shi 蘇軾 (1037–1101). For many, and I speak for myself as well, the odes on the Red Cliff by Su Shi are among the most profound and moving of all works of Asian literature. Moreover, the Nelson Gallery scroll is a major art historical landmark, for it is an early example of the unity of poetry and painting and of the seemingly artless painting techniques that lie at the heart of literati (*wenren* 文人) aesthetic values. Itakura has explored the conditions under which Su Shi wrote his original poems, reconstructed the original appearance of the Kansas City handscroll, and established that it was painted about twenty years after Su's death. He has determined its stylistic lineage, identified the group of literati patrons for whom it was made, and evaluated its aesthetic achievement in creating an idealized image that is not based upon historical fact or natural appearances.

The second essay, by Sano Midori 佐野みどり of Gakushuin 学習院 University, also focuses on a canonical masterpiece of both literature and art—but in a manner different from that of Professor Itakura. Well-read in European critical theory, Sano has written a great number of essays on narrative and decorative painting which were brought together in 1997 in her monumental *Elegance, Shaping, Narration: Construction and Modalities in Japanese Art* (*Fūryū zōkei monogatari—Nihon bijutsu no kōzō to yōtai* 風流・造形・物語―日本美術の構造と様態). Her subject here is the oldest surviving illustrated version of surely the most revered work of Japanese fiction, the romantic novel *The Tale of Genji* (*Genji monogatari* 源氏物語). The novel itself dates from roughly the same time as Su Shi's Red Cliff odes, the late tenth to early eleventh century; the illustrated version is about one century later. Rather than exploring the novel and painting as historical artifacts—which dozens of scholars have done repeatedly—she builds upon recent advances in reception theory to analyze the psychological and linguistic activities that are produced in the minds of the viewers by the compositions of the paintings. She discusses, for example, the path of the "gaze"—the movement of attention from the viewer to the figures represented in the paintings, and from one depicted figure to another. She shows how much of the story is not depicted in the painting, and how much the viewers must combine their own knowledge with what they are seeing. She also adopts the "New Critical" position—seen in writers like Derrida, Foucault, and Barthes—that the original content of the scroll painting is forever lost, and that the true authors of the painting and its story are the present-day viewers themselves.

The third essay is by Timon Screech at the School of Oriental and African Studies at London University. Screech has had a major impact through his incisive studies of Japanese popular illustrated literature, called *gesaku* 戯作, of the eighteenth and nineteenth century and tying it to major issues of cultural history. His *Western Scientific Gaze and Popular Imagery in Late Edo Japan* of 1996 demonstrated how deeply Western learning had penetrated into the consciousness of Japanese city dwellers as well as the élite. His book entitled *Sex and the Floating World: Erotic Images in Japan, 1700–1820* expanded our understanding of Japanese prints by introducing the psychologically cogent

themes of auto-eroticism and homosexuality into an art historical discourse that had long been largely limited to the subject of glamorous courtesans. His essay explores how, in popular literature, Japanese painters defined their relationship to those of China.

The fourth essay in this section, by Satō Dōshin 佐藤道信 of the Tokyo National University of Fine Arts and Music (Tōkyō geijutsu daigaku 東京芸術大学), is written from a theoretical point of view. His much-admired *Birth of "Japanese Art"—Terminology and Tactics in Modern Japan* (*Nihon bijutsutanjō—Kindai Nihon no "kotoba" to senryaku* 日本美術誕生—近代日本の「ことば」と戦略), published in 1996, analyzed the manner by which Japan devised new words to embody Western historical and aesthetic concepts. The new terms included even the now familiar *bijutsu* 美術, which was invented only in the 1870s to translate the Western concept of "fine arts." The essay explores the manner by which changing Japanese government policies affected the efforts of Japanese art historians to define "modern" and "contemporary" arts. (Defining "modern" and "contemporary" is also a major theme in the fifth section of this volume.) Satō frames his discussion by references to Japan's invasions of the Asian mainland, its defeat in World War II, and its post-war constitution. His book *The Meiji Nation and the Art of the Recent Era: Beauty and the Political Science* (*Meiji kokka to kindai bijutsu—Bi no seijigaku* 明治国家と近代美術—美の政治学) explored many of those themes. His essay here compares the different ways by which, in recent times, Japanese, Chinese, and Korean scholars have viewed the history of East Asian art. He also recommends that we should compare that history to a weather map in which wind and air pressure—like major movements and contexts of the arts (Buddhist, Confucian, Daoist, literati, or popular)—move over the large region and cross the national boundaries. That thought, so beautifully formulated by Professor Satō, is indeed one of the ideals of the organizers of this conference and volume.

John Rosenfield

第四節　美術史的方法論
引言

John Rosenfield
哈佛大學榮譽教授

　　第四節欲彰顯後現代批評理論所引起的方法學論辯。這股後現代思潮以法國哲學家的理論爲宗，企圖藉由來自社會學、經濟學、人類學、心理學及語言學等其他領域的洞見，一新藝術史學的研究。此外，亦揚棄以往被視爲藝術史家基本功的鑑定學，並以爲藝術市場總是無可避免地染污藝術品本身。

　　頭兩篇文章便是兩種極端的觀點。板倉聖哲教授站在保守的立場，分析北宋詩人蘇軾的名篇〈後赤壁賦〉現存最古老的繪本；他探討蘇軾作詩的情境、重建此畫的本來面目、並斷定其成畫年代與可能的贊助者。另一篇佐野みどり教授的論文，分析的是《源氏物語》現存最早的插畫版本，然卻探討此畫對觀者心中所造成的心理、及語言學上的活動。她認爲小說與畫作最原始的意義已經永遠消失了，畫作與故事的眞正「作者」，是當下正在欣賞的觀衆。

　　第三篇由Timon Screech所撰寫的文章則探討國家認同的問題、以及日本畫家如何界定他們與中國畫家的關係。第四篇佐藤道信教授的論文，討論明治政府的政策變動如何影響日本藝術史家的論著。文中更比較了近期東亞學者如何看待這個區域裡的藝術史。他亦提議應該將歷史的發展比擬作氣象圖，一些大的藝術門類，諸如佛畫、水墨畫、文人藝術等，就像是風向與氣壓一樣，是以整個大陸爲範疇而移動的，決不受限於國家的疆域。

第四部　美術史の方法論
序言

John Rosenfield

ハーバード大学名誉教授

　第四部では、ポストモダン批評理論と呼ばれる知的運動によりもたらされた学問的手法に関する議論を明確に示そうとするものである。主としてフランス哲学者の著述に基づくこの運動は、社会学、経済学、人類学、心理学、言語学といった分野からの洞察を応用することにより美術史を再活性化することを目論んでいる。それはまた、かつて美術史家の基本的技能であった鑑識眼が、美術市場により致命的に汚染されたとして、その重要性を否定している。

　最初の二論文は正反対の視点を示す。板倉聖哲氏は、保守的な役割を演じられ、宋代の詩人蘇軾の現存最古の「後赤壁賦」を分析する。この詩が制作された状況を検討し、画巻の当初の外観を再構築し、制作年代とパトロンの特定を試みる。二番目の佐野みどり氏による論文は『源氏物語』の現存する最古の物語絵巻の分析であり、作品が鑑賞者の心に作り出す心理学的、言語学的活動を探求している。氏の結論では、小説と絵画の元来の意味は永遠に失われ、絵画と物語の真の「作者」とは現在の鑑賞者である。

　Timon Screech氏による第三論文は、国家的アイデンティティーの問題、日本画家が中国画家との関係をどのように定義したかを探求する。佐藤道信氏の第四論文は、明治政府の政策の変化がいかに日本の美術史家の仕事に影響を与えたかを論じている。近年、東洋の研究者がその地域の美術史をどう見てきたかを比較する。氏が提唱するのは、美術史を天気図にたとえること、大きな芸術上の連携――仏教絵画、水墨画、文人画など――を国境とは無関係に大陸上を移動する風や気圧に似たものと考えるべきということである。

是歲十月之望步自雪堂將歸
于臨皋二客從予過黃泥之坂
霜露既降木葉盡脫人影在地
仰見明月顧而樂之行歌相答
已而歎曰有客無酒有酒無肴
月白風清如此良夜何客曰今
者薄暮舉網得魚巨口細鱗狀
似松江之鱸顧安所得酒乎

Text and Images:
The Interrelationship of Su Shi's Odes on the Red Cliff and
Illustration of the Later Ode on the Red Cliff by Qiao Zhongchang

Itakura Masaaki

University of Tokyo

The *Odes on the Red Cliff* (*Chibi fu* 赤壁賦) stand out as being among the most famous works by Su Shi 蘇軾 (1037–1101; style name, Zizhan 子瞻; sobriquet, Dongpo jushi 東坡居士). The two odes that make up this work were written by Su Shi in the fifth year of the Yuanfeng 元豐 reign (1082) upon the occasion of a boat trip with friends during his exile in Huangzhou 黄州 (Huanggang 黄岡 County, Hubei Province) to one of the sites identified as the historic Red Cliff.

Amid fierce political struggles, Su Shi was accused of insulting the throne, tried, and convicted in the so-called "Case against [Su Shi's] Poetry at the Black Terrace" (*Wutai shi'an* 烏臺詩案) during the autumn and winter of the second year of the Yuanfeng reign (1079). The following year, he was exiled to Huangzhou along the Yangtze River in Hubei. The years 1080 to 1084 represented for Su Shi a period of recovery, both emotional and political, from the downfall caused by the "Poetry at the Black Terrace Incident," and it was also a time for searching and enquiry as he sought a path from adversity to a new life. Indeed, this was one of the most epochal periods in Su Shi's life. During this time, in addition to the *Odes on the Red Cliff*, Su's poetic writings included "To the Tune 'Recalling Her Charms': Cherishing the Past at the Red Cliff" (*Niannüjiao Chibi huaigu* 念奴嬌赤壁懷古) and "Eight Poems on East Slope" (*Dongpo ba shou* 東坡八首)—a turning point in Su's creative development. Through the poet's gift of *yonghua* 鎔化 ("melting," the selfless, total identification of artist with the subject), Su was able to conjure up the enraptured realm seen in the *Odes on the Red Cliff*. The work has subsequently enjoyed great acclaim and popularity through the ages.[1]

During his exile, Su was deprived of his freedom of movement and his political authority. He arrived in Huangzhou with his family and attendants on the first day of the second month of the third Yuanfeng year (1080), and his hardships increased daily thereafter. Witnessing these privations, one friend gave him money to add rooms to the Lin'gao Pavilion (Lin'gao ting 臨皋亭) to house his family. In the following year, another friend leased Su some fallow land to the southeast of Huangzhou for cultivation. Su named that plot of land "Dongpo 東坡," literally "East Slope," and in 1082 he built a modest scholar's study called "Xuetang 雪堂" (Snow Hall) at the edge of Dongpo,

1. Regarding critiques and evaluations of the *Odes on the Red Cliff*, see Yamamoto Kazuyoshi, "Sekiheki no fu ronkō (Study on the Red Cliff Odes)," in *Shijin to zōbutsu—So Shoku ronkō* (*Poetry and Creator: Studies on Su Shi*) (Tokyo: Kenbun shuppan, 2002). For English translations, see Cyril Clark, *The Prose-Poetry of Su Tung-p'o*, 1st ed. (Shanghai: Kelley, 1935); Burton Watson, *Su Tung-p'o: Selections from a Sung Dynasty Poet* (New York: Columbia University Press, 1965); and Ronald Egan, *Word, Image, and Deed in the Life of Su Shi* (Cambridge, Mass.: Harvard University Press, 1994).

where he would devote himself to meditation and self-cultivation. On a snowy day in the second month of 1082, Su hung a name plaque that read, "Dongpo Xuetang." Acquiring the use of a little farm and constructing the studio were epochal in Su's life, and it was from this time that he began to call himself "Dongpo jushi" (Layman of East Slope). That year, Su visited the so-called "Red Cliff" at least three times, and two of those visits, in early autumn on the sixteenth day of the seventh month and in winter on the fifteenth day of the tenth month, became the inspiration for his two *Odes on the Red Cliff*.[2]

Su refrained from publicizing the *Odes* immediately after their composition. The handscroll of calligraphy entitled *Early Ode on the Red Cliff* (*Fig. 1*) was composed the following year (1083) and sent to Su's friend Fu Yaoyu 傅堯愈 with the following note by Su, which reads in part:

> Except for one or two people, I haven't shown this work about, and would rather have it avoid all eyes. I would like its existence to be hidden.
> 見者蓋一二人而已。···欽之愛我。必深藏之不出也。

The reasons for this avoidance of public display lay in the political battles between the "Old Faction" (Jiudang 舊黨) and the "New Faction" (Xindang 新黨) at the time, which had brought exile and hardship for Su in Huangzhou, and the fact that Su himself believed that political opponents would ascribe a hostile political message to his odes, plunging him into even deeper disfavor.[3]

The Red Cliff of Huangzhou, supposed site of the ancient naval battle that inspired the *Odes,* was so cited in the text of *Cherishing the Past at the Ancient Red Cliff* (*Chibi huaigu*), which refers to the Chibiji 赤壁磯 ("Chibi Jetty") located outside of the city of Huangzhou. Su's words evoke the magnificent scenery of this cliff face, and the *Early Ode on the Red Cliff* states explicitly that this is where, in 208 C.E., the Wu general Zhou Yu 周瑜 defeated Cao Cao 曹操 (155–220), ruler of the Wei kingdom. Many sites have been proposed for this ancient battle, but thanks to Su's poem, the Red Cliff near Huangzhou has long been the favorite candidate.[4] In fact, the ancient battle took place at the Red Cliff of Puqi 浦圻, upstream from Huangzhou in Hubei. Had Su mistaken the battle site? No, he did not, for he knew that the Huangzhou Red Cliff was not the site, instead superimposing his musings on the battle with the scenery of the site of his excursions to create a poetic composite. The Tang poet Du Mu 杜牧 (803–852) had already composed a poem that located the battle at the Huangzhou Red Cliff, and Su adopted that fictitious construct as a setting for the drama enacted by those ancient heroes.[5] Historical fact and legend are fodder for poetic creation, and

2. Regarding Su Shi during his exile in Huangzhou, see Rao Xuegang, *Su Dongpo zai Huangzhou* (*Su Dongpo in Huangzhou*) (Beijing: Jinghua chubanshe, 1999).

3. Kobayashi Tadateru, "So Shoku Sekiheki-fu shōkō (Study of Su Shi's 'Chibifu')," in *Kokugakuin Chūgoku gakkaihō* (*Bulletin of the Sinological Society of Kokugakuin*), vol. 44 (1998); Egan, *Word, Image, and Deed in the Life of Su Shi*, ch. 8.

4. As the battle of the Red Cliff became familiar to Chinese audiences as a trope of heroism and tragedy, through poetry, novels, and plays, its site became a matter of debate, and these debates can also be considered cultural phenomena. See Li Wenlan and Lei Jiahong, "Tang Song Chibi wenhua xianxiang shulun (Study on the Cultural Phenomena of the Red Cliff in the Tang and Sung)," in *Jiangnan luntan* (*Forum on Jiangnan*), third period, 1998.

5. Matsuo Yukitada, "Toboku to Kōshū sekiheki: Sono shisekika ni kansuru kōsatsu (The Red Cliff in Du Mu and Huangzhou:

many sites became celebrated monuments thanks to their appearance in a famous poem. But Su, in exile, was not free to travel, except in his imagination; the small, red clay mountain within his permitted range evoked images of historical sites, and his two odes, in turn, made the Huangzhou Red Cliff one of the most famous sites in literature. Today, the course of the Yangtze River is no longer the same and the scenery has radically altered, but this area is still fully imbued with the thoughts of Su Shi.

Documentary evidence shows that paintings with Su Shi as their topic, including portraits, were created during his own lifetime. An artistic network formed around him, centered on a group of land-owning scholar-officials from the "Sichuan Faction" (Shudang 蜀黨), and the portraits created by other members of the group, such as Li Gonglin 李公麟 (ca. 1041–1106), were highly prized. A student of Su Shi, Li Jian 李薦, in his *Memoir of Teachers* (*Shiyou tanji* 師友談記), stated that Su Shi began to wear a Dongpo cap—so named because of his affiliation with the site— and it became his trademark. Records state that a dramatic sketch parodying Su Shi's trademark cap was performed for both the emperor and Su himself. Portraits of the poet therefore standardized the Su Shi image, as did the poet's representations in drama and other mediums. After Su's death, his friend Huang Tingjian 黃庭堅 (1045–1105) hung a portrait of the aged Su in his room, and every morning donned full ceremonial garb, lit incense, and paid homage.[6] Paintings inspired by Su's poems were also executed shortly after the poet's death (*Fig. 2*).[7] Not only were his poems acclaimed by all levels of Chinese society, his fame even spread to Korea and Japan, where he became the subject of a variety of paintings.

Though Su Shi himself avoided publication of the *Odes on the Red Cliff*, these writings nonetheless became his signature works and the most commonly depicted theme in paintings related to him.[8] The Red Cliff paintings and

Essay on its Historic Reptutation as a Poetic Subject)," in *Chūgoku shibun ronsō* (*Studies in Chinese Classical Literature*), vol. 8 (Tokyo: Sōbunsha, 1989).

6. See Shao Bo, *Shaoshi Wenjian houlu* (*Latter Record of Thing Heard and Seen by Shao*), *juan* (fascicle) 21.

7. Regarding the development of painting themes related to Su Shi, see Kunigō Hideaki, "Nihon ni okeru So Shoku zō: Tokyo Kokuritsu Hakubutsukan hokan no mohon o chūshin to suru shiryō shōkai (Paintings of Su Shi in Japan: Centering on Copies in the Tokyo National Museum)," *Museum*, no. 494 (1992); and Kunigō Hideaki, "Nihon ni okeru So Shoku zō (2): Chūsei ni okeru gadai tenkai (Paintings of Su Shi in Japan [2]: Development of Their Subject Matter in the Middle Period)," *Museum*, no. 545 (1996).

8. The following are the major discussions concerning the pictorialization of the theme on the Red Cliff odes, listed in chronological order:
 Stephen Wilkinson, "Paintings of 'The Red Cliff Prose Poems' in Song Times," *Oriental Art*, vol. 27, no. 1 (1981);
 Daniel Altieri, "The Painted Visions of the Red Cliffs," *Oriental Art*, vol. 29, no. 3 (1983);
 Chibi fu shuhua tezhan tulu (*Illustrated Catalogue of the Special Exhibition on Painting and Calligraphy on the Red Cliff Odes*) (Taipei: Guoli gugong bowuyuan, 1984);
 Jerome Silbergeld, "Back to the Red Cliff: Reflections on the Narrative Mode in Early Literati Landscape Painting," *Ars Orientalis*, vol. 25 (1995);
 Miyazaki Noriko, "Nansō jidai ni okeru jikkeizu (True-View Paintings in the Southern Song Period)," in *Sekai bijutsu daizenshū: Tōyō hen* (*Compendium of World Art: East Asia*), vol. 6, "Nansō-Kin (Southern Song-Jin)" (Tokyo: Shōgakukan, 2000);
 Yi Luofen, "Zhanhuo yu qingyou: Chibi tu tiyong longxi (Fiery Battles and Pure Wanderings: Illustrating Eulogies of the Red Cliff)," in *Gugong xueshu jikan* (*National Palace Museum Research Quarterly*), vol. 18, no. 4 (2001);

their accompanying colophons and inscriptions have had a great impact on the interpretations of the *Odes* themselves. With this in mind, I should like to discuss the relationship between text and image in the earliest extant painting of this subject, *Illustration of the Later Ode on the Red Cliff (Fig. 3)* in the Nelson-Atkins Museum of Art, Kansas City, which was painted by the little-known artist Qiao Zhongchang 喬仲常 (act. early 12th c.).[9]

This handscroll is impressed with the collection seal of Liang Shicheng 梁師成 (?–1126), the political minister who enjoyed the patronage of Emperor Huizong 徽宗 (1082–1135; r. 1101–1126). The scroll is accompanied by a title inscription dated to the seventh day of the eighth month of the fifth year of Xuanhe 宣和 (1123), written by Zhao Lingzhi 趙令畤, a Song imperial prince who was close to Su Shi at court. We therefore know that this work was painted approximately twenty years after Su's death. Its image of Su, then, was created soon after Su's own lifetime and during the lifetimes of people who had known him. The seventh stanza in volume nine of Huang Tingjian's *Ten Spontaneous Poems on Awakening Ill in the Jingjiang Pavilion* (*Bing qi Jingjiang ting ji shi shi shou* 病起荊江亭即事十首), mentions that Su's hair fell out from the privations suffered in his two periods in exile, calling him "the Bald Old Man of Zhanzhou" (Zhanzhou tubinweng 瞻州禿鬢翁). The Kansas City painting shows Su as healthy, but with hair sparse and dishevelled.

The *Later Ode on the Red Cliff*, used as the text on this painting, is divided into eight stanzas. The sixth stanza

Itakura Masaaki, "Sekiheki o meguru jikkei-kotoba-gazō (True Views: Words and Images of the Red Cliff)," in *Ajia yūgaku* (*Intriguing Asia*), no. 31 (2001).

9. In addition to the sources listed in Note 7, see the following principal discussions of the Nelson-Atkins version, listed in chronological order:

James Cahill, "'Ode on the Red Cliff' attributed to Ch'iao Chung-ch'ang," in *Chinese Calligraphy and Painting in the Collection of John M. Crawford, Jr.* (New York: The Pierpont Morgan Library, 1962);

Toda Teisuke, "Den Kyō Chūjō Kōsekihekifu zukan kaisetsu (The *Second Ode on the Red Cliff* Attributed to Qiao Zongchang)," in *Ryōkai-Indara* (*Liang Kai—Yintuoluo*), *Suiboku bijutsu taikei* (*Outline of the Art of Ink Painting*), vol. 4 (Tokyo: Kōdansha, 1975);

Fu Shen and Kohara Hironobu, "Kyō Chūjō ga Kōsekihekifu zukan daibatsu (Colophon on Qiao Zhongchang's *Second Ode on the Red Cliff*)," in *Ōbei shūzō Chūgoku hōshō meisekishū* (*Masterpieces of Chinese Calligraphy in European and American Collections*), vol. 1 (Tokyo: Chūō kōronsha, 1981);

Kohara Hironobu, "Kyō Chūjō Kōsekihekifu zukan (The *Second Ode on the Red Cliff* Handscroll)," in *Shoron* (1982);

Suzuki Kei, "Den Kyō Chūjō jōhitsu Kōsekihekifu zukan (The *Second Ode on the Red Cliff* Attributed to Qiao Zongchang)," in *Chūgoku kaigashi* (*History of Chinese Painting*) (Tokyo: Yoshikawa kōbunkan, 1984);

Wang Wenyi, "Qiao Zhongchang Hou Chibi fu tu jieshuo (Discussion of the *Second Ode on the Red Cliff* Painting by Qiao Zhongchang)," in Shih Shou-chien *et al.*, *Zhongguo gudai huihua mingpin* (*Selected Masterpieces of Chinese Ancient Painting*) (Taipei: Xiongshi tushu, 1986);

Wai-yee Li, "Dream Visions of Transcendence in Chinese Literature and Painting," *Asian Art*, vol. 3, no. 4 (1990);

Ding Xiyuan, "Qiao Zhongchang Hou Chibi fu tujuan shiyi (A Question Concerning the *Second Ode on the Red Cliff* Painting by Qiao Zhongchang)," in *Duoyun: Zhongguo huihua yanjiu jikan* (*Duoyun: Research on Chinese Painting*), vol. 31 (Shanghai: Shuhua chubanshe, 1991);

Fu Zheng and Wang Kewen, "Qiao Zhongchang Hou Chibi fu tu (Qiao Zhongchang's *Second Ode on the Red Cliff* Illustration)," in *Zhongguo minghua jianshang cidian* (*A Connoisseur's Dictionary of Famous Chinese Paintings*) (Shanghai: Cishu chubanshe, 1993);

Ogawa Hiromitsu, "Sansui, fuzoku, setsuwa—Tō Sō Gen dai Chūgoku kaiga no Nihon e no eikyō—(Den) Kyō Chūjō Kōsekihekifu zukan to Shigisan engi emaki o chūshin ni (Landscape, Genre, and Narrative—The Influence of Chinese Painting of the Tang, Song, and Yuan Periods on Japanese Painting)," in *Nichū bunka kōryūshi shōsho* (*Library of Chinese-Japanese Cultural Exchange*), vol. 7 of *Geijutsu* (*The Arts*) (Tokyo: Taishūkan shoten, 1997).

begins with the character for "evening" (*xi* 夕), which is a mistake for the correct character for "returning" (*fan* 反); the text of the seventh stanza contains the phrase "dream of two Daoist monks" (*meng er Daoshi* 夢二道士). This wording accords with the text of the Northern Song printed edition of the poem; versions written after the beginning of the Southern Song all refer to one monk instead of two. The text inscribed on the handscroll, then, is the pre-Southern Song version of the poem.[10] In the handscroll, each of the scenes described in the poem is depicted literally, a type of composition based on the traditional narrative mode found in narrative handscrolls of the Six Dynasties period and later.[11] First, let us look at the contents of the Nelson-Atkins handscroll in more detail.

The inscription for the first scene reads:[12]

> On the fifteenth of the tenth month of the same year (1082) I set out on foot from Snow Hall, intending to return to Lin'gao. Two guests accompanied me as we passed Yellow Dirt Hill. Dew had fallen and the trees had shed all their leaves. Our shadows lay on the ground, and we gazed up at the bright moon. Delighted by our surroundings, we sang back and forth to each other as we walked. After some time, however, I heaved a sigh. "I have guests but no wine; and even if I had wine, I have no foods to go with it. The moon is bright and the wind fresh. Are we going to waste such a fine evening as this?" One of my guests said, "Today at sunset I caught a fish in my net. It has a large mouth and tiny scales and looks just like a Song River bass. But where can we get wine to go with it?"
> 是歲十月之望。步自雪堂。將歸于臨皋。二客徒予。過黃泥之坂。霜露既降。木葉盡脱。人影在地。仰見明月。顧而樂之。行歌相答。已而嘆曰。有客無酒。有酒無肴。月白風清。如此良夜何。客曰。今者薄暮。舉網得魚。巨口細鱗。狀似松江之鱗。顧安所得酒乎。

In its present state, the beginning of the handscroll (scene 1) opens with images of leafless trees of Yellow Dirt Hill (Huangni ban 黃泥坡.) Su Shi and his party have left his Snow Hall retreat intending to return to his residence at Lin'gao. They are shown approaching the Yangtze River, their shadows reflected on the ground, and we can see the moon directly above their heads. The fisherman, who is pulling in his evening nets, hands fish to his young helper.

The text for the second scene reads,

> We returned to my house and consulted my wife. She said, "We do have one jug of wine I hid away, keeping it for just such an emergency." Taking the wine and the fish, . . .
> 歸而謀諸婦。婦曰。我有斗酒。藏之久矣。以待子不時之須。於是携酒與魚。

Past the willows and wooden bridge stands the Xuetang Studio. Su Shi takes the wine and delicacies from his wife, who, with a child, watches him leave for the Red Cliff. In the side wing of the building facing us, a horse groom is napping.

The inscription for the third scene continues as follows:

> . . . we went boating again below Red Cliff. The river made noise as it flowed, and the sheer cliff rose a thousand feet. The peak was towering and the moon tiny. The water level had fallen and rocks on

10. Yi Luofen, "Tan Su Shi Hou Chibi fu zhong suo meng Daoshi renshu zhi wenti (A Question Concerning the Number of Daoist Monks in Su Shi's *Second Ode on the Red Cliff*)," in *Chibi manyou yu Xiyuan yaji—Su Shi yanjiu lunji* (*Travels to the Red Cliff and the Elegant Gathering at the Western Garden*) (Xi'an: Zhuang shuju, 2001).

10. Chen Pao-chen, "Three Representational Modes for Text/Image Relationships in Early Chinese Pictorial Art," in *Taida Journal of Art History*, no. 8 (2000).

12. All translations are from Egan, *Word, Image, and Deed in the Life of Su Shi*, pp. 245–46. Adaptations have been made for the paragraph breaks.

the bottom were exposed. How many months had it been since my last visit? And yet the landscape seemed completely unfamiliar to me.

復游於赤壁之下。江流有聲。斷岸千尺。山高月小。水落石出。曾日月之幾何。而江山不可復識矣。

Su Shi and his party are seated beneath the cliff face, Su in the middle and depicted the largest of the three. One of his friends looks up at the moon, the other at Su Shi. An attendant stands off to the side.

The short text for scene four reads, "So thinking, I picked up my robe and began to climb. I stepped over jutting rocks, pushed back undergrowth, . . . (予乃攝衣而上。履巉巖。披蒙茸。)." Su Shi is shown walking alone on the verdant grass growing between the rocks. The clump of trees bears three characters, "*ju hu bao* 踞虎豹 (. . . squatted on tigers and leopards, . . .)," these trees functioning as the link between Su Shi, who is advancing against the flow of action, and his destination, which is further along the scroll, counter to his direction of movement.

The text for the fifth scene continues as follows:

> . . . and climbed along scaly dragons until I could pull myself up to the perilous nests of the hawks and look down into the River Lord's palace in the depths. My two guests were quite unable to follow me. All at once I let out a long, low whistle. The trees and grasses shook; the mountains sang out and the valleys answered; a wind arose and the water surged. I grew apprehensive and melancholy, humbled and fearful, and felt so cold that I knew I could not remain there long.
>
> 登虬龍。攀栖鶻之危巢。俯馮之夷幽宮。蓋二客不能徒焉。劃然長嘯。草木震動。山鳴谷應。風起水通。予而悄然而悲。肅然而恐。凜乎其不可留也。

Su Shi is not present in this scene. We see instead the arcing curve of a great sedimentary boulder eroded in sharp angles by the bounding waves of the lake. These are depicted with light ink lines, with birds' nests seen above.

The inscription for the sixth scene reads,

> I climbed down and got back into the boat. We rowed out into the middle of the river, then let the boat drift freely about and come to rest wherever it would. By that time it was nearly midnight and there was no sign of life anywhere around us. Just then a lone crane appeared, cutting across the river from the east. Its wings were as big as cartwheels, and it wore a black skirt and white robe. It let out a long, grating screech and swooped down over our boat before continuing westward.
>
> 夕而登舟。放乎中流。聽其所止而休焉。時夜將半。四顧寂寥。適有孤鶴。橫江東來。翅如車輪。玄裳縞衣。戛然長鳴。掠予舟而西也。

This is the climax of the scroll, with the party in a boat beneath the cliff. A single crane is flying across the river from the east, calling as it disappears to the west.

For the seventh scene appears the following text:

> A short while later the guests departed, and I, too, went home to sleep. I dreamed of a Daoist dressed in a fluttering feather robe who passed before Lin'gao. He bowed to me and said, "Did you enjoy your outing to Red Cliff?" I asked his name, but he dropped his eyes and made no reply. "So! Aha!" I said, "Now I understand. Last night it was you who flew screeching over my boat, wasn't it?" The Daoist turned away with a smile, . . .
>
> 須臾客去。予亦就睡。夢二道士。羽衣翩躚。過臨皋之下。揖予而言曰。赤壁之遊樂乎。問共姓名、俛而不答。嗚呼噫嘻。我知之矣。疇昔之夜。飛鳴而過我者。非子也耶。道士顧笑。

The Lin'gao Pavilion appears here again, with Su Shi seated inside, opposite two gentlemen who are shown looking at him.

Finally, in the eighth section, appears the concluding part of the ode: ". . . and just at that moment I woke up. I opened the door to look, but he was nowhere in sight. (予亦驚悟。開戶視之。不見其處。)." Here we see the Lin'gao Pavilion once more, this time viewed from the side. Su Shi, only sketchily depicted, has opened the door and stands looking out.

With the exception of the fifth scene, in which Su Shi does not appear, every scene in this handscroll shows him facing outward, as if talking to the viewer. He therefore appears simultaneously as a figure in the text and also as its narrator. Moreover, the one scene that omits Su's figure is depicted from a high vantage point, as it would have appeared to Su. This device layers the viewer's gaze with that of the absent Su Shi.[13]

In its current state, the first sheet of the handscroll is only 10.9 centimeters long, but the other sections are all about 78 centimeters long. It therefore has been surmised that some 67 centimeters are missing from the first section. *The Early and Later Odes on the Red Cliff* (*Qianhou Chibifu tu* 前後赤壁賦圖) handscroll attributed to Zhao Mengfu 趙孟頫 (1254–1322; *Fig. 4*) and *The Red Cliff Scroll* (*Chibi tu* 赤壁圖) attributed to Wen Zhengming 文徵明 (1470–1559), both in the National Palace Museum, Taipei, depict at the beginning the Lin'gao Pavilion, where Su Shi intended to go after his excursion to the Red Cliff. The text itself indicates that he departed from Xuetang, the studio that he built on his farm at Dongpo. One of the images in *Albums of Reduced-scale Sketches* (*Shukuzu-satsu* 縮図冊; *Fig. 5*), by the early Edo period artist Kanō Tan'yū 狩野探幽 (1602–1674), shows a composition that accords with the opening of the Nelson-Atkins handscroll, and the building that it shows may be the Xuetang.[14] Inferring the composition of the first section of the present handscroll from Tan'yū's oft-copied miniature image, the front of Xuetang would be seen from a low vantage point slightly below the middle of the section.

Qiao Zhongchang employed remarkable sophistication in the depiction of architecture. In the second section, for example, the building is shown close-up from the side in great detail, enclosed by its bamboo fence and with its entrance gate carefully foreshortened. On the other hand, the Lin'gao Pavilion in the seventh section is depicted frontally from a high vantage point and with much less detail. In the eighth section, it is turned ninety degrees, and the artist thereby avoided repetition. The scale of the buildings, larger in the second scene and smaller in the seventh and eighth, reflects the *Later Ode* itself, which offers realistic descriptions in the first half and a combination of dream and reality at the end.

This handscroll was largely created in *baimiao* 白描, or linear ink drawing without wash or color, with the primarily dry brush strokes heightening the effect of linearity. The forms were basically built up through a progression of light, medium, and dark ink lines. A major change in the drawing of the forms, however, is evident in the middle

13. Opinion expressed by James Cahill during the Taipei 2002 Conference.

14. Itakura Masaaki, "Kyō Chūjō Kōsekihekifu zukan (Neruson Atokinsu bijutsukan) no shiteki ichi (Historical Significance of Qiao Zhongchang's Handscroll of the *Second Ode on the Red Cliff* in the Collection of the Nelson-Atkins Museum of Art)," *Kokka*, no. 1270 (2001).

Itakura Masaaki

of the handscroll. Physical shapes are firmly delineated in the early part of the handscroll, but become more wavering and unstable in the latter part. As with the differences in scale, this contrast accords with the substance and mood of the *Later Ode* and further heightens the effect of the entire scroll composition.

Deliberate archaism and awkwardness, known in Chinese as *guzhuo* 古拙 and found in a wide variety of Li Gonglin's *baimiao* paintings, characterize this handscroll as well. The buildings of the Xuetang and Lin'gao Pavilion were drawn freehand, and in their three appearances in this scroll, details of the architecture are clearly disparate. Similarly, the figures are drawn larger or smaller, according to their importance within the *Ode*. These traits are distinctive elements of a deliberatively archaic style. Not only the painting style, but also the iconography itself connects this scroll and Li Gonglin's paintings. The front of Xuetang in the first scene and of Lin'gao Pavilion in the seventh are both shown to offer a glimpse of what is happening inside. In this regard, they resemble the Hall of Ink Meditation (Mochantang 墨禪堂) in the handscroll *Longmian Mountain Villa* (*Longmian Shanzhuang tu* 龍眠山莊圖) attributed to Li Gonglin (*Fig. 6*) and can be traced to the depiction of the thatched hut in *Ten Views from a Thatched Hut* (*Caotang shizhi tu* 草堂十志圖), attributed to Lu Hong 盧鴻 (act. 713–742) in the National Palace Museum, Taipei.

The iconography of the depiction of the building in the second scene has its precedent in the first scene of *Tao Yuanming Returning Home* (*Yuanming guiyin tu* 陶淵明歸隱圖), also attributed to Li Gonglin (*Fig. 7*). This scene shows Tao Yuanming (365–427) on a boat being moored, as described in his long narrative poem *Homecoming* (*Guiqulai ci* 歸去來辭). The gate of his old house shown from the side, his wife coming out to greet him, and the clumps of land along the water's edge are all repeated in the depiction of Xuetang—the wife watching Su's departure and the land forms along the great river. Furthermore, the boat trip to the Red Cliff seen in the sixth scene shares the basic iconography and texture strokes of the arched rock depicted in the Magpie Garden (Queyuan 鵲源) of the *Longmian Mountain Villa* scroll (*Fig. 8*). A bird sits and rests its wings on the top of the rock to the upper left of the boat, an image found also in the iconography of the Magpie Garden. These are clear examples of iconographic elements borrowed from Li Gonglin paintings. In addition, the arrangement of the three seated figures centered on Su Shi in the third scene reflects elements found in the Hall of Extending Blossoms (Yanhuatang 延華堂) and Suspended Cloud Bank (Chuiyunpan 垂雲泮) in the *Longmian Mountain Villa* scroll, while the image of Su Shi alone in the mountains in the fourth scene suggests the artist's awareness of the composition found the Lingling Valley (Linglinggu 冷冷谷) section of *Longmian Mountain Villa*. In these elements we can see the painter's awareness of the artistic network around Su Shi.

These images, which are fundamental to the Nelson-Atkins scroll, can also be placed within the lineage of eremitic landscape painting. Li Gonglin's *Longmian Mountain Villa*, which contains many elements from this lineage, is a depiction of the painter's own retreat. It can be seen as a continuation of Lu Hong's *Ten Views from a Thatched Hut* and Wang Wei's 王維 (699–759?) *Painting of Wangchuan Villa* (*Wangchuan tu* 輞川圖), which reveal the art-

ists' longing for reclusion by depicting them within the landscape.[15] Further, it goes without saying that the *Returning Home* handscroll is the pictorialization of Tao Yuanming's *Homecoming,* the archetype of poetry on reclusion, with the iconography of reclusion established by Li Gonglin becoming the norm in later painting. The present painting, with its *baimiao* technique linking Li Gonglin with Su Shi, exemplifies standard forms whereby the literati of the early twelfth century expressed their longing for, or idealization of, reclusion. As seen from the above, the now-fragmentary first section of the present scroll would have depicted the Snow Studio of East Slope (Dongpo Xuetang). Zhou Zizhi's 周紫芝 (1082–?) *Inscription on the Newly Engraved Painting of the Snow Studio by Qi'an* (*Ti Qi'an xinke Xuetang tu* 題齊安新刻雪堂圖) depicts Xuetang alone, which confirms that by the early Southern Song period it had already been established as an independent painting subject. The history of this building, and the significance to Su Shi of Dongpo and Xuetang can be found in *Record of Xuetang in Huangzhou* (*Huangzhou Xuetang ji* 黃州雪堂記).[16] The depiction of the Xuetang now lost here was not simply a pictorialization of the first scene in the *Ode,* but rather can be said to have symbolized the name "Dongpo," by which Su Shi was most familiar to later generations.

Depictions of the buildings in the second, seventh, and eighth scenes differ in detail, but present in all of them are willow trees that are nowhere mentioned in their respective texts. In addition, the position of these trees changes in each depiction. Why are willows present? This is perhaps because of their association with Tao Yuanming. When Su Shi wrote the *Odes on the Red Cliff,* he was in Huangzhou, farming for his livelihood. Though his reclusion was forced by exile and Tao's had been voluntary, Su identified strongly with Tao, comparing his own path in life with the first half of Tao Yuanming's as well as conjuring an idealized version of the latter half. *Poems Matching Tao's* (*He Tao shi* 和陶詩), a major group of works from Su's later years, almost completely follow the rhymes of Tao Yuanming's poems. According to Tao's fictive third-person autobiography, *The Biography of Mr. Five Willows* (*Wuliu xiansheng zhuan* 五柳先生傳), there were five willow trees by his villa, so the willow, along with the chrysanthemum, thereby became a symbol of Tao Yuanming. In light of Su Shi's self-identification with Tao, the willow shown by Xuetang in the second scene can now be seen as a layering of imagery on Su's dwellings with Tao's old home in his hometown of Zisang 紫桑 in Jiangxi Province. The aforementioned *Red Cliff Scroll* attributed to Wen Zhengming also shows chrysanthemums in front of the Lin'gao Pavilion, and this image can be seen as symbolic of Tao Yuanming as well.

Qiao Zhongchang, painter of the present handscroll, combined Li Gonglin's style and the iconography of his *Longmian Mountain Villa* with the "scorched ink" (*jiaomo* 焦墨) technique employed by Su Guo 蘇過 (1072–1123),

15. Robert E. Harrist, Jr., "A Scholar's Landscape: *Shan-chuang t'u* by Li Kung-lin" (Ph.D. diss., Princeton University, 1988).

16. This record is in *juan* 12 of *Su Shi wenji* (*Literary Collection of Su Shi*). See Yuasa Yōko, "Sō Shoku Kōshū Setsudō-ki ni tsuite (A Study of Su Shih's Memoir of the Snow Hall in Huangzhou)," in *Kōzen kyōju taikan kinen Chūgoku bungaku ronshū* (*Essays in Chinese Culture in Honor of the Retirement of Professor Kōzen Hiroshi*) (Tokyo: Kyūko shoin, 2000).

Itakura Masaaki

Su Shi's youngest son and companion in exile in Huangzhou—thereby further linking Li and Su. At the same time, Qiao's painting evokes the tradition of reclusion as it connected Tao Yuanming, Li, and Su.

The Nelson-Atkins work was created during the reign of Huizong, a time of great factionalism, turmoil, and confusion in ruling circles. The conservative Yuanyou 元祐 Faction to which Su had adhered was suppressed by followers of the more radical "New Laws" (Xinfa 新法) of Wang Anshi 王安石 (1021–1086), and scholarship on Su was officially forbidden. Even so, during this period Su Shi was highly regarded among the scholar-gentry.[17] Liang Shicheng was a strong force behind the scenes in Huizong's government, so powerful that he was known as the "Concealed Prime Minister" (Yinxiang 隱相). Liang called himself Su Shi's "son of a different surname" (waizi 外子) and acted as a protector for Su Guo and Su Shi's other disciples. The previously mentioned courtier Zhao Lingzhi, an owner of this handscroll, was closely connected to sympathetic officials even after Su Shi's death. In the tenth month of the second Xuanhe year (1120), Liang Shicheng contested the rule forbidding the recitation of Su Shi's verses and opposed the destruction of his surviving letters. Given Huizong's trust in Liang, the restrictions against opponents of the New Laws were briefly loosened, and this handscroll is likely to have been created sometime between the tenth month of 1120 and the date of the colophon by Zhao Lingzhi, the eighth month of 1123 (*Fig. 9*).

About that time, Liang Shicheng was actively amassing a collection of painting and calligraphy related to Su Shi that he would study and share with other literati. This painting could well have been one of those works. Savoring the *Later Ode on the Red Cliff*, however, was no mere private act of literary or aesthetic appreciation; it took on political meaning, even though the sphere of people who viewed and appreciated it was limited. From the beginning, there was a close relationship between the artist who created the work, the patron who commissioned it, and the viewers—along with their political positions. In essence, the literati who thought highly of Su Shi were under the patronage-protection of a minister such as Liang Shicheng, a courtier like Zhao Lingzhi, and even some members of the party related to the New Laws. Sections of this handscroll show that it is not only a pictorialization of Su's *Later Ode on the Red Cliff*, it is also imbued with the premises of Su Shi's other writings. Its audience would have been familiar with Su's life and well versed in his writings, and, like Su, they would have idealized reclusion.

The text of *Later Ode on the Red Cliff* itself can be interpreted as both public and personal statement, but the Nelson-Atkins scroll emphasizes the personal. This may well reflect the painter's conscious decision to omit all overt political or public implications, given the complex and perilous political situation of the period. The act of avoiding a

17. For the reception of Su Shi's literary works, calligraphy, and paintings after his death, see Kōyama Kiwamu, "Shushi no Sogaku hihan: josetsu (Zhu Xi's Criticism of the Su Dongpo School: An Introduction)," in *Chūgoku bungaku ronshū* (*Collected Essays on Chinese Culture*), no. 3 (1972); Murakami Mitsutsumi, "So Tōba shokan no denrai to Tōbashū shohon no keifu ni tsuite (Study on the Transmission of Su Dongpo's Letters and Versions of *Dongpo ji*)," *Chūgoku bungaku hō* (*Reports on Chinese Culture*), vol. 27 (1977); Saeki Tomi, "So Tōba to sono meisei (Su Dongpo and His Fame)," *Shoron*, no. 20 (1982); and Uchiyama Seiya, "Tōba udai shian rūdenkō: Hokusō sue-Nansō hajime no shitaifu ni okeru So Shoku bungei sakuhin shūshūnetsu o megutte (Essay on the Prevalence of Dongpo Wutai Shi'an and Its Text—Mainly Concerning the Enthusiasm of Intellectuals from late Northern Song Through the Late Southern Song for Collecting Su Shi's Works)," *Yokohama shiritsu daigaku ronsō, Jinbun kagaku keiretsu* (*Yokohama City University Essays, Humanist Series*), vol. 47, no. 3 (1995).

political message, however, is itself a political act. Su Guo, who accompanied Su Shi through his period of adversity, built a place of retirement to the south of Yapi 鴨陂 in the west part of Yingchang 穎昌 city (Xuchang 許昌 County, Henan Province), and named it "Little Xie River" (Xiao Xiechuan 小斜川), based on Tao Yuanming's *Travels of the Xie River with a Foreword* (*You Xiechuan bing yin* 游斜川并引).[18] When we consider that after 1121 Su Guo was both under the patronage of Liang Shicheng and in the position of being Su Shi's heir in painting and calligraphy, the viewers of this handscroll surely associated it with Su Guo.

From the beginning, Qiao Zhongchang, the creator of this scroll, assumed that the viewers would be familiar with Su Shi's writings and would have readily perceived the influence of Li Gonglin in its style and iconography. Even if the viewers were unfamiliar with the actual scenery of the Red Cliff, they would have known Su Shi's poetic description of it, and this, as well as the use of Li Gonglin's archaistic style, signified that the scenery in the picture was not a "true-view" depiction of the site.

The present handscroll's fanciful pictorialization of the *Later Ode on the Red Cliff* is, in fact, a valid expression of Su's text. Su's own images far transcend the actual scenery of the Red Cliff; his words carve out a broad expanse of poetic space that the painting helps to communicate to the mind's eye of the viewer. Eighty-eight years after the composition of the *Odes on the Red Cliff*, in 1170, the major Southern Song poet Lu You 陸游 (1125–1209), en route to Sichuan, visited Huangzhou to see the sites related to Su Shi.[19] He stayed overnight at the Lin'gao Pavilion and visited the sites of Dongpo and Xuetang. He found the Red Cliff site itself to be nothing more than a reed-covered knoll, with barely any large trees or other foliage. His image of the Red Cliff, which he carried deep in his heart, had been fabricated from Su's words and their subsequent pictorializations, and Lu You was thereupon unstinting in his praise of Su Shi's imagination.

Important in Su Shi's odes on the Red Cliff was the concept of eremitism. He sought to comfort himself by creating scenes that linked his place of exile in Huangzhou with his homeland of Sichuan. He went even further, likening his surroundings to the halcyon land of Tao Yuanming's "Peach Blossom Spring" (Taohuayuan 桃花源). As the possibility of return to his homeland waned, memories of it appeared in Su Shi's poems as simplified, purified images.[20] At the same time, he began to develop the theory that any place where one could achieve peace at heart

18. Regarding Su Guo, see Zhong Laiyin, "Su Shi zhi zi Su Guo (Su Shi and His Son Su Guo)," in *Su Shi yu Daojia Daojiao (Su Shi and Daoism and Daoists)* (Taipei: Taiwan xuesheng shuju, 1990); Shu Dagang, *San Su houdai yanjiu (Studies on the Three Su's: Su Shi, Su Che, Su Xun)* (Chengdu: Bansu shushe, 1995); Sunayama Minoru, "Shasenshū o yomu—So Ka to Dōkyō (Reading the *Xiechuan ji*: Su Guo and Daoism)," in *Jinbun, bunka, shakai (Humanity, Culture, Society)* (Iwate daigaku jinbun shakaika gakubu chiiki bunka kison kenkyū kōza: 1997); Zeng Zaozhuang, "Su Shudang yu ta de *Xiechuan ji* (Su Shi's Sichuan Party and His *Xiechuan ji*)," in *San Su yanjiu (Research on the Three Su's)* (Chengdu: Bashu shushe, 1999); and Hokari Yoshiaki, "Su Shi han Su Guo fuzi yu You Xiechuan (Su Shi, His Son Su Guo, and Wandering in Xiechuan)," in *Su Ci yanjiu (Study on Poetry by the Su's)* (Xi'an: Zhuang shuju, 2001).

19. Lu You, *Ru Shu ji (Record of Entering Sichuan)*, vol. 4.

20. Yuasa Yūko, "So Shoku no kiden to baiden (Yearning for Home and Obtaining Land in Su Shi's Writings)," in *Chūgoku bungaku hō (Reports on Chinese Culture)*, vol. 54 (1997).

Itakura Masaaki

was thereafter one's homeland. With this idea of Su's in mind, the artists and literati of the day might also have been able, through symbols of the journeys to the Red Cliff, to re-envision the place of harsh exile into an ideal milieu for a retired gentleman.

The concept of depicting an intriguing natural scene in a painting is called the "picturesque." In China, this type of descriptive imagery developed largely during the Tang dynasty and became widespread during the Song. Contemporary with the picturesque, however, Chinese literati also took another stance, finding "poetic lyricism" (*shiyi* 詩意) in the natural landscape, and using words and images to convey the essence rather than the appearance of landscape. Although words and paintings inherently speak a different language, one of the premises of the literati approach was the concept of the "unity of poem and painting" (*shihua heyi* 詩畫和一), and hence those who sought lyricism in the landscape emphasized that shared fundamental unity.[21] Hong Mai 洪邁 (1123–1202) of the Southern Song, however, offered a critical discussion of this approach.[22] Even though he quoted from the verses of Su Shi, Huang Tingjian, and other Northern Song poets, he claimed that the relationship between painting and actual landscape (the painting of a scene and the site itself) is that of a "copy" (*jia* 假) to the "original" (*zhen* 眞). He believed that when one sees a superb painting, one has a sense of approaching the original truth. However, he also believed that when one views a lovely site and likens it to a painting, the viewer is infusing "the original with a sense of the copy" (*nong zhen wei jia* 弄眞爲假) and "the copy with a sense of the original" (*nong jia wei zhen* 弄假爲眞). He disapproved of this type of commingling of painting and the natural world, saying that it takes place in the mental "realm of vanity" (*wangjing* 妄境). A dangerous reversal occurs when the copy is believed to surpass the original, he claimed, and the original is lost sight of. Titles of paintings and poems inscribed on paintings indicate that from the High Tang onward this reversal of original and copy had become quite marked. In other words, the image created by the poem and/or painting acquired a currency distinct from and displacing (at least in part) that of the actual scene. In fact, the line "the landscape looks like painting" (*jiangshan ru hua* 江山如畫), quoted by Hong Mai, came from Su Shi's poem "To the Tune 'Recalling Her Charms': Cherishing the Past at Red Cliff." Given the prevalence of the mental habit that Hong Mai disdained, viewers of the present handscroll then surely must have imagined within themselves the fictitious world Su Shi had created from words and images.

21. Regarding Chinese theories comparing and equating painting and poetry, see the following by Asami Yōji: "'Shi-chū yūga'o megutte: Chūgoku ni okeru shi to kaiga ('Pictures Within Poems' Reconsidered: Poetry and Painting in China)," in *Shūkan Tōyōgaku* (*Eastern Studies Weekly*), no. 78 (1997); "'Shi-chū yūga' to 'Enzen zaimoku': Chūgoku ni okeru shi to kaiga ('Pictures Within Poems': Poetry and Painting in China)," in *Chūtō bungaku no shikaku* (*Perspectives on Literature of the Mid-Tang*) (Tokyo: Sōbunsha, 1998); "'Shichū yūga' to 'Choheki seikai': Chūgoku ni okeru shi to kaiga ('Pictures Within Poems'and 'Zhuo bi cheng hui': Poetry and Painting in China)," in *Nihon Chūgoku gakkai hō* (*Bulletin of the Sinological Society of Japan*), no. 50 (1998); and "Kyori to sōzō: Chūgoku ni okeru shi to medeia, medeia toshite no shi (Distance and Imagination: Poetry and Media, or Poems as Media of Communication)," in *Sōdai shakai no nettowaku* (*Networks in Song Society*) (Tokyo: Kyūko shoin, 1998). See also Susan Bush, *The Chinese Literati on Painting: Su Shih (1037–1101) to Tung Ch'i-ch'ang (1555–1636)* (Cambridge, Mass.: Harvard University Press, 1971).

22. Hong Mai, *Rongzhai suibi*, chap. 16.

At the same time, the earlier premise that painting should be based on the actual scenery clearly endured. Amid the rapid advances in landscape painting that occurred during the Northern Song, the formal vocabulary based on geographic and topographic characteristics was organized into clear forms. Landscape painters appeared in both the Jiangnan 江南 and Huabei 華北 regions; a system of three different perspectives was developed ("high," "middle," and "low" distance) for conveying spatial distance; and the standardization of texture strokes and tree motifs continued. These methods all worked to make the painting into a unified spatial unit. Guo Xi 郭熙 (ca. 1020–1090), one of the major painters of the late Northern Song, stated, "Now painters from the Qi-Lu area only imitate the style of Li Cheng [919–967], while painters from the Guan-Shan area only imitate the style of Fan Kuan [fl. 10th–11th c.] (今齊魯之士。惟摹營丘。關陝之士。惟摹范寬。),"[23] perhaps meaning to disparage paintings based on geographic qualities (*Figs. 10, 11*). Conversely, however, this statement could also mean that, from a broader perspective, the use of distinctive formal vocabularies to represent specific regional sceneries had been acknowledged.[24]

Qiao Zhongchang's *Illustration of Su Shi's Later Ode on the Red Cliff* handscroll must be positioned as an experimental effort within literati painting circles. Its very opening scene informed viewers that it was unrelated to the actual scenery of Chibi, and the composition then deployed imagery familiar to the literati network surrounding Su Shi. In this handscroll, the Red Cliff, site of an ancient epic and tragic naval battle, existed only as a fictitious, idealized mental picture shared by the artist and the readers of Su Shi's unforgettable *Odes*.

23. From Guo Si, *Linquan gaozhi ji* (*Lofty Messages in Forests and Streams*).

24. Masaaki Itakura, "Representation of Politicalness and Regionality in Wen-chi's Return to China," *Acta Asiatica*, no. 84 (February 2003).

環繞「赤壁賦」的語彙與畫像—
以喬仲常「後赤壁賦圖卷」爲例

板倉聖哲

東京大學

　　北宋的代表性文人蘇軾(字子瞻，號東坡居士，1036–1101)最有名的文學作品爲赤壁賦，是他流放黃州(湖北省)的謫居期間，元豐五年(1082)蘇軾與友人舟遊赤壁後吟詠成此二賦。這二首賦不但在中國成爲繪畫題材，在日本、韓國也很盛行，成爲東亞文人繪畫的流行主題。

　　現存以「後赤壁賦」爲文本之最早作品乃喬仲常的「後赤壁賦圖卷」(納爾遜美術館)，其忠實地將賦文的各場景予以視覺化，形成所謂故事畫的形式。從本畫卷的現狀來判斷，卷頭應有描繪東坡雪堂的部份，現已亡佚，然而，卻可以在江戶時代初期狩野探幽(1602–1675)的「縮圖冊」(京都，個人收藏)中找到一幅能夠符合本圖卷卷頭部份的圖樣。

　　如果依據可能作爲重摹本的此件縮圖，來推想本圖卷的卷頭部份的話，就能夠將本圖卷的全體構成予以復原，亦即卷前(雪堂與臨皋亭)與卷尾(兩座臨皋亭)出現兩次家屋的反覆性的描繪。畫卷中臨皋亭三度登場，並且還出現了在文本中完全沒提及的柳樹。推測此乃畫家在描繪時，心中浮現出蘇軾晚年傾心於隱逸詩人陶淵明的形象，且將陶淵明故鄉尋陽柴桑舊居疊合於臨皋亭上的結果。

　　本圖卷畫風的來源是李公麟，他乃蘇軾周邊藝術網絡的一員。畫家借用了象徵李公麟自身隱居空間的「龍眠山莊圖」之圖式，而且在整體畫卷中強調蘇軾書畫繼承者蘇過擅長的焦墨效果，成功地將蘇軾與李公麟二者的繪畫成就融合於一畫面中。由於徽宗皇帝(1082–1135，在位1101–1126)彈壓元祐黨人，這段期間是蘇軾評價中的寒冬時代，然而他在士大夫之間還是獲得相當高的聲望。尤其是受到徽宗寵幸的宦官梁師成(?–1126)也自稱是蘇軾的「外子」(譯註：養子)，並保護蘇軾的子弟蘇過等人。本圖卷推測是在徽宗朝蘇軾歿後，其弟子們所鑑賞之物。對於這群鑑賞者而言，此圖卷雖與實景相差甚遠，然而卻可喚醒記憶中蘇軾與李公麟的書畫世界，並成爲追憶蘇軾周邊藝術網絡的一個媒介。

「赤壁賦」をめぐる言葉と画像——
喬仲常「後赤壁賦圖卷」を例に

板倉聖哲

東京大学

　「赤壁賦」は北宋時代を代表する文人、蘇軾（字子瞻、号東坡居士、1036–1101）が生み出した文学作品の中でも最も有名なもので、流罪となった黄州（湖北省）に謫居している間、元豊5年(1082)に友と赤壁に舟遊した時に詠じた二賦である。この二賦は中国ではもちろんのこと韓国・日本でも盛んに絵画化され、東アジアの文人的主題として非常に流行した。

　中でも、「後赤壁賦」をテクストとする現存最古の作例である喬仲常「後赤壁賦図巻」（ネルソン・アトキンス美術館）は、賦の各場面を忠実に絵画化した説話画的構成をもっている。現状から判断して、本図巻巻頭に描かれていたはずの東坡雪堂の部分が亡失したと考えられるが、本図巻の巻頭部分と合致する図様が江戸時代初期の狩野探幽(1602–1675)「縮図冊」（京都・個人）中の一図に見出だすことができる。おそらく重模本であろうこの縮図によって本図巻の巻頭部分を想定すれば、2つの家屋表現を巻前方（雪堂と臨皐亭）と後方（2つの臨皐亭）で反復的に描く本図巻の全体的構成を復元することができよう。3度登場する臨皐亭においてテクストに全く触れられていない柳樹が登場するのは、晩年により顕著になる蘇軾の隠逸詩人陶淵明(365–427)への思いを念頭にして、臨皐亭に陶淵明の故郷尋陽柴桑の旧居のイメージを重ね合わせたからであると考えられる。

　本図巻は全体に蘇軾周辺の芸術ネットワークの一員であった李公麟の画風を用い、李公麟(約1041–1106)自身の隠居空間の表象である「龍眠山荘図」などの図様を借用しつつ、蘇軾書画の継承者である蘇過がさらに追究した焦墨の使用を画面全体に強調することで、蘇軾と李公麟両者の画業を一画面に融合させる事に成功している。徽宗皇帝(1082–1135、在位1101–1126)は元祐党を弾圧したため、蘇軾理解において冬の時代と見なされるが、士大夫の間で蘇軾は非常に高い評価を受けていた。中でも、徽宗の寵を得た宦官梁師成(?–1126)は自ら蘇軾の外子と称し、蘇過ら蘇軾の子弟を保護しており、本図巻は徽宗朝における蘇軾没後の子弟たちによって鑑賞されたものと推測される。そうした鑑賞者たちにとって、実景とはかけ離れたこの図巻は、記憶の中の蘇軾や李公麟の書画の世界を喚起させ、蘇軾周辺の芸術ネットワークを追憶するメディアとなっているのである。

Fig. 1. Su Shi (1037–1101). *Early Ode on the Red Cliff*, detail. Handscroll, ink on paper, 23.9 × 258 cm. National Palace Museum, Taipei.

Fig. 2. Li Song (act. ca. 1190–ca. 1230). *The Red Cliff*. Album leaf mounted as a hanging scroll, ink and light color on silk, 24.8 × 26.0 cm. Nelson-Atkins Museum of Art, Kansas City.

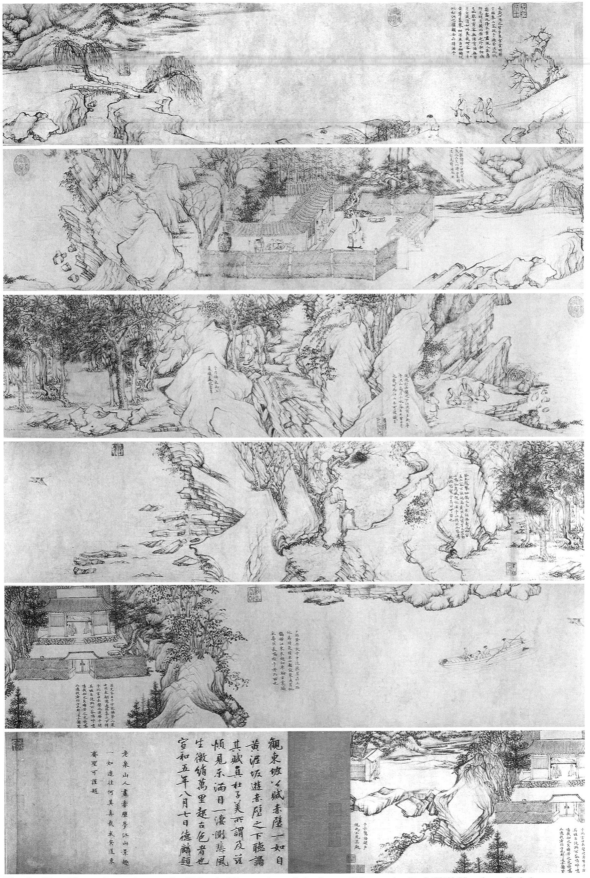

Fig. 3. Qiao Zhongchang (act. early 12th c.). *Illustration of the Later Ode on the Red Cliff.* Handscroll, ink on paper, 29.5 × 557.9 cm. Nelson-Atkins Museum of Art, Kansas City. *(details on pages 421 and 487)*

Itakura Masaaki

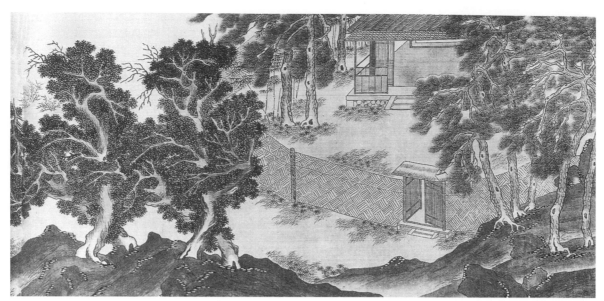

Fig. 4. Attributed to Zhao Mengfu (1254–1322). *The Early and Later Odes on the Red Cliff*, detail. Handscroll, ink and color on silk, 31.1 × 647.0 cm. National Palace Museum, Taipei.

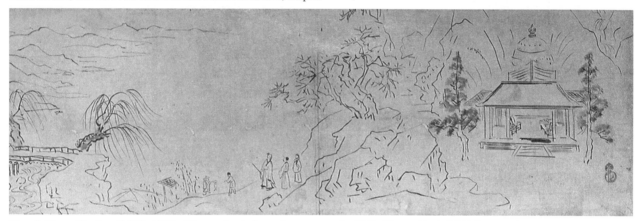

Fig. 5. Kanō Tan'yū (1602–1679). Illustration of section one to Su Shi's "Later Red Cliff Ode." *Album of Reduced-scale Sketches*, detail. Album, ink and light color on paper, 40.0 × 26.9 cm. Private collection, Kyoto.

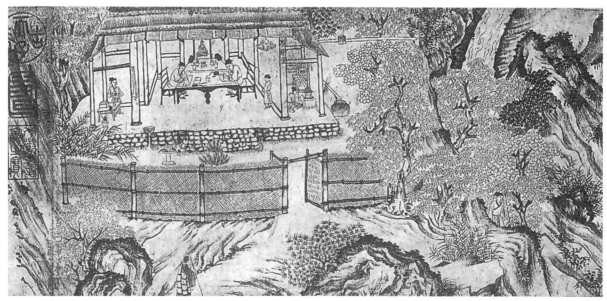

Fig. 6. Copy after Li Gonglin (ca. 1041–1106). *Longmian Mountain Villa*, detail of the "Hall of Ink Meditation." Handscroll, ink on paper, 27.7 × 513.0 cm. Palace Museum, Beijing.

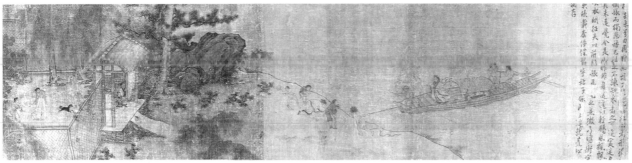

Fig. 7. Attributed to Li Gonglin (ca. 1041–1106). *Tao Yuanming Returning Home*, detail. Handscroll, ink and colors on silk, 37.0 × 518.5 cm. Freer Gallery of Art, Washington, D.C.

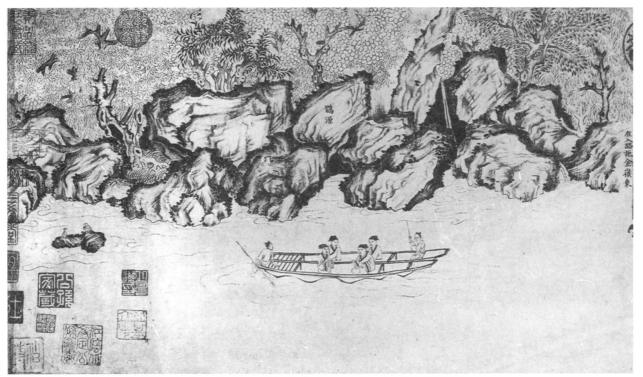

Fig. 8. Copy after Li Gonglin (ca. 1041–1106). *Longmian Mountain Villa*, detail of "Magpie Garden." Handscroll, ink on paper, 27.7 × 513.0 cm. Palace Museum, Beijing.

觀東坡以賦赤壁一如自
黃涯坡遊赤壁之下聽誦
其賦真杜子美而謂及茲
頓見示滿目一悽惻悲風
生微緒萬里趣古色者也
宣和五年八月七日德麟題

Fig. 9. Detail of Figure 3.

Itakura Masaaki

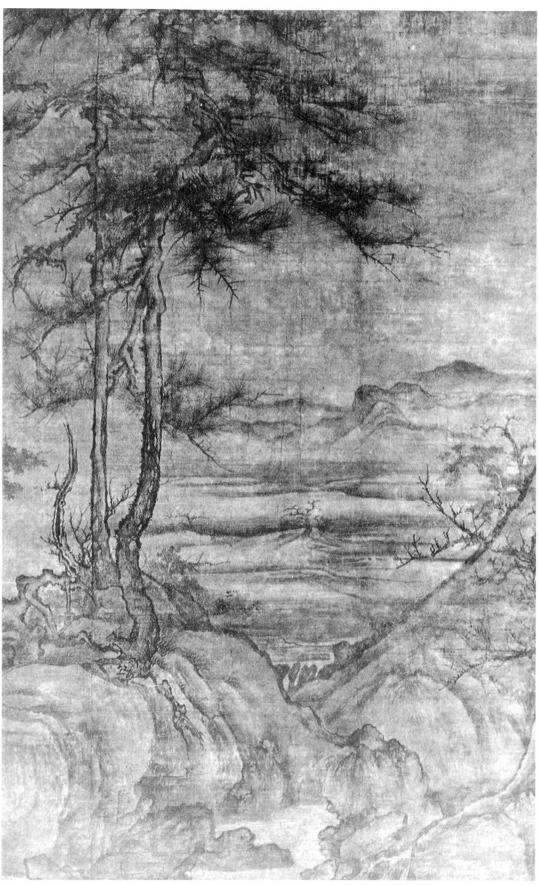

Fig. 10. Attributed to Li Cheng (919–967). *Landscape with Pine Trees.* Hanging scroll, ink on silk, 205.6 × 126.1 cm. Chōkaidō Institute of Arts, Mie.

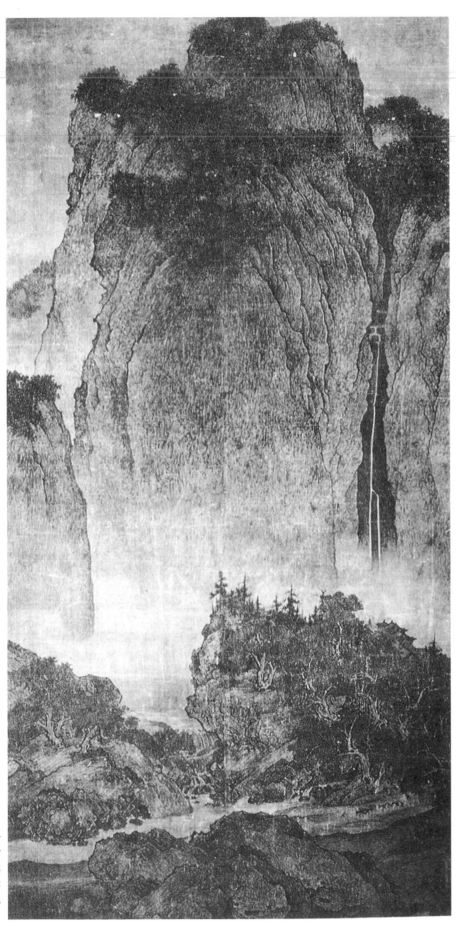

Fig. 11. Fan Kuan (act. ca. 990–1030). *Travellers amid Mountains and Streams*. Hanging scroll, ink and light color on silk, 206.3 × 103.3 cm. National Palace Museum, Taipei.

Itakura Masaaki

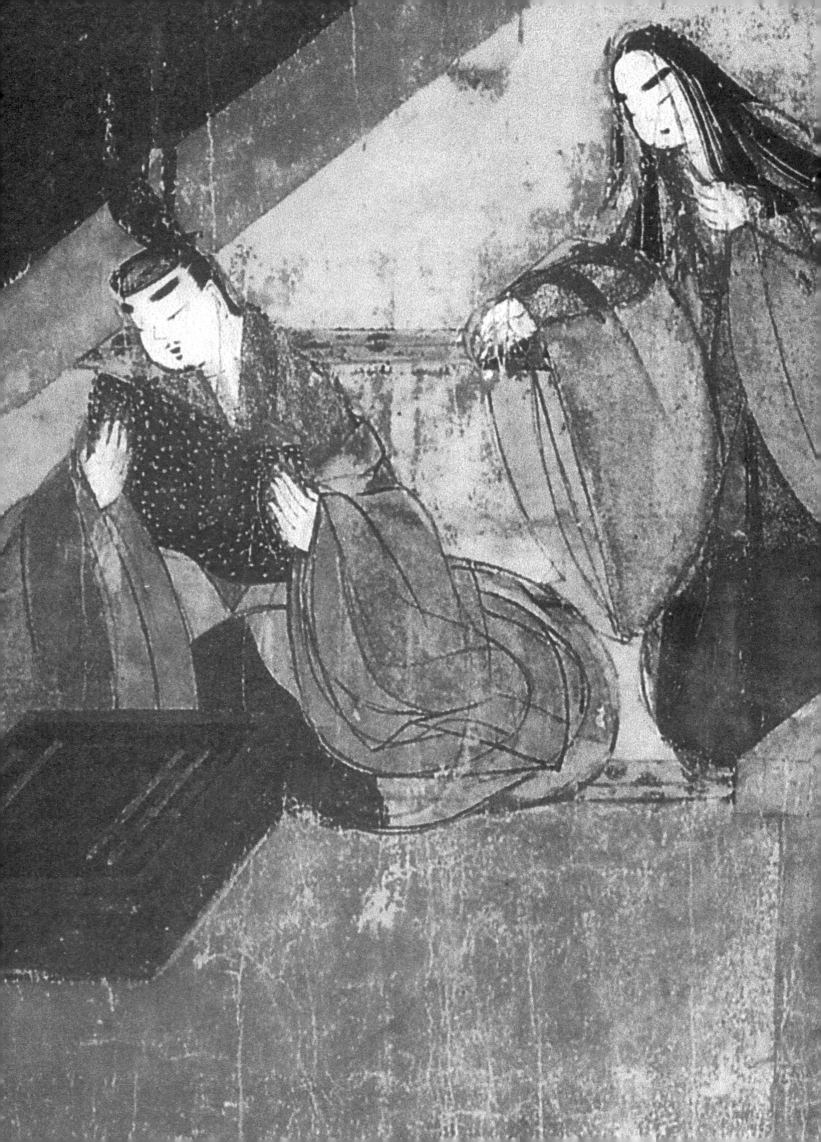

The Narration of Tales, The Narration of Paintings

Sano Midori

Gakushuin University

The illustrated handscroll of *The Tale of Genji* (*Genji monogatari* 源氏物語) in the Tokugawa 德川 and Gotō 五島 museum collections speaks to the maturation of Japanese narrative painting in the first half of the twelfth century. The original scrolls contained text and illustrations of all fifty-four chapters of this romantic novel based on court life in the capital. Only twenty pictures are extant today, divided between the two collections.

Narration in the Illustrated *Tale of Genji* Handscroll

A product of court culture in the 1130s, the later part of the Heian period, the *Tale of Genji* handscroll is relatively small in format, measuring approximately twenty-two centimeters from top to bottom. The text covers several sheets of paper, but each illustration is limited to a single sheet, giving the narration an episodic (J: *danraku* 段落) character. This format stands in marked contrast to the continuous narrative scenes in such scrolls as *The Miraculous Origins of Mt. Shigi* (*Shigisan engi* 信貴山縁起) and *The Illustrated Story of Chancellor Ban* (*Ban dainagon ekotoba* 伴大納言絵詞)—illustrations of so-called *setsuwa* 説話, short didactic or religious tales. Those paintings depict one episode of a story flowing immediately into the next and covering a number of pages. They are executed in a linear manner often called "masculine painting" (*otoko-e* 男絵), the human figures highly animated, lightly colored, and rapidly executed.

By contrast, the Genji paintings are executed in a style called "feminine painting" (*onna-e* 女絵), which is characterized by brightly colored, static figures. Imbued with a romantic aura, the compositions employ such distinctive conventions as "eyes drawn with a line, noses with a hook" (*hikime kagihana* 引目鈎鼻) and rooms with "blown-away roofs" (*fukinuki yatai* 吹抜屋台). Because the handiwork of different painters and calligraphers can be detected, we may surmise that the full set of scrolls was produced in collaboration by several groups, very possibly supervised by members of the imperial court. The pieces of paper used for the text were lavishly sprinkled with gold and silver foil; pigments in the paintings were of the highest quality and chromatic intensity. In all likelihood, each chapter was illustrated with two or three separate scenes, and each painting was accompanied by a section of the text suitably edited and shortened. The condensation was premised on an audience thoroughly familiar with the original text, who could derive aesthetic enjoyment from the way in which the world of the narrative was visualized in the illustrated scroll format.

Inspired by the classic novel composed by the lady Murasaki Shikibu 紫式部 (ca. 973–ca. 1014), many scholars have analyzed the narrative imagery in the Tokugawa and Gotō Genji paintings, giving special attention to the selection of scenes and the manner in which they were depicted. I wish to concentrate here on only two topics: the different forms of perspective employed and the process by which the viewers become the key figures in the action of the narrative. Since *The Illustrated Handscroll of the Tale of Genji* (*Genji monogatari emaki* 源氏物語絵巻) requires both reading and viewing, I consider the terms "reader" and "viewer" in this context to be virtually interchangeable.[1]

Perspective

Figure 1 illustrates Chapter 40, "The Law" (*Minori* 御法), which contains poems exchanged among the Empress, Genji, and Genji's long-time paramour Murasaki no Ue 紫の上 (who was given much the same name as the novel's author). Here, Murasaki no Ue is fatally ill, and all three principals are preoccupied with the tragedy of her impending death. The composition is emphatically diagonal, organized by blinds and screens slanting down from the right, dividing the interior of the room from the garden on the left. The garden is shown simply as autumn grasses waving in the wind against a silver surface—an image fraught with symbolism. Interior and exterior are sharply contrasted; there is little sense of spatial consistency, and (as explained below) the angles of vision are disjunctive. The sharp diagonal of the composition and its abrupt cut-off at the top and bottom convey a sense of unease and anxiety. Murasaki leans weakly against her armrest. Genji and the Empress are exposed to the bitter wind, signified by the dull silver background to the autumn grasses. All three figures are joined in sorrow.

Time and again scholars have pointed out that this illustration combines three viewpoints. First is the all-over bird's-eye view afforded by the "blown-away roof" convention, which allows viewers to see into the room like a god looking down from above, or at least a child peering into a doll house. Next is the close-up view of the figures within the painting, so that Genji and Murasaki are shown disproportionately large relative to the size of the room. Finally, there is the viewpoint of the persons within the painting. The garden grasses appear as Genji, Murasaki, and the Empress would have seen them.

The viewer's gaze begins at the upper right and is led downward along the diagonals formed by the framing members of the blinds and screens to the emotionally-charged figures. The gaze then moves to the grasses blown by the wind and, having taken in the entire painting, begins to examine the details. As is common in Japanese court painting (in which prohibitions were set in place against producing exact likenesses of imperial personages), the Empress is seen from the back, implausibly small and unsubstantial. Genji and Murasaki, by contrast, are large relative to the architecture, and their size, in combination with their gestures, summons the viewer's scrutiny. The gaze is drawn from Genji, shown from the back, to Murasaki, shown in front view, and thence to the grasses that Murasaki

1. See the author's "Expressions of the Multiple Figures in Narrative Painting," in *People's Forms, People's Figures*, International Symposium of the Tokyo Cultural Properties Research Institute (Tokyo: Tōkyō kokuritsu bunkazai kenkyūjo, 1992).

mentions in her poem. The viewer's gaze has thus moved from the overview, the so-called "zero focalization,"[2] to the individual figures. When it moved from Genji to Murasaki, it corresponded with Genji's vision, and when it moved toward the grasses, it corresponded with that of Murasaki.

Clearly the painter has positioned the images to guide the reader's gaze, and, having read in advance the novel itself or the abridged text in the text passage adjacent to the painting, the reader expects to interpret the connection of Genji and Murasaki as romantic. Though such interpretations are guided by text, the texts themselves possess many voices: that of the author (the narrator), those of the "voicing," or diegetic, characters (who themselves tell stories), and those of the subjects of their narrations. The painting captures this polyphonic world of voices by guiding the viewer's gaze from the bird's-eye view of the entire scene to the separate parts.

Having examined both the whole and the parts, the viewer's gaze then oscillates. For example, Murasaki is shown observing both the autumn grasses and the characters who are speaking with her, Genji and the Empress. The viewer's gaze follows the same path, moving from one figure to another, assimilating them and the objects within the world of the narrative. Neither the omniscient narrator (the original author) nor the other narrators living in other parts of the world of this tale (telling the story from differing viewpoints) are depicted here. It is the viewers themselves, situated outside the work, who have become "omniscient." They take in the entire scene and interpret the sequence of events according to their own logic. In a certain sense, the readers themselves have become the "authors" of the illustrated story. The voice of the text has also been rendered as a third-person narrative.

Long after the Heian period, a less aristocratic public required more graphic and explicit versions of the tale that left less scope to the interpretations of the reader. Take, for example, the 1650 woodblock-printed *Illustrations into the Tale of Genji* (*E'iri Genji monogatari* 絵入源氏物語) by Yamamoto Shunshō 山本春正 (1610–1682; *Fig. 2*), an enormously popular guide to the old novel.[3] The afterword of *Illustrations into the Tale of Genji* states, "From long ago there have been people with an interest in putting illustrations in books, so now, too, at places where poems and phrases are particularly worthy of attention, I have augmented the text by humbly appending illustrations." Another book of the day, *Genji in Outline* (*Genji kōmoku* 源氏綱目) of 1660, states, "[Genji] paintings displayed since early times have so many mistakes in the color of the clothing that a person grows faint. For that reason, I have inserted illustrations next to the texts that should be illustrated."[4]

2. Regarding the use of this term, see Gérard Gennette, "*Discours du récit,*" in *Figures* (Paris: Editions du Seuil à Paris, 1972).

3. See Yoshida Kōichi, "Keian sannen Yamamoto Shunshō batsu '*E-iri Genji monogatari*' rokujū kan no sonzai kachi to e-iribon toshite no igi (The Existence and Value of the Sixty-volume *Illustrated Tale of Genji* of 1650 and its Significance as Illustrated Literature)," in *Heian bungaku kenkyū* (*Research in Heian Literature*) 72, 73 (1984.12, 1985.6). Many illustrations from that book appear in Edwin Seidensticker, trans., *Genji Monogatari*, 2 vols. (New York: Knopf, 1976).

4. See the author's "Kinsei ni okeru Genji monogatari kyōju no ichi sokumen (One View on the Reception of *The Tale of Genji* in the Early Modern Period)," *Gazō to gengo: Heisei 4 nen, 5 nen, kagaku kenkyūhi hojokin kekyū seika kōkoku sho* (*Visual Images and Language: Report on Research Results of the Science Research Assistance Fund, Heisei Years 4 and 5*) (Tokyo: Tōkyō bunka kenkyūjo, 1994.6).

Let us consider an example of how certain present-day readers cope with *The Tale of Genji*. Figure 3, for example, shows pages from a comic-book style adaptation of the novel, the lavishly produced *Passing Dreams: The Tale of Genji* (*Asaki yume mishi: Genji monogatari* あさきゆめみし―源氏物語) by Yamato Waki 大和和紀.[5] This ambitious work relates the story primarily through direct speech and overt expressions of the inner thoughts and emotions that were left unspoken or obliquely implied in the Heian illustrated novel. Events are narrated exclusively by the characters involved. Dialogue, thoughts, and feelings are recorded in detail in the separate "thought bubbles." This does not mean that the "omniscient narrator" has completely vanished, but rather that her function has been transferred to the vividly realized characters living within the world of the narrative. The invisible narrator has been assimilated into these characters.

Figure 3 illustrates the chapter described above, "The Law." Let us trace the frames, which for convenience I have numbered for the most part in parentheses. In the opening scene, (1), Murasaki is seen in profile, and the reader is her conversation partner, looking at her as would the Empress. In the next scene, (2), Murasaki's interior monologue is shown, with her thoughts recorded around her. In the following frame, Genji appears only as a voice. Then in (4), all three figures are present, with Murasaki and the Empress in the background. In the next scene, (5), Genji's thoughts are verbalized and directed to Murasaki. The frame below is complicated as Murasaki, the main protagonist, is staring outward while the viewer looks at her, reads her thoughts, and assumes her viewpoint. Genji, the object of her concern, is also depicted. The next three frames—(7), (8), and (9)—focus respectively on Murasaki, Genji, and the Empress, and finally in the last one, (10), all three appear.

Both the twelfth-century single-sheet painting (*Fig. 1*) and the present-day compositions (*Fig. 3*) depict the same climactic events described in "The Law." The modern interpretation has divided the story into many contiguous slices that we call frames, painstakingly tracing the changes in viewpoints that occur in the original novel and reproducing the story line. For example, though not reproduced here, the dialogue between the Empress and Murasaki no Ue is expanded into four pages. The Heian painting, on the other hand, isolated this particular episode in a single frame and superimposed the different perspectives within it, making possible for the viewer to move from outside the narrative world to inside it. Common to both versions is a framework in which the omniscient viewpoint is located outside the picture plane and exterior to the narrative world. The narration created by the twelfth-century and by the modern pictures is not necessarily the same as that of the text, but the role of these pictures as narrators requires frequent, dynamic consultation with the text.

Ladies-in-Waiting

In the previous section, we distinguished among different narrators. The original text of *The Tale of Genji* revealed the presence of the "omniscient narrator," who existed outside of the story, and the "voicing (or 'transparent')

5. Thirteen volumes. *Mimi* version (Tokyo: Kōdansha, 1980–1993).

narrators," who, in the Tokugawa/Gotō paintings, are depicted within the scenes they narrate. Take, for example, the illustration of the scene from Chapter 39, "Evening Mist" (*Yūgiri* 夕霧) (*Fig. 4*). Two ladies-in-waiting are depicted on the near side of the sliding screens (*shōji* 障子) from the main room in which we find the principal couple (Yūgiri and Kumoi no Kari 雲井の雁). Partitioned off to the right by the leftward-descending line of the tie beam, the ladies are peripheral in their placement on the picture plane and in the degree of detail in their depiction. The central event of this painting is Kumoi no Kari stealing up behind Yūgiri, intending to snatch the letter that was written by the mother of his new love. The two ladies-in-waiting eavesdrop upon the explosive quarrel between the couple, but neither the scroll text nor the novel itself mentions their presence. Of course, to the reader familiar with the daily life of the Heian aristocracy, their existence is understandable. Even though they are not mentioned, we expect them to be present. We, the viewers, join with the artists in rescuing the ladies-in-waiting from their "transparent" existence, and in animating them as characters active in the narrative. Although they do not participate directly in the central occurrence (the dispute between Yūgiri and Kumoi no Kari), they substitute for us, the readers.

Let us now trace how we scan this picture plane. As is standard in East Asia—and in the illustrated narrative-scroll format in particular—our gaze first sweeps across the scene from the right. That motion is likely guided by the diagonal line of the tie beam, which slants down from the right. At the left, past the two principals, our view is blocked by the black chest running parallel to the tie beam, and our view is therefore led back into the scene, first to the charged incident occurring between Yūgiri and Kumoi no Kari, and then to the spying ladies-in-waiting in the outer room. Their eavesdropping in turn directs the viewer's gaze back to the marital quarrel that is the object of their attention.

The first scene of Chapter 49, "Ivy" (*Yadorigi* 宿木; *Fig. 5*), shows Kaoru 薫 playing a game of *go* 碁 with the Emperor while, again, two ladies-in-waiting spy on them from the next room. The ladies witness the marvelous Kaoru, suitable to be the son-in-law of the Emperor, winning the first game. The text tells of the Emperor's offering him as prize the right to pick a flower from the palace garden—a prize Kaoru accepts, understanding, as do the ladies-in-waiting and we the readers, that it is a promise of the Second Princess's hand in marriage.

These court ladies do not participate in the central event. They are placed at the periphery of the narrative and observe the ongoing events from the side, implying what they have seen and heard. The novel tells of narrators whose voices are heard but whose forms do not appear. The illustrated narrative scrolls give them a physical existence. They are not, however, infallible witnesses. Though they keep their ears pricked to the neighboring rooms or peer through blinds, they do not see or hear or understand perfectly what is happening. Their perceptions, like their existence within the novel, are incomplete.

Though the author of *The Tale of Genji*, Murasaki Shikibu, served as the Auspicious Event Reporter in the residence of the mighty Fujiwara no Michinaga 藤原道長 (966–1027), she often noted in her diary, "I did not see all the details." Her stating of this caveat reminds us of the style used by court women who composed records of poetry

contests, writing with the phonetic *kana* 仮名 syllabary, which left much latitude for subjectivity and incompleteness. It was the reverse of formal records written by men in Chinese characters and therefore more likely to contain fabrications, omissions, misperceptions, and flattery. Even so, narratives by ladies-in-waiting possessed a certain legitimacy, derived from an ancient tradition that primeval narratives, handed down from the gods, had been recorded by "heavenly maidens" (*miko* 巫女).[6] If a narrative such as *The Tale of Genji* was derived from a chronicle and written from the viewpoint of a presumably "omniscient narrator," we must understand that the narrative is limited by the perceptions of the author. The tale told by the "omniscient narrator" is, in fact, fundamentally unbalanced, an inadequate representation of the reality it purports to describe. Indeed, we may ask if an "omniscient viewpoint" actually exists, and who may possess it. If the novel's narrator provides an inadequate account of the purported events, then the reader is placed in a similarly "omniscient" position, subject to its own limitations.

The painting for the second scene of Chapter 36, "Oak Tree" (*Kashiwagi* 柏木; *Fig. 6*), exemplifies the symbolic significance implicit in the act of looking. The five ladies-in-waiting arrayed at the left do not look at Yūgiri and the dying Kashiwagi on the other side of the screen. By not looking, they avoid knowing about the death of Kashiwagi, as if their not knowing can prevent it from occurring.

Conclusions and Amendments—Beyond Plot, or the Reader

The Tokugawa/Gotō version of *The Tale of Genji* presupposes an audience closely familiar with the novel. Given that audience, what kind of narration do the illustrations create?

Let us consider, as example, the second scene of Chapter 38, "Bell Cricket" (*Suzumushi* 鈴虫; *Fig. 7*), in which Genji and young courtiers are said to visit Retired Emperor Reizei 冷泉 (950–1011) on the evening of the full moon. Among the twenty paintings that survive today from the original set of more than one hundred, this picture is conspicuous for its powerfully controlled and intimate composition. The palette is limited, the organization clear-cut, and the figures masterfully handled in the ordered depiction of the verandah. The green of the *tatami* 畳 mats and the browns of the floorboards form rhythmically repeated bands which guide the reader's gaze from the lower left-hand side of the painting to the upper right.

Arranged in echelon at right angles to the diagonals are Genji, Retired Emperor Reizei, and Yūgiri, shown playing a flute (Reizei is Genji's illegitimate and unacknowledged offspring by Genji's stepmother, whereas Yūgiri is an acknowledged son of Genji). Genji and Reizei are like mirror reflections of one another, a visual manifestation of their father-son relationship of which both are aware but neither can bring himself to speak. The flute-playing Yūgiri is likewise mirrored by the lord placed lowest on the picture plane, who is likely playing a *shō* 笙 instrument. Yet a third pair is formed by the lord between these two and the figure at the base of the pillar at the far left keeping time

6. This issue evokes the feminine axis of narrative in the discourse on gender.

to the music. Each of these two pairs is separated by a member of the other pair, which makes their grouping less intimate. Genji and Reizei, on the other hand, form the closely linked nucleus of this scene.

We must note here that the original novel describes this event in brief and summary fashion, ending with the comment that Chinese poems were read as dawn came to the sky. In the artists' interpretation, Genji is located at the center of the composition, but they also gave prominence to Yūgiri, who is barely mentioned in the text. Moreover, the artists depicted the musical performance as taking place in Reizei's presence, whereas the novel describes it as occurring before the courtiers reached the palace. The painters thus conflated two separate episodes from the novel into a single illustration, and, by emphasizing Yūgiri and the mouth organ, placed their own interpretation on the scene.

The flute, as related in previous chapters, had been a cherished possession of Genji's friend Kashiwagi, who had died of remorse over an adulterous affair with Genji's wife (resulting in the birth of a son, Kaoru). The mother of Kashiwagi's widow gave the flute to Yūgiri, and on the night he first played it, Kashiwagi appeared in his dream. As he plays it in this scene, the viewer, familiar with the entire novel, imagines the melancholy that Genji must feel as he laments the death of Kashiwagi as well as his own adulteries and romantic misadventures. Since the original text mentioned Chinese poems, the moon (shown here at the upper right) recalls a passage by the Tang poet Bo Juyi 白居易 (772–846), "At mid-month I think of the new moon's radiance, and of an old friend three thousand leagues away."

The illustrated narrative is bound to the text of the novel but is also free from it. In the twelfth-century illustrated handscroll, each calligraphy section was an excerpt from that novel, and each painting represented a single scene. Most of the paintings depict the scene as described in the adjacent text, but some, like Figure 6, also include motifs from scenes preceding or following them, as well as narrative elements added by the painters. The informed viewers, moreover, interpreted the pictures within the greater context of the novel, which they intimately knew. Of course, that knowledge will differ from one reader to another, but that is not the point here. The point is, rather, that each reader reconstructs a narrating text; the reading itself is a form of narration. Just as the memory of the novel expands one's viewing of the handscroll, so also in reading the novel, one brings to bear everything one knows about the world of that novel.

As one final example for consideration, Figure 8 illustrates the third scene from the *Illustrated Handscroll of the Tale of Nezame (Nezame monogatari emaki* 寝覚物語絵巻), thought to have been produced about the middle of the twelfth century, several decades later than the Tokugawa/Gōto *Genji* scrolls. The illustrations convey considerable emotion, even though they are less faithful than the *Genji* scrolls to the text proper. In this scene, Masako no Kimi is identifiable only by the glimpse of his pantaloons spied through the open door of the residence. This mode of representation is known in Japanese as *kaimami* 垣間見, literally, "spying through a fence." A corridor running from upper right to left divides the picture plane in two, a garden with a large tree, and the barely defined people behind the curtains. This painting recalls the first scene of Chapter 44 in the illustration of *The Tale of Genji*, "Bamboo River"

Sano Midori

(*Takekawa* 竹河), in the Tokugawa Art Museum (*Fig. 9*). Though the former painting does not so much depict the protagonist, Masako no Kimi, as suggest him, the garden is executed in a stylized, patterned manner, and the similarities between this scene and the Genji painting are clear. The stylistic similarities reflect the fact that the text of *The Tale of Nezame* makes abundant reference to *The Tale of Genji*, its main prototype.

In these illustrated narrative handscrolls, the plots coexist with external associations. The viewers merge what is told in the text or depicted in the illustration with their own store of knowledge, memories, and expectations—elements that are external to the texts. In the analysis here of both texts and paintings in the oldest surviving illustrated handscroll version of *The Tale of Genji*, I hope to have made clear that narration is manufactured by the omniscient viewpoint of the reader. As is well known, Aristotle in his writing on drama argued that plot (the organization of events) must be both logical and natural, and that it must exclude arbitrary interventions by the gods and the fates. At the same time, however, he also acknowledged that drama of necessity includes those aspects. As the drama unfolds on stage, the audience recalls things offstage or events that took place before the beginning of the plot. Aristotle suggests a dramaturgic method in which irrational or extraneous elements are carefully excluded by the playwright but are nonetheless evoked by the actions on stage, and the evocations are merged with those actions in the minds of the audience.

Thus, to me, Aristotle's phrase "matters external to the plot" illuminates the role of the reader in the construction of narrative. Commentators have agreed that "matters external to the plot" refer to events occurring before the beginning of a play but are nonetheless taken as a part of the plot. Others will debate whether it is the author/painter or the reader/viewer who possesses the "omniscient viewpoint" when observing narrative paintings that illustrate a text. However, as far as I am concerned, because the entire view of the scene also includes that which is external to the text, the reader *a priori* transcends that narrative.

故事的敘事、繪畫的敘事

佐野みどり

學習院大學

　　本文藉由「情節」、「敘事者」、「讀者」這三個極點來掌握故事的結構性要素，以《德川、五島本源氏物語繪卷》爲例考察「繪畫的敘事」。

　　在此，畫卷詞章由所根據的故事文本中截取故事的片段，將其場景提示於讀者的面前。原則上，畫面是所截取詞章情景之繪畫化，但是有時也由詞章前後的場景選取母題。而讀者讀取詞章、凝視畫面，在不斷回復原典（所根據的文本）記憶的同時，讀取並解釋展現於眼前的故事世界。畫卷促成了一個完結的作品世界的獨立，但同時又附帶著其外部作爲文本依據的故事全貌。亦即，讀者在其所理解的故事全貌中解釋眼前的畫卷。

　　《寢覺物語繪卷》第三段顯示了與《德川本》〈竹河〉第一段相似的畫面。《寢覺物語》作爲畫卷文本在《源氏物語》的強烈影響下成立，但是《寢覺物語繪卷》第三段正是將這樣的「根本典據」（作爲引用架構的《源氏物語》）作爲可觀看的對象而提示給讀者。

　　情節總是與「情節之外」[1]共存、故事隨著「閱讀」而被創造出來、讀者在形象的森林中發現並走出各自的道路。所謂隨著讀者的「閱讀」而顯現形態的作品，是交織了作品內部的各種情節以及「情節之外」讀者的記憶、期待等等而呈現在讀者眼前。

　　繪畫的「敘事」爲我們清楚地顯示了故事「敘事」的根本性論點，即爲先驗上故事具備讀者、敘事的全知視點以及情節之外。

1. 出自亞里斯多德《詩學》第17章1455b中的用語「exō tū mythū」。

物語の語り、絵画の語り

佐野みどり

学習院大学

　本稿は、物語の構造的要素を〈筋〉〈語り〉〈読者〉の三極と押さえた上で、「徳川・五島本源氏物語絵巻」を例に、〈絵画の語り〉を考えるものである。

　この作品では、絵巻詞章は、依拠する物語テキストから物語切片を切り取り、読者の前に場面を提示する。画面は、原則的には、その詞章が切り取る情景を絵画化するが、時には、詞章の前後のシーンからもモチーフを取り込む。そして読者は、詞章を読み画面を眺め、原典（依拠テキスト）の記憶を回帰させつつ、眼前に広がる物語世界を読み、解釈する。絵巻は一個の完結した作品世界を自立させながらも、同時にその外側に依拠テキストである物語の全貌を付帯させているのである。つまり、読者は、目の前にある絵巻を、読者が捉えている物語の全体像の中で解釈するのである。

　また、「徳川本竹河第一段」と相似する画面を示す「寝覚物語絵巻第三段」の場合。絵巻のテキストである『寝覚物語』は、『源氏物語』の強い影響下で成立したと説かれるものであるが、この「寝覚物語絵巻第三段」は、そのような〈本説〉（引用の枠どりとしての『源氏物語』）を読者に可視的なものとして読者に提示しているのではないか。

　筋は常に〈筋の外〉[1]と共にあること、物語は〈読み〉ごとにいま創出されていること、読者はイメージの森の中にそれぞれの道を見つけ歩んでいること。読者の〈読み〉によって姿を現す作品とは、作品内のもろもろのプロットと、読者の記憶と期待という＜筋の外＞が縒り合わされ現前するものなのである。

　絵画の〈語り〉は、物語の〈語り〉の根源的な論点を私たちに明示しているのだ。すなわち、物語が先験的に読者を有していること、語りの全知視点、そして筋の外、といった論点を。

1. アリストテレース『詩学』第17章1455bでの〈exō tū mythū〉の用語による。

Fig. 1. Genji, the Empress, and Murasaki no Ue exchange poems. Illustration of Chapter 40 ("The Law"), *The Illustrated Handscroll of the Tale of Genji*, early 12th c. Handscroll, color and silver leaf on paper. Gōto Museum, Tokyo.

Fig. 2. The infant Genji being presented to the emperor. Illustration of Chapter 1 ("Paulownia Court"). Black-and-white woodblock print from Yamamoto Shunshō (1610–1682), *Illustrations into the Tale of Genji*, 1650.

Sano Midori

Fig. 3. Genji, the Empress, and Murasaki no Ue. Illustration of Chapter 40 ("The Law"), from Yamato Waki, *Passing Dreams: The Tale of Genji* (*Asaki yume mishi: Genji monogatari*). Black-and-white prints, 1980–1993.

Fig. 4. Snatching the letter. Illustration of Chapter 39 ("Evening Mist"), *The Illustrated Handscroll of the Tale of Genji*, early 12th c. Handscroll, color on paper. Gōto Museum, Tokyo. (*detail on page 443*)

Fig. 5. Kaoru and the emperor playing *go*. Illustration of Chapter 49 ("Ivy"), *The Illustrated Handscroll of the Tale of Genji*, early 12th c. Handscroll, color on paper. Tokugawa Reimeikai, Tokyo.

Fig. 6. Kashiwagi dying. Second illustration of Chapter 36 ("Oak Tree"), *The Illustrated Handscroll of the Tale of Genji*, early 12th c. Handscroll, color on paper. Tokugawa Reimeikai, Tokyo.

Sano Midori

Fig. 7. Genji visits Retired Emperor Reizei. Second illustration of Chapter 38 ("Bell Cricket"), *The Illustrated Handscroll of the Tale of Genji*, early 12th c. Handscroll, color on paper. Gōto Museum, Tokyo.

Fig. 8. Masako visits the lady-in-waiting of the third princess. Third illustration in *The Illustrated Handscroll of the Tale of Nezame*, mid-12th c. Handscroll, color on paper.

Fig. 9. Young Kaoru being compared to a plum tree. First illustration of Chapter 44 ("Bamboo River"), *The Illustrated Hand-scroll of the Tale of Genji*, early 12th c. Handscroll, color on paper. Tokugawa Reimeikai, Tokyo.

Sano Midori

A Japanese Construction of Chinese Painting in the Eighteenth Century

Timon Screech

School of Oriental and African Studies, University of London

In this brief essay on an immense subject, I shall attempt to offer only some notions of how, in the mid-Edo period, Chinese painting was conceived in Japan, and how this was then counterposed with an indigenous "Japanese painting." The terms used today—China and Japan—refer to our contemporary political entities, but at the time other terms were employed, and their connotations were, rather, cultural in tone. People of the Edo period spoke of *kara* 唐 or *kan* 漢 styles of painting, referring to any painting in what they considered Chinese style; neither term carried any political reference to Qing China. In much earlier times, *kara-e* 唐絵 had been the common designation for "Chinese painting" (*e* meaning "picture"), but this had largely fallen out of use, and by the seventeenth century people spoke of *kanga* 漢画 (*ga* also means "picture"). The obverse of this had once been *yamato-e* 大和絵, but again, this term was largely defunct, and people spoke of *waga* 和画. As we shall see, it was quite common to argue the merits of these two, and to propose antinomies for them. Whether such theorizings convince the modern art historian is not the point (generally they do not). Rather, we should assess how they came to hold so much weight for people living at the time.

A Competition in a Boat

We may begin a little further back. A *nō* 能 play by Zeami 世阿弥 (1363–1443), written in the late fourteenth century, told how the great poet Bo Juyi 白居易 (772–846) had been sent to Japan by the Chinese emperor to test the natives' poetic skill. In Japan, he was revered under the Japanese version of his name, Haku Rakuten, which became the title of Zeami's play. Haku Rakuten arrived by boat at Sumiyoshi 住吉 Bay, near modern Osaka, and encountered a humble fisherman laboring over his nets. Seizing an apparently unfair advantage, Haku Rakuten engaged the fisherman in poetic competition. Haku Rakuten produced the first verse, only to be met with a surprisingly good response. The chorus sings, "Truly the fisherman has the ways of Yamato in his heart. Truly this custom is excellent."[1] Haku Rakuten has to admit that the fisherman's verse actually surpassed his own. The *nō* theater audience realized that this was not a fisherman at all, but Sumiyoshi Myōjin 住吉明神 (the guardian deity) in disguise, come to maintain Japanese honor. To punish the arrogance of the continental challenger, the gods raise a *kamikaze* 神風 ("divine wind") and blow Haku Rakuten back to Tang China.

1. Zeami, *Haku Rakuten*, in *Nihon koten bungaku taikei* (*Complete Collection of Japanese Classical Literature*) (Tokyo: Iwanami shoten, 1968), vol. 41, p. 308.

Not everyone went to the *nō*, or knew Zeami's play, but the story was popular enough to take on a life of itself outside the theater. The tale of the expulsion of the arrogant Haku Rakuten became a part of the national myth. In about 1690, Ogata Kōrin 尾形光琳 (1658–1716) put the story on a six-fold screen (*Fig. 1*). The painting was famous in Edo times, and it was published in 1815 by Sakai Hōitsu 酒井抱一 (1761–1828) in his *One Hundred Paintings by Kōrin* (*Kōrin hyakuzu* 光琳百図), a book produced to mark the centenary of the artist's death (*Fig. 2*).

Kōrin and Hōitsu were members of what became known as the *Rinpa* (or *Rimpa*) 琳派 school. However, the same theme was also painted by artists of the officially recognized Kanō 狩野 school. Kanō Eisen-in Michinobu 狩野栄川院典信 (1730–1790), the artist attached to the Kobikichō 木挽町 atelier who led the shogunal academy, produced a work in collaboration with his son and successor, Kanō Yōsen-in Korenobu 狩野養川院惟信 (1753–1808), some time in the 1770s. Michinobu, who was promoted with the honorific title *hōin* 法印 in 1780, on this painting signs himself *hokkyō* 法橋 (*Fig. 3*). These works both bring together and set apart the poetic styles of China and Japan. Note that both depict the foreign boat as grand and flamboyant, whereas the local one is modest and small. This is a point to which we shall return.

Although the encounter shown in these two paintings relates to poetry, not art, the Haku Rakuten model was clearly available for application in areas other than verse. Its larger theme was the cultural anxiety that Japan, small and perched at the "Far East" of a vast continental mass, was intermittently bound to feel.

Ueda Akinari 上田秋成 (1734–1809), the doctor and writer from Osaka, addressed the same issue in 1776, in the first of his two collections of supernatural stories, *Tales of Moonlight and Rain* (*Ugetsu monogatari* 雨月物語). Akinari was much indebted to contemporary Chinese literature for his own works, but in the opening tale of the book, "The White Peak" (*Shiramine* 白峰), he sharply differentiates China and Japan over a vast philosophical issue, specifically, a doctrine of Mencius (Mengzi 孟子; 372?–289? BCE). Mencius justified tyrannicide, which the Japanese held to be an inappropriate doctrine for their land, where, thanks to the "true succession of divine sovereigns," tyrants simply could not occur. Therefore, although Mencius was known and read in Japan, simultaneously there persisted the myth that his book had *not* entered the country. Mencius's writings, says Akinari's narrator (a fictionalized version of the medieval poet-monk Saigyō 西行 [1118–1190]), are unknown in Japan because the native gods would blow back to China any boat carrying them: "They say the eight million gods despise the book, and will raise up a *kamikaze* to command any ship [carrying it] to the bottom."[2]

This legend is clearly linked to that of Haku Rakuten. A little later in "The White Peak," Saigyō makes his real point: "There are many times when the teachings of foreign sages do not suit this land." Though certainly not a xenophobe, Akinari tells a more rejectionist story than Zeami. Even in spheres where the Chinese mode is not deemed to be inferior to, but only different from, the Japanese, what is good for the former is not necessarily applicable to the latter. Like good poetry, good philosophy—or anything else deemed good—varies from place to place and is not

2. Ueda Akinari, *Ugetsu monogatari*, in *Nihon koten bungaku taikei*, vol. 56, p. 42.

necessarily transferable. At the end of the eighteenth century, the Haku Rakuten theme began to be applied to painting.

In the 1760s, Suzuki Harunobu 鈴木春信 (1724–1770), one of the most celebrated artists in the *ukiyo-e* 浮世絵 ("floating world") genre, designed a print of Haku Rakuten's encounter with the God of Sumiyoshi, here represented as a beautiful woman (*Fig. 4*), presenting it as a competition over visual representation. In keeping with his genre, Harunobu, following a popular *ukiyo-e* convention, has abandoned the grand historical dimensions of the *nō* play, substituting figures in contemporary dress: a modern Japanese confronts a modern Chinese. Since a Korean embassy came to Japan in 1764, the man in the print may be intended as Korean. The Japanese popular term, however, made no distinction between the two; all Continentals were "Chinese people" (*karabito* 唐人).

Harunobu depicts Haku Rakuten and Sumiyoshi Myōjin as his contemporaries, thereby making their encounter refer to contemporary painting, not to that of the antique past. Haku Rakuten has become an artist in the *nanga* 南画 manner, and he holds an ink painting of an orchid, presumably painted by himself. In Zeami's play, the fisherman was not a poet, but rather a medium for Japanese poetic excellence. Likewise, for Harunobu, the Japanese figure is not a painter, but an artist's theme. The beautiful woman (*bijin* 美人) is a typical subject of *ukiyo-e*, and she holds up a pillar print (*hashira-e* 柱絵) of just such a woman as herself, standing near the corner of a vermilion shrine gateway. Anyone familiar with Harunobu's work would know that this is Osen 阿仙, a waitress at the Kagiya 鍵屋 teahouse beside the Kasamori 笠森 Shrine in Yanaka 谷中, in Edo. Osen was considered one of the greatest beauties of her day, and Harunobu had done much to promote her in a series of prints. The fact that her teahouse was next to a shrine equates Osen with the fisherman, although Kasamori Shrine was dedicated to Inari 稲荷, not to Sumiyoshi Myōjin.

Harunobu parodied the Haku Rakuten legend to address a real concern (one might say problem) in later Edo culture—the proliferation of pictorial style. An explosion of manners and techniques, of ideologies and claims, seemed to be propelling the world of art to break up, even collapse. In this print, Harunobu asks the viewer who determines the language of depiction, or, more abstractly, what representation is supposed to be. *Nanga* and *ukiyo-e* have different epistemologies. Each in its own terms can give rise to excellent works of art, just as Haku Rakuten and Sumiyoshi Myōjin can both produce exemplary poems. The two are, however, incompatible.

Adding *Ran*

The debate over the relative value of *kanga* and *waga* was old, perhaps traceable as far back as the Heian period. However, in the eighteenth century, a third element entered the debate: the painting of Europe, *ranga* 蘭画.

In 1777, a writer for the first time inserted *ranga* into the Haku Rakuten myth. He did this in the context of a popular illustrated story (*kibyōshi* 黄表紙) entitled *Nandara the Monk and the Persimmon Seed* (*Nandara hoshi no kaki no tane* 南陀羅法師の柿の種). The author was Hōseidō Kisanji 朋誠堂喜三二 (1735–1813), a frequenter of the

Timon Screech

pleasure districts and on friendly terms with many of the *ukiyo* artists and writers of his day. Kisanji, however, was also a senior *samurai* 侍 and Edo Representative (*rusuiyaku* 留守居役) of Satake Yoshiatsu 佐竹義敦 (1748–1780), *daimyō* 大名 head of Akita 秋田. In that context, he used the name Hirazawa Tsuneyoshi 平澤常當. Edo Representative was an extremely important position, and particularly so for Akita, which was both large and rich in copper mines (copper being the shogunate's principal export). Yoshiatsu was no ordinary *daimyo*, either, for he was one of the sponsors of Western learning ("Dutch Studies [*Rangaku* 蘭学])." He became a *ranga* artist himself, using the studio name Shozan 曙山. The Westernizing experimenter Hiraga Gennai 平賀原內 (1728–1779) had gone to Akita to help improve mining technologies; there he met a young Akita *samurai*-painter named Odano Naotake 小田野直武 (1749–1780), and introduced him to *ranga*. It was probably Naotake who, in turn, introduced Yoshiatsu to the same imported mode. Naotake accompanied Gennai back to Edo to illustrate the forthcoming translation of a European medical text—Japan's first full anatomical treatise, *New Anatomical Atlas* (*Kaitai shinsho* 解体新書) of 1774. In Edo, Naotake lived in the Akita mansion and would have met Kisanji/Tsuneyoshi.

The timing here is noteworthy: Gennai went to Akita in 1773, and *New Anatomical Atlas*, with illustrations copied from Western books, was published the following year. Yoshiatsu/Shozan took up *ranga* in 1778 and wrote two treatises on Western art—the first written in Japan—about the same time. Kisanji's story appeared in 1777, and its addition of *ranga* to the Haku Rakuten story was extremely apt. Kisanji was no artist, so he had the illustrations provided by another senior *samurai*, Kurahashi Itaru 倉橋格 (1744–1789), who in his *ukiyo* existence used the pen name Koikawa Harumachi 恋川春町. Harumachi was also an Edo Representative, for the much smaller state of Ojima 尾島 in Suruga 駿河.

Kisanji also fleshed out the encounter. His story tells of an Indian monk, Nandara, said to be disciple of Indara, a famous temple painter. Indara had received a magical persimmon stone from the Buddha, which when rubbed with water formed an ink with which pictures of unfailing excellence could be produced. Nandara steals the stone, but unlike his master, is dissatisfied with producing just religious icons and thirsts for new and more wide-ranging styles. He determines to learn the painting of other parts of the world. He travels to China and acquaints himself with *nanga*. Harumachi's illustration shows Nandara learning to paint ink bamboo, although according to the text he also did orchids—like Harunobu's continental figure (*Fig. 5*). As it turns out, this was not in fact the first stop on Nandara's route. Initially he went to Europe, specifically Holland. We see him on the right-hand side of the same page learning from a European master whose large nose, curly hair, and buttoned clothes seem in contradiction to his sitting on the floor and using an arm rest in the Japanese way. Harumachi lines up all the typical features of Western art as understood in Edo at the time: an oil painting on an easel, a topographical view done in perspective, and a portrait roundel.

Equipped with a mastery of *kanga* and *ranga*, Nandara heads for Japan to see how they paint there. He arrives by boat, not in Sumiyoshi Bay, but in the center of modern life, Edo 江戶 Bay, where he meets a fisherman. This was a

clever transposition, for an island in Edo Bay where fishermen lived, Tsukudajima 佃島, had a shrine to Sumiyoshi Myōjin on it. Of course, this fisherman is the Sumiyoshi Myōjin in disguise. Harumachi's illustration shows him with several extra paintings in the bottom of his boat but holding up just one, showing an arched bridge, a clear reference to the Sumiyoshi Shrine in Osaka, the most famous feature of which was this bridge. In return, Nandara offers a landscape, presumably a synthesis of the Chinese and European styles he has recently learned. The comparison inevitably goes against Nandara. A *kamikaze* arises to expel him.

Coming Back for More

Some years after Kisanji's and Harumachi's publication, an event occurred which seemed to give the old tale direct relevance. In 1795, a group of Chinese castaways was washed ashore on the coast of Sendai 仙台. A cultural battle similar to the fictional one actually occurred, as recorded by Tachibana Nankei 橘南谿, a doctor from Ise 伊勢 who combined great interest in things foreign with belief in the enlightenment of his homeland. Nankei included the episode in his miscellany (*zuihitsu* 随筆), *Remarks from a Northern Window* (*Hokusō sadan* 北窗瑣談).[3] The Chinese men were at once led to Sendai Castle for questioning. The official Confucian scholar (*jukan* 儒官) saw this as a wonderful opportunity to find out about the classical arts of China, and he questioned the castaways thoroughly. This, like Haku Rakuten testing a fisherman, was not really fair. These *were* fishermen who had been overtaken by a storm which (in a reverse kind of *kamikaze*) had washed them *to* Japan. But there was no god to step in here, so they could not answer the questions that the scholar, Shimura Tōzō 志村藤藏, kept asking them. Tōzō also demanded some poetry and calligraphy, which, of course, they could not provide. Nankei explains to the reader: "The men were completely illiterate, and their handwriting was a real sight—they could neither compose poetry nor read."

Tōzō was disappointed but would not give up, and he refused to allow the crew to be repatriated until they had improved. He himself acted as their tutor, "although it was a thankless task," and practiced poetry and calligraphy with them daily. Nankei's illustrator, Hitotsuyanagi Kagen 一柳嘉言 (fl. latter half of the 18th c.), pictured the rather ludicrous scene of the aged scholar instructing his dull Chinese students (*Fig. 6*). In the end, Nankei wrote, the fishermen attained a reasonable educational level and could manage "a single line of text, or an inscription on a fan in response to a commission," which was a measure of Tōzō's devotion. However, Nankei ends with the real point of the story (which this time, we may note, deals with calligraphy, the sister art of painting): China has lost even its own arts, and Japan preserves both its own heritage and that of the Continent. "When the fishermen returned to their own land and told their countrymen all about what had passed, everyone must have been very surprised at their having learned proper writing here. How proud for Japan!"

3. Tachibana Nankei, *Hokusō sadan*, in *Nihon zuihitsu taisei* (*Complete Collection of Japanese Miscellanea*) (Tokyo: Yoshikawa kōbunkan, 1974), ser. 2, vol. 15, pp. 293–95.

Nankei simplifies the original Haku Rakuten theme into a difference in level of skill: the Japanese can do it, and the Chinese (fishermen) cannot. However, the original issue had not been one of *level* of skill, but of value of *genre*. The Haku Rakuten myth had not claimed the Japanese were better poets (or painters), but that in Japan, Japanese *genres*, like Japanese philosophy, were more appropriate. Haku Rakuten was acknowledged as the finest Chinese poet ever: he was expelled because *no* Chinese verse, however good, could match a vernacular one in its appropriateness to Japan.

In Nankei's story, all the Chinese need do is practice and improve; plausibly, they could go home and improve further, then return to Japan as equals. In Zeami's version, the foreigner is already excellent. Improving is not the issue. To achieve excellence in *Japanese* terms, the foreigner would have had to exchange his Chinese idioms for Japanese ones. A comic verse of the period (*senryū* 川柳) humorously made this very point: "As expected, he never came to quiz Japan a second time."[4]

Except for Kisanji, all tellers of the Haku Rakuten tale end with the expulsion. In Kisanji's tale, Nandara is blown away by the *kamikaze* but *does* return, not to test and challenge but to learn. This entails abandoning his foreign styles. He begins to study the then most fashionable style, *ukiyo-e*. Harumachi depicts Nandara attempting the two principal *ukiyo-e* subjects: *bijin* and actor pictures (*yakusha-e* 役者画)—he is shown producing a portrait of the most celebrated *kabuki* 歌舞伎 star, Ichikawa Danjūrō 市川團十郎 (*Fig. 7*).

Ukiyo-e masters saw themselves as working in an indigenous painting (or printing) manner; they considered *ukiyo-e* a continuation—even rejuvenation—of *waga*, and the first *ukiyo-e* artists (Nishimura Shigenaga 西村重長 [1697–1756]), Okumura Masanobu 奥村政信 [1686–1764], and others) sometimes signed themselves so as to denote this: for example, as *Nihon gakō* 日本画工 or *Yamato eshi* 大和絵氏 (both meaning "Japanese painter").

When Kisanji wrote of the Indian Nandara learning *ukiyo-e*, he was really saying, I think, that by the end of the eighteenth century, all talk of artistic style as a national preserve had become meaningless. *Kara-e*, *kanga*, *nanga*, and *ranga* were all being practiced in Japan, by Japanese, and entirely legitimately. So why could not *waga* and *ukiyo-e* be produced by overseas people? A limited variety of *kara-e* had been produced in Japan since early times, but the full and complete uncoupling of *country* from style was a new—and startling—phenomenon of this age.

4. Anonymous, *Yanagidaru* (*The Willow Barrel*); see Kasuya Hiroki *et al.*, eds., *Haifū yanagidaru* (Tokyo: Kyōiku bunko, 1987), vol. 6, no. 488.

十八世紀的日本對中國繪畫的一種建構

Timon Screech

倫敦大學亞非學院

這篇論文將思考「中國繪畫爲江戶時代中期的日本所理解」之時，諸多假設（觀點）的其中一種。關於日本仰慕（東亞）大陸的藝術，一直以來就有著長久而延續的歷史；然而，同時也有一段不願認同（大陸）的歷史不斷地困擾著他們。所以，當外國人與本地人獲得同樣地讚賞時，有時卻存在著區分出兩者差異的暗示。

本論文研究的戲劇性對白，便時常用來傳達上述的議題。傳說中，白居易曾抵達日本試探當地的詩賦技藝。當然，與白氏本身高尚卓越的詩賦相比，白氏預期在當地所找到的文學成就將會十分貧乏；但是，令他驚訝的是，當舉辦詩文競賽時，日本詩賦竟然更加優秀。上述這個由世阿彌所創作的神話，是一齣著名的能劇，過去曾在江戶時代不斷的上演，同時也是當時繪畫與版畫的主要題材。

事實上，正如世阿彌的解釋，這位日本詩人確實就是住吉明神，是白居易不經意而抵達之地的保護者。日本藝術看來不只是更加優越，而且由當地神祇們來護衛著。關於這點，那些當地神祇們後來便聚集了「神風」，以浪擊將白居易逐回中國。

這個故事之所以會以戲劇性對白的方式來敘述，是因爲它提供了一種參考架構，藉以傳達各式途徑的外國問題。根本的觀念正是日本文化（不只是詩，而且包括所有藝術）存在著地理上的特殊性。在此，他們並不是暗示大陸的文化成就很糟糕，只是，當這些大陸的文化成就在日本起作用時，他們發揮的效力絕對比不上當地的藝術文化形式。

18世紀における日本の中国絵画の構築

Timon Screech

ロンドン大学東洋アフリカ研究学院

　本論では、中国絵画が江戸時代中期に日本で理解されるにあたって用いられた多くの置き換えのうちの一つを考察する。日本では、中国大陸の芸術を古くから、長きにわたって賞賛してきた。しかし同時に、あまり知られてはいないが、大陸の芸術を問題視する風潮もあった。外国のものは自国のものに劣る、と示唆する姿勢が明らかなケースもあったのである。

　本論では、この問題を扱う際によく用いられる作品を検証する。白居易が日本人の詩歌の力量を試さんと、日本に赴いたという伝説である。当然ながら白居易は、自分の卓越した歌と比べれば、日本で出会う歌などまったくくだらないものだろう、と思っていた。ところが、歌比べをしてみて、日本の詩歌のほうがすぐれていたことに驚く。この神話的ともいえる創作は世阿弥の能楽で有名となり、江戸時代に入っても上演され、絵画や浮世絵の題材にもなった。

　世阿弥が解説するところによると、実は、白居易が対戦した日本の歌人は、たまたま上陸した場所の守り神である住吉明神であった。日本の芸術は、単に優れているだけではなく、日本の神々に導かれているものと位置づけられる。そして日本の神々は神風を呼び起こし、白居易を中国に押し返すのである。

　この物語はたとえ話として論じることができる。というのは、これには外国のあらゆる事物について語る枠組みが含まれているからである。根底にある考えは、文化（詩歌だけではなく、あらゆる芸術を含む）には地理的な特有性があるということだ。中国大陸における偉業には欠けているものがあると言っているのではない。ただ、日本の地では本国と同じようにはいかない、ということなのである。

Fig. 1. Ogata Kōrin (1658–1716). *Haku Rakuten*, ca. 1710. Six-fold screen. Nezu Art Museum, Tokyo.

Fig. 2. Sakai Hōitsu (1761–1828). *Haku Rakuten*, from *One Hundred Paintings by Kōrin*, 1816. Printed book. Private collection.

Timon Screech

Fig. 3. Kanō Michinobu (1730–1790) and Korenobu (1754–1808). *Haku Rakuten*, 1770s. Hanging scroll, ink and color on silk. National Museums and Galleries on Merseyside: The Liverpool Museum.

Fig. 4. Suzuki Harunobu (1725–1770). *Parody of Haku Rakuten*, 1765-1770. Woodblock color print. Private collection.

Timon Screech

Fig. 5. Koikawa Harumachi (1744–1789). *Nandara in Holland* (right); *Nandara in China* (left), illustrations to Hōseidō Kisanji, *Nandara hōshi no kaki no tane*, 1777. Printed book. Tokyo Municipal Central Library.

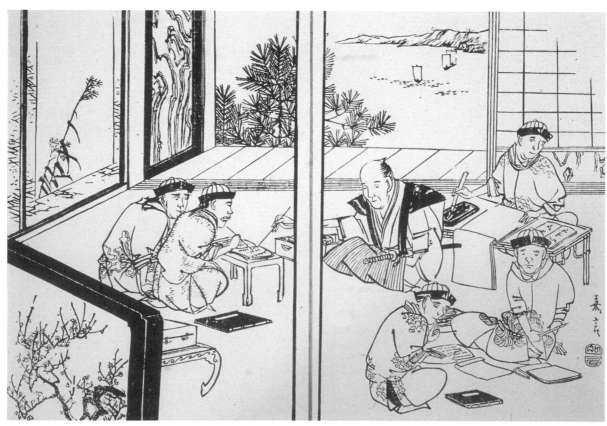

Fig. 6. Hitotsuyanagi Kagen (act. late 18th c.). *Chinese Sailors*, illustration to Tachibana Nankei, *Hokusō sadan*, 1796. Printed book. National Diet Library, Tokyo.

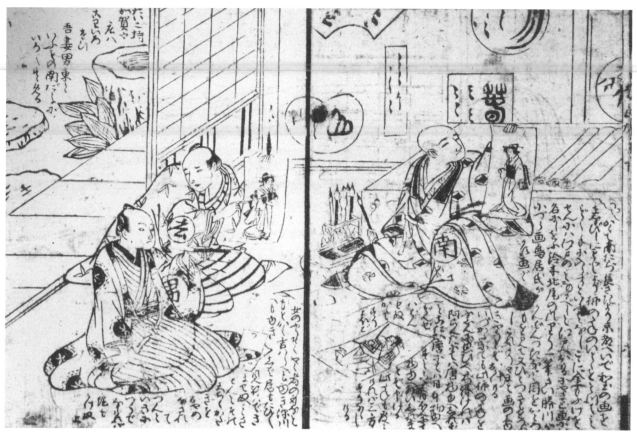

Fig. 7. Koikawa Harumachi (1744–1789). *Ichikawa Danjūrō*, illustration to Hōseidō Kisanji, *Nandara hōshi no kaki no tane*, 1777. Printed book. Tokyo Municipal Central Library.

Timon Screech

東洋美術大觀 一

"History of Art":
The Determinants of Historicization

Satō Dōshin

Tokyo National University of Fine Arts and Music

Before embarking on the topic of "The Determinants of Historicization," I should like to explain briefly why I have chosen it. I must also note that the terms *kindai* 近代 ("modern") and *gendai* 現代 ("contemporary") in the Japanese context refer respectively to the periods of 1868 to 1945 (i.e., from the beginning of the Meiji period through the end of World War II) and from 1945 to the present (i.e., the postwar period), respectively.

In the past decade or so, I have been conducting research on theories regarding the organization of art, prompted by the question inspired by a striking discrepancy. Over ten years ago, while surveying a collection of modern Japanese art in America, I came to realize that the American image of Japanese art comprised mainly *ukiyo-e* 浮世絵 prints and decorative arts. This diverged greatly from Japan's view of Japanese art and of the history of Japanese art. In American collections, except for those few formed by collectors with some personal connection to the world of modern Japanese art, the works by modern artists that have been exalted in Japan were all but entirely absent. Almost exactly the same is true of major European collections of Japanese art. To a specialist in the history of modern Japanese art, such as myself, this was particularly distressing. Differences in taste cannot be the whole or even a major part of the reason. Given that the concepts of "art," "art history," and "the study of art history" in modern Japan all came from the West, why this discrepancy in the idea of what constitutes Japanese art? Neither view is wholly valid at the expense of the other. The starting point for our discussion is the meaning of these historical views and, indeed, of our own "present."

Since Kitazawa Noriaki 北澤憲昭 published his theory of the "systematization of art" in his book *Palace of the Eye* (*Me no shinden* 眼の神殿) in 1989,[1] these questions have been examined in Japan on the premise that the "art," "art history," and "study of art history" in modern Japan were various forms of the systemization of the concept of "art" transplanted from the West.[2] The conclusions drawn from those studies form the premise of this paper, namely, that the "history of Japanese art" is a modern concept projected back onto the concepts of "Japan," "art," and "history." Similarly, the "history of Asian art" in Japan was also a projection of modern Japanese theory onto the past of "Asia." In other words, the basic forms of these concepts were created as one aspect of the "interpretations of history" for-

1. Kitazawa Noriaki, *Me no Shinden* (Tokyo: Bijutsu shuppansha, 1989).

2. See Satō Dōshin, *"Nihon bijutsu" tanjō: Kindai Nihon no "kotoba" to senryaku* (*The Birth of "Japanese Art": "Words" and Strategy in Modern Japan*) (Tokyo: Kodansha sensho mechie, 1996); and Satō Dōshin, *Meiji kokka to kindai bijutsu: Bi no seijigaku* (*The Meiji Nation and Modern Art: The Political Studies of Art*) (Tokyo: Yoshikawa kōbunkan, 1999).

mulated as part of modern Japanese theory. On the other hand, "the history of Japanese art" was created as a "self-portrait" aimed at refuting *japonisme*, and "the history of Asian art" in Japan was formed against the background of Japan's Asian policies. Therefore, the questions of what constitutes Japanese art or Japanese art history cannot be answered, or even approached, as purely domestic Japanese matters. Nor can they be productively engaged unless the largely modern-centric debate is enlarged to include the contemporary and the "now." This essay is an attempt to arrive at requirements for historicization as a necessary preliminary to conceiving of the "history of Japanese art" and "history of Asian art" within the appropriate temporal and spatial contexts.

Let us first consider the "history of Japanese art." The first characteristic of historicization is that it is created "after the fact," by looking back upon the preceding flow of events and dividing that flow into major time blocks. By graphing this image, we can see that, during the modern period, art through the Edo period was termed "history of Japanese art," and during the post-World War II era the arts of the modern period were dubbed as the "history of modern Japanese art" (*Fig. 1*). Soon the art of the postwar period will be subject to discussion as the "history of contemporary Japanese art."

The second characteristic of historicization is that the concepts and theories which support the historicization came not from the period being historicized, but rather from the period doing the historicizing. In other words, the Japanese formulation of the "history of Japanese art" was based upon the modern nationalist and imperialist ethos. The "history of modern Japanese art" is the reading and interpretation formulated in the postwar atmosphere of anti-nationalism and democracy about art that had been created within a nationalist, authoritarian ethos. What value systems will, in the near future, be used to determine the "history of contemporary Japanese art"? We must remember, too, that the historicizers not only interpret the data but determine what constitutes the data, and both processes are subject to the conscious agendas and subconscious assumptions of the historicizers. This is why it is essential to critically examine the historicizing discourse itself in order—perhaps—to approach a more accurate view of the period under discussion "as it really was." Now let us examine these concepts in a bit more detail.

Figure 2 shows *Histoire de L'Art du Japon*, the Japanese government publication on the subject exhibited at the 1900 Paris World Exposition. A Japanese edition, *Draft Version of the Brief History of Art of the Imperial Nation of Japan* (*Kōhon Nihon teikoku bijutsu ryakushi* 稿本日本帝国美術略史) was published in Japan the following year. This was not the first Japanese history of Japanese art, but it was the first to be produced by the government to serve national purposes, and it was the first to be published in book form with photographs. Moreover, it was not first published domestically and in Japanese, but rather in a European language for display and sale at a world exposition, a place for nations to demonstrate their nationalism.

In fact, art played an important role in Meiji-period Japan's international strategy. Greatly supporting this function was *japonisme*, the fad for Japanese art which overtook Europe and America in the latter half of the nineteenth century. The Japanese government used this fortuitous foreign enthusiasm to the hilt, in two major strategies. One

was economic: to increase foreign reserves by exporting decorative arts that appealed to Western tastes. The second was cultural: to offer Japanese art as proof to Western nations that Japan was a "first-class nation," fully deserving of an end to the unequal treaties that had been imposed by the West.[3] As employed to take advantage of *japonisme*, the art policy of this period can be said to have advanced the Japanese political and economic structure and organization. The economic strategy required Japanese manufacturers to produce art objects that matched the West's general image of Japanese art. The cultural strategy was two-pronged: it featured the modern art of the day, largely history paintings that reflected nationalist ideology, and it also presented the "history of Japanese art" (i.e., Japanese art from its beginnings through the Edo period). In other words, the Japanese government was proffering for Western approbation both "present" and "past" works from a quite newly conceived category called "Japanese art." Yet, despite this effort, both pre-Meiji art and modern art were essentially missing from the West's general image of Japanese art.

The Japanese "history of Japanese art" was centered on the arts produced by and for the civilian and military aristocracy—the cultural and political elites—and on Buddhist arts, which were likewise predominantly the purview of the elites. This was natural, given art's role as an ideological pillar of the imperial nation and the nationalistic construction of its own history. In the general Western view, "Japanese art" consisted mainly of *ukiyo-e*, decorative arts, and, in general, arts of the newly flourishing commoner class of the Edo period. Art of Japan's modern period did not figure in the Western view at all. This would therefore account for the almost total incongruence between the images of Japanese art held in Japan and those in the West.

The method, focus, and tone of Japanese study of the "history of Japanese art" was set by *Histoire de L'Art du Japon,* that first official history of art published in 1900 to accompany the Japanese exhibits at the Paris Exposition. For this book, it is likely that the Japanese took their cue from the retrospective exhibitions of various Western nations, such as the 4,774 works displayed as a "retrospective exhibition of the ancient arts of France."[4] From the beginning, the study of the "history of Japanese art" centered not on the artistic merit of individual art works or on artists, but on the authenticity, date, and artistic lineage or "school" into which the work might be slotted. This exerted a profound and continuing influence on the methodology of later research on the history of Japanese art.

Doubtless also influenced by the requirements and models presented by international expositions, the study of art works, with their immediate visual appeal, took precedence over research on the artists, with its far more limited audience.[5] This held true for individual, private art historians as well as for government publications. In other words, research on the "history of Japanese art," seen broadly, began by emphasizing artistic lineage or school over indi-

3. The cultural strategy is demonstrated in Takagi Hiroshi, *Kindai tennōsei no bunkashiteki kenkyū* (*Research on the Modern Imperial System from a Cultural-Historical Stance*) (Tokyo: Azekura shobō, 1977).

4. *Sen kyūhyaku nen Pari bankoku hakurankai: rinji hakurankai jimukyoku hokōkusho shimo* (*1900 Paris World Exposition, Temporary Exposition Office Report*), 2 vols. (Tokyo: Nōshōmusho, March 1902), vol. 2, sect. 1, pp. 147–88.

5. Yashiro Yukio, "Jo—bijutsushi to bijutsu (Preface—Art History and Art)," *Geijutsu shinchō*, vol. 9, no. 1 (January 1958).

Satō Dōshin

vidual aesthetic qualities, and artworks over artists. Possibly this tendency arose out of the perceived need to cater to *japoniste* tastes.[6]

If the arts policies of the Meiji period developed in the context of response to *japonisme*, then what happened when the *japonisme* boom ended, as it did about 1910, almost concurrently with that of the Meiji period? Two developments occurred: as *japonisme* receded, rapidly advancing industrialization reduced Japan's need to promote decorative arts. In consequence, government attention turned inward, to domestic national exhibitions. The Bunten 文展 exhibitions, begun under the aegis of the Ministry of Education (Monbushō 文部省) in 1907, were the first official exhibits to exclude crafts and display only "high art" according to the Western definition—painting in both Japanese and Western modes and sculpture. Ferocious artistic factionalism ended the Bunten exhibitions in 1918. In 1919, the Imperial Academy of Fine Arts (Teikoku Bijutsuin 帝国美術院) was founded to administer annual juried exhibitions, and also to serve as an art academy similar in function to those in the West. The second development was related to Japan's emerging colonialism, beginning with the annexation of Taiwan in 1895 and continuing with the annexation of Korea in 1910, the latter marking Japan's first advance onto the Asian continent. Paralleling these political developments, the non-governmental journal *Overview of Asian Art* (*Tōyō bijutsu taikan* 東洋美術大観; published between 1908 and 1918 by Shinbi shoin 審美書院; *Fig. 3*), began publication, marking the beginning in Japan of the "history of Asian art." Starting in the 1920s, the Japanese organized official exhibitions of colonial arts in their respective homelands, the Korean exhibitions from 1922 through 1944, and the Taiwanese art exhibitions from 1927 through 1936. In other words, as *japonisme* ended, Japan shifted the focus of its art policy from the West to Japan and Asia.[7] Both developments—the Japan-centric and the Asia-centric—accorded well with the increasingly strident nationalism and imperialism of the 1930s onward. It is noteworthy that publications related to the "history of Asian art" reached their peak during the fascist period, when Japan was touting its leadership of the "Great Asian Co-prosperity Sphere" (*Dai Tōya kyoeiken* 大東亞共榮圈). The "history of Asian art" created in Japan during this period thoroughly reflected the political climate.

After Japan's defeat in World War II in 1945, and amid the revival of a democratic system, the "history of Japanese art" lost its previous ideological cast. The new regime sought to soften the image of the arts into a "heritage of beauty" and the "arts of the nation's citizens." This is evident in the "Cultural Properties Protection Act" (*Bunkazai hogohō* 文化財保護法), approved by the General Headquarters of the Allied command and promulgated in 1950, in which the prewar "nation's treasures" became "treasures of the nation's citizens." Pre-1945 ideological statements

6. Satō Dōshin, "Mokuteki to hōhōron (Goal and Methodology)," in *Nihon ni okeru bijutsushigaku no seiritsu to tenkai* (*The Formation and Development of Art History Studies in Japan*), in Scientific Research Fund Report (Tokyo National Research Institute for Cultural Properties, March 2002), pp. 222–30.

7. Satō Dōshin, "Nihon bijutsu to iu seido (The System Known as Japanese Art)," in *Kindai chi no seiritsu* (*The Formation of Modern Knowledge*), *Iwanami Koza, Kindai Nihon no bunkashi* (*Iwanami Lectures: The Cultural History of Modern Japan*) (Tokyo: Iwanami shoten, Jan. 2002), vol. 3, pp. 53–82.

were also stripped from art history studies, and the discipline was reconceived as a "science" of human culture. The hierarchical ranking both of artistic media and of individual art works, however, underwent almost no changes and still remains with us today.

It was the "history of modern Japanese art" which underwent re-historicization in the postwar years. With the establishment of a "contemporary" era, extending from 1945 to the present, the modern was made part of the past. As with all historicizing, context is significant. This re-historicization was not created by a government publication, but rather by the social forms of cultural consumption: exhibitions held at newly-opened museums, art compendia, the media's coverage of art, and the art market—all of which are interrelated. In other words, this new historicization was based upon socially accepted ideas. Moreover, in line with the ongoing democratization of Japan, the prewar artistic groups affiliated with the Imperial Household Agency (Kunaichō 宮内庁), and particularly with artistic trends under fascism, were largely excised from the descriptions of this period. The Ministry of Agriculture and Commerce (Nōshōmushō 農商務省) definitively ceased its promotion of industrial arts production—decorative arts—for export to the West. Moreover, its role in modern Japanese art was excised from the history of that art. Finally, a "history of modern Japanese art" was created that reflected Japan's postwar internationalization and gave pride of place to Westernizing art. The "masters" of modern art thus recognized in Japan and supported by the Ministry of Education's policies were the Westernizers. In the West, however, this image and assessment were strongly criticized as the "breakdown of Japanese traditions." Even more than the "history of Japanese art," the "history of modern Japanese art" is a tale told differently in Japan and in the West.[8]

Now let us consider the Japanese "history of Asian art." This has been and still continues to be something of a mare's nest. First, how should the Japanese term Tōyō 東洋 be defined—as "Asia," "the Orient," or "the East"? How are these translations related, and how do they differ? Japanese-English dictionaries list three different definitions of the term: (1) the area to the east of Turkey, (2) eastern and southern Asia, and (3) Japan, from the perspective of China. "The area east of Turkey" might refer to either "Asia" or "the Orient," but both these latter terms were created from and are redolent of the European perspective. "Eastern and southern Asia" is the closest equivalent to what the Japanese mean by Tōyō; in other words, from the Japanese perspective. "Japan, from the perspective of China" is a definition geographically valid but irrelevant to this discussion. Given the multiplicity of partly overlapping, partly contradictory definitions, how could there not be all manners of a "history of Asian art"?

A single contrast can help to explain why the "history of Asian art" is so problematic. Let us consider the plan of one floor of the Louvre Museum in France (*Fig. 4*). At this large national museum, galleries focus on the chronologically arranged "history of Western art": with German and French art in the Medieval galleries, Italian art in the Renaissance galleries, Dutch art in the seventeenth-century galleries, and French art in the eighteenth- to nine-

8. Satō Dōshin, "'Kindai Nihon bijutsushi' no seiritsu to sono kenkyū dōkō (The Formation of the 'History of Modern Japanese Art' and Its Research Trends)," *Bijutsushi rondan* (*Art History Forum*), vol. 10, no. 1/2 (2000), pp. 229–45.

Satō Dōshin

teenth-century galleries. Of course, the arts of France preponderate, but basically the history of French art has been conceived as one part of a larger "history of European art." What, then, is the case with similar museums in East Asia?

The national museums of Japan, China, and Korea each focus on a chronological display of their own nation's art history, as that chronology is currently defined. It would be hard to imagine an East Asian museum offering chronological displays of its own national art amid those of its neighbors and calling this the "history of East Asian art." By way of example, take the Tokyo National Museum (*Fig. 5*). While considering this difference of approaches, I read an interview given by the South Korean president, Kim Dae Jung 金大中, after he was awarded the 2000 Nobel Peace Prize, in which he used the term "opened ethnocracy" to describe South Korea. Let us consider this term in the context of "modern" and "contemporary" Japan. Modern Japan created the myth of a homogeneous race, based on the even greater myth that Japan's imperial family had descended in unbroken rule from the native gods. These myths were employed in the service of Westernization. Following 1945, the goal changed from Westernization to internationalization, but still based on ethnocracy. Contemporary Japan maintains a strong sense of "Japanese-ness" internally, and presents that view to the outside world. This conception of one's nation as an ethnocracy that is anything but "opened" goes far to explain the current structure of the national museum, which focuses on displaying the nation's own art history, differentiated and set physically apart from the "history of Asian art."

The situation is different in China, which is a multi-ethnic nation, but with a political history viewed as a unity based on ideology, regardless of changes in dynasty or, indeed, of ruling people. Therefore, on the same ideological basis, China also sees the "history of Asian art" as essentially the history of its own art (*Figs. 6, 7*), whereas Japan (and also Korea) continue to define the "history of Asian art" as something apart from the history of their own arts. The "history of Chinese art," which encompasses the arts of diverse dynasties and diverse peoples, but is conceived as a single country's art history, is in fact structured similarly to the "history of European art." However, it does not include the "history of Japanese art." In Japan at the beginning of the modern era, it was considered necessary to connect the "history of Japanese art" with the "history of Chinese art." From about the 1880s, Ernest Fenollosa (1853–1908; *Fig. 8*) and Okakura Tenshin 岡倉天心 (1863–1913; *Fig. 9*), as part of their efforts to create a hierarchy of excellence for the "history of Japanese art," attempted to establish parallel art histories for China and Japan. Once propelled to political importance in Asia by victory in the Sino-Japanese War, the Japanese established the concept of *Tōyō*, which included Japan and Asia. They then turned their attention to the art as well as the territory of the continent, and thereupon began to historicize "Asian art" from the viewpoint of Japanese nationalism.

Because Japan did not have access to information on famous works in China's Imperial Household (Neifu 內府) and other Chinese collections, Japanese art historians began to compile a "history of Asian art" that included, along with Japanese arts, the Chinese art works in Japanese collections. "National treasures" (*kokuhō* 国宝), first designated in legislation of 1897, included Chinese art objects, reflecting the impulse to unify the history of Japanese and of

Asian art in contradistinction to the "history of Western art." This impulse is exemplified in Okakura Tenshin's *The Ideals of the East*, with its grandiloquent opening assertion that "Asia is One." Written in English and published in England in 1904 (*Fig. 10*), the book was an attempt to position Asia—with Japan pre-eminent—as a unified, "spiritual" civilization, in contrast to the "materialistic" West. During Japan's fascist period, "Asia is One" was taken up as a slogan for the "Greater East Asian Co-prosperity Sphere."

After Japan was defeated in World War II, Japanese research on the "history of Asian art," like that on the "history of Japanese art," was stripped of its ideological agenda. Research in both areas continued on individual topics, but art historical research maintained the connection between the two histories. At the same time, political history as taught in Japanese schools through high school is divided in American fashion into national (Japanese) history and that of the rest of the world, with "Asian history" included in the "world history" category. The Tōyōkan 東洋館, or Asian Wing, of the Tokyo National Museum was built as a separate building in 1965 (*Fig. 11*), perhaps reflecting the postwar *political* concept of "Asia" as part of "world history," rather than connected with Japan's history.

What would be the best concept—that is, the most fruitful of knowledge and understanding—of the relationship between the histories of Japan's arts and those of Asia? I am not sure what the answer is to this question. Normally, the powerful polities promote the idea of universality, while the weaker ones claim unique qualities as part of their attempt to establish a sense of inherent identity. Today's competing claims of globalism and regionalism further complicate the question. For some reason, this brings to my mind the kind of weather map we often see today in newspapers or on television (*Fig. 12*). To predict the weather for one's own country, an image of the atmosphere above that country alone is not helpful. We need a weather map that transcends national boundaries, one that in fact ignores them. Would it not be beneficial for art historical research similarly to disconnect from national boundaries and the perhaps subconscious nationalism imposed by thinking within the framework of such boundaries? I hope that the development of art history may some day proceed in a similar fashion.

Satō Dōshin

「美術史」——
歷史化的必要條件

佐藤道信

東京藝術大學

「美術史」的歷史化是具備什麼必要條件而得以發生的呢？

以日本美術史而言，第一個必要條件，是歷史化乃經過一段大的時代區分之後，在下一個時代中所進行的工作。亦即近代把至江戶時代爲止的美術加以歷史化爲「日本美術史」；到了第二次世界大戰後的「現代」則形成了「近代日本美術史」。第二個必要條件是，作爲歷史化支柱的理念或原則，是以進行歷史化工作的時代爲基礎，而非研究對象的時代。所謂的「日本美術史」，是以日本近代國家主義與皇國史觀來解讀歷史；而「近代日本美術史」則是一種用戰後民主主義，解讀以國家主義爲主軸創造出的近代美術之「歷史解釋」。因此，史實的取捨與解釋，是根據與設定的理論之間的整合性來進行，就這點而言，我們應當十分留意所謂的歷史化不但是一種「形成」；同時也是一種「削除」的作業。

另一方面，「東洋美術史」中，由於對「東洋」所指的地理範圍不統一（Asia, Orient, the East 彼此的異同）、各國基本理念的差異等因素，產生各種分立的「東洋美術史」觀。歐美各國的國立美術館舉行的美術展示，大多是由共有的「歐洲美術史」所構成，本國美術史爲當中的一部份。但是東亞各國中，中國以中華思想、韓國和日本以民族主義爲基準理念，因此本國美術史成爲展示的中心。而關於各國的「東洋美術史」定義，中國大致將之和自己的美術史化約爲等號；韓國、日本則從與本國美術史的關係論出發記述。此外，若西方世界的「東洋美術史」基本上源自東方主義，則「東洋美術史」歷史化的必要條件本身就各自分立，成爲各種史觀並存的狀況。因此檢証其實際狀況時，在以國家或民族論爲基礎的同時，更要有超越這兩種觀點、相互而廣泛的檢証。

「美術史」—
歴史化の要件

佐藤道信

東京芸術大学

「美術史」という歴史化は、どのような要件で行なわれてきたのか。

日本美術史の場合の第1の要件は、歴史化の作業が、歴史の流れが大きな時代の区切れ目を経た、次の時代に行われたことである。つまり江戸時代までの美術史を歴史化した「日本美術史」は、近代に、「近代日本美術史」は第二次大戦後の現代に、それぞれ形成されている。そして第2の要件は、その歴史化の際の支柱となる理念や論理が、対象の時代ではなく、歴史化する側の時代のそれが基本ベースとなっていることである。「日本美術史」は、近代の国家主義や皇国史観で歴史を読み解き、「近代日本美術史」は、国家主義を軸に作られた近代美術を戦後の民主主義で読み解いた形の"歴史解釈"になっているのである。そこでの史実の取捨や解釈が、設定論理との整合性から行なわれた点、歴史化が「形成」と同時に「削除」の作業でもあったことは、十分に留意すべきだろう。

一方「東洋美術史」は、「東洋」の地理範囲の不統一（Asia, Orient, the Eastとの異同）、各国の基軸理念の違いなどから、各種の「東洋美術史」観が分立した形になっている。欧米各国の国立美術館の美術史展示は、ほぼ「ヨーロッパ美術史」を共有し、自国美術史はその一部という構成になっている。しかし東アジア各国では、中国は中華思想、韓国・日本は民族主義を基軸理念に、自国美術史が展示の中心となっている。そしてそこでの各国の「東洋美術史」も、中国は自国美術史とほぼイコール、韓国・日本は自国美術史との関係論から記述したものになっていると考えられる。さらに西洋世界での「東洋美術史」は、基本的にオリエンタリズムに起因したとすれば、「東洋美術史」は歴史化の要件自体が分立した、各種の歴史観が並存する状況になっていると考えられる。その実態の検証には、国家や民族論をふまえつつ、しかしそれを超えた視点による相互かつ広域的な検証が必要だろう。

歴史化のプロセス

近世　1868　　　　近代　　　　1945　　　　現代　　　　21C

「日本美術史」
「東洋美術史」　　　　「近代日本美術史」　　　　「現代日本美術史」？

Fig. 1. An outline of Japanese historicization and art history.

Fig. 2. Cover of *Histoire de L'Art du Japon*, 1900 (Paris World Exposition, 1900).

Fig. 3. Cover of *Overview of Asian Art* (*Tōyō bijutsu taikan*) (Tokyo: Shinbi Shoin, 1908 V1918), vol. 1. *(detail on page 473)*

Fig. 4. Musée du Louvre, floor plan of the second floor galleries.

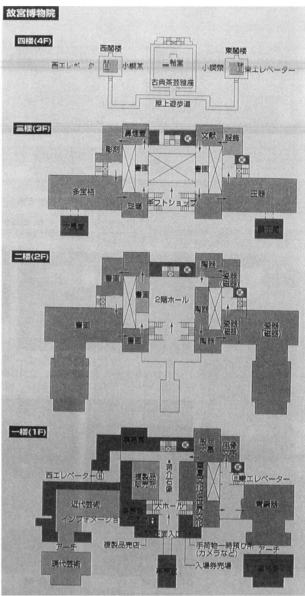

Fig. 5. Tokyo National Museum, floor plan of the Honkan (Main Wing).

Fig. 6. National Palace Museum, Taiwan, floor plan in Japanese for the four floors of the main building.

Satō Dōshin

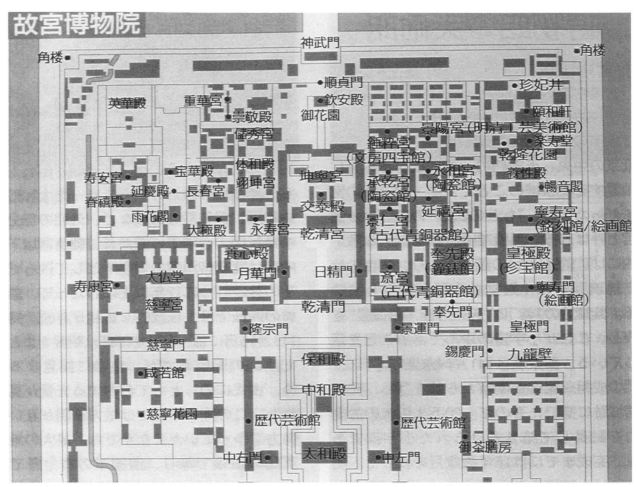

Fig. 7. Palace Museum, Beijing; detail of the layout of the buildings.

Fig. 8. Ernest Fenollosa (1853–1908).

Fig. 9. Okakura Tenshin (1863–1913).

Fig. 10. Cover of Kakuzō Okakura, *The Ideals of the East* (London: John Murray, 1903).

Fig. 11. Tokyo National Museum; layout of the buildings with the Honkan (Main Wing) in the center and the Tōyōkan to the right.

Fig. 12. Japanese newspaper weather map superimposed on a satellite image of East Asia. *(detail on page 415)*

Satō Dōshin

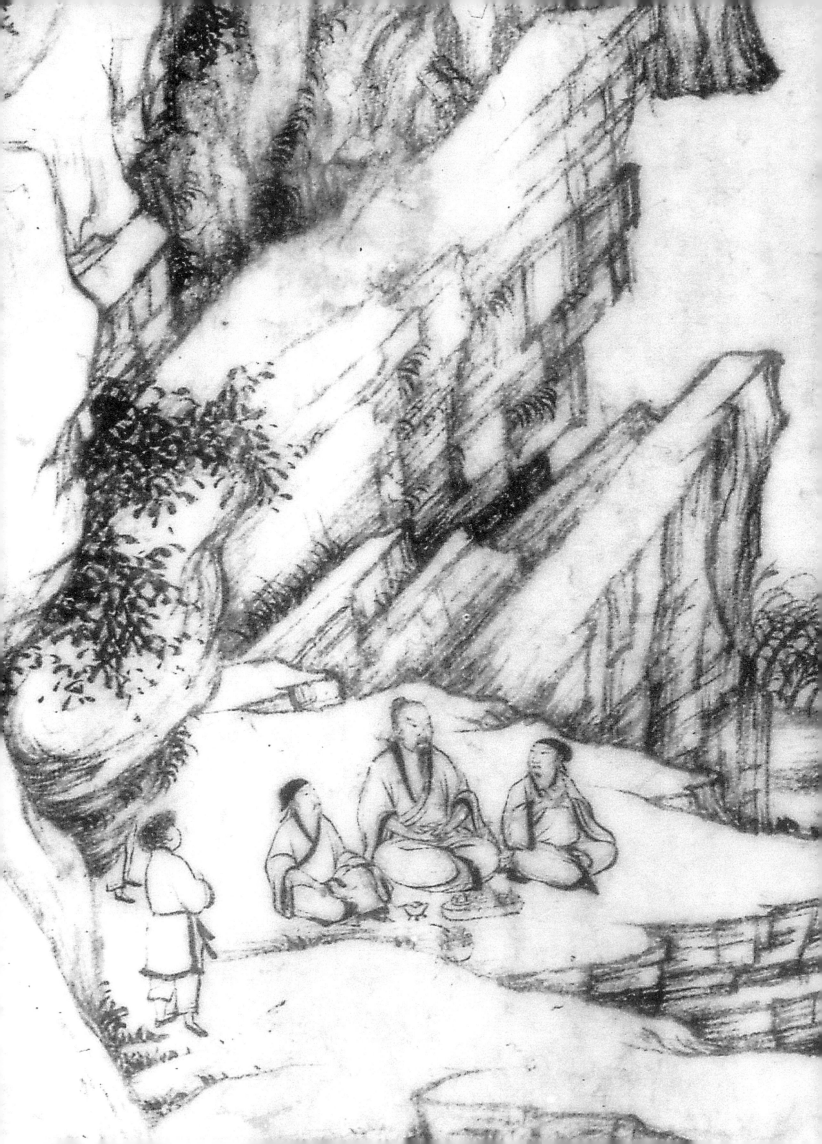

Section IV: Art Historical Methodology
Response

James Cahill
University of California, Emeritus

Let me begin by quoting, not for the first time, something that my colleague Michael Baxandall wrote in 1978. The debate over methodology that was then going on among art historians seemed, he said,

> oddly hortatory and peremptory: I dislike being admonished. On the other hand, what I do like is there being a manifold plurality of differing art histories, and when some art historians start telling other art historians what to do, and particularly what they are to be interested in, my instinct is to scuttle away and existentially measure a plinth or reattribute a statuette.[1]

I am in profound agreement with his desire to leave methodological room open for a "plurality of differing art histories," and would only add to his dislike of being admonished about what to do an even stronger dislike of being admonished about what we are *not* to do, what has now been identified as somehow illegitimate or outmoded art history. No one can fault those colleagues who follow through in their writings with their personal convictions, such as that the only issues worth addressing today are race (or ethnicity), class, and gender (a formulation I learned from our graduate students in Berkeley), or that too close an engagement with individual works of art can leave one sullied, since it unavoidably enhances their commercial value and so implicates one, however unwillingly, in the marketing of art. We can respect those positions without quite crediting their claim to occupy a moral high ground. Nor is there any problem with adopting new theoretical and methodological positions of other kinds, assuming again it is real conviction, not a desire to join the self-designated "cutting edge" of the discipline, that motivates the adoption.

Problems arise only when taking up new positions implies a claim that they discredit and supplant older ones, and, most seriously, when it has the effect of inhibiting healthy, even necessary pursuits within our field. I argued in a recent lecture, for instance, that the great project of constructing a coherent style history for early Chinese painting comparable to what has been done (over a much longer period, to be sure) for European and American painting—a project begun by the generation before mine that should have been carried much further than it has been by mine—is now even less likely to go forward, since younger specialists are mostly uninterested in so-called "diachronic" or developmental approaches, or in style generally.[2] In effect, the project has been discredited before it has been accomplished. It is as though, I said, we had abandoned the practice of architecture before we had built our city. I do not, of course, mean that style history should again become a central concern of Chinese painting studies, only that

1. Michael Baxandall, "The Language of Art History," *New Literary History*, vol. 10 (1978–79), p. 454.

2. James Cahill, "Some Thoughts on the History and Post-History of Chinese Painting" (Haley Lecture delivered at Princeton University, 16 November 1999).

someone should continue doing it, along with other things, and that the project should not be branded as hopelessly backward.

The predictable question, "Why do we need a style history anyway?" is disingenuous and easily answered: because insecurities and booby traps of a kind long left behind in Western art studies, or at least rendered infrequent, will continue to plague our field until we have one. We should, for instance, be able to resolve and agree on, more easily than we have, questions such as whether a certain painting dates from the tenth century or the twentieth. The application of new methodologies in Western art studies is carried out on a relatively firm foundation of more or less securely placed works of art, about which there is far more agreement among specialists than with us. I hold myself as responsible as others for this situation, having made the move from heavily stylistic studies following on Max Loehr into later writings that take a more contextual approach, for which the principal model was Michael Baxandall's variety of social art history and his inferential criticism (although I certainly do not claim to have produced anything that would satisfy his rigorous criteria).

Having opened my commentary in this oldster's cautionary, "view-with-alarm" way, I can go on to congratulate the authors in this section and in the volume as a whole for representing collectively a healthy diversity of art historical methodologies.

Itakura Masaaki's 板倉聖哲 paper on the illustration of the "Second Ode on the Red Cliff" (*Hou Chibi fu* 後赤壁賦) by Qiao Zhongchang 喬仲常 (act. early 12th c.) is a strong example of the contextualizing mode of art history. His situating of both the ode itself and the painted scroll illustrating it in the specific historical and political circumstances surrounding Su Shi 蘇軾 (1037–1101) and his circle of admirers is enlightening, expertly done, and entirely convincing. It is helped by Itakura's discovery, in a Kanō Tanyū 狩野探幽 (1602–1674) reduced-version (*shukuzu* 縮図) copy, of the now-missing opening section of the scroll in which Su's residence, the Lin'gao 臨皋 Pavilion, was depicted. (That discovery was announced previously in a related article that Itakura published in *Kokka* in 2000.)[3] His concept of "a layering of images," with pictorial styles, poetic resonances, and literary and political associations overlaid onto visual experience of the natural landscape, is a valuable formulation, and tempers our disappointment on learning, by way of the poet Lu You's 陸游 (1125–1210) firsthand account of a visit to the place, that the real Red Cliff of Su Shi's ode "was nothing more than a reed-covered knoll." Itakura's contextualization of the scroll is correspondingly multi-layered; his treatment of the style of the painting is also contextual, relating it to works associated with Li Gonglin 李公麟 (1049?–1106), as well as those associated with Su Shi himself and with his son Su Guo 蘇過 (1072–1123).

3. Itakura Masaaki, "Kyō Chūjō Kō Sekiheki fu zukan (Neruson Atokinzu Bijutsukan) no shiteki ichi (Historical Significance of Qiao Zhongchang's Handscroll Illustration to the Second Prose Poem on the Red Cliff in the Collection of the Nelson-Atkins Museum of Art)," *Kokka*, no. 1270 (August 2000), pp. 9–22.

The problem with this approach, even when it is carried out so well as here, is that it can draw attention away from important aspects of the work itself, its individual style and its narrative method. Itakura writes only the briefest summary of how the imagery of the painting responds to that of the ode, thereby slighting some of Qiao Zhongchang's notable expressive achievements, such as the passage where, after Su Shi has climbed the cliff, he disappears from our sight and we are made to internalize his experience of looking down, through an extraordinary wrenching of space, into the seething water below. That, for me, is the true climax of the composition, as it is of the ode. One must in fairness add that an ideally balanced treatment of a work of art is an elusive goal, and that the elucidation of a truly rich and complex work is probably best accomplished as a collective project made up of successive studies by writers with differing assumptions and kinds of expertise. The Qiao Zhongchang scroll has fortunately called forth such a series, beginning with an inadequate entry by myself in the 1962 Crawford catalogue[4] and including valuable contributions by Hironobu Kohara 古原宏伸,[5] Jerome Silbergeld,[6] and others. Itakura's study is an important addition to that series.

Sano Midori's 佐野みどり paper is, by contrast, a highly sophisticated exposition of the narrative method of *The Tale of Genji* (*Genji monogatari* 源氏物語) paintings in the Tokugawa 德川 and Gotō 後藤 museums. She argues convincingly that these are not narrative pictures of the simpler types that seem to turn literary images into pictorial ones (they are never, of course, *that* simple), or that present elements of a scene belonging to some moment or episode in a story as a pictorial representation of that episode. The hypothetical but persuasive readings of the *Genji* pictures that Sano proposes begin with a "zero focalization" view that takes in the whole scene at once, and proceed through stages in which the viewpoints of participants in the scene are adopted, along with those of external and internal narrators. The construction of a narrative situation in the picture can be accomplished only by a reader-viewer with full knowledge of the text. Those of us in Chinese painting studies are familiar with narrative pictures that presuppose a viewer who already knows the story: I once wrote about Chen Hongshou's 陳洪綬 (1598–1652) well-known *Scenes from the Life of Tao Yuanming* (*Tao Yuanming gushi* 陶淵明故事) scroll as an example of this, pointing out how, working for an elite patronage, he could omit elements that a more popular audience would need to spell out the story.

The *Genji* paintings, however, as Sano shows us, are not merely allusive on this model of portraying less and recalling more. In her account, they work in a far more complex way: the reader constitutes the narrative by absorbing and synthesizing the various viewpoints within the picture, including those of the "narrators living in other parts

4. Laurence Sickman *et al.*, *Chinese Calligraphy and Painting in the Collection of John M. Crawford, Jr.* (New York: Pierpont Morgan Library, 1962).

5. Kohara Hironobu, "Kyō Chūjō hitsu *Kō sekiheki fu zukan* (*Second Ode on the Red Cliff* by Qiao Zhongchang)," *Shoron*, no. 20 (1982), pp. 285–306.

6. Jerome Silbergeld, "Back to the Red Cliff: Reflections on the Narrative Mode in Early Literati Landscape Painting," *Ars Orientalis*, vol. 25 (1995), pp. 19–38.

James Cahill

of the world of this tale" and the understood omniscient narrator outside it. Images that in the text are apart in time and space can be brought together in the pictures: people within the paintings, such as waiting women spying on the principals, can be imagined as the "ladies-in-waiting" who are the supposed narrators of the whole story. Seeing the viewing process in this elaborate way allows Sano to make at one point the somewhat startling statement that "in a certain sense, the readers themselves have become the 'authors' of the illustrated story." The complexity of her analysis matches that of the pictures, and in this respect goes well beyond others I have read. I recall an old article by Alexander Soper on the *Genji* scrolls that showed how heightened dramatic tensions in the narrative were conveyed by steeper diagonals in the compositions; admirable at the time, it seems simplistic now.[7] Sano Midori's paper is anything but that, bordering rather on the esoteric.

Tim Screech's paper, like his other writings, is wide-ranging, stimulating, and unexpected. He has immersed himself so deeply in Japanese culture of the Edo period, and especially the city culture reflected in *ukiyo-e* 浮世絵 and popular fiction, that he can write authoritative and entertaining book-length studies on aspects of it such as its uses of Western optical devices and its production of sexual imagery. All this is far removed from the limited themes treated in older *ukiyo-e* print studies, and vastly richer. If Screech's paper is to be criticized, it is for presenting as though it were general to Japan in the eighteenth century the special attitude toward China and Chinese painting that belongs to this world of urbane and stylish city-dwellers, to whom *Rinpa* 琳派 and *ukiyo-e*, different as they are, both appealed. These people's attitude toward China and Chinese painting, like their attitude toward much of classical Japanese culture, favored playful put-downs in anecdote and parody, *mitate* 見立て and *share* 洒落. They were inclined to leave serious engagement with such weighty concerns to others, and liked their writers and artists to treat them as matters that scarcely merited serious engagement anyway. Their artists' version of Chinese painting, then, which reduces it to ink orchids and bamboo and what Screech rightly calls "a rather anonymous landscape," represents only one kind of Japanese response to what he identifies as "the cultural anxiety that Japan, small and perched at the 'Far East' of a vast continental mass, was intermittently bound to feel."

It was very different elsewhere. Kanō school painters earnestly depicting didactic and moralizing Confucian themes on walls and screens for powerful patrons, sometimes depending on Chinese paintings and prints as sources, had to exhibit a proper reverence for them. *Nanga* 南画 masters typically worked for patrons who were sincerely sinophile, many of them writing Chinese-style poetry and owning and admiring Chinese paintings. The artists needed to pursue diligently a real understanding of Chinese painting styles through all the channels open to them: woodblock-printed pictures (of limited use), real Chinese paintings long preserved in Japan or coming in as commercial goods through Nagasaki 長崎, the works of Chinese amateur artists in Japan, whether Ōbaku 黃檗 priests or merchants such as I Hai 伊海 (known to the Japanese as I Fukyū 伊孚九; 1698–after 1747), who was only mar-

7. Alexander Soper, "The Illustrative Method of the Tokugawa 'Genji' Pictures," *Art Bulletin*, vol. XXXVII, no. 1 (1955), pp. 1–16.

ginally better qualified to transmit the glories of Chinese painting than the hapless fishermen who so disappointed Shimura Tōzō 志村藤藏 in Screech's paper. The problem of how Edo-period painters learned about Chinese painting and what they knew about it is a large one, a comprehensive investigation of which is still needed, as underpinning for *Nanga* and other Edo painting studies. I myself, with help from Japanese scholars such as Oba Osamu 大庭脩, attempted an outline presentation of it in a 1979 paper titled "Phases and Modes in the Transmission of Ming-Ch'ing Painting Styles to Edo Period Japan," which was published, however, in a symposium volume so obscure that no one has noticed it in the years since then.[8]

Satō Dōshin's 佐藤道信 ambitious and admirable paper on "The Requirements for Historicization," with special attention to the distinguishing of the "recent" and "contemporary" eras in Japanese art history, begins with his "innocent question": he discovers, as he is surveying modern Japanese art in American collections, that the American and European images of Japanese art "comprised mainly *ukiyo-e* prints and decorative arts," a view very different from his own as a specialist in modern Japanese art history. Except for a few private collectors, "works by modern artists that have been exalted in Japan were all but entirely absent" from American collections. He grants that there are some "differences in taste," but concedes that in itself is not a problem. Having thus dismissed quickly these differences in taste, he goes on to look for causes of this gap in the historical views of the two regions in broad historical and political factors, such as the Japanese government's efforts to "increase foreign reserves by exporting decorative arts that reflected Western tastes," their exploiting of Japonisme, and their imperialist cultural policy, concluding that these factors contributed to a tale of "the 'history of modern Japanese art . . . told differently in Japan and in the West." The implication is that if it were not for these large forces acting from above, appreciation would have been more or less uniform in Japan and abroad.

The circumstances he adduces are indeed to the point in underlying some part of the disparity he notes. However, if we *do* consider matters of taste and accessibility to foreign audiences, along with economic factors, simpler reasons emerge that cannot be so easily dismissed. What he refers to as "works by modern artists that have been exalted in Japan" must of course be primarily *nihonga* 日本画, traditional painting of the Meiji and Taishō periods that was indeed until recently a blank spot in American collecting and appreciation of Japanese art, including my own. The Japanese "exaltation" of the *nihonga* masters, an evaluation of them elevated beyond the understanding of most foreigners, has meant extremely high prices in relation to other Japanese art. I remember trying to acquire in Japan one of the mysterious and lovable landscape paintings by Murakami Kagaku 村上華岳 (1888–1939), only to learn that even a minor one would cost far more than a good Ming dynasty painting. Tomioka Tessai 富岡鉄齋 (1837–

8. James Cahill, "Phases and Modes in the Transmission of Ming-Ch'ing Painting Styles to Edo Period Japan," in *Papers of the International Symposium on Sino-Japanese Cultural Interchange* (Hong Kong: Institute of Chinese Studies, Chinese University of Hong Kong, 1985). The symposium was held in 1979.

James Cahill

1924) appeals more to foreign audiences than most of his contemporaries, especially in his late works, but again sky-high prices have discouraged buyers outside Japan.

Other kinds of *nihonga* paintings, besides fetching high prices, require for their appreciation sensibilities finely attuned to specifically Japanese nuances of style and feeling, a requirement that has excluded most foreigners until recently, when exhibitions at the St. Louis Art Museum ("*Nihonga*: Transcending the Past, Japanese-style Painting," 1995)[9] and the Seattle Art Museum ("Modern Masters of Kyoto: The Transformation of Japanese Painting Traditions—*Nihonga* from the Griffith and Patricia Way Collection," 1999)[10] have reflected some belated breakthroughs in understanding. A foreign art lover of modest means and simpler tastes could, by contrast, collect the very appealing *ukiyo-e* prints, and more ambitious collectors and museums could search out and acquire screen paintings that were compositionally bold and visually brilliant, or *Rinpa* paintings with those same qualities, or the works of the masters now sometimes called "eccentrics," such as Nagasawa Rosetsu 長沢芦雪 (1754–1799), Itō Jakuchū 伊藤若沖 (1716–1800), and Soga Shōhaku 曾我蕭白 (1730–1781). With these to be had for comparable or even lower prices, it was the rare foreigner who would pursue Yokoyama Taikan 横山大観 (1868–1958) or Maeda Seison 前田青村 (1885–1977).

A parallel might be made with the foreign reception of Japanese films. For a long period, it was *jidai-mono* 時代物, or "costume dramas," beginning with Akira Kurosawa's 黒澤明 1950 *Rashōmon* 羅生門, that were most enthusiastically received abroad. These were by no means, however, the genre most highly regarded by Japanese audiences and critics. Contemporary family dramas of the kind beloved of Japanese audiences became accessible to us only later, and still have a much smaller and more specialized following, for easily apparent reasons. Alongside Kurosawa's stirring dramas, the films of Ōzu Yasujirō 小津安二郎 are deliberately static, with famously protracted views of nothing in particular, and long passages in which people sit quietly and talk. For foreign audiences, they can be boring; for those in tune, sublime. The broad and blustery acting of Mifune Toshirō 三船敏郎 brought him great international fame; Ryū Chishū 笠智衆, the archetypal Japanese father who in Ōzu's films is forever worrying about how to marry off his daughter Hara Setsuko 原節子, appears not to act at all, and could never enjoy that kind of reputation abroad. All cultural expressions are not equally accessible to those outside the culture; some, and some of the best, do not travel comfortably.

My point is a simple one. When we descend from the abstract theoretical realm into the rich, messy world of real artists and pictures and their audiences, more immediate explanations for large cultural phenomena are likely to present themselves; and when those phenomena can be adequately accounted for by factors concrete and close at hand,

9. Ellen P. Conant, *Nihonga: Transcending the Past. Japanese-style Painting, 1868–1968* (St. Louis: St. Louis Art Museum, 1995).

10. Michio Morioka, *Modern Masters of Kyoto: The Transformation of Japanese Painting Traditions. Nihonga from the Griffith and Patricia Way Collection* (Seattle: Seattle Art Museum, 1999).

the need to search for causes for them in the broader modes of theorizing and cultural criticism may be lessened. This is not to question the value of Satō Dōshin's periodization or his insights into how Japan's governmental policies and its relations with foreign countries, along with the West's biased and constricted views of Japanese art, affected the construction of a Japanese art history. It is only to say that some questions can be adequately resolved on simpler levels. His discussion of the creation of the concept of *Tōyō* 東洋, or "Asia," is enlightening. I would only add to his three dictionary definitions of *Tōyō*—the area east of Turkey, the eastern and southern sections of Asia, and Japan from China's perspective—a fourth, which one encounters frequently in Japan: *Tōyō* as the rest of Asia, from a Japanese perspective, *excluding* Japan. If one buys a set of books in Japan entitled *Tōyō bijutsu* 東洋美術, one expects they will contain Asian art but not Japanese: if one goes to the *Tōyōkan* 東洋館 galleries at the Tokyo National Museum, one sees Asian art other than Japanese, which is displayed in the *Honkan* 本館, or "Main Building." But Satō accommodates that view later when he writes perceptively about how China makes the history of its own art the history of Asian art, while Japan and Korea construct the history of Asian art in relationship to the history of their own arts.

This symposium demonstrates, among other things, that the practice of making deep and detailed studies of individual paintings continues to thrive, at least among those scholars who get invited to great international symposia. Naturally, titling the first session "Studies of Canonical Paintings" more or less guaranteed that such would be so. Of the four papers in that first session, Chen Pao-chen's 陳葆眞 and Bob Harrist's easily live up to the high expectations we have come to have of those two excellent scholars. Satō Yasuhiro's 佐藤康宏, on the other hand, as the writing of a young, to me unfamiliar, scholar on a very familiar painting, was a special pleasure to read. Although it does not belong in my session, let me say anyway that it has the important virtue of making clear why Yosa Buson's 与謝蕪村 (1716–1783) great *Houses on a Snowy Night* (*Yashoku rōdaizu* 夜色楼台図) scroll is, in fact, a great painting. One aspect of the art historian's job, or even an obligation, is to deal effectively with issues of quality. As teachers, we owe it to our students, and as writers to our readers, to do this as evenly and sensitively as we can, using our own readings of the works as a basis but trying to open up, through informed combining of analysis and imagination, what other readings, recorded or possible, by other people in other times could have been.

Sano Midori's paper also, although not expressly aimed at bringing out the quality or greatness of her paintings—the Tokugawa and Gotō *Genji* scrolls, implicitly does that in its method of analysis, since no lesser paintings could sustain such a rigorous exposition of what formal features underlie their multi-layered expressive and narrative method. And Tsuji Nobuo's 辻惟雄 keynote address left no doubt that he feels entirely comfortable with the concepts of masterpieces and of quality, while recognizing that both are always provisional, not eternally fixed. Again, the ideological objections to distinguishing in this way between greater and lesser works of art are well known to those of us who choose to continue doing so; we can coexist comfortably with those who denounce the practice as judgmental and elitist. Let us have the "Busons"; they can have the "Goshuns" (Matsumura Goshun 松村呉春 [1752–1811]).

One announced purpose of this symposium is to celebrate the achievements of Shimada Shūjirō 島田修二郎 and his role in training younger scholars. I can testify, from his guidance of my studies as a Fulbright student during my year in Kyoto in the mid-1950s and from many years of association after that, to his profound and beneficial impact on my work and on the field as a whole, especially his role at Princeton University, along with John Rosenfield's at Harvard, in rescuing Japanese art studies in America from the depressed, almost dead-end predicament they had fallen into. (Here, if I had a more detailed knowledge instead of only a hearsay account, I would include also a tribute to Wen Fong for making, at a crucial moment, the hard decision to use a position that would have relieved him of much undergraduate teaching, instead to keep Shimada, who could work effectively only on the graduate level. But that is a story for someone else to tell, and I can only allude to it, admiringly.)

I would like to broaden the tribute, however, to include others of Shimada's generation, the teachers of mine: Ludwig Bachhofer, Max Loehr, Laurence Sickman, Alexander Soper, Osvald Sirén, C. C. Wang, and Sherman Lee (the last-named the only survivor). They came from very different backgrounds, brought very different strengths to the field, and made very different contributions. Of course, I have my own opinions about the relative virtues of these people's work, as will any other in the field, or as they themselves expressed in their famous feuds: Loehr versus Bernhard Karlgren, or sinologues such as John Pope and Otto Maenchen versus art historians such as Bachhofer, or Sirén versus everybody else. Trying to grade or rank them, however, is outside my present point. I recall coming to the realization, while still quite new to the field, that the arguments they made about the requisites for productive engagement with East Asian art correlated closely with their own backgrounds and strengths. Now I would only add: how could it be otherwise? And yet our field of study, without any one of them, would be significantly poorer.

The moral should be obvious. Of course, we should try always to understand and explore other approaches, expand and enrich our methodological toolbox. In my early years, I boastfully described my training as like that of the boy Sudhāna making his tour of the great bodhisattvas, since I had had the good fortune to work with quite a few of the leaders of the generation before me. But any implied claim to have absorbed and combined their approaches was largely a delusion, as it must always be, along with claims to "combine the best from East and West" or otherwise reach a "Great Synthesis" of competing methodologies. Recognizing that should make us aspire not so much to synthesis as to peaceful coexistence and mutual respect, as well as cooperation where it seems fruitful. To move from some older methodological position into a new one, however intellectually dazzling the new one may appear, should not be thought of as any kind of progress, except insofar as it entails also a move into somehow better scholarship; better informed, wider ranging, deeper probing, more precise, more enlightening. When I praise some of the papers in the present symposium, it is for advances of that latter kind over previous work, not for their employment of more advanced methodologies.

All of us who have done university-level teaching in recent years are familiar with students whose pride in their deployment of new methodologies leads them to shy away from older modes of scholarship and scant the simple

acquisition of knowledge, including visual knowledge of the materials they are to work on. And, given the current criteria for ranking and hiring in too many art history departments, some of them will occupy teaching positions themselves and pass on the same attitudes to their students. It is that methodological presumptuousness more than methodological backwardness that makes me uneasy about the future of our field. Our salvation is in the firm expectation that people of this persuasion will be balanced, or better yet overbalanced, by the continuing appearance of well-trained young specialists capable of solid, high-level scholarly work. On that score, the evidence of the present symposium is cause for optimism.

James Cahill

第四節　美術史的方法論
論評

James Cahill

加州大學柏克來分校榮譽教授

我相當贊同Michael Baxandall所言，盡管將方法學的空間讓給那些「多元化的藝術史」。採取新的方法立場當然無妨，只要這麼作不是在暗示過去的方式足可被取代、或禁止這個領域內較爲健康的追求。比方說，我們不應該在完成早期中國繪畫貫串一氣的風格史之前便放棄這計劃，正如我們不應該在建立城市之前便停止蓋房子。我們的研究仍需以之爲基礎。西洋藝術史之所以能應用新的方法研究，是因爲大多數的作品皆已安全地擺放在時間的軸線上；他們有著相對而言較爲穩固的堅實基礎，這堅實的基礎正是中國藝術史所缺乏的。而本論文集則展現了藝術史研究取徑上的健康分歧。

板倉聖哲關於《後赤壁賦圖卷》的論文可說是脈絡研究的絕佳範例。他將文本與畫卷放置在蘇軾及其交遊圈所獨具的歷史與政治情境裡。這樣的方法，雖有其自身的價值，卻會將注意力轉移到作品之外；因爲此手卷的敘事模式，其實更值得注意。相反的，佐野みどり則對《德川、五島本源氏物語繪卷》的敘事手法有精闢的闡釋。她主張從不同的觀點閱讀畫作，不只從「生活在敘述情境裡的敘事者」的角度，也從全知的外部敘事者的角度來觀畫，從而下了有點驚人的結語：「在某種意義上而言，讀者本身也成爲繪卷故事的『作者』。」

Timon Screech 的文章則討論十八世紀日本城市居民對於中國的特別觀點。這些民衆是浮世繪的擁護者，他們喜歡藉著軼事、諧擬（parody）等遊戲的手法顛覆傳統文化，故這類藝術家所繪的中國繪畫，也限定於墨蘭、墨竹與簡單的山水畫。然其他類型的畫家卻以較嚴肅的態度看待中國畫：如狩野派畫家著意於道德性的儒家主題，而南画大家則滿足仰慕漢文化的客戶層。

佐藤道信在〈歷史化的必要條件〉一文的開頭即指出美國與歐洲對日本畫的想法「集中在浮世繪版畫與裝飾藝術」，或多或少忽略了「在日本本土業已獲得高度讚揚的近代藝術家作品」，也就是所謂的「日本畫」。他從宏觀的歷史與政治因素裡找到促成此現象的原因，如日本政府，利用西方世界對日本風的愛好，「藉著出口裝飾藝術來增加外匯存底……」。然實則有其他更簡單的原因阻礙外國人收藏或欣賞所謂的「日本畫」，像是高居不下的價格以及專業鑑賞能力的要求等。

本研討會是爲了紀念島田修二郎先生的卓越成就而舉辦的。在此我還欲列舉上個

世代其他值得紀念的先驅：Bachhofer、Loehr、Sickman、Soper、Sirén、C. C. Wang與Sherman Lee（唯一健在者）。他們各來自不同的背景，亦有著殊異的貢獻，我們的領域若少了他們必定會大大失色。眼下的原則其實很明顯：我們不應把目標放在集各種方法之大成，而應著重和平共存與相互尊重。新舊方法學的過渡，不應被視為某種「進步」，除非它真的促成了更高的學術水平。我們這些教過書的，對那些運用新方法並以此沾沾自喜的學生都司空見慣了，而新的方法使他們可以避開單純的知識吸收，包括他們將要處理的視覺材料。正是這方法學上的驕慢（而非退步），使我不禁擔心起這領域的未來。必得持續出現訓練有素且能作出紮實而高水準學術作品的年輕學者，這種情況才得以平衡，甚至是往好的那一方傾斜。以此觀之，這本論文集實提供了值得樂觀的理由。

James Cahill

第四部　美術史学方法論
論評

James Cahill

カリフォルニア大学バークレー校名誉教授

　「多種多様な美術史」のために方法論的な余地を残しておきたいというMichael Baxandallの望みを、まず最初に深く同意しながら引用する。新しい方法論の立場をとることは、古くからの立場に取って代わるという主張を暗に意味したり、この学問分野の健全な研究を妨害するのでない限り、何の問題もない。たとえば初期中国絵画の一貫した様式史を構築しようという計画は、達成される以前に威信を失うべきではない。それはまるで街を作る以前に建物の建設を諦めるようなものである。我々はなお、この研究分野に基盤を必要とする。欧米の美術史における新しい方法論の使用は、多少なりとも評価の安定した美術作品という比較的堅固な基盤に支えられている。そうした基盤を中国絵画研究は享受していない。本書は美術史の研究方法の健全な多様性を提示するものである。

　「後赤壁賦図巻」に関する板倉聖哲氏の論文は、コンテクスト化の手法の顕著な例であり、詩と図巻を、蘇軾やその信奉者グループをめぐる特定の歴史的政治的状況に位置づけている。しかしながら、こうした手法は、それ自体ではどれほど有益なものであるにせよ、作品そのものから注意をそらしてしまう可能性がある。特に、画巻の物語的手法はさらなる注目に値するものである。これに対して、佐野みどり氏の論文は、『源氏物語』絵画の物語的手法をきわめて巧みに説明している。佐野氏は、物語世界内に住む語り手」や、物語外の存在が認識される語り手の視点といった、異なる視点に基づく絵画の複数の読みを主張し、「ある意味で、読者自身が物語絵巻の『作者』となっている」という幾分、驚くべき意見を述べられた。Timon Screech氏の論文は、浮世絵の支持層でもあった18世紀日本の都市生活者の中国に対する特別な態度を提示する。彼等は、伝統文化を奇談やパロディーで面白おかしくこきおろすことを好んだ。その芸術家達は、中国絵画を水墨の蘭と竹、また単純な山水へと縮小して描いた。中国伝統画をより真摯に受け止めなければならなかった画家達もおり、狩野派の大家は道徳的な儒教の主題を描き、南画の大家は洗練された中国贔屓の施主の注文に応じて制作を行なった。佐藤道信氏の論文、「歴史化の要件」は、欧米の日本観が「浮世絵と工芸品に集中して」おり、「日本で隆盛していた近代画家による作品」であ

る日本画を幾分、無視していたという発見から始まる。佐藤氏は、この現象の原因を広く歴史的、政治的要因に見出した。たとえば、日本政府は欧米でのジャポニズムを利用して、「工芸品を輸出することにより外貨を獲得しようとする」努力をした。だが、外国人が日本画を蒐集し鑑賞することが出来なかったことには、他のさらに単純な理由も根底にあった。価格が高騰していたこと、かなり特殊な支持層にしか訴えなかったことなどがある。

　台湾でのシンポジウムは島田修二郎氏の業績を讃えるものであった。私はその世代の他の先駆者の方々にも賛辞を述べたい。Bachhofer・Loehr・Sickman・Soper・C.C. Wang・Sherman Lee（唯一ご存命である）の方々だ。彼等は、全く異なった経歴を持ち、この分野にそれぞれ違った貢献をされた。だが、彼等の一人でも欠けていれば、私たちの研究分野は著しく貧弱なものになっていることだろう。ここから引き出される教訓は明らかだ。我々が目指すべきものは、統合よりも、むしろ平和な共存と相互の尊重である。古い方法論的立場から新しい立場への移行は、より優れた学問へと進化するのでなければ、いかなる進歩とも考えるべきではない。教師をした者なら誰でも知っているように、新しい方法論を得意気に使う学生が、研究しようとする題材の視覚的知識といった単純な知識の習得を敬遠することがよくある。私がこの分野の将来について不安を覚えるのは、方法論の退行よりもむしろ、この方法論的傲慢である。健全で高い水準の学術的研究が可能な、よき訓練を受けた若い専門家達が続けて現れることによって、そうした姿勢のバランスが取り戻され、あるいはいっそのこと、一転させなければならない。そうした理由で、本書は希望を与えてくれるものである。

James Cahill

Section V
Recent and Contemporary Painting

Section V: Recent and Contemporary Painting
Introduction

Jerome Silbergeld

Princeton University

As employed in the following essays on "Recent and Contemporary Painting," the terms "recent" and "contemporary" not only locate and limit the subject chronologically, as "Yuan painting" or "Ming-Qing painting" might do, but they are actually centrally-operative and hotly-contested aspects of the discussion. Diverse opinions about what "recent and contemporary" art is all about are conflated here with the diverse meanings ascribed to the very words "contemporary," "recent," and "modern"—the last of these terms so notably absent from the title of this section. Although the meaning of these words might seem self-evident, we live in an academic "Alice-in-Wonderland" era when hardly anything is quite what it seems, and to cite a dictionary definition is simply to beg the question. "Contemporaneity," according to Wu Hung 巫鴻 in his paper for this conference, is not merely a neutral description of the moment when a current work is done but represents a construct, a strategy that is relational to the past and that many present-day artists use (in his words) "to subvert established artistic genres and mediums"—in other words, to *overturn* the past. Far from operating simply to extend the past tense into the present, what is labeled here as "the contemporary," according to Wu Hung and his artistic subjects, extends into "contemporaneity" and functions there as a manifesto of things *intended*, proclaiming an agenda meant to extend a rebellious present into a reconstructed future.

I suspect that the somewhat neutral word "recent" in our section title was chosen by the symposium organizers to substitute for and avoid the more contentious "m"-word—"modern." Like "recent," in American academic practice, "modern" tends to include the contemporary moment but also to incorporate a broader temporal range, pointing in the opposite direction from future-oriented "contemporaneity" and extending well back into the past no less than a century and perhaps much further. In a post-modern world, both "the recent" and "the modern" seem to become transmuted into the old-fashioned and traditional just about as quickly as views about them can change, which is very quickly, and their positivist associations are virtually incompatible with a "contemporary," deconstructive outlook.

This is, of course, hardly the first time that Chinese artists have experienced a rupture with the past or chased after theory in their practice and made this the basis of their art and their art history. Yet in most regards, present thinking and practice display a reversal of tradition: what here is a celebration of fragmentation was traditionally a cause for lament. In the classic pattern, as we recall it, those in the historical present lamented their detachment from

the past as a failure of their own era to live up to past standards, and cultural activity served as a tool of their desire to reattach to a mysticized and mnemonically reconfigured past. Within decades of the Mongol conquest, Ni Zan 倪 瓚 (1301–1374) wrote on a painting by Zheng Sixiao 鄭思肖 (1241–1318), whose sobriquet was Suonan 所南:

> Autumn wind has turned these orchids to straw,
> The fate of the Southern Song no longer causes weeping or chills the breath.
> Others soon forgot, only Suonan's heart remains unchanged;
> He wrote of Qu Yuan and mixed his ink with tears.[1]
> 秋風蘭蕙化爲茅，南國淒涼氣已消，只有所南心不改，泪泉和墨寫離騷。

Under Ni Zan's brush, the painting of a few orchid leaves by artist Zheng became ennobled, and with it a whole era was saluted for its noble resistance; and with Ni attaching himself by way of Zheng Sixiao to a whole series of ghosts linked to Qu Yuan 屈原 (343–278 BCE), the immortalized patriotic poet and official from the southern state of Chu 楚, he contributed to his own era being remembered for its loyalty to the past. Ni's own "contemporaneity" did not seek to challenge or belittle the past, it sought radically to embody it.

The rupture with the past in Zheng and Ni's era, as we well know, was not just political but stylistic. According to Wen Fong in his paper in response to the "Literati Painting" section of this conference, the end of the Southern Song brought an end to "illusionism" and the Yuan dynasty brought the "literati painter [who] inscribes his own physical presence onto the flat picture plane with the traces of his brush and ink." James Cahill has spoken of the pre-Yuan era as the equivalent to the entire "Giotto-to-Gauguin phase" of European art, whereas Yuan art and all that followed was distinguished, according to Cahill, by its lack of any "clear, unilinear development . . . like those [logical evolutionary sequences] the old art historians defined for European painting." This lack brought Chinese painting, long before its European counterpart, to (in Cahill's words) "the end of the history of art."[2] That is to say, Chinese art at that point in time became "modern." Or should we say "post-modern"? And if we do say so, where in the calendar of Chinese art history do we locate the so-called "early modern"? Is it the eleventh century, with Su Shi 蘇軾 (1037–1101) and Mi Fu 米芾 (1052–1107), or in the eighth century, with Wu Daozi 吳道子 (?–792) and the Daoist ink-splashers? To discuss "the modern," we must first know where to locate it. Jonathan Hay, elsewhere, spreads "early modernity" across the sixteenth and seventeenth centuries, identifying well the commercial conditions that defined this as early modernity and shaped the artistic practice of Shitao 石濤 (1642–1707) in his late years.[3] In this volume, Wan Qingli's 萬青力 essay pushes the economic conditions that make for artistic early modernity further back, into the mid-fifteenth century. He links modernity and the eventual demise of literati painting to the eighteenth-century rise of artists of mercantile background and their distinctive employment of *jinshifeng* 金石風 (a style derived from

1. Translated by Yau Chang-foo, *A Study of Chinese Paintings in the Collection of Ada Small Moore* (London: Oxford University Press, 1940) (slightly amended).

2. James Cahill, "Some Thoughts on the History and Post-history of Chinese Painting," Haley Lecture delivered at Princeton University, November 1999, pp. 3–4.

3. Jonathan Hay, *Shitao: Painting and Modernity in Early Qing China* (Cambridge: Cambridge University Press, 2001), p. xviii.

bronze and stone inscriptions). All of these writers make their point well, but they are using "modernity" in different ways, emphasizing different aspects of a concept that still means different things to each of us.

Yen Chuan-ying's 顏娟英 paper here looks at two Taiwan artists who sought to *apply* notions of modernity in response to the changing political conditions brought about by modern circumstance, but were impelled by this attempt in very different directions. Quite unlike Wu Hung's contemporary artists, Professor Yen's two artists, Huang Tushui 黃土水 (1895–1930) and Lin Yushan 林玉山 (1907–2004), did not set out with contemporaneity in hand to undo modernity but rather with modernity as a means by which to undo contemporaneity, and with that to establish a distinctive Taiwanese artistic identity. Yet notwithstanding these artists' similarity of purpose, their different understandings of modernity remind me of nothing less than the equally great differences persistent still among ourselves.

When looked at too closely or too skeptically, *everything* collapses—every reality becomes a mere construct, and every monument becomes a ruin. The vaunted "single-narrative" (the so-called "logic") of Europe's medieval-to-modern sequence, which is used to establish later Chinese painting history's *lack* (a kind of "narrative-envy") as well as to establish the early onset of Chinese artistic post-modernity, is just as artificial and as risky an art historical construct as any other. By the same token, such deconstruction includes semantic destruction itself, so that every ruin becomes a new monument, and every anti-canon risks becoming just another, newer, authoritarian canon. In other words, every perceived instability becomes part of the continuing stability of the unstable. The kind of anti-painting described by Wu Hung simply is the latest new painting. Despite the best efforts of some contemporary artists to bring anything and everything to a halt, painting just goes on. Many art historians, afraid of essentializing, Orientalizing, and canonizing, have developed an inherent distrust of anything stable. Notions like "Chinese," "art," and "Chinese art" are all under attack, and not without some justification: yet they are denigrated as being mere "modern" constructs notwithstanding the apparent consensus that "early modernity" itself is at least four hundred years old in China. We cannot agree on the matter of "modernity," but we can hardly do without concepts of modernity and contemporaneity. So a hearty set of *mea culpa*s is in due order for whatever ways we assembled scholars have collectively used and/or misused the concepts of "modernity," "early modernity," "post-modernity," "recentness," "contemporary," and "contemporaneity," and a special nod goes to the hundreds and thousands of Chinese and Taiwanese artists painting today in traditional styles who should not and cannot be denied *their* contemporaneity. And, in conclusion, here is a strong affirmation of the notion that lies at the heart of Richard Vinograd's essay in the present volume, that "to see Chinese painting as plural, multiple, or polyvisual . . . need not imply a total atomization of painting or the uselessness of any categorization."

Jerome Silbergeld

第五節　近代與當代繪畫
引言

Jerome Silbergeld

普林斯頓大學

　　在「近代與當代繪畫」議程中發表的論文，探討各個藝術家和運動—他們與「現代性」結合是爲了表達某種藝術體制的開始或終結，甚或是繪畫史本身的「終焉」。萬青力的論文探討十八世紀時，商人階級中興起「文人風格」的繪畫、書法與刻印，最後終結了文人階級對中國繪畫的統治，並有助於定義一新的中國藝術現代性。顏娟英發表的主題，則是那些運用現代性以追求台灣藝術認同的藝術家。巫鴻檢視「當代性」之藝術議程，視之爲「挑戰繪畫在視覺藝術中的傳統宰制地位，甚而將繪畫解散爲一種獨立的藝術形式之廣泛努力」的一部份。Richard Vinograd則檢驗更大範圍的現代藝術運動與現象，它們結合了物質邊界、定義上的限制、「終焉」、與繪畫的多元終點。各式各樣和「現代性」的邂逅，顯示術語本身的流動性，然而很難被認爲會縮小其概念上的吸引力、刺激，與其在藝術知覺世界中的勢力—這個世界裡，改變、或是改變的可能性似乎統治著穩定與傳統。

第五部　近代・現代絵画
序言

Jerome Silbergeld

プリンストン大学

　この「近代・現代絵画」のセッションで発表される論文は、「モダニティー（近代・現代性）」を、芸術的な制度の始まりを意味するもの、逆に、その終わりを意味するもの、あるいはそれ以外を意味するもの、さらには絵画史の「終結」を意味するものとして取り組んださまざまな芸術家や彼らの活動について論じている。

　萬青力氏は、18世紀の商人階級が「文人風」の絵画、書、篆刻を盛んにたしなむようになったことを論じ、そのことが、結果として文人階級による中国絵画の独占に幕を下ろすことになり、中国の新たな芸術的モダニティーを定義づける一因となったとしている。顔娟英氏は、特に台湾の芸術的アイデンティティーを求めてモダニティーに取り組む芸術家達をテーマとしてとりあげている。巫鴻氏は、ビジュアルアートにおける絵画の伝統的な支配に対抗し、さらには絵画を独立した芸術形態であるとはねつけるような幅広い努力の一部としての「コンテンポラニティー（現代性）」という芸術的アジェンダを検討する。Richard Vinograd氏は、絵画の物理的な意味でのさまざまな限界線や最終的限界、絵画の「終結」や複数の「終点」に関して、さらに広い範囲にわたるさまざまなモダン芸術運動や現象を検討する。

　発表に見る「モダニティー」とのさまざまな遭遇、取り組みが示すものは、「モダニティー」という、その言葉自体の持つ流動性である。しかし、変化、あるいは変化の潜在力が安定や伝統の上に常に揺れ動いている芸術的意識のなかでは、その概念が訴えること、刺激、世の中に対して持つ力は軽減されることはないのである。

The Ends of Chinese Painting

Richard Vinograd

Stanford University

Painting's end has been declared at many times and places, though perhaps never more decisively than in the 1923 tract by the Russian avant-garde art theorist Nikolai Tarabukin entitled *From Easel to Machine*, which declared Alexander Rodchenko's (1891–1956) monochrome *Pure Red Color (Fig. 1)* "the last 'picture' to have been created by an artist" and part of "the death of painting, the death of easel forms."[1] Reaching the end of painting might, of course, equally be understood as the fulfillment of its purposes, but it has often, in our own millenarian era, been taken to be a finishing, death, or termination, whether of art or of its histories.[2] Some recent Chinese art and commentary has likewise been concerned with the ambiguities and opportunities of the ends of painting, in ways that at times engage deep historical issues.

Dead Ends

Huang Yong Ping's 黃永砅 (b. 1954) installation of 1987, *"The History of Chinese Painting" and "The History of Modern Western Art" Washed in the Washing Machine for Two Minutes (Fig. 2)*, may not have announced the outright end of Chinese painting, but suggested that it is, at the very least, recycled and "all washed up." Huang's avant-garde Chinese laundry had something to offer beyond its neo-Dada humor and art historical "agitation." It recognized that art production (and reduction) are bound up inextricably with history writing, criticism, and discourse, which might, as here, make up the very stuff of art, or serve as incitements to artistic action, or supply accompanying narratives of affirmation or irritation for art acts. Moreover, Huang's act of cultural synthesis is both absurd and real, caught up,

The author gratefully acknowledges the generosity of Dr. Britta Erickson in making her personal collection of contemporary art images available for the preparation of this paper.

1. See Maria Gough, "Tarabukin, Spengler, and the Art of Production," *October*, no. 93 (Summer 2000), pp. 79–108, especially pp. 85–88, 79.

2. See Douglas Crimp, "The End of Painting," *October*, no. 16 (Spring 1981), pp. 37–86, and the citations of Paul Delaroche, Ad Reinhardt, and Robert Ryman on the death of painting and the last paintings on pages 75 to 77; also Yve-Alain Bois, "Painting: The Task of Mourning," in *Endgame: Reference and Simulation in Recent Painting and Sculpture*, ed. David Joselit and Elisabeth Sussman (Boston: Institute of Contemporary Art, 1986), pp. 29–50. Compare the reference to Li Xiaoshan, "Zhongguohua daole quntumolu zhiri (The End and Death of Chinese Painting)," *Jiangsu Pictorial*, July 1985, in *Inside Out: New Chinese Art*, ed. Gao Minglu (San Francisco: San Francisco Museum of Modern Art, 1998), p. 199. See also Hans Belting, *The End of Art History?* (Chicago: University of Chicago Press, 1987); Donald Preziosi, "The End(s) of Art History," in *Rethinking Art History: Meditations on a Coy Science* (New Haven: Yale University Press, 1989), pp. 156–79; and Peter Seddon, "From eschatology to ecology: the ends of history and nature," in *History painting reassessed: The representation of history in contemporary art*, ed. David Green and Peter Seddon (Manchester: Manchester University Press, 2000).

despite its "liquidation" of art historical structures, within art world categories of neo-Dada, soft sculpture, and such. Further, it was a liminal, transitive object, operating between categories of Chinese and Western, sculpture and text.

Huang Yong Ping offers one possible denouement to the grand narrative of Chinese painting history, one that ends not with a bang, but with a "hamper." Another vision of endings appears in the photographic tableau of Hong Lei 洪磊 (b. 1960), *After the Song Dynasty Painting "Quail and Autumn Chrysanthemum" by Li Anzhong (Fig. 3)*. Hong's fan-shaped image is a double transposition of its announced Song dynasty model—from painting to photography, and from an image of living bird-and-flower to a real *nature-morte*, stilled life with a dead quail. Hong's image signals the terminus of a certain modality of representational painting, in part because it surpasses the Song-era ambition of vivid representation through the photographic exactitude and "lifelikeness" of its rendering of death. At the same time, Hong's work revivifies a long-moribund pictorial tradition by updating its representational technologies and putting it into productive contact, or friction, with a European tradition of still life, opening the Chinese mode to previously untapped territories of subject matter and expression.

Ends in Sight: Disciplinary and Categorical Horizons

Huang Yong Ping and Hong Lei offer perspectives on the ends of Chinese painting in general and of one of its major modalities, choosing to show, respectively, the "dregs" of historical synthesis and the "dead-ends" of representation. It should be noted that neither of their works is a painting; instead each operates as an imagistic or material embodiment of critical commentary. Other implications of the ends of Chinese painting might be found within the disciplinary practices of art history. "When and where does Chinese painting end?" perhaps makes most straightforward sense as a curriculum question. This is a not entirely trivial issue in a conference devoted to the history, and the historians, of East Asian painting; at least it admits the possibility of straightforward answers. For James Cahill, circa 1960, *Chinese Painting* ended with the eighteenth century; for him and an international team of co-authors in *Three Thousand Years of Chinese Painting* of 1997, Wu Guanzhong's 吳冠中 (b. 1919) *Yellow River* of 1993 is close to the end, and Chinese painting's beginnings are pushed back to Paleolithic rock engravings.[3] These are literalistic answers, but remind us of several things: that Chinese painting is and has always been bound up tightly with its historiographic constructions; that "Chinese painting" indeed has its fullest and most meaningful (and perhaps sole?) existence as an intellectual category; and that thinking or teaching about any episode of Chinese painting, or about its totality, requires some shaping narrative. Those narratives have beginnings and endings, limits and boundaries— even if only inexplicitly—as framing guidelines for what is discussed.

3. James Cahill, *Chinese Painting* (Geneva: Skira, 1960). Yang Xin, Richard M. Barnhart, Nie Chongzheng, James Cahill, Lang Shaojun, and Wu Hung, *Three Thousand Years of Chinese Painting* (New Haven and London: Yale University Press; Beijing: Foreign Languages Press, 1997). Cahill has offered a more theorized account of the end of the historical or developmental era of Chinese painting about 1300 in his unpublished Haley Lecture at Princeton University, "Some Thoughts on the History and Post-history of Chinese Painting" (16 November 1999).

When Chinese painting ends (beyond the arbitrary termination points imposed by publication deadlines) is a question that transposes readily into inquiry about *where* it ends—some notional horizon or territory defined by medium, purpose, language, ethnicity, or by theoretical and historical self-awareness. We can identify many different end points (or more commonly, ending zones, where endgame possibilities are gradually played out) for modes of Chinese painting variously defined by historical, purposive, social, or theoretical criteria, even before the many twentieth-century movements that explicitly rejected or disassociated themselves from some idea of traditional Chinese painting.[4] Chinese painting should then be understood as plural, or multiple.

Craig Clunas has usefully reminded us that notions of "Chinese art" (and subcategories, such as Chinese painting) are recent and culture-bound constructions based on nineteenth-century European historiography.[5] Other makeshift terms are also just as problematic. "Painting in China" might avoid some of the implicit essentializing of "Chinese painting," but it would seem to assume an unproblematically stable geocultural identity for China—an identity that was, in fact, no less historically variable than notions of "Chinese-ness." Terms such as "Chinese painting(s)" or "modalities of Chinese painting" might be useful, as ways of signaling multiple modes and episodes of painting, were they not so awkward. Perhaps we must simply accept the contradiction that "Chinese painting" is a term that has clearly outlived its usefulness, except that it is such a useful and nearly unavoidable term.

Recognizing plurality represents a challenge to, or even a destruction of, stable notions of Chinese painting and likely entails a diminishment of its elite status. At the same time, however, it allows expansions and enhancements of what Chinese painting might comprise. To see Chinese painting as plural, multiple, or polyvisual (elite and popular, masculine and feminine, ritual and personal modes of painting coexisting) over whatever long duration we might choose and within any given era or locality need not imply a total atomization of painting or the uselessness of any categorization. While some modes of painting that have been collapsed into a long history of "Chinese" or "literati" painting might more accurately be understood as having much briefer and more specific trajectories, by contrast some relatively newly attended-to modes such as popular religious images might have very long, trans-dynastic histories. Thus, we might conceive of clusters of distinct pictorial modes, with broadly separate underlying purposes, protocols, and visual realizations.

We might still choose to bracket a stable notion of Chinese painting as an historical artifact, a conceptual construct that is also a reminder of an era when, however it might otherwise have been characterized in terms of autograph brush production and high cultural status, Chinese painting was above all something that had the potential to be completely known and archived.[6] This was hardly an exclusive ambition of the modern era of disciplined art his-

4. For examples of such statements of disjunction, see Michael Sullivan, *Art and Artists of Twentieth-Century China* (Berkeley: University of California Press, 1996), pp. 44, 49, 62.

5. Craig Clunas, *Art in China* (Oxford: Oxford University Press, 1997), pp. 9–12. See also his discussion in *Pictures and Visuality in Early Modern China* (Princeton: Princeton University Press, 1997), pp. 11–18.

6. Compare Osvald Sirén, *Chinese Painting: Leading Masters and Principles*, 7 vols. (New York: Ronald Press, 1956–); James

Richard Vinograd

tory. Dreams of the completion of the archival record have earlier echoes in the encyclopedic and cataloguing proj-ects of the Qing dynasty Kangxi 康熙 (1662–1722) and Qianlong 乾龍 (1736–1795) courts, and perhaps as far back as Zhang Yanyuan 張彥遠 (ca. 815–after 875) in the late Tang.[7] More to the point, however, has there ever really been a time when Chinese painting has not been (more or less) inflected by and interpenetrated with broader arenas of picture making, ultimately including anything with an image on or in it—mass-produced and stencilled produc-tions, prints, ceramic, lacquer, and textile designs, all in circulation?[8]

Archives imply a spatialization of history, or at the very least an organized placement system. Much contempo-rary art-making, however, consciously destabilizes the archive of Chinese painting, by thoroughly complicating any clear sense of its spatial reach or potential completion. Hong Hao's 洪浩 (b. 1965) *New Political World Map* from his *Selected Scriptures* of 1995 (*Fig. 4*) accomplishes this by reshuffling geopolitical categories (and by implication cultural politics as well), so that the historical United States is occupied by the mapped People's Republic of China, and historical China is parcelled out among several European and Near Eastern countries, suggesting also a mock diagram of the complexities of transnational identities and art careers. Another kind of blurring of cultural geogra-phies appears in the oil-painted *Shan Shui* 山水 series by Zhang Hongtu 張洪圖 (b. 1943). In works such as *Dong Qichang—Cézanne* of 1999 (*Fig. 5*), the implied source-derivation and primary-secondary hierarchies of inter-cultural influence are suspended in a threshold state of cultural double identity. We could read Zhang's paintings as gestures of redress for art historical partialities toward Europe as the site of innovation, or as experimental realiza-tions of unfulfilled historical convergences, such as the structured dynamics of Dong Qichang 董其昌 (1555–1636) and Paul Cézanne (1839–1906), or elsewhere the energetics of Shitao 石濤 (1642–1707) and Vincent van Gogh (1853–1890).[9] Most of all, however, they are material realizations of the trans-categorical, refusing to lie quiet on either side of a Chinese-European divide, oscillating before our eyes not so much between alternate perceptions as between mental categories of reception, in ways that make them at once intensely familiar and impossible to recognize. Roy Lichtenstein's (1923–1997) *Landscapes in Chinese Style* series, despite the use of oil and magna colors, seem to be more thoroughly Chinese paintings than Zhang Hongtu's, in their relentless engagements with and interrogations

Cahill, *An Index of Early Chinese Painters and Paintings* (Berkeley: University of California Press, 1980); Suzuki Kei, ed., *Chūgoku kaiga sōgō zoroku* (*Comprehensive Illustrated Catalog of Chinese Paintings*), 5 vols. (Tokyo: University of Tokyo Press, 1982–1983); Toda Teisuke and Ogawa Hiromitsu, eds., *Chūgoku kaiga sōgō zuroku: Zokuhen* (*Comprehensive Illus-trated Catalogue of Chinese Paintings: Second Series*) (Tokyo: University of Tokyo Press, 1998–); Zhongguo gudai shuhua jianding zu, ed., *Zhongguo gudai shu hua tu mu* (*Illustrated Catalogue of Selected Works of Ancient Chinese Painting and Calligraphy*), 22 vols. (Beijing: Wenwu chubanshe, 1987–1999).

7. See the bibliographic summaries in Hin-cheung Lovell, *An Annotated Bibliography of Chinese Painting Catalogues and Re-lated Texts* (Ann Arbor: Michigan Papers in Chinese Studies, no. 16, 1973), pp. 41–42, 49–58, 99–101.

8. Compare Clunas, *Pictures and Visuality*, pp. 16–18.

9. See *Zhang Hongtu: an on-going painting project* (New York: on-going publications, 2000), pl. 5; also Jerome Silbergeld's essay "Zhang Hongtu's Alternative History of Painting" in the same volume, pp. 3–8.

of the mechanisms of Southern Song academy landscape modes.[10] At the same time, they bring that mode of painting to a kind of finality, through techniques of disillusionment and dissolution of an esthetic of perceptual unity and unique, unmediated experience. In *Landscape with Silver River* of 1996 (*Fig. 6*), Lichtenstein manages simultaneously to deconstruct the literati painting mode of overlaid "Mi 米 style" ink dots and the Song dynasty Ma Yuan 馬遠 (fl. ca. 1160–after 1225) academy mode of seamlessly graded ink washes into a ruthlessly systematic application of illustrator's dots that instead bespeaks procedures of formula, artifice, and constructedness.

Ends and Endlessness

We are reminded that ends-in-sight can serve as incitements or provocations—for Lichtenstein, the open-endedness of Southern Song academy landscapes was an incitement to systematic closure. The physical limits of paintings as objects could similarly provoke a complex dialectic between ends and their alternatives. Historical accounts of Chinese painting kept in view the repeated destruction or scattering of court and private collections.[11] Connoisseurial literature manifests an awareness that a painting's spirit might be exhausted by age or insults, and that some kinds of pictorial images might be intended to be used up, such as popular prints for seasonal use, or religious paintings the functional life of which might end with their participation in ritual performances.[12] Huang Yong Ping's aforementioned *Two Minutes in a Washing Machine* may offer a metaphor of the entropic fate of all art and art history, while Cai Guo-Qiang's 蔡國強 (b. 1957) pyrotechnic event *Drawing for Dragon Sight Sees Vienna: Projects for Extraterrestrials, No. 32* of 1999 (*Figs. 7A, 7B*) provides a contemporary counterpart of destruction during ritual performances.[13]

Chinese paintings in formats that are viewed sequentially, chiefly handscrolls and thematic albums, have self-evident visual endpoints, although these are not necessarily the last part of the work to have been painted. In this regard, they differ markedly from such other kinds of painting, in China and elsewhere, as murals and easel paintings, which are available to the viewer all at once.

Such endpoints have sometimes served as a source of anxiety or a provocation to artists, who seek to avoid or transcend those bounding limits by invoking the endlessness implicit in such themes as "streams and mountains without end" (*xishan wujin* 溪山無盡), "a thousand *li* of rivers and mountains" (*qianli jiangshan* 千里江山), or "ten myriads"

10. *Roy Lichtenstein: Landscapes in Chinese Style* (Hong Kong: Hong Kong Museum of Art, 1998). There are several slightly different versions of this catalogue.

11. See William R. B. Acker, *Some T'ang and Pre-T'ang Texts on Chinese Painting* (Leiden: E. J. Brill, 1954), pp. 110–46.

12. Zhao Xigu (act. ca. 1195–ca. 1242), *Dongtian qinglu ji* (*Compilation of Pure Earnings in the Realm of the Immortals*), cited in *Early Chinese Texts on Painting*, ed. Susan Bush and Hsio-yen Shih (Cambridge, Mass.: Harvard University Press, 1985), p. 239.

13. See Shanghai Art Museum, ed., *Shanghai Biennale 2000* (Shanghai: Shanghai shuhua chubanshe, 2000), pp. 19–20.

Richard Vinograd

(*shi wan* 十萬).[14] In another avoidance of ending, Huang Gongwang 黃公望 (1269–1354) resorted to the aesthetic of the unfinished, by placing a residue of sketch-beginnings at the end of his *Dwelling in the Fuchun Mountains* (*Fuchun shanju* 富春山居) scroll (1347–1350).[15] Endlessness can therefore be thematized as spatial or temporal, either boundless geography, which might also convey aspirations to power and abundance, or implied unending production. Hong Hao's *Rivers and Mountains Without End* of 2000 (*Fig. 8*) combines elements of potential spatial and temporal endlessness in a photographic seriation that transposes the performative act of painting, subject at least to limits of physical or material exhaustion, to the mechanically reproductive mode of photography, with its possibilities of indefinite repetition. Since Hong's photographs were shot from the window of a jet aircraft, the endlessness of his vistas are based on a stratospheric perspective and on the mechanics and optics of the jet engine and the camera shutter and lens, rather than on continuous extension of length or duration of performance. Indeed, the discontinuities of his composition are emphasized by the regular interruptions of film frame divisions, a mechanical syntax that replaces the rhythms of near and far or opening and closing passages in traditional handscroll compositions.

End Lines

Handscroll paintings also often have endpapers, set aside for commentarial colophons. Colophons are by implication and custom "after-words," positionally and temporally. Various kinds of textual endings—colophons, dedicatory inscriptions, signatures, and seals—signal completion, but the colophon or lengthy artist's inscription are the types of framing texts, or paratexts, that can turn the event of painting into a narrative, sometimes told explicitly as the story of the painting's motivation, production, or destination.[16] The texts may also speak of the purposes of the painting, and hence invoke another sense of ends as goals. The endpapers of paintings might be thought of also as end zones, liminal or transitive spaces where the pictorial is embedded in or interpenetrated with the textual. There, too, painting opens out into intertextual realms of narrative, history, theory, or discourse, and then into the life spaces of readers and writers in the wider world, where colophons, inscriptions, and seals mark the entry of a painting into the social realm, as an object of group viewing and commentary, or of possession and exchange.

The interpenetration, verging on identity, of writing and painting is one of the most fundamental and persistently recurring theories of Chinese representation, with the often stated assumption that writing and painting were alike in origin:

14. See Sherman E. Lee and Wen Fong, *Streams and Mountains Without End: A Northern Sung Handscroll and its Significance in the History of Early Chinese Painting*, rev. ed. (Ascona: Artibus Asiae Publishers, 1967). For Wang Ximeng's 王希孟 (1096–1119) "A Thousand *Li* of Rivers and Mountain," see *Three Thousand Years of Chinese Painting*, ed. Yang *et al.*, p. 124, fig. 115. For Ren Xiong's 任熊 (1823-1857) "Ten Myriads," see Julia F. Andrews and Kuiyi Shen, *A Century in Crisis: Modernity and Tradition in the Art of Twentieth-Century China* (New York: Guggenheim Museum, 1998), pl. 2, a–j.

15. See James Cahill, *Hills Beyond a River: Chinese Painting of the Yüan Dynasty, 1279–1368* (New York: Weatherhill, 1976), pp. 111–12.

16. Compare Gerard Genette, *Paratexts: Thresholds of Interpretation* (Cambridge: Cambridge University Press, 1997).

> When the sages of antiquity and the first kings accepted Heaven's commands and received the [divine] tablets, they thereby came to hold the magic power in the Tortoise Characters and the proffered treasure of the Dragon Chart. . . . Then Creation could no longer hide its secrets. . . . At that time writing and painting were still alike in form and had not yet been differentiated. . . .[17]
>
> 古先聖王受命應籙，則有龜字效靈，龍圖呈寶⋯造化不能藏其秘⋯是時也，書畫同體而未分⋯

The underlying notion that images, whether pictured or written, are direct transmissions, rather than simply representations, of heavenly patterns is sufficient to account for the continuing prestige of the idea, which takes many forms, including the often-noted commonality of brush techniques in calligraphy and painting. Xu Bing's 徐冰 (b. 1955) *Landscript* (*Fig. 9*) projects, hybrids of writing, graphic icon-signs, and landscape compositions, suggest another dimension to the writing-painting identification: they present spaces of unresolved ambiguity between reading and seeing that are in their own way transcendent of such mental categories and operations.[18]

Ends, Means, Beginnings

An expanded notion of Chinese painting as a multifarious image culture should recognize a correspondingly diverse array of end purposes. At the other extreme, if "Chinese painting" is understood primarily as a modern-era construct, then its purposes might readily be identified in one or another manifesto or programmatic agenda, such as that associated with constitutions of a "National Chinese Painting" (i.e, *guohua* 國畫).[19]

In the large in-between territory of pre-modern painting, we might identify two major, admittedly oversimplified, kinds of end purposes. In the social and political mode, primarily associated with figure and narrative painting, "painting is a thing which perfects civilized teachings and helps social relationships (夫畫者，成教化，助人倫⋯理亂之紀綱⋯)." In the mode concerned with manifesting "all of the myriad things that fill heaven and earth (盈天地之間者萬物)," associated with landscapes, birds, flowers, animals, and other related genres, "[painting] penetrates completely the divine permutations of nature and fathoms recondite and subtle things (悉皆含毫運思，曲盡其態)."[20] Although these foundational purposes shaped painting in its beginnings, they unfolded and developed over time, even if not in progressive or teleological fashion. Guo Ruoxu 郭若虛 (act. ca. 1080) recognized, if not uniform progress, then a differential fulfillment of genres, with religious and secular figure painting having reached a summit in the Tang, and landscape reaching an apogee closer to his own time in the eleventh century.[21] The completion, or

17. Zhang Yanyuan, *Lidai minghua ji* (*Record of Famous Painters of All the Dynasties*), cited in *Early Chinese Texts on Painting*, ed. Bush and Shih, pp. 49, 50.

18. Britta Erickson, *Words Without Meaning, Meaning Without Words: The Art of Xu Bing* (Washington, D.C.: Smithsonian Institution, 2001), pp. 71–74.

19. See Sullivan, *Art and Artists*, pp. 44, 49, 62, 132–34, 263.

20. Bush and Shih, eds., *Early Chinese Texts on Painting*, p. 49. For "all the myriad things," see p. 131, citing Deng Chun (ca. 1167), *Hua ji* (*Painting, Continued*).

21. Guo Ruoxu, *Tuhua jianwen zhi* (*An Account of My Experiences in Painting*), cited in *Early Chinese Texts*, ed. Bush and Shih, p. 94.

exhaustion, of one of Chinese painting's foundational ends, the representation of the myriad phenomena and "recondite and subtle things," was located by Max Loehr in the ink landscape of the late Southern Song, "the end of a long tradition of representational art."[22] This is admittedly a modern art historical formulation, although some Southern Song painting conveys its own preoccupation with distant ends, in images of gazing and absorption into undefined distance, and in contemporary commentary that betrays an awareness of the increasing subtlety, and perhaps the approaching limit points, of representational projects.

Whatever may have reached an end at the close of the Song era was surely not painting in general, but perhaps instead the idea of a consistent trajectory of its unfolding and development. Thereafter, writers and theorists were more likely to locate painting's end purposes at its beginnings, or at least somewhere far back in time. Among the most prominent examples, Dong Qichang sought a new purpose for painting as the fulfillment of a retrospective genealogy, envisioning a community of literati affinities. Shitao located the fulfillment of painting at its earliest beginnings, before methods and models had been differentiated (*Fig. 10*).[23] Rather than manifesting a simple nostalgia or blind valorization of antiquity, both Dong Qichang's and Shitao's approaches sought to redeem painting from a devolution into identification with its means, or techniques, rather than its ends—as, for example, in the reduction of the deep identity of painting and writing to a repertory of brush stroke types shared by calligraphy and painting, or in turning the manifestation of the myriad phenomena into an elaborate cataloguing of brush and ink techniques. Shitao sought to rescue painting from its entrapment by techniques and formulas, by imbuing its most fundamental element ("the single brush stroke" [*yihua* 一畫]) with a metaphysical significance ("the primordial line"), and resituating it in deep, even prehistorical places of beginning.[24]

In the contemporary arena, Shitao's primordial line is both imaged and deconstructed in Roy Lichtenstein's *Small Landscape*, which adds a single, idiosyncratic- and irregular-looking color brush stroke to an array of systematically gradated dots and bands of pure color. At first seemingly a disruption of the surrounding surface mechanics, the brush stroke's isolation ultimately defamiliarizes it, recapturing it in the process as an indexical sign of the idea of autograph brushwork, just one among many other conventional devices.[25] Cai Guo-Qiang's *Drawing for Dragon Sight Sees Vienna: Projects for Extraterrestrials, No. 32*, a burned gunpowder painting, engages the primordial as

22. Max Loehr, "Chinese Landscape Painting and Its Real Content," in *Four Views of China, Rice University Studies*, ed. Robert A. Kapp, vol. 59, no. 4 (Fall 1973), pp. 67–96, especially pp. 78, 82.

23. For discussions of Dong Qichang's painting theory, see James Cahill, *The Distant Mountains: Chinese Painting of the Late Ming Dynasty, 1570–1644* (New York: Weatherhill, 1982), pp. 13–14, 27, 120–23. See Kojiro Tomita and Hsien-Chi Tseng, *Portfolio of Chinese Paintings in the Museum (Yüan to Ch'ing Periods): A Descriptive Text* (Boston: Museum of Fine Arts, 1961), p. 24, for a translation of the inscription on Shitao's album leaf, which states that "the later people let themselves become the slaves of the ancient models."

24. See Ju-hsi Chou, *The Hua-yü-lu and Tao-chi's Theory of Painting*, Arizona State University Center for Asian Studies Occasional Paper No. 9 (Tempe, 1977).

25. See *Roy Lichtenstein: Landscapes in Chinese Style*, no. 20.

an elemental process of ungoverned combustion; the single matchstroke, one might say, that is both a self-consuming act of negation and one that leaves residual traces. A counterpart of Dong Qichang's pictorial itineraries of contact with the past appears in Qiu Zhijie's 邱志傑 (b. 1969) multi-media project *Writing the "Orchid Pavilion Preface" One Thousand Times* (*Figs. 11A, 11B*). Qiu's multiple iterations of a calligraphic icon imply an ambition of maintaining performative contact with a lineage of reenacted versions. This is another self-consuming or self-cancelling process, doomed from the outset by the acknowledged loss of the original, and further troubled by the accumulation of overlaid interference patterns, that move each iteration progressively and ironically farther from its presumed goal.[26] The undifferentiated black patch of ink of Qiu's "finished" work is an obliteration of history, temporality, and even the touch of the brush, ending in a seeming negation that is incoherent as text, and a terminal stage for painting and imagery as well. It brings us back, however, to the beginning of this account, in its convergence with the monochrome "last picture" of Rodchenko, and ultimately with the 1915 Suprematist *Black Square* painting of Kazimir Malevich (1878–1935; *Fig. 12*) and later, similar works by Ad Reinhardt (1913–1967), Frank Stella (b. 1936), and others. Qiu Zhijie's black surface was arrived at by a route very different from that of the Russian and American monochromes, and they in turn differ one from the other in their agendas, protocols of production, and historical engagements.[27] Each can claim positive content along with its seeming negations, and as a type, terminal or end paintings are remarkably productive of responses. Qiu's project is dense with personal and cultural histories, and at the very least embodies the foundational end of unity of writing and painting, albeit realized in an ironic sharing of the inchoate.

It would be both insipid and inadequate to take the many intersections of historical Chinese painting with concerns in contemporary art practice as evidence that the latter is simply a continuation of the traditional. It seems more productive to see the present *in* the past rather than the presence *of* the past, and to recognize the ways in which historical Chinese painting modes were, in many times and places, similarly trans-cultural, textualized, critical, liminal, and transitive. Diminishing the scope and autonomy of "Chinese painting" as a totalizing entity can thus result in an expansion and enhancement of its potential connections with other arenas of culture, and indeed with other cultures. If at many points "Chinese painting" ends, perhaps something richer and still more interesting begins.

26. Compare Norman Bryson, "The Post-Ideological Avant-Garde," in *Inside Out*, ed. Gao Minglu, pp. 51–58, especially pp. 56–57.

27. For the complex critical and historical trajectory of the Malevich painting, see Jane A. Sharp, "The Critical Reception of the 0.10 Exhibition: Malevich and Benua," in *The Great Utopia: The Russian and Soviet Avant-Garde, 1915–1932*, ed. Solomon R. Guggenheim Museum *et al.* (New York: Guggenheim Museum, 1992), pp. 39–52. See also Hal Foster, "Some Uses and Abuses of Russian Constructivism," in *Art Into Life: Russian Constructivism 1914–1932*, ed. The Henry Art Gallery (New York: Rizzoli International Publications Inc., 1990), pp. 241–53; also Benjamin H. D. Buchloh, "The Primary Colors for the Second Time: A Paradigm Repetition of the Neo-Avant-Garde," *October*, no. 37 (Summer 1986), pp. 41–52.

Richard Vinograd

中國繪畫的終結

Richard Vinograd

石丹佛大學

　　繪畫和藝術史相似地都經驗著一個世紀多以來與「終結」、「死亡」等想法的糾纏——諸如繪畫的「終結」、「死亡」、「最後的」繪畫，或是藝術史的終結。本文探索中國繪畫終結具有的多重隱喻，在強調當前藝術創作的同時，也採用宏觀的歷史觀點。

　　中國畫的界線，是基於許多紛呈的媒材、地理、時代、文化所作的定義與分類而定下來的。本文引入一種更寬泛、多元、多面的對中國繪畫的想法，以順應多重目的、媒材及文化。接下來的段落探討由終結所激發的互補與衝撞的想法：終結與無盡、結束與開始、終結與方法。對這些狀況的回應通常會讓作品採取某種跨界或轉換的形式：界乎中國與歐洲文化型態間、界乎繪畫與書寫或評論間、界乎繪畫與照片間、界乎繪畫與事件間。

　　最終，中國繪畫可能的終結或危機或許是來自對其傳統與地位的挑戰，並導致其強化與擴張挈入其他文化、媒材（如照片、書法及文字藝術、裝置、概念藝術、油畫、煙火），及其他無論當代或史上作品的重要模式。

中国絵画のさまざまな終焉

Richard Vinograd

スタンフォード大学

　絵画と美術史はどちらも一世紀以上にわたり、絵画の「終末」・「死」・「最終」あるいは、美術史の終焉など、終焉と死という観念を折にふれてさまざまな形で扱ってきた。本稿では特に現代美術の実際の様相を中心に、歴史的見解も視野に入れたうえで、中国絵画のさまざまな終焉を示唆する多様な見解のうちのいくつかを取り上げる。

　中国絵画という概念の考えうる限界点は、メディア、地理、歴史、文化といったさまざまな定義とカテゴリーに基づいたものであったが、本稿では複合的な目的、メディア、文化を含む幅広く、複数のものからなる、ポリヴィジュアルな中国絵画の概念を視野に入れる。

　さらに本稿では終焉という概念から引き起こされる、不十分さに対する補足や挑発、すなわち終焉と無限、終わりと始まり、終末と方法などについても考察する。このような状況に対する反応は、中国とヨーロッパの文化形態、絵画と執筆、評論、絵画と写真、絵画とイベントといったような、何らかの移行性を持った作品形態をとって現れることがしばしばある。

　最終的には、伝統的規範や地位に対する挑戦によっておこりうる、中国絵画の減退、あるいは中国絵画の危機とは、他文化や他メディア（写真、書、言語芸術、インスタレーション、概念芸術、油彩画、花火技術など）へ向かっての、また、現代作品、歴史的作品両者における重要性を持つ別の様式へ向かっての中国絵画の拡大、拡張、という見解にとってかわられる。

Fig. 1. Alexander Rodchenko (1891–1956). *Pure Red Color, Pure Yellow Color, Pure Blue Color* (left to right), 1921. Oil on canvas, each panel 62.5 × 52.7 cm. Rodchenko-Stepanova Archive, Moscow. © Estate of Alexander Rodchenko/RAO Moscow/ VAGA New York.

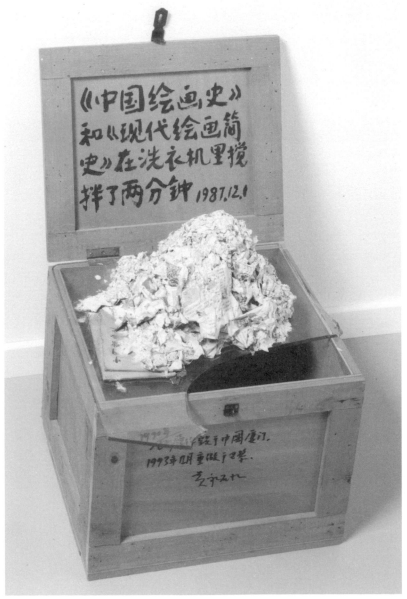

Fig. 2. Huang Yong Ping (b. 1954), *"The History of Chinese Painting" and "The History of Modern Western Art" Washed in the Washing Machine for Two Minutes*, 1987–1993. Installation with Chinese teabox, paper pulp, glass, 76.83 × 48.26 × 69.85 cm. Collection of the Walker Art Center, Minneapolis. T.B. Walker Acquisition Fund, 2001.

Fig. 3. Hong Lei (b. 1960), *After the Song Dynasty Painting "Quail and Autumn Chrysanthemum" by Li Anzhong.* Color photographic print, diam. 82 cm.

Fig. 4. Hong Hao (b. 1965). *New Political World Map.* From *Selected Scriptures*, 1995. One of six panels; silkscreen on paper, each 55 × 76 cm. Collection of the artist. Courtesy of the Courtyard Gallery, Beijing, and the artist, Hong Hao.

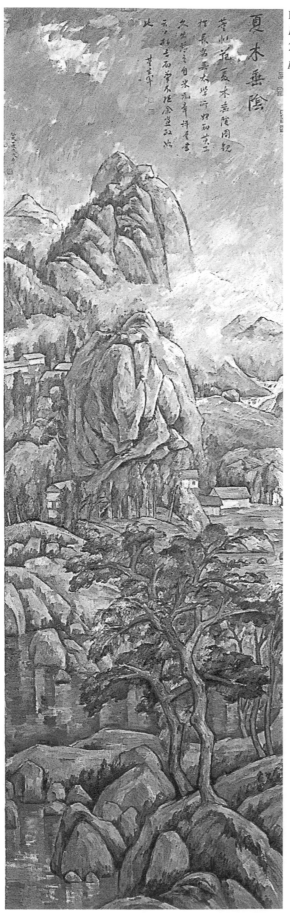

Fig. 5. Zhang Hongtu (b. 1943). *Shan Shui* series: *Dong Qichang−Cézanne*, 1999. Oil on canvas, 243.84 × 76.2 cm. Courtesy of the artist. *(detail on page 509)*

Fig. 6. Roy Lichtenstein (1923–1997). *Landscape with Silver River,* 1996. Oil and magna on canvas, 210.82 × 168.9 cm. © Estate of Roy Lichtenstein. *(enlargement on page 615)*

Figs. 7A, 7B. Cai Guo-Qiang (b. 1957). *Drawing for Dragon Sight Sees Vienna: Projects for Extraterrestrials, No. 32.* Kunsthalle Wien, Vienna, Austria, 1999. Ignited gunpowder on paper (left) and remains of spent gunpowder on paper (right). Photo by Fritz Simak. Courtesy of the artist.

Fig. 8. Hong Hao (b. 1965). *Rivers and Mountains Without End*, 2000. Photographs. Courtesy of the Courtyard Gallery, Beijing, and the artist, Hong Hao.

Richard Vinograd

Fig. 9. Xu Bing (b. 1955). *Landscript: Helsinki-Himalaya Exchange*, 2000. Ink on two sheets of paper, together approximately 100 × 300 cm. Courtesy of the artist.

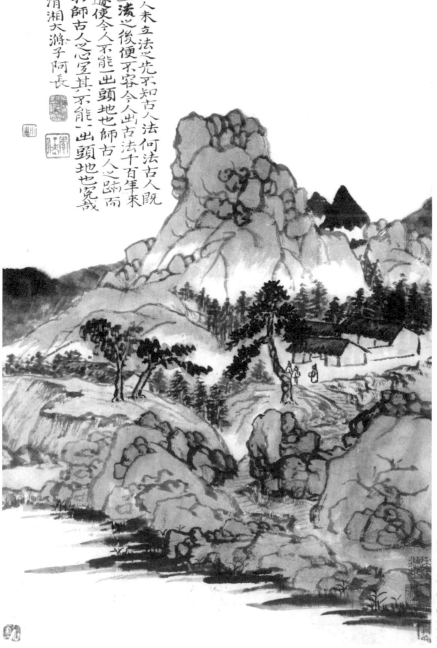

Fig. 10. Shitao (1642–1707). *Album of Twelve Landscape Paintings, Leaf I: Retreat under a Cliff,* dated to 1703 on the final leaf. Album leaf, ink and colors on paper, 47.5 × 31.3 cm. Boston Museum of Fine Arts, 48.11-I. William Francis Warden Fund.

Figs. 11A, 11B. Qiu Zhijie (b. 1969). *Writing the "Orchid Pavilion Preface" One Thousand Times*, 1986-1997. Multimedia installation with video documentation and ink-on-paper calligraphy; calligraphy 75 × 180 cm. Courtesy of the artist.

Fig. 12. Kazimir Malevich (1878–1935). *Black Square*, 1915. Oil on canvas; 79.5 × 79.5 cm. State Tretyakov Gallery, Moscow.

Richard Vinograd

Chinese Merchants as Influential Artists: 1700–1948

Wan Qingli

University of Hong Kong, Emeritus

Following the rise of urban economy in Chinese cities in the late eighteenth century, "the role of rich merchants was not confined to . . . patronage . . . , but . . . extended to . . . direct participation in artistic creation. Some even became the founders of new art schools and leading figures in art circles."[1] This new breed of townspeople who were both artists and merchants was created by social changes occurring in the middle and later Qing period.

From the middle Ming dynasty onward, a succession of travelling merchant fraternities (*bang* 幫) appeared, each prefixed by the name of its native province, such as Hui 徽, Jin 晉, Shaan 陝, Min 閩, and Yue 粵. They accumulated capital from long-distance trading and were significant in creating a highly competitive market environment that directly influenced the development of subsequent Chinese society.[2] By the eighteenth century, the economies of cities were increasingly controlled by wealthy businessmen such as salt merchants (who purchased monopoly rights to the salt trade), securities merchants (who dictated the flow of capital), and bankers (who presided over specific trades). These merchants constituted the most powerful stratum among ordinary citizens. Their active participation in cultural affairs meant that they played a part in directing the social and cultural transformation of China. In the late eighteenth century, accomplished and influential artists began to appear in the merchant class. Since their circumstances differed from those of traditional scholar-official painters, they cannot be categorized as literati artists.

Past studies have been either silent or perfunctory with regards to the mercantile status of calligraphers, painters, and seal engravers, particularly those antedating the mid-nineteenth century. One reason for this scholarly deficiency may be that the development of merchant groups during the mid-Qing economic transition is not yet well understood; a stronger reason may be the traditional Chinese disdain for commerce in all its aspects. In addition, the number of artists who continued to be or who once had been in business grew considerably by the end of the nineteenth and the beginning of the twentieth century, making it difficult to distinguish merchant-artists from non-merchant-artists born into a mercantile family.

This essay focuses on several important artists of the eighteenth to twentieth centuries whose mercantile activities have been clearly documented. It examines the artistic views and styles of these businessmen-cum-artists, their major accomplishments, and their impact on the development of modern Chinese art.

1. Wan Qingli, "The Transformation of Jiangnan," *Journal of Oriental Studies*, vol. XXXV, no. 1, 1997, pp. 14–21.

2. Zhang Haipeng and Wang Tingyuan, eds., *Huishang yanjiu* (*Studies on Hui Merchants*) (Hefei: Anhui renmin chubanshe, 1995), pp. 1–16.

Eighteenth-century *Jinshifeng*: The Wine Merchant Ding Jing and His Impact on Seal Engraving

By the first half of the eighteenth century, merchants renowned for their paintings or painters who had abandoned scholarly pursuits for commerce were not uncommon. Yi Fujiu 伊孚九 (1698–after 1747), a merchant of Wuxing, Zhejiang Province, was also a painter of landscapes. He made numerous business trips to Nagasaki 長崎 (the permitted Chinese enclave in Japan), the first in 1720, and while in Japan he made friends through his art. Virtually unknown in China, Yi Fujiu influenced a number of important Japanese painters, including Ike Taiga 池大雅 (1723–1776), and is considered "an important figure in the development of Japan's Southern School of painting."[3] Further examples of artists with business experience can be found among Yangzhou painters throughout the eighteenth century. Fang Shishu 方士庶 (1692–1751), from a family of Anhui salt merchants, became a professional painter after failing in business. Qian Dong 錢東 (1752–1817), on the other hand, came from a literati background, but "abandoned Confucianism for commerce." Other artists with connections to commerce have also been documented.[4]

It is therefore not surprising that the accomplished artist Ding Jing 丁敬 (1695–1765) would emerge from a merchant background in the first half of the eighteenth century. Known as the foremost seal carver of his time and the originator of a new style,[5] Ding Jing was the recognized founder of the Zhe 浙 school of seal carving, which would continue influential for the next two hundred years. He was the first leading figure among the seal carvers called the "Eight Masters of Xiling" (Xiling bajia 西泠八家). Ding Jing was a painter and calligrapher as well, with close ties to Yangzhou painters such as Jin Nong 金農 (1687–after 1764) and Luo Ping 羅聘 (1733–1799), and he was also significant in the formation of the "Trend of Bronze and Stone" (*jinshifeng* 金石風) in late Qing and early Republican art.[6] Even though Jin Nong and Luo Ping are best known for their paintings and Ding Jing for his seal carving, all three artists in fact were accomplished in the "Four Perfections" (*siquan* 四全), that is, excellence in poetry, calligraphy, painting, and seal carving (*Figs. 1, 2*).[7] This expansion of the traditional "Three Excellences" (*sanjue* 三絕)—

3. John M. Rosenfield in collaboration with Fumiko E. Cranston, *Extraordinary Persons: Works by Eccentric, Nonconformist Japanese Artists of the Early Modern Era (1580–1868)*, ed. Naomi Noble Richard, 3 vols. (Cambridge, Mass.: Harvard University Art Museums, 1999), vol. 3, B. 98.

4. Ginger Cheng-chi Hsü, "An Anhui Artist in Yangchou: A Case Study of Region and Network in Chinese Painting," in *Quyu yu wangliu: Jin qiannian lai Zhongguo meishushi yanjiu yantaohui* (*Regions and Networks: Research Papers from the International Symposium on the Study of Chinese Art from the Past One Thousand Years*) (Taipei: National Taiwan University, 2000). See also Li Dou, *Yangzhou huafanglu* (*Record of Yangzhou Pleasure Boats*) (Taipei: Xuehai chubanshe, 1969); *Guochao huazheng xulu* (*Record of Paintings in the Qing Dynasty*), vol. 2, *Huashi congshu (3)* (*Collectanea of Painting History [3]*) (Shanghai: Renmin meishu chubanshe, 1963).

5. Qian Juntao and Ye Luyuan, *Xiyin yuanliu* (*The Origin and Development of the Seal*) (Beijing: Beijing chubanshe, 1994), pp. 132–39.

6. I use the term *jinshifeng* rather that "Jinshi school" because I feel that the concept of a Jinshi school of painting is very difficult to establish and, in particular, cannot be categorized as part of the *jinshixue* movement. See Wan Qingli, "The Transformation of Jiangnan," *Meishu yanjiu* (*Art Research*) (no. 4, 1998), pp. 63–66. See also Wan Qingli, "The Southern Painting Style in Beijing: Leading Figures of the Beijing Painting Circle in Early Republic Years," *Quyu yu wangluo: Jin qiannian lai Zhongguo meishushi yanjiu yantaohui*, pp. 605–28.

7. In the twenty-third year of the Qianlong reign, corresponding to 1758, Ding Jing carved the seal *A Piece of My Longing* (*Qi*

poetry, calligraphy, and painting—to include seal carving attests to its recognition as an art form and its increasing popularity.

Some early records about Ding Jing do not evade the artist's commercial background. Hang Shijun 杭世駿 (1696–1773), a good friend of Ding Jing, born like him in Hangzhou, and the father-in-law of Ding Jing's son, wrote "A Biography of the Recluse Ding Jing" (*Yinren Ding Jing zhuan* 隱人丁敬傳) that includes the following account:

> The recluse Ding Jing, style name Jingshen 敬身, sobriquet Chunding 純丁, called himself Longhong shanren 龍泓山人. His home was outside Houchao 候潮 Gate in Hangzhou; his neighbors were all humble people. He brewed alcohol himself, sold it among laborers and peddlers, and never felt himself different from them.[8]

Similarly, Qian Lin 錢林 (1762–1828), writing considerably later, noted in his *Collection of Historical Records* (*Wenxian zhengcunlu* 文獻徵存錄), which he edited, that "Ding Jing, style name Jingshen, a native of Renhe, lived in the marketplace, where he brewed and sold alcohol to provide for himself. As for his business, he was not ashamed of it."[9] Wang Ren'an 汪紉安 (1728–1799), who claimed a long friendship with Ding, recorded that Ding had "vowed to pursue learning despite coming from a poor class," and that "he continued to study in his old age, but his family became ever poorer. Depressed and lonely, he often drank and became offensive, so quite a few people avoided him."[10] From these accounts, it is evident that Ding Jing lived by brewing and selling wine, kept company with laborers and peddlers in the marketplace, and in old age was an impoverished member of the lower classes.

Ding Jing knew many scholars and artists in Hangzhou and Yangzhou. When both were young, Jin Nong was Ding Jing's close neighbor, living "a chicken's flight apart" outside the Houchao Gate at Hangzhou. After Jin Nong moved to Yangzhou, the two kept in touch.[11] It was recorded that "Ding Jing and Jin Nong bought and sold antiques for a living. In addition, Hang Dazong 杭大宗, Wang Rongfu 汪容甫, and Jiang Ziping 江子屏 were scholars as well as businessmen."[12] Hang Dazong was another name for Hang Shijun. Wang Rongfu (1744–1794), a native of Yangzhou, was a scholar of *jinshixue* 金石學 (the study of inscriptions on ancient bronzes and stone), and Jiang Ziping (1732–1780) a Yangzhou painter. Apparently, the trading of antiques was one accepted way for devotees of *jinshixue*

jide xiangsi yidian 祇記得相思一點), which he sent to Jin Nong in Yangzhou. Jin Nong's return gift was a self-portrait. See *Qingdai Zhepai yinfeng* (*The Seal Style of the Zhe School in the Qing Dynasty*) (Sichuan: Chongqing chubanshe, 1999), p. 45. In 1763 Luo Ping produced *Picture of Mr. Jingshen [Ding Jing] Sitting on a Rock and Leaning on His Staff* (*Jingshen xiansheng yizhang zuoshi tu* 敬身先生依杖坐石圖). Attached to it are a letter and poetry by Ding Jing, as well as poetic inscriptions by Yuan Mei 袁枚 (1716–1797) and others. The work is now in the Zhejiang Provincial Museum.

8. Hang Shijun, *Yinjun Ding Jing zhuan* (*A Biography of the Recluse Ding Jing*), in *Daogutang ji* (*Collection of the Daogu Hall*) (1792 ed.; repr., Shanghai: Saoye shanfang, 1912), vol. 32, p. 5.

9. Qian Lin, comp., and Wang Zao, ed., "Ding Jing, Jin Nong", *Wenxian zhengcun lu* (1858 ed.; repr., Jiangsu: Guangling guji keyinshe, 1987), vol. 10, p. 69.

10. Wang Ren'an, "Ding Jing," *Xu yinren zhuan* (*Sequel to Biographies of Seal Engravers*), in *Yeshi cungu congshu* (*Ye's Collectanea of Antiquity*) (Hangzhou: Xiling yinshe, 1910), vol. 2, pp. 1–2.

11. Hang Shijun, *Daogutang ji*, vol. 10, p. 5.

12. Deng Zhichang, "Jin Dongxin," *Gudong suoji* (*A Fragmentary Record of Antiques*), vol. 6; see *Gudong suoji quanbian* (*Complete Edition of a Fragmentary Record of Antiques*) (Beijing: Beijing chubanshe, 1996), p. 165.

to earn money. The account also indicates commercial activities undertaken by artists residing in different cities: Ding Jing and Hang Shijun in Hangzhou, and Jin Nong, Wang Rongfu, and Jiang Ziping in Yangzhou. Ba Weizu 巴慰祖 (1744–1793), who came from a Hui merchant family and lived in Yangzhou at about the same time, was a famous seal carver, but he also excelled in many other art forms, including calligraphy and painting in the *jinshi* style as well as faking ancient bronzes, which he passed off as genuine (*Fig. 4*).[13] Then, as now, the counterfeiting of antiques was rife.

In the role of a small-time wine merchant, Ding Jing's social status was similar to that of Tang Guangde 唐廣德, father of the famous Tang Yin 唐寅 (1470–1523). In the fifteenth century, to improve the family's circumstances, Tang Guangde could only hope for his son to succeed in the civil service examinations;[14] a little over two centuries later, by contrast, Ding Jing the wine seller could also be a prominent scholar of *jinshixue* without taking, much less succeeding in, the examinations. Underlying this difference is the social transformation that had taken place in the intervening centuries, whereby mercantile culture and the mercantile livelihood itself had achieved a certain acceptability. Ding Jing's reputation and the significance of his influence are unprecedented in the history of seal-carving art.[15] In the century following Ding Jing's death, followers continued to develop his artistic vision, so that the Zhe school of seal carving formed and the "Eight Masters of Xiling" came to prominence.[16]

Persons who had never taken the civil service examinations were generally known as *buyi* 布衣 (literally, "cotton clothes"). Ding Jing and Jin Nong, however, differed from artists of earlier generations who had not attained official status or scholarly recognition. Before the mid-Ming period, most artists as well as scholar-officials belonged to a class of educated landholders, or gentry, within an agrarian society, whose income was derived primarily from government salaries or land ownership (with members of this class who became officials depending on the former, and those not holding or not qualified for office relying on the latter).[17] Yet by the mid-Ming, a lower-class merchant family in Suzhou had produced the illustrious painter Tang Yin, who also succeeded brilliantly in the examinations. The

13. Yu Jianhua, ed., *Zhongguo meishujia renming cidian* (*Dictionary of Chinese Artists*) (Shanghai: Renmin meishu chubanshe, 1980), p. 32.

14. Zhu Yunming 祝允明: "His father, Guangde, a merchant who conducts himself as a scholar, wishes to improve the family standing through his son, so he employed teachers to teach his son (其父廣德，賈業而士行，將用子畏起家，致業師教子畏)." From "Tang Bohu muzhiming (Epitaph for Tang Bohu [Yin])," quoted from Chiang Chao-shen, *Guanyu Tang Yin de yanjiu* (*Studies on Tang Yin*) (Taipei: Guoli gugong bowuyuan, 1976), p. 2.

15. A number of studies deal with Ding Jing's contribution to and position in the history of seal art. See, for example, Ye Yiwei, "Chonglun Zhepai (Rethinking the Zhe School)," *Qingdai Zhepai yinfeng*, pp. 1–19.

16. The other seven masters of Xiling were: Jiang Ren 蔣仁 (1743–1795), Huang Yi 黃易 (1744–1802), Xi Gang 奚岡 (1746–1803), Chen Yuzhong 陳豫鐘 (1762–1806), Chen Hongshou 陳鴻壽 (1768–1822), Zhao Zhichen 趙之琛 (1781–1852), and Qian Song 錢松 (1818–1860).

17. Wan Qingli, "Wenrenhua yu wenrenhua chuantong: Dui ershi shiji Zhongguo huihuashi yanjiu zhong yige gainian de jieding (Literati Painting and the Literati Painting Tradition: Defining a Concept in Twentieth-century Chinese Art History)," in *Huajia yu huashi* (*Painters and the History of Painting*) (Hangzhou: Zhongguo meishu xueyuan chubanshe, 1997), pp. 64–76.

high regard in which he was held by the most exalted members of the scholar-official class reflects the changes that had taken place in the social position of townspeople.[18]

Persons such as Ding Jing and Jin Nong differed from the archetypal scholar of the gentry class not only in their means of livelihood and social status but also in their educational background. Traditionally, scholars had pursued the learning codified and sanctioned by the imperial examination system, whose core was the Confucian classics, specifically the Four Books and Five Classics, plus their notes and commentaries. Through the Ming and Qing dynasties, Zhu Xi's 朱熹 (1130–1200) interpretation of Confucianism—"Cheng-Zhu *lixue* 程朱理學"—was institutionalized, and the civil service examinations were based largely on that interpretation. However, by the start of the Qing dynasty, *lixue* Neo-Confucianism was in decline, and many disaffected scholars turned from that uncongenial but still official curriculum to establishing and interpreting the original texts of the Classics. They searched out ancient stelae and studied their inscriptions, and they collected and researched antiquities. Even scholars who had attained recognition in the examinations turned increasingly to these interests, and particularly to *jinshixue*. Artists whose distinguished achievements in calligraphy, painting, and seal carving were directly related to their lifelong immersion in *jinshixue* include Cheng Sui 程邃 (1607–1692), who formed the Wan 皖 school of seal carving, Ding Jing of the Zhe school, and Deng Shiru 鄧石如 (1743–1805), the creator of the Deng school of seal carving (*Fig. 3*). Spanning two centuries, these three innovators and masters of the art of seal carving all belonged to the "cotton clothes," a fact of great significance to understanding their art and its relation to their milieu.

Jinshixue was a form of specialized study that grew out of *puxue* 樸學, or "Plain Learning," the study of ancient texts rather than their later commentaries. *Jinshixue* also included paleography, the basis of the art of seal carving. The learning of *jinshixue* was in some ways similar to that of practical fields like medicine, geomancy, mathematics and construction. Its social implications differed, however, in that specialists in *jinshixue* often mingled on equal terms with scholar-officials, whose *lixue* education rendered them socially superior but many of whom were also deeply interested in *jinshixue*. *Jinshixue* thus came to be considered a more elevated branch of practical learning. The first scholar-official to take note of the seal carving of commoner artists was the eminent art patron Zhou Lianggong 周亮工 (1612–1672). Zhou searched out and befriended these artists, and set a precedent of recording their lives and attainments.[19]

The majority of Qing dynasty seal carvers were *buyi*, and most of them had to supplement their income in seal carving with other modest business activities that accorded them a social status not much higher than that of quack

18. Tang's demotion to the lowest level of commoner following the accusation of cheating in the metropolitan exam, and his consequent need to paint for a living, seem not to have diminished his contemporary reputation as a painter. Chiang Chao-shen, *Guanyu Tang Yin de yanjiu*, pp. 8–10.

19. Zhou Liangong's unfinished work *Yinren zhuan* 印人傳 (*Biographies of Seal Carvers*) comprises sixty-one figures. Most were "poor scholars" or professional seal carvers. See *Yinren zhuan*, rev. Ye Ming, 3 vols. (Yeshi cungu congshu ban; Hangzhou: Xiling yinshe, 1910).

doctors, *fengshui* 風水 practitioners, or so-called "legal experts." For example, the late Qing master Huang Shiling 黃士陵 (style name Mufu 牧甫; 1849–1908), who was as famous as the painter Wu Changshi 吳昌碩 (1844–1927), not only carved seals, but also worked as a photographer.[20] Anthologies of seal carvers' biographies even include some concubines and servants, which reflects the widespread popularity of the art during the Qing period.[21] In addition, some late Qing officials were accomplished seal carvers, and several "modern" intellectuals of the early twentieth century mingled with folk craftsmen; both trends indicate the rising position of artisans as well as the changing social role and attitudes of the literati. The gifted and eccentric scholar-official Chen Hongshou 陳鴻壽 (1768–1822), a noted painter and seal carver, provided designs for the potters Yang Pengnian 楊彭年 and Yang's sister, as well as Shao Erquan 邵二泉, to produce Yixing 宜興 wares. Other examples of artistic collaboration across class lines include Chen Shizeng 陳師曾 (1876–1923) and Yao Hua 姚華 (1876–1930), scholars of *jinshixue*, who collaborated with the bronze-casting master Zhang Shouchen 張壽辰 to make copper ink boxes and paperweights. They also worked with Zhang Qi 張啓 to create albums of woodblock prints.[22]

Seals came into use in China as early as the Bronze Age, and until the Yuan period, most were designed and made by anonymous craftsmen. In the Yuan dynasty, however, exceptions began to appear, such as Zhao Mengfu 趙孟頫 (1254–1322), who designed his own seals and had them cast by bronze artisans. Scholars believe that, toward the end of the Yuan, figures like Wang Mian 王冕 (1287–1359), the celebrated painter of ink plum blossoms, began to carve their own seals in soft stone.[23] By the mid-Ming, master carvers were beginning to acquire a certain recognition, and about the beginning of the eighteenth century, seal making was succeeding to the status of an art form. Since then, makers of seals—known as *yinren* 印人, *zhuankejia* 篆刻家 ("seal carvers"), or *jinshijia* 金石家 ("seal-carving specialists")—have no longer been anonymous artisans. This accrual of status and reputation was related to the change in the materials used to make seals (from bronze to more easily worked soft stone), but also and more importantly to changes in society and in modes of thinking. Because seal making requires knowledge of *jinshixue* and also great skill in carving, it took long, disciplined study and practice to become a master, and few scholar-officials had the time to devote to this training. That is why the movement to revive the art of Han seal carving in the Qing period was led by *buyi*. In short, the emergence of the *buyi* seal carver Ding Jing reflects certain transformations in

20. Luo Tianxiang, "Shilun Huang Shiling de zhuanke fengge ji qichengjiu (An Attempt to Discuss Huang Shiling's Seal Carving Style and Achievements)," *Xiling yinshe guoji yinxue yantaohui lunwen ji* (*Research Papers from the Philology Symposium of the Seal Society of Xiling*) (Hangzhou: Xiling yinshe, 1989), pp. 315–22.

21. For example, Wang Ren'an, "Yang Ruiyun zhuan (Biography of Yang Ruiyun)" and "Jin Sujuan zhuan (Biography of Jin Sujuan)," in *Xu yinrenzhuan* (*Sequel to Biographies of Seal Carvers*), vol. 8, pp. 196–97, 204.

22. See Shi Juntang and Sheng Pansong, eds., *Zisha chunqiu* (*Chronicle of Yixing Wares*) (Shanghai: Wenhui chubanshe, 1992), p. 16. Wan Qingli, "The Southern Painting Style in Beijing: Leading Figures of the Beijing Painting Circle in Early Republic Years," pp. 605–28.

23. Han Tianheng, *Zhongguo yinxue nianbiao* (*A Chronological Table of Chinese Seal Art*) (Shanghai: Shuhua chubanshe, 1993), p. 5.

Chinese society, notably the emergence of an educated mercantile class, an increased permeability of class boundaries, and a re-evaluation of what constituted "art."

Late Qing and Early Republic Industrialists: Wang Yiting, Jin Cheng, and Modern Urban Art

In the later nineteenth century and particularly in the first half of the twentieth century, scholars fairly commonly turned to business, representing a fundamental erosion of the Confucian derogation of commerce. Mercantilism might even be considered one of the features of "Chinese modernity." As members of the elite entered into commerce, growing numbers of merchant-artists appeared, and even greater numbers of artists who had once been "in trade" or who had continued to supplement their incomes that way. For instance, Zhao Zhiqian 趙之謙 (1829–1894), who came from a merchant family, applied the style of northern stele (*bei* 碑) calligraphy to painting and founded the Zhao school of seal carving; he is also credited with attaining the "Four Perfections." Huang Binhong 黃賓虹 (1865–1955), likewise a seal carver from a merchant family, was a proponent of the *guocuipai* 國粹派 ("School of Chinese Essentialism") in the arts, a *jinshi* specialist, and a master of landscape painting. Huang, Ba Weizu (mentioned above), and Ye Ming 葉銘 (1866–1948), one of the founders of the Xiling Seal Society (Xiling yinshe 西泠印社), all came from Hui merchant families—an indication of merchant participation in the *jinshifeng* art movement (which derived from *jinshi* study).

By the beginning of the twentieth century, there were innumerable artists known to have been businessmen at some point in their lives, and many others who practiced art and business at the same time. Most did not rely on selling their artworks for a living, and some were best known as collectors. Their calligraphy and painting, however, were often overlooked. Whatever styles they may have practiced, clearly these were not "literati painters." Moreover, with the Westernization of the education system in 1901 and the elimination of the civil service examination system in 1905, the traditional literati class was nullified and the rubrics of "literati painter" and "literati painting" could no longer be applied. Likewise, the terms "merchant painter" and "merchant painting" turn out to be not merely inadequate but also misleading.

Born out of the commercial environment of the late nineteenth century, the art scene in Shanghai was at its height by the early Republican era. Its leading figures were Wu Changshi and Wang Yiting 王一亭 (Wang Zhen 震; 1867–1938), known as the "Two Treasures of Shanghai" (Haishang shuangbi 海上雙璧). After the death of Wu Changshi, Wang Yiting became the "Pillar of the Shanghai School" (Haipai juqing 海派巨擎).

Wang Yiting lived a remarkable life. From humble beginnings as an apprentice and salesman, he became a comprador for Japanese merchants, a business tycoon, a hero of the 1911 Revolution (Xinhai geming 辛亥革命), and a pivotal figure in the Shanghai art scene. His accomplishments in the arts developed simultaneously. Under the influence of his grandfather, Wang Yiting, who was born into a modest cloth merchant's family, came young to a love of painting. His father's early death, however, left the family poor, and in 1880 Wang Yiting, aged thirteen, became

a junior clerk in a banking house founded by Li Yeting (1807–1868). Though the work was hard, he never stopped painting. He studied and copied the many works waiting to be mounted at Yichuntang 怡春堂 (a local supply shop for scholars' studios). Among them were works by Ren Bonian 任伯年 (1840–1896), already a painter of renown in Shanghai. Soon afterward, Wang Yiting met Ren and became his student. Wang's early works clearly show the profound influence of Ren Bonian, which persisted even after Wang became Wu Changshi's student a few years later.

From apprenticeship and low-level position in two Li-family banking firms, Wang Yiting at age twenty-two (1888) became manager of the shipping department of the Tianyuhao 天餘號 Banking House, the linchpin of the Li family fortune.[24] All this time, he continued to produce a large number of paintings, of which the most representative was the eight-sheet album *Warning Bells* (*Jinshi chenzhong*; 1888).[25] In 1902, at age thirty-four, Wang Yiting became a comprador for the Japan Osaka Merchant Shipping Company (Nippon Osaka yūsen kabushiki kaisha 日本大阪郵船株式會社). This could be seen as the turning point of his career, as well as the first indication of the significant role he would play in Sino-Japanese relations. While working for the company, he made many Japanese friends, including such calligraphers and painters as Kawai Senrō 河井仙郎 (1871–1945) and Mizuno Sobai 水野疏梅 (1864–1921) (*Fig.* 5). In Japan at that time, some artists and intellectuals were interested in *beixue* (study of the content and primarily the calligraphy of ancient Chinese stelae), then popular in China. Some Japanese artists visited China with the intention of bringing the study back to Japan, so as to invigorate the calligraphy there. Wang Yiting played an indispensable role in introducing Japan to *jinshixue*, and in particular to the art of Wu Changshi.

Wu Changshi, who was Wang Yiting's senior by twenty-three years, was undoubtedly one of the foremost artists to emerge from modern *jinshifeng*. He was influenced early on by Ren Bonian and later, following Zhao Zhiqian, he became another master of the "Four Perfections." He met Wang Yiting in 1911, and at the younger artist's repeated invitation and assurance of living expenses, moved from Suzhou to Shanghai. There the two became close friends and artistic allies. With many new schools and trends burgeoning, including Western-style art and commercial art, Shanghai's visual culture was undergoing a period of unprecedented vitality. Under their influence, the *jinshi* style became dominant in Shanghai during the early years of the Republic.

Wang Yiting's art changed after meeting Wu Changshi. Under the influence of the older artist, Wang Yiting turned away from the suave and ingratiating style of Ren Bonian's painting toward the powerful and classical *jinshi* manner. He did not, however, become a mere epigone, but developed his own style, which employed strong and vigorous brushwork to imbue his paintings with the qualities of ancient seal script. Moreover, Wu Changshi painted mainly flowers and trees, whereas Wang Yiting excelled at figures. His depictions of icons of Chan 禪 Buddhism,

24. See Xiao Fenqi, "Wang Yiting shiji (Wang Yiting's Life)," *Duoyun* (*Cloud*) (Shanghai: Shuhua chubanshe, 1998), no. 49, p. 47.

25. Wang Zhongde and Xu Chungwei, eds., *Wang Yiting huaji* (*The Paintings of Wang Yiting*) (Shanghai: Shanghai shuhua chubanshe, 1988), pl. 1–4.

of which he was a devotee, were particularly popular with his Japanese friends (*Fig. 6*). His zest for learning new things is attested by ten or more oil paintings from his hand. To pursue painting, business, and piety, Wang Yiting maintained a studio close to his office, where he started the day by worshipping the Buddha, then painted from seven to ten o'clock in the morning before turning his attention to business.

Wang Yiting's commercial career was nearly at its apex when he met Wu Changshi. He was then comprador for both the Nisshin Shipping Firm (Nisshin kisen kaisha 日清汽船會社) and the Japan Osaka Merchant Shipping Company, as well as chairman of the board of the Shanghai Silk Manufacturing Company (Shanghai zhizhao juansishe 上海製造絹絲社) established by the Mitsui Foreign Company (Mitsui yōkō 三井洋行). He was also director or chairman of the board for numerous Chinese companies and banks, and he was twice elected president of the Shanghai Chamber of Commerce. In 1910, Wang Yiting joined the Chinese Revolutionary League (Tongmenghui 同盟會). When Shanghai was reclaimed in full by China in 1911, he became Minister of Transportation (Jiatong buzhang 交通部長) of the Republic's Shanghai government and later its Minister of Commerce (Shangye buzhang 商業部長). To his business and political activities, Wang Yiting added philanthropic work, such as disaster relief and orphan education. As a leader in painting circles, he participated in, sponsored, and lent his name to innumerable art schools, societies, exhibitions, and publications, gaining no less than ten honorary titles. Notwithstanding these numerous activities, Wang the accomplished artist also led the Shanghai art scene for a decade.[26]

Wang Yiting was not unique in his double role as business magnate and master artist. In Beijing, another businessman and comprador, Jin Cheng 金城 (1878–1926), became known as the "godfather" (Guangda jiaozhu 廣大教主) of the city's painting circles during the early years of the Republic.[27]

Unlike Wang Yiting, a Shanghai native who began his career as an apprentice, Jin Cheng came from an affluent merchant family in Zhejiang Province. He studied in England and became an official under the Qing dynasty. When the Republic was established, he served the new government in Beijing, becoming the leader of that city's art scene.[28] His father and grandfather, both successful merchants, had become merchant-gentry by "purchase" of official rank (*mai gongming* 買功名). As the eldest son, Jin Cheng began his rise in business by inheriting the family business interests and the government post. He also established his own enterprises. He once collaborated with English busi-

26. Zheng Weijian, "Wang Yiting", *Zhongguo shuhua mingjia jingpin dadian* (*Masterpieces by Famous Chinese Calligraphers and Painters*) (Hangzhou: Zhejiang jiaoyu chubanshe, 1998), vol. 3, pp. 1113–30.

27. Chen Xiaodie, "Cong meizhan zuopin ganjuedao xiandai guohua huapai (Perceiving the Stylistic Schools in Modern Chinese Painting from Works in the Art Exhibition"), *Meizhan* (*Art Exhibition*) (Shanghai, 29 April 1929), no. 4, p. 1.

28. Jin Cheng was originally called Jin Shaocheng 金紹城, style name Gongbei 拱北 and Gongbei 鞏北, and sobriquet Ouhu 藕湖. He was born in Nanxun 南潯, Guian 歸安, Zhejiang Province, into a family of wealthy raw silk producers. In 1902 Jin Cheng went to study law in England; he remained in the West to study art in France and America. Toward the end of the Qing dynasty, Jin Cheng was sent to Europe to attend the International Conference on Prison Reform and to observe the prisons there. When he returned to China, the dynasty had ended. See Chen Baochen, "Qing gu tongyidafu Daliyuan tuishi Jinjun muzhiming (Epitaph of the Former Qing Learned Official and Daliyuan Judge, Mr. Jin)," *Minguo renwu beizhuanji* (*Epitaphs of Persons of the Republic*) (Beijing: Tuanjie chubanshe, 1995), pp. 709–10.

nessmen in a machinery-trading joint venture.[29] In 1916 he accepted an appointment as Beijing branch manager of the Chartered Bank of India, Australia, and China, founded in 1853 with headquarters in London. Its Shanghai branch, established in 1857, was the first foreign financial institution in China. In addition, Jin Cheng owned a major antique shop, Boyunzhai 博韞齋, which he had opened in 1911 in the Liulichang 琉璃廠 antiques district of Beijing (*Fig. 7*).

Jin Cheng contributed to the Beijing art scene in three main ways. First, he helped create the Institute for the Study of Ancient Objects (Guwu chenliesuo 古物陳列所). During his five years of study in England, Jin Cheng had visited numerous European museums and historic sites, and in 1910, when he was sent to Europe to attend the international Conference on Prison Reform, he observed European museum management in his spare time. He returned to China just as the new government was inventorying the artifacts and artworks kept at the Imperial Palace (Gugong 故宮) and the Rehe 熱河 Palace. In 1912 Jin Cheng was appointed to the Beijing Ministry of Internal Affairs (Neiwubu 內務部). His European experiences provided the inspiration for the aforementioned Institute for the Study of Ancient Objects within the Ministry. The Institute, opened to the public in October 1914, showed objects from the Forbidden City. With the departure from the Imperial Palace of the last Qing emperor, Puyi 溥儀 (1905–1967), the Imperial Palace Museum (Gugong bowuyuan 故宮博物院) was founded on 10 October 1925. Now art students and scholars could study and copy famous original works from the former imperial collection, making a major contribution to modern Chinese art history.

Second, Jin Cheng promoted the exchange of artistic ideas between China and Japan. He helped to establish the Oriental Painting Association (Dongfang huihua xiehui 東方繪畫協會), which organized four separate "China and Japan Joint Painting Exhibitions" (Zhong-Ri lianhe huihua zhanlan 中日聯合繪畫展覽). At the second exhibition, held in Tokyo, the works of Qi Baishi 齊白石 (1865–1957) were introduced to Japan.[30]

Last, Jin Cheng founded the largest art society in Beijing, the Society for the Study of Chinese Painting (Zhongguo huaxue yanjiu hui 中國畫學研究會). Its establishment was announced on 29 May 1920 at a meeting of the Western Returned Scholars Association (Ou-Mei tongxuehui 歐美同學會) at the Shidazi 石達子 temple in the western part of the city. The stated aim of the Society was to "carefully study ancient methods; extensively gather new knowledge," and it trained a large number of professional Chinese painters. It held regular exhibitions, recruited students, employed teachers, and focused on instructing fledgling talents. Its instructional method differed from that of other contemporary art colleges by maintaining the Chinese tradition of master-disciple tutelage and by stressing the work

29. Xiao Weiwen, "Study on Jin Cheng" (Ph.D. diss., Chinese University of Hong Kong, forthcoming).

30. Yun Xuemei, "Zhongguo huaxue yanjiuhui de meishu jiaoyu (The Art Education of the Society for the Study of Chinese Painting)," in *Ershishiji Zhongguo meishu jiaoyu* (*Art Education in Twentieth-Century China*), ed. Pan Yaochang (Shanghai: Shuhua chubanshe, 1999), pp. 40–57. See also Zhang Zhaohui, "Hushe shimo ji qi pingjia (The Origin and Decline and an Evaluation of the Hu Society)," in *Jinbainian Zhongguohua yanjiu* (*Research into Chinese Painting of the Past Century*) (Beijing: Renmin meishu chubanshe, 1996), pp. 126–42.

of copying as a basic part of training; both these emphases were consonant with the society's aim to "carefully study ancient methods." Teachers numbered approximately ten, including Chen Shizeng 陳師曾 (1876–1923), He Liangpu 賀良樸 (1860–1938), Xu Zonghao 徐宗浩 (1880–1957), Xiao Qianzhong 蕭謙中 (1865–1949), Yu Ming 俞明 (1884–1935), and Jin Cheng himself. In 1927, after Jin Cheng's death, a battle for leadership split the Society into two groups. Jin Cheng's son, Jin Qian'an 金潛安 (1895–1946) formed the Hu Society (Hushe 湖社) with about two hundred members who were known as Jin Cheng's disciples. Over the next nine years, it published more than one hundred issues of the *Hu Society Monthly* (*Hushe yuekan* 湖社月刊). The remaining Society for the Study of Chinese Painting carried on for another twenty-odd years under the leadership of Zhou Zhaoxiang 周肇祥 (1880–1954); at its height it had more than five hundred members. It organized nineteen exhibitions of student works and published *Art Thrice-Monthly* (*Yilin xunkan* 藝林旬刊; from January 1928) and *Art Monthly* (*Yilin yuekan* 藝林月刊; from January 1930) for many years.

In the early years of the Republic, *guohua* 國畫 ("national painting") artists sought various responses to the notion of a "revolution in art." Some looked to the styles of the Tang and Song periods, some to the seventeenth-century manners of the "Four Monks" (Bada Shanren 八大山人, Shitao 石濤, Hongren 弘仁, Kuncan 髡殘) in the early Qing period, and others to the new Shanghai school or to the *jinshi* painting style formed during the Qianlong 乾隆 and Jiaqing 嘉慶 reigns of the mid-Qing in the eighteenth and early nineteenth centuries. The variety of artistic views and manners fostered in the capital helped spread southern painting styles to the north. The Society for the Study of Chinese Painting espoused a return to Tang and Song painting styles, but practiced assorted styles of the Song, Yuan, Ming, and Qing periods, both the literati and the academic modes, and even the methods of the Italian Qing court artist Giuseppe Castiglione (Lang Shining 郎世寧; 1688–1766). Starting from 1928, the generation of painters trained by the Society, including many northerners, became the core figures of the *guohua* movement in Beijing. Though Jin Cheng died at forty-seven and was only in Beijing for about fifteen years, he had an incomparable impact on painting circles in the capital, especially on the formation of the Beijing style known as the "Minor Northern School" (Xiao Beizong 小北宗; *Fig. 8*).

Not only were Jin Cheng and Wang Yiting significant artists and businessmen, they were also important organizers and promoters of Chinese art exhibitions, especially joint events with Japan. The country's first national art exhibition was held at the Nanyang Trade Development Fair (Nanyang quanyehui 南洋勸業會) in 1910, one year before the establishment of the Republic. Organized by the Qing government, the Fair featured an "Art Gallery" (Meishuguan 美術館) displaying *guohua* and handicrafts. Art exhibitions thereupon underwent unprecedented development in China at the start of the Republican era, and they rapidly became popular in Beijing and larger Chinese coastal cities, such as Shanghai, their organizational format copying that used in Japan. Chen Shizeng's 1917 work *Looking at Paintings* (*Duhua tu* 讀畫圖) recorded one of several charity art exhibitions held at the Central Park (Zhongyang gongyuan 中央公園) in Beijing, which Jin Cheng and others attended. Jin Cheng's Society for the Study of Chinese

Painting was highly active in promoting art exhibitions, especially those sponsored by the Japanese Boxer Indemnity (Gengzi peikuan 庚子賠款) that facilitated Chinese and Japanese art exchange. These became major art events in the early Republican era. In 1930 Wang Yiting established the Chinese and Japanese Artists Society (Zhong-Ri yishu tongzhihui 中日藝術同志會) and organized group exhibitions in Japan as well as in China.

I believe that the advent of formal art exhibitions in China was a natural result of the popularization and commercialization of culture, and that exhibitions accelerated the demise of traditional "literati painting." The original ideal of literati painters was to transform painting from a socially functional and propagandistic medium that served religion and politics to a personally expressive, recreational activity. To literati painters, the self-expressive process of creation mattered more than the end result, since it was not their intention to produce art for the service of society or for market consumption. In other words, literati paintings were not meant for public display. They were to be appreciated in private by, at most, a few like-minded souls, who would view them close up, even held in their hands. Literati painters never would have imagined that the "records" of their ink play would one day be shown to the public at large. In Europe, the exhibition format of salons, which appeared in the sixteenth century, did not fundamentally change painting formats or habits of art appreciation, because Western painting had always been created specifically for display. In contrast, the first Chinese public exhibitions, which prompted artists to paint mainly for public display, shook the very foundations of the literati painting tradition.

Scholars usually pay more attention to painters' artistic accomplishments than to their promotion of contemporary art activities. That Jin Cheng and Wang Yiting, both compradors for foreign companies, led the Beijing and Shanghai painting circles to prominence can be seen as the result of particular historical developments at the beginning of the Republic. Such figures could only have emerged at the end of the Qing dynasty and the start of the Republican era, when the country's political system and social structure were undergoing dramatic changes. Their experiences and accomplishments reflect broader transformations and demonstrate that art historians cannot ignore the impact of social and political change on later Chinese art.

The Republican Era: The Entrepreneur Chen Xiaodie and Art Criticism

The Chinese artists of merchant origin had diverse artistic interests; not all were followers of *jinshifeng*. Yet the relationship between *jinshifeng* and other stylistic schools or traditions was not polemical or adversarial; artists were not required to pledge exclusive allegiance to being either "innovative" or "conservative." The more urbane flavor of the Shanghai school coexisted peacefully with the *jinshi* style of painting. In fact, the so-called "Orthodox school" (Zhengtong huapai 正統畫派) as represented by the "Four Wangs" of the seventeenth century, which became imperially sanctioned and a widely popular Qing painting style, was not entirely unrelated to the *jinshifeng* trend.[31]

31. Wang Shimin 王時敏 (1592–1680), Wang Jian 王鑑 (1598–1677), Wang Hui 王翬 (1632–1717), and Wang Yuanqi 王原祁 (1642–1715) all studied Han clerical script. In particular, Wang Yuanqi's brushwork style contained hints of clerical script.

Wang Tongyu 王同愈 (1855–1941), a famous calligrapher and painter whose life spanned the end of the Qing and far into the Republican period, was highly regarded by Shanghai art aficionados. At the same time, he was a typical gentry merchant. Wang entered Qing officialdom via the civil service examinations, but in 1903 retired from office and went back to his hometown in Suzhou. Thereafter he devoted himself to commerce and industry. In 1905 he initiated a campaign to establish a Suzhou Chamber of Commerce (Suzhou shanghui 蘇州商會). Later he became the president of the Sujing Sulun Silk Curtain Factory (Sujing Sulun sishachang 蘇經蘇綸絲紗廠) and, together with Zhang Jian 張謇 (1853–1926), also took charge of the Jiangsu Provincial Railway Company (Jiangsusheng tielu gongsi 江蘇省鐵路公司).[32] During the 1911 Revolution, Wang Tongyu was living in Shanghai; his old age was spent near Shanghai, in Nanxiang 南翔, Jiading 嘉定, Jiangsu Province (*Fig. 9*).

Wang Tongyu did calligraphy and painting in the canonical styles of the "Two Wangs" (Wang Xizhi 王羲之 and Wang Xianzhi 王獻之) of the Eastern Jin in the fourth century and the Four Wangs, respectively, and at times considered himself an Orthodox artist.[33] Yet he also followed the painting styles of Wen Zhengming 文徵明 (1470–1559) and Tang Yin of the Wu school, and he studied all calligraphic script types (*Fig. 10*). His small seal script was modelled after inscriptions on Han dynasty steles; for the pre-Qin script, he practiced that based on an inscription on a Zhou-period bronze from the state of Guo known as *Guojizi pan* 虢季子盤. His model for clerical script was the *Stele of Sacrificial Vessels* (*Liqibei* 禮器碑) in the Temple of Confucius (Kongmiao 孔廟) at Qufu 曲阜, Shandong.[34] Wang Tongyu also wrote on *jinshixue*, including *A Dictionary of Difficult-to-Decipher Words in Standardized Seal Script* (*Xiaozhuan yinanzi zidian* 小篆疑難字字典), still a useful reference. He was a skilled seal carver as well. Clearly, Wang Tongyu did not completely disregard *jinshifeng*.[35] Jin Cheng also has been erroneously labelled an ardent and conservative advocate of "Chinese essentialism" (*guocui* 國粹) with little use for modern *jinshifeng*. To the contrary, Jin Cheng had a passion for seal carving. He followed the Zhe school founded by Ding Jing, and he also learned from other schools, including those of Deng Shiru and Zhao Zhiqian. His posthumously published *Collected Prints of Seals by Jin Cheng* (*Beilou yincun* 北樓印存) illustrates more than six hundred of his seals, carved over a period of twenty years. Although Jin Cheng made no great contribution to philology, his art of seal carving attests to the strong influence of *jinshifeng*.

During the Qing period, new calligraphic styles emerged and the aesthetic standards by which calligraphy was judged had changed fundamentally. This "revolution in calligraphy" directly and indirectly effected important

32. Zhang Kaiyuan, Ma Min, and Zhu Ying, eds., *Zhongguo jindaishishang de guanshen shangxue* (*The Commerce of Gentry Merchants in Modern Chinese History*) (Wuhan: Hubei renmin chubanshe, 2000), p. 222.

33. Lu Yanshao, *Lu Yanshao zishu* (*Autobiography of Lu Yanshao*) (Shanghai: Shanghai shuhua chubanshe, 1986), pp. 10–21.

34. Gu Tinglong, ed., "Qing Jiangxi tixue Wanggong Xingzhuang (Biography of Mr. Wang, Minister of Education in Jiangxi Province During the Qing Dynasty)," in *Minguo renwu beizhuanji* (*Epitaphs of Persons of the Republic*), ed. Bu Kaoxuan and Tang Wenquan, pp. 239–44.

35. See Gu Tinglong, ed., *Wang Tongyu ji* (*Collected Essays of Wang Tongyu*) (Shanghai: Guji chubanshe, 1998).

transformations in other visual arts, including painting. Painters modelled compositional arrangement, balance, and contrast after seal, clerical, and Wei stele calligraphy, and sought to imbue their works with the *jinshi* aesthetic. The *beixue* calligraphy theories, the *jinshi* taste found in painting, and the various schools of seal carving during the Qing are all important parts in modern Chinese art. Yet in the outpouring of revisionist sentiment that marked the Reform Movement of 1898 (Wuxu bianfa 戊戌變法) and the New Culture Movement (Xinwenhua yundong 新文化運動) of the early twentieth century, Chinese painting was estimated to be "at the worst point of decay," "unscientific," and in need of a turn to Western realism or a "fusion of East and West." Specifically and overwhelmingly condemned was literati painting, from the "Four Masters of the Yuan" (Yuan si dajia 元四大家) down to the Orthodox "Four Wangs" of the Qing. Amid this current of radical thought appeared a highly inconsistent painter and industrialist, Chen Xiaodie 陳小蝶 (1897–1989).[36]

Beginning in 1918, Chen Xiaodie sold his writings to earn money and help his father, Chen Diexian 陳蝶仙 (1879–1940), establish a family manufacturing business (*Fig. 11*).[37] For more than twenty years thereafter, he worked in the business in various capacities, including assistant manager and operations manager. The Chen industry began with tooth powder and cosmetics, then expanded in scale and range of products to include paper, magnesium, boxes, glass, soft drinks, mosquito repellent, and printing. Besides assisting in the family business, Chen Xiaodie also opened the Dielai 蝶來 Restaurant in Hangzhou and founded the Hanwen Zhengkai 漢文正楷 Publishing House with Zheng Wuchang 鄭午昌, Qiu Peiyue 裘配嶽, Sun Xueni 孫雪泥, and Li Zuhan 李祖韓. In 1935 he started a pawlonia tree plantation of over three hundred acres on Mt. Ding 定 in Dongyang 東陽, Zhejiang Province. In the same year, Chen Xiaodie also suffered great financial losses from failed property investments, but he continued to form other enterprises.

Chen Xiaodie was also deeply interested in history and the arts; in his early years, he headed the Hangzhou City Xiuzhiguan 修志館 (an officially sponsored county historical society). Around 1920 he began to participate in the Shanghai art scene. Initially, he joined the Tianma 天馬 Society as a *guohua* painter, along with Wang Yiting, Feng Chaoran 馮超然, Wu Hufan 吳湖帆, Qian Shoutie 錢瘦鐵, and Tang Jisheng 唐吉生.[38] He then served on

36. Chen Xiaodie was born in December of 1897 in Hangzhou and died on 9 August 1989 in Taipei. Originally named Qu 蘧, style name Xiaodie 小蝶, he was also known as Dieye 蝶野, Zuilingsheng 醉靈生, and Zuilingxuan zhuren 醉靈軒主人. After age forty, he signed his name Dingshan 定山, and in later years Dingshanren 定山人 and Yonghe laoren 永和老人. He was also respectfully addressed as Dinggong 定公. Note that different sources give slightly differing birth and death dates.

37. Chen Diexian was a well-known man of letters and writer of popular fiction and also skilled in calligraphy and painting. See Wan Qingli, "Meishujia, shiyejia Chen Xiaodie (Artist and Businessman: Chen Xiaodie)," *Meishu yanjiu* (*Art Research*), no. 1 (2002), pp. 9–16.

38. The Tianma Society was formed on 28 September 1919 in Shanghai. Its founders included Jiang Xiaojian 江小鶼 (Jiang Xin 新), Ding Chu 丁怵, Liu Yanong 劉雅農, Zhang Chenbo 張辰伯, Yang Qingqing 楊清磬 and Chen Xiaojiang 陳曉江. It was one of the most famous Chinese art societies of the 1920s, with eight exhibitions and more than two hundred members by the time it disbanded in 1927. See *Chunshen jiuwen* (*Old Tales of Shanghai's Spring*), no. 1, p. 70. See also Xu Zhihao, *Zhongguo meishu tuanti manlu* (*A Broad Record of Chinese Art Groups*) (Shanghai: Shanghai shuhua chubanshe, 1994), pp. 33–38.

the organizing committee for the first National Art Exhibition (Quanguo meishu zhanlan 全國美術展覽) in China (1929) and edited the journal for that event, *Art Exhibition* (*Mei zhan* 美展) with Xu Zhimo 徐志摩 (1896–1932), Yang Qingqing 楊清磬, and Li Zuhan (*Fig. 12*).[39] After *Art Exhibition* ceased publication, he became one of the chief editors of *Art Weekly* (*Mei zhou* 美週).[40] In 1931 Chen Xiaodie served as an executive committee member for the Chinese Painting Association (Zhongguo huahui 中國畫會). Six years later he was one of eleven members in the calligraphy and painting division of the appraisal committee for the Burlington Exhibition that opened in London in 1937. In 1945 Chen Xiaodie founded the Chinese Painters' Gallery (Zhongguo huayuan 中國畫苑) in Shanghai with Li Zuhan, Wang Jiqian 王季千, Qin Ziqi 秦子奇, and others; it was one of the largest private art galleries in China at the time.[41] At the first general meeting of the newly founded Shanghai Art Association (Shanghai meishu xiehui 上海美術協會; 25 March 1946), Chen was elected to its twenty-six-member executive council.[42] In April of the following year Chen worked on the design committee of the Shanghai government's planning office for the building of the Shanghai Art Gallery (Shanghai meishuguan 上海美術館).

Chen Xiaodie's best-known writing is probably "Theory that Qing Paintings Are of No Significance" (Qingdai wuhualun 清代無畫論).[43] This essay, representative of the most vehement and sweeping criticisms of the "Orthodox Wang Painting" (Wang hua zhengzong 王畫正宗), joined earlier works such as Kang Youwei's 康有為 (1858–1927) "Paintings of the Modern Period are Utterly Decadent" (*Jinshi zhi hua shuaibai ji yi* 近世之畫衰敗極矣)[44] and Chen

39. First published on 10 April 1929 by the Shanghai National Art Exhibition Preparatory Committee, it was followed by nine more issues. Among its special contributors were the most influential Chinese painters and critics of the time, including Ye Gongchuo, Zeng Rannong, Wu Hufan, Feng Zikai, Xu Beihong, Wang Jiyuan, Huang Binhong, Shao Xunmei, Zheng Manqing, He Tianjian, Yu Jifan, Yu Jianhua, Lin Fengmian, Chen Ziqing, Zhang Yujiu, Ni Yide, Di Chuqing, Zhu Litang, Zhang Ruogu, Zheng Wuchang and Tang Yulu. The famous written debate between Xu Beihong and Xu Zhimo regarding European modernist paintings, and Li Yishi's and Yang Qingqing's responses, were printed in issues 5, 6, 8, and 9 of the magazine, and in the special last issue. Chen Xiaodie published three essays in *Art Exhibition*: "Yishu zishen de reli (The Heat within Art)" (no. 1), "Cong Mei zhan zuopin ganjue dao xiandai guohua huapai (Perceiving the Stylistic Schools in Modern Chinese Painting from the Exhibits in the Art Exhibition)" (no. 4), and "Kan hua de jueqiao (The Key to Appreciating Paintings)" (no. 10). His categorization in the second essay of *guohua* stylistic schools at the time continues to be used today.

40. *Art Weekly* published eleven issues. It printed one essay by Chen Xiaodie entitled "Xiandai huapai zhi wenluan (The Confusion Regarding the Stylistic Schools in Contemporary Painting)." See *Zhongguo meishu tuanti manlu*, pp. 59–60.

41. The Chinese Painters' Gallery offered exhibition and gathering spaces for painters. Exhibitions were held on the three levels of the main hall, which could show three hundred works. The east veranda served as an art studio, and sometimes as a banquet hall. The "Exhibition of Original Works from the Song to Qing Dynasties," the first exhibition at the Chinese Painters' Gallery, showed the best works from private collections. Over the seven days of the exhibition, the one-dollar entry fee yielded a total of more than twenty thousand dollars, from which a Painters' Gallery fund was set up; from this fund loans were made to poor artists to pay for exhibition costs, such as mountings and advertisements. See *Chunshen jiuwen*, no. 1, pp. 71–72, no. 2, pp. 49–50, and *Chunshen xuwen*, p. 153.

42. The Shanghai Art Association, an artist group initiated jointly by members of the Shanghai art scene, was Shanghai's largest comprehensive art organization before 1949. See *Chunshen jiuwen*, no. 2, pp. 53–54; and *Zhongguo meishu tuanti manlu*, pp. 245–46.

43. Chen Xiaodie, "Qingdai wuhua lun", *Guohua yuekan* (*Guohua Monthly*), no. 2 (1934), pp. 18–19; no. 3 (1935), p. 37.

44. Kang Youwei, *Wanmu caotang* (*Thatched Cottage of Ten Thousand Trees*) (Taipei: Wenshizhe chubanshe, 1977), preface, p. 1.

Duxiu's 陳獨秀 (1880–1942) "Abolish the Wangs' Painting" (Ge Wanghua ming 革王畫命),[45] which advocated the radical reform of Chinese painting. Chen Xiaodie believed that true creativity in every era was unique; he criticized painters of the Qing dynasty, in particular Wang Hui 王翬 (1632–1717), whom he considered the most influential of them, for eschewing originality in favor of emulating the ancients. Chen asserted that in the three hundred years of Qing rule, no paintings of importance had been created. In addition, Chen made the rather forced argument that a polity's art historical development mirrored its political fortunes. His essay concludes,

> Painting relates to the rise and fall of a dynasty; how can it be inconsequential? Therefore, I say, paintings of the Qing dynasty are of no significance at all. We must learn [from this] as the Zhou dynasty learned from the mistakes of the Shang dynasty; how can one not be concerned?[46]
> 則於畫也，關係一代興亡，又豈小哉？故吾曰：清代無畫者，亦殷鑑知周之義耳，可不懼乎！

He Tianjian 賀天健 (1891–1977), then chief editor of *Guohua Monthly* (*Guohua yuekan* 國畫月刊), in the following year (1935) vehemently supported Chen's arguments in the pages of that journal.[47] Perhaps Chen Xiaodie was reflecting the dissatisfaction felt by some of the young *guohua* elite toward Chinese painting in the Republican era as well as their own inner conflicts about what modern Chinese painting should be. At the same time, the works produced by these same artists emulated the ancients and synthesized existing styles, and many of them in their writings were willing to recognize the accomplishments of painters after the Qianlong and Jiaqing reigns. Thirty-three years later (in 1967), Chen himself wrote,

> Since the two Shi [Shitao and Shiqi 石谿 (Kuncan)] and Bada [Shanren] became popular, the Four Wangs, Wu [Li] 吳曆, (1632–1718), and Yun [Shouping] 惲壽平 (1633–1690) have been considered 'not worth mentioning,' and *there are those* [italics supplied] who even theorize that there were no paintings of significance in the Qing period.[48]
> 自二石、八大盛行於時，提到四王吳惲，一概視為『不足道』，甚（至）有作清代無畫論者。

Chen seems to be disclaiming his "Theory that Qing Paintings Are of No Significance."

As an organizer and critic, Chen Xiaodie not only actively promoted art exhibitions, but also made pioneering contributions to the study of painting at the end of the Qing and the beginning of the Republican era. After the Shanghai Art Gallery planning office was established in 1947, one of its initial responsibilities was the organization of the first "Exhibition of Chinese Paintings of the Past Century" (Jin bainian huihua zhan 近百年繪畫展). Its success had the effect of refuting the widespread persuasion that "paintings of the modern period are utterly decadent," which had prevailed for more than half a century. Chen Xiaodie and Xu Bangda 徐邦達 (b. 1911) had originated the idea of the exhibition. Chen in particular—having repudiated his early denunciation of Qing painting—championed

45. Chen Duxiu, "Meishu geming: da Lu Cheng (Art Revolution: Response to Lu Cheng)," *Xin Qingnian* (*New Youth*), vol. 6, no. 1 (1917).

46. Punctuation added by the present author.

47. He Tianjian, "Shu Xiaodie Qingdai wuhualun hou (Following Xiaodie's 'Qing Paintings are of No Significance')," *Guohua yuekan*, no. 3 (1935), pp. 37–38.

48. Chen Dingshan, "Tongyin lunhua pinghou (Postscript to the Discussion of Paintings from the Tongyin Studio)," *Dingshan lunhua qizhong* (*Seven Essays on Painting by Dingshan*) (Taipei: Shijie wenwu chubanshe, 1969), p. 123.

the project as a ground-breaking undertaking, since exhibitions of ancient paintings in the past had "popularized works of the Tang and Song dynasties, and denigrated those of the modern period." The new exhibition comprised paintings dating from 1848 to 1947. The exhibition was held at the French Association on Nanchang Road from September 15 to 28, 1947. "It was a systematic and historical exhibition, which received an enthusiastic response from collectors and brought new knowledge to the art world. The head of the French Embassy Cultural Office . . . considered it a revelation of new life in Chinese art."[49]

For the occasion, the Shanghai Art Gallery Planning Office published *Catalogue of the Exhibition of Famous Chinese Paintings of the Past Century* (*Zhongguo jin bainian minghua ji* 中國近百年名畫集) and *Commentaries on the Catalogue of the Exhibition of Paintings of the Past Century* (*Jin bainian huazhan shilu* 近百年畫展識錄), both written by Chen Xiaodie, Xu Bangda, Wang Jiqian, and others. The latter gave a detailed account of the format, size, inscriptions, seals used, and provenance of each painting, as well as a brief biography of the artist. This voluminous work was the first published exhibition catalogue of academic value since formal exhibitions appeared in Chinese in 1910. In coordination with the establishment of the Shanghai Art Gallery Planning Office and its first exhibition of modern Chinese painting, *Shanghai Education Weekly* (*Shanghai jiaoyu zhoukan* 上海教育週刊) published the *Special Issue on Art* (*Meishu zhuanhao* 美術專號; vol. 4, no. 1). It consisted of twelve essays, ten of which were directly related to the exhibition, including Chen Xiaodie's "Introduction to the Exhibition of Paintings of the Past Century (including users' guide; *Jin bainian huazhan xu fu fanli* 近百年畫展序附凡例)". In discussing the significance of the exhibition, most of these essays defensively acknowledged the weaknesses of modern Chinese painting, but urged the importance of its study nonetheless. The writers hoped that the exhibition would prompt its viewers to deplore the confused state of modern Chinese painting and rouse them to work toward a revival. Like Jin Cheng, Wang Yiting, and other early Republican painters, Chen Xiaodie was also an active promoter and organizer of art exhibitions.

Chen Xiaodie's response to a poem by Zhang Daqian 張大千 (1899–1983) in "Introduction to the Forty-Year Retrospective Exhibition" (*Sishi nian huigu zhan zixu* 四十年回顧展自序) reveals Chen's confidence in his generation of artists: "The elders from the Qian[long] and Jia[qing] periods have flown away, but our generation can hold for three hundred years (乾嘉老輩飛騰過，我輩能支三百年)."[50] Only 140 years separated the death of Ding Jing in 1765 from the founding of the Xiling Seal Society in 1904. The Zhe school of seal carving had originated with a Hangzhou wine merchant, Ding Jing, and the founders of the Xiling Seal Society included the businessman and seal carver, Wu Yin 吳隱 (1866–1922), who had used his own funds to start the group.[51] The many masters and accom-

49. *Chunshen jiuwen*, no. 2, pp. 54–55.

50. Zhang Daqian's essay was published in Hong Kong's *Daren* magazine (predecessor of *Dacheng*), no. 31 (May 1972), p. 4. Chen's essay was published in the same magazine, no. 35 (September 1972), pp. 14–16.

51. Li Zao, "Liuchuan pulu renjuncan—Xiling yinxueshe chuangbanren zhi yi Wu Yin (Records Handed Down for the Reader's Perusal—Wu Yin, a Founder of Xiling Seal Society)," in *Xiling yinshe jiushinian* (*Ninety Years of the Xiling Seal Society*)

plished artists who came out of the *jinshifeng* movement since the Qianlong and Jiaqing periods had thus become "the ancients."

Then, for at least thirty years after 1949, the development of a commercial society in China that had begun in the middle of the fifteenth century was interrupted. In the last two decades, however, China is bustling with commercial activities, and the merchant class is once more on the rise. In these recent decades, some painters, sculptors, movie stars, and other artists have become merchants as well, but no accomplished artist has yet emerged among these businessmen. Perhaps a partial explanation of the discrepancy is that most present-day merchants do not aspire to traditional literati accomplishments.

(Hangzhou: Xiling yinshe chubanshe, 1993), pp. 31–32.

中國商人中有影響的藝術家—
1700–1948

萬青力

香港大學名譽教授

　　本文從藝術史研究的角度，考察了近代中國社會商業化進程，揭示了近代商人不僅是藝術贊助人，而且是美術創作和美術評論的參與者。他們積極推動美術展覽，組織美術社團，出版美術書刊，其中有些人甚至成爲藝術開派宗師或廣爲藝壇所擁戴領袖人物。本文通過對大量史料的歸納分析，證明近代中國藝術的轉型，是因爲中國社會出現了中不可忽略的新變數和新動力。明代中葉以後陸續出現的商人社會群體，成爲市民階層中的最有勢力的核心集團，對近代中國社會經濟、文化的轉型有重大影響。新興商人對文教事業的直接參與，在一定程度上左右了中國社會文化的演變格局。也正是在十八世紀，有實力、有影響的美術家（書畫家、篆刻家、評論家）開始在商人社會群體中出現，這種兼有藝文與商業雙重身份的新型市民，與歷史上的「文人士大夫」藝術家的性質顯然不同，仍然籠統地把這些人歸屬爲“文人”藝術家，已經與史實不相符合。雖然近代儒家思想經歷了從輕商主義到重商主義的自身改革，然而傳統「農本商末」的輕商觀念遠未消失。近代文獻對書畫家或篆刻家(印人)中的商人身份，特別是十九世紀中期以前，仍然存在有意迴避或語爲不詳的現象，爲研究帶來一定困難。而到了十九世紀末及二十世紀初，具有商人身份、或某一時期作過生意的藝術家則越來越多，如何界定這種雙重身份，也有相當的難度。本文從十八世紀以來，商人身份確實、並且在藝術上有成就有影響的數十位代表人物中，選擇了丁敬、王同愈、金城、王一亭、陳小蝶等，以近代流行的「金石風」藝術潮流作爲切入點，探討他們的藝術主張，成就，貢獻和影響，及其他們在中國近代藝術史上的重要位置。

中国商人の中における影響力を有した芸術家たち—1700–1948

萬青力

香港大学名誉教授

　本論は、芸術史研究の視点から、近代中国社会が商業化していく過程を考察したものである。まず商人が美術制作に直接参加した新しい現象を示して、近代中国芸術の変化が、中国社会に現れた、見落とすことのできない新たな変化・原動力によったものであると指摘した。明時代中期以後、続々と出現した商人集団は、近代中国社会の経済・文化の変化に大きく影響を与えた。18世紀になると都市・鎮の経済は次第に豊富な資本を持った豪商や裕福な商人が左右するようになり、市民階層の中で最も勢力のある中心的な集団となった。新興商人は文化教育事業に積極的に参加し、中国社会文化の変化する様相をある程度左右した。又、18世紀には影響力のある優れた芸術家（書画家・篆刻家・評論家）が商人集団の中に現れるようになり、単なる芸術家のパトロン役を演じるだけでなく、芸術制作に直接参与し、芸術の流派の祖となる者、さらには芸術界の領袖となる者さえ登場した。芸術文化と商業という二重の身分を持つ新しいタイプの市民は、それまでの「文人士大夫」芸術家と性格が異なっている。彼らは漠然と「文人」芸術家とされてきたが、それは明らかに史実と合致していない。近代の儒家思想は軽商主義から重商主義へと自立的に変化していったが、商業を軽んじる伝統的な「農本商末」の観念が消えてなくなることはなかった。近代の文献では、商人身分の書画家・篆刻家（印人）について、特に19世紀中期以前、言及は依然として故意に避けられたか大まかなものでしかなく、研究はかなり困難な状態にある。19世紀末から20世紀初めになると、商人であるか、もしくは一時期商売を行った経験のある芸術家はだんだん増えていったが、この二重の身分を持つ者たちの範疇を定めるのも又かなり難しい。本論では、18世紀以降、商人であることが確かな代表的な芸術家を数十人選び出し、近代流行した「金石」スタイルの芸術の流れを切り口として、彼らの芸術の主張・達成・貢献とその影響を検討した。中でも、丁敬・王同愈・金城・王一亭・陳小蝶ら商人が近代中国芸術史上、如何に貢献し影響したかを重視した。

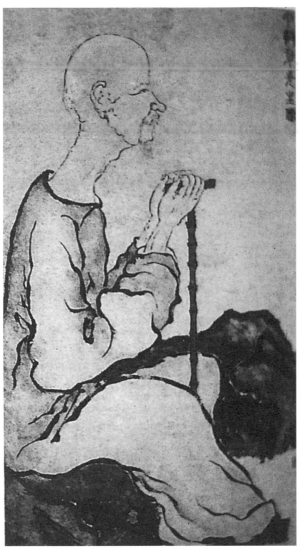

Fig. 1. Luo Ping (1733–1799). *Portrait of Ding Jing* (1695–1765). Hanging scroll, ink and light color on paper, 108 × 60.7 cm. Zhejiang Provincial Museum.

Fig. 2. Luo Ping (1733–1799). *Portrait of Jin Nong* (1687–1764). Hanging scroll, ink and light color on paper, 113.7 × 59.3 cm. Zhejiang Provincial Museum.

Wan Qingli

Fig. 3. Luo Ping (1733–1799). *Portrait of Deng Shiru* (1743–1805). Hanging scroll, ink and light color on paper, 113.7 × 59.3 cm. Beijing Palace Museum.

Fig. 4. Min Zhen (1730–?). *Portrait of Ba Weizu* (1744–1793). Hanging scroll, ink and light color on paper, 113.7 × 59.3 cm. Beijing Palace Museum.

Fig. 5. Photograph of (left to right) Wang Yiting (1867–1938), Mizuno Sobai (1864–1921), and Wu Changshi (1854–1927). Shanghai, 1920.

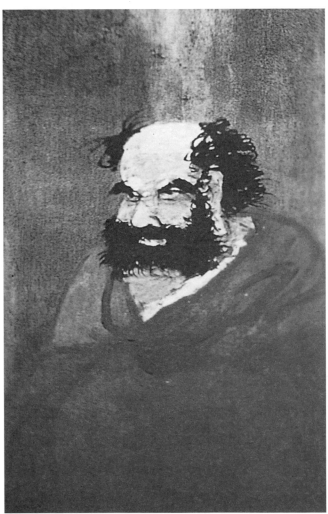

Fig. 7. Photograph of Jin Cheng (1878–1926). Beijing, 1917.

Fig. 6. Wang Yiting (1867–1938). *Bodhidarma*, 1930. Oil on canvas. Photo provided by the Wang Family.

Fig. 8. Jin Cheng (1878–1926). A *Herd of Goat in the Evening Glow*, dated to 1926. Hanging scroll, ink and color on paper. Private collection, Tainan. *(detail on page 527)*

柴斧溪渓法搨遠出雙蹄砥立夕陽中挑毛如綿羊存

白牲亚山坡佃卅叢　丙寅五月十司吳興金城

Fig. 9. Photograph of Wang Tongyu (1855–1941). Suzhou, 1924.

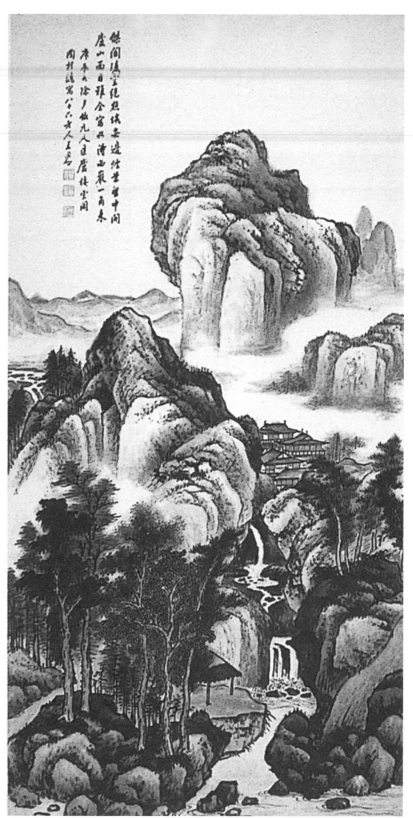

Fig. 10. Wang Tongyu (1855–1941), *Mt. Lu*, dated to 1940. Hanging scroll, ink and color on paper, 105 × 52 cm., Duoyun Xuan collection, Shanghai.

Wan Qingli

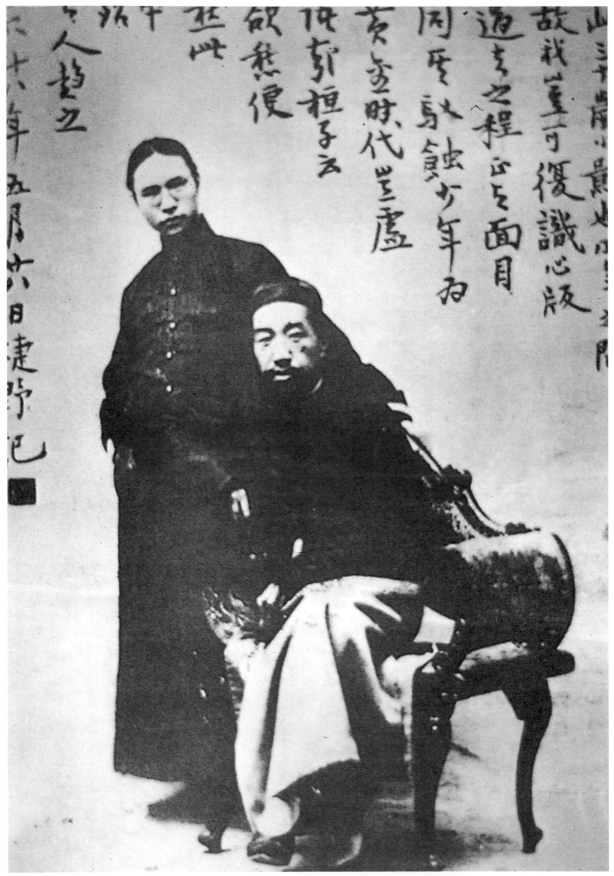

Fig. 11. Photograph of Chen Xiaodie (1897–1989) and his father Chen Diexuan (1870–1940). Photograph taken in 1927 and inscribed in 1929. Photo provided by the Chen Family.

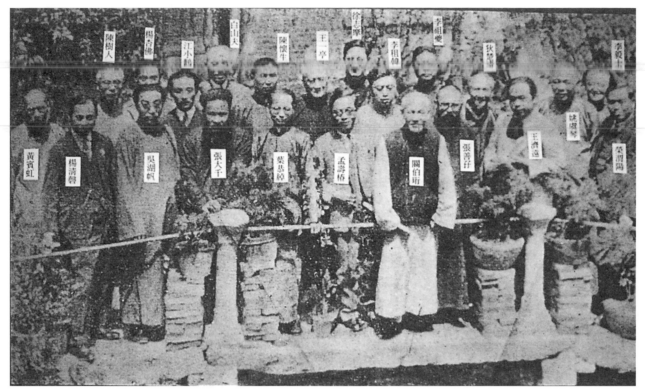

Fig. 12. Group photograph of art critics invited by the Art Exhibition, 1929.

Images of Cultural Identity in Colonial Taiwan:
From Huang Tushui's Water Buffalo to Lin Yushan's Home Series

Yen Chüan-ying

Institute of History and Philology, Academia Sinica, Taipei

In the spring of 1926, an artist who ran a mounting shop in the Taiwan city of Chiayi 嘉義, Lin Yushan 林玉山 (1907–2004), left home for the first time in his life and travelled to distant Tokyo to study art. Although the nineteen-year-old Lin had only six years of public school education, he was raised in his family's mounting shop, where he had learned a few basic painting techniques from painters hired by his family. At about age eleven, he started painting figures of traditional deities to sell. Whenever a customer came in with a fine old Qing-era painting to be remounted, he would study and copy it. From childhood, he especially liked to paint tigers, and before he had ever seen a living tiger he was already familiar with different kinds of tiger images. He also studied the tiger paintings and the large colorful pottery reliefs of dragons and tigers found in many local temples. His tiger paintings attracted a fair number of customers.[1] At sixteen, he made the acquaintance of Isaka Asahie 伊坂旭江, an amateur painter in the *nanga* 南画 (Southern School) style who worked in the Chiayi District Court. Under him, Lin studied the *nanga* painting tradition and encountered many Japanese art books from which he learned watercolors, the Japanese painting tradition, and concepts of realism.[2]

At the time, public education for most Taiwanese was limited to the primary school level; secondary and higher education was mostly for Japanese. Only a small number of Taiwanese students had the opportunity to go to Taipei and study in normal (teachers') or medical schools. In 1915 Taiwanese had raised capital to establish the first and only officially approved middle school for Taiwanese students in the Japanese colonial period, Taichung Middle School (Taizhong zhongxue 台中中學). But for Lin Yushan, living in Chiayi and needed in the family business, studying in Taichung was out of the question. No art school existed in Taipei, let alone in Chiayi. In 1923, when his *Descending the Mountain to Capture a Tiger* (*Xiashan qinhu* 下山擒虎) was selected for display in the exhibition held by the Chiayi Industrial Association (Kangyō kyōshinkai 勸業共進会), he decided to prepare himself for study

1. Lin Yushan, "Huahu mantan (A Casual Chat on Painting Tigers)," *Shida meishuxi jikan* (*Journal of the Taiwan Normal University Fine Arts Department*), 1974.3, repr. in *Taocheng fengya—Lin Yushan de huihua yishu* (*The Style of Taocheng—The Painting Art of Lin Yushan*) (Taipei: Taipei Fine Arts Museum, 1991), pp. 213–9. For the events of Lin Yushan's life, see Wang Yao-ting, "Lin Yushan de shengping yu yishi (The Life and Artistic Affairs of Lin Yushan)," *Taiwan meishu quanji—Lin Yushan* (*Comprehensive Anthology of Taiwanese Fine Arts—Lin Yushan*) (Taipei: Yishujia, 1992), pp. 17–47.

2. Interview with Lin Yushan conducted 15 December 1988. Isaka Asahie, who was originally named Isaka Shinnosuke 新之助, was included in the 1927 Taiwan Fine Art Exhibition, or Taiten 台展. In November 1933 he returned to Taiwan to organize a painting sale. He later retired to Kaohsiung 高雄; see *Taiwan nichi-nichi shinpō* (*Taiwan Daily News*), 1933.11.29, Chinese section, p. 4.

in Tokyo. *Tiger* (*Laohu tu* 老虎圖), completed the same year and still extant, reveals that he had already refined the traditional techniques to a considerable degree (*Fig. 1*). In 1924, a distant relative of Lin's, Chen Chengpo 陳澄波 (1895–1947), became the first student from Chiayi to be admitted to the Tokyo School of Fine Arts (Tōkyō bijutsu gakkō 東京美術学校). Every holiday, when Chen returned to Chiayi, Lin accompanied him on sketching expeditions and learned how to paint watercolor landscapes. He was strongly attracted to the techniques of Western realism that Chen had brought back.

Lin arrived in Tokyo in April 1926 and entered the Kawabata Painting School (Kawabata gagakkō 川端画学校) to study Western painting. In his very first summer in Tokyo, three major exhibitions opened that greatly expanded his perspective and left an indelible impression on him. The first, from May 1 to June 15, was an exhibition commemorating Prince Shōtoku 聖德 (574–622), which included more than one thousand works of Japanese-style painting from all of Japan's major schools and contemporary art groups, oil painting, sculpture, and handicrafts.[3] This exhibition made him realize the richness and consummate craftsmanship of modern Japanese art. He was particularly moved by the exquisite technique of Takeuchi Seihō's (1864–1942) 竹內栖鳳 *Cockfight*.[4] The second was an exhibition of contemporary French art (held from May 11 to June 25) that included painting and sculpture. Lin was impressed by the sense of color and overall gentle harmony of French painting that differed from the feeling one got from nature in Taiwan. The third one was a joint Sino-Japanese art exhibition (June 18–30). Most of the approximately four hundred Chinese paintings on display were by well-known contemporary Beijing artists, including the last emperor of the Qing dynasty (Puyi 溥儀 [1906–1967]), Qi Baishi 齊白石 (1863–1957), Jin Cheng 金城 (1878–1926), and others. These were displayed together with works by renowned Japanese artists. This was the first time that Lin had seen works by leading Chinese contemporary artists, and it bore home to him the preciousness of the ink painting tradition in which he had immersed himself since childhood. He decided to abandon the study of Western painting in favor of Japanese painting, but he continued to utilize extensively the techniques of realism, both on paper and on silk.[5]

Without doubt, among the works in the Prince Shōtoku exhibition that captivated Lin Yushan was the sole exhibit by a Taiwanese artist, Huang Tushui's 黃土水 (1895–1930) *Scenery of a Southern Country* (*Nanguo de fengqing* 南國的風情; *Fig. 2*). This is a large relief carving centering on water buffalo, a subject very representative of the "southern country" in question, Taiwan. Huang Tushui, born and raised in a Taipei woodworking family, was

3. This exhibition commemorating Prince Shōtoku was held in the Ueno 上野 New Art Museum and included 1,058 works. See Asahi shinbunsha, ed., *Nihon bijutsu nenkan* (*Japanese Art Yearbook*) (Tokyo: Asahi shinbunsha, 1927; repr. Tokyo: Kokusho kankō fukan, 1996), pp. 14–19, 28–30.

4. Takeuchi Seihō was born in Kyoto and studied the Shijō 四条 school of painting. In 1900–1901 he studied painting in Europe. Establishing his own new style, he taught at Kyoto Municipal School of Arts and Crafts (Kyōto shiritsu bijutsu kōgei gakkō 京都市立美術工芸学校) and elsewhere, and he served as a judge for the Bunten 文展 and Teiten 帝展 exhibitions in Taiwan.

5. Interview with Lin Yushan at his home on 18 May 2002.

the first Taiwanese student to study in the Tokyo School of Fine Arts. On graduating from Taipei Japanese (Normal) School ([Taihoku] Kokugo [Shihan] gakkō [台北]國語[師範]学校) in March 1915, he taught at a public school near his home. In September of that year, through the recommendation of the Governor-general of Taiwan, he was admitted as a special student in the Department of Sculpture at the Tokyo School of Fine Arts. Between 1920 and 1924, his work was included four times in the Imperial Fine Arts Exhibition (hereafter referred to as "Teiten 帝展"), which quickly made him something of a celebrity in Taiwan.[6]

Establishing the Rubrics of Taiwanese Art

Huang Tushui achieved fame for his images of Taiwan's water buffalo. Although water buffaloes are by no means unique to Taiwan, Huang's large images of them earned him a reputation as the first artist to have successfully captured them as part of Taiwan's essential landscape.[7] His several life-size relief images and sculptures of water buffaloes are set amidst other elements suggestive of Taiwanese life and scenery, such as egrets, herdboys, and banana trees. In 1923, on first planning to submit a work depicting water buffalo to the Teiten, Huang returned to Taiwan, where he obtained a buffalo and kept it indoors in order to study its form closely. He took more than five months to complete the plaster cast of the realist work *Water Buffalo and Herdboy* (*Shuiniu yu mutong* 水牛與牧童), which he shipped to Tokyo, only to have it destroyed in the Great Kantō 關東 earthquake of that year. In 1924 he returned once more to Taiwan and there produced *In the Country* (*Jiaowai* 郊外), which centered on water buffalo and egrets, earning him his fourth showing in the Teiten (*Fig. 3*). The 1925 Teiten contained no work of his, although he experimented continually with the water buffalo as subject. In his aforementioned *Scenery of a Southern Country* of 1926, the work that Lin Yushan saw in Tokyo, freestanding and purely realistic sculpture is superseded by a pastoral image with fluid, expressive lines that convey temporal continuity. Why, however, would Huang Tushui have focused his art so extensively on images of the water buffalo?

On entering the Tokyo School of Fine Arts, Huang devoted himself to studying the various techniques of contemporary sculpture, including work in stone, clay, and bronze, and at the same time considered which subject matter would best convey the particularity of Taiwan. *Aboriginal Boy* (*Fantong* 蕃童), his first work chosen for inclusion in the Teiten in 1920, was as its name indicates an image of a Taiwanese aborigine. But, like most Taipei dwellers, Huang knew very little about aboriginal life, so he abandoned this subject matter the following year. His next two works to be shown in the Teiten were typical academic marble sculptures of female nudes. In the spring of 1922, having graduated from the Tokyo School of Fine Arts and become a professional artist in Tokyo and having re-

6. Yen Chüan-ying, "Paihui zai xiandai yishu yu minzu yishi zhijian—Taiwan jindai meishushi xianqu Huang Tushui (Pacing between Modern Art and Ethnic Awareness—The Forerunner of Taiwanese Modern Art, Huang Tushui)," *Taiwan jindai meishu dashi nianbiao* (*A Chronology of Major Events in Taiwanese Modern Art*) (Taipei: Xiongshi, 1998), pp. vii–xxiii.

7. "Wuqiang di (The Tuneless Flute)," *Taiwan nichi-nichi shinpō*, 1924.7.11, Chinese section, p. 4.

examined his purposes, he published an important essay in Japanese entitled, "Born in Taiwan" (*Taiwan ni umarete* 台湾に生てれ). In this essay he declared his resolve to base his work on his Taiwanese identity and to devote his life to artistic creation. He recommended Taiwan's excellent natural environment as fine artistic subject matter and appealed to Taiwan's young people to create a "Formosan" art. Later, in a news interview entitled "Huang Tushui Bitterly Decries Taiwan's Art as an Extension and Emulation of Chinese Culture" (*Taiwan no bijutsu wa Shina bunka no enchō to mohō to tsūtan suru Kō Tosui shi* 台湾の芸術は支那文化の延長と模倣と痛嘆する黄土水氏), he strongly criticized contemporary Taiwanese art as vulgar, citing the art appearing in Taiwan's temples as an example and disparaging some of it as merely a remnant of "Chinese culture."[8] Thus, when he submitted his *Scenery of a Southern Country* to the Prince Shōtoku commemorative exhibition in 1926, he was asserting his Taiwanese identity and declaring his ambition to create a distinctively Taiwanese art.[9]

Huang Tushui's imagery of water buffalo must have been instructive for Lin Yushan, for when the first officially supported Taiwan Fine Arts Exhibition (hereafter "Taiten 台展," organized by the Association of Education [Kyōikukai 教育会]) was held in October 1927, Lin successfully submitted two works containing images of water buffalo, *Great South Gate* (*Da Nanmen* 大南門; *Fig. 4*) and *Water Buffalo* (*Shuiniu* 水牛; *Fig. 5*). The first, a horizontal composition in color, depicted a young buffalo grazing near the Qing-era South Gate in Tainan 台南, which, though dilapidated, retained vestiges of its former grandeur. Lin's second painting is a tender close-up scene of a water buffalo licking its young, executed in the traditional ink medium but revealing the chiaroscuro effects that imply Western techniques of painting from life. Both works may be described as realistic. Huang Tushui's use of the water buffalo as symbol of Taiwan and as a distinctive subject of a new Taiwanese art resonated with Lin Yushan's predilection for animal paintings. Though Lin as a youngster had favored tiger painting, he never submitted a tiger painting to any of the sixteen Taiten, but the water buffalo, which had come to symbolize the new Taiwan, was one of his frequent subjects in art.

In the World of Modern Art

Huang Tushui was born twelve years before Lin Yushan and only nineteen days after the Qing court ceded authority over Taiwan to Japan.[10] During his formative years, Huang experienced the transition from Qing Chinese culture to Japanese colonial rule. Why would he criticize Taiwan's culture as vulgar, a mere remnant of old Chinese

8. "Taiwan no bijutsu wa Shina bunka no enchō to mohō to tsūtan suru Kō Tosui shi," *Taiwan nichi-nichi shinpō*, 1923.7.13, p. 7; translated into Chinese and reprinted in Yen Chüan-ying, *Fengjing xinjing* (*Landscape Moods: Selected Readings in Modern Taiwanese Art*), ed. Yen Chüan-ying (Taipei: Xiongshi, 2001), vol. I, pp. 131–32.

9. Huang Tushui, "Taiwan ni umarete," *Tōyō* (*Eastern*), 25-2, 3 (1922.3); trans. into Chinese and repr. in Yen Chüan-ying, ed., *Fengjing xinjing*, vol. I, pp. 126–30.

10. Huang Tushui was born on 3 July 1895, and Kabeyama Sukenori 樺山資紀 (1837–1922), the first Japanese governor-general of Taiwan, held the "installation ceremony" of the new government in Taipei on June 17.

culture? He grew up in a wood-carving family in the old Taipei neighborhoods of Wanhua 萬華 and Dadaocheng 大稻埕 and learned the techniques of carving images of folk deities. As noted above, after he graduated from the Japanese Normal School in Taipei, he became the first Taiwanese to receive a government scholarship to study at the Tokyo School of Fine Arts. Lin Yushan, growing up in his family's mounting shop in Chiayi, learned the techniques of painting Buddhist folk images. He could have remained in his hometown and made his living with such works, but he was drawn to study in Tokyo in order to pursue the techniques of realism and "sketching from life" (*xieshi* 寫實) to which Chen Chengpo had introduced him. Both Huang and Lin started from a foundation of traditional Chinese arts and crafts and went on to study modern art. Soon after they were exposed to modern art, they developed quite different attitudes toward traditional Chinese culture. This divergence may be attributed not only to differences in personality but also to the different historical backgrounds of Taipei and Chiayi, of which more later.

During his years in Tokyo, Huang's strong sense of mission, combined with his hunger for a place on the global art stage, led him to begin by highlighting Taiwan's distinctiveness. His decision not to return to Taiwan after graduation may perhaps be related to the early demise of most of his relatives, leaving virtually no family to which he could return.[11] More importantly, he thought that by remaining in Japan to continue his creative work and research he would keep in touch with contemporary art circles.[12] To keep pace with the modern era, Huang considered it necessary to create a new, contemporary Taiwanese art, one completely distinct from the Chinese tradition. To that end, he drove himself continuously (and ended up dying prematurely in 1930). All the art that appeared in Taiwan's temples, the painting and sculpture inherited from Chinese folk traditions, and even the realistic antique-style ink paintings, bird-and-flower paintings, and works of the type that hung in middle-class homes had to be rejected. The water buffalo images that he explored were not just a display of academic realist technique but a means of praising Taiwan's distinct characteristics and homely, artless scenery, as in, for example, his representative work *A Southern Country* (*Fig. 6*), completed in 1930 with heroic effort just before he died. In brief, his pursuit of modern sculpture led Huang to cut himself from old Chinese traditions and to attempt a new Taiwanese art suited to the spirit of the times.

For the art scene in Taiwan, Huang was ahead of his time. To pursue his creative activities and invent contemporary modes of expressing Taiwanese subject matter, he had to be in Tokyo. Europe, to him the fountainhead of sculpture, was out of reach, and China provided no inspiration for modern sculpture. Likewise, Taiwan lacked public art spaces or exhibitions that could accommodate large sculpture, and the omission of a sculpture division in the first Taiten in 1927 was to be expected. Although Huang hurried back to Taipei to hold his one and only solo show at the

11. Huang Tushui's father, Huang Neng 黃能, passed away in 1906; his mother's brother and mother died one after the other in 1918; and his older brother died in 1924, leaving an orphaned son whom Huang Tushui brought with him to Tokyo.

12. "Huang Tushui yixi tan (A Talk by Huang Tushui)," *Taiwan nichi-nichi shinpō*, 1923.5.9, Chinese section, p. 4.

same time, it could not compete in prestige with the Taiten.[13] His decision to make his career in the intensely competitive art world of the colonizer contributed to the exhaustion that led to his death.[14]

By contrast, for Lin Yushan, whose background was in ink painting, abandoning tradition and starting anew was simply not an option. Although Lin went to Japan twice to study, he never withdrew from his life and cultural circle in Chiayi and the *Tōyōga* 東洋画, or Eastern Painting, division of the annual Taiten became the most important venue for displaying his work. Like Huang Tushui, Lin studied diligently. But while he studied *nihonga* 日本画 and modern techniques in Japan, Lin had to continue producing images of deities and traditional works in order to support his parents, his extended family, and his own seven children.[15] Of a warm and courteous demeanor, during the three years (1926–1929) spent studying at the Kawabata Painting School, he returned to Taiwan every vacation to look after operations of the mounting shop. Meanwhile, he continued painting divinities for Buddhist or Daoist temples and bird-and-flower paintings for private homes, which provided the main source of income for the mounting shop. He also received commissions for illustrations from book and magazine publishers. Most of these were for illustrating traditional, popular folk tales, such as *Tale of Monk Ji* (*Jigong zhuan* 濟公傳), *Tale of the Water Margin* (*Shuihu zhuan* 水滸傳), and *Romance of the Three Kingdoms* (*Sanguozhi yanyi* 三國志演義), though some were for works of popular modern fiction like *Ah Q's Younger Brother* (*A Q zhi di* 阿Q之弟).[16] Despite the difficulties of making ends meet, Lin was able to draw from the rich cultural resources within his Chiayi circle.

Whereas Taipei began to develop rapidly through commerce and trade at the end of the Qing dynasty and was completely transformed into a modern commercial hub after the office of the Governor-general was established there, Chiayi began as an agricultural village in the early seventeenth century, brought under cultivation by the Chinese and Dutch. About seventy kilometers from Tainan, the local seat of government in the Qing dynasty, and situated in the middle of the Chiayi-Tainan plain, Chiayi during the Japanese colonial era was still under the jurisdiction of Tainan Prefecture (Tainan-sho 台南州). In 1908 the railway linking the north and south of Taiwan, which runs through Chiayi, was completed, and in 1910 the railroad from Chiayi to Alishan 阿里山 was finished. From 1906 to 1911 a plan to rebuild the streets of Chiayi according to a grid pattern was carried out, and by 1920, with a population of approximately four hundred thousand, Chiayi was named a city. With its main industries related to wood-

13. For reports concerning Huang's solo show, see Yen Chüan-ying, *Taiwan jindai meishu dashi nianbiao*, p. 89. Most of the works shown were busts and sculptures of small animals. None of his large-scale representative works were included, probably out of consideration for shipping costs. None of the newspapers printed any reviews.

14. For a discussion of Huang's absence from the 1925 Teiten, see Yen Chüan-ying, "Taiwan jindai meishushi xianqu Huang Tushui," pp. xviii–xix.

15. The most vivid description of Lin's personality and his living conditions during the colonial era may be found in Huang Oupo, "Lin Yushan jiaoshou qiren qihua (Professor Lin Yushan—His Person and His Paintings)," in *Taocheng fengya—Lin Yushan de huihua yishu*, pp. 20–43.

16. Lin Po-ting, *Jiayi diqu huihua zhi yanjiu* (*A Study of Painting in the Chiayi Area*) (Taipei: Guoli lishi bowuguan, 1995), pp. 64–70.

working and sugar refining, it also became an emerging hub for tourism.[17] Meanwhile, the activities of numerous local poetry groups that originated during the Qing dynasty continued and extended to include the Japanese in the colonial period. They would invite well-known teachers with whom members would study poetry and calligraphy.[18] When the Taiten was established, local gentry established the Raven Society (Yashe 鴉社) for the study of traditional painting and calligraphy and to promote the development of local culture.[19] After the young Lin Yushan had gained recognition by showing his work in the Taiten, he was invited to join several poetry societies, where he studied the composition of Chinese poetry and shared his knowledge of painting. Chiayi's prosperity attracted many artists from Japan and China to visit, depict the local scenery, and hold art exhibitions. The local gentry also enjoyed interacting with them, and this further stimulated local cultural development.[20] The open-minded and diligent Lin Yushan made full use of the resources available to him to organize reading groups and join poetry societies, through which he studied Chinese poetry and the Mandarin dialect. At the same time, he organized several painting societies, through which he guided other local artists and persons with artistic interests. They organized regular shows, and eventually this led to a steady increase in local representation at the Taiten.[21]

The first Taiten of 1927 was divided into two sections, Western Painting (*Seiyōga* 西洋画) and Eastern Painting (*Tōyōga*). Many of the artists exhibiting in the Western Painting division were only about sixteen years old, being students at the Normal School in Taipei. Only three Taiwanese artists had their works selected for the Eastern Painting division, and all of these, including Lin Yushan, were about twenty years old.[22] The local gentry of Chiayi organized a special banquet to celebrate the success of Lin and Chen Chengpo. By this time Chen, twelve years older than Lin, had already exhibited twice in the Teiten in Tokyo, so his reputation had already soared. The Chiayi gentry revelled in the young artists' honors, and many younger students were eager to emulate them. The success of

17. Lin Zihuo, "Rizhi shiqi Jiayi jieshi shishi chutan (A Preliminary Exploration of the History of Chiayi City and County in the Japanese Colonial Era)," *Jiayishi wenxian (Documents of Chiayi City)* 5 (1989.8), pp. 1–16.

18. Lai Hezhou, "Zhulo wenhua sanbainian gaishuo (Three Hundred Years of Chiayi Culture)," *Jiayishi wenxian (Documents of Chiayi City)* 1 (1961.10), pp. 43–47.

19. The Raven Society was established in the spring of 1928 by Chiayi literary figures; see the short biography of Su Xiaode 蘇孝德 (1878–1941) in *Xiandai Taiwan shuhua daguan (General Survey of Contemporary Taiwanese Painting and Calligraphy)*, ed. Huang Yingbao, n.p., October 1929 (unpaginated). (The author wishes to thank Lin Yushan, in whose private library this rare volume was preserved, and Lin Po-ting 林柏亭, who provided the information.) Because Lin was only twenty-one years old at the time and still studying abroad, he must have joined the Society the following year at the earliest.

20. The poetry societies that Lin Yushan joined included the Chiayi Society, Seagull Society, and Song of Jade Mountain Society; see Huang Oupo, "Lin Yushan jiaoshou qiren qihua," pp. 20–43, and Lin Po-ting, *Jiayi diqu huihua zhi yanjiu*, pp. 145–64.

21. It raised eyebrows that as many as eighteen people from Chiayi (second in number only to the Taipei area) were represented in the various Taiten, and most of them had been taught at one time or another by Lin Yushan; see Lin Po-ting, *Jiayi diqu huihua zhi yanjiu*, pp. 119–30.

22. For a discussion of the problems surrounding the Eastern Painting division of the Taiten, see Yen Chüan-ying, "Yingzao nanguo meishu diantang—Taiwan zhan chuanqi (Creating a Heaven of Art for the Southern Country—The Legend of the Taiten)" and "Taizhan dongyanghua difang secai de huigu (Reflections on the Local Color of *Tōyōga* in the Taiten)," both in Yen Chüan-ying, *Fengjing xinjing*, vol. I, pp. 174–87 and 486–99.

the Taiten, moreover, enhanced the social prestige of producing art. For young people intending to pursue careers in art, exhibiting in the Taiten was equivalent to obtaining a diploma or certificate, since there were no art schools in Taiwan at the time.[23] The only route to artistic recognition was repeated participation in the Taiten. At the same time, the Taiten provided an opportunity for artists not only to compete but also to learn from each other in matters of technique.

Both of Lin's works exhibited in the first Taiten depicted water buffalo and were done in a faithfully realistic style. His love of nature would continue to influence the style of his paintings throughout the next stage of his artistic career. In depicting animals, Lin Yushan emphasized the accurate rendering of their natural environment, as in *Water Buffalo* (*Shuiniu* 水牛) of 1927 (see *Fig. 5*) and *Goats* (*Shanyang* 山羊) from 1928. In the latter, the very delicate rendition of a nanny goat and kid expresses by analogy the tender feelings of a mother and child. *Water Buffalo*, with its close-up view of a cow and calf, was favorably reviewed by the Chinese journalist Wei Qingde 魏清德, who also published a poem in its praise.[24] The water buffalo theme became quite popular in the Eastern Painting division, especially among artists who, like Lin Yushan, hailed from Chiayi or nearby Tainan. All of these artists had backgrounds in traditional painting, took Lin as their model, and aspired to join the ranks of the realists. For example, Huang Jingshan 黃靜山 (b. 1907) produced *Water Buffalo* (1928; *Fig. 7*), *Calves* (*Du* 犢; 1929), and *Spring Wilderness* (*Chunye* 春野; 1930); Pan Chunyuan 潘春源 (1891–1972) did *Observed in a Pasture* (*Muchang suo jian* 牧場所見; 1928), *Oxcart* (*Niuche* 牛車; 1929), and *Bathing* (*Yu* 浴; 1929); and Lin Dongling 林東令 (1918–1959) painted *Oxen* (*Niu* 牛; 1929). Obviously, such subject matter had become popular among Taiwanese artists, especially those from the south. The large number of images featuring cattle produced within this short span of time confirms a point raised above, that artists of the Eastern Painting division had only limited channels through which to learn their craft and that exhibitions figured importantly among them. From important exhibitions, young artists gleaned ideas not only about style and technique but also about subject matter. In the exhibition of the following year, they could show similar works, though with altered compositions, thereby generating a quick cycle of viewing, re-producing (emulating), and selling. This forced the better-known painters, whose works served as models, to rack their brains continually for new subject matter.

The Restructuring of Traditional Ink Painting

In an exhibition in August 1929, organized by the Hsinchu Painting and Calligraphy Refinement Society (Xinzhu shuhua yijing she 新竹書畫益精社) and featuring works by artists from all over Taiwan, Lin Yushan won first prize

23. An artist from Tainan at this time submitted an open letter to the Taiten organizing committee proposing that formal certificates, "in the manner of certificates of official schools and other organizations," not ordinary announcements, be issued to each successful entrant. See Ziyunsheng, "Dui Taiwan meishuzhan xiwang (A Hope for the Taiwan Art Exhibition)," *Taiwan nichi-nichi shinpō*, Chinese section, p. 4.

24. Wei Qingde was also a renowned poet, calligrapher, and critic at the time; see *Taiwan nichi-nichi shinpō*, 1927.11.2, Chinese section, p. 4.

for his painting *Morning Mist* (*Xiao'ai* 曉靄). The Hsinchu Painting and Calligraphy Refinement Society had been established in May 1928 by local traditional artists,[25] and this exhibition included more than one hundred works, in an implicit bid to compete with the Taiten in size.[26] Up-and-coming Taiten artists like Chen Jin 陳進 (1907–1998) and Guo Xuehu 郭雪湖 (b. 1908) did not participate, but Lin Yushan's inclusion suggests his closer ties with traditional artists. It is also worth noting that *Morning Mist* is an ink landscape in a handscroll format. In the left foreground is a dense stand of acacia trees, and at the foot of the mountain in the middle distance are a traditional house, a farmer, and a water buffalo rendered in sketchy outline. In the far distance is a range of mountains. The same elements disposed in a vertical composition would markedly resemble the familiar style of Taiwan landscape in watercolor by Ishikawa Kinichirō 石川欽一郎 (1871–1945). Takeuchi Seihō, the Japanese artist whose work Lin admired, had also created watercolor-style landscape paintings in ink.

Traditional Taiwanese ink painters for the most part depicted the "Four Gentlemen" (*si junzi* 四君子; orchids, chrysanthemums, plum blossoms, and bamboo) and landscapes that they tended to copy from earlier Chinese masters. After the Taiten was organized, such copying was no longer permitted. Instead, learning how to express distinctly Taiwanese landscapes became a common concern and goal among Japanese and Taiwanese painters alike, whether they worked in the Western or Eastern mode.[27] Many parts of subtropical Taiwan and temperate Japan are vastly different in natural environment and culture, a point made repeatedly by Japanese artists such as Ishikawa Kinichirō, who came to Taiwan to paint.[28] This recognition inspired a continual emphasis on sketching and painting outdoors. The pressure to express "local color" (*difangse* 地方色) was greater among artists who competed in the Eastern Painting division of the Taiten than among those in the Western Painting division. Artists in the Eastern Painting division adhered mostly to Japanese painting techniques; the painting styles of the Qing dynasty, once the norm in Taiwan, had become utterly invalid. Japanese techniques, however, were not easy for Taiwanese artists to acquire. The reformed *nihonga*, or Japanese painting style, that had developed in response to Western style painting beginning in the Meiji era, not only involved absorbing Western techniques but also studying and rediscovering Japan's historical and cultural traditions, its practitioners also adjured to expressing ethnic characteristics. It had become a highly complex tradition. Taiwanese artists, who generally lacked connection with Japan's historical tradition

25. See Yen Chüan-ying, *Taiwan jindai meishu dashi nianbiao*, p. 93.

26. See *Xiandai Taiwan shuhua daguan* (*Overview of Modern Taiwanese Painting and Calligraphy*). More than eight hundred works were submitted to the exhibition organizers; fifty works of calligraphy and fifty paintings were selected for inclusion. The judges included both Japanese and Taiwanese.

27. Yen Chüan-ying, "Jindai Taiwan fengjingguan de jiangou (The Construction of Modern Taiwanese Views Concerning Landscape)," *Taiwan daxue meishushi yanjiu jikan* (*Taida Journal of Art History*), 9 (2000.9), pp. 179–206.

28. The watercolorist Ishikawa Kinichirō was born in Shizuoka 靜岡 and taught by Shōdai Tameshige 小代爲重 (1863–1951) and Asai Chū 淺井忠 (1856–1907). In 1891 he joined the Meiji Fine Arts Association (Meiji bijutsukai 明治美術会). From 1907 to 1916 and from 1924 to 1932, he lived in Taiwan, teaching at the Japanese Language School (Kokugo gakkō) and later at the Taipei Normal School (Taihoku shihan gakkō). See Ishikawa Kinichirō, "Taiwan hōmen no fūkei kanshō ni tsuite (Appreciating the Landscape of the Taiwan Area)," *Taiwan jihō* (*Taiwan Times*), 1926.3.

as well as with its art schools, found it more difficult to learn how to paint in the Japanese style than in the Western style, which they took to mean simple realism.[29]

In 1929, 532 paintings were submitted to the judges of the Western Painting division of the third Taiten, but only 75 to the Eastern Painting division, an imbalance that the organizers found troubling.[30] The new head of the judges' committee and the president of Taipei Imperial University (Taihoku teikoku daigaku 台北帝国大学, the predecessor of National Taiwan University [Guoli Taiwan daxue 國立臺灣大學]), Shidehara Taira 幣原坦 (1870–1953), appealed to "this island's artists who, as Orientals," should work harder on "Oriental painting, the main body of Oriental art." He expected the Taiten to demonstrate the essence of Taiwan's native arts; in other words, that artists would concentrate on local subject matter and Taiwan's distinct characteristics to the fullest extent.[31] His ideas echoed those of Matsubayashi Keigetsu 松林桂月 (1876–1963),[32] who had been invited from Japan to judge the Taiten and had also advocated developing Taiwan's "local color," or "native art" (xiangtu yishu 鄉土藝術).[33] Matsubayashi emphasized that the content and techniques of East Asian painting derived from the fundamental content of a people's lifestyle, so that every region had its own distinctive characteristics.[34]

These influential opinions spurred the appearance of many paintings depicting Taiwan's unique animals, plants, scenery, and ethnic peoples, such as Chen Jin's *The Scent of Irises and Orchids* (*Zhilan de xiang* 芝蘭的香; 1932; *Fig. 8*). Artists also produced landscape paintings in which they sought to convey the spirit of the new era in Taiwan through a heavily decorative style, such as Guo Xuehu's *Near Yuanshan* (*Yuanshan fujin* 圓山附近; 1928; *Fig. 9*) and *Fragrant Courtyard* (*Xunyuan* 薰苑; 1932), in which symbols of the new government filter through the scenery. Alternatively, Guo's paintings like *A Sale on South Street* (*Nanjie yinzhen* 南街殷賑; 1930) purveyed the colorful and crowded imagery of a prosperous street lined with shops to represent a peaceful era. Lin Yushan's works were regularly shown in the Taiten, starting with the first, although unlike Chen Jin he did not wholly adopt the form and content of *nihonga*. As opposed to Guo Xuehu, he also did not emphasize a folkish awkwardness and bright, insistent colors. Consequently, he was by no means the earliest painter to achieve "star" status.[35] From a mounting shop for traditional

29. Yen Chüan-ying, "Ribenhua zhi si—Rizhi shiqi Taizhan Dongyanghua de kunjing (The Demise of Japanese Painting [Nihonga]—The Difficulties of *Tōyōga* in the Japanese Colonial Taiten)," forthcoming.

30. *Taiwan nichi-nichi shinpō*, 1929.10.13, p. 2.

31. *Ibid.*

32. Matsubayashi Keigetsu served as a judge in the Teiten and Shinbunten 新文展. A great supporter of the *nanga* group, he introduced a new emphasis on realism to traditional ink painting.

33. Matsubayashi Keigetsu, "Dainikai Taiwan bijutsu tenrankai shinsa shokan—Tōyōga ni tsuite (Impressions on Judging the Second Taiten—Concerning the Eastern Painting [*Tōyōga*] Division), *Taiwan kyōiku* (*Taiwan Education*), 1928.11, p. 11.

34. "Songlin Xiaolin er shenchayuan jiu Taiwan meishuzhan yanjiang (The Two Judges Matsubayashi and Kobayashi Speak About the Taiten)," *Taiwan nichi-nichi shinpō*, 1929.11.15, Chinese section, p. 4.

35. The Taiwanese artists who attracted the most attention in the Eastern Painting division of the Taiten were Chen Jin, Guo Xuehu and Lü Tiezhou 呂鐵州 (1900–1942). From 1928 to 1931, Chen and Guo won consecutive special selection awards. Chen also became a judge in the sixth to eighth Taiten. Starting in the third Taiten, Chen and Guo both received "review-

Chinese painting, Lin always maintained a high level of interest in the traditional subject matter of Chinese painting, temple murals, and other forms of folk art, aiming to find his own artistic stance between the art of China and that of Japan.

The two works that Lin Yushan submitted to the Taiten in 1929, *Clearing After Rain* (*Yuji* 雨霽; *Fig. 10*) and *Zhou Lianxi* 周濂溪 (*Fig. 11*) clearly reveal this young artist's alternating experiments with *nihonga* and with Chinese ink painting. *Clearing after a Rain*, which depicts birds in the rain, is a study in *nihonga* style.[36] *Zhou Lianxi*, a large painting approximately two meters in height,[37] presents one of the great figures of the Chinese Neo-Confucian school from a modern perspective—a kind of painting that was seldom seen in the Taiten. It portrays Zhou Lianxi (Zhou Dunyi 周敦頤; 1017–1073), who was said to be especially fond of lotus flowers (shiny white though growing through muddy water, thus symbolizing purity), sitting leisurely in the shade by a pond, burning incense and reading as he enjoys a tranquil moment.[38] This painting of a historical subject celebrates Confucian values and traditional forms, but the realistic depiction of the background and the subject's concentrated expression makes it seem that Zhou is sitting on a stage, under spotlights. The painting juxtaposes the palpably real with the illusory. Zhou's posture and the arrangement of the rocks and other compositional elements were clearly influenced by Noda Kyūho's 野田九浦 (1879–1971) *Portrait of Sesshū*, which was shown in the previous year's Teiten in Tokyo.[39] Certain elements of Lin Yushan's composition, such as the perspective view of the courtyard and the subject's facial expression, clearly embody modern realism, but the subject's reading posture, the boy brewing tea, and the inscription are deliberate perpetuations from the Chinese painting tradition. Lin, however, was criticized for adding color to the main figures in both paintings (only to the subject's face in *Zhou Lianxi*): "The application of color instead burdens the painting," that is, it diminishes the tone.[40] Whether these works, blending elements of Chinese and Japanese, traditional and

exempt" status, meaning that their works would be automatically accepted. Lü received review-exempt status beginning in the fourth Taiten, but Lin did not obtain it until the sixth Taiten. In his reviews of the fifth and sixth Taiten, Ōzawa Sadayoshi 大澤貞吉 (1886–?) referred to Chen, Guo and Lü as the "darlings" or "stars" of the Eastern Painting division. See Ōzawa Sadayoshi, "Taiten hei (1) (Review of the Taiten [1])," *Taiwan nichi-nichi shinpō*, 1931.10.31, p. 4; "(Taiten no inshō (1) (Review of the Taiten [1])," *Taiwan nichi-nichi shinpō*, 1932.11.4, p. 6.

36. This work is similar to one by Katsuta Shōkin 勝田蕉琴 (1879–1963), who had once visited Chiayi; see Lin Po-ting, "Taiwan Dongyang huajia de xingqi yu Tai, Fuzhan (The Rise of Taiwan's Eastern Painting Artists and the Taiten and Futen)," *Yishuxue* (*Art History*) 3 (1989), p. 111.

37. This painting is currently in the artist's collection and now measures 179 by 116 centimeters. However, comparison with the photographic record of the third Taiten reveals that nearly ten centimeters has been cut from the top. See *Taiwan meishu quanji—Lin Yushan*, pl. 2.

38. Zhou Lianxi figures in Chinese cultural allusion as a literatus who loved lotuses (the others associated with the plum blossom, bamboo, and chrysanthemum). In 1934 Lin Yushan made a painting of another of these worthies—Lin Bu 林逋 (Lin Hejing 和靖; 967–1028), whose blossom of choice was that of the plum tree. This work he exhibited in the fifth exhibition of the Sendan 栴檀 Painting Society. See *Taiwan meishu quanji—Lin Yushan*, pl. 6.

39. Noda Kyūho studied first at the Tokyo School of Fine Arts and the Japanese Academy of Art, and he was known for portraits of historical figures. *Portrait of Sesshū* was entered in the ninth Teiten (1928).

40. Yijizhe ("A Reporter"), "Disanhui Taizhan zhi wo guan (My Views on the Third Taiten)," *Taiwan nichi-nichi shinpō*, 1929.11.16, Chinese section, p. 4. This essay was divided into three parts and printed on consecutive days, and was the main

modern art, may be considered "mature" is a matter of question, but the works themselves reveal that the reviewer's perspective was limited, and that Lin was attempting to respond to the expressed demand for "Oriental painting."

Images of Home

Starting in 1930, Lin Yushan's Taiten works returned to outdoor scenes such as Chiayi Park, lotus ponds, or sugarcane fields. Then for three years, beginning with *Setting Sun* (*Xizhao* 夕照; *Fig. 12*) from 1933, he completed three large Chiayi scenes that centered on the theme of home. *Setting Sun* gives a bird's-eye view of Chiayi's Hongmaobi 紅毛埤 ("Red-hair Marsh"), which was said to have been the new frontier of the Dutch, and the broad terraced fields nearby. The viewer's line of sight is evenly directed around the canvas, as if it were an early Dutch painting.[41] For this work, Lin received the "Taiten Award." The painting exemplifies Lin's care in recording the scenery and activities around Chiayi, which recalls Huang Tushui's goal of creating distinctively Taiwanese scenes. Murakami Kagaku's 村上華岳 (1888–1939) *In February*, which was shown in the fifth Bunten 文展 of 1911, has a similar view of expansive farm fields.[42] Ōzawa Sadayoshi 大澤貞吉 (1886–?), who reviewed the Taiten for the *Taiwan Daily News* (*Taiwan nichi-nichi shinpō* 台湾日日新報), questioned whether Lin's seeming use of Japanese painting materials in a Western-style composition detracted from its value as an Asian painting.[43] It is worth noting that Lin inserted the narrative elements of folk painting into the scene. Specifically, in the foreground, we see a family of four leading a water buffalo to a house in the left of the middle ground that is, by implication, their home.

Lin Yushan's *Setting Sun* was not the first Taiten painting to depict homes or villages. In 1931 the Japanese artist Murakami Mura 村上無羅[44] showed a four-fold screen painting, *Morning in Nanlong* (*Nanlong no asa* 南隆の朝; *Fig. 13*), in the Eastern Painting division of the fifth Taiten. Nanlong, a village in Kaohsiung 高雄 Prefecture, was originally an aboriginal settlement, but after 1908, when Japanese capitalists began developing this area into the Nanlong Plantation, large numbers of Chinese were brought in to clear the land. This simple composition has a

review of that year's Taiten.

41. This site is now the Lantan 蘭潭 Reservoir, situated to the east of Chiayi City and considered one of the eight scenic spots of the Chiayi area. The reservoir was originally built by the Dutch to supply water to the troops stationed there. By the Qing dynasty, it had silted up and become rice paddies. During the Japanese colonial period, it was made once again into a reservoir, which still supplies Chiayi with drinking water.

42. Murakami Kagaku graduated from Kyoto Municipal College of Painting (Kyōto shiritsu kaiga senmon gakkō 京都市立絵画 専門学校). In 1918 he took part in establishing the Society for Creating a National Style of Painting (Kokuga sōsaku kyōkai 国画創作協会).

43. Ōzawa Sadayoshi graduated from the Department of Philosophy at the University of Tokyo, then began working in the newspaper industry. In August 1923 he went to Taiwan and became a principal writer for *Taiwan nichi-nichi shinpō*. See Ōzawa Sadayoshi (writing under his pen name Ou'ting Sheng 鷗汀生), "Kodoshi no Taiten (This Year's Taiten)," *Taiwan nichi-nichi shinpō*, 1933.10.30, p. 2.

44. Murakami Mura (original given name Hideo) graduated in 1926 from the Department of Japanese Painting at the Tokyo School of Fine Arts and taught at Keelung 基隆 Girls' Senior High School. Starting in 1927 he continuously participated in the Taiten and Futen, and he was a member of the Sendan Painting Society.

Section V: Recent and Contemporary Painting 567

strong decorative quality. The judges praised it as "expressing the native art flavor that befits the Taiten."[45] Clearly, local farm villages and rural scenes were both considered characteristic features of Taiwan under the Japanese. In 1933, the same year that Lin's *Setting Sun* was shown, Mamiya Tadashi's 間宮正 (1911–1984) *Quiet Village* (*Shizuka na mura* 静かな村; *Fig. 14*) garnered praise from the reviewer Ōzawa Sadayoshi, who thought it "a work of light, facile brushwork, uncommon perspective, and revelatory of a special world."[46] From today's perspective, this is not a "special world" so much as an illusory, uninhabitable dream world. With a fine brush, the artist has depicted a mixed forest such as might constitute the background of a folding screen. In the foreground, enlarged oxen and miniaturized houses, seen from a bird's-eye perspective, are arrayed in a circle, creating a strong sense of incongruity. Whereas Ōzawa Sadayoshi thought that Lin Yushan's *Setting Sun* did not resemble a traditional Eastern painting (that is, it was compromised by its Western style composition), Mamiya Tadashi's *Quiet Village* earned his praise as an untrammeled work. These contrasting judgements indicate only that the critic, who had moved to Taipei from Tokyo in 1923, shared Mamiya's false romanticism about Taiwan's villages but could not understand the emotionally rich realism of works by Huang Tushui and Lin Yushan.

In the Eastern Painting division of the following year's (1934) Taiten were many works on the theme of home, all of them depicting farm women at work: Xu Qinglian's 徐清蓮 (1910?–1960?) *Morning* (*Xiao* 曉) and Zhu Feiting's 朱芾亭 (1905–1977) *Pleasures of Autumn in a River Town* (*Shuixiang qiuqu* 水鄉秋趣; *Fig. 15*; both Xu and Zhu were from Chiayi); Guo Xuehu's *Village Mood in a Southern Country* (*Nanguo cunqing* 南國村情) and Lü Chuncheng's 呂春成 *Outskirts of Taoyuan* (*Taoyuan jiaowai* 桃園郊外; Guo and Lu hailed from Taipei); and the Japanese artist Kita Shūichirō's *Mid-Autumn*.[47] Lin Yushan's *Driving Rain* (*Zhouyu* 驟雨; *Fig. 16*) likewise shows a farm woman with a child but is centered on a farmhouse outside the old South Gate in Chiayi. Located on the Tropic of Cancer, Chiayi is subject to many rainstorms from the northwest in summer; thunder, lightning, and hard, driving rains can burst over the land in an instant. Lin Yushan captured in detail the moment when the mother set her work down and hurried with her child into the house. Lin used the techniques of detailed realism to record the environs of the house, including some elements that one normally would not see in life. A strong narrative quality informs this painting and appears also in Chen Chengpo's *Street Entrance* (*Jietou* 街頭; *Fig. 17*), shown in the Western Painting division of the Taiten in the same year. Japanese critics for the most part disparaged the Taiwanese propensity for detailed paintings suggestive of narrative quality.[48] They assumed that Taiwanese artists tended to use their hands and

45. Ōzawa Sadayoshi, "Taiten hyō (Critique of the Taiten)," *Taiwan nichi-nichi shinpō*, 1931.10.31, p. 2.

46. Ōzawa Sadayoshi, "Kotoshi no Taiten (This Year's Taiten)," *Taiwan nichi-nichi shinpō*, 1931.11.1, p. 2.

47. Kita Shūichirō was then the office director of the *Osaka mainichi shimbun* 大阪毎日新聞 (*Osaka Daily News*) branch office in Taipei. See Ōzono Nishikura, *Jinji taisei to jigyōkai* (*Personnel Arrangements and the Business World*) (Taipei: Shinjidai Taiwan jisha, 1943), p. 24.

48. One Japanese critic, Miyatatsu Yoshio 宮辰武夫, criticized Chen Chengpo's painting for "indulging too much in entertaining anecdote. Generally speaking, most Taiwanese creations depict too many explicit details; one hopes to find greater emphasis on creating an aura of charm (過於墮入遊藝表演趣味。總體而言，台灣人的創作大多描寫得過多，希望今後多留意

Japanese artists their minds, so that the Japanese works were conceptually superior. In fact, however, the Japanese pundits of that time had limited knowledge of Taiwan's traditions; judging from the standpoint of the Japanese painting tradition, they praised works that were richly decorative, replete with literary allusions, or redolent of exoticism. Lin Yushan and Chen Chengpo, on the other hand, were accustomed from childhood to seeing in local temples narrative paintings that told stories, often edifying, from Chinese history, fiction, and drama. Consequently, they found it natural to insert mother-and-child images into their landscapes, thus privileging the theme of family rather than the lyricism, seasonal atmosphere, or indirect tone that tended to imbue the themes in Japanese painting.

Although his paintings had been shown in eight consecutive Taiten exhibitions, Lin Yushan still felt dissatisfied with his own style and wanted strongly to go to Kyoto and study the manner of Takeuchi Seihō, whose *Cockfight* had so impressed him eight years before and who had become the guiding spirit of the Kyoto art world. Even before the 1934 Taiten opened, Lin had gone to Taipei to organize a solo exhibition in order to raise funds for another period of study in Japan, but few of his paintings sold. Finally, in May of the following year, through the sponsorship of Chiayi friends and elders, Lin went to Kyoto, where he studied for one year in a painting school run by Dōmoto Inshō 堂本印象 (1891–1975).[49] In the same year (1935) he sent a two-fold screen painting, *Recalling Home* (*Guxiang zhuiyi* 故鄉追憶; *Fig. 18*), for show in the Taiten. This work, based on numerous sketches that he had made in his hometown, Lin completed in Kyoto, and it shows clearly influence of the detailed realism found in *nihonga* painting of the Taisho era. The blue sky clearly recalls Hayami Gyoshū's 速水御舟 (1894–1935) 1918 depiction of a Kyoto scene, *Shūgakuin Village in North Kyoto* (*Rakuhoku Shugakuin mura* 洛北修学院村; *Fig. 19*).[50] Both are large compositions rendered from a high perspective, show a compound shaded by tall trees, and impart a mood of grandeur and stillness. The ox and trees in the right foreground of *Recalling Home* anchor the composition, and the woman feeding pigs on the left has been reduced in size to a still, symbolic presence. The Western-style painter Tateishi Tesshin 立石鉄臣 (1905–1980),[51] born in Taiwan, educated in Japan, and who had recently returned to Taiwan, wrote the review of that year's Taiten and praised this work as follows: "In its plain appreciation of nature, it is a work of fine taste."[52]

餘韻餘情的趣味)." See Miyatatsu Yoshio, "Taiten sozoro aruki-seiyoga o miru (Review at Leisure of the Eastern Painting Division of the Taiten)," *Taiwan nichi-nichi shinpō*, 1936.10.25, p. 6.

49. Dōmoto Inshō was born in Kyoto, graduated from Kyoto Municipal High School of Arts and Crafts in 1910, and from the Kyoto Municipal College of Painting in 1921. He was a judge in the Teiten and established the Eastern Hills Society (Tōkyūsha 東丘社), a private school, or *juku* 塾, for painting in 1934.

50. Hayami Gyoshū, a *nihonga* painter, studied in Matsumoto Fūko's 松本楓湖 (1840–1923) private painting school. He was influenced by Imamura Shikō 今村紫紅 (1880–1916) and joined the Red Child Association (Kojikai 紅兒會). His style was detailed and realistic.

51. Tateishi Tesshin was born in Taipei and returned to Tokyo when he was six. After graduating from the Middle School of Meiji College and studying under Kishida Ryūsei 岸田劉生 (1891–1929) and Umehara Ryūzaburō 梅原龍三郎 (1888–1986), he returned to Taiwan in 1933. He was a member of the National Painting Association (Kokugakai 国画会).

52. Tateishi Tesshin, "Taiten sogohyō" (Cross-criticism in the Taiten—A Western-style Artist Judges the Eastern Painting Divi-

The theme of home became much emphasized in the Taiten Eastern Painting division. Many of the well-known artists in the tenth Taiten (1936) submitted such works; examples include Lü Tiezhou's 呂鐵洲 (1900–1942) *Village Home* (*Cunjia* 村家) and Takanashi Katsusei's 高梨勝瀞 *Home in a Bamboo Grove* (*Takebayashi denka* 竹林山家), which received both the special selection award and the *Asahi Newspaper* (*Asahi shimbun* 朝日新聞) award. Lin Yushan submitted *Morning* (*Chao* 朝; *Fig. 20*), which depicted his young daughter brushing her teeth next to the family's well early in the morning. In the background is a wax-apple tree in bloom. However, a Japanese newspaper critic commented,

> The human figure is not depicted in a high-class manner, so this work falls outside of the scope of art. Using a human figure to explain the content is really like "adding feet to a snake"—it is best to avoid and reconsider it.[53]
> 人物が調子の低いものとなって藝術の分野を通り越している。人物を以てした説明は蛇足である。無かった方がいい。再考。

From the perspective of a Japanese art critic, the painting lacked lyricism because its subject was both humble and ordinary, therefore failing as a work of art. As it turned out, *Morning* was Lin Yushan's last painting on the theme of home.

Conclusion

Taiwanese cultural identity has been constructed through modern education, propaganda, and various social reform movements. Taiwan under the Qing dynasty was not made a province until 1885, so its official or public infrastructure developed relatively late, and education had not spread to ordinary people. Although universal primary education was gradually implemented during the Japanese colonial era, Taiwan at this time could not develop its culture and cultural images autonomously. One of the most obvious manifestations of this was the fact that all the judges and reviewers of the Taiten were under Japanese control. Still, for a brief period from the 1920s to the early 1930s, several artists, aiming at realism and exploring traditional native art, made serious efforts to know the land and to create a distinctively Taiwanese art. In this respect, Huang Tushui occupies a special place in Taiwanese art history. As one of the earliest and most intelligent figures in this movement, he assumed a stance of responsibility for all aspects of his culture. He believed that creating new works of art was equivalent to forming a new Taiwanese culture, or that it was at least one of the most important methods of elevating Taiwan's society and culture. Some others among the elite of his generation felt similarly.[54] From his *Aboriginal Boy* in 1920 to his *A Southern Country*

sion)," *Taiwan nichi-nichi shinpō*, 1930.10.30, p. 2.

53. Ōtaka Buntō, "Tōyōga bu bekken—jidai no nagare o ha-aku se yo (A Glance at the Eastern Painting Division—Getting a Grasp of Time's Flow)," *Taiwan nichi-nichi shinpō*, 1936.11.25, p. 6; for the Chinese translation, see Yen Chüan-ying, *Fengjing xinjing*, vol. I, p. 256. The writer's biography is unknown. The essay mentions that he had visited the fourth Taiten (1930) as a touring Japanese artist, and that the tenth Taiten was the second that he had seen.

54. For instance, the arguments in Huang Tushui's essay "Born in Taiwan" may be compared with those of Cai Peihuo 蔡培火 in "Ge ernianhou zhi gui Tai (Returning to Taiwan After Two Years)," *Taiwan qingnian* (*Taiwan Youth*), 3.2 (1921.8), pp. 8–16.

in 1930, he persistently sought to create a uniquely Taiwanese art, aiming at an arcadian, lyrical tone realized in the motifs of herdboys and water buffalo. To attain a distinctive and recognizable Taiwanese idiom, he repudiated Taiwan's Chinese tradition and set upon himself to create a modern art for his homeland. Unfortunately, he died young, and no one was able to immediately take up his call to create a "Formosan art."

Lin Yushan, by contrast, closely represents the kind of Taiwanese artist who strove to develop his art under colonial limitations. He patiently searched the painting traditions of both China and Japan for an expressive method that was faithful to his concepts and his environment. His starting point was modern realism—faithful rendering of what he saw and felt. However, once oxen and lotuses as subjects gave way to home as a theme, his paintings were no longer direct products of eyes and hand, but instead became realizations—by means of eyes and hand—of feelings and ideals refined from experience. Ironically, though, the cultural image of home could only be appreciated by those who understood and valued the same cultural background. Consequently, Lin's "Home" series, so ardently and arduously accomplished from 1933 to 1936, failed to gain the approval of Japanese judges and critics. After war between China and Japan broke out in 1937, Lin suddenly abandoned images of home and the bucolic in the works that he submitted for exhibition in favor of realistic depictions of plants and animals and scenes related more or less to the war, such as *Attack* (*Jixi* 擊襲; *Fig. 21*). From then on, both artists and judges gradually devalued or forgot about "local color." "The color of the times" (*shijuse* 時局色), meaning wartime, became the slogan of the day, and forced "nipponization" (J: *kominka* 皇民化) gradually replaced any cultural movement to develop Taiwanese characteristics.

日治時期台灣畫家的文化認同問題—
從黃土水的「水牛」到林玉山的「家園」系列作品

顏娟英

中央研究院歷史語言研究所，臺北

本文起首談到1926年嘉義裱畫店出身的林玉山（1907–2004）與成名雕塑家黃土水 (1895–1930)的作品，在東京的展覽會上相遇。他們的背景與個性相當不同，但顯然都思考殖民地展覽的《地方色彩》的表現問題。選擇留在東京創作的黃土水，自1923年開始處理水牛的題材，他很快地放棄寫實的手法，而以浪漫的詩情爲主調，如1930年臨終前完成的作品《南國》。林玉山也曾兩次留學日本，日本畫的細密寫實技法熟練，但他顯然與台灣的書畫傳統關係更密切，除了水牛或黃牛等系列作品之外，1933–1936年他也嘗試家園主題，如《夕照》、《故園追懷》等巨幅作品頗受重視。然而，1937年中日戰爭爆發後，此一系列作品即告中斷，林玉山改繪製單純的動植物以與緊張的時局配合。這篇文章分析日治時期年輕的藝術家從追求「地方色彩」到表現台灣意識的過程。

日本統治期における郷土色と台湾意識について—
林玉山「水牛」から「家園」シリーズまで

顔娟英

中央研究院史語所、台北

　林玉山は1907年、表具屋の家に生まれた。1926年4月、彼は東京に到り、川端画学校に入った。春に開催されている展覧会の内、彼は日華連合美術展（6月18日〜30日開催）を見た。主に北京からの有名画家の作品が日本の有名画家の作品と共に展示されていた。彼は西洋画をやめ日本画科で習い直すことにしたが、写実技法は依然として追求し続け、紙本でも絹本でも幅広くその技法で描いた。この他、聖徳太子奉讚展（5月1日〜6月15日開催）は日本・油絵・彫刻を含む美術工芸の展覧会だが、彼はここで日本の現代美術の多様さに触れた。さらに、出品者中唯一の台湾人、黄土水の「南国の風情」に深く感銘を受けた。この作品は水牛を主題として南国、即ち台湾を表した一幅の大型レリーフであった。

　1922年春、黄土水は東京美術学校研究科を卒業し、東京で活躍する最初の台湾人専門芸術家となった。彼が発表した重要な文章「出生於台湾（台湾に生まれる）」で、台湾人の立場から出発して、創作に命を捧げる決心をし、台湾の青年に「福爾摩沙（フォルモサ＝台湾）」芸術を共に創造することを呼びかけた。1923年から黄土水は数回に渡って等身大の塑像の水牛を制作し、牧童・芭蕉・鴛鴦などと組み合わせ台湾の文化的景観の意味を込めた。

　1927年10月、政府当局が支持する教育会が主催した台湾全島の現代美術展、第一回台湾美術展覧会（以下、台展と略称）が開催され、林玉山は「大南門」と「水牛」を出品・入選したが、この2作品は共に牛に関連する画である。黄土水はそれまでの中国伝統を惜しまずに断ち切り、時代の意義に合った新台湾美術を改めて作り出した。一方、林玉山は、第二次大戦終結まで嘉義の生活文化圏から離れることはなく、台展の東洋画部門が毎年の主要な発表の場となった。彼は自分が把握できる郷土の資源を存分に利用し、読書会を組織し、詩社に加入し、同時に現地の絵画創作の志がある者を指導していくつかの画会を組織した。

　林玉山は中国絵画に、寺院壁画など民間伝統の題材に及ぶまで終始高い関心を持ち続け、中国と日本の伝統、さらに西洋画の写実技法の間に自分の立脚点を見出そうとした。彼の水牛画は多くの学生や若い画家に受け入れられ模倣された。

林玉山は1933年の「夕照」を皮切りに3年続けて台展に故郷を中心テーマにした嘉義の風景写生3点の大幅を出品、シリーズを完成させた。当時の日本の評論家は、台湾画家は叙述的すぎて含蓄のある雰囲気が少ないと考えていた。しかし、林玉山ら伝統的な台湾人は、幼いときから寺院壁画に見慣れていた。寺院には中国の歴史や小説戯曲の中から選択された主題の、説教的な意味を持つ故事画が描かれていた。そのため、彼らの風景画にはしばしば家庭倫理観を表した母子の情愛、叙述への欲求が明らかに挿入されており、日本画が強調する文学的詩意、季節の雰囲気、婉曲的で含蓄を含む風情といったものではなかった。

　1935年、林玉山は再び来日して京都に赴き、堂本印象の画塾に入って1年間学んだ。同年、彼は二曲屏風の「故園追憶」を台展に出品した。画家が故郷から携えてきた多くのスケッチを基にして、京都で再構成し制作・完成させたもので、彼が大正期日本画壇の細密写実派から吸収した影響が明らかに見て取れる。そして、「家園（家の庭、故郷）」は台展東洋画部において非常に重視される画題となった。第10回台展(1936年)では、有名な画家も次々とこうした主題の作品を発表した。林玉山が出品したのは、早朝、幼い女の子が家の井戸の側で真面目に歯を磨いている姿を描いた「朝」で、背景には花が咲き実をつけている蓮霧（レンブ）の木が見える。日本から来た評論家は、人物の格調が低く、芸術の範疇に入らないと評した。日本画の観点からすれば、この画の内容は質素な生活の情景から直接取っており、含蓄のある詩意的な表現に乏しく、それ故に得るところがないとされたのである。林玉山の「家園」シリーズもここに至って終わりとなった。

　林玉山は植民地の限られた教育・経済条件の下、努力し成長した台湾画家の姿を忠実に示している。彼は中国の伝統と現代日本画の間にあって、自己やそれを取り巻く環境に忠実な表現手法を根気よく捜した。1937年、日中戦争の勃発で台展は一年間中止、一年おいて開かれた府展では、戦争の空気で多くの人々の理想、浪漫的な家園を築くことは消し飛んでしまった。この展覧会に林玉山は、それまでとは異なる動植物の写生作品を出品しており、それは戦争と微妙に釣り合った主題を意識したものであった。この後、画家や審査員たちは次第に「郷土色」を忘れていき、反対に時局色、つまり戦争の空気がスローガンとなった。1940年代、台湾の特色ある文化芸術活動は皇民化運動に取って代わられ、台湾意識の発展も棚上げになったのである。

Yen Chüan-ying

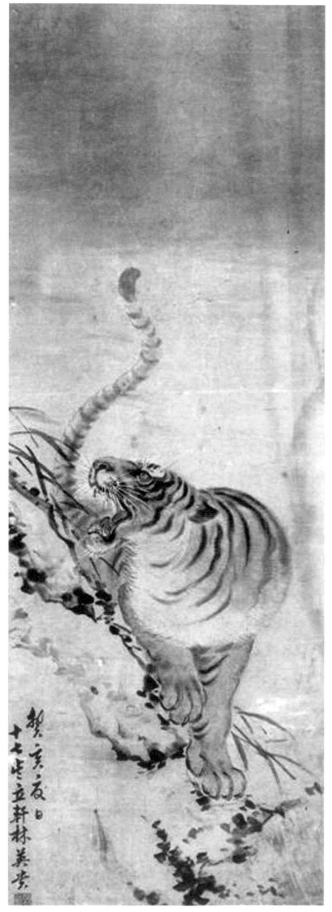

Fig. 1. Lin Yushan (1907–2004). *Tiger*, 1923.
Paper. Artist's collection.

Fig. 2. Huang Tushui (1895–1930). *Scenery of a Southern Country*, 1926. Destroyed.

Fig. 3. Huang Tushui (1895–1930). *In the Country*, 1924. Destroyed.

Yen Chüan-ying

Fig. 4. Lin Yushan (1907–2004). *Great South Gate*, 1927. Destroyed.

Fig. 5. Lin Yushan (1907–2004). *Water Buffalo*, 1927. Destroyed.

Section V: Recent and Contemporary Painting 577

Fig. 6. Huang Tushui (1895–1930). *A Southern Country,* 1930. Clay relief, 555 x 250cm. Chung-shan Hall, Taipei.

Fig. 7. Huang Jingshan (b. 1907). *Water Buffalo*, 1928. Destroyed.

Yen Chüan-ying

Fig. 8. Chen Jin (1907–1998). *The Scent of Irises and Orchids*, 1932. Destroyed.

Fig. 9. Guo Xuehu (b. 1908). *Near Yuanshan*, 1928. Silk, 91 x 182 cm. Taipei Fine Arts Museum.

Fig. 10. Lin Yushan (1907–2004).
Clearing After Rain, 1929.

Fig. 11. Lin Yushan (1907–2004), *Zhou Lianxi*,
1929. Paper, 179 x 116 cm. Artist's collection.

Yen Chüan-ying

Fig. 12. Lin Yushan (1907–2004). *Setting Sun*, 1933. Destroyed.

Fig. 13. Murakami Mura. *Morning in Nanlong*, 1931. Destroyed.

Section V: Recent and Contemporary Painting 581

Fig. 14. Mamiya Tadashi (1911–1984).
Quiet Village, 1933. Destroyed.

Fig. 15. Zhu Feiting (1905–1977).
*Pleasures of Autumn in a River
Town*, 1934. Destroyed.

Yen Chüan-ying

Fig. 16. Lin Yushan (1907–2004). *Driving Rain*, 1934. Destroyed.

Fig. 17. Chen Chengpo (1895–1947). [*Chiayi*] *Street Entrance*, 1934. Oil painting, 91 × 116.5 cm. Artist's family collection.

Section V: Recent and Contemporary Painting 583

Fig. 18. Lin Yushan (1907–2004). *Recalling Home,* 1935. Silk. National Taiwan Art Museum. *(detail on page 555)*

Fig. 19. Hayami Gyoshu (1894–1935). *Shūgakuin Village in North Kyoto,* 1918. Silk, 132 × 97.5 cm. Museum of Modern Art, Shiga.

Yen Chüan-ying

Fig. 20. Lin Yushan (1907–2004). *Morning*, 1936. Destroyed.

Fig. 21. Lin Yushan (1907–2004). *Attack*, 1942. Paper. Artist's family collection.

Contemporaneity in Contemporary Chinese Art

Wu Hung

University of Chicago

Although the stated subject of this book is the "history of East Asian painting," I have deliberately substituted the word "art" for "painting" in the title of this essay. The reason for changing the frame of my discussion lies in the content of Chinese contemporary art (*dangdai yishu* 當代藝術) and the concept of contemporaneity (*dangdaixing* 當代性). Although paintings in traditional media and styles—whether literati ink landscape or realistic oil portraiture—are continuously being produced in Beijing or Taipei, these are not recognized as *contemporary art*, because contemporaneity is not the goal of these images. In fact, contemporaneity in contemporary Chinese art entails a wide-ranging effort to challenge the traditional dominance of painting in visual art and even to dismiss painting as an independent art form.

Contemporaneity therefore does not simply pertain to whatever is created in the here-and-now, but must be understood as an intentional artistic/theoretical construct, which asserts a particular historicity for itself. To achieve this construct, the artist/theorist self-consciously reflects upon the conditions and limitations of the present, thereby substantiating the present—a commonsensical time/space—with individualized references, languages, and points of view. This essay locates contemporaneity in current Chinese art by identifying these references, languages, and points of view. Necessarily based on individual works by individual artists, my study is also intended to reveal common trends underlying separate attempts. I therefore deal here with individual artistic expressions on the one hand and large artistic movements on the other; the dialectical relationship between the two poses further methodological questions in interpreting contemporary Chinese art.

Subverting Painting

A chief strategy employed by many Chinese artists to make their works explicitly "contemporary" is to subvert established artistic genres and mediums. Originating in Western avant-garde art, this strategy of transgression is now prevalent on a global scale: the over fifty biennales and triennales staged extravagantly around the world teem with installations and multimedia works, just as the traditional art exhibition was dominated by painting and sculpture. "Experimental artists" (*shiyan yishujia* 實驗藝術家)[1] from China—the subject of this paper—actively contribute to

1. For definitions of "experimental art" and "experimental artist," see Wu Hung, *Transience: Chinese Experimental Art at the End of the Twentieth Century* (Chicago: Smart Museum of Art, 1998), pp. 15–16.

this burgeoning international art. At the same time, these artists retain their local identity and respond to China's reality in their works—it is in this sense that they can still be considered "Chinese artists." One can draw interesting parallels between them and an earlier generation of Westernized Chinese artists, who abandoned the traditional Chinese brush for the "modern" medium of oil painting. But if those artists, in the early twentieth century, chose between different types of painting, their successors in the present choose whether to abandon painting altogether, either in actual practice or in interpretation.

The trend of subverting painting emerged as an intrinsic feature of the '85 Art New Wave (85 yishu xinchao 八五藝術新潮) and signified a deepening stage of an "avant-garde" art movement in China after the Cultural Revolution (Wenhua dageming 文化大革命). Experimental artists before the mid-1980s, even the most radical ones, such as the members of the Stars Group (Xingxing huahui 星星畫會), still employed the techniques of painting and sculpture. From the mid-1980s through the 1990s, however, an increasing number of young artists abandoned their former training in traditional or Western painting, or only made paintings privately (even furtively) to finance their more adventurous but less marketable art experiments. Installation and performance became the two trendiest art forms in contemporary Chinese art.

This phenomenon was doubtless related to the growing influence of Western contemporary art: since the country opened after the Cultural Revolution, information about recent developments in Western art has become increasingly available in China. However, a more essential reason for the popularity of installation, performance, and multimedia art must still lie in the fundamental purpose of the movement of experimental art itself, which is to forge an independent field of art production, exhibition, and criticism—a field outside orthodox art. Through denouncing painting, experimental artists can effectively establish an "outside" position for themselves, because what they reject is not just a particular art form or medium, but an entire art system, including education, exhibition, publication, and employment. Such a break from the orthodox modes is sometimes related to an artist's political identity. However, it can also be a relatively independent artistic decision, motivated by the liberating and challenging aspects of the new art forms. These artists also negotiate with painting in different ways: some of them squarely reject painting, others subvert painting and calligraphy from within, and still others reframe painting as components of installation or performance.

The Beijing artist Song Dong 宋冬 (b. 1966) can be taken as a representative of the first tendency. Always interested in drawing, he took extracurricular art classes in the Youth Palace (Qingniangong 青年宫) while in elementary and middle school. Afterward he entered the Art Department of Normal University to study oil painting. One of his academic-style works was selected for the National Art Exhibition (Quanguo meishu zhanlan 全國美術展覽) in 1989—an unusual achievement for a young artist who had not even graduated from college. Suddenly, however, he abandoned his academic training and the career path of a successful professional artist. Two circumstances caused this change: a pro-democratic student movement that was suppressed in Tiananmen 天安門 Square on 4 June 1989

and the introduction of new contemporary art forms to China in the late 1980s and early 1990s. Song Dong was elated by the pro-democracy student movement and dumbfounded by its tragic ending. Watching the tanks overrun Beijing's streets, he felt that he had matured and transformed overnight. As an artist, he found freedom in installation, performance, and video; a framed canvas had become too limiting for his newly discovered creativity. He held his first installation/performance exhibition, called *One More Lesson: Do You Want to Play with Me?* in 1994 in Beijing. He transformed the exhibition hall into a classroom, in which some students were reading wordless textbooks, while the audience freely participated in the performance (*Fig. 1*). The local authorities cancelled the show the day it opened, but Song Dong never returned to painting. In fact, unlike some other installation and video artists, the many art projects he has conducted since the early 1990s have betrayed little influence from his former academic training.

In this way, Song Dong differs from Qiu Zhijie 邱志杰 (b. 1969), another leading video, installation, and performance artist in China. While growing up in a scholar's family in Fujian, Qiu Zhijie studied calligraphy. Upon graduating from high school, he entered the Zhejiang Academy of Fine Arts (Zhejiang meishu xueyuan 浙江美術學院) with the highest marks on the entrance exams in both culture and studio art. Mainly by reason of his facility with classroom assignments and technical requirements, he soon became a star student in the academy. He was selected by the school's leadership to study abroad, but this plan was cancelled following the student pro-democratic movement (the June Fourth Movement [Liusi yundong 六四運動]), leaving Qiu Zhijie adrift. From his high school years he had been reading widely, from Lu Xun 魯迅 and Karl Marx to Jean-Paul Sartre and Friedrich Nietzsche; now he embraced post-modern deconstructionism and read whatever he could find on the subject. The performance/video project he undertook from 1990 to 1995, entitled *Assignment No. 1: Copying "Orchid Pavilion Preface" a Thousand Times*, can be seen as a post-modern deconstruction of traditional Chinese calligraphy, an art form linked to China's cultural heritage as well as to his childhood memories. For three years, Qiu Zhijie kept overwriting the *Orchid Pavilion Preface* (*Lantingxu* 蘭亭序), the most celebrated masterpiece of Chinese calligraphy, on a single piece of paper, continuing even after the entire paper was pitch black. Traditional calligraphic training is based on copying historical masterpieces repetitively, and the *Orchid Pavilion Preface* has served as a primary model for such practice. By making "repetition" the subject of his art project, however, Qiu Zhijie erased any trace of the brush, thus rejecting calligraphy itself (*Fig. 2*).

Similar experiments are also found in the domains of traditional ink painting. The Guangdong artist Yang Jiechang 楊志昌 (b. 1956), for example, began to paint abstract ink paintings in the early 1980s and related such artistic expressions to Chan 禪 Buddhism and Daoism (he actually studied Daoism with a Daoist master at Mt. Luofu 羅浮 in Guangdong from 1984 to 1986). However, a series of works he created in the 1990s, collectively entitled *100 Layers of Ink*, demonstrated a new direction: these works negated not only concrete painted images but also the concept of painting. On sheets of paper, he obsessively applied layer upon layer of ink, creating abstract "black holes"

with shining surfaces. Sometimes he framed multiple layers of such ink work with an open metal box, giving them a three-dimensional, sculptured appearance (*Fig. 3*). Following a similar path, the Hebei artist Hu Youben 胡又笨 (b. 1961) has made huge "murals" that show nothing but layered black paint on a wrinkled surface; the visual effect is largely generated by painting materials, not by a painted representation (*Fig. 4*). This type of experimentation with materials has produced other striking works of contemporary Chinese art. One such work is an installation by Zhu Jinshi 朱金石 (b. 1954) called *Impermanence*: without painting a single brush stroke, he used fifty thousand sheets of white *xuan* 宣 paper to construct a fortress-like structure, which was both massive and fragile, powerful and vulnerable (*Fig. 5*).

The next example, the oil painter Shi Chong 石冲 (b. 1963), represents yet another tendency, which is to dismiss the independence of painting by redefining this "canonical" art form as one integral component of an all-encompassing process of artistic creation. In his own practice, this creative process consists of five different forms of visual art—sculpture, performance, installation, photography, and painting. Each of these forms generates independent visual spectacle and meaning as the project gradually unfolds, ending with the creation of a framed painting. Using his 1996 project *The Stage* as an example, the initial phase consisted of making and finding individual objects (including casting a mask from the model's face and collecting ready-made materials, such as fragments of toys and medical instruments); this was followed by assembling the objects upon the model, a performance whereby the model was transformed into an image for presentation. The result was an "installation"—a still-life scene conceived as the third phase of the project. This installation was exhibited, then photographed, and finally made into a painting (*Fig. 6*). In Shi Chong's words:

> In the process of employing figurative forms to represent a "second reality," I try to incorporate the creative processes and concepts of installation and action art, creating what I call "artificial copies." The incorporation of these concepts and techniques, as well as the employment of a supra-realistic painting style, not only increases the amount of visual information in a two-dimensional painting, but also injects the spirit of the avant-garde into easel painting.[2]

Shi Chong realizes the "avant-garde" spirit by debasing the classical ideal of a painting as a self-contained and superlative representation of the world surrounding the artist. This spirit, which equals "contemporaneity" in his thinking, requires that painting be affiliated to a larger program of artistic practice and interpretation. In this way, Shi Chong also theorizes a common practice of Chinese oil painters and turns it into a component of avant-garde art. I have called this practice "painting from photos": although almost all these painters learned their techniques from life-drawing classes in art academies, their postgraduate "creative" works are usually based on photographs. Even the most accomplished realists of the country, such as Liu Xiaodong 劉小東 (b. 1963), Chen Danqing 陳丹青 (b. 1963), and Yu Hong 喻紅 (b. 1966), routinely use this method. Their reason, as I have discussed elsewhere, is that by inserting photography between a realistic painting and reality itself, they distance the one from the other. The seem-

2. Cited in *Shoujie dangdai yishu xueshu yaoqing zhan 1996–1997* (*The First Academic Exhibition of Chinese Contemporary Art, 1996–1997*) (Guangzhou: Guangdong Linnan meishu chubanshe, 1996), p. 58.

ingly technical matter of painting from photos therefore already implies a hidden desire to detach art from life.[3] Shi Chong legitimizes this desire by dismissing any connection between his painting and reality: his amazingly realistic pictures actually translate photographs that, in turn, record installations and performances. Rather than referring to the "real," such a painting realizes its meaning through embodying layers of representations.

Contemporary Subjects

As proposed earlier, this essay aims to locate references, languages, and points of view that signify contemporaneity in current Chinese art. My discussion thus far has identified one such signifier in artists' active engagement with art forms and mediums: through subverting traditional forms and embracing new, contemporary forms, they identify themselves as "contemporary" artists. The present section concerns the content of their work. My focus is on those subjects that are prevalent in experimental art but seldom seen in more traditional art genres, such as oil and ink painting. These subjects thus reveal the contemporaneity of experimental art by means of the content of representation.

Against Monumentality

Any kind of avant-garde art has the tendency to subvert traditional "monumentality," whose Latin root *monumentum* couples "admonition" (*monu*) and "reminder" (*mentum*). To serve the role of admonition, a traditional monument is frequently an imposing and impersonal structure dominating a public space—the Arc de Triomphe, the Lincoln Memorial, or the Monument to the People's Heroes (Renmin yingxiong jinianbei 人民英雄紀念碑) in Tiananmen Square. For Georges Bataille, these and other monumental structures "are erected like dikes, opposing the logic and majesty of authority against all disturbing elements: it is in the form of cathedral or palace that Church or State speaks to the multitudes and imposes silence upon them."[4]

It is therefore not surprising that monuments as symbols of power and collectivity become targets of avant-garde attacks. A pioneer in this avant-garde tradition is Claes Oldenburg, who designed a series of "counter-monuments," including a pair of scissors that parodies the Washington Monument: "The scissors are an obvious morphological equivalent to the obelisk, with interesting differences—metal for stone, humble and modern for ancient, movement for monumentality."[5] In China, numerous counter-monuments have been attempted by young experimental artists in the past ten to fifteen years. Many of these projects have taken place along the Great Wall (Changcheng 長城), a prime national symbol that stands for both the country's political identity and its historical legacy. Xu Bing's 徐冰 (b. 1955) *Ghosts Pounding the Wall,* for example, started out as a project to make ink rubbings from the Great Wall.

3. Wu Hung, "Once More, Painting from Photos," in *Chen Danqing: Painting After Tiananmen*, ed. Ackbar Abbas (Hong Kong: Hong Kong University, 1995), pp. 142–47.

4. See Denis Hollier, *Against Architecture: The Writings of Georges Bataille* (Cambridge, Mass: MIT Press, 1992), p. 47.

5. Barbara Haskel, *Claes Oldenburg: Object into Monument* (Pasadena, Calif.: Pasadena Art Museum, 1971), p. 59.

When the rubbings are put together in an exhibition, the solid brick structure is transfigured into its volume-less shadow, and the national monument is transformed into the work of an individual artist (*Fig. 7*). Wang Youshen 王友身 (b. 1963), on the other hand, covered a section of the Great Wall with newspapers. Having worked as a newspaper editor for many years, he knows too well how much the Wall owes its monumentality to propaganda. Other counter-monuments subvert traditional monumentality on a more abstract level. Gu Wenda's 谷文達 (b. 1955) series *Monuments of the United Nations* is well known. Instead of building "national" monuments with stone or steel, he uses human hair to create spectacular but ephemeral structures symbolizing different countries and races (*Fig. 8*).

Another group of works in contemporary Chinese art should be differentiated from counter-monuments and identified as "anti-monuments." A counter-monument subverts traditional monumentality by transforming a conventional monument into something else. Its violation of traditional monumentality still refers to a conventional monument. This violation results in a new monumental form (such as the imposing installation of Xu Bing's paper Great Wall or Gu Wenda's *Monuments of the United Nations*). An anti-monument, on the other hand, rejects any form of monumental expression and gains its significance from erasing such expression.

Anti-monuments are far fewer than counter-monuments, partly because the former are, by nature, works of conceptual art and demand greater radicalism in conceptualization and design. Song Dong's performance *Breathing*, offers an exceptionally powerful example in this genre (*Fig. 9*). It was New Year's Eve, 1996. Holiday lights outlined the familiar contour of Tiananmen in the distance, and the temperature was minus nine degrees centigrade. Song Dong lay prone and motionless in the deserted Tiananmen Square, breathing onto the cement pavement for forty minutes. On the ground before his mouth, a thin layer of ice gradually formed, which seemed to increase in thickness and solidity with each breath. When he left the square, the ice was still shimmering like an elusive islet in an ocean of concrete. It disappeared before the next morning, leaving no visible trace.

To be sure, many works in contemporary Chinese avant-garde art have attempted to demystify Tiananmen by blaspheming this most sacred symbol of Communist China. Shifting his focus from Tiananmen to Tiananmen Square, however, Song Dong departs from the logic of iconoclasm. The meaning of *Breathing* lies in the artist's desperate effort to inject life into that immense official space where the June Fourth Movement ended in bloodshed in 1989. There is little doubt that Song Dong designed the project to commemorate this failed pro-democratic movement. His performance (and the photograph that documents it) brings us back to that heated month in 1989 when demonstrating students transformed the space in front of Tiananmen into an exhilarating "living place," and reminds us that whatever the year, 1996 or 2002, the Square still remains a soulless, stifling barrens.

Urban Ruins as Sites of Contemporaneity

The pursuit of contemporaneity gives rise to many images of ruins in contemporary Chinese art. Although modern representations of ruins generally emphasize the present, images of war ruins in the early part of the twentieth

century served Chinese nationalists as negative proof of a bright future, while "memory images" of the Cultural Revolution and other human calamities allude to a tragic past in the history of a specific country.[6] In contrast, images of urban ruins in contemporary Chinese art are remarkable for their lack of any sense of historicity—not only no past and future, but even no concept of the present.[7] Rong Rong's 榮榮 (b. 1968) photograph in Figure 10, for example, shows Beijing, or part of Beijing, in the late 1990s. The scene is terrifying: hundreds of houses were turned into ruins and a whole area in this famously crowded city suddenly became a no-man's land. What has happened? Where are the residents? The picture offers few clues to answer these questions. What it offers, at the center of the image, are abandoned illusions—pin-ups posted on a surviving wall of a half-destroyed house. The pictures are torn, but the women stare sweetly and immutably at the broken bricks and dirt.

This photograph is one of many images in contemporary Chinese art that represent the transformation of the city. A striking aspect of a major Chinese city like Beijing or Shanghai over the past ten years has been never-ending destruction and construction. This situation is both the context and the content of Rong Rong's photograph. As a result, the image highlights three characteristics that define the contemporaneity in this type of work: (1) the lack of an apparent political or ideological agenda, (2) the absence or disappearance of the human subject, and (3) a breakdown of conventional temporality and spatiality. Whereas the very act of representing architectural ruins testifies to the artists' fascination with torn and broken forms and their attraction to shock and wound, it is by no means clear what is actually wounded, besides the buildings themselves. The absence of the human subject implicit in Rong Rong's photograph becomes the central theme of Zhan Wang's 展望 (b. 1962) series of tortured, sculpted figures, which are empty shells without a real body to feel pain. Sometimes Zhan Wang displayed these figures in a ruined building and took photographs. The pictures recall wartime ruins; but the resemblance is deliberately superficial, because the figures are mannequins, and even the ruin appears like a stage set under artificial lights.

The missing subject is sometimes identified as the artist himself. Sui Jianguo's 隋建國 (b. 1956) site-specific installation, *Ruins*, is arguably the best example of this type. The Central Academy of Fine Arts (Zhongyang meishu xueyuan 中央美術學院), China's premier art school during the past fifty years, was located near Wangfujing 王府京, the most famous commercial district in Beijing. In 1994 the school was informed that it had to move to a new location within a few months, because the city government had sold (or "rented") its campus to a Hong Kong real estate developer. Some protest was attempted by teachers and students, but before long the school's northern section, where the Department of Sculpture had its classrooms, was demolished. Sui Jianguo, then an assistant professor in the department, cleared and paved the ground of a nonexistent classroom, and arranged rows of chairs, a desk, and

6. See Wu Hung, "Ruins, Fragmentation, and the Chinese Modern/Postmodern," in *Inside Out: New Chinese Art,* ed. Gao Minglu (Berkeley: University of California Press, 1998), pp. 59–66.

7. For the concept of historicity, see Paul Ricoeur, *Time and Narrative,* trans. Kathleen Blamey and David Pellauer, vol. 3 (Chicago: The University of Chicago Press, 1985), pp. 60–98.

two bookcases filled with broken bricks (*Fig. 11*). "This is not a protest," he told me in an interview, "because *we* are no longer there."[8]

Like Zhan Wang's work, the content of Sui Jianguo's installation is the absence or disappearance of the subject. Rong Rong's photograph has a related but different focus: he fills the vacancy and replaces the missing subject with *images*, which originally decorated an interior, but which have now become the exterior. The viewer, however, is still clueless about the missing owner of the pin-ups, which are too generic to help us recognize any individuality; that is exactly why they were left behind. In other words, ruins in this and similar images do not register a specific past, nor are they associated with the present or the future. What they help construct is a breakdown between private and public spaces. Ruins in Beijing are places that belong to everyone and to no one. They belong to no one, because the breakdown between private and public space does not generate a new kind of space. Captured by artists, their images represent "non-spaces" outside normal life.

Such breakdown of the conventional spatial dichotomy between private and public spheres is linked to the breakdown of a conventional temporal scheme. The contemporaneity of these ruin-related art projects should be distinguished from the concept of the present, conceived as an intermediary, transitional stage between the past and the future. As subject of artistic representations, ruins break the logic of historical continuity, as "time" simply vanishes in these "black holes." The past of these sites has been destroyed and no one knows their future; they are simply identified as "demolition sites."

Self-Portraiture: Invisibility as Individuality

Self-portraiture constitutes an important genre in contemporary Chinese art and demonstrates a strong desire to reconstruct the self through visual representations. This desire comes from an absence: self-portraiture disappeared entirely in China during the Cultural Revolution from the mid-1960s to mid-1970s. In a period when every action and thought had to be directed by a collective ideology, self-portraiture was naturally identified with bourgeois self-indulgence and was therefore considered counter-revolutionary. On the other hand, the art of portraiture was exaggerated in importance by being reduced to the mass production of the image of one man—Mao Zedong 毛澤東 (1893–1976).

The desire and practice of representing the self resurfaced soon after the Cultural Revolution was over, but the form and logic of these representations have been conditioned both by the country's recent past and by the global culture that China was entering. Instead of regaining the possibility of representing one's physical appearance and emotional state, experimental artists have more commonly tended to a conscious denial of explicit self-display. Numerous "self-portraits" by these artists demonstrate a voluntary ambiguity in their self-images, as if they felt that the best way to realize their individuality was to make themselves simultaneously visible and invisible.

8. Private communication with the artist.

Self-mockery—a type of self-distortion and denial—became popular in avant-garde Chinese art in the early 1990s and was represented by Fang Lijun's 方立均 (b. 1963) skin-headed youth with a gaping yawn on his face (*Fig. 12*). A trademark of cynical realism, this image encapsulated a dilemma faced by a generation of Chinese youth in the post-1989 period. As Li Xianting 栗憲庭 has explained, these young people

> have lost faith in the dominant ideology, but also have no intention of making any effort to oppose this ideology and replace it with a new one. Finding no way out, they have developed a practical and self-serving attitude. Boredom is the most effective means of these cynics to free themselves from any shackle of responsibility.[9]

Fang Lijun's images introduced what may be called an "iconography of self-mockery," which has been followed by many more recent experimental artists. Among them, Yue Minjun 岳敏君 (b. 1962) has created a stereotyped image of himself laughing hysterically. If this image is still a self-portrait, what it portrays is no longer a real human subject but an autonomous figure; and the artist's creativity has been realized through transforming himself into such a figure.

In a sense, the distorted faces in these works are all masks—a "false facade" (*jiamian* 假面) assumed as a means of performance and disguise. This idea becomes explicit in Zeng Fanzhi's 曾凡志 (b. 1964) paintings. It is difficult to determine whether these are "portraits" or "self-portraits," because the sitters invariably wear a mask to conceal their faces (*Fig. 13*). The mask thus blurs the distinction between portraiture and self-portraiture, and actually debases both artistic genres because it conceals, not reveals, the figures' likeness and identity.

Both Yue Minjun and Zeng Fanzhi participated in *It's Me*, an experimental art exhibition organized by the independent curator Leng Lin 冷林 in 1998 in Beijing. Other artists in this exhibition employed a different method of self-distortion to destroy one's own image by making it blurry or fragmentary, a technique I have termed "self-effacing." Yang Shaobin's 楊紹濱 (b. 1963) oil painting *No. 8* is one such example; the rapid brushwork and dripping paint create the impression of flux, "as if the image is in constant danger of ruination."[10] There is evidence that "self-effacing" has become a primary mode for self-representation in more recent experimental art: in a new publication called *Faces of 100 Artists* (*100 ge yishujia de miankong* 100個藝術家的面孔), more than one third of the self-portraits by experimental artists use this representational formula.[11] Most of these images are intentionally ironical. Jin Feng's 金鋒 (b. 1962) work, for example, shows a series of increasingly featureless images of himself seen through a wall of half-filled drinking glasses (*Fig. 14*).

9. Li Xianting, "Wuliaogang he 'wenge' hou de disandai yishujia (Boredom and Third-Generation Artists in the Post-Cultural Revolution Era)," 1991; cited in Lü Peng, *Zhongguo dangdai yishushi, 1990–1999* (*A History of Chinese Contemporary Art, 1990–1999*) (Changsha: Hunan meishu chubanshe, 2000), pp. 95–96.

10. Leng Lin, "Jiuwei Zhongguo yishujia (On Nine Chinese Artists)," in idem., *Shi wo, Jiushi niandai yishu fazhan de yige cemian* (*It's Me: An Aspect of Contemporary Chinese Art in the 1990s*) (Beijing: Contemporary Art Center Co., Ltd., 1999), pp. 103–11; quotation from p. 107.

11. Shen Jingdong, *100 ge yishujia miankong*, 2001. Private publication.

Wu Hung

These ambiguous images are, of course, still about the authenticity of the self, but they inspire the question "Is it me?" rather than the affirmation "It is me!" This new rhetorical significance of self-portraiture is related to the changing meaning of self in the contemporary world. It has been contended that, in our time, the traditional view of a fully integrated, unique, and distinctive individuality has been increasingly compromised, causing the fragmentation of self and the decline in the belief that the individual is a legitimate social reality.[12] Examples from Chinese experimental art both agree and disagree with this contention. On the one hand, these works indeed demonstrate heightening doubts about the self. On the other hand, a masked or blurred image does not deconstruct "a fully integrated and distinctive individuality," because the image is still created as an individual expression. Approached as such, the voluntary dismissal of an identifiable self in such works is a particular strategy to construct contemporaneity, realized through making the subject both visible and invisible.

Contemporaneity as Internalization—An Interpretative Strategy

It is a truism that the course of contemporary art is inevitably affected by external factors, among which social change looms large. The recent development of Chinese art offers perhaps the most dramatic evidence for such causality: not long ago this art was reduced to Communist propaganda posters and Mao Zedong's portraits, but now young experimental Chinese artists travel to every major exhibition in the world, from Venice to Havana, with government-issued passports. From a sociological point of view, this startling transformation of art is itself part of a broad transformation of Chinese society brought about by Deng Xiaoping's 鄧小平 economic reforms and open-door policy: one can trace the "social changes" in Chinese art step by step from the late 1970s, when these reforms were first put into practice.

To summarize some basic facts, unofficial art societies and exhibitions appeared in 1979, followed by a nation-wide "avant-garde" movement in the middle to late 1980s. The 1990s saw the emergence of commercial galleries and private museums of experimental art—a radical branch of contemporary art that self-consciously challenges official, academic, and popular art with its "cutting-edge" media and controversial subjects. Independent curators and art critics played increasing roles in advocating this art, and the experimental artists themselves were rapidly internationalized. Some of these artists emigrated and gained fame abroad; others remained local while cultivating global ties. Numerous books and magazines on contemporary art have been published over the past twenty years, and many experimental exhibitions have been staged in all sorts of public and non-public spaces. Clashes between the avant-garde and political authorities have never ceased. But to many observers, two government-sponsored contemporary art exhibitions during the past two years—the 2000 Shanghai Biennale and the 2001 *Living in Time* in Berlin—reflect a new level of normalization of international-style contemporary art in China.

12. Richard Brilliant, *Portraiture* (London: Reaktion Books, 1991), p. 171.

The close relationship between contemporary Chinese art and the country's sweeping transformation has encouraged the compilation of a macro-history of this art, which interprets the contemporaneity of artists and artworks against large social and political movements. Taking a textual form and largely reflecting an academic interest, this historical narrative contributes to our knowledge of contemporary art by documenting specific conditions and stimuli for art creation in a communist country that is nevertheless attracting numerous overseas investors as well as a growing number of international curators. On the other hand, this macro-narrative has little impact on these curators, who rarely base their selection of artists and works on a historical textbook, but are guided, often spontaneously and intuitively, by what they find new and compelling in visual forms. Artists not only respond to such interest and judgement, but are also stimulated—again, spontaneously and intuitively—by their ever-changing environment as well as by information about international art trends.

Such spontaneity and intuition, though alien to many academic art historians, play crucial roles in advancing contemporary art by leading to the discovery by curators and critics of new styles and the promotions of new trends. For example, this is how Harald Szeemann selected as many as twenty young experimental Chinese artists for the 1999 Venice Biennale, more than the combined number of American and Italian participants.[13] This decision had a profound impact on contemporary Chinese artists, because many young experimental artists took it as an unmistakable indication of the direction of international art.[14] More generally, visual spontaneity underscores any exhibition of self-consciously "contemporary" art: while the supposed novelty of such exhibitions defies historical determinism, their stimulating and often challenging display generates instantaneous response. An art exhibition of this kind thus always poses unanswered questions, but also confines the viewers' responses to the display itself. (An excessive textual framing of a contemporary art exhibition often effectively kills the exhibition by transferring authority from image to word.)

From this approach, if the contemporaneity of contemporary Chinese art has anything to do with social change, such change cannot remain an external frame, but must be *internalized* as intrinsic features, qualities, intentions, and visual effects of specific works and art projects. This leads back to a proposal I made at the beginning of this essay, that contemporaneity must be recognized as a particular artistic/theoretical construct, which self-consciously reflects upon the conditions and limitations of the present. Now I can further propose that contemporaneity as such results from the artist's internalization of complex contextual factors; to locate contemporaneity in art is to discover the logic of such internalization. This interpretative strategy discards the overall framework of a macro-history of contemporary art, but forges micro-narratives that emphasize artists' individual responses to common social problems.

13. In a conversation with some Beijing artists, Szeemann emphasized the role of curators as "hunters" working from intuition and experience. See "Harald Szeemann Talks to Chinese Artists about Venice, CCAA and Curatorial Strategies," in *Chinese Art at the Crossroads: Between Past and Future, Between East and West*, ed. Wu Hung (Hong Kong: New Art Media, 2002), pp. 148–61.

14. *Ibid.*

Wu Hung

Coda: Locating Contemporaneity in Contemporary Chinese Art

Monument and ruin are antithetical—one is supposed to last forever, the other signifies continuous decay. A work of contemporary art acquires contemporaneity by defying the former's immortality and by transforming the latter into representation. As spatial signs, monument and ruin are also imbued with temporality, since both are linked with historical events and evoke memories. Furthermore, monument and ruin are both connected with people's collective and individual identities, which are constructed and contested around these historical and memory sites. In this way, these two states of architecture provide nexuses of space, time, and identity, revealing a conceptual triangle that underlies any construction of contemporaneity in art.

This conceptual triangle supplies a grid for mapping contemporaneity in contemporary Chinese art, a critical endeavor that can be exercised on different levels and on different scales. On a very general level, numerous works in this art reflect on globalization, a phenomenon that concerns not only geopolitics but also histories, memories, and identities. Globalization has different meanings and impacts for different countries. To many Mainland Chinese artists who have witnessed the end of the Cold War but still find themselves subject to a Cold War mentality, globalization is often perceived through the relationship between East and West. This relationship offers them a general framework in which to relate their art to global problems, as their thinking about the power relationship between East and West is deeply connected to all aspects of their art—medium, image, style—and also to their personal lives and political outlooks. Some of the most powerful works of contemporary Chinese art are the result of such intense thinking and experiments. Two representative artists in this tradition are Xu Bing and Cai Guo-Qiang 蔡國強 (b. 1957). Xu has invented a type of English writing that can be practiced as Oriental calligraphy—a perfect fusion of different cultural heritages. Cai's installation *Cry Dragon, Cry Wolf: Genghis Khan's Ark* alludes to Western paranoia about the "Yellow Peril" (*Fig. 15*).

On a local level, experimental Chinese artists define the contemporaneity of their art in relation to the rapid transformation of the city: the city *is* contemporary and constantly challenges them to reinvent their art. The city attracts artists with its urban ruins as well as its new skyscrapers, the ambition and superficiality of which stimulates escalated novelty in visual representation. New types of urban spaces also generate new art. Urban development in Beijing, for example, has pushed experimental artists to the city's peripheries. Some of the most compelling performance projects in contemporary Chinese art were produced in the so-called "Chinese East Village" (Dongcun 東村), a tumbled-down residential district on the eastern fringes of Beijing. From 1993 to 1994, a group of immigrant artists from the provinces founded their community there. They were attracted to this garbage-filled place by its cheap housing as well as its ugliness, conceiving their move into the Village as a form of voluntary self-exile. Deriving inspiration from the Village's "hellishness" in contrast to "heavenly" downtown Beijing, they identified themselves with the place in their works. It is in this spirit that Zhang Huan 張洹 (b. 1965) performed his now infamous *12*

Square Meters: covering his naked torso with a foul-smelling substance to attract hundreds of flies, he sat motionless for an hour in the Village's dirtiest public toilet.

These examples made it clear that any attempt to construct contemporaneity in art is intrinsically intertwined with the artist's self-identity. Although this is a common phenomenon in contemporary art in general, the issue of self-identity is given extraordinary urgency in the fast-changing Chinese society. As discussed earlier, experimental artists are obsessed with depicting themselves, but a prevailing tendency is to deny explicit self-display. We find strong parallels between these images and the representations of counter-monument, anti-monument, and ruins, but what is deconstructed and reconstructed here is not an external reality, but the self as an internal existence.

Wu Hung

中國現代藝術的現代性

巫鴻
芝加哥大學

現代性不只與當下有關，本文將其定義為有意的、具有自身特殊歷史的一種藝術／理論建構。為了完成這種建構，藝術家／理論家自覺地反應當前的條件及限制，也因此將當前——一般所謂的時間／空間——各自的參照、語言和觀點具體化。本文透過對這些參照、語言和觀點作定位，追蹤現代中國藝術裡的現代性。除了以個別藝術家的作品為本，也希望能揭示個別嘗試下的一般潮流。在個人表達與較大型藝術運動間的對話關係，產生了詮釋中國現代藝術時進一步的方法學問題。本文分為三節：

1．顛覆性繪畫

這種為許多實驗性藝術家採用的主要策略，是透過顛覆已有的繪畫類別與媒材達成完全的「現代性」。本節檢視這股自1980年代以來潮流的出現、發展及種種體現。

2．現代主題

一些現代主題在實驗性藝術中十分普遍，但在如油畫和水墨畫一類較為傳統的藝術類別中則極少見。本節檢視這類主題的三種類型：(1)歷史與記憶(2)城市與都會文化的轉變(3)藝術家的自我認同及個別性。

3．將現代性作為一種內化——一種詮釋策略

本論節點為較廣的社會脈絡仍不足以詮釋中國現代藝術。因為如果這種藝術的現代性與社會變化有任何關係的話必然不是變化可以給予的延續性外部框架，而一定是內化成特定作品及藝術計畫的內在特色、品質、意圖以及視覺效果。因此要定位藝術中的現代性，就是要發現這種內化的邏輯。這種詮釋策略忽略宏觀性現代藝術史的整體框架，但卻將強調藝術家個人反應的微型論述與一般社會問題結合起來。

中国現代芸術における「現代性」

巫鴻

シカゴ大学

「現代性」とは単に「今、ここで」という状態に関連するものを指すのでなく、それ自体の固有の歴史性を主張する国際的な芸術的、理論的構成概念として本稿では定義づける。このような概念を構築するために、芸術家、理論家は意識的に現在の状況とその範囲、限界を省察し、その結果、現在、すなわち通常の時間と場所を独自の基準・言語・観点によって実体化するのである。当論文はこれらの関連・言語・観点を明確にすることにより、現在の中国芸術における現代性の位置付けを行うものである。当研究は必然的に個々の芸術家の作品に基づいているが、それら異なる試みの根底に共通する傾向をも明らかにしたいと考える。個々の表現と大局的な芸術活動との間の弁証法的関係は、中国現代芸術を解説して行く上で、さらなる方法論的問題を提示すことになる。本稿は次の三セクションから構成される。

1．反絵画

作品の「現代性」を明確に打ち出すために多くの中国実験的芸術家が採用している主な方法は、既存の芸術ジャンルおよび手法を破壊することである。この章では、1980年代以来の、この潮流の出現、発達、明確化を検討する。

2．現代芸術の主題

現代芸術の主題の中には、実験芸術ではよく採り上げられるが、油彩画や水墨画のような伝統的ジャンルではめったに使われない主題がある。この章ではそのような主題を(1)歴史と回想、(2)都市文化の変遷、(3)芸術家の自己アイデンティティーと個人としての存在、に関連付けて考察する。

3．国際化という現代性—解釈的アプローチ

この章では、広い社会的文脈化は現代中国芸術を解釈する上で不十分であるという提案をする。その理由は、もし現代中国芸術の現代性が社会的変化と何らかの関係があるとするならば、そのような変化は外的要素としてとどまるはずがなく、特定

の作品や芸術的企画に固有の特徴・質・意図・視覚的効果として内在化されなけれ
ばならないのである。そのように考えると、芸術において現代性を位置づけること
は、この内在化のロジックを発見することなのである。このような解釈的アプロー
チは、現代芸術のマクロヒストリーの全体的枠組みを放棄することを意味するが、
共通の社会的問題に対する芸術家達の個々の反応を重視するマイクロ・ナラティブ
を生み出すのである。

Fig. 1. Song Dong (b. 1966). *One More Lesson: Do You Want to Play with Me?* 1994. Performance and installation, Central Academy of Fine Arts Gallery, Beijing.

Fig. 2. Qiu Zhijie (b. 1969). *Assignment No. 1: Copying "Orchid Pavilion Preface" a Thousand Times.* 1990–95. Ink, calligraphic text on rice paper.

Wu Hung

Fig. 3. Yang Jiechang (b. 1956). *Square 100 Layers of Ink*, 1994-1998. Ink, rice paper, metal box, 48 × 47 × 15 cm.

Fig. 4. Hu Youben (b. 1961). *Abstract Series, No. 14*, 1997. Ink painting installation, 2.85 × 4.20 m.

Section V: Recent and Contemporary Painting 605

Fig. 5. Zhu Jinshi (b. 1954). *Impermanence*, 1996. Mixed media (rice paper, bowls, and water), 15 × 15 × 3 m.

Fig. 6. Shi Chong (b. 1963). *The Stage*, 1996. Oil on canvas, 239 × 86 cm.

Fig. 7. Xu Bing (b. 1955). *Ghosts Pounding the Wall*, 1990. Mixed-media installation, 2.74 × 6.09 m.

Wu Hung

Fig. 8. Gu Wenda (b. 1955). *Monuments of the United Nations: The Babble of the Millennium.* Mixed media; h. 22.50 m, diam. 10.20 m. *(detail on page 587)*

Section V: Recent and Contemporary Painting 609

Fig. 9. Song Dong (b. 1966). *Breathing*, 1996. Performance, Tiananmen Square, Beijing.

Fig. 10. Rong Rong (b. 1968). *Untitled*, 1996-1997. Black-and-white photograph, 51 × 61 cm.

Wu Hung

Fig. 11. Sui Jianguo (b. 1956). *Ruins*, 1995. Part of the group installation *Property Development* by the Three Men United Studio, Central Academy of Fine Arts, Beijing.

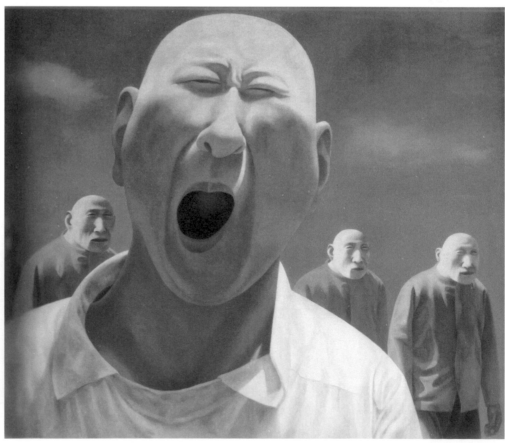

Fig. 12. Fang Lijun (b. 1963). *Series 2: No. 2.* Oil on canvas, 2.01 × 2.01 m.

Section V: Recent and Contemporary Painting 611

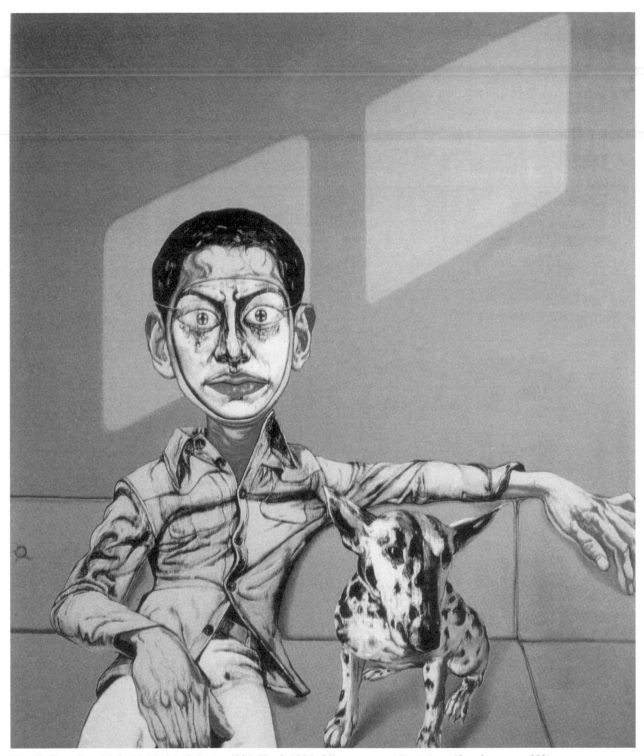

Fig. 13. Zeng Fanzhi (b. 1964). *Mask Series 1996: No. 8*, 1996. Oil on canvas, 1.7 × 1.4 m. *(detail on page 503)*

Wu Hung

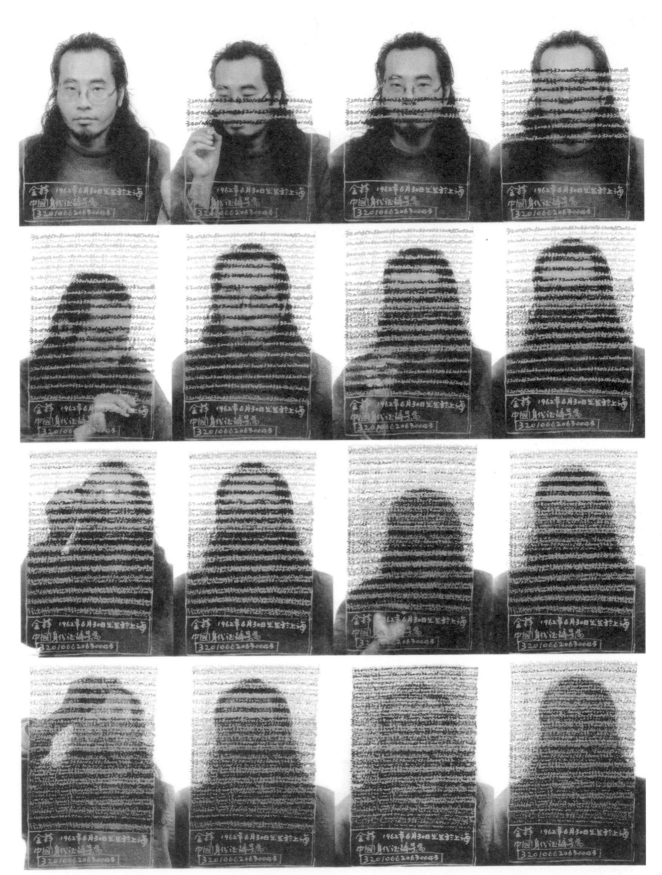

Fig. 14. Jin Feng (b. 1962). *The Process in Which My Image Disappears*, 1998. Performance, color photographs, 1.2 × 0.9 m.

Fig. 15. Cai Guo-Qiang (b. 1957). *Cry Dragon / Cry Wolf: Genghis Khan's Ark*, 1996. Mixed-media installation (109 sheepskin bags, wooden branches, paddles, rope, 3 Toyota engines, and other materials), 3.5 × 19.86 × 2.61 m.

Section V: Recent and Contemporary Painting
Response

Yoshiaki Shimizu

Princeton University

Included within the topic of this section, "Recent and Contemporary Painting," are questions relating to two eras: (1) painting in East Asia from the late eighteenth century through most of the nineteenth century, including East Asia's tumultuous encounter with the West and its consequences through the mid-twentieth century, and (2) painting in the aftermath of World War II and its consequences in China, Taiwan, Korea, and Japan. The essays by Wan Qingli 萬青力, Yen Chüan-ying 顏娟英, and Wu Hung 巫鴻 address the relationships between artists and the ever-changing and evolving societies they inhabit. Richard Vinograd, on the other hand, deals not only with what the artists produced and how, but also with the question of how to define "Chinese painting"—pointing out that the criterion may be time or space, artist's ethnicity or mother tongue, or format and medium. Only after acknowledging multiple definitions, says Vinograd, can we begin to speculate usefully about the equally ambiguous concept of beginning(s) and end(s) of Chinese painting.

These four essays stimulate and reward readers by acting as guides to unfamiliar as well as familiar territories of the more recent history of painting in East Asia. The absence, however, of essays on the painting of Korea and Japan during the corresponding period is a significant lacuna in this section. As a historian of Japanese art, this respondent felt particularly the lack of any comparison with the well-documented artistic situation of Japan, first from the Meiji Restoration (Meiji ishin 明治維新) of 1868 through 1945 and second from 1945 to the present. The omission of any discussion of Japanese artistic endeavors during the drastic Westernization of the second half of the nineteenth century feels especially egregious, but I will deal more on this later.

Wan Qingli

Informed liberally by the rich biographical accounts of more recent artists in China, Wan Qingli's "Chinese Merchants as Influential Artists: 1700–1948" is an extensive narrative of the emergence of merchants and townsmen as both artists and patrons of artists in the shifting socio-economic centers of China during the eighteenth and nineteenth centuries. This process helped shape a new artistic demography of China in the twentieth century, which ultimately undermined the traditional constituency of painting and calligraphy—the scholar-gentry class. The commercial classes, Wan asserts, afforded a "breathing space" to artists and intellectuals alike in the early twentieth century, a social identity from which they could transcend their traditional artistic and scholarly boundaries, educational

opportunities, and career possibilities. Among the urban elite of the middle and late Qing, amateur enthusiasm for *jinshixue* 金石學 (the study of ancient inscriptions on bronze and stone) ran deep, and the scholarly and antiquarian cachet of *jinshixue* was instrumental in elevating seal carving from a lowly craft to an art. Seal carving became the fourth "perfection," joining poetry, calligraphy, and painting as an approved art form. Because it remained at the same time a difficult and exacting craft, seal carving became the particular province of businessmen-artists.

In the late nineteenth century, knowledge of Western-style painting and of the social matrix of Western art converged with the phenomenon of townsmen-artists to make the career profiles of painters much more complex. Some of the new and highly cosmopolitan artists-cum-entrepreneurs, such as Wang Yiting 王一亭 (1867–1938) from Shanghai and Jin Cheng 金城 (1878–1926) from Beijing, also acted as patrons and exhibition sponsors. In traditional China, and especially within the literati tradition, art viewing was an essentially private activity; exhibitions, apparently begun with the entrepreneurship of men like Jin and Wang, made art viewing public.

Having expanded from private residences into public venues, the viewing of art continued to evolve: Chinese art was sent abroad for exhibition. Jin Cheng was largely responsible for Chinese painting being shown in Tokyo in 1930, and Chen Xiaodie 陳小蝶 (1897–1989), likewise an entrepreneur and painter, was instrumental in the Burlington House exhibition of Chinese art, which opened in London in 1937.

International exhibitions, foreign diplomacy, and the frequent foreign business contacts of entrepreneur-artists all served to enhance Chinese artists' awareness of their own cultural and historical background. Contact with the otherness of Western art and consciousness of Chinese art being viewed through Western eyes served to direct Chinese artists' attention back to their own tradition. In other words, the snake had found its own tail.

Yen Chüan-ying

Yen Chüan-ying's "Images of Cultural Identity in Colonial Taiwan: From Huang Tushui's *Water Buffalo* to Lin Yushan's *Home* Series" examines the work of Taiwanese painters under Japanese colonial policy. Focusing on lesser-known but well-documented painters working in Taiwan between the 1920s and 1940s, this essay relates their search for "right" subjects and styles—in other words, for artistic programs that would express the essence of Taiwan. But in the absence of public museums or private galleries, their artistic identities could only be validated through success in the competitive Taiten 台展 exhibitions. These annual events were planned and controlled by Japanese organizers whose artistic values and expectations differed from those of native Taiwanese artists. The narrative is a story of the relationship between artists and the institutions that overtly or covertly prescribe what is desirable in subject matter and style.

In the first half of the twentieth century, these Taiwanese felt caught between an etiolated Chinese tradition of ink painting and the foreign neo-*nihonga* 日本画 mode of the Taishō and Shōwa eras of Japan. In addition, their art was further constricted by their own narrow search for the types of image and modes of representation that best repre-

sented Taiwan. The Japanese exhibition committee and art critics were of no help, either, characteristically disparaging Taiwanese painting for what they felt to be its homely subject matter, strong narrative quality, and insufficiently lyrical style. In 1936, at the tenth Taiten, we are told, Lin Yushan's 林玉山 (1907–2004) *Morning* (*Chao* 朝), depicting his young daughter brushing her teeth, was savaged by the Japanese critics. Lin never painted such a domestic subject again.

Here we might ask whether the search for an art distinctively indigenous in content and rendition is motivated by social or artistic concerns. In other words, were these artists seeking to assert Taiwan's identity or their own?

Yen Chüan-ying's essay portrays the artists, some of whom were trained at the Art Academy (Geijutsugakuin 芸術学院) in Tokyo, as victims of Japanese colonial policy. In the years, after 1937 in particular, "Nipponization gradually replaced any cultural movement to develop Taiwanese characteristics." Here we might ask, "How is subject matter expressed in form?" To seek themes exclusively in Taiwan's history or present-day life, or to look for artistic motifs that are symbolic solely of Taiwan (if such actually exist)—is this not the artists' own self-stereotyping? This question also leads to another, larger one: "What is the context of a work of art?"

Taiwan's colonial period ended with the conclusion of World War II, but not, it seems, the issue of cultural identity. In 1982 Lin, now a mature painter, did the painting *Grand Canyon* (*Daxia gu* 大峽谷).[1] What was the context of this painting? Are we to see this painting as another expression of cultural identity against the new political reality—the Cold War era of the 1950s and later? Or can we see this work simply as Lin's artistic statement about the grandeur of an American place, perhaps seen from an airplane window, and the form he chose to express that grandeur?

Wu Hung

Wu Hung writes not about contemporary painting, but about the notion of "contemporaneity" in today's China as it applies to a particular group of artists working in non-traditional media. He deliberately separates the subject from the works of more traditional artists, whether literati ink landscape or realistic oil portraiture, which are outside the field of contemporary art due to their voluntary exemption from contemporaneity. Wu Hung focuses narrowly on avant-garde artists who are culturally dissevered from traditional China. The paper asks what might be their motivation and who are their audience.

Like the desire to show one's work, so the desire to experiment with the ideas of other artists, including those from other cultures, might almost be considered a basic instinct among some artists. Contemporary painting, in all its fickle permutations of mediums, venues, and modes of transmission (Internet transmission and display of images being among the latest trends), allows artists to act on these instincts, which in the past may have been inhibited by the various kinds of material or cultural restraints. Arts of other cultures liberate artists from particular fixed cultur-

1. Ink on paper, 48 × 59 cm; reproduced in *Together/To Gather—Sun Ten Museum Collection,* Taipei Fine Arts Museum (Taipei, 1999), p. 54.

Yoshiaki Shimizu

al, social, or artistic habits, or from stereotyped notions of ethnicity or nationality. It is the positive, creative force of these instincts that I should like to affirm when assessing modern and contemporary works produced in East Asia.

Though Wu Hung's essay deals with the contemporary avant-garde and Wan Qingli's with early twentieth-century painting and the impact of Western art, it is clear that the artists they discuss share the same basic instinct: to connect with the larger world of artistic practices found outside China—to emulate, copy, appropriate. The models that each group looks to are not difficult to find in modern and contemporary art as practiced in the artistic centers of Europe or America of the past one hundred years. They stimulated the Chinese artists to do similar things or to improvise, to invent and reinvent works, to muster their own creative capacity and artistic resources or raw materials (calligraphy, photographs, or images of city ruins) together with newly encountered ideas. What is difficult is to identify a meaningful constituency, critics included, among the contemporary audiences, including artists who cling to traditional genres and are described by Wu Hung as "voluntary exemptions" from the avant-garde.

How can the most recent art of China be compared meaningfully with that of the West? Are they conceptually so far apart that we can only frame Chinese avant-garde experimental art in its own terms and historical dialectic? In short, does contemporary Chinese art have meaning beyond its social context?

In a review of the 2002 Whitney Biennial, Arthur Danto, contemplating the exhibition against the broader world of art today, observed that

> [A]rt today is pretty largely conceptual. It is not Conceptual Art in the narrow sense the term acquired when it designated one of the last true movements of late Modernism, in which the objects were often missing or even non-existent, but rather in the sense that being an artist today consists in having an idea and then using whatever means are necessary to realize it. Advanced art schools do not primarily teach skills but serve as institutes through which students are given critical support in finding their own way to whatever it takes to make their ideas come to something. This has been the case since the early 1970s.[2]

The contemporary Chinese experimental works discussed by Wu Hung are conceptual in the form of installations, mixed media formats, and performances. They are multimedia art, in which objects, assemblage, happenings, and other signs of popular culture are marshalled into a single structure that invites multiple interpretations. To mount objects as subjects occurred during the decades of the 1950s and 1960s in America, and, in Europe, much earlier. These works proclaimed the era of alternative media and the birth of new genres of art, both of which occurred at a time of visible social and technological transformation in society.

It is generally understood that artists' search for alternative media coincided with radical social changes: World Wars I and II, the consumer boom of the 1950s and 1960s, and the rapidly advancing electronic technologies of the last three decades of the twentieth century.[3] New alternative but firmly established artistic media are photography and film, exerting their impact on most twentieth-century art.

2. Arthur Danto, "The Whitney Biennial 2002," *The Nation*, vol. 274, no. 16 (29 April 2002), p. 32.

3. Kenneth G. Hay, "Alternative Media," in *Oxford History of Western Art,* ed. Martin Kemp (Oxford and New York: Oxford University Press, 2000), p. 444.

Now, artists experimenting in alternative media generally do so, according to Kenneth G. Hay, for three types of reason:[4]

1) Celebratory: to celebrate the new century or new social order, or to delight in new materials;
2) Critical: to criticize outmoded genres or ideologies;
3) Formalist: may overlap with either of the above reasons, but formal experimentation or playfulness predominate.

Artists may participate in all of the above at different times.

New genres in art began to emerge at the beginning of the twentieth century—the Futurist movement, which inaugurated Dada at end of World War I, and Surrealism. The Berlin Dadas, represented by Kurt Schwitters, were known in Japan already in 1923.[5] Marcel Duchamp's found objects of 1922 influenced Robert Rauschenberg and Jasper Johns; in the 1960s, John Cage, Merce Cunningham, Robert Rauschenberg, and Claes Oldenburg constituted the New York "happening" called the International Fluxus movement, which, as Arthur Danto explains, "originated in the early 1960s as a loose collective of artists-performers-composers who were dedicated, among others things, to overcoming the gap between art and life."[6]

The works of contemporary East Asian artists, whether they work in their home countries or have migrated elsewhere but maintain their cultural ties with their homes, are relevant to art historians, because the ways in which they shape and change the concept of art affect our concept of art and of art history. Unless we relate clearly to the art of the contemporary world, we cannot plausibly imagine the art of the past.

Like Wu Hung, Richard Vinograd addresses the subject of Chinese avant-gardism, but from a quite different perspective. Vinograd treats avant-gardism in China as a conceptual subject, relating it to the avant-gardism of painters in other parts of the world, such as Kazimir Malevich in Russia and Ad Reinhardt in America.

Wu's paper treats China's avant-gardism as a forum for contemporary Chinese artists who are reacting to rapid social changes. Avant-gardism in China consists of unique responses of individual artists to social conditions peculiar to China. According to Wu Hung, the impulse to create, the motivation to install, assemble, synthesize different media, comes from this reaction to the social phenomena of China. Thus, avant-gardism is seen as a product of the dialectic between society and individuals. One might say the context of avant-gardism in China is Chinese politics or society or cities in ruins.

Much of Wu Hung's deft and insightful essay is an account of a group of self-proclaimed "avant-garde" artists. Methodologically, however, the essay simply deals with this "avant-garde" as an autonomous group of artists, isolated as a self-perpetuating entity and claiming immunity from any relevance to the traditionalists. It might be

4. *Ibid.*, p. 442.

5. The most recent scholarship on Japanese avant-garde in English is in Gennifer S. Weisenfeld, *Japanese Artists and the Avant-garde, 1905–1931* (Berkeley: University of California Press, 2002).

6. Danto, "The Whitney Biennial, 2002," p. 32.

Yoshiaki Shimizu

profitable to consider the Chinese artists in the context of the art of other alternative practitioners or modes of avant-gardism across the globe. These might include Korean-American artist Nam June Paik, the Gutai 具体 ("Concrete") artists of Japan in the 1950s, Jean Tinguely, and Christo, in performance (the use of robotics and video), cyberspace, installation art, and Land Art, for example.

Traditionalists within a modernizing society and culture may resist its tide, but often their work reveals traces or signs that they were touched by some aspects of the New. Similarly, artistic concepts undergo change, eventually affecting the entire discourse on art, both in practice and theory. It is hard to imagine, then, that as part of history, we are free to dismiss "traditional art" from the discussion of the radically changing frontiers of art in China. There must be a meaningful interface between the avant-garde and the traditionalists. What might that relationship be?

Richard Vinograd

For Richard Vinograd, Chinese painting is both a concrete material entity and a concept that is based upon the historicity of the art of painting and upon art criticism. In "The Ends of Chinese Painting," he characterizes sequentially-viewed Chinese painting formats both as physical realities (such as handscrolls or albums) having length, width, and spatial limit, and as metaphors of a larger entity that both precedes a painting's production and ends it. He puns on the word "end(s)," using it to mean "purpose" as well as "terminus."

Further, the author deftly conceptualizes the notion of "end" or "ends" of Chinese painting as the physical limits of the painted thing itself, the temporal limits of the process of production, and the purpose (i.e., to what end?) of the work. At this point, the term "end" has acquired three distinct meanings: (1) the point in time after which a painting tradition cannot progress further, (2) the physical limits of a sequentially-viewed painting, which imply an unlimited reality outside the painting, and (3) intentionality.

This is an extremely interesting concept of an artistic process itself. Here the physicality of a scroll, a painting—as Richard Wollheim puts it,[7] or the materiality of painting—is responding to an assumed concept of a landscape harbored by the artist who does something to that scroll. Taken as a statement of the artist who wants to "avoid" as well as "transcend" (using Vinograd's words) the physical limitation of the handscroll format, these landscape compositions may be seen as vignettes of a longer, even "endless," vista—an enframed portion of a much grander landscape that was "conceptual" in the artist's mind until enframed by the handscroll format. For the artist, indeed, the landscape vignette is just such a portion of a much larger universe. Perceived this way, handscrolls play a performative role, "framing" portions of a larger landscape universe conceived by a host of artists of similar aspirations.

7. "[W]e can postulate a theory that emphasizes the material character of art, a theory according to which a work of art is importantly or significantly, and not just peripherally, a physical object." See Richard Wollheim, "The Work of Art as Object," in *Modernism, Criticism, Realism*, ed. Charles Harrison and Fred Orton (New York: Harper and Row, 1984), p. 11.

The commonality of these aspirations and that universe helps explain why Chinese landscape painting in whatever format is a communal enterprise: artists share a memory storehouse of the known past of Chinese painting, from which they can retrieve differentiated visions and techniques in order to pursue, according to individual predilection, a common end.

The memory storehouse may also contain visions and techniques from outside the artist's own culture, that is to say, from foreign lands. Artists whose inclination is to ignore, resist, or reject all outside artistic stimuli may produce painting which does not reveal any influence. However, artists who are curious, adventuresome, and creative will peruse these foreign visions and techniques and integrate into their own work, either overtly or covertly, what serves their purposes. Such painters stand in the artistically arable grounds of Chinese painting tradition.

An artistic tradition comes to a temporal "end" when it evolves no further. Toward the end of the Southern Song, the representational image of natural phenomena in the landscape began literally to fade: the space given to void increasingly dominates the compositions, and none of the forms appear solid. This has been interpreted as a symptom of the "end" of a Chinese landscape tradition. However, like Vinograd, I cannot but think that the tradition has an afterlife, having become raw material for creative transformation by a painter living in a totally different time and culture. When in 1996 Roy Lichtenstein created *Landscapes in Chinese Style*, an example offered by Vinograd, Chinese landscape painting as a concept was no longer China-bound. Thus, neither temporally nor geographically has it "ended."

Modernization

Art, artists, artistic ideas, society and social changes all appear in these four essays. Lurking unmentioned is the theme, relevant to all four discussions, of modernization in East Asia, which to some means Westernization. How has East Asian painting been affected by this historic change?

The historical period under discussion includes one of the most traumatic and dramatic occurrences in East Asian history: for various reasons and at different times, each of the countries was driven toward modernization/Westernization by the thrust of Western powers. Nor, within each country, did modernization affect each sphere of life at the same time or rate. As the Dutch historian Johan Huizinga has noted, ". . . a wave might break at different points along the shore in response to the topography and resistance it encountered, but . . . it was nevertheless one single tide."[8] The essays that give weight to social, economic, or political changes and their effects on artists, however, seem disengaged from what this respondent considers a cultural and psychological trauma experienced by artists and non-artists alike during the second half of the nineteenth century. How did that trauma affect the artists and how did it manifest, if at all, in their works?

8. Quoted by Marius Jansen, "Meiji Culture," in *The Making of Modern Japan* (Cambridge and London: Belknap Press of Harvard University Press, 2000), p. 456.

Yoshiaki Shimizu

Japan's modernization of politics, economics and foreign policy—its reshaping into a nation-state—is well chronicled. Less noted is Japan's perceived need, and corresponding effort, to maintain its own culture in the face of dazzling Western novelties, and to reshape the concept of its art as a creative cultural act in the face of the same Western thrust.

Here follows a brief account of how Japan, as a nation-state, dealt with its cultural patrimony, and how it redefined its artistic tradition as part of its effort to enter the wider world dominated by Western art and culture. During the early decades of modernization, government efforts at cultural preservation were uncoordinated: registering "national treasures" was done by the Ministry of Imperial Household (Kunaishō 宮內省); protecting Buddhist temples and Shintō 神道 shrines was the purview of the Home Ministry (Naimushō 內務省); and art education came under the Ministry of Education (Monbushō 文部省). Prominent art administrators of the 1880s, most notably Okakura Tenshin 岡倉天心 (1862–1913), Kuki Ryūichi 九鬼隆一 (1852–1931), and Takahashi Kenzō 高橋健三 (1855–1898), frustrated at the lack of a considered and coordinated cultural policy, articulated their disparate ideas on the subject in the first issue of *Kokka* 国華 (October 1889). Most likely the editorial was the work primarily of Okakura and Kuki, both of whom had travelled in the West (France, Italy, and the United States) in the early 1880s. In its first sentence, the editorial defines the newly minted term *bijutsu* 美術 ("fine art"): "Fine arts is the quintessence [national treasure] of the Nation (*Bijutsu wa kuni no seika [kokka] nari* 美術は国の成果[国家]なり)."[9] Among its key statements is:

> The quintessence is embodied in the mystery of Buddhist images, in the loftiness of landscape; it is expressed in the emotions conveyed by the pictorial biographies (of saints and sages) as well as by other picture handscrolls; and in the divine resonance of flowers, plants, birds, and beasts.

The subjects, the terminology, and the concepts defined were all gleaned from age-old Chinese discourse in art criticism, and especially from Chinese painting theory. The editorial goes on to say that the artistic standards should be maintained by the study of the works both ancient and modern and in the knowledge of both East and West. Of utmost significance in this editorial is the equivalence it posits between Japanese narrative handscrolls and European "history painting," then held (especially in France) in high esteem. The editorial urges (the government's) coordinated initiative to protect and preserve traditional arts[10] and to elevate the artistic sensibilities of the populace toward loftiness of theme and elegance of style, in order to help create an international market for the arts and crafts of Japan. *Kokka*'s mission is to function as a beacon to preserve, promote, and instruct in all matters of fine arts and crafts, in order to vitalize the nation's core spirit.

9. *Kokka*, no. 1 (October 1889), pp. 1–4.

10. The Japanese word is *hoji* 保持 ("maintain and preserve"), which is similar to *hozon* 保存 ("protect and preserve"), as in *bunkazai* 文化財 *hozon* ("protection and preservation of cultural properties"), which is the mission of government-funded conservation labs in Ueno and elsewhere in Japan.

As the late distinguished historian Marius Jansen has noted, Meiji period art is only beginning to receive attention in the West. In the cultural encounters of East and West, the Japanese were not a passive vessel facing an intrusive "other." Professor Jansen goes on to quote an apt description of Japan's response to the overwhelming tide of Western influence, by Irokawa Daikichi 色川大吉, who uses a military metaphor:

> The influence of European and American civilization on Japan during the 1860s and 1870s was traumatic and disruptive to a degree that is rarely found in the history of cultural intercourse. . . . For a time, any thought of defending traditional culture was scorned as an idle diversion from the critical need to respond to the urgency that faced the country. What had to be done was to penetrate the enemies' camp, grasp their weapons of civilization for use against them, and then turn to use them in the national interest.[11]

Responses to artistic stimuli from abroad do not require a military metaphor: art is more accommodating. Historians of East Asian art, whether specializing in China, Korea, or Japan, must compare notes about the impact of that great tide of artistic stimuli upon their visual worlds. Such a comparison awaits another opportunity.

11. Irokawa Daikichi, "The Impact of Western Culture," in *The Culture of the Meiji Period*, trans. and ed. Marius B. Jansen (Princeton: Princeton University Press, 1970), p. 51.

Yoshiaki Shimizu

第五節　近代與當代繪畫
論評

清水義明

普林斯頓大學

　　本場次共有四篇文章，或論當代中國的繪畫，或對中國繪畫進行全面反思。萬青力教授關注的是十八世紀時出現的新興商人畫家與贊助者。這個新興階層不僅挑戰了文人畫家幾世紀以來在藝壇的主導地位，更帶來藝術科目的變革；如篆刻的加入，便是值得矚目的成就，且足與傳統詩、書等藝術形式相抗衡。商人藝術家的興起，同時也促成了更動態的贊助環境；作品的展示空間與展覽的本身，皆鼓勵著公開展示的藝術觀念。公共展場的出現，亦從而刺激了藝術家對大型場地的關注，並由此衍生國際展覽的想法。

　　顏娟英教授的論文主題是日治時期的台灣繪畫。對台灣畫家而言，傳統的中國與步入現代化的日本，皆是文化地平線上的龐然存在；而顏教授的研究，則呈現台灣藝術家除得益於多樣的藝術表現型態外，同時亦是日本台、府展狹隘評賞標準下的犧牲品。文章更隱約地對日本帝國殖民政策如何扶植台籍畫家藝術之事給與評價，並以深具啟發性的手法縷述這Edward Said 所謂「東方主義」的另一樣貌。[1]

　　而巫鴻教授則討論中國大陸的前衛藝術家；這些藝術家對於文化上或歷史上與「傳統」有關的一切，不僅採取拒斥的態度，且以此拒斥的態度作為對「當代性」的認同。巫鴻更指出，中國前衛藝術與過去世界各地的前衛藝術運動大相逕庭。對這些中國藝術家而言，「當代性」指的並非時序，而是對他們尚未改造完成、卻不斷設法影響的世界的藝術認同。正如其歷史所示，這是避開本土觀看群眾的藝術運動，故亦必須於中國之外找尋知音。

　　Vinograd教授則直指中國繪畫各種論述的不同本質與不同終點（ends，在此處可指企圖或目的，亦可指媒介或終點）。他以為中國繪畫「必須以多元、多樣的角度來理解」，其「終點」（ends，不管是上述哪個意思）亦因此得依據各種「媒材、意圖、語言、種族、或理論與歷史的自覺」來決定。他更進一步指出用語方面的不固定性：當我們說「中國繪畫」（Chinese painting）時，便強調著畫家的種族；正如我們說「在中國的繪畫」（painting in China）時，即是在藝術作品上作政治疆域的區別。最後，他更提出要定義近期繪畫使之得以擺盪於中／西分野的問題，並舉一件宋代手卷為例。這卷宋畫激發

1. Edward W. Said, *Orientalism* (New York: Vintage Books, 1979).

一現代西方藝術家創作一類似畫作，我們或可將這西方畫家的作品視爲是原本宋畫的延續，然此作雖自中國的傳統而來，卻不屬於中國文化的範圍。

Yoshiaki Shimizu

第五部　近・現代絵画
論評

清水義明

プリンストン大学

　当セクションの四つの論文は、中国の比較的最近の絵画、あるいは中国絵画全般に関する近年の思潮を論じている。萬青力教授の論文は、18世紀、中国の商人階級に新しい芸術の創作者と庇護者が出現し、数世紀続いた文人画家の支配に異議を唱えたことを論じている。新しい画家達は美術の教育制度にも実質的変化をもたらした。たとえば、篆刻術が立派な嗜みとして、また伝統的に高尚な芸術である書や詩と肩を並べるものとして確立された。商人の芸術家の隆盛は、より活力に満ちた庇護者の登場と期を一にし、またその道を開いた。一般大衆が鑑賞するための芸術という全く新しい概念が、それに付随する展覧会や芸術家のための展示スペースとともに発展した。公共の展示場の創造が今度は芸術家を刺激して、より広大な展示場を求めさせることになり、そこから国際博覧会の概念が生じる。

　日本の統治下にあった台湾の絵画が顔娟英氏の論文の主題である。台湾の画家にとっては、伝統的な中国と、近代化する日本が、共に文化の地平線に立ちはだかっていた。顔教授は、台湾の人々が、日本の提供する美術教育課程の受益者であるとともに、展覧会主催者の日本人の偏狭な美術的判断基準の犠牲者でもあると述べている。後者は台湾の芸術家の大志と衝突するものであった。この研究は日本の帝国主義の植民地政策がいかに台湾出身の画家の芸術を抑圧したかを暗示している。故Edward Saidの定義した「オリエンタリズム」のまた別形態のものがここに刺激的に示されている。[1]

　巫鴻教授は、中国本土の前衛芸術家が文化的そして歴史的に「伝統的」とされるものすべてを否定し、その否定によって「現代性」の概念を体現していることを述べる。中国の前衛芸術は、世界の他の場所で先立って起こった運動とは全く異なるものと特徴づける。こうした中国の芸術家にとって、現代性とは単なる時代区分を指すのではなく、自分達が作ったものではないが影響を及ぼしたいと願う世界における芸術的アイデンティティーを指す。その歴史から明らかなように、これは自国の支持層たる鑑賞者を欠いた芸術運動であり、必然的に中国の外部に観客を求めなければならない。

1. Edward W. Said, *Orientalism* (New York: Vintage Books, 1979).

Vinograd教授は、中国絵画に関する多くの異なった言説の本質と、多くの「終焉（ends）」（ここでは「目的」「狙い」また「形式と媒体」「終結」とも読める）を説明している。教授の指摘によると、中国絵画は「複数として、多数として理解するべきであり」、それゆえ、その「終焉」（その語を我々がいかに定義しようとも）は「メディア、目的、言語、民族性、または理論的、歴史的自己認識によって」様々に定められる。さらに、我々の使う用語さえも不安定だと指摘される。「中国絵画」と言えば、ただちに画家の民族性の意味についての問題を提起するが、「中国における絵画」と言えば、国家の境界線と芸術作品のカテゴリーの関係についての問題を提起する。最後に教授は、中国、西欧の芸術家を問わず、中国／西欧の境界線で「揺れ動く」近年の絵画の定義づけを問う。一例として、現代の西欧の芸術家が、宋代のある画巻に触発されて、変種の作品を創作すると、それはある中国絵画の後生であると考えられるかもしれない。その作品は、紛れもなく、その究極の源を生み出した文化に由来してはいるものの、その文化には属さないのである。

Yoshiaki Shimizu

Concluding Remarks

Concluding Remarks

John Rosenfield
Harvard University, Emeritus

Now in my late seventies, I was the oldest person speaking at this conference, having been active in the study of Asian art for over five decades. I was born and raised in Dallas, Texas, then a small and isolated inland town with few connections to any part of Asia. But like many American Orientalists of my generation, I was introduced to Asia through military service. The United States Army sent me to India, Burma, Srī Lanka, and Thailand in World War II. In the Korean War, I served in Korea and Japan. As my abhorrence of war and militarism increased, my interest in Asian art and thought deepened, and I finally I settled on the study of Japanese art.

During my lifetime, the history of Asian art has flourished in many places, but nowhere more vigorously than in Japan. It is hard to explain why, but since the beginning of the modern era, Japan has produced more art historians per capita than any other nation on earth. It has created a system for maintaining its cultural properties that is unrivalled for efficiency and impartiality anywhere in the world. It has established chairs for art historians in its great universities, and built a vast network of art museums at national, prefectural, local, and private levels. It has invented an ingenious system of sponsorship (often by newspapers and publishing houses) that produces each year many ambitious art exhibitions, and it regularly sends exhibitions overseas. It has created foundations to support the study of Japanese art throughout the world; it offers generous assistance and a warm welcome to foreign scholars. Its vast and tireless publishing industry prints a flood of learned journals, lavish exhibition catalogues, and monographs. Very recent economic difficulties have caused a severe retrenchment in some of these activities, but I hope that this is temporary.

During the past fifty years, Japan has sent forth art scholars and administrators of extraordinary vision and ability. I would like to echo James Cahill's tribute to his teachers and predecessors by mentioning a few Japanese scholars who exerted great influence on me at an early stage of my studies. Yashiro Yukio 矢代幸雄 saw Japanese art in an international perspective and helped revise and liberalize the system of registering national cultural properties. Tanaka Ichimatsu 田中一松 wrote tightly focused essays on connoisseurship, each a mini-masterpiece, which set a new high standard of objective, comprehensive research. Akiyama Terukazu 秋山光和 brought the resources of laboratory equipment (such as X-ray and infrared photography) to connoisseurship. And Shimada Shūjirō 島田修二郎, equally at home in Chinese, Korean, and Japanese painting, developed an inclusive vision that inspired the organizers of this conference. I should also note that the positivist, empirical research in art history in postwar Japan has been in close harmony with the nation's great emphasis on technology and science. Largely vanished today are the

polemical, nationalist (if not imperialist) sentiments found earlier, for example, in the writings of Okakura Kakuzō 岡倉覚三 (Tenshin 天心; 1863–1913)—as Satō Dōshin 佐藤道信 mentioned.

In America, which emerged relatively unscathed from World War II, the study of Asian art also developed dramatically. For example, when Harvard University asked me to begin a program in Japanese art in the early 1960s, there were only three American art historians in senior positions able to read Japanese publications. Now there are dozens, and art history has become one of the most effective branches of the humanities in training college students in the history of Asian civilization. Of the many professionals who exerted powerful influences on me, I will mention only three. Lawrence Sickman's profound scholarship brought Chinese art of the highest quality to the Nelson-Atkins Museum in Kansas City. Alexander Soper at New York University selflessly edited the fine scholarly journal *Artibus Asiae* in difficult times and trained many gifted students. Sherman Lee's publications and exhibitions made the Cleveland Museum of Art a major source of stimulus and insight.

The nations of Europe suffered terrible destruction in World War II. France, in particular, lost many of its fine Orientalists and has had difficulty replacing them. England and Germany, however, have seen a recent and heartening increase in activity in our field, due in part to those who kept the tradition alive in the difficult postwar years. I will name only Basil Gray and Jack Hillier in England, and Dietrich Seckel and Roger Goepper in Germany. Korea began its own developments after the end of hostilities in the 1960s. Scholars such as Kim Chewon 金載元 and Kim Won-yong 金元龍 helped preserve the field and laid the groundwork for the extraordinary growth of publications, exhibitions, and museum building of recent decades. In the People's Republic of China, changes in cultural policies since the 1980s have resulted in a similar outburst of activity, with publications pouring from its presses in great quantity.

Thanks to advances in language teaching, students in the West have become much more fluent in Eastern languages than their predecessors, much more able to read old documents, and much more comfortable in private conversations with Asian scholars. Libraries everywhere have become far richer in research materials (including the new electronic media). Generous fellowship programs have allowed longer periods of study abroad. The younger generations are capable of far more specialized research than their predecessors. And we are eagerly waiting the next major development in the East Asian field, the emergence of Vietnam. A number of Vietnamese scholars are now training abroad, and before long we shall learn of that nation's surprising and unheralded artistic achievements.

In the introduction to the fourth section, I briefly mentioned that art historians in Europe, America, and, to a lesser extent, Japan have been engaged in serious debates about the goals and methods of scholarship. Some thirty years ago an intellectual movement that is very loosely called "Post-modern Critical Theory," or the "New Art History" (see Tsuji Nobuo's 辻惟雄 paper), began to challenge Modernism in art and architecture and to contradict some of the most basic principles of traditional scholarship. Though this movement has little internal cohesion, it is united in the belief that long-established fields of study have become stagnant and oppressive. Its criticisms are occasionally combative and self-righteous. More often, however, they are implicit and unspoken, as younger scholars simply turn

their backs on the old "common-sense" methods and adopt new ones. We should not be surprised, however. Changes occur constantly in technology, economics, government, and in our daily lives. Since its beginnings in the late nineteenth century, our profession—the systematic study of Asian art—has never been stable. It has been continually moved by the shifting tides of aesthetic preference, artistic practice, political doctrine, economic conditions, and—of course—the clash of nations at war.

Ethics

I am convinced that the sharpest conflicts between Post-modern Critical Theory and traditional scholarship arise from ethical issues, and they reflect, consciously or otherwise, long-standing conflicts between the political Left and the political Right. At one time this meant the contest between collectivists and those who believed in the freedom of private enterprise. Today it is changing into a contest between so-called globalization and those who resist it. The impact of Post-modern Theory has occurred most dramatically in China, as Wu Hung's 巫鴻 paper on studio practice makes so very clear in its account of the subversion of established artistic genres and the resistance to official art. In the realm of art history in Europe and America, these ideas have opened a divide between academic art historian-theorists and the alliance of private collectors, art dealers, museum curators, and publishers who sustain the commercial art market and museum exhibitions—the public face of our profession.

At the root of the conflict lie codes of right and wrong. Post-modern Critical Theory places primary emphasis on the search for social justice and human well-being; and in art history it focuses on social and economic issues, such as the class structure of patronage, or the effects of discrimination by race and gender on artists and their subjects. At a more material level, the New Art History criticizes the present-day collector-curator-dealer alliance for depriving poor nations of their cultural heritage and for alienating works of art from their proper contexts. It claims that the art market promotes the category of ideal golden ages, master artists, and masterpieces—elitist canonical values—and ignores ethically important matters. It notes that some private collectors are financial speculators (buying cheaply and selling dearly after bidding up the market), while others arrogate to themselves the high virtues inherent in great art, a process known as "vanity collecting" or "merit scavenging." It maintains that public scandals (auction-house officials convicted of fraud, art dealers jailed for violating export laws, forgers hauled into court) are the surface manifestations of the corruption that drives idealistic young scholars from this aspect of the art world. In particular, it drives them away from the tradecraft of connoisseurship.

Connoisseurship may be defined as the ability to determine the authorship, conditions of origin, physical condition, authenticity, and relative quality of a work of art, and it was long considered the most fundamental of the art historian's professional skills. In my graduate school days at Harvard, students were constantly being asked to compare the quality of one painting with another. Those who excelled at this were said to have an "eye," and we often heard comments like, "Mr. X may be able to read inscriptions in Chinese, but he doesn't have an eye for quality."

John Rosenfield

Today, however, many students in Europe and America believe that connoisseurship has been fatally contaminated by its service to the art market, and they refuse to engage in it. They maintain that to authenticate paintings, advise collectors, or organize exhibitions is to ally themselves with reactionary, conservative forces.

In my fifty years' experience in our field, I have seen at first hand the ethical and intellectual offenses mentioned above, and I have tried to resist them. But I have also encountered honest and scholarly dealers, curators with great knowledge and high integrity, and collectors moved by genuine admiration for the objects of their desire. Few private collectors have Asian language skills or systematic training in art history, but many have honed their intellects in business or medicine, education, or law. Responding to the expressive power of works of art, they collect without the constraints of museum acquisition committees and peer reviews, and they have opened the eyes and minds of scholars to important bodies of material. Many collectors are public-spirited and respectful of scholarship. They publish catalogues of their holdings, subsidize symposia, sponsor visits to their collections by teachers and students, serve on museum and gallery boards, and recognize the importance of collections as unique educational resources. The brains, money, and energy of responsible collectors have enlivened the field. To discriminate against all collectors, dealers, and curators because of the misdeeds of some is shortsighted. To adopt a rigid, puritanical attitude toward the commercial aspects of the art world is to deny the historical importance of collecting and art dealing, which Craig Clunas' paper demonstrates so clearly. To abandon the craft of connoisseurship is to weaken the scientific, empirical base from which our theoretical judgements should derive. For theorists to withhold their high intelligence from the public aspects of the art historian's world is to fracture and impoverish our community.

Changing Research Topics

Professional art history in Japan and the West began with a strong preference for early material. In 1899, for example, Kuki Ryūichi 九鬼隆一 (1852–1931), then Japan's most influential art administrator, wrote that Japanese art had declined steadily since the thirteenth century. In a publication of 1910 the American scholar Ernest Fenollosa (1853–1908) claimed that the art of China from the middle of the Ming dynasty onward was childish, confused, and merely ornamental (*bric-a-brac*), and he said that Japanese art of the Edo period had descended into triviality. Indeed, as late as the 1950s, largely owing to Fenellosa's influence, the West considered Southern Song painting to be the pinnacle of East Asia's artistic achievements. In the 1950s, however, Western scholars began paying serious attention to literati painting in China and then in Japan and Korea. This change in taste was the result of the growing acceptance of expressionism in Modernist art in the West. Continuing this trend, Western scholars have recently turned to the arts of the twentieth century in all East Asian countries, finally overcoming the preoccupation with earlier periods that had long dominated the field.

If the subjects of painting scholarship have changed, so also have its techniques. For the past half century, the chief idiom of Western research in the history of painting was the life-and-works study of a famous artist. I can

name three dozen Western books and doctoral dissertations of this type. There are, however, shortcomings in this approach. First of all, an authentic biography requires such an enormous amount of data that writing an accurate biography alone is a major task. (The detailed essays of the tireless Japanese biographer Mori Senzō 森銑三 offer a stern warning on this point.) Second, it is still exceedingly difficult to define a body of authentic paintings by a single artist, and the output of very few Eastern painters has been the subject of an authoritative compendium.

Among other major, long-established Western scholarly idioms are translations of painting treatises, or the focus on a single major work of art, its origins, and significance. These have the advantage of setting a realistic limit to the scope of a study, but have as a side effect a severe narrowing of the scholar's vision. Though they are still being undertaken, the older customary idioms are rapidly losing favor.

In their place have come thematic studies. Some are focused on the visual content of painting, such as aspects of portraiture, the development of "true-view" (or topographic) landscapes, or the role of certain composition types. More often, however, the visual components are being ignored or made secondary. Coming into great favor are discussions of how artistic endeavor is affected by patronage and the art market, for example, and by gender (especially feminism), race, and social class, or semiotic studies (such as the relationship between poetry and painting). A factor promoting the new themes is an intellectual strategy known as "deconstruction," which has been applied to many branches of knowledge, such as literature, linguistics, philosophy, law, and history. Jerome Silbergeld and Wu Hung used this term prominently, for it is a major element in Post-Modern Critical Theory—with roots in serious questions of epistemology.

I find the term "deconstruction" impossible to define succinctly. Its main effect on studio practice is to deny the traditional media of painting and calligraphy in favor of installation, performance, and video art. In art history it resists traditional conceptual guidelines and categories of thinking. For example, it distrusts aesthetic judgements of the beauty or uniqueness of a work of art. It rejects the kind of thinking on which the rank-orders of great artists and great works are based, as Tsuji Nobuo mentions in his essay. It resists the focus on the artist as a solitary creator; it discredits the notion of "genius," discourages egoism, and abandons the writing of biography. It resists the familiar division of art history into epochs and golden ages; it opposes the ranking of high art above popular art. It pays no homage to the social institutions (imperial academies, official painting schools) that have supported the old value systems. It ignores many of the established research themes, such as the stylistic evolution of a given motif (Chinese monumental landscape painting of the Five Dynasties period, for example). Other rejected themes include the influence of artist upon artist, of painting school upon painting school, or the influence of one nation upon another. In the place of traditional categories of thought, deconstruction prefers what it calls "indeterminacy." It is highly skeptical about dogmatic certainties. Willfully ambiguous, it refuses to define its doctrines. It loves parody, irony, and humor—elements that were especially prominent in Wu Hung's account of the present-day Chinese avant-garde. The Post-Modern Critical Theory movement, however, is over thirty years old. In some circles it has evolved into "Cultural

John Rosenfield

Studies," in which the rupture with the past is even more pronounced. Cultural Studies embrace even more unconventional subjects—the sexual content of advertising art, for example, or the nature of amusement parks.

Nationalism

Of all the old interpretative themes in art history, none has been more powerful in Asia than nationalism, which George Orwell defined as the habit of identifying oneself obsessively with a single nation and recognizing no other duty than that of advancing its interests and enhancing its prestige. As described by Orwell, this attitude is a poison that clouds the brain and leads to folly, whereas non-obsessive forms of nationalism can be a health-giving tonic that inspires an entire population. I gained insight into this issue when, in 1964–65, I translated into English a survey book on early Japanese art by Noma Seiroku 野間清六, a learned and highly cultivated scholar who passed away in 1966. I greatly admired his erudition, the organization of his book, and his graceful use of the Japanese language, but I was troubled by nationalistic passages in which, for example, he boasted of Japan's unique artistic sensibility and its special vision. When I pointed these out to him, he said, "Cut them out. They are intended for the Japanese." The exchange with Noma taught me that nationalism is not an export commodity; it has no appeal to foreigners. Present-day Japanese scholars have become increasingly aware that Japanese art is now an important part of the world's cultural heritage. Not that they are indifferent to their own national culture, but they no longer feel the need to insist on its superiority or uniqueness or to search for a national essence. Furthermore, their ideas have an important foreign audience, which would feel little sympathy for expressions of hyper-nationalism.

The question of nationalism brings into focus the contrast between the local and universal content of the study of East Asian art. Much of traditional art history has focused on concrete, specific topics in a local setting—introducing new works, reinterpreting or re-dating familiar ones, or finding new documentation. Hovering above such topics is the question of the larger interpretations of the material. If an object is re-dated, does this change our understanding of developments in the stylistic make-up of its type? If its meaning is reinterpreted, does this change our understanding of its patrons or its role in society? And if scholars move to such larger questions, are they prepared to address them in the wider, more universal contexts? As Helmut Brinker put it, a field of study (say, Buddhist painting, or literati painting) functions on three levels. It arises in a local, regional, or national context. It next becomes a subcategory of Asian art, and then may be seen as a part of world art. Ideally, scholars should think of all three levels of understanding, but, in fact, circumstances dictate how best a scholar functions. An Asian student of Buddhist or literati painting will closely study the local evidence concerning the origins and social life of a painting. A scholar working abroad will more likely be aware of its broader, international aspects and its relationship to other similar idioms elsewhere. Indeed, one of the purposes of this conference has been to encourage understanding of the second and third levels of analysis by bringing together scholars with similar interests from different regions and asking if they perceive the themes and interests that they share in common.

The planning committee of this conference limited its scope to the history of painting for both practical and intellectual reasons. Archaeology, sculpture, architecture, and handicrafts, to be sure, are of great importance. As Brinker pointed out, archaeological excavations in China and the discovery of important new Buddhist sculptures have caused major changes in the larger history of East Asian civilization. However, for practical purposes, the conference planners needed a coherent theme. They reasoned that painting—with its links to calligraphy and poetry evokes central issues in the cultural evolution of mature societies and shares many topics with the history of Western art. These international topics include the gradual decline of religious imagery, the character of landscape painting, the rise of urbanism, the outpouring of individualism and expressionism, and the commercialization of the arts. Even if Wu Hung's predictions of the death of contemporary painting are correct, we can still take comfort from Richard Vinograd's assertion that painting has been absorbed into other mediums and idioms, and that it will live on as part of something newer and perhaps richer.

This conference has brought together historians in three age groups: the old, the middle-aged, and the young. The old are senior scholars (retired or nearly so). Next are those who have begun to replace them at major universities and museums, and then comes an even younger group that will provide leadership deep into the twenty-first century. The conference has brought together persons who employ different methods and analytical approaches, and those who work in different contexts: professors, curators, and private scholars. Parenthetically, I must note with great sadness that missing from the middle group is one of Japan's most adventurous and creative art historians, Chino Kaori 千野 香織 of Gakushūin 学習院 University, whose sudden death caused shock waves of grief throughout our profession.

As the oldest contributor to this volume, and active in the study of Asian art for a half century, I conclude by offering a few personal comments. I agree with Sir George Sansom that Western-trained scholars cannot achieve the depth of knowledge and understanding of Asian materials and topics that our Eastern colleagues possess. We are their pupils, not their teachers. We depend upon their spadework and are grateful for the help they give us. At the same time, we can contribute because, inescapably, we see the same material from a different, perhaps broader, perspective, and that we are equipped to interpret those materials to Western audiences. The spread of the understanding of Eastern civilization abroad is a vital function.

For myself, Western-trained, to be an historian of Asian art is a privilege greatly cherished. I have been given close access to some of the most accomplished creations of the great civilizations of the East, to the philosophic ideals that inspired them, and to Eastern colleagues who have generously offered their friendship and helped me in my studies. I welcome the recent tumult over scholarly methods and goals. I approve of the emphasis upon heightened ethical standards in collecting, museums, and scholarship. I agree with the sharp skepticism about inherited methods and canons as I welcome the introduction of new insights from sociology, economics, anthropology, and linguistics. The papers in this volume—diverse in their methods and goals but harmonious in their larger principle—have filled me with great optimism for the future. As my generation leaves the stage, I hope that our field of study is in a better condition than it was when we entered it.

John Rosenfield

閉幕詞

John Rosenfield
哈佛大學榮譽教授

　　過去半個世紀以來，系統地研究東亞藝術已有很大的進展，但沒有比日本來得更劇烈的了。充滿野心的博物館展覽、新的大學中藝術史的職缺、豪華出版品的橫流—在在都讓這片領域吸引一般觀眾的目光。同樣在這段時間裡，藝術史的操作方式有了急速的改變，這是受到美學品味改變、藝術創作、政治信念、經濟環境，以及戰爭中國家崩解的影響。

　　五十年前的這塊領域仍以早期為焦點，並且宋代宮廷繪畫被認為是亞洲圖像藝術的巔峰之作。然而，一些西方學者受到現代藝術表現主義的影響，開始正視中國、日本及韓國的文人畫。延續著這股風潮，近來許多人轉向所有東亞國家二十世紀的藝術，終於打破長期主宰研究領域的早期藝術獨霸的狀況。

　　五十年前，大部分論繪畫的書及博士論文，都是對有名藝術家生平與作品的研究，但這種取向就現代標準來說不但無法繼續而且不受青睞。不僅因為它的主要工作只是為了製作一部可靠的傳記而進行大量資料的收集，而且對這種稀稀落落的幾位東亞畫家研究的成果，也不過成為權威概論的主題而已。因此，學者們開始轉向主題研究，像是肖像畫、「實景」（或地誌式）山水的發展，或是某種構圖種類的角色。

　　約在三十年前出現了一波知識界的運動，可以非常鬆散地稱呼為後現代批評理論，或者新藝術史，它們開始挑戰傳統研究的許多最基本假設。這個運動雖然少有內聚力，但是卻整合在相信藝術史長久建立起來的方法因為強調偉大藝術家、黃金時期及美學價值，已經變得陳腐及退流行了。這種批評是由政治左派與右派間長期存在的緊張所引發的。

　　接受傳統藝術史訓練的學生傾向於評斷藝術品的真偽與品質、追蹤風格的發展、解釋這些作品的表現力。後現代批評理論則將重點放在社會正義的研究，並聚焦於經濟與道德議題—贊助的階級結構、種族與性別的歧視對藝術家及其主題造成的效果、富有集團對藝術品豐富的貧弱國家之劫掠。新的理論批評推動偉大的「經典」藝術以及金錢交易的藝術仲介商—收藏家—美術館員所組成的聯盟。受到這種觀點影響而富於理想的年輕學者摒棄鑑定這種商業技術，也謝絕鑑定畫作、為收藏家提供建議，或是籌辦展覽。

　　另一個今日研究越見重要的因素是所謂的「解構」這種知識性策略，它已被應用在文

學、語言學、哲學、法律、歷史等其他知識分支中。要為此作簡潔的定義有些困難，它對藝術史的主要影響在於對藝術品的美或獨特性的美學評斷失去信任。它聲稱一件作品原本的脈絡不可能被完全確定，並且如同佐野みどり所言，聲稱觀者才足定義者。它略去了辻惟雄先前提到的偉大畫家的排名問題。

它反對被視為獨立創造者的藝術家成為焦點；不承認傳記所寫的「天才」這種想法；不贊成讓經典藝術凌駕於大眾藝術之上。故意地模糊，它拒絕定義其運作的準則。它喜愛諷刺、嘲諷及幽默─這些因素在巫鴻對今日中國前衛藝術家的敘述中格外顯著。後現代批評理論運動已有超過三十年的歷史了。在某些領域中已轉成文化研究，而與過去有更明顯的斷裂。文化研究擁抱了更多非傳統的主題，例如：廣告藝術中的性別脈絡，或是遊樂園的本質。

這份論文集聚集了採用不同方法與分析途徑的眾人之作，他們也分屬於大學與美術館等不同的脈絡中。論文集中的論文，雖然方法和目標歧異，但在增進彼此瞭解這更寬泛的原則下卻十分協調，也讓我們更加樂觀地展望未來。

結び

John Rosenfield

ハーバード大学名誉教授

　過去半世紀にわたって東洋美術の体系的研究は大きく発展してきたが、それが最も端的なのは日本であった。意欲に満ちた美術館の展覧会、大学の新しい美術史講座、膨大な刊行物、それらによりこの分野は一般大衆の注目を集めるに至った。同時期に美術史の実践法も急速に変化した。それは、美的趣向、工房制作、政治的主張、経済状況、そして当然ながら、戦時の国家間の衝突といった激変の影響を受けた。

　50年前、この分野はまだ初期の時代を重視し、宋代の絵画が東洋絵画芸術の頂点と考えられていた。だが、欧米の学者の中には、近代芸術における表現主義の受容に影響を受け、中国、そして日本、韓国の文人画に真摯に注目する研究者が現れ始めた。この傾向に従い、東洋すべての国の20世紀美術に目を向ける学者も近年現れ、長らく支配的であった初期美術への偏重がついに克服された。

　50年前には絵画に関する書物や学位論文の大多数が有名芸術家の生涯と作品の研究であった。だが現代の基準からはこうした研究方法は実際的ではなく人気を失った。信憑性のある伝記に要求される莫大なデータを収集することが主要な作業であったばかりか、ほんの数人の東洋画家の作品が権威ある美術概論の題材であった。しかし、今日の研究者は、肖像画法の諸側面、「真景」図の発展、ある種の構図の役割といった主題研究に目を向けている。

　およそ30年前にポストモダン批評理論、あるいは新美術史と漠然と呼ばれる知的運動が、伝統的な学問の最も根本的な原則に異議申し立てを始めた。この運動は内的凝集力には欠けるものだったが、美術史の古くからの手法が、偉大な芸術家、黄金時代、美的価値を強調するために停滞し、旧態依然のものになったという信念においては結束していた。この批判は政治的右派と左派との長く続く緊張関係から生じたものである。

　伝統的な美術史の教育を受けた研究者は、美術作品の真偽や特質を判断し、様式の発展を辿り、作品の表現力を説明する術を学んでいた。ポストモダンの批評理論では社会正義の探求が第一に強調され、経済的、倫理的問題—擁護者の階級構造、人種やジェンダーによる差別が芸術家とその主題に及ぼす影響、美術作品を豊富に持つ貧国

の富者による略奪――が重点的に取り扱われる。新しい理論は、美術商―コレクター―美術館学芸員の連携が、美術品の価値を吊り上げ、金融投機に関わっていることを批判する。こうした見解に影響された理想に燃える若き研究者は、鑑識眼というスパイ技術を放棄し、絵画が本物であることを証明すること、コレクターに助言すること、展覧会を企画することを拒否するのである。

現代の研究者の間でますます重要となっている要素は、「脱構築」として知られる知的戦略である。これは文学、言語学、哲学、法学、歴史学といった多くの学問分野に応用されている。簡潔に定義するのは難しいが、美術史におけるその主要な働きは、ある美術作品の美や独自性に関する美的判断を疑うことだ。作品の元来の内容は決して正確に決定することが不可能だと主張し、佐野みどり氏が述べるように、作品の意味を決定するのは鑑賞者自身であるとする。先に辻惟雄氏が説明された偉大な芸術家の序列を無視する。唯一の創造者として芸術家に焦点を合わせることを拒む。伝記作品の「天才」の概念を信頼できないものとする。高尚な芸術を大衆芸術の上に位置づけることに反対する。故意に曖昧な立場を取り、自らの学説の定義を拒む。巫鴻氏による現代中国のアバンギャルド芸術家の解説で浮き彫りにされたパロディー、アイロニー、ユーモアといった要素を好む。ポストモダン批評理論は誕生してから30年以上になる。ある分野ではカルチュラル・スタディーズへと進化し、そこでは過去のものを扱う喜びが高らかに宣言される。そして、はるかに因習に捉われない主題―たとえば、広告芸術の性的内容や、アミューズメント・パークの本質―が採用される。

本書は、様々な手法や分析的方法を使い、大学や美術館という異なった環境で働く研究者達の論文をまとめたものである。本書に収録した各論文は、手法と目的において異なりはしても、相互理解というより大きな原則において調和のとれたものであり、将来への希望を抱かせてくれるものとなっている。

John Rosenfield